INVENTING THE MODERN ARTIST

INVENTING THE MODERN ARTIST

ART AND CULTURE IN GILDED AGE AMERICA

Sarah Burns

Yale University Press *New Haven and London*

Designed by Rebecca Gibb
Set in Bulmer Type by Rainsford Type, Danbury, Connecticut
Printed in the United States of America by BookCrafters, Inc., Chelsea, Michigan

Library of Congress Cataloging-in-Publication Data

Burns, Sarah.
 Inventing the modern artist: art and culture in Gilded Age America / Sarah Burns.
 p. cm.
 Includes bibliographical references and index.
 ISBN 0-300-06445-4 (cloth : alk. paper)
 0-300-07859-5 (pbk. : alk. paper)
 1. Art, American. 2. Artists—Psychology. 3. Art and society—United States—History—19th century. 4. Art and society—United States—History—20th century. I. Title.
N6510.B87 1996
701'.03'0973—dc20 96-5929
 CIP

A catalogue record for this book is available from the British Library.

10 9 8 7 6 5 4 3 2

CONTENTS

ACKNOWLEDGMENTS

Over the course of several years spent researching and writing this book, it has been my good fortune to have strong intellectual, moral, and practical support from many colleagues and friends. For their vital assistance in locating hard-to-find paintings and illustrations, I thank Lynn Corbett and Vicky A. Clark, The Carnegie Museum of Art; Catherine Gordon and Colum Hourihane, Witt Library; Susan Marcotte, Archives of American Art; Mary Holahan, Delaware Art Museum; Elizabeth Broun, National Museum of American Art; and Sarah J. Moore. Abigail B. Gerdts read a draft of the chapter on Winslow Homer and generously volunteered important information. Erica Hirshler, Museum of Fine Arts, Boston, graciously shared research and ideas on Edward W. Hooper. I also thank the staffs of the Boston Athenaeum; Massachusetts Historical Society; Houghton Library, Harvard University; the Harvard Archives; and the Boston branch of the Archives of American Art. For reliable cooperation and consistently excellent work, I am grateful to the office of Photographic Services, Indiana University. A year's sabbatical leave granted by Indiana University provided me with much-needed time for writing. To Terri Sabatos, who as my research assistant tracked down innumerable niggling details, I owe a special debt of gratitude for her efficient and energetic sleuthing. Heidi Downey at Yale University Press edited the manuscript with a sharp eye and a deft hand.

When the work was in progress, a number of colleagues provided important opportunities to try out versions of the material in public—in print or "on stage." I thank Katherine Manthorne, Cécile Whiting, Elizabeth Johns, Marianne Doezema, Barbara Groseclose, Erika Doss, Eric Rosenberg, and Gloria Fitzgibbon; also Tamar Garb, Jane Van Norman Turano, and Jayne Kuchna. I am most grateful to David C. Miller for his invaluable criticism and support of my ideas about late nineteenth-century studios and their meanings. David Tatham, Neil Harris, and Roger Stein were also helpful at an early stage of the project. I thank Bryan J. Wolf for his illuminating and thoughtful reading of the manuscript, and Judy Metro at Yale University Press for her consistent enthusiasm, engagement, and encouragement, which have been fundamental to the development and completion of this book. Finally, I owe a special thanks to the comrades-in-arms whose long-sustained interest, good humor, and friendship never failed to charge my batteries and keep me on track, especially Michele Bogart, Vivien Fryd, Karal Ann Marling, and Angela Miller.

INTRODUCTION

Templates for Modernity

In 1900, American artists—as seen by contemporary critics—presented a vigorous, triumphantly self-assertive front at the Paris Universal Exposition. John Singer Sargent's vivid portrait *Mrs. Carl Meyer and Her Children* (see fig. 73), occupying the center of one muted green wall in the American rooms, made an arresting impression as the "crack-a-jack picture of the show." Symmetrically flanking Mrs. Meyer—the quintessence of fashion and artifice—were images of raw, ostensibly unmediated nature: Winslow Homer's *Maine Coast* (1896; Metropolitan Museum of Art, New York) and *Summer Night* (1890; Musée d'Orsay, Paris). Paradoxically, these three works, oceans apart literally and figuratively, claimed equally to represent modern America and the modern American artist. Other artists contributed to this composite of national identity as well: acclaimed aesthete James McNeill Whistler joined his name with fellow expatriate Sargent's at the "head of the list of American painters," and Winslow Homer's stark marines stood for a flourishing school of "purely and entirely" American landscape painting, distinguished by its commitment to "genuineness" of vision. Viewed together, the stylistically and thematically disparate paintings displayed at the Universal Exposition formed a constellation signifying American modernity, which was in turn embedded in contemporary discourses of genius, individuality, authenticity, health, virility, civilization, and progress. This constella-

tion cohered only briefly before realigning its contours, and it proffered merely an illusion of a unitary American culture. But at the same time, it furnished a durable template of artistic modernity for the twentieth century.[1]

The artists whose works adorned the galleries during this immensely prestigious international exposition did not achieve such eminence through natural ability alone. They were the products of shifting networks of discourse on the questions of who and what an artist was to be in a changing and rapidly modernizing world, and what it meant to be modern and American. Until quite recently it has been something of a convention in American art historical scholarship to view the "Eight" (Robert Henri, John Sloan, and their cohorts), along with Alfred Stieglitz and his artists at the "291" gallery, as the first bona fide moderns: radicals and "revolutionaries" who boldly ruptured their links with nineteenth-century tradition and an older generation that they considered pallid, effeminate, and exhausted. These artists only seemed dramatically new and different, however. The terms of their engagement with culture had been drawn up by their predecessors, and in many ways their "revolution" proceeded along paths already marked.[2]

In this book I focus on the cultural construction of the artist during the last decades of the nineteenth century and the first years of the twentieth.[3] I ask how images of artists were assembled, by whom, and for what purposes, and how the burgeoning media played an increasingly dynamic role in representing the modern artist in the public realm. The vigorous growth of the book and magazine publishing industry was of utmost significance to the art world of the late nineteenth century. Through frequent appearances in the new mass-marketed, heavily illustrated journals, books, and newspapers, the American artist gained a wider public than ever before. The publishing industry helped make reputations and establish canons, rendering the artist a public, media-generated figure. Concurrently, artists learned to manipulate the media to their own advantage. This dialectic—artists as actors who are acted upon, representing themselves and being represented—constituted the phenomenon of "modernization": that process through which artists responded, reacted to, and were remodeled by new conditions of producing and marketing their work, and themselves, in a rapidly urbanizing and incorporating society in which mass culture, spectacle, commercialism, and consumerism were fast becoming common denominators of modern experience. Underpinning the study as a whole is the assumption that during the period under review, "artist," like "gender" was an unstable category, continually contested, appropriated, and reshaped by artists themselves, critics, writers, dealers, patrons, the public, and the media—interests sometimes colluding, sometimes competing, in a contest for the authority to define the nature and function of art, and its producers, in contemporary society.[4]

I propose to look at the subject from several angles, using selected key figures as both focal and jumping-off points. This book is a cluster of essays that sometimes overlap, sometimes complement one another. The dynamic is kaleidoscopic rather than linear: the same constants shift again and again to create different yet intricately

interconnected patterns. The chapters are united, however, in their sustained dialogue with a set of fundamental themes: image making, art in the marketplace, gender politics, and the formation of national artistic identity.

A word about absences. There are several here: the "big names" of Thomas Eakins and Mary Cassatt; sculptors, assigned to bit parts and glimpsed only occasionally; and African-Americans. Eakins and Cassatt are absent for the simple reason that the construction of their reputations has been a largely twentieth-century enterprise. Eakins received considerable press coverage during the last quarter of the century, yet he remained a peculiar kind of misfit whose true fame began to build only much later, after his death. In the 1890s, Cassatt was much less renowned in her native land than was Cecilia Beaux, her contemporary and fellow Philadelphian.[5]

For the sake of consistency and coherence I focus on painters and illustrators. In many ways sculptors and painters shared the same concerns and traversed the same social and cultural networks. Whereas painting came to be associated more and more with individualism, personal expression, and private vision, the function of sculpture in public was still largely commemorative, didactic, allegorical, and officially ideal. For that reason, public and critical response to sculpture tended in somewhat different directions. Despite the near-exclusion of sculptors, however, I often use the word *artist* to denote the generic figure—painter, sculptor, poet, novelist, musician, actor—that often stood for all in contemporary writing about the state of art in modern America.[6]

There was one African-American painter of renown in late nineteenth-century America: Henry Ossawa Tanner. He has only a walk-on role here, however, more or less reflecting his stature in the late nineteenth century as the unique exception to the rule that whiteness and high culture were interchangeable as values. The absence of race in this study should not be inferred as an evasion but rather a reflection of its nonexistence in cultural discussions of the Gilded Age, when there was little or no question that only whiteness counted in building, defending, and advancing civilization. Certainly there was a tacitly acknowledged substructure on which white superiority erected its triumphal towers, since the very assertion of betterness required the existence of "lowly" races to function as a measure of difference. The fact that the U.S. Supreme Court in 1896 upheld the "separate but equal" system of segregation in the South is significant. During the post-Reconstruction years an unwritten set of artistic Jim Crow laws remained in effect, and "equal" was of course a euphemism.

The star players here are James McNeill Whistler, John Singer Sargent, Cecilia Beaux, William Merritt Chase, George Inness, Winslow Homer, Charles Dana Gibson, Thomas Hovenden, and Albert Pinkham Ryder, with a large cast in minor roles. I emphasize eastern metropolitan culture, though Chicago has a place in the billing, and the patterns sketched provide models for examining other regional art worlds. The "stars" appear here because during their own lifetimes all of them—despite dramatically different styles, career patterns, and even expatriation in the case of Whistler and Sargent—earned preeminent status as exemplary American painters, all uniquely gifted

and individual yet representing and setting standards (often contradictory ones) for contemporary culture on a larger scale. The fact that some of these artists, notably Whistler and Homer, have become, for complex reasons, "canonical" giants might arouse the suspicion that I am reinforcing or perpetuating a canon that should instead be pried open and picked apart. By investigating how fame was manufactured in the artists' own day, however, I hope to expose the roots, and the politics, of canon formation rather than merely ratify the process and its consequences.

The Artist in the Age of Mechanical Reproduction

By the 1890s the machinery of American publicity was in high gear, its momentum so relentless that, as Henry James observed, "it procures for the smallest facts and the most casual figures a reverberation to be expected only in the case of a world-conqueror. The newspaper and the telegram constitute a huge sounding-board, which has, every day and every hour, to be made to vibrate, to be fed with items." Among the delicacies consumed by the mass media and relished in turn by an expanding public were artists of all kinds, served up along with politicians, statesmen, adventurers, socialites, philosophers, scientists, and tycoons. Although the rise of publicity was international in scope, Chicago author Henry Blake Fuller attributed its intense cultivation in America to the poverty of national cultural traditions combined with a characteristically energetic popular interest in human nature. As a result, "Our public, in so far as it cares for the artist at all, cares only for his personality, his individual presence. It gives little heed to his ideas, and less to his expression of them. It wants to see the man himself—once; the interest is that of a mere personal curiosity, and is soon gratified."[7]

By the end of the century, mediated versions of "the man himself" (or the woman) were everywhere, in representations devised by critics, reporters, and gossip columnists for the monthly, weekly, and daily press. Those representations introduced a huge audience to a vivid constellation of ideas about what an artist in fin de siècle America was—and was not—supposed to be. At the same time, improved technologies for reproducing visual images dramatically enhanced the sophistication and credibility of the portraits, illustrations, and cartoons of artist figures that inhabited the pages of the media in growing numbers. Hundreds of thousands of readers who were unlikely to encounter an actual living artist could now claim firsthand acquaintance with the next best thing. This was not altogether a sudden development. By the 1850s the artist was well on the way to becoming a public figure, even a celebrity, as demonstrated by the well-orchestrated advertising campaigns attending the exhibitions of Frederic E. Church's blockbuster landscape paintings. What was new in the later years of the century was an insistent emphasis on the personal, and on the personality.[8]

Often this new emphasis entirely displaced appreciation and criticism of the work itself and seemed to account in large measure for an artist's success. Any artist who refused to posture in the limelight of publicity stood the risk of failure, no

matter how fine the work. In M. H. Vorse's wry opinion, this was precisely the problem with Joseph Conrad. Conrad was well known, yet he had not enjoyed the success he deserved. For every reader of *Lord Jim* there were a thousand to consume books like Charles Major's best-selling romance *When Knighthood Was in Flower*. The cause was not far to seek, and it was really Conrad's own fault: "He has neglected to court the interviewer. Why, we do not even know whether Mr. Conrad takes lemon or cream in his tea, or just what the circumstances were which induced him to leave his earlier profession for the trade of writing books, or any of the other interesting details which we feel entitled to know about authors—details which make an author popular. Then, too, we see no pictures in popular magazines of Mr. Conrad reefing a sail in a breeze, Mr. Conrad and his dogs, Mr. Conrad putting trees in his shoes. He has merely been writing books." Percival Pollard, an equally sardonic observer of celebrity culture, wondered rhetorically why anyone should care whether the author of " 'Mrs. Patch's Wig' " spent the summer in Speonk and the winter in Elliott's Key, or why anyone would hunger to have "books of portly size, of grandly glazed photographs . . . which depict the magnificence with which our authors live when they are at home."[9]

Like the authors referred to by Pollard, American artists became the stars of articles devoted to their summer vacations, urban studios, domestic habits, and personal traits. Whether courting publicity or shunning it, the artist of the period had to confront an unavoidable fact of modern life: in addition to being a producer of aesthetic commodities, he (or she) had to become a commodity as well—a consumable personality, fodder for a curious public never satisfied for long. At the turn of the century, the identification of producer with product became complete, and consideration of personality was almost inseparable from appreciation of the artist's work. Some artists—notably Winslow Homer—certainly became well known without ever allowing interviewers to divulge their eating, grooming, and recreational habits. In Homer's case, critics who were unable to pry personal information out of the fiercely reticent Yankee simply made him up, freely imagining the kind of man he must be to paint such pictures and (as I discuss later) falling wide of the mark on numerous occasions. Disparities between "real" artists and media representations of them were more often than not beside the point, however. The public version was the one that most people saw, read, and believed.

In the Magazines

The great boom in mass publishing late in the century was directly responsible for kicking the publicity machine into high gear. In 1893, Nathaniel Fowler, producer of how-to manuals for success in business, declared that the magazine had become an absolute necessity of life. The mass production of books also flourished, and in the 1890s the first official best-seller lists appeared. American readers now lived in an environment permeated and saturated by the printed word and, even more significantly, the printed image. So rapidly did illustrations of every sort invade the

magazines that some feared the eventual disappearance of the word under the "Tyranny of the Pictorial," as one journalist put it. Lower prices also extended the range of the media. Introduced in the 1890s, the new ten-cent magazines, such as *Munsey's*, *McClure's*, and *Cosmopolitan*, attracted many thousands of new readers to their lively, abundantly illustrated pages. In response to the threat of competition, established magazines, including *Harper's* and *The Century*, scrambled to adopt a sprightlier tone. Also important was a steady increase in advertising patronage, which enabled editors to pay top dollar for popular writers and illustrators.[10]

Although circulation figures are unreliable, it is certain that they mushroomed. By 1905 there were twenty mainstream monthly magazines with circulations of 100,000 or more, reaching in aggregate an audience of 5.5 million. For the mainstream publications (*Harper's*, *Munsey's*, *McClure's*, *Ladies' Home Journal*, *Cosmopolitan*, *Collier's*, and others) the audience was largely if not exclusively composed of middle- and upper-class readers, with a strong feminine component and a divide between older readers partial to well-established periodicals and younger ones attracted to the ten-centers.[11]

Along with the powerfully influential daily papers, the new magazines and books of all descriptions represented the world to millions of readers. They did not of course represent any broadly consensual points of view. Their politics ranged from liberal (*The Arena*) to conservative (*The Nation*), and their tone from snappy (the redoubtable *Munsey's*) to dignified (*Harper's*). But they did stand for distinct regional biases: New York remained a center of publishing, followed by Boston and Philadelphia. Even though Chicago and a few western or southern towns supported a healthy publishing establishment, the world's center for the majority of editors and critics remained an eastern city whose culture and problems defined what was important, and what was American. The configuration of the American art world was similar. As represented in the magazines, this world privileged eastern art culture and its producers while purporting to represent a larger, vaguer norm of national cultural identity. A study of what was said (and by and to whom) about artists in the media, therefore, can begin to reconstruct how such representations worked to construct or dismantle patterns of artistic identity and to shape expectations about what constituted artistic manhood and womanhood, not just for New York, Boston, or Chicago, but for all of America.

The New Critics

Specialization and professionalization attended the development of late-nineteenth-century magazines, as in the sciences, humanities, medicine, business, and other fields. Dozens of special-interest publications now appeared: humorous and satirical magazines, sporting magazines, radical magazines, physical fitness and mind-cure magazines, religious magazines of all denominations, children's magazines, and fashion, art, and settlement house magazines. Many, including most art magazines, had modest circulations. According to Frank Luther Mott, only the *Art Am-*

ateur and the *Art Interchange* maintained circulations of as much as ten thousand between 1885 and 1905, indicating an audience as specialized as the magazines themselves. By contrast, true mass magazines attained circulations of a million or more. Art features, however, were not limited to ultraspecialized journals. They appeared regularly in both the established and the upstart quality magazines, which ran essays and columns on art, artists, and art history, along with more or less regular reviews of exhibitions. For these features editors looked more and more to specialized art writers. "Writing for the magazines has become a profession, employing a considerable number of trained experts," noted one commentator in 1877.[12]

The development of art criticism as a professional specialty had roots in middle decades of the century, when *The Crayon* and a handful of other journals began to publish serious, informed writing on the theory and practice of art, and critics such as Clarence Cook, well known in the 1870s and 1880s, began to establish themselves. Later in the century the field of art criticism still allowed for a plurality of voices. Novelists often functioned as generalized cultural observers, and Henry James and William Dean Howells, for example, were generous suppliers of commentary on the art scene. While their criticism was often keen, they were not "professional" art critics. Indeed, whether any of the post–Civil War critics were "trained experts" might be debated. Their backgrounds were diverse, and their training equally so, frequently self-administered. A number were artists themselves; John La Farge, Kenyon Cox, and Will H. Low, among others, contributed actively to the magazines and were important voices for and about art from within the borders of art practice itself.

At the same time, a pattern for the new professional critic was becoming clearer. The majority who were not also practicing artists shared middle- or upper-middle-class backgrounds, allowing for the cultivation of a love for art through independent reading, privileged educational opportunities, and European travel. William Howe Downes (1854–1941), art critic of the *Boston Evening Transcript* for more than three decades, was the son of a socially prominent attorney and banker in Derby, Connecticut. The privately educated Downes traveled to the Vienna Exposition in 1873 as a fledgling newspaper correspondent, and after several peripatetic years of journalism he joined the staff of the *Transcript* as art critic in 1882. Royal Cortissoz (1869–1948) served several years in the office of the architectural firm of McKim, Mead, and White, but in 1890 he left to assume the duties of art critic on the New York *Commercial Advertiser.* Soon after, he transferred to the *Tribune,* where he remained for fifty-three years. Charles Henry Caffin (1854–1918), a graduate of Oxford University, settled in New York in 1897 and became a full-time professional art critic for various newspapers and magazines. The background of Mariana Griswold Van Rensselaer (1851–1934), one of the most prominent women art writers of the period, matched those of her male colleagues: a descendant of New England Puritan colonists, she received private tutoring at home and finished her education by traveling in Europe. Only after her husband's death in 1884, however, did she begin the more significant phase of her career as a writer on art and architecture.[13]

These critics—cultivated, refined, and literate—forged their own credentials by being who they were, fitting into the right network of clubs and other social institutions, and speaking authoritatively from the pages of major newspapers and magazines. Most of them enhanced their visibility by producing art books and monographs. In some cases they differed ideologically. Cortissoz, for example, defended and promulgated the highest cultural traditions of classicism, whereas Caffin, no less a believer in the ennobling power of art, represented a more contemporary sensibility, as well as a kind of cultural populism symbolized by his efforts to democratize art knowledge and appreciation. Such differences, however, were less divisive than they might at first seem and were overshadowed by the class interests that nearly all of these professional critics had in common. H. Wayne Morgan has summarized the "new" critics' mission as a multivalent campaign to encourage the best painters, to develop canons of taste in an era of rapid and often confusing change, to enlarge and educate the audience for art, and to champion art's vital role in representing (as well as adorning) national life. They were part of a modern art world support structure that included emerging and developing commercial galleries and auction houses, art institutions, social clubs, art schools, and art colonies.[14]

The critics' enterprise was nearly as speculative as the enterprises of the capitalists, financiers, and companies that underwrote America's economic expansion in the final decades of the century. Gambling on the establishment, ascent, and profitmaking cultural capital of reputations—their own and their artists'—critics sought to maintain order, hierarchy, and stability in a fluid and sometimes even threatening art world, just as industrial America confronted and resisted the terrible threat of class warfare at a time when the gulf between the luxurious classes and the laboring poor had never seemed deeper and more dangerous. The critics risked failure on a lesser order of magnitude, but their cultural enterprise still intersected with the larger social one of suppressing disorder and stabilizing class relations. In this function, they joined the "professional-managerial" class defined by Barbara and John Ehrenreich. This class emerged in response to specific conditions, including the development of an enormous social surplus, the occurrence of episodic but violent warfare between the industrial working class and the capitalist class, and the incorporation of business and industry, necessitating the refinement of management systems and long-term planning. The Ehrenreichs diagram the professional-managerial class as one "consisting of salaried mental workers who do not own the means of production and whose major function in the social division of labor may be described broadly as the reproduction of capitalist culture and capitalist class relations." This work could take the form of direct social control or the more or less subtle labor involved in the "production and propagation of ideology." These cultural transmitters—consisting of teachers, social workers, psychologists, entertainers, writers of advertising copy, and the like—assumed the role of mediating the fundamental class conflict of capitalist society to create a rational, reproducible social order. In this process, theoretically, they produced culture to replace, or displace, the autonomous working-

class culture destroyed by capitalism in the interests of subordinating workers to a uniform and harmonizing cultural system.[15]

This paradigm, in which passive, empty working-class bodies wait only to be filled and tranquilized by whatever the culture industry deems good for them, is more than a little top-heavy. Yet it illuminates the larger social and economic function embraced by newly professionalized art critics around the turn of the century. Nearly all of them strove to promote an ideal of art as an active and vital agent in elevating, ordering, healing, harmonizing, and edifying a diverse and disorderly American people. Whether they voiced support for traditionalist values (ideal beauty, classical form) or modernism (nature, real life, subjective expression), they seldom seemed to waver from the hierarchical assumptions that governed cultural and social structure in America, always defending art's privileged status as product and symbol of the refined and cultured classes.[16]

The magazines resounded with the rhetoric of elevation. Charles Dudley Warner admonished his readers that it was the duty of the educated to spread refinement and civilized values among the working classes, where the "great movement of labor" was "real, and gigantic, and full . . . of primeval force." The function of art should and must be to awaken the proper (patriotic, nonviolent) sentiments in those working-class hearts. In this endeavor, the best culture was needed most urgently to "guide the blind instincts of the mass of men who are struggling for a freer place and a breath of fresh air." Like many other critics, sculptor William Ordway Partridge urged the introduction of universal art education in the public schools. Such a course was simply wise political economy, he stated, pointing to the example set by France, where on weekends the working classes flocked to the art museums, presumably becoming better educated, more civilized, and more tractable in the process. The campaign in the 1880s and early nineties for the Sunday opening of the Metropolitan Museum of Art in New York had a similar political agenda, as did the 1895 loan exhibition of paintings at the University Settlement Society on the city's east side. At the opening, Will H. Low extolled the generosity of those wealthy New York collectors so willing to contribute to the pleasures and cultural elevation of their east side brethren. Popular magazines were also conscripted as aids in the domesticating and civilizing process. The girl studying her copy of *Munsey's,* wrote U.S. Commissioner of Labor Carroll Wright, would be stimulated to "desire something better than her shop life." Art critics certainly supported this cultural enterprise to instruct the public, guiding it to know, appreciate, and respect the best and most beneficial forms of art. Their job was to preside over judging which forms measured up to the standards of taste the critics had mandated themselves to regulate and maintain.[17]

For all their exhortations on the ennobling and civilizing power of art, the critics policed the boundaries of an exclusive world of taste and cultivation. By 1900 the population of the United States had reached 76 million, of which fewer than 10 percent must have been readers of the mainstream general magazines.

With circulations seldom exceeding 10,000, the art magazines catered to a tiny fragment of the citizenry indeed. Although newspaper readership may have represented a larger segment of the population at the local level, these figures are still suggestive. The rhetoric of elevation, despite efforts to make it inclusive, reached only a fraction of the population. For this small group the critics created a standard of shared values defining a community of the cultivated, or those who sought to become so. Critics, who were themselves elites by virtue of background, connections, and refinement, spoke in authoritative tones both to fellow elites and to middle-class readers striving for membership in a culturally informed and thereby superior class. What readers knew about art and its producers might be derived from ventures into galleries and museums, but their expectations and knowledge probably were directed and shaped equally by what critics and other art writers had told them.

Critics had the power to authorize particular (though sometimes competing) points of view and ways of responding to art and thinking about artists and their place in modern America. Like the media in which their words appeared, they stood forcefully between events, individuals, things, and the reader-consumer. By no means did their authority go uncontested. G. B. Rose frankly dismissed the contemporary critical enterprise as a failure. Instead of helping to enhance relations between art and the public, critics relentlessly sought out fads, their criteria being simply that whatever the public did not understand was worthy of support. A short time later, however, the same journal published an article by Oscar Lovell Triggs, a vigorous proponent of the American Arts and Crafts movement. Triggs proclaimed with serene confidence that democratic art and democratic art criticism were on the rise. These strongly contrasting positions indicate that the profession of art criticism, and the public it aimed to reach, were as fluid and unstable as the art world itself. Critics in these decades of emergent professionalism and self-definition tried out different roles: as democratic educators, voices for elite taste and tradition, or vanguards on the riskiest edges of progress in art. In many cases, these roles alternated and overlapped.[18]

What critics wrote had commodity status as well: art writing was a commercial venture. Indeed, the magazines created a necessity for generating the fads that so many commentators deplored even as they themselves entered into complicity with a system that built planned obsolescence into the diffusion of information and opinion. For magazines to sell, new material must constantly displace the old, new stories catch the attention of the jaded consumer, new opinions about what constituted fashion and value be aired. A vivid illustration of this is the frenzy of publicity excited by Jean-François Millet's *The Angelus* (1859; Musée d'Orsay, Paris). The painting was bought in Paris in 1889 for the stupendous price of $110,000 by James Sutton, president of the American Art Association, and exhibited in New York later that year. It was received with pious rapture by critics, who tirelessly publicized it as a prayer in paint. The humor magazine *Life* published an imaginary dialogue between

the artist's two reverently bowed peasants, who are wondering why the American audience is making such a fuss over them:

He: And this crowd—to see them standing before us with their false enthusiasm blinded by the glory of that hundred thousand of their *damnés* dollars—bah! I sicken at it. . . .

She: . . . But *mon cher* Jules, they must see that we are not such an extraordinary picture.

He: Not they! They only see what they are told.

She: But what is the reason for it all?

He: The reason for it all, my *bien aimée,* is that the Yankees love to be hum-bugged and now they are just getting it in the neck.

She: But we are no humbugs, we are honest enough.

He: *Diable,* I should say so! . . . But these imbeciles have heard no end of stuff about a "deep religious feeling" in us, and when a deep religious feeling brings a hundred thousand dollars the cultivated American is going to see it, you know, and let his friends realize that he appreciates it.

Jules finally finds consolation in the fact that he and his companion are a "gigantic and successful practical joke on the American people." This cheeky little dialogue brings into sharp relief the connections linking fame, fashion, publicity, and com-modity status. Americans flocked to see the picture because it had cost a fortune, had made headlines, and—as critics and journalists told them—it had moral and religious value. That value, however, depended heavily on the extent to which news about the painting circulated through various media, and on how long interest could be kept from flagging.[19]

The Critics' Reach

In 1892 a survey found that American periodicals exercised "an almost incal-culable influence upon the moral and intellectual development of individuals, upon home life, and upon public opinion. [Their] great increase and improvement may be regarded as one of the most important signs of the times."[20] Such statements discount the likelihood of variation in individual reception. Gender, personal taste and affiliations, personal or class-bound cultural agendas, and any number of other circumstances could help determine a reader's understanding and internalization of critical points of view. Nonetheless, given the press's ever-increasing reach, dyna-mism, and power, its ability to shape thoughts and mold attitudes was considerable.

There is evidence that critical influence could be real and effective. Letters from friends and associates to William Howe Downes contain striking testimonials to his authority. In 1899, Henry Sandham wrote to tell Downes that the notice of his paintings in the latest edition of the *Transcript* was "the best one I've ever had." Sandham reported that a gentleman visiting the gallery "said he came because when he read the article last night he was so much impressed with it that he must see the

pictures first thing this morning." Sandham also heard one journalist tell another that "he envied the power of a man who could write an article that without mentioning one single picture could fill you with longing to see them all." Shortly after the death of George Inness in 1894, Downes published a passionate appreciation of the landscape painter's power and genius. This piece generated such interest that E. H. Clement, editor of the *Transcript,* sent Downes a memorandum praising that "corker of yours on Inness" which had received so "many compliments." When he published outside the *Transcript,* Downes's range extended far beyond Boston. In 1900, the editor of the *Art Interchange* noted that he still received frequent requests for copies of Downes's articles on Inness, Homer, and La Farge, even though six years had passed since their publication in the magazine. Laura R. McAllister wrote from Columbus, Ohio, telling Downes that the Columbus Art History Club had found his late work very helpful in the club's study of Dutch and American art. She herself was preparing a paper on John La Farge for presentation at the club, and she hoped that Downes would be able to supply her with some information. Chicago collector Frank W. Gunsaulus also paid tribute to Downes's good influence as an educator; he wrote that he had given so many copies of the critic's work to friends that he was convinced "that there must be a desire, if not a *need,* for all the studies you have made and published." Such letters suggest the visibility and influence of the critic as well as the persuasive power of the media in general.[21]

Much of this power depended on manufacturing credible images, whether visual or verbal. Nowhere was this better illustrated than in William Coffin's observations on the work of Frederic Remington, prolific storyteller and picture maker of the American West. "It is a fact which admits of no question that Eastern people have formed their conception of what the Far-Western life is like, more from what they have seen in Mr. Remington's pictures than from any other source, and if they went to the west or to Mexico they would expect to see men and places looking exactly as Mr. Remington has drawn them. Those who *have* been there are the authority for saying they would not be disappointed." Remington's highly edited, fanatically masculine, and flamboyantly racist imagery primed visitors to see *his* West, regardless of any evidence to the contrary in the "real" West that lay before their eyes. Looking for Remington's version of the western scene, they edited their own perceptions to conform with his. The desire to believe in this west rather than some other (a west of oppressive prejudice against native Americans, for example, or a west of bustling, domestic towns rather than vast, primitive spaces) would also help solidify the authority of Remington's representations.[22]

Charles Dana Gibson's *The Seed of Ambition* (fig. 1) amplifies the Remington scenario. In a squalid neighborhood of garbage cans and smokestacks, a schoolgirl carrying a bulky carton looks wistfully at theater posters on a high fence along the way. The posters show a glamorous actress in eighteenth-century costume, posed as a princess in one scene, dressed as a dueling gentleman in another. The title of the cartoon makes it clear that these advertisements both represent and stimulate the

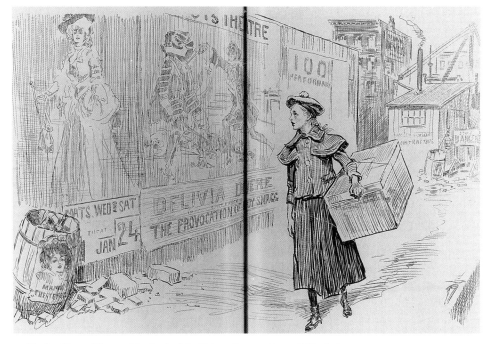

1. Charles Dana Gibson, *The Seed of Ambition.* Cartoon from *Collier's,* January 31, 1903.

girl's desire for those gorgeous figures upon the stage. These representations of sensational melodrama may clash egregiously with the girl's drab reality, yet they create an illusion more real than her surroundings. (The pretty head on the poster affixed to the garbage can, though, hints at sham and disappointment.)

Together, Remington and Gibson serve as evidence for Amy Kaplan's contention that in the nineteenth century the "growing dominance of a mass culture—in the form of newspapers, magazines, advertising, and book publishing—created a national market which constructed for consumers a shared reality of information and desire."[23] But like the pretty face on Gibson's garbage can, mass media images could represent the world in potentially dangerous ways. Sensational reporting of violent crime, for example, was bound to produce the most degrading results in the reading public:

> An atrocious murder takes place. The daily press, by full detail and embellishment, graphically engraves it . . . upon the public consciousness. . . . The criminal is surrounded by the halo of romance and the glamor of notoriety. His likeness is given a prominent place in a leading column, and is thus brought before the eyes of unnumbered thousands. And, recently, modern "enterprise" reproduces the whole scene—as supposed— not omitting the weapons. A mental picture of the *tout ensemble* is thus photographed upon all minds and memories. . . . No one escapes untarnished. The soundest and sanest minds cannot thus have the image mak-

ing faculty tampered with, without some deterioration, even though it be unconscious.

Why, demanded this writer, should "some nameless outrage in Alabama . . . be put in thought pictures, framed, and hung up in the mental chambers of millions, where high ideals are scarce for lack of room? . . . A material photograph may be destroyed in an instant, while an immaterial one, printed by the imaging faculty, may remain for a lifetime. . . . What men mentally dwell upon they become or grow like." Seldom did anything so lurid surround the doings of art and artists as reported in the contemporary media. But Remington's pictures, Gibson's cartoons, and what Royal Cortissoz or William Howe Downes or artist-critics said about American artists were all products of the same immense mental picture factory that the mass media had become by the turn of the century. As participants in the creation of the "shared reality of information and desire" produced by the media, they devised images that were bound to structure the ways that readers thought about and responded to the world of art in late-nineteenth-century America.[24]

Art writers had a great deal at stake, not only in the business of building and legitimizing their individual reputations for taste and judgment but also in the kind of culture their writings helped construct and support. Certainly, they did not achieve anything like a unitary ideal of culture. Staking out canonical territories involved contest and conflict among thorny issues of materialism and idealism, aestheticism and morality, surface and depth, health and degeneration, manliness and effeminacy, and the role of the artist as priest, therapist, or clown of modern culture. But whatever role the writers and other producers for the media fashioned for the artist, the mental pictures they broadcast and the packages they devised were amalgams of personal response, social construction, and historical circumstance, inflected with the often conflicting and contradictory values, aspirations, and anxieties of their class. Piecemeal or not, their authority was real, though never unchallenged, and nearly everyone in the ferociously competitive world of art was acutely aware of the power of publicity to make or deface an artist's image, reputation, and credibility. At least some who found critical favor, therefore, knew the importance of currying that favor with the right people.

Artists and critics in eastern cultural centers frequently met socially. Royal Cortissoz belonged to New York's exclusive Century Club and Players Club, both of which numbered artists and collectors among their members. In Boston, William Howe Downes was on the rosters of the Boston Art Club and the Paint and Clay Club. Both critics received grateful, sometimes fawning letters from painters whose works they had praised. Thomas Wilmer Dewing, who sometimes complained about doltish public incomprehension of his ethereal paintings, wrote deeply appreciative notes to Cortissoz and the publisher of *Harper's New Monthly Magazine* about Cortissoz's lengthy article in celebration of Dewing, Dwight Tryon, and Frederick Macmonnies. To the publisher Dewing wrote that he found the piece "very successful

and kindly." Nothing, he said, "could be more graceful or in better taste than Mr. Cortissoz's literary achievement. It has always been a shock to me to find the wrong thing said—even in praise about my pictures." He addressed Cortissoz in much the same vein, implying that the critic must have written as he did out of intellectual motives that harmonized with Dewing's own.[25]

Downes received an impressive number of letters from thankful painters. Some expressed their pleasure that Downes had perceived in their work what no one else ever had. As landscape painter J. Foxcroft Cole put it, "You have seen what I have been driving at for the last thirty years." Downes also received occasional gifts from painters who wished either to express their appreciation of a favorable review or improve their chances of getting a good one. Childe Hassam, who had just left Boston to study at the Académie Julian in Paris, told Downes: "I wanted to leave you a little something of mine to add to your already charming little collection and ask you to do what you could toward the success of my auction in February. I know you would do it up as kindly as you always do." Hassam noted that "Weeks [another reviewer] got a little oil of mine just before I left so he will I am sure feel kindly disposed to drive his quill a few blocks for Hassam." As for Downes, "some little Paris thing of the studio will probably please you. . . . It will probably be worth more to you at any rate as they are in some good American collections in New York in Clark's [Thomas B. Clarke] and others as you know." Two years later, Hassam sent Downes a "little sketch" from Paris as a token of gratitude for another favorable notice. Over the years, several other artists offered similar tributes to Downes.[26]

How prevalent was this practice is difficult to say. It was common enough, at least, for Brander Matthews to satirize it in a prose sketch about a private view of an exhibition in New York. One of the most striking portraits in the show is of "Mr. Rupert de Ruyter, the poet, by a young artist named Renwick Brashleigh, painted quite vigorously yet sympathetically, and quite extinguishing the impressionistic 'Girl in a Hammock' " nearby. Two art students pause before Brashleigh's portraits (the other depicts a wealthy Wall Street railroad man) and wonder how Brashleigh secured his commissions. One of them says: "Guess he did Rupert de Ruyter for nothing. You know de Ruyter wrote him up in one of the magazines." The tenor of this casual remark suggests that such practices are normal and quite unsurprising. Fruitful exchanges need not have taken place on a material level at all, of course. As the many letters to Downes show, tributes to the intelligence and sensitivity of the critic would do as well.[27]

Not every artist felt the need to keep critics in good humor and kindly disposed. James McNeill Whistler was acutely aware of the value of publicity, but in carefully crafting his self-image he adopted an exaggerated posture of animosity and combativeness toward what he styled the obtuse Philistine mediocrity of the average critic. A painter might (purposely or not) generate a mystique that made his pictures and his personality so alluring that courting the critics was never necessary. Winslow Homer, for example, made himself conspicuously mysterious by seeming to shun

publicity altogether. Yet he thought enough of criticism all the same to keep a scrapbook of his clippings, a practice widespread among artists of the later nineteenth century. Whistler, scourge of the critics, had a scrapbook too.[28]

The market contributed to the dynamics of the artist-critic equation as well. In some cases, an ambitious collector could elevate the status and encourage warmer criticism of a certain painter, while in others warm criticism might encourage collectors to buy. Thomas B. Clarke's collection of works by contemporary American artists became a rallying point for critics who supported the development of a non-cosmopolitan, native school, and Clarke's especially heavy investments in Homer and Inness raised their cultural and economic currency considerably. On the other hand, the vigorously favorable criticism and publicity that such painters as the exuberant William Merritt Chase often received was no guarantee of good sales. The prices fetched by Chase's landscapes and interior scenes in the 1880s and 1890s were depressingly low even in these years of a weak market for American paintings. On still another hand, John Singer Sargent enjoyed enormous favor painting portraits of American and English elites during the same two decades, despite mixed criticism that repeatedly mentioned the painter's pitiless regard, which showed his sitters at their worst.

The factors contributing to a painter's success or failure were in every case overdetermined. Artists acted in the construction of their own images, just as much as they waited to be acted upon by image makers. Most often, the public figure represented some blending of the two. Talent, energy, institutions, connections, gender, and luck played their parts in promoting reputations. But intrinsic to being an artist in modern America was the media-driven cult of surfaces, personality, and celebrity that made the artist a new kind of public figure, partly self-made yet culturally constructed and media-generated, each part, increasingly, no less real than the other.

PART ONE

The Traffic in Images

1 FINDING THE "REAL" AMERICAN ARTIST

If we were to construct a composite image of the late-nineteenth-century American artist, this generically white, male, Anglo-Saxon figure would be highly individualistic, possessed of a powerful personality, spiritual, sensitive, close to nature, self-absorbed, reclusive, marginal, childlike and primitive, yet simultaneously materialistic, sociable and socially adept, gentlemanly, civic-minded, worldly, urbane, businesslike, and fully integrated into every aspect of modern life. As individuals, most artists—like people in general—combined traits and tendencies from the "spiritual" and "material" columns. But the media tended to represent artist figures as one or the other, thereby gradually sorting out and constituting several interlocking sets of binary pairs or coordinates that mapped the American artist's body and soul. These pairs and coordinates guide my exploration of how the identity of the American artist was shaped, and why.

W. Ray Crozier proposes that "rather than ask what artists are 'really like' we should ask what are the social conventions for what it is to be an artist?" As Crozier sees it, art in the twentieth century has been socially constructed as an "irrational activity" practiced by those whose personality (introverted, intuitive, inspired, neurotic, impractical, bohemian) suits them for such pursuits or may even be a prerequisite for them. Other factors, such as the systematic acquisition of the technical skills and knowledge appropriate for a particular art form, tend to receive less weight.

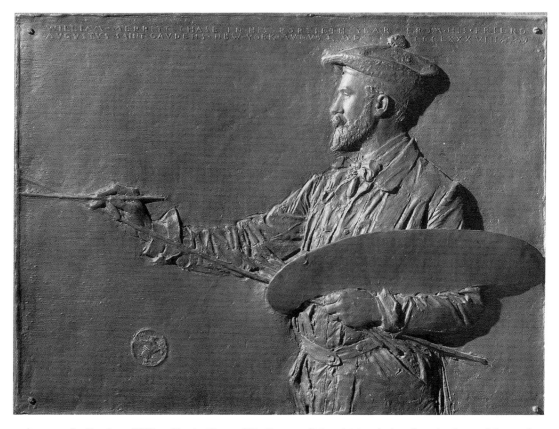

2. Augustus St.-Gaudens, *William Merritt Chase,* 1888. Bronze relief, 21⅝ × 29½. American Academy of Arts and Letters, New York City; Gift of Mrs. William Merritt Chase. Photograph courtesy of Geoffrey Clements.

This sweeping overview is subject to many exceptions and qualifications. Even so, it provides a serviceable model for investigating the social and cultural construction of artists in late-nineteenth-century America, when a process of filtration got under way and began to produce an artist of personality fitting Crozier's proposed pattern.[1] Although there was never less than a plurality of patterns existing at any one time, some, endowed with higher currency and greater longevity, served as templates for versions of artistic identity that would come to dominate much of the twentieth century. These patterns, shaped out of particular social and cultural circumstances, represented specific responses to those circumstances as well.

What was expected of American artists during the turn-of-the-century decades was a matter of much debate and some confusion. Magazines, newspapers, and books teemed with contradictory reports and interpretations of what artists were seen and thought to be. The figure of William Merritt Chase (1849–1916) is exemplary, because in successive, overlapping phases of his career he explored the major available alternatives. Augustus St.-Gaudens's bronze relief portrait of 1888 (fig. 2) shows Chase at work, in elegant profile, with a large palette, a clutch of brushes, and a

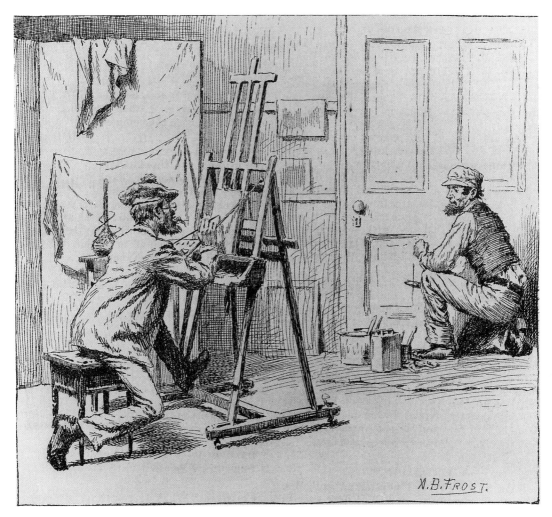

3. Arthur B. Frost, *Bonds of Sympathy*. Cartoon from *Harper's New Monthly Magazine* 81 (July 1890).

maul stick. His clothes are unmistakably artistic, consisting of a kind of belted smock, a flowing bow tie, and a natty tam-o'-shanter with a pom-pom. Transcending by a considerable margin the need for functional and appropriate work apparel, Chase's outfit seems contrived to conjure the notion of artist as a different being in a different world. The conspicuously artistic uniform provided an easy target for satirical fun, as in Arthur Burdett Frost's cartoon (fig. 3) of an artist applying paint to a canvas in his studio while a laborer paints the door, the joke being that the artisan-painter considers the picture-painter a kind of brother-in-arms, with the same problems in "gettin' our money when our jobs is done." Certain details—especially the artist's tam-o'-shanter with its pom-prom, and his flaring moustache—make it impossible not to speculate that Frost (with Chase a member of the elite Tile Club) was making a friendly dig at his colleague's habit of flaunting his artistic identity. By looking the way an artist was expected to, Chase excited attention even as he opened himself to

4. Walter T. Smedley, *William Merritt Chase.* Illustration from Charles De Kay, "Mr. Chase and Central Park," *Harper's Weekly* 35 (May 2, 1891).

ridicule that, however mild, interfered with his need to project an image of serious competence.

Not many years later, a substantially different Chase lectured to members of the Contemporary Club in Philadelphia. As a reporter described him, "The artist has an arresting personality. This does not mean that he assumes any exaggeration of attire or a general unlikeness to others of his species, 'the what-manner-of-man-is-this?' attitude which is popularly supposed to bespeak the artist. His coat, which hung from his shoulders in the manner of all swallow-tail coats, was cut long and his hair was cut short. He did not wear a single eye-glass, rather pince-nez, through which he surveyed with calm deliberation the audience before him."[2] This writer had been fully prepared to see an eccentric Chase. The fact that the painter had elected to wear gentlemanly dress (fig. 4) confirms his keen awareness of the power of appearances. By donning conventional costume he enhanced his credibility before the public. In his various guises, from young bohemian to well-groomed professional, Chase embodied the instability of artistic identity at the turn of the century.

As one of the most visible of that cosmopolitan generation of painters born in

the 1850s and trained abroad during the 1870s and '80s, the mature Chase cut an authoritative figure. He continued to inflect his appearance with distinguishing marks of artistic identity—a flowing tie (the "Chase cravat") and a round, flat-brimmed hat—but he bound these accessories firmly into the code signifying the successful, refined, artistic gentleman. James Pattison, a visitor to Chase's house in Stuyvesant Square in New York, noted the artist's insistence "that his wife and a long line of handsome children should wear artistic costumes, that his home and studio should be as artistic as his taste, that he should act the life of a gentleman," to which ends he spent freely, even extravagantly. Somewhat inconsistently, Pattison also praised Chase's moderate habits and freedom from the "fashionable vices." In this construction, the painter represented an attractive blend of qualities in which the discipline of acceptably "normal" behavior contained and controlled the artistic component, a potentially disorderly force. The same blend characterized his art. William Howe Downes described Chase as a "typical American artist" in a "certain sense." Master of a "national style" eclectically compounded of old and new schools of painting, Chase was a sophisticated, well-traveled man—"sane, unsentimental, truthful, and unpretentious." The national style that Chase had so smoothly perfected seemed to match the man. As Downes put it, this style was a "refined, orderly, intelligent eclecticism" showing "more cleverness than inspiration, more skill than passion."[3]

A highly public figure, Chase projected a particular pattern of artistic behavior associated with the most up-to-date, enterprising modes of art practice. He was prominent among a considerable number of contemporaries who shaped themselves in this mold, which rejected anything more than cosmetic eccentricity and sought to construct an image of competence, discipline, social skill, organization, and managerial acumen. This was the model praised by art writer Alfred Trumble, who stated: "The Artist of to-day no longer rests under the popular stigma of chronic pauperism; he is no longer regarded as a mere visionary, incapable of caring for himself. Even that portion of the public which cannot understand his art is compelled to respect him, with his summer home and winter studio, his faculty for enjoying his holiday without ceasing to enjoy his work." Painter William Walton noted that even in the Latin Quarter "the long hair and the velvet coat have almost disappeared; the painter is no longer content to live in ostentatious poverty and to make of himself a Guy Fawkes in the street." In late-nineteenth-century America, velvet jackets, long hair, floppy hats, and garret dwelling functioned as universal signifiers for the kind of artist Americans had ceased to be, at least in the discourse of professionalism then in the making. The velvet jacket in particular was layered with negative connotations. Indelibly tainted by its connection with the notorious aesthete Oscar Wilde (see Chapter 3), it was further degraded by association with the older, stuffier generation of National Academy patriarchs—such as Wordsworth Thompson (see fig. 12)—that Chase and his cohorts repudiated. Whatever their status as artistic fashion, however, velvet jackets and other markers served a transcendent symbolic function in their capacity as signs of otherness, against which the

professional look of the competent gentleman could shine forth in all its glossy, attractive modernity.[4]

The "Velvet Jacket" Syndrome

The setting up (or making up) of long-haired, velvet-jacketed garret dwellers against the new man-of-the-world professionals indicates a high degree of ambiguity attending the place and function of artists in modern America, where active striving to professionalize, modernize, and normalize the artist's image coexisted with expectations that artists were and should be different. The fact that many younger artists were intent on looking and acting in ways that confounded preconceptions points to a deliberate effort at role change, at readjusting the parameters of modern American artistic identity to accommodate the vital, central place they were trying to claim for themselves. Eccentric dress and unconventional behavior tended more and more to be confined to rituals of carnivalesque license, such as costume parties, stag dinners, or studio revels. Yet the conventions of the velvet jacket—the constellation of signs denoting the eccentric, outsider artist—continued to rule expectations of what an artist was to be.

Velvet-jacket conventions even extended to artistic physiognomy and physique. *The Critic,* for example, could not reconcile the art of Pre-Raphaelite painter-poet Dante Gabriel Rossetti with his physical appearance: "One would naturally expect to see him portrayed as a poetical if not aesthetical looking man. I have seen all the portraits of him that were ever made . . . and not one of them looks the poet or the Pre-Raphaelite painter. They rather suggest the well-fed man of business. The round face with its 'chin-whiskers' is not of the type we associate with poetry."[5]

Notions that artists should look artistic underscored one commentator's reaction to the figure of the mesmerist musician Svengali (fig. 5; see fig. 102) in George Du Maurier's best-selling novel *Trilby*: "He is as grotesquely romantic, as Mephistophelean a figure in the illustration as in the printed page. . . . Where he stands in the midst of the crowded studio, 'All as It Used to Be,' he looks every inch the artist. . . . If there were such a man, one who had sunk his whole soul in his art, he might look like this, or like the same figure in the hussar uniform, a Semitic conqueror, 'out of the mysterious East.'" When Svengali first appears in the narrative, his looks instantly mark him as "artist"—of a certain kind. Du Maurier's narrator describes Svengali as tall, bony, well-featured but sinister, and of Jewish (that is, automatically Other) aspect. More, "he was very shabby and dirty, and wore a red beret and a large velveteen cloak, with a big metal clasp at the collar. His thick, heavy, languid, lusterless black hair fell down behind his ears onto his shoulders, in that musicianlike way that is so offensive to the normal Englishman." Musicianlike or not, this was a sign for "artist" so culturally rooted that there was no other way to read it.[6]

Elsewhere, the same insistence on seeing and reading physical markers of artistic difference persisted. In a story for *Harper's,* popular writer Robert Grant portrayed Robin Temple, the young artist, as "slim, rather delicate-looking with . . . a figure

5. George Du Maurier, *A Voice He Didn't Understand*. Illustration from Du Maurier, *Trilby* (1894).

of the dainty type one associates with the era of miniatures, flowered waistcoats, and tight-fitting coats with brass buttons. His hair was wavy, his expression thoughtful, and his eyes—dark, eloquent pleaders—were now wistful, now scintillant with enthusiasm." The practical man in the story is Temple's polar opposite: "a typical square-shouldered, compact, sturdy specimen of humanity, with the bearing already at twenty-five of an alert, shrewd man of affairs." The association of Temple with miniatures evokes the image of a man shrunken, trivial, excessively fine; his garments—flowered and tight fitting—hint at the feminine as well, just as Svengali's long hair does in *Trilby*. The impractical, trivial Temple is ill equipped to succeed in life: abandoning his art, he attempts to go into business to make enough money for the support of his intended bride. She refuses him, and he dies romantically of pneumonia.[7]

This binary play between the artistic and the practical was a consistent note in numerous handbooks on the popular pseudoscience of physiognomy, which purported to reveal character by reading and decoding external, physical signs. M. O. Stanton, whose hefty *Encyclopedia of Face and Form Reading* (1889) went through several editions, claimed that "nearly all" artists were "round-built persons . . . lithe and elastic." They had large, wide-open eyes with arched brows, small bones at the joints, and taper fingers. None of them were noted for the "high grade of practicality

6. *Artistic Type.* Illustration from
V. G. Rocine, *Heads, Faces, Types,
Races* (1910).

and reason" found in scientists, whose province was to "investigate natural laws and explain them, while Art is merely imitative, and aims at exciting the emotions mainly." In 1910, V. G. Rocine had little to add; the artistic type (fig. 6) was small and delicate, though happily possessed of such a large brain that the head perforce became pear-shaped. "Notice," said the caption to the illustration, "how small the neck, how refined the features. This face means delicacy of constitution, heart trouble, nervous indigestion. The brain is too heavy for the body." The artist type tended to be nervous, sensitive, and restless, suited only for light work, while the business and scientific types were adapted to heavy work because they were "built upon the principle of the driving-wheel, in a power house." The scientific type in Rocine's gallery (fig. 7) was marked by a "long, bony nose, a heavy under jaw . . . indicating . . . an iron will, which makes him stubborn, unyielding, deliberate, and determined." Strong, "iron-like," and caring for "nothing but facts and proofs," the scientific was "the most masculine type that we have."[8]

Such simplistic constructions point in one direction. Attributing power, vigor, and decisiveness to the practical man, they celebrate the physical and mental refinement of the artist figure while indicating its weakness, effeminacy, or triviality relative to the affairs (bellicose and masculine) of the great world. These were the assumptions that Chase's generation confronted as it attempted to move art practice somewhat closer to the center of worldly affairs. How was the young professional to surmount such perceptual obstacles?

Networking

The necessity for younger artists to create new patterns of professionalism and gentlemanly status came into sharp focus at the century's end, when the art world

7. A. A. Demuth, *Scientific Type.*
Illustration from V. G. Rocine, *Heads,
Faces, Types, Races* (1910).

was rapidly changing. Existing institutions for the exhibition and sale of work proved inadequate to the requirements and goals of artists—many of them foreign-trained—maturing after the Civil War.[9] The need for new organizations was exacerbated by two factors: an unpredictable and depressed market for American art, which suffered as the market for European art flourished, and the burgeoning population of artists, which strained established outlets and created severe competition. In 1870 the recorded total of "artists and teachers of art" in the United States was 4,081. By 1890, this number had soared by 510 percent to 22,496, by 1900 to 24,873, and by 1910 to 34,104; it was nonetheless a small fraction of the total population. From 1870 to 1900 the relative number of women in the profession increased dramatically, from a recorded 10.10 percent in 1870 to 44.3 percent in 1900—a state of near numerical parity with male artists that was seldom reflected in the exhibitions of the day. New opportunities afforded by the expanding fields of illustration, design, and advertising art helped absorb some of this population, as did teaching in a growing number of venues. The market was so competitive, in fact, that many painters depended on teaching to provide steady income between commissions. Beginning his sixteenth year of teaching at the Art Students League in New York, James Carroll Beckwith, a Paris-trained portrait painter, confided to his diary that "without the Schools we would be in poverty." With a flat market and steadily swelling ranks, it was critically important for artists to attach themselves to organizations that would provide social support, separate insiders from outsiders, increase chances for publicity, and promote contact with patrons.[10]

In New York, Augustus St.-Gaudens, Walter Shirlaw, Wyatt Eaton, and Helena de Kay Gilder organized the Society of American Artists in 1877 to provide an alternative venue for exhibitions and sales. Identified with cosmopolitanism from the

start, the society held its first exhibition at the Kurtz Gallery in March 1878. Of the twenty-two initial exhibitors, the majority had studied in Europe. For nearly thirty years the society maintained a high profile, affording visibility to younger artists in particular. In the 1880s it enjoyed the reputation of a progressive and even radical group, since it was widely viewed as a challenge to the National Academy, which by contrast seemed conservative and *retardataire*. At the same time, some observers, like the *New York Times,* were pleased by the rivalry between the organizations, seeing it as a sign of healthy prospects for American art. Although in the end the society merged with the National Academy, it established an important model for future organizational maneuvers.[11] Like the Society of American Artists, the Art Students League took shape as an up-to-date alternative to the instruction offered by the National Academy. Founded in 1875, it enrolled one hundred and thirty-three students in its classes in 1880. Thousands more passed through its doors over succeeding decades, and it provided material support to many New York painters who served on the faculty, including Chase, Beckwith, Thomas Wilmer Dewing, Walter Shirlaw, Kenyon Cox, and Robert Blum. In the 1890s the popular summer schools of art, usually featuring one teacher of renown in a picturesque summer art colony, expanded the field of teaching opportunities and offered courses of holiday self-improvement to hundreds of amateurs and professionals. Backed by wealthy socialites, Chase's summer school (1891–1902) at Shinnecock Hills on Long Island was one of the most prestigious, but there were many others: Cos Cob and Old Lyme in Connecticut; Round Lake, Saratoga, Saranac Lake, and Woodstock in New York; Gloucester, Rockport, and Provincetown in Massachusetts.[12]

A growing number of clubs played a dynamic role in developing social networks among artists, elites, and prosperous professional and businessmen collectors. Some clubs, such as the Union and the Travelers, were purely social. The Union League, the Manhattan, and others were more politically inclined, whereas the venerable Century, along with the Lotos, Palette, and Arcadian devoted themselves to a variety of cultural pursuits. Whether social or political, nearly all, as Linda Skalet notes, "demonstrated a marked interest and participation in the fine arts during the late nineteenth and early twentieth centuries."[13] Certain organizations were dedicated to special interests: the American Water Color Society (founded as the American Society of Painters in Water Colors in 1866), the New York Etching Club (1877), the Society of American Painters in Pastel (1882). Some, notably the Salmagundi and the Tile Clubs, were exclusive artists' organizations dedicated in equal measure to art production, good fellowship, and recreation.

The Salmagundi was formed as a sketch club in 1871 by artist-illustrators Will Low, F. S. Church, J. Scott Hartley, Joseph Hartley, and W. H. Shelton. Later, Howard Pyle, Walter Appleton Clark, and other rising illustrators became members. In the early years, its purpose was primarily social. Members would gather to critique each other's work but also to sing, box, eat, and drink. In 1878 the club mounted the first of ten annual exhibitions of black and white drawings, modestly priced to

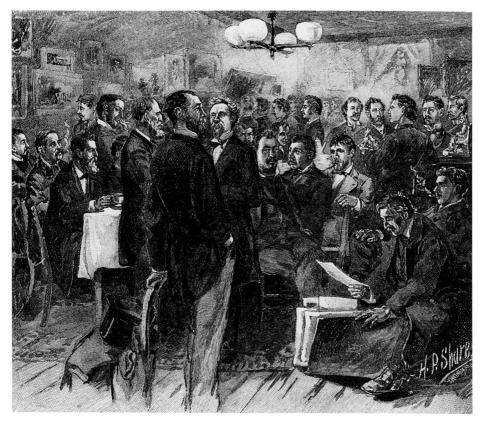

8. H. P. Share, *A Modern Meeting of the Salmagundi Club.* Illustration from W. H. Bishop, "Young Artists' Life in New York," *Scribner's Monthly* 19 (January 1880).

appeal to a middle-class clientele. When the introduction of photogravure reproductions of artworks began to to undermine that market, the club turned to large, profitable, juried shows featuring oil paintings and watercolors. Coexisting with the broad appeal of the Salmagundi exhibitions was an aura of distinction emanating from the club's limited membership, which numbered about thirty in 1880. The illustration of a "modern meeting" by club member H. P. Share (fig. 8) shows a crowd of about two dozen serious, neatly dressed young men. One of them is inspecting a crammed portfolio, and sketches and paintings line the walls. On the long, white-draped central table sits the club's emblem: a pot full of the chocolate and coffee mixture the artists imbibed at their gatherings.[14]

The most exclusive of all the clubs, perhaps, was the Tile Club, organized in 1877 and active for about ten years. Its restricted membership included Elihu Vedder, Edwin Austin Abbey, Augustus St.-Gaudens, Stanford White, and, briefly, Winslow Homer. At meetings, members painted blue and white tiles; later they branched out into other decorative media. Taking turns as master of ceremonies, they met weekly to drink, dine, tell tales, and devise the designs that ornamented their tiles and plaques. In the tradition of secret societies, members called each other "Brother

Brush" and went by individual code names: Cadmium, Bishop, the Bone, the Pagan, the Obtuse Bard—a somewhat tortured play on Winslow Homer's surname and personality. As Doreen Bolger writes, the Tile Club provided a sense of security and even sanctuary for its members, who as relatively young, mostly cosmopolitan "radicals," were still on uncertain professional ground. Countering this, the Tile Club asserted the solidarity and viability of the younger artistic community in New York. Yet far more than the Salmagundi Club, it generated an atmosphere of assiduously guarded exclusivity that was publicly promoted in magazine articles describing the club's jolly (and restricted) gatherings, travels, and high jinks. Like the other clubs, it constructed an image of the art world, especially its inner circles, as a privileged masculine enclave.[15]

With the other clubs and professional societies, the Tile Club constituted one strand of an increasingly complex network of art world insiders and their coteries of supporters, critics, and patrons. Negotiating this sometimes treacherous territory required more than talent: it demanded social skills and political acumen. A correspondent who signed himself "Free Lance" announced to the *Times* that he had retired from art, having found that "painting had very little to do with success. The most important points are to be in good society, to toady to different artists' 'rings,' and to be on good terms with the gents who control the club and other exhibitions, and to paint to please the fashion of the hour." The field was overcrowded, the competition intense and the rivalry bitter, especially between the generations. "I once heard an Academician say: 'The cheek of these younger men is astonishing; they ought to be put down; it is all we can do to make a living.' "[16] "Free Lance" could have been a no-talent failure venting his bitterness against an array of enemies, rather than recognizing his own lack of ability. All the same, his observations accurately targeted the social, institutional, and cultural politics at play as the younger men gradually established themselves. Their new prominence did little to abate continuing conflicts over such thorny issues as cosmopolitanism and the rise of commercialism in the art world. Even so, by the 1890s the competent, energetic, well-connected painter–teacher–club member very often took center stage as representative of the typical modern American artist, fully integrated with the social body.

Incorporation

Efforts made by the post–Civil War generation to establish and diversify the institutions and organizations of their trade, to professionalize their images, to act as cultural leaders, to join clubs and tap into the most advantageous social and professional networks all symbolize their attempts to incorporate themselves into a modern society undergoing the strains of an all-encompassing transformation. What had been a regionally dispersed economy based largely on agricultural production was rapidly changing into a centralized, rationalized system, in government and business alike. This modern system profited by expanding urban marketplaces, which were filled over and over again with the products of a vast and growing industrial complex. By

the turn of the century, major industries—oil, steel, shipping, railroading, finance—were concentrated in a few corporate hands. Consolidation of transportation networks (the result of corporate maneuvers) facilitated centralized distribution of goods as well. As business grew bigger it required large-scale organization, necessitating new hierarchies in which managers occupied the many interconnected layers between labor and the board of directors. As government became bigger and more complicated, it too required more and more management structure and centralized command.[17]

Increasingly, the group rather than the individual wielded power and exercised control. Even the rich, in Anna Youngerman's view, could no longer make their own independent fortunes: "The group has attained such importance that to understand an individual's gain it is necessary to undertake an examination of the character and the activities of the group of which he is a member." For those without the consolation of great wealth, the outlook was unremittingly bleak: "The combinations of capital and enterprise on a large scale have impaired and threatened to destroy the importance of the individual. The incentives to individual effort and its rewards are disappearing. . . . Men are becoming not mere machines, but minute parts of great machines. The inspiration of initiation is vanishing . . . [leading to] the slow deterioration and final decay of that free and varied intellectual energy the exercise of which is a delight in itself, and the love of which in the past made the professions what they were, and are no longer." Others, however, insisted that individuality was the vital ingredient for success in the corporate world. Montgomery Ward exhorted ambitious men to heed the truth that "enormous organizations, instead of crushing the personal, have made it stronger, recognized it, stimulated it, advertised it, banked on it, rewarded it. Carnegie has made millionaires of a whole battalion of his young lieutenants. He has made managers of thousands of men who worked in the ranks." In this discourse, personality was the vital spark. As the president of one company asserted, "I have never known of a great business success without a personality. I have never known of a great personality without a system." The ideal, as business writers stressed over and over again, was to strike a productive balance between cooperation and individual initiative. That this represented a form of accommodation seems clear. It was the refitting of the individual to function effectively as part of an intricate, bureaucratic, and strongly hierarchical system while being reassured that his singularity counted for something.[18]

The process of centralizing and systematizing work, management, professions, and government represented a mode of modernity engaged in retooling society as a smoothly running engine in which consoling vestiges of individual autonomy meshed soundlessly with an enveloping corporate authority. This was what happened in the art world as well among the younger generation of cosmopolitans with their clubs, schools, and professional organizations. For them, the essence of modernity was a harmonious blend of "incorporated" structures and pursuits, judiciously played against insistent proclamations of individuality. To be a modern artist in modern

America meant to be incorporated, to be involved in organized, directed group projects, part of an art world system that could function only by sustained collaborative effort.

The 1893 World's Columbian Exposition in Chicago is the best and grandest example of late-nineteenth-century corporate activity uniting artists, architects, businessmen, and civic leaders. Artists and their sponsors celebrated the project as a return to the ideals of the Italian Renaissance. More precisely, it was the greatest moment of artistic incorporation and integration into the mainstream of modernizing America. The huge buildings may have been academic in their references and the murals recollections of the classical ideal, but the kind of rationalized effort that brought dozens of artists together to create a vision of unity and harmony was modern indeed. For Will H. Low, the exposition marked the triumphant passage of American artists into the centers of modern life and industry. "Our artists," he wrote, "claimed the right to do something larger and finer and better than the private house, the portrait statue, or the *genre* picture." Backed by capital from the business community, the exposition gave artists their first opportunity to work together on a grand, public scale. This work was not only "surprisingly" good, but it also inspired pride for the "valiant craftsmen who have produced this result" and for the "country at large which has stood behind them, and above all for the solid men of the city of Chicago who have planned the work so bravely and so wisely." Artists had entered into full-fledged status as public-spirited, responsible patriots, working together for the glory of America, engineering progress and modernization in the national art, and loyally supported by the entire citizenry.[19]

Low himself (fig. 9) neatly fit the profile of the modern, incorporated culture producer as a clean, progressive, civic-minded, professional—the very opposite of a velvet-caped Svengali. Trained in Paris and based in New York, Low (1853–1932) dedicated himself to the advancement of American art, and the record of his activities had a strongly managerial emphasis. To make a living in the 1880s he did a great deal of illustration work and produced designs for stained glass, medals, and even currency, but his most ambitious public projects in the 1890s were murals. He was versatile, involved, active, and public-spirited, and his commitment to American art led to a quarter-century career as an art critic. Cleveland Moffett's article in the popular *McClure's Magazine* presented Low as a dedicated professional, a healthy, vigorous man who immediately conveyed the impression of being a "good fellow, with no affectations or posings. He is a fine looking man, with strong features and magnetic blue eyes. His dress is rather careful, but not too careful; and his manner is simple, straightforward, and kindly. When he talks of himself, or of his art, he talks unpretentiously." He worked hard, was devoted to teaching, and served on at least eight committees to further the progress of American art, explaining that he did this out of a "sense of patriotism," since the Americans, a utilitarian race, would support art when it became necessary to them. Low's mission was to create that necessity through a protracted campaign of organized and individual activities ded-

9. J. H. E. Whitney after Kenyon Cox, *A Corner of the Studio*. Wood engraving, published in *Century Magazine* 41 (January 1891).

icated to keeping high-quality art before the public and educating the public to value what it saw.[20]

The pattern suggested by the representation of Low in *McClure's* was repeated, with variations, throughout the artist community. Supportive critics wrote about individuals and groups, taking particular care to highlight their good citizenship and competence as cultural managers. William Coffin's tribute to Low's friend Kenyon Cox (1856–1919) was almost interchangeable with Moffett's, with a special stress, however, on Cox's purity and decency. This was a vital strategic maneuver, since, as a figure painter specializing in the classical female nude, Cox put himself under suspicion of immorality. The image of Cox constructed by Coffin was high-minded and tenacious, conscientious and energetic, alert, keen, and responsive. He too served on numerous committees and taught at the Art Students League. He was a busy illustrator, active in the Society of American Artists, secretary of the National Free Art League, and a true believer in, and worker for, the future of American art. Artists like Low and Cox, acting as cultural producers and cultural transmitters, fully

qualified themselves for membership in the professional-managerial class entrusted with the maintenance of cultural and social order.[21]

The group mentality shaped and governed artists' life styles in addition to their professional activities, and the rhythms of their years followed similar lines. Painters and sculptors maintained studios and apartments or houses in New York or another urban center, but in summers would migrate to vacation homes in lovely rural settlements where in most cases they practiced and refined certain social rituals meant to underscore the sense of artistic community and harmony. While the migratory pattern was nothing new—antebellum landscape painters habitually went in search of subjects during the summer—its institutionalization, in the form of established colonies and more or less permanent summer homes, some of them quite elaborate, was. In fact, artists' life styles were often replications, in miniature, of patterns that characterized their patrons—businessmen, professionals, corporate directors. Their social and domestic habits announced a common desire to achieve high status, or at least its appearance. For example, J. Carroll Beckwith (1852–1917) always found the money to retain a cook in his household, despite often-severe financial problems. And his wife, Bertha (who bemoaned the tedium of looking for new servants), enjoyed the leisured lady's routine of shopping, calls, and evenings at the theater or opera. Such moves nudged the modern artist closer to the center, away from the fringes symbolized by long hair, velvet jackets, and shabby garrets. They also reinforced the appearance of the artist's productive incorporation into the high end of the mainstream of modern life.[22]

Cox, Low, and their cosmopolitan contemporaries established one set of conventions for what it was to like to be an artist in their time. Writing about the art world themselves and supported by influential critics, they devised a model of group cohesion, incorporation, and public-spiritedness. This model staked a hopeful claim on the kind of typical, modern Americanness that Downes ascribed to William Merritt Chase(eclectic, professional, solid, competent, orderly.)Even some of the work they produced had the aura of a corporate style: the superb Parisian draftsmanship on show in a myriad of figure paintings, or the refined tonalism that constituted the corporate "language" of so much landscape painting around the turn of the century. This was particularly true at the sites of official, high-minded decoration where, as in the Columbian Exposition or the Library of Congress, painting and sculpture were in striking stylistic harmony. In one respect this was nothing new. Much the same could be said, for example, of seventeenth-century Dutch genre painting, in which certain stylistic and technical characteristics were diffused through a range of individual works, producing an instantly recognizable look. What was different in late-nineteenth-century America was the intense consciousness of modernization that prompted efforts to secure order and unity through incorporation while attempting to integrate art into the social and cultural mainstream. Working through group-oriented modes of artist behavior and art practice, this consciousness produced the generic image of the up-to-date professional as well.

Engineering the Corporate Look

In 1893, George Parsons Lathrop declared that a fruitful new alliance between art and business was under way, betokening art's progress toward complete social and economic integration. Lathrop noted the formation of stronger ties between art and industry, the flourishing field of illustration, and the rise and diffusion of decorative painting that carried fine art into everyday life. The Metropolitan Museum of Art had been a tremendously valuable educator, and prominent, wealthy citizens had given liberally to prize funds and endowments. As a result, "through all these enterprises a web is weaving that brings together more and more the artist, the artisan, and the business man who has a use for art."[23] Lathrop's canvass of the art scene in New York underscored the possibility for a model of the artist built along more businesslike and practical lines, dramatically different from those dreamy, lightweight, impractical types circulated through stories like the tale of the delicate Robin Temple, or the formulas in the physiognomy handbooks. Attempting to gain secure status and promote their cause, artists maturing after the Civil War had to reinvent the image of the artist as one of practicality and civic responsibility to match the new roles they hoped to play in modern America. Artists and critics insisted on the businesslike qualities of modern American art, characterized by "a generally high order of technical ability and artistic sanity, a general temperance and discretion." Articles on art schools emphasized the methodical, disciplined acquisition of skills as the surest way to a prospering career: "Mastery of the elements of one's occupation," stated artist Benjamin Lander, "is almost a guarantee of success." Commensurate with this emphasis on technical competence was the new artist's businesslike attitude: "[The artist] no longer expects to paint and picturesquely starve. If he cannot sell his paintings, he looks about in a sensible way and tries to understand why. He knows it must be because they are not up to the standard, for the demand for good work distances the supply. He goes into illustrative work, perhaps, and draws for some of the innumerable pictorial journals." The appropriate look for these young professionals was not a velveteen jacket but a well-tailored business suit.[24]

Self-portraits, portraits of colleagues, and illustrations or photographs in the magazines presented something of a corporate appearance among artists.[25] Allowance must be made for a range of individual variations in style on the part of painter and subject alike. Still, visual representations tended to emphasize elegance, good grooming (connoting respectability, discipline, and conformity), and sometimes a certain aloofness. Through dress, accessories, and demeanor they also managed to suggest a secure and superior status. J. Carroll Beckwith's portrait of fellow painter and critic William Walton (fig. 10) displays an impeccably neat figure, with the stiffest of white collar and cuffs, a dark, sober suit, a shining gold watch chain, a pince-nez, and a stiffly flaring moustache. He stands very straight and looks directly at the viewer; behind him, suggesting a studio setting, are some plein air sketches pinned on the red wall, and a fencing mask. There is little or nothing about Walton to signal

10. James Carroll Beckwith, *Portrait of William Walton*, 1886. Oil on canvas, 47⅞ × 28⅜.
The Century Association, New York.

"artist," at least not according to the Svengali code. The sketches behind him could easily be items belonging to any prosperous professional and collector. At the same time, though, the cigarette and perhaps even the pince-nez project subtle signals of difference, setting the artist off, if only slightly, from the world of buttoned-up conformity.[26]

Cigarettes could connote a range of bohemian states, from decadence to outright insanity. The appearance of cigarettes in images of artists visibly linked the artist figure and the borderland spaces of social marginality and deviance. In late-nineteenth-century portraits the artist often flaunts a cigarette: Chase, reclining like an odalisque in an 1878 photograph (William Merritt Chase Archives, Parrish Art Museum); sculptor Paul Bartlett in a portrait by Charles Sprague Pearce (c. 1890; National Portrait Gallery, Smithsonian Institution); Will Low in Kenyon Cox's *Corner of the Studio* (see fig. 9). In these images, though, the cigarette seems to be an accessory in a system of cosmetic bohemianism. With a cigarette in hand the artist could play at deviance of some sort without necessarily subscribing to it, could sow a little doubt about his morals while remaining eminently respectable. Walton, after all, became a member of the exclusive Century Club (in 1892), while Low was—or was represented as—a solid citizen of the New York art world. Like the exaggerated moustache or the pince-nez, the cigarette was an accessory for the "corporate" look; it was something artists were supposed to carry. As a writer in *Harper's Weekly* stated, "Most artists smoke; tobacco seems to stimulate the imagination."[27]

Many portraits of artists, however, barely hinted at the subject's vocation. The *Self-Portrait* by J. Alden Weir (1852–1919) relies for effect almost entirely on rich tone and resonant contrast: the play of rust and amber wall panels and ruddy facial planes against deep, chocolate brown shadows and fabric, with a slash of white at the collar and a sleek coolness of blue-gray provided by the vase at left (fig. 11). The large head and bulky shoulders, securely centered, suggest substance and stability. To the uninitiated, at least, the image does not say "this is an artist," only that this is a presentable young man, down-to-earth and keenly serious. He looks as if he might have taken the advice of someone like Nathaniel Fowler, who counseled youths ambitious for success in business to "look as well as you can. Don't be a dude or a dandy. Look clean because you are clean. . . . Never look slovenly. Be manly and look it. Appear the gentleman and be the gentleman."[28]

Magazines seemed to favor the same formulas when illustrating articles with photographs or sketches of artists, who even when shown working were almost always fully suited and spotless. One of William Howe Downes's essays on the American art scene featured twenty-nine photographs and drawings of living painters; of these, nineteen were of the gentleman-businessman formula. Only the older painters George Inness (1825–1894; see fig. 43) and William Beard (1824–1900) exhibited longish and, in Inness's case, quite untidy hair; and only Wordsworth

11. J. Alden Weir, *Self-Portrait*, 1886. Oil on canvas, 21¼ × 17¼. National Academy of Design, New York City.

Thompson (1840–1896) wore a beret (fig. 12). The sketch of Whistler featured the monocle and the snow-white forelock that set him apart (see Chapter 7). The rest, whether in or out of studios, share for the most part a generic resemblance: they are serious, soberly clad professionals.[29] There were precedents for such representations. American colonial painters such as John Singleton Copley and Benjamin West portrayed themselves as successful gentlemen, and in the antebellum period there are many images, including Charles Loring Elliott's portrait of Jasper Cropsey (fig. 13), displaying the marks of gentlemanly dress and taste; the mode of the day dictated long hair. But in the later portraits and photographs, the subjects seem to have a more professional edge. Having entered so fully into the public realm, most artists knew the value of the well-engineered public image, combining "corporate" uniformity and consistency with interesting but not outrageous accents of individuality and artistic flair.

Herein, however, lay the problem that permitted and encouraged competing patterns of artistic identity to lay claim to Americanness and modernity. In adopting the model of incorporation, young cosmopolitans laid themselves—and their work—open to being seen in exactly that way: as a group, a flock, a collective entity, a network of individual accents along a binding continuum. Sensing the danger, many

12. *Wordsworth Thompson.* Photograph from William Howe Downes and Frank Torrey Robinson, "Later American Masters," *New England Magazine* 14 (April 1896).

feared that the new culture of professionalism, incorporation, and accommodation spelled the demise of authenticity, sincerity, and personality in art practice. William Henry Hyde's *The Giant's Robe* (fig. 14) gets to the nub of the problem. Two painters at an exhibition have the following exchange:

Daubson: The painter of that portrait has a strong individuality.
Brush: (who thinks it rather an obvious steal): Oh! do you think so?
Daubson: Yes—Whistler's.

The portrait in question is a ridiculously exact facsimile of Whistler's *Arrangement in Brown and Black—Portrait of Miss Rosa Corder* (1876–1878; Frick Collection, New York), and the obvious implication of Daubson's punch line is that individuality is a commodity well worth stealing in the case of proven formulas like Whistler's. Of course, by "stealing" another's individuality, the perpetrator exposed his own imitativeness and unoriginality. In the case of Whistler's many followers, simply not imitating him too much or too obviously could suffice as an occasion for praise. John White Alexander (1856–1915) created graceful, rhythmic arrangements by weaving women's figures into decorative patterns that alluded to Whistler unmistakably as one of the prime sources in a suave synthesis that incorporated Japanese design, art nouveau, and classicism (see fig. 56). One reviewer stolidly upheld Alexander nonetheless as an original and independent painter who had resisted Whistler's "tyrannical influence." The modern practice of making art from a set of recipes for skillfully blended eclecticism encouraged critics to see the art of the young professionals en bloc and to sort them into various departments. Charles Caffin, for

13. Charles Loring Elliott, *Portrait of Jasper Francis Cropsey,* 1851. Oil on canvas remounted on masonite, 22 × 19. National Academy of Design, New York City; Gift of Samuel P. Avery.

example, wrote at length about John Singer Sargent as a supremely original master and then summarily described the flotilla of painters in Sargent's wake as small craft certified either for "portraits *d'esprit*" or "portraits of character." Identified with imitative, "corporate" styles, they failed to muster the power of commanding individuality and autonomy that became one of the most influential common denominators of greatness in the manufacturing of fame around the turn of the twentieth century.[30]

14. William Henry Hyde, *The Giant's Robe*. Cartoon from *Harper's New Monthly Magazine* 81 (August 1890).

The Return of the Native

The currency of individualism rose in direct counterpoint to the encroachment of corporate culture. Although there was disagreement over limits (how much was too much?), there was little debate on the principle that a great artist must at all costs be original and unique. Yet the new culture of professionalism was structured to encourage uniformity and smooth over abrasive difference. This was glaringly evident in assessing the results of the foreign training by which a generation of young cosmopolitans had earned their credentials. Critic Ellis T. Clarke recalled that the director-general of the 1889 Paris Exposition had described the U.S. section of the international art exhibition as a brilliant annex of the French, making it difficult to mention many "who do not draw their inspiration directly from French masters." At the Universal Exposition of 1900 the situation had not changed: the U.S. exhibition was un-American, untrue to national ideals and national temperament. The reason for this was plain: "American artists go to Europe, and especially to Paris, to complete their education, and are not strong enough to resist the dominating influence of their masters in after-work."[31] In reaction to this insidious culture of imitation, the rhetoric of individualism exalted the opposite of French training and in many cases privileged painters who had

had no training at all or who had so transcended early shaping influences that no traces of them seemed to remain.

The more that art training became a fixture in the new American art world, the more some insisted that real art could not be taught. Henry Adams warned an artistic niece to avoid art school because there a student learned only "just enough of professional methods to disgust one with one's own limitations. The professional artist is a fraud of the worst kind in that respect. . . . In both the Paris salons you may seek a whole season to find a work of art that is more than clever. . . . A third-rate Rembrandt knocks the stuffing out of all the picture-exhibitions in Europe and America combined." Architect and philosopher Henry Rutgers Marshall advised against the teaching of art in American universities. The true artist must follow the commands of the Muse and be "a listener for inspiration to which he should yield himself unreservedly, almost passively." The spark of genius could never be kindled "by deliberate effort or by any sort of intellectual process," and "pedagogical machinery" could never produce it. The true artist, in other words, was the unincorporated individual, who produced himself.[32]

Critics elevated very few modern American painters to the exalted ranks of authentic, original greatness. Indeed, most of the young professionals, including Will Low and Thomas Wilmer Dewing, would "probably be superseded in a decade or so by superior women painters in the same phase of art," according to William Howe Downes and Frank Torrey Robinson. Lacking originality and pioneering spirit, Low, Dewing, "and their ilk" could do no more than inspire imitations even paler than their own. Only a handful of modern painters broke through this insipid profile, supreme among them "Winslow Homer, the recluse," and "George Inness, the seer," because both were uncompromising, unincorporated, authentic individualists, innocent of foreign cleverness and taught by nature alone.[33]

Almost invariably the critics installed Homer and Inness in special shrines. The enterprising collector Thomas B. Clarke explained why he had relinquished his active interest in pictures after 1899, when he auctioned off his extensive holdings. "In my collection there was a God [Inness] and a Giant [Homer]. They stood alone. When they went out of my life there was no one to take their place." By cornering the market Clarke had done his part to raise the God and the Giant to great heights, giving them both an aura of exceptional desirability. Yet all of Clarke's buying could not account completely for their exaltation by writers and fellow artists.[34]

Homer (1836–1910) stood for everything that was native and real. He disparaged fashionable French art (and any American art that followed in its train) as miserably, contemptibly phony: "I wouldn't go across the street to see a Bouguereau. His pictures look false; he does not get the truth of what he wishes to represent; his light is not out-door light; his works are waxy and artificial. They are extremely near being frauds." There was a distinct "buy American" undertone to this as well. If Bouguereau and his compeers were frauds, then Homer, who claimed to work entirely in the honest light of nature, must be the real thing. The press took up this

refrain, setting up Homer as the opposite and counterpoise of the "facile Americans who reflect Bouguereau, Gérôme, or Piloty, who are Fortuny-mad or subject to the massive genius of Jean-François Millet." Homer stood chief among that band of native painters who were not " 'eclectic' in any sneering sense" but represented the United States in both its genius and limitations.[35]

Homer's independence became an unquestioned object of appreciation in scores of articles and reviews, confirming the notion that "greatness begins to feed on itself" once an artist has become valuable property. In Homer's case, greatness and independence remained tightly woven together. Homer himself helped construct this image, declaring in 1878 that he had been a determined loner ever since quitting the "slavery" of his apprenticeship to Bufford's, the Boston lithographer. "From the time that I took my nose off that lithographic stone, I have had no master, and never shall have any." Early critics often pointed out Homer's technical flaws: the crudeness of his color, the baldness of his effects. Once his currency was on the rise, though, his independence became a glorious thing. "No painter in this country has so aggressive an individuality, founded upon and justified by such superiority of individual force. . . . In his art, as in his life, he dwells alone." Downes's choice of *recluse* to convey the essence of Homer compressed an entire critical discourse on independence and greatness into one powerfully connotative word. The conventions that defined what it was to be a Winslow Homer differed radically from those that defined Chase and his cosmopolitan colleagues. For Downes, Chase was a "typical" American painter in his refined eclecticism, sophistication, and worldliness. As constructed in the media, Homer—once Chase's Tile Club crony—was none of those things, yet he was by critical acclaim the most quintessentially American artist of all.[36]

While George Inness was in many ways as different from Homer as Homer was from Chase, he too benefited by being seen as an individualist. Like Homer, Inness went on record as a scourge of modern, academic, cosmopolitan painting. According to George William Sheldon, he denounced Bouguereau's commercialism and dismissed "most of the pictures in the dealers' collections . . . [as] 'intellectual dishwater.' " The construction of Inness seemed methodically to counter, point for point, everything that the "incorporated" artist stood for. If the incorporated artist strove for success and (like Chase) lived on an ostentatious scale, Inness was "utterly indifferent to financial gains." If the incorporated artist worked with colleagues and through institutions to promote the cause of art and culture in America, Inness "took little part in the official doings of his fellow artists. Medals, honours . . . meant absolutely nothing to him." If his younger peers secured professional status through years of academic study, Inness "was a painter by the grace of God." If the incorporated artist subscribed to faddish eclecticism, Inness was "absolutely impatient" with "all manner of artistic 'humbugry.' " Finally, Inness, like Homer, was a genuine native: "an American, through and through, because he painted American subjects almost exclusively." Even better, he subscribed to the sturdy old values of Ralph Waldo Emerson; at all times a truth seeker, Inness was "self reliant in character . . .

self-reliant in his methods of work. No landscape painter in the art history of this country has accomplished more . . . in convincing the uninitiated of the unity and glory of nature."[37]

Homer and Inness belonged to an older generation, having launched their careers in the expansionist 1850s and turbulent 1860s. They were therefore old masters by the end of the century, yet few writers seemed to consider their age, representing them instead as forever young and vital, simultaneously at the forefront of American artistic progress and (spiritually) in an idealized past of self-reliance and unsullied nature. Seemingly indifferent to art organizations and to social life in general, Homer and Inness, unlike artistically as well as personally, were thrust into identical roles as defiers of encroaching corporate culture. In this position they became markers along the path of mainstream American artistic development, a path that privileged certain appearances of independence and uniqueness. Because the two contracted with dealers, brought their work before the public, and received abundant critical notice in magazines and newspapers they were as "incorporated" as their younger colleagues—dependent on a network of individuals, organizations, and commercial enterprises to mediate between themselves and the public. But their function, in part, was to mask those links and to assert—or have asserted for them—that pure individualism was no myth in modern America, despite an abundance of evidence to the contrary.

The appearance of isolation, finally, was all important to the pattern of authenticity molded from the careers of Homer and Inness. Modern life in America was relentlessly gregarious, wrote H. C. Merwin. Everything had to be done en masse, and even in rustic summer towns people herded together. Such activity spelled danger to serious art: the gregarious artist inevitably was shallow and second rate. When the artist was a man of genius, however, he became a law unto himself: "His eye is turned inward, not outward, and the necessity for being gregarious disappears." The ideal artist envisioned by Hamilton Wright Mabie fit this superior, solitary mold precisely. "People . . . seem to think a man is miserable unless they crowd his studio. For my part, I don't want them there. Don't you understand that all an artist asks is a chance to work? What we want is not success, but the chance to get ourselves on to canvas. I paint because I can't help it; I am tortured with thirst for expression."[38] Such constructions have deep roots in the figure of the romantic (male) artist—the free, creative spirit of untrammeled imagination and unembarrassed ego. In a prolonged period of stressful social and economic transition, this figure's currency was floated almost desperately as a kind of charm to ward off the effects of modernization. There were many more "typical American" artists of the Chase species than otherwise, and those who were constructed as "real" Americans, like Homer and Inness, were the least typical. In a sense (though not to trivialize them) they became cultural mascots, symbols of genuine Americanness, yet they were no more like America than are tigers, bulls, and colts like the teams for which they are the signs.

The case of Homer and Inness provides persuasive support for Crozier's thesis: they had (or were attributed with) the kind of personality prerequisite to producing genuine works of art, and it was the personality evident in their works that made them genuine. Each surpassed the conventions of great artisthood that so many of their critics and admirers worked to establish. What S. G. W. Benjamin said of Inness could apply equally to Homer: "One of the chief characteristics of [his] artistic achievement is its suggestion of reserve force. There was a man behind it." A man, that is, as opposed to one of the interchangeable "pawns in the game" that passed for men in modern, corporate life. Neither of the painters was extravagantly bohemian, nor did they exhibit the delicacy and frail sensitivity of the stereotypes circulated in popular fiction or physiognomy handbooks. They recast difference in a modern format, however, and difference was the key. Conventions privileging difference molded the artists and their reputations into high relief, and in twentieth-century histories, these least representative painters of the late nineteenth century continued to project, while the others, who had worked so hard to secure a place in the mainstream of modernizing, corporate America, gradually flattened.[39]

It is odd and interesting that William Merritt Chase, for all his prominence and admirers and accomplishments over a long career, should have been denied entrance into the "greatest" category—especially since in his teaching he stressed the importance of individuality and personality in art.[40] He was, moreover, an individual difficult to ignore—a flashy personality at times—as well as the producer of scores of superb, distinctive paintings and pastels. But he was also a social animal, an actor in groups, the most visible and therefore the ordained figurehead of certain artistic networks and institutions. As the teacher of hundreds of painters, both amateur and "professional," he seemed to be promulgating the culture of imitation so harshly criticized at the time. Not that he turned out students who produced cookie-cutter likenesses of the master, but the fact that he was able to transmit art knowledge and technical lore so professionally set him on a slightly lower plane than Homer and Inness, whose art was so personal—so autonomous—that it could never be passed on in any form (though each had a train of followers and imitators). Whereas Chase reproduced himself many times over, Homer and Inness were self-contained, inimitable originals. At a time when, numerically, the "typical" artists in the Chase mode were dominant and even flourishing, the "real American artist" mode of Homer and Inness gained an edge because it seemed so desirable and rare.

2 THE ARTIST IN THE AGE OF SURFACES

The Culture of Display and the Taint of Trade

In 1905, B. O. Flower, editor of the liberal magazine *Arena,* described the great crisis of contemporary art as a battle "between those who stand for sane and normal freedom and who though true to the basic principles of art refuse to be copyists or imitators," and "those . . . imbued with the soul-stagnating spirit of modern commercialism" who are intent on forming a trust "where the measuring-rod of mediocrity would become paramount." Pitting incorporated modes of artistic practice against the ideology of individualism that guaranteed authentic works of art, Flower tellingly linked modernity and commercialism with second-rate production. In this fatal chain, the material culture of display in the art market was the visible sign of that soul-stagnating spirit. Indeed, an essential component of the new professionals' equipment was an arsenal of retailing skills and strategies not unlike those being developed to market vast quantities of merchandise in America's emergent consumer culture. The use of such "dealers' tricks," however, engendered massive resistance from those convinced that commercial practices in art would lead inexorably from mere mediocrity to spiritual bankruptcy.[1]

Frames, picture-glass, and shadow boxes lined with crimson plush were among the devices used by artists and dealers alike to create seductive illusions of greater worth, prompting a buyer "to make up his mind to exchange his money for a bit

15. *Reminiscences of the Academy, Where the Frames Are So Much Better Than the Pictures.* Cartoon from *Life* 20 (December 15, 1892).

of canvas," as W. Lewis Fraser put it. *Life*'s cartoon *Reminiscences of the Academy, Where the Frames Are So Much Better Than the Pictures* (fig. 15) shows a crowded array of paintings, most depicting low-life subjects: crowds of screaming newsboys, a barroom scene, a washerwoman. The delicately ornamented frames surrounding these ignoble scenes, however, are in the very best of taste and by implication "better" than the pictures both in beauty and in value. To eliminate them would be to expose the paintings as miserable daubs, worth no more than the trompe l'oeil fifty-cent banknote hanging in the topmost register of the display. Arthur T. Jameson's cartoon (fig. 16) of life in an artist's studio advanced the same argument. The exchange between "Mr. Chrome," the painter, and his visitor "Miss Ethel" discloses the fact that he has just delighted her with the offer of a painting. Miss Ethel, though, has one reservation: "Oh, it's perfectly lovely! But you must let me return the frame, as Mamma does not allow me to accept valuable presents from gentlemen."[2]

There was nothing new about the opulent frame in itself: views of collectors' galleries in the seventeenth and eighteenth centuries show paintings elaborately encased. What was new was the recognition that ambience (literally: surroundings)—

16. Arthur T. Jameson, *Valuable Presents from Gentlemen.* Cartoon from *Life* 24 (November 29, 1894).

including frames and other accessories for effective display—had become a vital element in the manufacture of desire. And this in turn brought uneasy attention to the status of the art object as a material thing, a commodity. As William J. Stillman wrote, art had sunk to the level of fashions and fancies, becoming "huckster of stuffs and bric-à-brac."[3]

In a cultural climate increasingly disposed to disparage the commercializing of art, it was advantageous to create the appearance, at least, of detachment, and Winslow Homer managed this in an exemplary way. Tongue in cheek, he confided to J. Eastman Chase in 1888: "I have an idea for next winter, if what I am now engaged on is a success, and Mr. K. [Klackner] is agreeable. That is to exhibit an oil-painting in a robbery-box [Homer's own pejorative for the shadow-box] with an etching from it at the end of your gallery, with a pretty girl at the desk to sell." As Chase explained, to Homer the "gaudy glamor of a plush-lined shadow box and thick plate glass meant nothing less than 'robbery.' I think it could be truly said that no man was less moved than he by the prestige of high prices and the entrance to great collections which are so often the 'successful' artist's stock-in-trade. His honest soul revolted at a success bought at such a cost." Homer wrote to Michel Knoedler, his New York dealer after 1898, that in making the sale of *West Point, Prout's Neck* (for $3,000) he reserved the right to exhibit the painting at the Society of American Artists, "and I forbid any glass or 'robbery-box' put onto the picture." Refusing to sanction decep-

tive selling.devices, he calculated the value of his work by the force of its naked authenticity and that of its producer, no huckster by any measure. But Homer in truth had money very much on his mind and closely tracked the selling of his work. While robbery boxes may have been anathema to him, he was aware of the importance and power of display, instructing Knoedler to show *The Gulf Stream* (1899; Metropolitan Museum of Art, New York) "for all its worth, in the window or out of it. I had rather have a picture in your show window than any place." Late in life, he bragged that the $5,000 he had just deposited in a Cambridge bank "was *for one* picture." Just after Homer's death, *The Outlook* eulogized him as an *exemplum virtutis* to a materialistic society: "Homer's sincerity, honesty, and fearlessness of all social conventions showed itself in his art, which in a somewhat commercial age was not in the minutest degree tainted with commercialism." By forswearing robbery boxes and producing scenes of rugged and unspoiled nature, Homer sold himself as a painter well removed from the hothouse atmosphere of the marketplace, with its tricks, guile, and blandishments. He managed to negotiate an identity pinned to anticommercial interests while at the same time advancing himself by commercial means.[4]

By locating the fine line between transcendence and the marketplace, Homer solved the problem of balancing material ambition and the pursuit of aesthetic ideals. The problem dated back to midcentury at least, when the shrewd merchandising practices of such painters as Albert Bierstadt and Frederic E. Church seemed to go against the grain of their stupendous tableaux celebrating the purity and sublimity of America's God-given wilderness. But the controversy rose to a nearly hysterical pitch at the fin de siècle, when the status of art as commodity became too obvious to ignore and too threatening to discount. Artists had to weigh their options carefully in seeking to perfect their own precarious balancing acts—or risk being toppled from the higher planes of art. So tricky was that balance, however, and so grave the consequences of losing it, that it riveted the attention of cultural watchdogs, as though it were an unbearably suspenseful tightrope act. Writers generated a discourse on art and materialism that extended from simple fear of crass commercialism to virulent debates about the real versus the ideal. Since the reality of commercialization was something that no one could change, what the debate was really about, in the end, was the management of appearances, the cultivation of the right kinds of surfaces.[5]

Marketing Ambience: Studios and the Culture of Display

From the late 1870s into the 1890s, the skillful deployment of ambience in the form of the opulently decorated studio was an important tool for artists struggling for commercial success while seeming not to. This ambience—commonly known as art atmosphere—performed the same function on a larger scale as the dealers' plate glass and robbery-box strategy, only here the artist was his own middleman. Although older painters like Church equipped their studios with travel souvenirs and

17. *The Studio of J. G. Brown.* Photograph from Elizabeth Bisland, "The Studios of New York," *The Cosmopolitan* 7 (May 1889).

exotic bibelots, it was the younger, cosmopolitan generation that pushed the fashion to showy and often spectacular extremes symbolizing worldly sophistication, material success, and bohemian unconventionality. By 1889, indeed, the "plain" studio, such as that of J. G. Brown (fig. 17), was considered old-fashioned. So many young artists adopted the opulent fashion, and so often did the popular press highlight it, that by the century's end such interior decoration, thick with art atmosphere, had become inseparable from the image of the flourishing, cosmopolitan painter in urban America.[6]

William Merritt Chase's New York studio in the artists' building at 51 West Tenth Street was the best known and probably most representative of these artfully assembled habitats (figs. 18, 22, 107). These cavernous rooms (originally designed to be exhibition galleries) presented a dazzling array of beautiful, exotic, and curious objects, decontextualized and massed for maximum visual effect. Visitors who tried to describe them floundered amid the vast, bewildering accumulations. "It would take days," marveled John Moran, "to explore the contents of this studio, and even then one would only be entering on a knowledge of the variety, value, and interest of its contents." Attempting to guide the reader through the collection, he let his

18. *Studio of Mr. W. M. Chase.*
Illustration from John Moran,
"Studio-Life in New York," *Art
Journal* 5 (December 1879).

eye wander, picking out interesting items: "a Turkish coffee-pot of fine bronze, an Italian jar of exquisite green glaze . . . a white, pewter-mounted Renaissance jug of lovely shape and tone . . . a candlestick of delicate blue, an old Nuremberg pot, duelling-pistols" and a jumble of other things. There was a collection of women's shoes: "dainty little slippers of green and blue velvet, that have graced the feet of some sultana." Over the entrance the head of a polar bear grinned ferociously down on three white and pink stuffed cockatoos; elsewhere was a dried devilfish that looked "almost like bronze." Now a scarlet Spanish donkey blanket caught the eye, now the "weather-beaten sail of a Venetian fishing-boat." An ivory Japanese idol sat next to a carved wooden saint and a Greek bronze of Apollo; there were hats, tom-toms, knives, guns, and bugles. The studio was heaped with portfolios, crowded with paintings, and stacked with books that would "ravish the soul of a biblioma-niac." Despite the cacophony of objects, though, the place somehow produced a "restful sense of harmony in colour . . . the deep and mellow tone, the apparently fortuitous arrangement of line, drapery, and groups which never suggests awkward-ness. You cannot tell, you do not want to tell, how the effect has been arrived at. It is a matter of intuition rather than reason. And Mr. Chase . . . has the gift, the knack of doing it." During the tour Moran's mind and senses responded to contin-uous stimulation. At one point a "solemn, almost religious feeling" crept over him

19. *Studio of Mr. Humphrey Moore.* Illustration from John Moran, "Studio-Life in New York," *Art Journal* 5 (December 1879).

when "with church draperies and church lamps and burning incense" surrounding him he sat "in the subdued light" and heard Chase's organ sounding a nocturne by Chopin or a portion of a mass by Mendelssohn. At another, his eye rested on a Venetian Renaissance chest of the sort used as a seat in palace hallways. "Doubtless, could it speak, it could tell strange tales; it has heard many a page whisper soft speeches in the ears of pretty, black-eyed tirewomen . . . or assassins plotting some secret crime." It was the same in other studios, where rich ensembles of color and things triggered reactions both dreamy and sensuous. Humphrey Moore's studio (fig. 19) in the same building featured an Oriental theme "painted" in rich hues of gold, silver, mother-of-pearl, and gorgeous satins in "vivid greens, rich blues, brilliant oranges, scarlets, and purples." Leaning back on a divan and sending out smoke rings, said Moran, "one looks dreamily first at the embroidered, hand-wrought robes, and seems to gaze into some 'dim seraglio,' where languorous ladies, with henna-stained fingers and kohl-tinged eyes, recline, guarded by 'thick-lipped slaves with ebon skin,' sip their coffee or sherbet, and lazily smoke their nargiles." No mere workshop, the studio was a seductive wonderland of sights, sounds, smells, and textures.[7]

This type of city studio, noted Lizzie W. Champney, was a "*show* studio," where the artist surrounded himself with "rare bric à brac and artful effects of interior decoration." In the country the artist established the "necessary conditions of *work* . . . embracing little more than Nature and isolation." In the city the painter's mission was to sell, which entailed above all making people want to buy expensive objects with high exchange value and no material use value whatsoever. It was just at this point that the aims of the artist coincided with those of late-nineteenth-century retailers. To sell their goods, both had to perform and perfect the strategies of the showman. The artist's studio and department store displays were both productions of the showman's art.[8]

After the Civil War, department stores emerged as urban marketing systems. Although several had opened for business much earlier (Macy's, for example, in 1841), they all changed and expanded dramatically during the last three decades of the century, when they multiplied departments to encompass a universe of commodities, beautiful and luxurious as well as useful: from umbrellas, hats, and kitchen furnishings to Oriental rugs, antiques, imported bibelots, and splendid picture galleries. In 1881 the *Philadelphia Press* reported that Wanamaker's (established in 1861) displayed "the riches of the world brought together from all lands," representing "all departments of art and industry, tastefully arranged to be shown with advantage." Macy's in New York exhibited on the same large scale of sumptuousness and variety. One commentator estimated that a brief description of all the articles sold in Macy's, written out on ordinary commercial paper, would reach from Fourteenth Street to Central Park. The building itself was so large and sprawling that "one is at a loss to tell where it begins or where it ends. It is a bazaar, a museum, a hotel, and a great fancy store all combined."[9]

Like John Moran in Chase's studio, the shopper in a department store could easily spend days exploring its delights. Macy's pottery and glass department struck one visitor as "truly vast and and bewildering in its brilliancy," presenting a spectacle both ravishing and edifying. There was no better place "to study the character, the gracefulness of outline, the delicacy of blending shades and quiet and brilliant colorings in pottery and glassware. . . . Bisque figures and ornaments of the most elegant designs and decorations, and plain, engraved, and richly cut glass, domestic, German, Bohemian, French, English, and Venetian. . . . richly enameled Austrian, Bohemian, and shell goods. . . . Burmese shaded and tinted glass . . . pearl goods, and Charles' English fairy lamps, as well as a multitude of elaborate novelties impossible to mention in my limited space." The store interior (fig. 20) in a photograph from the late 1890s suggests the power of sheer accumulation of pretty, useless things converging on the senses from all points: rococo stands graced with filigree, ornamental lamps and vases, tassles and ribbons, dolls swinging from the crepe paper arches spanning the scene. Here was a cornucopian treasure trove, each commodity immersed in an ensemble so rich that the splendor of the whole shed radiance on and enhanced the allure of every component.[10]

20. *Interior Decoration.* Photograph from L. Frank Baum, *The Art of Decorating Dry Goods Windows and Interiors* (1900).

In modern marketing, image and exchange value counted for nearly everything. As business writer Nathaniel C. Fowler put it, "The old-fashioned idea that goods sell upon their merits, and that merit alone is essential, has grown moldy in its disuse. . . . No matter how good a thing you have, its selling quality depends upon your ability to make people accept its value. . . . It makes no difference what the article is. . . . You must please the buyer's eye." In show windows and interiors alike, display gradually rose to the level of an art intended to enhance visual and sensual pleasure while blunting practical judgment. Macy's introduced its extravagant Christmas windows in the 1870s, but it was not until the 1890s that window dressing and interior design came to be seen as marketing tools. By then, trade publications such as *Dry Goods Economist* and *The Show Window* (launched by L. Frank Baum in 1897) were beginning to disseminate the latest in display theory and practice. At the same time, professional societies were forming, the earliest being Baum's National Association of Window Trimmers, established in 1898. Baum (1856–1919) styled himself grand master of the new art and set out to "show merchants how to move their goods and increase profits" in an increasingly competitive marketplace, flooded with amounts of inventory that never seemed to shrink.[11]

Baum took up the problem of retailing strategies in Chicago in the 1890s, energetically producing *The Show Window* and ultimately publishing the fruits of his knowledge and craft in *The Art of Decorating Dry Goods Windows and Interiors* in

1900. In this book Baum defined the peculiar character of store windows, as specialized in their way as the stained glass windows of a cathedral. "Not intended to light up the interior," their "prime object" was "to sell goods." The goal of good display, in turn, was to capture the potential consumer's attention: "In order to make a window stand out from its fellows something more than a plain arrangement of merchandise is needed. It must be unusual and distinctive to the extent of arresting the attention of busy people as they hurry along the street." It was poor practice merely to crowd a window with articles, because the "simple artistic arrangement of a few attractive goods" served the purpose far more effectively. Baum devoted an entire chapter to the "harmony of colors," explaining color theory and interaction in great detail and illustrating his points with charts and a color wheel. He instructed window dressers in the art of draping and building backgrounds, creating mechanically operated moving displays, and procuring dazzling effects with electric light. The goal was to glamorize or otherwise transform commodities, just as the robbery box made a painting seem more precious or a romantically embellished studio added glamor to an artist's work. Indeed, Baum compared show windows to pictures and that all-important background to the frame. He recommended using the "Framed Form" to replicate the effect of a "life-sized picture": a large gilt frame would set off a costumed form in electric light against dark drapery. Despite his vaunted advocacy of the simple, artistic arrangement, Baum illustrated his points with examples that seem excessively busy, such as the *Art Goods* show window (fig. 21), stuffed with doilies, antimacassars, bobble fringe, reticules, and ruffled pillows. At the same time, however, it illustrates one of the principles of effective display: subordination of individual commodity to smoothly coordinated harmony of design, albeit far more regimented here than the calculated informality of the studio's clutter.[12]

Display strategist Kendall Banning likened the modern retailer to a theatrical producer (as Baum himself had been). Both were concerned with "staging," one a play, the other a sale. Color, light, arrangement, harmony—the elements of the merchant's stagecraft—added up to the production of a commercial variant on the studio's art atmosphere. Orchestrated into harmony, show window and interior displays were calculated to awaken desire by appealing to the imagination through skillfully crafted illusions. "The buying impulse," wrote one journalist, "is born of the noblest of human faculties: it is the child of imagination. The true genius in window-dressing is he who knows how to set the imaging faculty in action." In a sense, the window dresser—often raised to the status of artist in advertising discourse—had to have the same knack or gift that Chase possessed, of putting together mere things so that the shopper forgot they were commodities at all and yielded to their aesthetic and associational values. To stimulate the buyer's imagination, store displays elided facts of production (impoverished rug weavers, exploited lacemakers) beneath a seductive veneer styled by a Wanamaker's publicist as the "romance of Merchandise and Merchandising." In this romance, glamorous associations obscured the economic fact of

21. *Art Goods.* Photograph from L. Frank Baum, *The Art of Decorating Dry Goods Windows and Interiors* (1900).

the commodity, removing it to some fabulous, distant realm. Like the artist's studio, the store represented the world as an accumulation of glamorized exotica—items obtained by buyers (commercial versions of the cosmopolitan artist) who ventured "into strange places and over little-traveled roads to seek new and different things not found in the usual channels of trade." To be transported, the consumer had only to become immersed in the atmosphere of romance produced by these wonderful things: "Study . . . the exquisite beauty of yonder bit of rare Venetian lace, and there is presented to the imagination moonlit evenings on the Grand Canal. Examine the characteristic Swiss designs of these quaint textiles, and recall . . . the Alpine glow upon Mont Blanc. . . . Observe the infinite delicacy of one of these Viennese sculptures, and be transported to the blue Danube. . . . Behold the ancient symbolism, and experience the caressing touch, of the silken, high-caste Oriental carpets, and there comes a vision of another garden, in which blooms with fadeless beauty that perfect flower of architecture, the Taj Mahal!" The atmosphere enhanced the sensuous attractions of the objects themselves, and it was part of what the shopper purchased with the carpets and laces.[13]

Arrangement, harmony, color, and light in store displays spoke the language of advertising, and beneath the exotic and romantic stimuli they offered, they were, of course, geared to selling. Baum made the point plainly: beyond all the

technicalities to be learned, taste to be exercised, color harmony to be secured, "there must be positive knowledge as to what constitutes an attractive exhibit, and what will arouse in the observer cupidity and longing to possess the goods you offer for sale." While some recognized window display for the commercial strategy that it was, they acknowledged the pleasures of looking. One reporter observed that "the shop-windows, with their elaborate displays, their free exhibitions of the fashionable and the beautiful, are never without their crowds about them. Children are looking at toys, women at . . . shirtwaists, while the day-laborer with his tin pail stops at sundown to study great paintings." Still, however edifying or entertaining, the display had only one basic aim, as Anne O'Hagan recognized: "It [is] advertising . . . when McCreary [a New York department store], to stimulate the house furnishing branch of his business, makes a season's feature of an Indian room, perfect in every detail from the grille copied from an ancient temple to the brass box upon a stand, of a Marie Antoinette bedroom, pink and beautiful, or an old English hall, dark and rich." Pink beauty, dark richness, fantasies of the exotic and the aristocratic: the look of things, and the atmosphere generated by their arrangement, made them desirable. Whatever merits they had were beside the point. And it was the fundamental purpose of the department store, concluded O'Hagan, to create "appetites and caprices in order that it may wax great in satisfying them."[14]

The Artist as Showman

The show studio was in many respects an art world analogue of the show window. Art dealers of course had their own show windows—effective display sites, as Winslow Homer knew—but lacking these, and in a real sense debarred from resorting to baldly commercial tactics, artists used their opulent studios as advertisements for themselves. The need for advertising was crucial. After the boom years of the 1850s and 1860s, the market for American painting weakened dramatically in the last quarter of the century. Throughout the 1880s and 1890s the economy underwent cycles of depression and recovery while dealers sought the higher profits to be won by selling more prestigious European work to their wealthy clients. Few dealers represented Americans, though by the end of the century the balance would begin to shift as the market improved. In an often bitterly competitive environment, many American artists had to represent themselves, attract buyers, and struggle to elevate their prices.[15]

Dealers exercised an advantage because they were supposed to be merchants and nothing more. As the *New York Times* noted, the art dealer could advertise flamboyantly, the artist not at all; and while the dealer could drum up customers, the artist could not hawk his own wares. The dealer could send out circulars with the freedom of a slipper merchant, but no artist of any sensibility could even print his card in the papers without losing professional caste. The picture dealer could close out his superfluous stock with an auction; the painter had to disguise a similar

sale with a story about going to Europe. Foreign wares flooded the market; the home artist had a backlog in his own studio. "While the dealer, who draws from the rich storehouses of Europe, clamorously compels public attention, the native artist waits for the voluntary customer who must seek out that which he wants. Pride and professional etiquette keep the artist at home; they too often keep him poor." Marketing might be the "lowest aspect" of art production, concluded the *Times*, but there must be commerce in art: the painter must somehow be brought into contact with the picture buyers.[16]

The opulently bedecked studio, which was both a store and not a store and yet in every sense a showroom, answered (for a time at least) the need for artists to draw attention to themselves without creating the appearance of being crass retailers or advertising men. The studio interior was of course no conventional emporium designed for effective mass marketing. Most of the things there, all the bits and pieces of the collection, were not literally for sale. Their job was to produce an art atmosphere to make the place attractive and to advertise both producer and product. One writer discerned this, noting that the bric-à-brac and the studio were the ambitious painter's "properties," designed to "aid in bringing him customers and raising his prices." Most, however, chose not to highlight that function, tending instead to celebrate the studio as temple of art, shrine to taste, or haunt of genius. This in itself testifies to the success of the strategy.[17]

Functioning actively yet deviously as an advertising mechanism, the studio was the novel and attractive "packaging" that the artist devised to lure customers. Magazine and newspaper articles about the studios provided free publicity and helped construct the image of the well-traveled, highly cultivated artist in an opulent, tasteful habitat. The formal studio reception, which became a feature of art life in the early 1880s, was a mode of advertising as well, a public-relations event. This ritual promoted contact between painters and prospective clients, who were encouraged to shop around amid the pictorial wares displayed in exotic, evocative settings. Such receptions were popular, earning extensive coverage in the papers, where the language of the society column gushed forth to describe them. At Tenth Street, huge crowds streamed in from carriages lining both sides of the street, and the artists "spent the time shaking hands with their callers and answering inquiries" while the ladies drifted about the studios, exclaiming over the ravishing array of curios and examining paintings on easels. Chase's was the most brilliant of all: "The easels . . . were but a small part of the attractions of the place, and the ladies spent hours in talking to the artist's birds, and petting his spaniel, which lay stretched out lazily upon a couch of brilliant upholstery. The artist, with a little polo cap on his head, was kept busy entertaining his many friends. Two colored valets in gorgeous costumes directed the curious observers hither and thither through the place with quaint courtesy." This passage yields a vivid picture of Chase the showman, in his showroom-studio, performing the role of artist and in the process selling himself and the bits of himself, his personality, incorporated into his paintings.[18]

Such receptions met with mixed results, prompting artists to abandon them after several seasons as a regular feature of art life. Studios continued to be used as settings for social events, dinners, and parties; dealers visited them as well. Public shows, such as annual exhibitions of the National Academy of Design and the Society of American Artists, remained important vehicles by which painters reached their public, and late in the century a growing number of art dealers began to promote American art more actively. There were exhibitions at elite clubs, where artists also cultivated the social connections that might win them sales. American artists throughout the period were constantly engaged in marketing. Diaries of painters (Jervis McEntee and J. Carroll Beckwith, for example) demonstrate how obsessively artists thought and worried about how to improve their sales. Whether they used two-or three-dimensional robbery boxes or developed other strategies, they had to market what they produced. If they engaged too obviously in selling, though, they made themselves vulnerable to scathing and even apocalyptic denouncements.[19]

The Taint of Trade and the Fear of Surfaces

In 1893, English philosopher Frederic Harrison contributed a series of essays on modern culture to the distinguished liberal New York magazine *Forum*. Although Harrison's experience was of the British art world, his argument—directed to a small American audience—touched precisely on the points raised by legions of others in sermons warning against the evils of commerce and materialism. The one irreducible essence of all those claims was that under no circumstances could anything but corruption come of breaching the barrier erected to shield art from the taint of trade. Confident that he was on the side of truth, Harrison never questioned these terms. Whatever the factors at play in modern art's decline, the "real root of the mischief" was that "art in all its forms is become a mere article of commerce. We buy works of imagination, like plate or jewelry, at so much the ounce or the carat; and we expect the creator of such works to make his fortune like the 'creator' of ball costumes, or of a dinner service. . . .The artist has to boil his pot, and nowadays he likes his potage to be as savory and costly as that of his neighbors, and he has not the leisure or wealth to meditate for years on a truly immortal work. On the other hand, the buyer, who is usually a keen business man, not unnaturally says, 'I must have value for my money, and to keep an artist in luxury, whilst he is meditating a big thing, is not my idea of business!' " Because of this and other circumstances, such as the rise of art dealers and the institution of huge public shows, art had become "as much a matter of professional dealing as a corner in pork, or a Bear operation in Erie bonds." Competition, greed, and the demand for novelty now fueled art production rather than high ideals, and excellence was a matter of archaeological accuracy rather than the evocation of inspiring visions. Harrison asked the reader to imagine Michelangelo "communing with the mighty spirits of old alone" in the Sistine Chapel, or Giotto inspired by Dante's suggestions for "grand motives" in the Arena Chapel at Padua. "What would these works be," he demanded, "in

the screaming dissonance of a modern gallery, exposed to the higgling of the market, and designed to catch the accidental whim of some lucky investor?" Any "high type of art" under a system of trade and moneymaking was impossible to achieve, because the pursuit of fortune, which set deadly snares of temptation and lust for riches, spelled the ruin of art. With even more fire, and closer to home, B. O. Flower in *The Arena* indicted commercialism as a death-dealing influence that blighted and withered whatever it touched. It sapped "manly" instincts and "dipped its hands into the warm blood of the common people." Would it now "seek to make art its plaything, its tool, something for ignorance to toy with and cast aside because it has not the wisdom to know its worth?"[20] This kind of critique was not new. From the moment the Republic was founded anxious observers had worried about the equation of art with luxury and aristocracy, and about its potential to degrade democracy. The opposition acquired its hysterical edge, though, from the emergence and ripening of a consumer ethos based on abundance, luxury, and the satiation of desire.

What critics perceived in commercialized artists—that they debased themselves by catering to a vulgar taste for show—seemed to afflict American culture as a whole. The price to be paid for a "century of unprecedented progress," W. Carman Roberts asserted, was emptiness. "We skim the surface of life, without time to make our impressions our own. We are on the way to become a spiritually impoverished people. . . . We are ultra-sophisticated, yet easily deluded." Another writer noted in 1903 that the most popular novelists were little more than sociological adventurers with no psychological depth. This reflected the paucity of inner life in American culture: "Our spiritual life seems to have grown in thin soil. . . . Both the journalistic pressure and the romantic vogue, as at present cultivated, are symptoms of the fast and unreflective life." John Graham Brooks saw the effects of commercial culture in shallow, showy excess of all kinds: "the unnatural lust for bigness, glare, intensity, display, strain, and needless complication."[21]

For a superficial civilization, superficial art: social conditions had bred an art whose ignoble purpose was to beautify the skin of a materialistic world. The most popular art—the "decorative, household, profitable, professional"—was no deeper than cheap veneer, "sentimental, sensational, and fantastic," in Charles Eliot Norton's view. Marie C. Remick, of the Chicago Woman's Club, found that while the artist of the Italian Renaissance had been an active, well-rounded citizen, consulted on questions of civic policy and defense as well as on aesthetic matters, art had now become "the decoration . . . of life . . . the adornment of a civilization rich in material things, and scientific in its thinking." The new art of surfaces was well if deplorably suited to its epoch, and realism in particular the symptom of decline. In the eyes of Elizabeth Stuart Phelps, realism had all too evidently weighted art's "flying feet." "Paltry subjects" now occupied "petty brushes *ad nauseam*. Smatter and spatter, under the names of impressions and sketches, mock grand construction and noble toil." No longer kneeling before her angels, art now "painted two dropped eggs on toast" and seemed "content to do so." Certainly American artists were not all paint-

ing poached eggs. Abbott Thayer, among others, was even painting angels. But the new orientation to surface values threatened to eclipse any prospect for aesthetic redemption.[22]

Realism was in one sense an art *of* commercial culture. Originally identified with the literary art of Emile Zola and his imitators, it came to symbolize the ills of modernity on an extensive scale. Its critics condemned it as an art of surfaces exclusively, partaking of the faddishness and the cult of the spectacular that also marked consumer culture, along with that culture's insidious ability to devise stunning and seductive illusions, that is, the appearance of something that wasn't really there. The seeming alliance of realism with analytical, "scientific" vision further stigmatized it, since modern science itself was generally represented as the purely objective, impartial, and even mechanical scrutiny of physical facts.[23]

Opponents of realism tirelessly inveighed against its fidelity to superficial appearances at the expense of deeper and less tangible dimensions of the "truth." William H. Mallock maintained that the "full reality" of life could never be encompassed by any amount of "*verbatim* reporting." Such an art could "never be completely real, in the sense of reproducing the complete reality of anything, any more than a photograph of the outside of a house can reproduce its solidity, its rooms, its furniture, and its inhabitants." Not only did it fail to reproduce "complete reality," but it could also "monstrously misrepresent it," concocting a view of life that was false, feeble, and shallow. Suppose Zola were asked to describe a dreadful shipwreck. Whereas Lord Byron would have exalted it in poetic, romantic measures, "M. Zola would be describing the retching of the sea-sick passengers, and filling chapter after chapter with analyses of the contents of the stewards' basins." Yet for all its repellent exactitude, realism was what people somehow, perversely, wanted. Hiram M. Stanley, a professor at Wake Forest University, noted that art served the "science-born craving" and the "passion" for reality that dominated modern social and cultural life: "As the longing for the real becomes more and more exacting, we may expect every novel to be prefaced by an affidavit that every word has been taken from actual life by phonographic record and that the descriptions are attested by photographs, thus making the whole legally and scientifically verifiable. We shall then be besieged at every turn by the litterateur and artist eager for material and armed with camera and phonograph." These longings were pernicious, however, in their effect on art production, which by responding to demands for the spectacular ensured its own degradation: "A picture so realistic that we take it for the reality pictured is no more fine art than a mirror so clear we crash into it by mistake. The pictorial forgery of nature which deceived the expert is, of course, a marvel, but one more fit for the dime museum than for the art gallery. At the best such a production is but the bastard offspring of Art[,] . . . and while this realistic artifice will always please the multitude, it will ever be discriminated from true art by the intelligent amateur."[24]

What is significant here is not so much the identification of realism with exact

topological description. With the exception of a subculture of trompe l'oeil painting by William Harnett and his imitators, few artists pursued that course. Rather, it is the obvious unease in the face of the surface values beginning to pervade and define American culture that allies these texts with contemporary anxieties about the taint of materialism and its lowering effect on the visual arts. The shift to surface values, intrinsically identified with commercialism (and the passion for it), gravely threatened the legitimizing transcendental status that protected art from the infection of market values, which represented a fatal accommodation to the pressure of demand, at the sacrifice of imagination and ideals. By catering to the passion for looking at, and being taken in by, surfaces, art collapsed into the marketplace to become just another commodity whose exchange value depended upon its eye appeal, the desirability of its surfaces, and its ability to conjure up illusions—not of the trompe l'oeil variety necessarily, but also of the sort that John Moran described, of temporary immersion in an exotic and sensuous ambience.

The "Society Painter"

Unease over how commercial culture affected American civilization was projected onto artistic practice, which served as a space for rehearsing the scenarios of disaster or salvation playing simultaneously on the larger social stage. Artistic materialism came under intense scrutiny in the energetically circulating discourse that disparaged the "society painter" and exposed his habitat—the opulently decorated studio—as a theatrical showroom calculated to sell by deception. In this discourse all of the traits that conspired to arrest true greatness were collected and embroidered to encompass and define a baleful pattern of modern artistic identity, figuring the artist as a meta-phorical skull and crossbones warning against the poisonous influence of luxury and greed. In particular, the links that bound material display to fakery were powerfully drawn.

There was a real life example in the career of John Singer Sargent (1856–1925), whose dazzling success at the turn of the century interfered in both subtle and obvious ways with his attainment of unequivocal "great artist" status, regardless of the skill, taste, and facility that made him such a superb painter. As a portraitist, he could not possibly disguise the economic activity that brought him international fame and a princely income. He produced and sold images of and to his clients, who paid him readily and well. There was extensive disagreement regarding Sargent's abilities to do more than capture mere appearances, but at the same time there was near-universal consensus that he was an artist of little or no imagination or poetic sense, a limitation that confined him to the fascinatingly lively observation and de-piction of facts. This is not to say that Sargent failed to earn his share of praise. But the unconcealed commodity status of his best-known works (see figs. 71, 73) dragged at his heels.

Royal Cortissoz found Sargent to have "something of the fecundity and power of the old masters" but wondered whether he would ever "attain to their rank." If

he fell short it would be because of his "limitations as a colorist" and "want of spiritual depth." In portraiture, he was fascinating, original, splendid, fertile, and intensely superficial: "He is spectacular, if you like, but there is not a trace of vulgarity in the spectacle. . . . He is a type of materialism triumphant. . . . wonderfully refined by intelligence and taste." At a time when materialism in all its forms seemed to pose a danger to social and cultural life, designating one of the foremost portrait painters of the day a materialist, even a superbly refined one, was to praise with a vengeance. There was something about Sargent's very skill that raised suspicions; his work seemed too effortless to be sincere. To Christian Brinton he was was a "conjurer performing a trick," a "magician of the palette," a "Paganini of portraiture." Of course his subject matter counted against him. Perhaps if he had specialized in elemental seascapes he would have struck the critics as a more genuine painter. But as someone paid to glamorize and memorialize the well-to-do bodies of the cosmopolitan elites and upper classes, he had difficulty shaking off a reputation as a prodigiously talented faker.[25]

The Boston Public Library decorations, finally completed in 1925, were an elaborate attempt to invent another Sargent—a deep, intellectual, transcendent, philosophical one. Although Cortissoz thought that Sargent had gotten "out of his depth" in attempting the lofty subject of "Judaism and Christianity," some found his ambitious designs admirable and wondered why he had so wasted his time in pursuit of the superficial: "Has Sargent exchanged his genius for a mess of pottage? What would Sargent have been had he not given himself to promiscuous portraiture? What might he, with his powers, not have accomplished if, from the very beginning, his art were the result of the impetus of ideas and not a surrender to the material considerations of a matter of fact world?" The "promiscuous" Sargent had prostituted himself, painting material things for material gain at the expense of his higher self. Sargent's reputation suffered greatly under the regime of modernism, and Roger Fry's well-known and severely damaging attack on him in the 1920s only sharpened and summarized the reservations voiced earlier, when critiques of Sargent the materialist, the promiscuous, and the tricky magician summed up everything that made his path a risky one. Although Fry was only one voice among many in the critical chorus, which heaped his work with as much praise as otherwise, it draws a suggestive connection between the practice of an outstandingly successful portrait painter and the fictional figure of the society painter, a popular caricature of everything that Sargent seemed to represent, minus his talent.[26]

The society painter or society artist was a shallow profiteer and an egregious poseur who lived off the cult of luxury and pretense pervasive among the rich. Painters who circulated in the realm of society and fashion were corrupt almost by definition, because success depended on the mastery of slick sales techniques, practiced on those who lived only for pleasure and for the assertion of status through commodity display. In Edith Wharton's *Custom of the Country*, Claud Walsingham Popple specializes in the art of flashy, shallow image-making. All that his sitters

(exclusively female) ask of a portrait is that the "costume should be sufficiently 'life-like' and the face not too much so." To entice and entertain his clientele, Popple stages elaborate teas in his "expensively screened and tapestried studio" and always keeps it at "low-neck" temperature for the comfort of the empty-headed social climbers who frequent the place and drink up his oily compliments along with their tea. In *The Fortunes of Oliver Horn,* F. Hopkinson Smith (1838–1913) outlined an even more cynical profile in the career of "The Honorable Parker Ridgway, R. A., P. Q."—a painter who "can't draw, never could." Ridgway joined the right New York clubs and had his wardrobe made by the right tailor. Then he "hunted up a pretty young married woman occupying the dead-centre of the sanctified social circle, went into spasms over her beauty . . . grew confidential with the husband at the club, and begged permission to make just a sketch . . . for his head of Sappho, Berlin Exhibition. Next he rented a suite of rooms, crowded in a lot of borrowed tapestries, brass, Venetian chests, lamps and hangings; gave a tea—servants this time in livery— exhibited his Sappho; refused a big price for it from the husband, got orders instead for two half-lengths, $1,500 each, finished them in two weeks." Hearing this tale, a poor but honest painter mutters: "Just like a fakir peddling cheap jewelry." Another reasons: "Merchants, engineers, manufacturers, and even scientists, when they have anything to sell, go where there is somebody to buy; why shouldn't the artist?" The question was a rhetorical one, of course.[27]

Ironically, Smith himself was a commercially successful and socially prominent artist, if not a society painter, who freely admitted that his work was a commodity. Perhaps his subject matter—touristic views of Venice and other romantic, picturesque spots—mitigated the onus a bit: he was not in the business of glamorizing celebrity and wealth. Portrait painters, by contrast, could hardly avoid being associated with fashion and fame, and if they hobnobbed with their clients they exposed themselves to the pernicious atmosphere of wealth and the cult of celebrity it fostered. Journalist Aline Gorren warned that artistic recognition in this climate was bound up with the "idea of money, ostentation, show" at the expense of everything that provided true nutriment for the mind and soul. It was the artist's duty to avoid those surroundings "which stunt and cripple . . . instead of developing and enlarging him." The society hostess might lure her victim into a salon of the most pleasing and flattering ambience, but the result for the artist was "a relaxing of the mental fiber, and a fatigue, flat, stale, and unprofitable." Like a vampire, society fastened itself on the artist to sap him, empty him, and leave "only the husk of him behind." High society and commercialism produced the identical result: they sucked away the pith and soul, leaving nothing but surface, a simulacrum, a shell. Both turned on the same axis of materialism, consumption, status seeking, surface values, and commodity display. Both were equally deadly to the life and spirit of American art, because both exalted the language of facade, style, and veneer.[28]

Artist Priests

At this juncture artists and their interpreters found it necessary to insist on the use-value of art, its vital importance in the struggle against the same forces of materialism with which it was fully engaged. Their strategy was to present art in the least commercial light possible as they erected a counter-discourse figuring commercial activity as a fatal trap. Frederic Harrison urged that art be practiced as a "mode of religion"—disinterested, transcendent, pure, and lofty. "I would say but one word to the ingenuous youth who aspires to be an *artist* that he should shudder to become a *tradesman*[,] . . . that he hold by all that is pure, all that is beautiful, all that is broadly human." This was the standard prescription for artists who wanted to avoid the perils of modern materialism and establish themselves as leaders to a better and higher plane. John La Farge asserted that true grace was never to be found in "commercial warehouses of knowledge. There can be no Macy's for the intellectual and the moral. . . . And as in other matters that are for sale, even votes, what we need to know is the danger, and it is for us to be out of reach." In "The Priesthood of Art" another culture critic argued that the artist was obliged by nature itself to provide elevated ideals and a sense of gladness to viewers. Such was the "natural" course of artistic evolution, always rising toward higher perfection. Art should not be true to any kind of nature but the "most advanced." By presenting "low-grade" ideals, art went against nature by reversing those natural processes demanding forward and upward progress.[29]

Poverty and unworldliness were the best allies of the true artist. "A Story of the Latin Quarter," by Frances Hodgson Burnett, relates the tragic career of a poor, sensitive American art student in Paris. Before his untimely death the young artist produces one masterpiece, portraying a model whose beautiful soul only he can see and realize on canvas. The painter's room, with its low, slanted ceiling, is poor and bare, containing nothing but a narrow iron bed, a wooden table, and an easel. Even the hard-boiled model is affected by this monkish chamber: " 'He is one of the good,' she thinks. 'He cares only for his art. How simple, kind, and pure! This little room is like a saint's cell.' " In this construction the artist wants only to paint the truth, not to sell it. William Ordway Partridge conceded that while an artist might find it a practical necessity to sell his work, he must select buyers who were worthy of the privilege of ownership. Any other kind of transaction was lowering: "To sell a painting to a man who does not care for it is a degradation of one's art—one might almost say a prostitution."[30]

It is not difficult to see the advantage of staking a claim to such a position. Amid the welter of outcry against the crushing weight of American materialism, artists and their supporters erected a rhetorical platform above the fevered hotbeds of the marketplace. Poised (precariously) on their elevated plateaus, they figured themselves as a spiritual elite, marking the course of salvation from soulless luxury to high ideals. How much, or how deeply, artists internalized the prescription for anticommercialism varied with each individual, but many subscribed to it. Critic

and muralist Will H. Low exhorted students to avoid at all costs the perils of sell-ing out to commercial interests. Hoping for quick profits, some left art school early. These hapless adventurers provided a sobering example: "You have seen some of the more advanced of your fellows disappear from the school at a critical period of their career . . . to make a short apparition a few weeks later, with a high hat and a large cigar, to announce their engagement, at a good salary, as the artist of the 'Daily Screecher.'" The enormous use of illustration in the daily press was heavily responsible for "blighting" the future of talented artists and lowering aes-thetic standards. Commercialism had also devitalized the etching revival in Amer-ica, where because of low standards "anyone who could scratch a copper plate [could] put his wares on the market, the print-sellers and department stores saw the business opportunity, and today etching here is virtually dead." In the same way, mass production had cheapened the stained glass revival. Low's homily im-plied that it was advantageous to stay ahead of the market, to produce goods for which no demand existed, or at least to create the impression that there was none. Such maneuvering neatly tied together any sort of avant-gardism or nonpopularity with the highest and purest motivations.[31]

This is not to say that the noncommercial stance was never more than that. Violet Oakley (1874–1961), a successful illustrator and one of the only prominent women muralists of the early twentieth century, turned down a prestigious commis-sion for a *Collier's* cover illustration because of pressure to complete a series of stained glass designs contracted for All Angels Church in New York by the Church Glass and Decorating Company. After receiving Oakley's refusal, *Collier's* art director George Wharton Edwards wrote back, "The artist always suffers through dealing with the cold, hard, unfeeling business man, who is encased in a leathern hide, which may not be pierced by anything but the pointed dollar. Sad to relate the artist is not considered. To my mind the artist and the poet are survivals of the happier time, but it does us little good to cry out against existing conditions or attempt to battle with them, the result being always increased and added suffering for the sen-sitive personality of the artist." In her reply, Oakley aligned herself squarely with the forces protecting artistic integrity: "There is just one word that I would like to say on behalf of ourselves and the poets. Let us all beware how—today—we harden our hearts to our own precious birthright—our 'sensitiveness' and deafen our ears to its still small voice. If we can perceive that under these 'existing conditions' the tendency is to give up the struggle—to become likewise hardened—to encase our-selves in that very same 'leathern hide' in order to escape the suffering—let us realize that thus we capitulate[,] surrendering not only ourselves—but weakening the de-fenses of the whole city—and for what? Because—forsooth that Goliath of the Phil-istines is big and ugly and seemingly powerful—and we are *afraid*!" Against the Philistine threat the artist must never cease to struggle, never cease to produce good work, and "*never cease* to cry out against existing money conditions—Battle con-stantly—fight the good fight—*overcome*."[32]

22. William Merritt Chase, *In the Studio*, c. 1880. Oil on canvas, 28⅛ × 40⅟₁₆. Brooklyn Museum, 13.50; Gift of Mrs. Carl H. De Silver in memory of her husband.

The Aesthetic Commodity

The problem that nearly every artist faced was to create an aesthetic product destined for the marketplace without appearing to collude too deeply with its commodification. The further from the realm of market activity an artist could position himself the more legendary his status was likely to become. Such behavior answered the need for figures who succeeded in holding art aloft and aloof, where it was supposed to be. The artists who acted out the most compelling individualism against "corporate" art culture were apt to be the ones who engineered the greatest detachment from or indifference to the world of sales and the rituals of seduction. The trick was to formulate new representations of aesthetic expression and meaning to offer assurance that—appearances to the contrary—the contemporary painter's "dropped eggs on toast" harbored nutriments for the modern spirit.

William Merritt Chase's work traced a fine and precarious line between blunt materialism and something more. *In the Studio* (fig. 22) characteristically creates a ravishing display of color, pattern, and texture. However interesting the artifacts may be (the Japanese fans, the young woman's old-fashioned gown, the model ship, the Oriental rug), they exist first and last as notes in a skillfully composed ensemble,

23. William Merritt Chase, *Still Life with Fish*, c. 1910. Oil on canvas, 29 × 36. © Indianapolis Museum of Art, John Herron Fund.

embedded in juicy brush strokes that call attention to themselves as lush spots of textured color, creating chords of silky gold, vivid coral, cool turquoise, and chocolate brown. The language here is insistently visual: the painting is about the pleasure of beholding beautiful artifacts, beautifully arranged. With this emphasis, Chase's painting falls into place as paradigm of the aesthetic commodity: the luxuriously coated surface, the precious object celebrating the joys of seeing a material world full of delectably lovely things. Like his real physical environment, his pictured studio was an aesthetic boutique for the browsing eye. So gorgeous were his surfaces, however, that to some observers they seemed only that; like Harriet Monroe, they found behind the famously "brilliant workmanship" a "paucity of that high poetic quality which . . . is the soul of art." In one of Chase's popular fish still lifes (fig. 23) William Howe Downes saw technical wonders: "Nothing could be more painterlike than the make of his painting. In texture, shape, structure, weight, color, character, everything was broadly and tellingly suggested. . . . There is also . . . the unmistakable revelation of the pleasure that the thoroughly capable craftsman takes in the manipulation of his medium—a gusto and fluency which, as it were, elevate the materialism of the motive into the realm of feeling, taste, and almost of imagi-

nation." Whereas Chase's studio could waft visitors into dream worlds by the power of association, his paintings were too tightly rooted in the material present to carry that charge. As Mariana Van Rensselaer put it, Chase's art concerned itself with the things that lay about it, and he painted them as they were. His work was superbly artistic but not in the least poetic.[33]

For all his scintillating brushwork, Chase remained earthbound. Yet as John Van Dyke observed, Chase and the far more ethereal Whistler shared one salient trait: "Chase's painting is the concrete embodiment of his teaching.... He is just as frankly dealing with the surface as Whistler, with the mere difference that Whistler asks us to regard him decoratively and Chase desires to be looked at technically." This was a crucial distinction. It was the decorative that raised Whistler to a higher plane than Chase could ever hope to attain. It signaled the presence of ideal and poetic meanings that were literally embedded in design and color, rather than traditional symbol-making or narrative devices. In the late nineteenth century, *decorative* and *decoration* had a number of overlapping connotations, some more literal than others. Chase's own studio showed an exuberant decorative energy at work. The mural movement was about the decoration of public and commercial spaces in the interests of civic beautification and elevation of taste. Many artists extended their practice into the realm of domestic decoration as well: John La Farge and Louis Comfort Tiffany in stained glass, Augustus St.-Gaudens in relief sculpture and other forms of embellishment, Thomas Wilmer Dewing in ornamental screens. Whistler, maker of the Peacock Room and designer of tastefully coordinated exhibitions, was the foremost painter-decorator of the era. Even the crusty Homer and the unconventional Albert Pinkham Ryder dabbled in decorating—Homer through the Tile Club, Ryder under the aegis of his dealer Daniel Cottier, for whom he created painted screens, and small panels for use as furniture insets. This engagement with public or domestic space represented moves into the realm of social consciousness and civic-mindedness, which carried almost automatic exoneration from the charge of being a mere technician, however brilliant, or a sensualist mired in materialism. As George Parsons Lathrop saw it, the influence of decoration "is of the best . . . because it carries fine art into the resorts of every day, whether in drawing-room or dining-room at home, in business buildings, legislative halls, hotels, and halls for public assembly." Even barrooms and chophouses had responded to the new "rage," and while "all this may indicate only a superficial mood . . . the things done are frequently excellent, and the general result is not a lowering of art, but a gradual lifting up of popular taste." Edwin Blashfield, who was to become a leader in the mural movement, told young painters and sculptors at the Art Students League that "all good art should be decorative. Art is not a luxury but a necessity. . . . It is surprising to see how soon a man learns to enjoy his coffee more out of a cup with good and graceful shape than out of a clumsy and ugly one." The adornment of surfaces now had a missionary role in acquainting both the American elite and the American masses with the refining influence of beauty.[34]

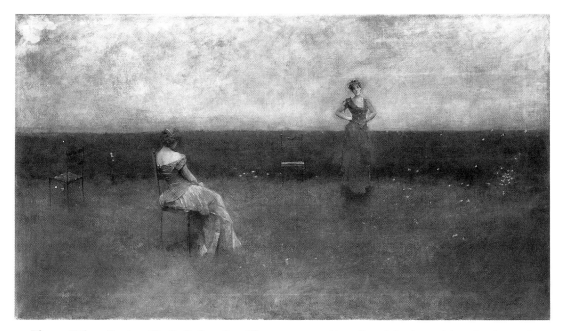

24. Thomas Wilmer Dewing, *The Recitation*, 1891. Oil on canvas, 30 × 55. Detroit Institute of Arts. Purchase: The Picture Fund.

The meaning and use-value of decorative art went beyond socially responsible ornamentation to reconcile the form of the physical surface, beautifully covered, with the function of providing metaphorical transportation to the world of spirit and poetry. Decorative meant many things to different people, and not everyone agreed about its transcendent power. Katherine Metcalf Roof, for example, thought that painters who strove for decorative effects tended to exalt formalism at the expense of sentiment. Still, there was significant consensus on the equation of decoration (that is, abstraction from nature) with the poetic expression of mood and soul, from which it followed that for a painting to be poetic it must be decorative, a synthesis rather than an analysis of nature.[35]

The work of Thomas Wilmer Dewing (1851–1938) illuminates that trajectory from decoration to spirituality. Dewing's austere, refined compositions representing gauntly elegant women in interiors or posing, in evening dress, in misty green outdoor spaces (fig. 24) might be taken as deliberate rejections of the lushness celebrated in Chase's studio scenes. Enthusiastically patronized by wealthy industrialist Charles Lang Freer, Dewing produced paintings in which he sought to transcend whatever was crude, commonplace, and shoddy in modern life. He evoked an exclusive world of beauty and taste, a world that—in the form of aestheticized household decor, the connoisseurship of rare and lovely objects, and the contemplation of exquisite paintings—was to become a new source of spirituality in a secular age. In Dewing's paintings, Royal Cortissoz perceived a direct connection between design and poetry, noting that "pictorial effect is largely a decorative effect, largely an affair of contour,

of proportion, of the relation of a figure to its surroundings." Out of these properties emanated enchantment, witchery, and poetic feeling, subjective yet rooted "deep in the truths of nature." Dewing's "decorations," as he called his landscapes, were in his own view too subtle for any but the most refined connoisseurs of beauty. For this reason he withheld his landscapes from the 1901 Pan American Exposition in Buffalo, New York. He explained his decision to Freer, writing, "My pictures of this class are not understood by the great public who go to an exhibition like the Pan American. They are above [their] heads. . . . My object in exhibiting at all is merely patriotic." He chose, therefore, to send only a few paintings of interiors with figures. "These stand squarely on their merits," he told Freer, adding, "My decorations belong to the poetic, imaginative world where a few choice spirits live."[36]

Dewing's art, like that of so many contemporaries, looked to Whistler, the preeminent decorator of two-and three-dimensional spaces. Whistler's style, which played on simplification, abstraction, spatial compression, and muted, often monochromatic harmonies, referred insistently to surface while promising spirituality and essence. Still, Whistler's flat screens of tone, however subtle, were like department store show windows in a sense: shallow displays promising the fulfillment of desire within. In Whistler's *Nocturne in Blue and Silver* (fig. 25) the ground is evenly covered from bottom to top with streaky swaths of the same opalescent blue, the brush marks showing no variation as they pass from water to sky. The tranquil blue field is interrupted only by the dim silhouettes of factories and chimneystacks along a horizon line so high that it nearly touches the upper edge of the composition, symbolizing depth without illusionism. At the lower edge, sketchy marks denoting a cluster of willowy branches, along with a colophon like an Oriental seal, intensify the surface orientation and two-dimensional coherence of the design. Almost paradoxically, paintings like this—flat as a signboard—seemed to open out avenues of escape from the material world. Again and again critics praised this avoidance of physicality. Kenyon Cox wrote, "In color he gives us no crashing climaxes, no vibrant full-orchestrad [*sic*] harmonies—his is an art of nuances and shadings, of distinctions scarce to be followed by the ordinary eye. What he calls blue or green or rose . . . are the disembodied spirits of these colors, tinges and intimations of them. . . . Finally he wraps everything in the gray mystery of night." In their washy character, their translucency, and their dimness, Whistler's "disembodied" colors signaled that the painter's compositions were to be read as expressions of delicate feeling and spirituality. No matter that Whistler's tints adhered as tightly to the surface as Chase's heartier pigment: certain differences indicated that the one signaled soul, the other matter. It was on difference from Chase's style of painting that Whistler's spirituality established itself. Where the eye enjoyed sensuous pleasures in the art of Chase, in Whistler's compositions it took flight through "places of dreamland, landscapes of the mind, summoned with closed eyes, and set free from everything coarse and material," in art historian Richard Muther's words. Whistler was a "wonderful harmonist," who had the "art of simplifying and rendering all things spiritual,

25. James McNeill Whistler, *Nocturne in Blue and Silver*, c. 1871. Oil on canvas, 17½ × 23¾. Fogg Art Museum, Harvard University, Cambridge, Massachusetts; Bequest of Grenville L. Winthrop.

whilst he retains the mere essence of forms." Christian Brinton, obsessed with neurasthenia and spirituality, found in Whistler a kindred spirit, one whose art had from fleshly beginnings become "fastidious and evanescent, the merest phantom suggestion of fact" undergoing a "continuous process of etherealization" so profound that his later portraits did not depict actual men and women so much as "eloquent disembodied souls."[37]

To look at Whistler's art, and Dewing's, as framed by the uneasy discourse on materialism and the rise of consumer culture, is to understand how paintings like theirs worked so well to evade the onus of physicality and earthboundedness that persistently clung to Chase. When read within that frame, Chase's paintings—the crammed studios, the opulent surfaces, the rich colors, the sparkling landscapes, the stylish women—signified abundance and amplitude while promising satisfaction of the eye and, vicariously, the tactile sense. While paintings by Whistler and Dewing were no less appealing to the eye, they supplemented eye appeal with the formal

and tonal cues that alerted the receptive viewer (taught to recognize them, perhaps, by critics like Cortissoz) to the spiritual depths behind the veneer. Compositions such as Whistler's *Nocturne in Blue and Silver* or Dewing's *The Recitation* distanced themselves from the world of things by sheer emptiness as well, by insisting on the high currency of disembodiment or by paring down women and chairs to the boniest, spindliest minimum. In their emptiness, these compositions proclaimed their remoteness from the marketplace of artifacts manufactured to satisfy the desires of the senses alone. Masking or eliding their techniques—intricate in both cases—by opting for evanescent rather than tactile effects, both painters managed to position themselves as merchants of a near-nothingness that stood for something higher.

Cultivating Detachment

Both artists also cultivated the look of asceticism in their studios. Muralist Edward Simmons, who met Whistler in London, noted that the expatriate's studio was "large, dignified, and very bare. I remember multitudes of little galley pots in which to mix colors." Elizabeth Bisland found it difficult to say anything at all about the workroom of Dewing, whom she styled a "monk." "Dewing . . . paints in a cell in the Fourth Avenue Studio Building, and [his] only bit of bric-a-brac is a maraschino jug, hung there on a nail by Chase, after a frugal luncheon, while sitting for his portrait, as his decorative soul was vexed by the contemplation of bare walls. Dewing owns a more elaborate abiding-place, but it is mostly for show; and when he wishes to work he immures himself in this little, bare room, from which emerge his beautiful, cool, chaste dreams of women." Given Dewing's other life as bon vivant companion to Stanford White and friends in predatory engagements with models and lower-class women, Bisland's observations are rich in (unintended) irony. Her thumbnail sketch of Dewing strongly suggests how critical a part representation played in the manufacture of artistic identity. A frugal monk in a cell, like the poor art student in Burnett's "Latin Quarter" story, Dewing (portly in real life) lived and worked only to capture on canvas some pure and immaterial ideal of beauty. The small and sprightly Whistler, in spite of his abrasive and colorful "show" personality (see Chapter 7), was also identified with the spare, ascetic emptiness of his canvases. "He so hated everything ugly and unclean," said one eulogist, "that even in club smoking-rooms . . . he never told a story which could not have been repeated in the presence of modest women. His personal daintiness was extreme. . . . He was abstemious in his living—simple in all that he did, his exquisite, sure, taste preventing him from extremes, gaudiness, or untidiness."[38]

In using Chase as foil to Whistler and Dewing I have for the sake of emphasis chosen examples that appear to function in extreme binary opposition. But *appear* is the key word here. These painters, seemingly poles apart, had much in common. Appearances and display mattered a great deal to all of them. All three shared a considerable expanse of common ground as tasteful, cosmopolitan elites speaking a sophisticated, modern language of formal values unencumbered by the

apparatus of storytelling. Chase, however, aligned himself much more obviously with the culture of abundance and the rising ethos of consumerism by which everything, including the self, came to be defined by the acquisition and display of commodities. Whistler and Dewing, on the other hand, displayed the appearance of detachment from materialism and commodity exchange by producing designs of reticence and emptiness. Yet these too, as much as Chase's, depended on appearance—on the look of the surface—as the primary means of access to whatever else the picture offered. In the absence of conventional narrative or symbolic cues, appearance was all in all.

Other kinds of appearances demanded cultivation as well. Whereas Chase and others used their exotic studios as more or less disguised showrooms and advertising vehicles, Whistler and Dewing cultivated the appearance of disdain for commercial activity, a stance that went so far in Whistler's case that not only did he refuse to defer to clients but he sometimes denied them possession of commissioned works. One anecdote concerned the trials of a Lady B———, who was unable to persuade Whistler to part with the painting she had purchased two years before. After charmingly dismissing her from his studio, the painter fumed about the "impudence of these people who think that because they pay a few paltry hundred pounds they *own* my pictures. Why, it merely secures them the privilege of having them in their houses now and then! The pictures are *mine*!" Whistler's art products became rare commodities or even (seemingly) noncommodities. Dewing, whose elitist pose was not even leavened by Whistler's self-promotional capers, took great pains to make his most subtle works unavailable to the public eye. Long before the Pan-American Exposition, Dewing was most reluctant to expose his paintings to the crude gaze of the untutored masses, telling Freer that it was a mistake to send pictures to "provincial exhibits" (the Pennsylvania Academy in this instance). The New York public was "stupid and provincial enough" without going "back into the interior." Selling as he did to Freer and a network of the latter's business associates, Dewing devised an anticommercial strategy that worked entirely too well, at least as far as his place in the annals of American art was concerned. He un-sold himself with such decisiveness that he succeeded in becoming almost completely unknown, save to a handful of loyal connoisseurs.[39]

Albert Pinkham Ryder (1847–1917) generated the most stupendous anticommercial legend, outstripping everyone except perhaps Whistler. Ryder drove patrons to despair by withholding his products for months and even years while he slowly ruined them by applying layer after layer of thick new paint. He was the ultimate (mythic) hermit in his cell, zealously fending off those who wished to possess his works. Sadakichi Hartmann told of the painter's flamboyant reaction to pressure from John Gellatly to deliver two commissioned paintings: "One afternoon I found [Ryder] greatly excited, in a state of silent fury as it were. . . . Ryder had promised to deliver but now regretted having done so. His eyes gleamed ominously. . . . There was a peculiar smell in the room, as if some metal was heated. . . . Somehow Ryder

was in the possession of an old hairclipper. This he had thrust into the glowing coals, and before I realized what he was up to (not that I would have attempted to hinder him), he had run it criss-cross through the picture surface, leaving deep gashes as if made by the prongs of a rake. 'He thinks he owns it (ha! unuttered!)! This will teach him who decides in such matters.' " Elizabeth Broun has pointed out that Ryder sometimes enlisted Whistler in support of his own views, and that he probably took an interest in the "flood of Whistler books and exhibitions" that followed the famous expatriate's death in 1903. Whistler's example was important to Ryder in authorizing the latter's own anticommercial stance, or in buttressing attitudes already in formation. If Whistler successfully acted out the "great artist" pattern, then disdain for clients and reluctance to sell must be important elements in the design of his artistic identity. By carrying that pattern to even more dramatic extremes, Ryder's actions in turn reinforced the necessity for the modern artist to guard his purity at all costs, or to seem to be doing so, in order to qualify for admission into the loftiest reaches of the pantheon.[40]

The construction of an image, and the problem of the marketplace, remained central to all negotiations about artistic identity, but the terms refocused with passing decades. Painters such as Robert Henri (1865–1929) and John Sloan (1871–1951), who practiced forms of urban realism in the first years of the twentieth century, promoted an ideology of life, energy, and vitalism that contrasted strongly with Whistler's reticent poetry. But by painting members of the urban working and slum classes they effectively distanced themselves from the taint of fashion and luxury that haunted the artist of high society, and by being observers of the rituals of mass consumption rather than its celebrants they constructed (fictive) positions for themselves outside of that world. Further, by representing their subject matter as "revolutionary" and therefore presumably less marketable, Henri and his cohorts were able to blur the commodity character of the artwork and sharpen the emphasis on whatever made the artist appear genuine and substantial.[41]

For this construction of the artist, the commodity display of the opulent studio was inappropriate. A photograph of Henri's studio in Philadelphia (fig. 26) exhibits almost nothing but male fellowship. Significantly, the photograph was taken around the time (1896) when Chase dismantled and disposed of the contents of the famous Tenth Street studio, prompting a critic to praise "better-inspired painters and sculptors" who were returning to "simpler and somewhat more austere forms of expression in their works and their working-places," and in the process eschewing the "bewildering" and "distracting" effects wrought by Chase's heady art atmosphere.[42] The Henri studio exemplifies that turn: there are no tapestries, no Oriental rugs, no bibelots, no pet spaniels, no uniformed valets, and no cooing women—only a bare room with a starkly unshaded gasolier, a couple of pictures tacked up, and, most prominently, a large pot-bellied stove, near which Henri and his friends perch on an assortment of common chairs. Nothing here is for sale, this interior says, except genuine art made by genuine artists who need no props. Low-ceilinged and ugly,

26. Group photograph in Robert Henri's studio, 1717 Chestnut St., Philadelphia, c. 1895. Delaware Art Museum, John Sloan Archive.

Henri's studio functioned as an eloquent sign that the artist rejected materialism, proving thereby his integrity, his depth, and his independence. It was a display that pretended not to be one, just as the opulent studio was a salesroom in disguise. In either case, the environment constructed an illusion, a fiction of appearances. It was not literally for sale, yet it exerted an insistent psychological influence, adding the persuasions of ambience to whatever package (of luxury, romance, sincerity) in which the artist—a creature of commerce, after all—should choose to wrap himself.

PART TWO

Sickness and Health

3 FIGHTING INFECTION

Aestheticism, Degeneration, and the Regulation of Artistic Masculinity

The taint of trade represented only one among a family of strains powerful enough to corrupt American art and culture in the waning years of the nineteenth century. Aestheticism, or art for art's sake, was equally virulent, and so dangerous that it incited an all-out campaign against any art, in any medium, that rejected the conventions of morality, legibility, and imitation of nature while worshipping at the shrine of incandescent, sensuous beauty. However ravishing, such beauty was really only the blind concealing a fatal trap. "No robing in the splendors of Solomon," wrote Professor Richard Burton, "can conceal the awful truth that death, not life, is in its person. . . . Art without spirituality (or ethical beauty, which I hold to be the same thing) is . . . a whited sepulchre, full of stinking bones." The highly colored jargon of aesthetic pathology quickly became common currency among critics and cultural watchdogs. For Harry Thurston Peck, editor of *The Bookman,* art for art's sake conjured up the "fetid odor of the charnel-house" and the "perverse, exotic, burning, hectic beauty which verges even upon disease." No matter how lovely its music, human nature, inherently wholesome and sane, must shrink from its "putrescent" themes.[1]

Art for art's sake posed a threat real enough to be taken seriously and potent enough to permit sighs of relief when the danger was thought to be over. In 1906,

Charles Caffin detected only a harmless vestige of its once-powerful presence: "Of the cry of 'Art for Art's sake,' there is little left but the echo of a memory, yet much of what it stood for is still a standing principle in American painting. In its extreme form, it meant that subject counts for nothing in a picture, and that the truth and skill of painting is the only thing. . . . We now recognize it as the subterfuge of those artists who have no brains, no ideas, nothing to say or give us of their own personality." The pseudo-artists had gone where they belonged, according to Stinson Jarves. "How much of the great aesthetic movement ended in prisons or asylums? What became of the so-called men?" Common sense had taken over once more, to the point that some could claim a natural immunity for America. As Elliott Daingerfield declared, "The morgue, the gutter, and the slum are not significant of a people who are at once clean, wholesome, and optimistic. These three words may well be a text for us. That we may think cleanly, paint wholesomely, with an optimism born of faith."[2]

At about the turn of the century, qualifiers such as *wholesome* and *sane* functioned like magic chants to ward off danger or to make wishes come true. Charles M. Skinner stoutly maintained that American art expressed the "mental sanity and independence and sound morals of the people. It is wholesome art, and clean. Let the American citizen cease his complaining and buy American pictures." Another writer admonished young art students not to rush off to Paris for art training. It would be far better to stay and breathe the "comparatively pure atmosphere of our American schools. What more do you really need for your growth than a model, a wholesome work-room, industry, and observation?" The wholesomeness discourse clearly involved resistance to all forms of cosmopolitanism, including the taste for European art that undermined the market for American work. There was much more to it it than simple nativism, however. Why, then, did art for art's sake pose such a threat to American art and culture in the late nineteenth century? Why was it necessary to assert, over and over, the health and sanity of American cultural products while mounting defenses against the infectiousness of the European?[3]

Degeneration

The anti-art for art campaign was one manifestation of concern over issues of individual, social, and political "degeneration" that dominated public attention for some years. Degeneration theory posited that behavioral and mental aberrations of all kinds were inherited traits that afflicted successive generations with increasing severity, resulting finally in catastrophic genetic decay and dissolution. The theory derived powerful support in the nineteenth century from Darwin's model of evolutionary change, and it became a versatile tool in the detection and regulation of differences considered dangerous to society, such as criminal tendencies, mental retardation, the ills of the poor, sexual aberration, and racial otherness. A catalyst for debate and controversy about the subject was the English-language publication of Max Nordau's *Degeneration*. Originally issued in Berlin as *Die Entartung* in 1893,

the book rose to ninth among best-sellers in the United States in 1895. "Max Nordau" was the pen name of Max Simon Sudefeld (1849–1923), a Hungarian Jewish doctor, novelist, and culture critic. He derived his theories of modern decay from the work of several French and Italian medical men who had postulated and "scientifically" demonstrated the existence of links connecting crime, heredity, madness, and genius. Although Nordau drew on a range of sources, the studies undertaken by criminologist Cesare Lombroso—in particular, *The Man of Genius*—provided the most important theoretical directions, and *Degeneration* was dedicated to him.[4]

Nordau refashioned Lombroso's man of genius to play a central role in his model of cultural decay. In Lombroso's view, genius was a neurosis, and inspiration was a pyrotechnical burst of neural energy, akin to an epileptic seizure. The degenerate genius—only a step away from the born criminal—was a law unto himself, abnormal and amoral yet an indispensable force in the progress of civilization. His brilliant ideas and actions, born perhaps of madness or megalomaniacal obsession, nonetheless made enduring contributions to the betterment of humanity, which eventually followed on the path the genius had blazed. Nordau departed from this ultimately positive construction of the genius's social function and entangled his borrowings from Lombroso with the grander and gloomier topic of the decline of western civilization. In the vanguard of this descent marched a host of degenerate geniuses— egomaniacal, erratic, morbidly sensitive, mystical, hysterical—who had succumbed to the influence of their lower nervous centers with the progressive atrophy of the higher. As Lombroso saw it, neurological degeneration was intrinsic to inspiration. Nordau, however, drew a further distinction between those who were neurotic yet genuine geniuses (Shakespeare and Goethe) and those who were merely neurotic degenerates (Wagner, Verlaine, Whitman). The latter were sham geniuses, frauds producing tainted works of literature, music, and art that aroused little more than nervous excitement in their receivers, victims of ennui who craved ever more bizarre and unnatural stimulation in order to feel anything at all. Nordau himself embraced the very obverse of the nonvalues promulgated by "degenerate" artists and so willingly absorbed by their deluded audience: self-control, discipline, science, rationality, law and order, enlightened progress, social harmony, and individual restraint in the interests of the greater good. He had patience, as Regenia Gagnier puts it, with "nothing but normality."[5]

The publication of *Degeneration* provoked extended controversy in Britain and America alike. Its checkered reception depended on individuals' social and political agendas. Those who shared Nordau's conservative stance were swift to enlist him in the resistance to the forces of destructive change. Boston's *Literary World* enthusiastically praised his ruthlessness: "Herr Nordau has studied the writings and the personalities of the mystics, the symbolists, the decadents, the Parnassians, the aesthetes, and the diabolists of recent Europe as the healthy man studies diseases of the body, not sympathetically or admiringly but with the wholesome contempt for the corrupt product and the determination to use the knife freely which characterizes

the humane surgeon." Others approved of selected points of his argument, and some rejected him with indignation and disdain. James Gibbons Huneker denounced him as a "contemptible specimen" and a "literary slop jar" whose soul lived "up an alley." William James, who called Nordau's opus a "pathological book on a pathological subject," was among those who drove straight through the chink in Nordau's armor, getting down to the personal fears and biases that fueled the jeremiad. Writers of Nordau's stripe, he deduced, used the names of symptoms to give objective authority to their personal dislikes. Behind the elaborate structure of pathological terminology and dire scene-painting lurked a threatened, conservative middle-class (and middle-aged) man, the archetypal Philistine so detestable to elite nonconformist culture producers.[6]

Nordau's ideas cast a long shadow. However soundly discredited, *Degeneration* was powerful in popularizing the jargon of aestheticism and disease already in circulation, and it helped shape a durable language of condemnation. Kenyon Cox, for example, roasted Nordau in 1895, ridiculing his ignorance of art, his laughable inaccuracies, inconsistency, humorlessness, and, in general, his obnoxious Philistine blockheadedness. Even so, Cox made Nordau's diagnostic tools his own weapons in a continuing struggle to suppress dangerous tendencies in art. Reviewing the Carnegie International Exhibition in 1907, Cox found the French and German paintings "blankly commonplace and photographically realistic, or . . . sensational, brutal, [and] decadent." One of the most decadent of them all was Munich symbolist Franz Stück's *Saharet* (fig. 27). This horror, with black-ringed eyes, green complexion, and twisted vermilion lips, suggested "nothing but disease." After shuddering over *Saharet,* Cox went on to praise American paintings, pausing before Abbott Thayer's *Caritas* (fig. 28) to state that Thayer's ardently idealistic images of pure American women and pure American landscapes struck the keynote of native devotion to art and the production of beauty. By the time Cox had reached the end of the show, no doubt remained in his mind that "the schools of painting on the Continent of Europe are in a state of decadence . . . and that the best and most hopeful work being done anywhere to-day is being done by Americans, and largely in America." Cox had finally teamed up with Nordau in the "Philistine" gallery at the point where new art surpassed his ability to tolerate or comprehend it and left him uneasy in the realization that the "disease" may have gone beyond his strength to prevent or skill to cure. While his point of view was decidedly conservative, less conservative voices also made use of the "decadent Europe" trope. The next year, Mary Fanton Roberts reviewed the Carnegie International for the liberal *Craftsman* magazine. Roberts brought out the Nordau blunderbuss once again, commenting on the lack of "force, truth, or vitality" and the predominance of "strange decadent fancies" in the French work, which was technically clever but spiritless and soulless, marked by the striving for eccentricity, whimsical novelty, and inventive degeneracy. Such criticism obviated analysis in favor of by-rote recitation of unquestioned assumptions structured around the binaries: America equals health, Europe disease.[7]

27. Franz Stück, *Saharet,* 1902. Location unknown. Courtesy of Prestel Verlag, Munich.

For American art to stay healthy, the pattern of European decay—its aesthetic corruption, perversion, and immorality—had to be maintained to serve as a standard of degeneration, as benchmark and warning. At the same time, assertions of the youth, political integrity, and progressiveness of America required constant reinforcement. Henry Loomis Nelson, stating that the literature of a true democracy had "never been decadent," prescribed democracy as the only sure cure for cultural

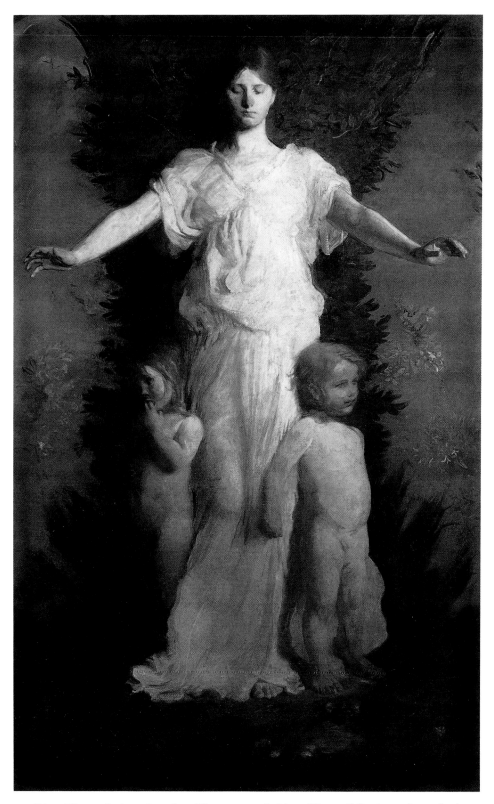

28. Abbott Thayer, *Caritas*, 1894–1895. Oil on canvas, 85 × 55. Warren Collection and contributions through the Paint and Clay Club; Courtesy Museum of Fine Arts, Boston. © 1995 Museum of Fine Arts, Boston. All rights reserved.

disease. "There are decadents in every capital of Europe, and they have their imitators in some of the commercial centers of our own country among the idle and unfortunate rich. Nordau can find illustrations of his philosophy of despair throughout the world. But the stream of social life under democracy is being constantly renewed from new and pure sources, and the great heart of the world . . . is sounder than it ever was." William Dean Howells dismissed the whole question of degeneration: "Our condition is that of a youth and health unknown to human thought before, and it is an excellent thing that with these we have so much courage." Peck avowed unshakable faith in steady progress not just onward but upward. Humanity was advancing, slowly, but "with every century its gaze is fixed with an increasing steadiness upon the lofty and immutable ideals of justice and mercy and purity and truth." While it remained unspoken, it can be assumed that Peck saw America in the vanguard of this ascent.[8]

The Dread of Eruption

Decadent Europe served as site for the displacement of haunting fears that degeneration had infected the American social and cultural body as well. That anxiety lurked behind every assertion of American vitality and every prescription for a healthy American art. Optimistic diagnosticians of America's social health more often than not ignored, or pretended to ignore, a highly visible parallel discourse centering on the nation's rotting social fabric. Society in late-nineteenth-century America was riven with unsettling problems—the effects of immigration, massive urban poverty, corrupt government, class warfare, anarchism—that turned once-solid ground into quicksand. Choruses of foreboding voices swelled. The radical periodicals, such as *The Forum* and *The Arena,* tended to publish a greater number of anxious and sometimes feverishly paranoid essays than did other magazines, but expressions of social concern and calls for reform also appeared in *The Century, Scribner's,* and *The National Review,* among others. In the country's midsection, the Populist movement also contributed to the literature of apocalypse and decay.[9]

In "Signs of Impending Revolution," William Barry offered a spectrum of apocalyptic themes to amplify the grim observation that "there is a depth below atheism, below anti-religion, and into it the age has fallen." Religious influence was in decay, and society was torn by the stress of competition, the struggle for markets, the fall in prices, the growth of the urban proletariat, the barrage of socialist propaganda, the decline of government authority, the iron law of wages, the failure of remedial emigration, and the transference of political power to the masses. The great God of modern life was Mammon—of "the gaping mouth and the fiery hands of Moloch"— and in modern America "dollar idolatry" had created a proletariat so that it could eat up the souls of men and women by the millions. Barry laid the ultimate blame for the "disease" on industrialism, which had spawned all the other ills. The titles alone of many *Forum* articles convey the same sense of dread: "The Perils of Democracy," "Criminal Degradation of New York Citizenship," "Organizations of the

Discontented," "Government by Aliens," "Alien Degradation of American Character." The alien, a nightmare of mysterious and elusive otherness, heralded the return of the repressed, an invasion of the things that Americans thought they had left behind at some primitive stage of development.[10]

Soon after the violent conclusion of the 1894 Pullman strike, in which federal troops and state militias battled mobs of railroad workers, John H. Denison claimed that America had elevated "animalism"—concern with self-aggrandizement at the expense of any other value—over nature, whose grand plan was to perfect the "type" that would produce an "Anglo-Saxon organic nation in which law is reduced to a minimum." Socialism, anarchism, commerce, and labor unions had disrupted nature's design and pitched America into auto-destruct mode. A struggle for survival now raged "between the lingering type of Americanism and the alien element that surrounds it." Cities were Americanism's "deadliest menace," and free institutions, "deprived of that type of life which is their sap and strength," had become a "harborage of the worst political vermin." Should the struggle be lost, America was doomed to repeat the fate of the old Roman Empire when "the Roman stock was gone, the live tissue dead, and the Roman constitution which had conquered the world fell like the rotten trunk in a storm."[11]

That the dilemma was class-specific is clear enough, the fear gnawing at the educated middle- and higher-class elite that supplied cultural producers and cultural transmitters to an array of institutions. Anxieties hovered over this elite at public and private levels, within families and in the larger community. Century-end pessimism engulfed Henry Adams and his brother Brooks, who in 1895 published *The Law of Civilization and Decay,* which portrayed the modern age as the culmination of a rise-and-fall cycle playing itself out in social disintegration as a result of unchecked commercialism, materialism, and corruption. After the financial panic of 1893, Henry sensed a malaise within and around him. Everyone was discussing, disputing, doubting, economizing, waiting for the storm to pass yet unable to agree on what had upset them or on how to cure it. Society trembled even though it seemed that there were no tangible dangers: no bombs, no violence, no wars to fear. "We want to know what's wrong with the world," demanded Adams, "that it should suddenly go smash without visible cause." During the same years, art critic Royal Cortissoz was steeping himself in Gibbon's *Decline and Fall of the Roman Empire* even while formulating his aesthetic principles on the basis of Matthew Arnold's exalted ideals of beauty, harmony, and high culture.[12]

The danger, however, came from within as well as without, and in an atmosphere of anxiety and dread, bacchic license among the cultural elite drew fire, nowhere more deadly than in the affair of the Pie Girl in 1895. Named for the pretty young model in black gauze whose emergence from a gigantic pie was the climax of the evening, the Pie Girl Dinner was an exclusively male party organized by the Wall Street broker Henry W. Poor in honor of a friend's tenth wedding anniversary. It took place in the studio of James L. Breese, a society photographer, and guests

29. *The "Girl in the Pie" at the Three-Thousand Five Hundred Dollar Dinner in Artist Breese's New York Studio.* Illustration from *The World,* October 13, 1895.

included eminent architect Stanford White and his painter friends J. Alden Weir, Robert Reid, Willard Metcalf, Edward Simmons, and J. Carroll Beckwith. Risqué motifs were said to have adorned the place cards and menus, and in addition to the woman in the pie, two other models were present as wine servers, a blonde for the white, a brunette for the red. As Paul Baker has written, the Pie Girl Dinner was characteristic of life among certain urban elites in the 1890s, consisting of a "society of male friends, mostly in the arts" who came together "with a good deal of secrecy for an elaborate, heavy dinner, some serious drinking, and sexually titillating entertainment." Several months later, after learning that Susie Johnson, the Pie Girl, had disappeared, the *World* ran a lurid exposé of the affair. An eight-column illustration (fig. 29) showed Susie revealing herself to devouring stares against a background of naughty French dance-hall posters. The paper, which boasted a circulation of over half a million, framed the tragedy of the Pie Girl in terms of class differences and oppression: "Somewhere in the big studio buildings of New York's Bohemia the girl is hidden. Perhaps this article will bring Susie Johnson home to her parents and put a stop to the bacchanalian revels in New York's fashionable studios. These amusements of wealthy young men-about-town are beyond the reach of police or municipal reformers. Safely screened in the luxurious studios of artist friends, the shocking scenes of dissipation are carefully kept from the knowledge of the public.

But the contamination reaches into the little flats and big tenements of the east and west sides and works sorrow and misery in these humble homes." The Pie Girl Dinner may or may not have been an orgy, but it bore the trappings of one. As such, it became a sign for the decadence of art and high society, fatally twinned in the pursuit of erotic sensation and in the ruin of innocence.[13]

Elite corruption burst into the headlines far more explosively in 1906, when Harry Thaw murdered Stanford White (b. 1853) in the rooftop cafe of Madison Square Garden. The reports exposed the exoticism of the architect's secret life, and the press with considerable relish proceeded to demolish his reputation. The left-leaning *Arena* deplored the latest eruption of moral disease:

> So recently as the middle of June we had one of those startling glimpses of the moral leprosy and death that fester in the circles of wealth and culture. . . . A [wealthy] youth . . . was drawn into the maelstrom of vicious life where unbridled appetites and passions dominate. After a time he came under the fascination of a girl who had been one of the many toys and vessels of dishonor used by one of the greatest of American architects. . . . The revelations that have come to light . . . indicate conditions of bestial excess and corrupt practices. . . . The democracy of darkness that is due to the triumph of sordid materialism over men of idealism must be overthrown or the doom of the Republic will have sounded and we will go the way of Babylon and Nineveh and Rome.

Others publications were, if possible, even more lurid: *Vanity Fair*'s headline read: "Stanford White, Voluptuary and Pervert, Dies the Death of a Dog." The *New York Evening Post* acknowledged the architect's genius but reported that his talents had been "underutilized or even perverted" by association with the wealthy society to whose taste he had too often pandered. The fate of Stanford White was a nightmare come true, the literal acting out of the metaphorical death and damnation (in moral terms) that the generic "society artist" so richly deserved.[14]

White's tawdry demise and the exposure of his double life ferociously entangled the question of artistic identity with the discourse of degeneration. In his double life, a facade of professional, cultivated decorum had obscured a maze of secret rendezvous sites, places of untrammeled indulgence. With the murder, the halves collapsed into each other with catastrophic force, providing unsettling proof that the artist of Nordau's paranoid imaginings had crossed the water after all. The jeremiads attending the revelation of White's "degenerate" life demonstrate the extent to which concern about degeneration had penetrated American discourse. To make things worse, there was no chance of displacing the taint onto the figure of some distant European decadent. If White had not encountered Harry Thaw's gun, his secrets may have remained concealed. With the murder, it was as if a fissure had burst open to display the unrestrained lust, corruption, and self-indulgence that threatened to undermine modern America's precarious social order.

Wilde Abandon

Coming when it did, the scandalous "truth" about White did less damage to art world public relations than might be expected. By the time of the murder, some two decades devoted to restructuring American artistic identity had resulted in a rhetoric of health and purity designed to neutralize the threat of corruption. Its effectiveness depended on controlling the parameters of acceptably "normal" masculine behavior. As an example of uncontained excess, a kind of unbalanced or overbalanced maleness running out of control, White stood at one extreme, representing a depraved masculinity abandoned to the consumption of youthful female flesh. At the opposite extreme stood the notorious aesthete Oscar Wilde, whose self-manufactured image posed its own radical alternative to the normative strictures of middle-class masculinity. Somewhere between them stood the figure of the wholesome American artist. This was the space in which a discourse of artistic maleness and health staked out its borders, beyond which lay the ever-present spectacle of European degeneration and the nightmare of American decay. Although Wilde was not always visible in the evolving discourse, he became the focus of multiple overlapping discussions and controversies and symbolized what was most feared for artistic maleness at the century's end.

Wilde (1854–1900) was identified with the English aesthetic movement well before he visited America in 1882, when he undertook a lecture tour as a living advertisement for Gilbert and Sullivan's comic opera *Patience,* which premiered in New York in September 1881. Since coming down from Oxford to London in 1878, Wilde had been refining his distinctive and attention-getting image as poet, dandy, aesthete, and art missionary. His fame in the United States preceded him via George Du Maurier's cartoons in *Punch,* the English humor magazine. *Punch* was widely read in America, and it was probably as much through Du Maurier's cartoons as any other vehicle that the aesthetic movement became familiar to a transatlantic audience. Beginning in 1873, Du Maurier (1834–1896), once Whistler's fellow student in Paris, devoted himself to poking fun at the aesthetes. In 1881, just when Wilde was making himself difficult to ignore in London, Du Maurier introduced the silly poet Jellaby Postlethwaite, whose airs lampooned Wilde's, and sensitive painter Maudle, a mixture of Wilde and Whistler, Wilde's model in perfecting the art of mannered public performance. Du Maurier's views and pictures were constantly before the American public for the better part of two decades: later, *Harper's Monthly* contracted him to produce drawings for its back pages, which were reserved for humorous topics.[15]

George Du Maurier's caricatures established a precise set of assumptions about the aesthetic male, presented as unmanly, both implicitly and explicitly. Here, the converse of "unmanly" was in every case a normative middle-class construction of masculinity. As Ed Cohen has noted, this kind of oppositional formulation, ubiquitous in the last half of the century, constituted a mode of stabilizing "proper" masculinity, which came into sharpest focus when contrasted with what it was not.[16]

30. George Du Maurier, *An Infelicitous Question*. Cartoon from *Harper's New Monthly Magazine* 81 (October 1890).

Du Maurier often relied on this oppositional schema to sharpen his mockeries. In *An Infelicitous Question* (fig. 30) for example, four figures stand about in an exotically cluttered room: two fashionably dressed young women, a sleek, perfectly groomed young man and an "Aesthetic Youth," who confides: "I hope by degrees to have this room filled with nothing but the most perfectly beautiful things." The "Simple-Minded Guardsman" responds: "And what are you going to do with *these*, then?" The caption incorporates half of the joke, which plays off the ultrasensitive aesthetic youth, absorbed in his quest for perfect beauty, against the ultrasensible guardsman, who has never thought about such things. The picture incorporates the other and more telling half, however. In the drawing, the guardsman stands in the most pointed contrast to the aesthetic youth. He is rigidly upright; his clothes fit like a glove; his hair is severely trimmed. The youth is soft, slouchy, and shaggy; his costume is more voluminous, with a suggestion of puffiness about the sleeves. The guardsman holds his immaculate top hat behind him with one hand and with the other clutches his walking stick, and taps it against his solid chin. The youth has his hands raised and clasped with droopy fingers at chest level, like a rabbit or a begging puppy. The aesthetic youth's body language, curvy and pliant, is deftly played off against the ramrod stiffness of the guardsman, so that they seem to constitute a perfectly calculated binary pair, the one clearly in greater alignment with conventional notions of the feminine than the other. Yet the guardsman, in contrast with a burly lumber-

31. George Du Maurier, *An Aesthetic Midday Meal*. Cartoon from *Punch* (July 17, 1880).

jack, might appear too slick, too bandboxy. He needs the aesthetic youth to be the kind of representation he is. The women complicate things further. They stand between the two men, and one looks towards the guardsman while the other faces the aesthetic youth, as if impartially comparing each version of masculinity.

Having worked out the grammar and syntax of aesthetic body language during the high tide of the aesthetic movement, Du Maurier settled into a fairly consistent repertoire of pliant pose and pensive looks to denote the aesthete. *An Aesthetic Midday Meal* (fig. 31) shows Postlethwaite in a tearoom, feasting his eyes, and nothing else, on a freshly cut lily for which he has ordered a glass of water. The poet's rapt gaze and gracefully clasped hands recall those many female idols by Dante Gabriel Rossetti, always yearning from windows and balconies. In *Maudle on the Choice of a Profession* (fig. 32) the figure of the artist, who closely resembles Wilde, wears Whistler's monocle. Maudle leans toward Mrs. Brown (a "philistine from the country") with the graceful handclasp once again, the yearning look, and a serpentine undulation all the way to his corkscrewed feet. He gushes: "How *consummately* lovely your son is, Mrs. Brown!" Replies the latter: "*What*? He's a *nice, manly* boy, if you mean *that*, Mr. Maudle." It appears that the manly young Brown wishes to be an artist, which causes Maudle to exclaim, "Why should he *be* anything? Why not let him remain for ever content to *exist beautifully*?" This determines Mrs. Brown that "at all events her Son shall not study Art under Maudle." In this instance, the sensible bourgeoise will keep a wary distance from Maudle's airs.

This was the figure that the American audience expected to see when Wilde

32. George Du Maurier, *Maudle on the Choice of a Profession.* Cartoon from *Punch* (February 12, 1881).

disembarked at the port of New York in January 1882, but it was difficult to pin down the aesthete: he was a new and unsettling blend. On an itinerary taking him from New York to Boston and as far west as San Francisco, Wilde gave lectures on "The English Renaissance of Art," "House Decoration," and "Art and the Handi-craftsman," all of which promulgated the aesthetic movement's central tenets of re-instating principles of beauty and use in household objects while restoring integrity to the craftsman and encouraging the love of beauty as a way to higher spiritual (and sensory) planes. Although the lectures met with mixed and sometimes tepid reaction, Wilde himself generated immense interest, much of it about his physical appearance and the question of his manliness. During the tour, quite a few of his hosts discovered that Wilde was poised, strong, and tough, with a prodigious ability to hold his liquor. Yet his costume of knee breeches, silk stockings, and short jacket (sometimes of velveteen) was outrageously unconventional, and his hair flowed over his collar.[17]

A great many women seemed fascinated by the alternative construction of mas-culinity that Wilde represented. Illustrations and cartoons played on this attraction, showing Wilde as the magnetic center of a bevy of adoring ladies. These followed the convention established by Du Maurier, for example, in *Nincompoopiana—The Mutual Admiration Society* (fig. 33), showing Postlethwaite's grand entrance into Mrs. Cimabue Brown's salon, where he instantly becomes the focus of mostly female attention, much to the disgust of the rugged "Gallant Colonel," who draws not a single female glance. In *Patience* too, the plot involves the charm of the aesthete (the fleshly poet Reginald Bunthorne), so alluring to young women that in order to

33. George Du Maurier, *Nincompoopiana—The Mutual Admiration Society*. Cartoon from *Punch* (February 14, 1880).

recapture their attention, a company of young, manly dragoons must become aesthetes themselves, at least temporarily. A sketch in the *Daily Graphic* after Wilde's opening lecture in New York shows two women bowing over his hands, kissing them, while two more do the same to his coattails, and an illustration in the Cleveland *Plain Dealer* (fig. 34) the next month depicts him expounding on the science of the beautiful, completely surrounded by a rapt audience of ladies. Mrs. Frank Leslie wrote: "Oscar Wilde is almost niched and pedestaled by society. . . . Letters, verses, flowers, petitions, flow in upon him in perfumed rivulets. Lilies pour in upon Mr. Wilde. In society, young ladies sport them over their beating hearts in order to attract his attention." Some women's feelings were shaped by their responses to what they sensed as the feminine in his persona. At a time when the doctrine of separate spheres remained in force despite (and because of) the gains women had begun to secure in higher education and the professions, the social worlds and interests of men and women were distinct. Higher-class women presided over domestic affairs and social functions, and from the 1870s on they played increasingly important roles in reforming and beautifying the domestic interior, but these activities remained largely sequestered from the masculine world of office and club. In his lectures Wilde addressed women's concerns; he shared their interests in style, fashion, and taste, and spoke their language with fluency and sympathy. He was identified with the female world in a way that most men would never be, and he showed an obsessive

34. *Oscar Wilde.* Cartoon from *The Plain Dealer* (Cleveland), February 18, 1882. Reprinted with permission from *The Plain Dealer.*

interest in his appearance that was also coded as feminine. Because of this, few commentators on his American visit could refrain from describing his dress in full, as they might a socialite's outfit at a ball.[18]

The reminiscences of Anna, Comtesse de Brémont, got to the heart of Wilde's fascination. The comtesse, an old friend of his mother, was a guest at a New York dinner in his honor. The company, she recalled, was all female. Many of the guests had "donned aesthetic robes that were evidently a delight to the eye of Oscar Wilde, for his glance roamed from one to the other of his fair followers with increasing pleasure." In his appearance she detected a mystifying yet attractive mix of signals: "His splendid youth and manly bearing lent a certain charm to the strange costume in which he masqueraded. . . . The long locks of rich brown hair that waved across his forehead and undulated to his shoulders gave his fine head an almost feminine beauty. It might have been the head of a splendid girl, were it not for the muscular white throat, fully displayed by the rolling collar and fantastic green silk necktie . . . [and] the broad, somewhat heavy shoulders encased in the well-fitting velvet coat with its broad lapels." As the dinner progressed, the comtesse became increasingly disturbed by what she sensed as pose and masquerade in Wilde's demeanor. Who was the person beneath that girlish disguise? But then Wilde suddenly turned to look at her, and they gazed deep into each other's eyes: "I saw his feminine soul . . . revealed in the mirror of those strange eyes. I beheld his feminine soul, a suffering prisoner in the wrong brain-house. There was mingled defiance and resentment in his glance. . . . Then the glance softened into an appeal that touched me infinitely, for it unconsciously revealed to me the burden of his secret." Handsome manliness, masking a soul profoundly feminine: this was the flawed yet compelling union that drew the comtesse's sympathy and at the same time exerted a powerful attraction.[19]

More conventional American males reacted with extreme hostility to this dis-

ruptive magnetism. Thomas Wentworth Higginson (1823–1911), the popular Boston minister and writer, collapsed Walt Whitman and Wilde into the same damning category of "unmanly manhood": "We have perhaps rashly claimed that the influence of women has purified English literature. When the poems of Wilde and Whitman lie in ladies' boudoirs, I see no evidence of the improvement. And their poetry is called 'manly' poetry! Is it manly to fling before the eyes of women page upon page which no man would read aloud in presence of women?" For all his "fine physique and his freedom from home-ties," Whitman during the Civil War had never risked his life but had merely been a nurse in hospital camps distant from the battleground. Wilde, instead of staying to right the wrongs of Ireland, chose to cross the Atlantic and "pose in ladies' boudoirs [and] write prurient poems which . . . hostesses must discreetly ignore." Higginson, suggests Jonathan Katz, felt his psychosexual equilibrium threatened by the two "unmanly" poets. An active proponent of Muscular Christianity, Higginson wrote extensively of the need to promote health through exercise and right living. He had been an abolitionist in charge of an all-black regiment during the Civil War, and he advocated women's suffrage. Like the young Ralph Waldo Emerson and Henry Ward Beecher, the youthful Higginson enjoyed an intensely romantic friendship with another young man, whose slender, raven-haired beauty "like some fascinating girl" he praised in letters to his mother. But his "deep puritanical concept of sin" in conjunction with the "existence of only a heterosexual model for conceptualizing sexual friendship" enabled him to see such relationships in the light of innocent, if intimate, male fellowship. His ideals, built on rigid foundations of places and spaces commensurate with true manliness, could not brook the challenge of a man out of place—in a lady's boudoir or nursing the wounded as guns boomed in the distance. While an "innocent" passion for an attractive male friend was permissible, the man in the boudoir, imparting dangerous knowledge to women, threatened social stability far more than could women's voting rights or education. The continuity of a controlled and disciplined social order (and the formation of subjects dedicated to perpetuating it) could be sustained only if men and women directed their lives to activities in their allotted places. To challenge this order was to invite chaos.[20]

Other attacks on Wilde took up the theme of unmanliness with even greater venom. Professor David Swing, a liberal clergyman, thundered, "A woman kissing a poodle comes nearer expressing the unmanliness of this peacockism. He is a peddler of childish jimcracks and his domain is not the world, but the showcase of some notion store. Wilde . . . is the enigma of today . . . an intellectual and emotional abyss . . . a man whose intellectual height and depth are expressed by the tailor and the laundress." By portraying Wilde as a store clerk selling ribbons and laces to women, Swing drew upon the image of the "man-milliner," a widely circulated pejorative that was one of many linguistic brickbats hurled by professional politicians against the Mugwumps, the liberal Republican, civil-service reformers identified with the educated elite of the Northeast. Richard Hofstadter has argued that in addition

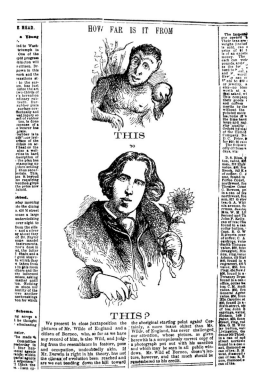

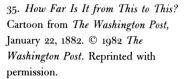

35. *How Far Is It from This to This?*
Cartoon from *The Washington Post*,
January 22, 1882. © 1982 *The
Washington Post*. Reprinted with
permission.

to effeminacy, *man-milliner* implied homosexual leanings. As a forbidden term, it was excised from an 1889 biography of Roscoe Conkling, who had lobbed it at George William Curtis, reformer and editor of *Harper's Magazine*. The use of such belittlements to discredit opponents suggests the extent to which sexual orientation could be made to count in any power struggle.[21]

No less insinuating were representations of Wilde as throwback to a primitive stage of evolution. The *Washington Post* juxtaposed a drawing of Wilde holding a sunflower with an image of the Wild Man of Borneo holding a coconut (fig. 35) and asked, "How far is it from this to this?" The startling resemblance between the two confirmed that the climax of evolution had been reached and that the race was "tending down the hill toward the aboriginal starting point again." This figure of regression was another sign of emasculation and decay. As Sandra Siegel writes, "Darwin had confirmed, and Frazer after him had reconfirmed, that civilization was a result of masculine vigor and intelligence. A man who had failed to be sufficiently masculine (or a culture that failed to be sufficiently civilized) was thought to be less than itself." Wilde as man-milliner, or as primitive man, came to the same thing in the end.[22]

The controversies around Wilde were aspects of a power struggle over masculinity in general and in particular over the authority to define and represent American art and the American artist in conventional masculine terms. It was paradigmatic of

broader social conflicts, having as much to do with competing modes of masculinity as it did with masculine resistance to emergent feminist activism and women's bids to expand their lives beyond domesticity. I am not discounting the latter. In the complexities of male crisis and confusion at the fin de siècle, the instability of women's socially constructed roles was a major source of anxiety. But the rhetoric of wholesomeness, nativism, and manliness that came to the foreground of American art discourse in the 1890s also represented the action of men asserting controls over each other through social networks, institutions, and the media.[23]

The case of young Theodore Roosevelt exhibits the effectiveness of such controls in the political world. In 1882 he was elected to the New York State Assembly, only to become the object of merciless derision. Roosevelt's elite background and Harvard degree were held against him in the Assembly, which was dominated by tough machine politicians. Worse, his appearance was laughable: "He wore eyeglasses on the end of a black silk cord, which was effeminate. . . . Even Isaac L. Hunt . . . who fought at Roosevelt's side in many a battle, was to recall him as a 'joke . . . a dude the way he combed his hair, the way he talked—the whole thing.' " Parting his hair in the middle, wearing tight trousers and a long-tailed cutaway coat, speaking in a high-pitched, affected voice, Roosevelt immediately acquired an impressive roster of nicknames, including "Jane Dandy," "Young Squirt," and "Punkin-Lily." The most damning of all, however, was "Oscar Wilde," bestowed on him the day he entered the State Assembly for the first time, which also happened to be the day of Wilde's much-heralded arrival in America. As Tom Lutz has observed, "That characterization was at least partially responsible for his defeat" in the next election. Roosevelt's much better-known persona as athlete, rancher, Rough Rider, Strenuous Life missionary, and big-game hunter was the result of his sustained efforts—under heavy masculine social and political pressure—to overcome that early and nearly disastrous mode of self-representation, which stemmed in part from a sickly childhood and adolescence.[24]

After Wilde's return to England, the sensation that he sparked died, and controversy lay dormant. His first American sojourn was followed by an anticlimactic revisit in 1883, when he attended the New York premiere of his drama *Vera; or, The Nihilist,* which closed after one week. Throughout the 1880s the American aesthetic movement flourished while Wilde's work received little critical notice. In the 1890s, however, the ambivalent and distrustful spirit aroused by the lecture tour returned with a vengeance, helped initially by the English press and perhaps indirectly by the antics of Wilde's brother Willie, who, as Mrs. Frank Leslie's parasitical second husband, spent some time making a drunken fool of himself in New York's Lotos Club in the early nineties.[25] The nineties began mildly enough when *Lippincott's Monthly Magazine* of Philadelphia published Wilde's *Picture of Dorian Gray* in its July 1890 issue. Julian Hawthorne, who knew Wilde, gave it a measured and positive review, as did Anne H. Wharton, though both were perhaps slightly compromised by the fact that they were writing for the journal in which the novel had

appeared. When it was published in England the following year, however, the press denounced it as a corrupt and corrupting story, overflowing with poison. Richard Dellamora argues that the publication of *Dorian Gray* on the heels of the Cleveland Street scandal of 1889–1890 "accentuated the deviant connotations of Wilde's text," in which the erotics of male beauty and male friendship played a major role. A sensational exposé of male prostitution, the Cleveland Street scandal glaringly spotlighted the existence of a flourishing homosexual underworld where aristocrats and gentlemen enjoyed the sexual services of working-class youths. W. E. Henley unambiguously connected the novel with the brothel at 19 Cleveland Street: "The story—which deals with matters only fitted for the Criminal Investigation Department or a hearing *in camera*—is discreditable alike to author and editor. Mr. Wilde has brains, art, and style; but if he can write for none but outlawed noblemen and perverted telegraph-boys, the sooner he takes to tailoring (or some other decent trade) the better for his own reputation and the public morals." While others may not have made such direct links between *Dorian Gray* and the world of homosexual pleasure, its publication just at the time when male homosexuality "became visible in public and in texts" as a crime and a perversion undoubtedly contributed to the loathing so evident in critical reaction.[26]

The same attitudes began to surface in America. George Parsons Lathrop blasted Wilde's plays as "disgusting filth areek with the atmosphere of unnatural debasement." *Life* condemned *A Woman of No Importance* as a repellent piece of work, fashioned to disgust the audience with an exhibition of "horrid scars and running sores to gratify curiosity and gain money." The reviewer was profoundly thankful that Wilde was not an American, but was also quite sure that he never could be: there was a "certain natural cleanliness in the American mind" that inoculated it against such nastiness. The 1893 publication of Wilde's *Salome* with Aubrey Beardsley's grotesque illustrations, and the first issues of the anti-Philistine and self-consciously decadent *Yellow Book* in 1894 played a part in reconfirming Wilde's connections with the most controversial and unhealthy expressions of modernity. Charles Dudley Warner, editor of *Harper's,* figured the new fashion of "yellow literature" (or Literary Jaundice) as a miasma, a mental epidemic, a "sign of degradation, like the phosphorescent light from decaying vegetable matter. . . . infectious . . . impure." At the same time, it was artificial—"too self-conscious to be called a natural phenomenon. . . . It easily shifts its hue, to gain notoriety, from yellow to a sickly painted green." In the game of attracting such unhealthy notoriety, no one maneuvered more skillfully than the "clever Oscar Wilde," who maintained a sophisticated pose calculated to gull the public, which nourished Wilde's reputation by taking his egregious affectations seriously. Egregious or not, those affectations were profitable. "It was the position of the late lamented Mr. Barnum," noted Warner, "who said that the people wished to be humbugged. Barnum would have covered himself with green carnations if it would have advertised his show. And perhaps Mr. Wilde knows his public equally well."[27]

Warner's allusion was to Robert Hichens's *The Green Carnation,* a parody of *Dorian Gray* that featured a caricature of Wilde as Esmé Amarinth, a cynical, egotistical, voluptuous aesthete. Warner's familiarity with the book reflects its surprising success in America: in January 1895 it was among the top fifteen best-sellers in New York bookstores. The green flower worn by Amarinth and his followers signified their dedication to a cult of urbanity and artifice. "It is like some exquisite painted creature with dyed hair and brilliant eyes," says Lord Reggie, a takeoff on Wilde's lover, Lord Alfred Douglas. "It has the supreme merit of being perfectly unnatural. To be unnatural is often to be great. To be natural is generally to be stupid." For initiates, the green carnation had other connotations as a badge of gay identity flaunted by Parisian men. Specialized knowledge may have been required to understand Hichens's many allusions to homosexual desire and eroticism, but even the uninitiated could appreciate the atmosphere of luxury, sin, and vague perversion constituting the unnatural habitat of the thinly disguised Oscar, easily and amusingly recognizable.[28]

When on May 25, 1895, Wilde was convicted of homosexual conduct and sentenced to a two-year jail term, the circle linking art for art's sake, degeneration, and homosexuality was complete. While the American press, like the British, was circumspect regarding the nature of Wilde's sins, many viewed his unmentionable crimes and hideous disgrace as the death blow to aestheticism. It was a stunningly convenient coincidence that Max Nordau's *Degeneration* was published in English that very year. Shortly after Wilde's arrest, *The Critic* reprinted Nordau's broadside attack on Wilde without further comment. None was needed, because Nordau summed up everything about Wilde that made him contemptible: "The ego-mania of decadentism, its love of the artificial, its aversion to nature, and to all forms of activity and movement, its megalomaniacal contempt for men and its exaggeration of the importance of art, have found their English representative among the 'aesthetes,' the chief of which is Oscar Wilde . . . [who] admires immorality, sin, and crime." The *Philadelphia Press* stated, "The fall of Oscar Wilde has put before the sight of all men the end, fate, and fruit of Art for Art. When right is shut out from the aims and acts of men, men rot. . . . [In Art for Art] the 'artistic instinct' is used as a veil and excuse for all that offends morals or outrages propriety." *Life* credited Wilde's downfall to the determined action of Lord Alfred Douglas's father, a truly (that is, conventionally) masculine man: "Sport as represented by the Marquis of Queensbury has won a signal victory over aestheticism. The kingpin of all the aesthetes languishes in jail, disgraced to a degree that makes it an offense to speak his name, while the sporting marquis triumphs as a defender of public morals. Decency and common sense, fresh air and honorable behavior get a little out of fashion from time to time, especially in great centers of wealth and luxury, but in the long run they have a hold on the liking of the Anglo-Saxon race which humbug finds it hard to overcome." As Ed Cohen has argued, the "supplementing of 'aesthetic' effeminacy with connotations of male sexual desire for other men" was "one of the consequences

of the newspaper representations of the Wilde trials." Although there had been plenty of vague hints in circulation for some time, the truth was now clear. Wilde's downfall dramatically crystallized a conjunction of effeminacy, homosexuality, degeneration, and aestheticism that seemed to embody all the insidious forces ranked against the social order and cultural progress. As the scapegoat and projection of all the otherness that America's educated higher classes dreaded (and perhaps feared within themselves), Wilde and the aestheticism he symbolized had to be expunged. After the brief flurry of outrage, his name vanished from the American press for the next ten years. According to Thomas Beer, however, the "yellow lord of hell's corruptions" was "mentioned by clergymen in at least nine hundred known sermons between 1895 and 1900."[29]

Not everyone subscribed to a black-and-white view of the case. For artists of the cosmopolitan generation, who had links with decadent Europe, the situation was more ambiguous. When J. Carroll Beckwith heard about Wilde's arrest, he noted in his diary, "The scandal about Oscar Wilde has filled all the papers. The type of man Oscar represents has always been disgusting but his intelligence made one forget his type." Whether Beckwith meant Wilde's sexual orientation or his "effeminate" posing is unclear. However, since he was a friend of playwright Clyde Fitch, romantically linked with Wilde several years earlier, Beckwith was probably no innocent. His remarks betray his own ambivalence toward the Wilde "type": on one hand, he acknowledged the attraction of the poet's intelligence (his wit, polished style, and sly mockery of social conventions), which controlled an exquisitely refined and rigorously controlled artistic stance before the world. On the other, the type was situated so far beyond the borders of acceptable male sexuality that it could excite only repugnance.[30]

The Regulation of Artistic Masculinity

The Wilde scandal occurred near the outset of the period when homosexuality came to the attention of the medical establishment, which defined it as deviant, the visible manifestation of underlying disease. By the early 1880s, medical literature on homosexuality had begun to appear in Europe and America, and by the turn of the century it occupied a large and growing discursive field. During the same period, large cities like New York supported a fairly well-organized underworld of homosexual activity. In his autobiography Earl Lind recalled that Paresis Hall, a female impersonators' club on Fourth Avenue several blocks south of Fourteenth Street, was a sight for out-of-towners on guided tours. Visitors understood *paresis* as a general medical term for insanity; it stuck to homosexual subcultures because, said Lind, in those days even the medical profession was obsessed with the superstition that a "virile man's association with the androgyne induced paresis in the former." Accordingly, "full-fledged" male visitors thought that the cross-dressers must be insane. Today it is well known that cross-dressing is practiced across the whole spectrum of sexual orientations, but in the late nineteenth century it was one of a

number of signs identifying the homosexual "invert": "Inversion, or contrary sexual sensation, is a perversion which . . . leans more to the passive or masochistic form. This coincides with what is known of the peculiar society of inverts. Coffee-clatches, where the members dress themselves with aprons, etc., and knit, gossip, and crochet; balls, where men adopt the ladies' evening dress, are well known in Europe. 'The Fairies' of New York are said to be a similar secret organization. The avocations which inverts follow are frequently feminine in their nature. They are fond of the actor's life, and particularly that of the comedian requiring the dressing in female attire, and the singing in imitation of a female voice, in which they often excel." There was no question that such activity was not only diseased but degenerate, as was anything associated with homosexual behavior. A witness giving testimony to a committee of the New York State Assembly in 1900 detailed his impressions of gay bars in New York City, referring to the clientele as "degenerate men" and "these degenerates." To be marked as excessively, effeminately aesthetic in stance, appearance, or product was to to become, like Oscar Wilde, the loathsome embodiment of social decay.[31]

Such appearances had to be avoided or sanitized to promote an acceptable, innocuous public image of the artist in America. Although a great deal of urban art life involved exclusively masculine social rituals—club nights, all-male dinners, committees—these were premised on an acceptable and "normal" mode of masculine fellowship. Any deviation from permissible norms presumably would have incurred in most circles the same kind of "disgust" that Beckwith permitted himself, with the almost certain consequences of ostracism and isolation from support networks. While certain bohemian eccentricities were tolerated and even expected, any act or appearance that suggested degeneration was not.

To what extent regulation of masculinity in art world circles was an organized enterprise is unclear; more likely it was the result of broad and spontaneous consensus. Organized or not, it was pervasive, appearing in such seemingly innocuous media as cartoons, as well as in serious pieces of art writing and cultural criticism. The many contributors to this campaign may have been tilting at windmills, since with the exception of small aesthetic subcultures such as that of pictorial photographer F. H. Day in Boston, there is little to suggest that the Wildean model had significant impact in America at that time. The fact that the regulators launched their attacks regardless indicates how threatening that model and its implications could be.[32]

The cartoons in *Life* frequently addressed the problems of modern masculinity. Often elaborating on Du Maurier's oppositional formula, cartoonists mixed signs of aestheticism with those of Anglomania, the two functioning almost interchangeably as pictorial codes for American decay. Charles Dana Gibson's *What the Child Has Grown To* (fig. 36) shows George Washington dandling the infant America on his knee, and a sturdy eighteenth-century John Bull shielding his eyes in horror from modern America, a young, mannequin-like dude—that is, a slick, overdressed dandy—in a stiff collar, with a monocle screwed into one eye. Meanwhile, through

36. Charles Dana Gibson, *What the Child Has Grown To.* Cartoon from *Life* 11 (February 23, 1888).

a gap in the bunting behind the figures, American socialites bow down to worship the Prince of Wales. The word *grown* has an ironic twist here, since the the "child" has dwindled into an effete champagne-drinker, a bad imitation of an English aristocrat, shameful in the eyes of the robust and manly eighteenth-century patriarchs. In another cartoon (fig. 37), the character Mr. Sissy represents the same type, with a pencil moustache, stiff collar, and monocle. Mr. Sissy, who recalls the young Theodore Roosevelt, stands for a native version of Oscar Wilde, with roughly the same connotations.[33]

Cartoons also used the oppositional formula to differentiate and rank contemporary masculine types. *In New York* (fig. 38) sets the scene at a soiree in which one of the lady guests stands with a trio of dapper, posing dudes while two other women converse with a robust, bearded gentleman. The pictorial cues are subtle, but the caption is not:

Mr. R. Lightleigh Dullying: "He's—aw—from Baltimore or Boston or somewhere."

She: "Probably. All the *men* one meets in society seem to come from somewhere else."

While *In New York* does not target artists in particular, it presents a clear hierarchy of men based on physical characteristics associated with authentic masculinity and its opposite. Gibson later used the same strategy in *The Triumph of Genius* (fig. 39)

37. C. Linton Peters,
Anglo. Cartoon from *Life*
10 (June 28, 1887).

to play off a clean-cut, broad-shouldered, all-American hero against a generic "artist" figure, a pianist with long hair, a halo, a monocle, and a slight, pliant physique. His listener is a Gibson Girl, enraptured and worshipful, just as Oscar Wilde's feminine audience was supposed to be.[34]

Gibson's *At Mrs. Daubleigh Crome's* (fig. 40) deployed an extreme and shocking version of the oppositional formula. This cartoon was one in a series satirizing the "Salons of New York" in the early 1890s. In each installment, a target group—blacks, the Irish, Jewish people—engaged in a parody or distortion of "real" cultural rituals carried out by the truly refined, the truly normal, and the truly Anglo-Saxon (as opposed to phony Anglomaniac). Gibson did not include an ideal salon in the set, but surely it would have been an assembly displaying appropriate dress, good grooming, well-bred decorum, and firmly drawn lines between the sexes. None of the above apply to the majority of the guests at Mrs. Crome's. The two exceptions are the couple at left, who stand as if they feel very much out of place among the bizarre aesthetes around them. Neat and elegant, the "normal" man and woman furnish a standard for assessing the deviations of the rest. The other women, like the central figure, with her wispy hair and sagging gloves, are dowdy, droopy versions of their proper colleague. The woman at right (probably Mrs. Crome herself), is fully rigged in a flowing, shapeless "aesthetic" gown and staring with characteristic aesthetic intensity at a painting on an easel. Of the remaining men, three have long, untidy hair and frowsy beards, and the man next to lady with the sagging gloves exhibits the coy contortions of a home-grown Maudle. The outstanding oddity, though, is the man in drag standing just left of center at the back. Tall and solid, resembling Wilde in profile, he wears a

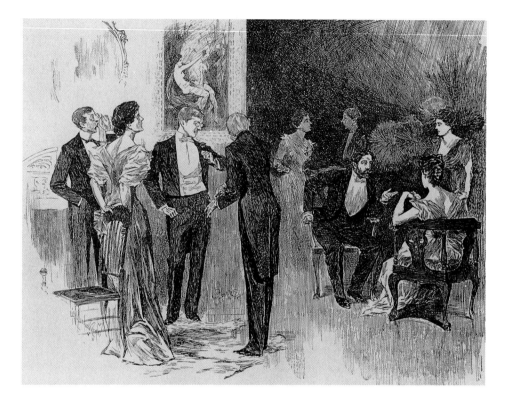

38. L. Woodward Ziegler, *In New York*. Cartoon from *Life* 19 (April 21, 1892).

gown with puffed sleeves and a peplum; his arms are gracefully disposed accord-
ing to the conventions of female portraiture. Gibson played with sex-role reversal
in other cartoons, showing men in low-necked evening dress and women in foot-
ball uniforms. These are obviously outright spoofs, however, having an air of lu-
dicrous impossibility (though at the same time masking some unease), whereas the
gowned male aesthete at Mrs. Crome's seems all too plausible. Here was the point
at which irreversible degeneration set in, fatally compromising the gendered social
order.

The oppositional formula also operated in the flurry of cartoons published in
the van of the bicycle craze of the mid-1890s, and in 1895 a considerable number
appeared in *Life*. These had nothing to do with aestheticism per se and much to
do with male panic at the implications of the bicycle for women, since this simple
and relatively accessible machine had breached the boundaries between the separate
spheres, enabling millions of women to enter into the public pursuit of health and
leisure.[35] The knickers some adopted for cycling became the special target of satire
and led predictably (and not for the first time) to fantasies of a world where women
literally wore the pants and controlled men. *In a Twentieth-Century Club* (fig. 41)

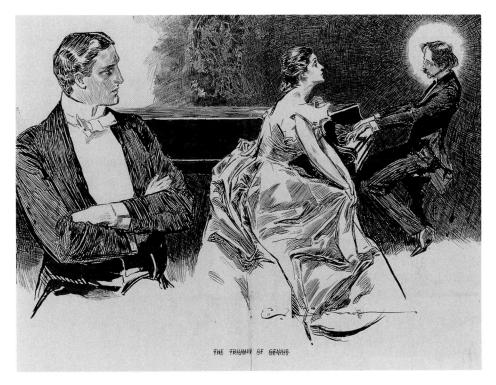

39. Charles Dana Gibson, *The Triumph of Genius*. Cartoon from *Life* 29 (March 18, 1897).

shows a cabaret patronized exclusively by women, now wearing knickers as a standard mode of dress. Drinking and smoking, they enjoy the pirouettes of the male ballerina up on the stage, tutu and tights contrasting ludicrously with beard and moustache. Such images could be read as straightforward male paranoid nightmares in which cross-dressing signified true role reversal and power shifting, but in the context of 1895, they did more. In the wake of Wilde's fall, feminized male figures also alluded to the totality of masculine degeneration that arrived at the point where homosexual conduct began. Effeminacy existed on a continuum that ran all the way from simple domination by females to genuine "inversion" and destruction of maleness.

Normalizing the Artistic Body

Proscribing marks of the feminine on men was part of an impulse toward social stabilization that focused on the individual male body—its surfaces and its humors. Mary Douglas argues that rapid social change and disintegrating social boundaries stimulate both greater external and greater internal control of the physical body. Thus, disorder in the body politic has implications for the individual

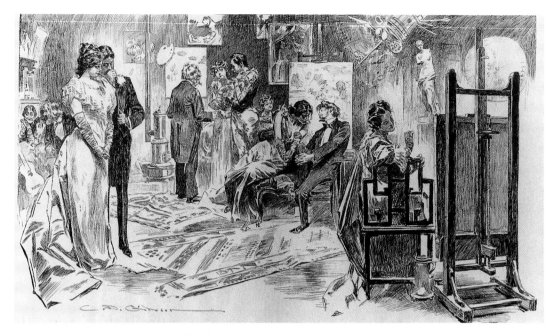

40. Charles Dana Gibson, *At Mrs. Daubleigh Crome's.* Cartoon from *Life* 20 (December 8, 1892).

body.[36] In the America of the late nineteenth century that discipline took hold in the form of the much-discussed "strenuous life" rhetoric under the aegis of former "Jane-Dandy" Theodore Roosevelt, who preached the need for strong, fit men and women to restore American health and ensure the nation's future. Much concerned with reinforcing the structure of culturally sanctioned sex roles and differences, Roosevelt laid the greatest emphasis on true manliness and genuine womanliness. The strenuous life doctrine is sometimes identified too narrowly with the ideology of male revitalization; it actually embraced both sexes in an urgent movement to prevent race suicide. In an address to the Congress of Mothers in Washington, D.C., Roosevelt exhorted his listeners to honor parenthood, telling them that the mother who successfully reared and trained the next generation occupied a more honorable, more important position in the community than any successful man. Unless the average woman was a good wife and mother, no brilliancy of genius, material prosperity, or scientific and industrial triumph would save the race from ruin and death.[37] This was obviously one maneuver among thousands to check or control the empowerment of women by feminism. Roosevelt's rhetoric also endorsed something yet more fundamental to survival: the maintenance of reproductive—that is, "normal"—heterosexual activity. To accomplish this, it was the duty of all Anglo-Saxon higher-class citizens to discipline their bodies and their minds in the interests of maximum health, enabling them to fulfill their ordained reproductive roles. For men, the enterprise of bodily dis-

41. F. Luis Mora, *In a Twentieth-Century Club*. Cartoon from *Life* 25 (June 13, 1895).

cipline outlawed the softness, frilliness, and hairiness associated with the effeminate and the aesthetic. At the same time, it encouraged vigorous physical activity and spartan regimes for the mind. In a "normalized" body, male intellect and temperament achieved the equilibrium that seemed so much imperiled at the century's end.

Critics took the prescription for health and equilibrium seriously when exhorting artists to strive for health in every sense of the word and to create art works commensurate with the fullness of their masculinity. One of their chief tactics was the disparagement of what were considered unhealthy and unnatural traits, chief among them the "morbidity" that seemed alarmingly on the rise among the moderns. In the English press, as John Stokes writes, *morbidity* stood for the "enemy within, an internal threat to the organism," and it was in constant use as a catchall "incorporating anything from the sluggish to the downright deadly. "The word (as Wilde very well knew) was also sometimes adopted as a "provocative euphemism for homosexuality," which further underscores the trajectory from homosexuality to disease and decay. In America, *morbidity* enjoyed the same status in the campaign to demonize aestheticism. As in England, it connoted

deviant sexuality: a doctor on the case of an effeminate young man, for example, described him as suffering from morbid attractions to persons of his own sex.[38] It is unlikely that all readers recognized that specific connection; nevertheless, even on its own the term could conjure up images of the unhealthy, the unwholesome, the antisocial, and the unnatural, and it turned up regularly whenever critics set out to scourge dangerous developments in modern art. A reviewer of the Etching Club exhibition in 1884 noted that the current passion for etching was merely the outgrowth of "that morbid tendency to exalt individuality above all other qualities in art which is the vice . . . of the painting of our time." More and more, the "nobler qualities of art" were giving way to "eccentricities, and the *cachet* of personality sinking down to *chic,* which is simply the settling down on the lowest level (dead level, too) of this morbid originality." Royal Cortissoz comprehensively framed the case against morbidity in an 1894 article attacking egotism in modern art. "Verily, in the Palace of Art," complained Cortissoz, "we have grown so morbidly self-conscious, so enamored of ourselves, that we are dissatisfied if our explorations bring us face to face with any image but our own." He was careful to note that he made exceptions of certain contemporary painters who put style and executive ability "unaffectedly at the service of pure beauty." This group included Whistler, Inness, La Farge, and Homer among the older generation and Sargent, Dewing, Edwin Austin Abbey, Dwight Tryon, and Homer Martin among the younger. In this small group, there were no signs of "anything but progress." But among the majority, there were "indications visible in its characteristics in which not the progress, but the decay of evolution" manifested itself. While eccentricity in American painting had not yet achieved the excesses seen among French symbolists and impressionists, Cortissoz worried over the "vitiating germ" infecting his artistic countrymen. The work of J. Alden Weir, John Twachtman, Edmund Tarbell, and others exhibited a kind of pictorial tunnel vision in their insistence on "the expression of the artist's point of view." Absolute freedom of expression unchecked by higher ideals and moral commitments was the ultimate outcome of art for art's sake, becoming the "exercise of personality . . . for the sake of the Person, the Personage." "Let personality degenerate into the . . . ignoble form of egotism," warned Cortissoz, "and it becomes an insidious but immensely effective force of disintegration." As antidote to the sinister spread of morbidity and decay in modern art, Cortissoz prescribed a return to the "inexorable habits of Neo-Greek discipline," happily unaware that *neo-Greek* would be one of the terms used to abominate Wilde and his homosexual leanings.[39]

Sculptor William Ordway Partridge (1861–1930) also exalted discipline as the cure for ailing manhood in an imperiled world. Partridge repudiated art for art's sake, declaring that "we love and practise art because it reveals to us, in every face and form and in the universe, the divine spirit." Only true manliness could get close to that spirit, and only a manly tone in society could produce the manly artist. The manly artist, in turn, was one who stood fast against fleshly temptation: "Manliness

in art, if it means anything, means a steady determination to endure the inevitable hardships that attend any great effort. It means the shutting out from one's life of many alluring pleasures. The moment the artist gives himself over to the benumbing pleasures of sense, that moment he ceases to be a great artist, because he ceases to govern himself. . . . It is one of the most flagrant wrongs and errors of the day, this idea that an artist is the child of the senses, or that he must abandon himself to them to attain success. France is falling into decadence, because her virility is cankered at the heart through such abandonment. . . . Dear God! save us from a like decadence." Partridge (who, oddly enough, had been raised in Paris) constructed the unmanly artist as a shallow sensualist, a prisoner of the body, a prostitute, an effeminate lover and a willing slave of all that was seductive. Where the real (and manly) artist read to the viewer "from the book of nature," the false and decadent artist reveled in artifice. Such an artist was scarcely better than a kind of picture-making man-milliner, winning fame for "painting fabrics and making dots of color look like the actual stuff." Enamored of surfaces, spirit narrowed to an obsession with paint and bristles, the unmanly artist was incapable of producing anything profound: "One [painter] becomes known for the brilliant way in which he handles sunlight; another I have heard of in New York has won fame for painting eyes that look down." A turn to physical and mental discipline, however, would redeem America from France's fate. Spartan regimes and rigorous education would ultimately "produce great artists and a great order of living."[40]

The discourse of artistic discipline and right-living manliness was one subset of a much broader one addressing the prevention of chaos. At a time when egomania seemed to have fragmented the art world into a dizzying plurality of viewpoints and styles, aesthetic chaos loomed dangerously near. Only the imposition of unifying principles in the form of common, outer-directed artistic goals offered a way to forestall that chaos. Just as artistic bodies must be brought back into proper proportion through discipline and conformity to the regimes of normality, so too must the production of art be brought under control. Fear of excessive individualism in art complemented distrust of corporate modes of association in the modern art world. Whereas corporate modes seemed to produce derivative work that lacked the animating spark of inspiration, excessively individual art introduced the problems of aestheticism and its cultural poisons because it pursued personal expression unbound from the core of shared social values and standards. Once art and morality parted company and the artist shed the restraints and abandoned the conventions governing social and cultural order, what was to prevent disintegration?

The problem in constructing artistic identity lay in balancing individual expression with social or at least cultural responsibility in some form. This involved the neutralization and normalization of aestheticism; eradication was out of the question, since aestheticism, despite all efforts, had taken hold as younger artists developed a variety of modern, personal styles. The trick now was to turn aestheticism inside out, to render it wholesome, progressive, and American. John Van

Dyke's 1893 treatise *Art for Art's Sake* aimed to do just that. Van Dyke had a two-fold purpose: to justify and cleanse aestheticism and to teach the public to appreciate·the formal refinements of the new art (as well as the old), which expressed thought not through old-fashioned storytelling but through a pictorial language of form, color, and tone, the essence of art for art's sake in painting. At every point, however, Van Dyke linked formalism to an all-important Something More, which was the power of art and artist to discover and reveal the "hidden beauties of nature and life."[41]

In the largely successful effort to neutralize aestheticism, American nature became the chief medium of a filtration system designed to segregate the poisonous sediment of aestheticism from a purer distillate. Hamilton Wright Mabie (1846–1917), whose books ran to many editions, was one of the most eloquent spokesmen for the "curing" of art through nature and manliness. In "Sanity and Art," he summarized his gospel: "We have suffered men of diseased minds to be our teachers, and, instead of looking up into the clear skies, or seeking the altitudes of the hills, or finding fellowship with strong, natural men in normal vocations, we have waited in hospitals, and listened eagerly to the testimony of sick men touching matters about which they were incompetent to speak. We have suffered ourselves to become the victims of other men's morbid tendencies and distorted vision. . . . We need to rid ourselves of the delusion that there is . . . any rare and precious quality in morbid tastes, temperamental depression, and pessimism." For the healthy man, he said in another essay, "Nature is sweet and sound and the world is sane," but for the sick man "the universe is a vast sick-room, with occasional glimpses of blue sky through the windows." Even the sick, however, could become well by taking the supreme medicine: "It is a deep and sound instinct which leads the man who has lost his health back to Nature. . . . There is no medicine so potent as the sweet breath and the sweeter seclusion of the woods; there is no tonic like a free life under the open sky. Insanity goes out of one's blood when the song of the pines is in one's ears and the rustle of leaves under one's feet. In the silence of the woods health waits like an invisible goddess. . . . And upon health in the fundamental sense depends the power of seeing clearly, of feeling freshly, and of producing continuously." Concerned with the restoration of artistic health and vigor, many others endorsed the same prescription. According to Stinson Jarves, art, holiness, health, and nature went together naturally. Decrying the harmfulness of art for art's sake, with its "low-grade visions," Jarves modeled the true artist as "nature's child" and "nature's priest," whose mission it was to assist the advance of culture, not its retrogression. "The most effective priests," he wrote, "do not always wear sacerdotal robes. I have seen them in sloppy clothes, smoking pipes, but with the joy of a god inside them."[42]

Faith in the healing power of nature promoted the course of immunizing American landscape painting against the insidious disease of degeneration. The changing fortunes of J. Alden Weir (1852–1919) illuminate this process. In the late 1880s and early 1890s critics found Weir's landscapes anemic, derivative (of Monet in particular)

and inauthentic. One linked the colors in his landscapes to the sickly hues of aestheticism: nature in his paintings seemed to have been conceived "as though in the last stages of consumption," and it spoke a "poetry of the sage-green, pale-moon order." His art was bloodless, impotent. "He gives us the poetry of nature in a minor, very minor, key," wrote Alfred Trumble, "and on a narrow, very narrow scale. It has a dainty, melodic charm which seduces the weaker senses only, and does not thrill the eye or stir the blood. But of the blood and bone of art there is nothing in it." Quite soon, though, Weir was recruited into the recovery movement. In 1895, the year of Wilde's downfall, Edward King discovered in Weir the key to what made everything natural and American so superior, authentic, and profound. King's article vividly illustrates the basic coordinates of the pattern interlacing nature, landscape painting, and cultural cure. He began by noting the "absence of mysticism" in that spring's European art exhibitions and wondered whether the mystics had been frightened away: "Gone is the Sar Peladan and all his uncanny crew; and the large, tranquil transcripts of nature and humanity resume their lead. Was it the onslaught of Max Nordau that frightened these *poseurs* into the darkness where they belong? Who shall say? They were so vain that they might have thought it fine to be pointed to as types of 'degeneration.' They were faddists and could not have a lengthy existence. . . . Sincerity and simplicity take up their guidance once more. Happy he who profits by them." Mystical, symbolist, and allegorical work amounted to mere banality, to conceal which the artists and their admirers had "invented a jargon, made of quaint mystical terms; and . . . imagined strange and wonderful stories to tell in it about what they really do mean." No such jargon, no such poses, and never any such degeneration attached to the art of a "true and faithful student of nature and men" such as J. Alden Weir (fig. 42): "Seen through [his] temperament . . . a rather prosaic New England pasture suddenly takes an interesting—I had almost said a romantic—look. The rugged outlines of the low hills are softened, the whimsically built rail fences, which often deface poetic landscapes, are called into the service of poetry; the rocks in the foreground, mottled and ancient, seamed and cracked, irregular in their march as if they had whimsically resolved that they would not serve the purpose of the artist—are brought in without extenuation; but they serve the general purpose of harmony. These unpromising and hard features are all mellowed in the rich warm light of the artist's fancy, until they seem enchanted." In Weir's landscape the "charm of a puissant individuality" was present, but it was tempered and completed by his feeling for his subject: "He glorifies nature by his fidelity in serving her, and by the communication of his own mystic enthusiasm." King did not develop the rhetoric of manliness and health in so many words, but his language represented those values well enough, since words such as *true* and *faithful,* in opposition to *poseur* and *faddist,* carried a full freight of culturally charged meanings. Weir's achievement showed the discipline that bespoke health and manliness, for "learning how to look at his subject is the work of a lifetime for an artist. His life passes in pleasurable struggle." Unlike the indolent and effeminate aesthete,

42. J. Alden Weir, *In the Shade of a Tree (Sunlight, Connecticut)*, 1894. Oil on canvas, 27 × 34. Sheldon Memorial Art Gallery, University of Nebraska–Lincoln. Nebraska Art Association Collection; Nellie Cochrane Woods Memorial; 1967.N–222.

Weir toiled and strove and in so doing embodied the ideology of progress, working to see, and reproduce what he saw, better and better. His "normal" manliness, moreover, revealed itself in the relation between nature and artist. Nature, figured as a sometimes coy and contrary woman, unfolded her heart (in addition to throwing aside her veil) to reward the painter's ardent, persistent probings.[43]

Weir, nature's pure-hearted worshipper, was among the guests at the Pie Girl Dinner, which, like the fall of Wilde, took place just about the time that King's article was published. This conjunction tells us that no simple reduction of any artist's character into a salient profile is possible—or useful. But it also suggests that the outcry over the Pie Girl Dinner and the rage concerning Stanford White's double life had as much to do with class, and the higher classes' predation on the lower, as with degeneration in a more extreme and deviant construction. For even though lewd studio revels offended middle-class morality, the sexual congress that took place in those venues was an extension of "natural" manliness—gross and repellent, perhaps, but decidedly heterosexual, emphatically virile, and not even incompatible with

the conduct of an otherwise disciplined and productive existence. The taint of effeminacy and its related signs was a far more alarming symptom of social decay.[44]

Close reading of texts on celebrated American artists at the fin de siècle reveals the lengths to which critics extended themselves not simply to avoid allusions that might encourage the remotest associations with degeneracy but also to represent their subjects as champions of American artistic manliness and health. Gibson, whose lampoon of the aesthete in drag affirmed his own position well within the borders of the "normal," stood for a distinctively American brand of artistic identity (see fig. 115). When Gibson invested his savings in an 1889 trip to Paris, the art mecca of countless young Americans, his biographer Fairfax Downey reported that unlike most of his fellow pilgrims, Gibson refused to dress the part—to wear the beret, velveteen jacket, and baggy corduroy trousers. "Never on Charles Dana Gibson, not even in a day when artists looked like artists. On him such apparel would have seemed like a pink ribbon tied around Plymouth Rock." When he courted the Virginia belle Irene Langhorne, the city of Richmond became uneasy: weren't artists rather rakish fellows, and didn't they stage riotous dinners in New York at which four and twenty nude models popped out of a huge pie? Yet Langhorne's suitor seemed well behaved, and he proved, moreover, to be a "real man." In his twentieth-century narrative, Downey embroidered on a Gibson mythology that dated from the 1890s and made much of his wholesomeness and incorruptibility. As Charles Belmont Davis put it, "He came to his life's work from a clean, country home; his capital—good health, a tremendous capacity for work, and an invaluable ignorance of the work of the modern Parisian and Viennese cartoonists." Even the Pie Girl Dinner, which Gibson too attended, failed to damage his name. Fortunately for the wholesome illustrator, whatever might tarnish his reputation was simply ignored or repressed. He could have attended a dozen Pie Girl Dinners without denaturing his image, because so much hinged on keeping it uncorrupted.[45]

Winslow Homer was an even greater hero of artistic maleness. As the authentic native he-man of late-nineteenth-century American art, he became the culture's most powerful metaphorical vaccine against effeminacy and degeneration. He was part of nature, and because he had never been anything but "wholesome and individual," wrote Frank Fowler, he stood "as a man receiving strong emotions from the noble aspects of nature . . . [which] seemed to pour through him and upon his paper." Presumably because his art was so deeply rooted in nature there was no danger that his celebrated individualism would take a freakish turn. His bachelor status—anomalous in an era that celebrated domesticity and family values—enhanced the purity of his masculinity. Here there was no oppositional formula beyond the femininity that was figured into nature. Homer was an absolute male, his virile energies unspent on wife or mistress and therefore able to be channeled into undiluted intercourse with nature, and the production of rugged, heroic natural scenes.[46]

The examples of Gibson and Homer are almost too obvious. How could they *not* be constructed as they were, given the cultural preoccupations and anxieties

43. *George Inness.* Photograph from William Howe Downes and Frank Torrey Robinson, "Later American Masters," *New England Magazine* 14 (April 1896).

among and within which they acted? The case of George Inness, though, is a fascinating instance of how an artist had to be written about and what terms were used to frame the interpretation of his works. On the face of it, he would seem to be a likely candidate for the "sick genius" formation, and some writings on him seem to skim perilously close to the border of degeneration. Given Inness's personality and his artistic habits, and indeed his epilepsy and mysticism, the performance of critics in making him part of what might be called a "wholesome genius" picture is truly acrobatic. William Howe Downes wrote that to be a landscape painter of Inness's stamp meant possessing sensitivities "almost morbid," a power of vision "extranatural," and a pleasure in seeing "so rapturous it borders on pain." Prominent critic Montgomery Schuyler described the painter's temperament as intense, impetuous, and highly unstable, vacillating between elation and despair. He was completely impractical and imprudent about money, and he lived in a "chronic condition of excitement." He pursued his work with incessant industry, which accorded with his most salient trait: intense, exclusive preoccupation with whatever concerned him at the moment. Such concentration negated the "notion of the man of the world." Inness was as much "possessed" in conversation as when painting; talk, indeed, was the safety valve of his "freaks and fantasies," enabling him to preserve the "sanity and balance" of his art. Finally, his appearance (fig. 43) was strikingly unusual: he

was small and nervous, with burning black eyes and a black and shaggy "fell of hair." Frank Fowler traced the same pattern, recounting how at some moments Inness would suddenly break off from conversation and rush for his palette, and then "this sensitive painter would stand like some frightened animal, body quivering and eyes dilating, for he had perhaps caught a glimpse of an eternal truth he feared to lose." One can imagine how Max Nordau might have construed the same set of characteristics, portraying an obsessive, wild-eyed, egomaniacal, and antisocial degenerate genius subject to fits and trances and given to harangues about spiritualism.[47]

These writers clearly allowed considerable leeway for the eccentricities of genius, and in alternative situations, such as that of Ralph Adams Blakelock, the "sick genius" trope proved advantageous (to his exploiters, at any rate) in the marketing of his work. Accounts also suggest that Inness enjoyed the status of a holy man whose visions, as nearly every critic maintained, lightened the leaden materialism of the age with an ethereal spirituality. Because they were the increasingly valuable property of Thomas B. Clarke, whose currency as a patron of American art was on the rise in the 1890s, Inness's paintings benefited. The star, with Homer, of the Clarke collection, he had to be constructed as the progressive, enlightened, all-American man of God and nature. George William Sheldon extolled the virility of Inness's intellect, which produced the noble ideas expressed in his landscapes (see fig. 59): "Most of the pictures in the dealers' collections could be described, he thought, by the phrase 'intellectual dishwater.' 'My compositions,' said Beethoven, 'are not intended to excite the pretty little emotions of women: music ought to strike fire from the soul of a man.' This is what Inness's best pictures do." In his fierce vitality, Inness was a torrent of concentrated masculine energy. Yet for all his fits and mood swings, in Sheldon's construction Inness was a model worker and pure to boot: he had no jealousies and few amusements; he smoked, took long walks, and sometimes painted fifteen hours a day. Given the climate of the 1890s, and the sustained effort to define a pure, wholesome, masculine identity for national art, the construction of Inness answered those concerns nearly point for point. An artist who could have been represented as mentally fragile, sick, and weak became for the late nineteenth century an unconventional yet splendidly functional model of the ideal, manly American artist.[48]

It is worth asking, finally, why Whistler, as a flamboyant, cosmopolitan champion of art for art's sake, and an artistic celebrity whose capers were recognized for the self-advertising mechanisms they were (see Chapter 7), so neatly avoided the heavy-hitting opprobrium that dogged Wilde. Because he preached a cult of pure beauty and tasteful expression that appeared detached from the pursuit of hedonistic, sensuous pleasures, Whistler was far less threatening than Wilde. The fact that he tangled publicly with the Irishman in the 1880s no doubt distanced the master from his studious if temporary apprentice. Another factor that kept Whistler on the right side of public opinion was that, despite his fancy dress and his facility as a decorator,

he projected a powerful aura of "normal" masculinity through his incessant, stylized, and highly publicized attacks on his enemies. Whereas Wilde, so often seen as effeminate, was dangerous because he attracted and fascinated women, Whistler was more a soldier of fortune in the world of art: an independent, bloodthirsty adventurer whose theatrical costumes (see fig. 90) were analogous to the plumes, ringlets, and ruffles that might decorate yet fail to feminize the pirate. As a young man Whistler showed a quick-tempered combativeness that on one occasion resulted in a fistfight with his brother-in-law Seymour Haden, whom Whistler hurled through the window of a Paris cafe. In middle age Whistler "substituted litigation for violence," as Leonée Ormond puts it, in addition to carrying on public epistolary duels with real or fabricated enemies. His correspondence was sprinkled with bellicose talk of bloody, brilliant campaigns that left the critics "simply slaughtered." His famous cane, of course, resembled a dueling foil as well as a painter's wand.[49]

Whistler benefited too by the shifting valences of gender construction in the late nineteenth century. Midcentury ideals of manhood acknowledged the persistence of aggressive impulses in the adult male while endeavoring to restrain them. In the last decades of the century, however, force, violence, and strife "were becoming synonymous with manhood," especially that of the Anglo-Saxon. With a few modifications, one writer's paean to male ferocity could have been slotted neatly into a magazine profile of Whistler: "Men of peace! No, we are nothing of the sort. The modern Anglo Saxon is a fighter, as his savage ancestors were. He goes into war with a zest as keen as any other nation's. . . . Between his wars he fights the lesser battles of the football field, the pugilistic ring . . . or looks on and shouts while others fight them. His boys learn to double their fists almost as soon as to walk; their favorite Bible stories are David's fight with the Philistine giant." In his own way, Whistler had been reenacting that favorite story through most of his career. Of course he himself had nothing to do with the movement toward racial salvation and revitalization that lay behind the cult of male vigor and savagery at the fin de siècle. He was an undersized, overaged, expatriated painter. Nonetheless, his hotheaded, pugnacious behavior was vividly coded as "naturally" masculine, in the extreme.[50]

To what extent was the message of health, manliness, and discipline exclusively a construction of critics and other art writers in the popular media, and to what degree did it shape the individual artist's construction of both personal and pictorial style? There may be as many answers as there were artists around the turn of the century, but certainly some younger artists maturing in the 1880s and 1890s responded positively to the widely circulated rhetoric of virility and the rest. The early efforts of the young George Bellows (1882–1925) to win recognition as a "virile athlete and forceful leader," in Marianne Doezema's words, suggest that he had internalized the rhetoric of artistic manliness as well as general prescriptions for toughening promulgated by Theodore Roosevelt and his disciples in the strenuous life. As Doezema notes, when Bellows's mentor Robert Henri styled himself a maverick, defying the stuffy National Academy by withdrawing his paintings on one occasion

and by staging independent exhibitions on others, he positioned himself as a vigorous, muscular, progressive force in the revitalization of American art. In his appreciation of the "school of Robert Henri," Samuel Swift took pains to point out that Henri and his acolytes had succeeded in making the cult of art and beauty a wholesome pursuit: "There is virility in what they have done, but virility without loss of tenderness; a manly strength that worships beauty; and art that is conceivably the true echo of the significant American life about them." With this new generation, the love of beauty did not represent strange sickness and deviation, because the artist's manly strength immunized him against degeneration and effeminacy. The style of the school, of course, with its bold brushstrokes and strong, earthy tones (of nature, not the boudoir), encouraged its reception as masculine expression.[51]

Perhaps the most dramatic example of a painter who fulfilled the prescriptions for manliness and wholesomeness in modern painting is that of Edward Redfield (1869–1965), a Pennsylvania native who trained at the Pennsylvania Academy of the Fine Arts and the ateliers of Adolphe William Bouguereau and Tony Robert-Fleury in Paris. After his return from Paris, Redfield settled at New Hope, Pennsylvania, in the rural Delaware Valley, and concentrated on the production of large, roughly painted impressionist landscapes, becoming best known for his gritty winter scenes (fig. 44). J. Nilsen Laurvik's tribute to Redfield revealed an almost obsessive concern with the painter's status as a supremely virile American. Words such as *progressive, energetic* and *rejuvenating* appear thickly on the first page, and *virile* and *masculine* occur insistently throughout. Since Redfield let it be known that he was no indoor painter but a vigorous outdoorsman who did his own farming and carpentry, it is evident that he situated himself on the "wholesome" side of the debate on what American painting should be. Laurvik in turn perceived him exactly that way: "He neither epitomizes nor philosophizes, nor is his work touched by any of that dreamy and speculative hyperaestheticism that is emasculating a section of our art. The fads and fancies, the frills and follies of the enemic [*sic*] worshippers of the pale shrine of art have no appeal for him. . . . His color is fresh, alive and truthful, laid on with a crisp, trenchant touch that bespeaks a robust, masculine vigor." Like Bellows's unrefined and sometimes brutal city scenes, Redfield's subjects helped promote his manly status. An open-air painter specializing in winter landscapes, he embodied his own ruggedness in his works. Redfield painted a nature that exacted Spartan fortitude from those who ventured into its frigid loveliness. This was a beauty that only the man with hot, red blood could endure.[52]

By the early twentieth century the discourse of effeminacy had become—as had that of degeneration—a tool in the hands of anyone endeavoring to demonstrate superiority over the foreign, the anachronistic, and the threatening. It also served as a weapon against the local senior competition in the attempt to validate an alternative style. Depending on their aims, different critics could call the same painters manly or effeminate. Christian Brinton surveyed the state of American art in 1908, the year of Robert Henri's first independent exhibition with his "revolutionary" group. Brin-

44. Edward Willis Redfield, *The Riverbank, Lambertville, New Jersey,* c. 1908–1910. Oil on canvas, 50 × 56½. Collection of the J. B. Speed Art Museum, Louisville, Kentucky.

ton took no issue with Henri and his coterie, but he believed that "The Ten" had already initiated the revitalization of American art by resigning from the Society of American Artists in 1898 to hold their own shows on a platform of art for art's sake and individual expression. "The Ten" comprised cosmopolitans, for the most part— including Thomas Wilmer Dewing, Edward Simmons, Childe Hassam, and Boston School painters Edmund Tarbell, Frank Benson, and Joseph R. DeCamp—painters who worked in impressionist and tonalist styles of considerable delicacy, complexity, and refinement. Their work stood for the "youth, enthusiasm, and vitality of American art." Brinton also praised the Metropolitan Museum of Art for purchasing a painting by John White Alexander, whose gracefully decorative compositions epitomized the premises of art for art's sake in the 1890s. All too seldom had the museum recruited items for its collection from the "virile and spirited ranks of contemporary art." Guy Pène du Bois, on the other hand, denigrated many of the same painters the better to assert the value of the Pennsylvania school of landscape that was headed

by Redfield. In Pène Du Bois's view, Tarbell, De Camp, Benson, and their colleagues produced timid, small, and snobbish work that was excessively refined. They painted figures of upper-class women who never strayed into places "outside of the province of the lady," and their compositions betrayed not the slightest evidence of struggle. Looking back at the vital, truthful, and manly art of such old masters as Rembrandt, Goya, and Manet, Pène Du Bois wondered, "Where is our national art . . . and when are we going to have one?" The answer and the hope lay in the Pennsylvania landscape painters, a "body of plain men" who, like the settlers, had been "pushed to rudimentary thought by rudimentary living."[53]

The resistance to aestheticism that marked the end of the nineteenth century leveled off somewhat in the early twentieth, and it seemed that a relatively stable "native" school of manly painters had secured a foothold in the art world and the art market. In the process of stabilization, aestheticism had taken on a healthier guise by association with the purifying influences of nature, and the rhetoric of progress had reached a draw, at least, with the doomsaying of degeneration. The "normal" had temporarily gained an advantage in defining the limits of art and the parameters of gender role construction. Combining resistance to cosmopolitanism with panic over American social decay in the closing years of the century, and cloaking these under the discourse of degeneration and effeminacy, the neutralization of aestheticism was critical in shaping patterns of artistic identity for the new century. The process also framed the terms of continuing conflict and contest for decades to come, when the limits of masculinity and femininity, health and disease, progress and decay would be tested anew, many times over.[54]

4 PAINTING AS REST CURE

The campaign to neutralize and Americanize aestheticism extended beyond prescriptions for wholesomeness and manly discipline in art. Those seeking normalization also undertook to restructure the very concept of artistic vision. At the core of this enterprise was the remodeling of "morbid" egotism into healthy and specialized subjectivity. This newly legitimized subjectivity in turn helped create a dynamic role for art as a form of therapy couched in a purely visual language, acting directly on the senses without the mediation of conventional narrative structures. In this transformation, James McNeill Whistler was an influential model. Whistler's *Nocturne in Black and Gold: The Falling Rocket* (fig. 45) exemplifies the artist's claim to aesthetic authority premised on the power to see, and interpret what he sees, uniquely, while dispensing with anecdote, sermon, and fidelity to outward appearances. During the *Whistler v. Ruskin* trial the painter was asked whether his two days' labor on the painting justified the two-hundred guinea asking price. Whistler retorted, "No. I ask it for the knowledge I have gained in the work of a lifetime." In the 1885 "Ten O'Clock" lecture Whistler asserted that such knowledge was solely the property of the genuine artist. Only the artist could "pick and choose and group with science" the jumbled and aesthetically inert components of nature. Only the artist—and not the dilettante or the spurious aesthete—could perceive beauty where

45. James McNeill Whistler, *Nocturne in Black and Gold: The Falling Rocket,* 1875. Oil on oak panel, 23¾ × 18⅜. Gift of Dexter M. Ferry, Jr. Photograph © Detroit Institute of Arts, 1995.

46. Childe Hassam, *Church at Old Lyme, Connecticut,* 1905. Oil on canvas, 36¼ × 32¼. Albright-Knox Art Gallery, Buffalo, New York; Albert H. Tracy Fund.

others could not. When night veiled the discordant scenes of the modern metropolis, the artist alone perceived its poetry; all others could neither see nor understand what lay before their eyes. Often read as a manifesto of Whistler's art for art's sake stance, the "Ten O'Clock" lecture also incorporated the artist's claim to knowledge, power, and control. By asserting his exclusive entitlement, Whistler appropriated authority in all artistic matters to the genuine artist alone.[1]

Although controversial at first, the aestheticizing gaze settled into the cultural mainstream. When painter and critic Frank Fowler reviewed the National Academy of Design exhibition in 1907, he remarked on the predominance of paintings in which fresh vision and the emotional portrayal of nature outweighed story and subject. He rated Childe Hassam's refined, impressionistic *Church at Old Lyme, Connecticut* (fig. 46) as the "high-water mark of sensitive vision" in the show and discussed the artistry of George Bellows, who could make the "sordid" theme of *River Rats* (fig. 47)—scrawny urchins bathing from a grimy urban embankment—so appealing visually and aesthetically. It was the "newer and fresher tendencies that one would dwell on," he concluded, "evidences of the progressive spirit which has seized some of our painters . . . [and a] larger welcome to independent vision, a readier acceptance of the individual point of view." How the painters had personalized the scenes they witnessed, fair or foul, church or guttersnipe, now transcended or at least equaled the narrative or social significance of the places and people depicted on their canvases. Morbid egotists no longer, artists displayed the highly

47. George Bellows, *River Rats*, 1906. Oil on canvas, 30½ × 38½. Private collection, Washington, D.C.

refined visual acuity that legitimized them as specialists of sight and professionals in self-expression.[2]

The late-nineteenth-century art world produced an array of academic and social professional institutions that regulated the population, endowed credentials, and facilitated contacts with potential patrons. The "professionalization" of sight, less concrete to be sure, was no less important in retooling artistic function to align it with the paradigms of progress and modernization. As essential tools of the trade the artist's eyes and manual skills had intrinsic worth, of course, and the high value assigned to personal vision was rooted in the aesthetics of romanticism. What was new was the linkage on one hand of visual expertise with an increasingly professionalized world of single-track specialists, and on the other with an evolutionary model featuring specialization as the prime instrument of advancement toward higher civilization.

The modern world had become vastly more complicated, demanding new modes of organization and behavior. As business success writer Nathaniel Fowler declared, "This is the age of specialists. The Jack of all trades is the jackass of all trades. No one can do two things equally well." Frederic Harrison, looking with some trepi-

dation on developments in the art world, admitted that nothing more completely characterized the modern era than specialization: "In science, in sociology, as in practical things, the most curious subdivision of employment has become the rule. Histories of a single country over a few years fill many volumes, and occupy exactly the same time in composition as the events occupied in transaction. A great reputation in natural history is achieved by a life-long study of one specimen of *coleoptera*. . . . A painter spends a long and laborious life in reproducing one class of scene or subject. I will not say that specialism is otherwise than essential. . . . But it is most antipathetic to Art. . . . Art means unity of conception; and specialism means disparate and dispersive observation."[3]

Specialism was the order of the day nonetheless. As self-styled professional seeing specialists, artists of the late nineteenth century affiliated themselves with Herbert Spencer's model of progress, well known and influential among Anglo-American elites. Spencer (1820–1903) invested his concept of evolution with moral purpose, arguing that evolutionary change was for the better, its purpose the production of superior types. The law that governed the evolution of species directed the advance of civilization in a march from inferior to superior, from brute to philosopher, from indifferent homogeneity to ever more complex heterogeneity. In this lay the essential law and dynamic of progress. Spencer, a jack of all intellectual trades himself, modeled the history of art along those same lines in *Principles of Sociology*. It had been necessary for civilization to pass through stages devoted first to the defense of life and then to its regulation. Only then could it rise to the "augmentation" of life, the stage at which the professions evolved. Artistic specialization, an outgrowth of this advanced stage, represented civilization in its highest form and positioned the artist at the forefront of even further progress.[4]

Specialization increasingly defined and distinguished an artist's product line, or subject matter. Again, in some ways this was not altogether new. In antebellum America, as in seventeenth-century Holland, painters had occupied niches as portrait, landscape, or genre experts. In the decades bracketing the turn of the century, though, specialization came to be identified not just with subject, but with place as well. The picturesque world became a mosaic of aesthetic territories, each artist identified with a particular place or type. In addition to promoting name recognition, these territories were the raw material from which each painter fashioned aesthetic commodities. The art colonies and summer schools of art that sprouted everywhere in the late nineteenth century were evidence of the quest to discover, appropriate, and personalize the paintable place. So territorial were aesthetic imperatives that Lizzie W. Champney described artists' summer "haunts" as "property"—apparently accepting the idea, without a trace of irony, that such places existed to be packaged as art. Nearly every painter Champney mentioned was in search of "suggestive material," which could be found even in so meager a place as the Jersey Flats, New Jersey. Some artists were associated with more than one place. George H. Smillie, for example, worked in Easthampton on Long Island but was "also identified

with Marblehead," in Massachusetts. Others, like F. Hopkinson Smith, were professional tourists, venturing to Cuba or Venice for attractive motifs. But American artists knew that "there is hardly a picturesque spot in Europe which is not so copyrighted by genius and association with some great name that any further painting of it seems plagiarism and impertinence." This did not stop Whistler, Sargent, and many others from "doing" the seductive scenes of Venice. Still, it was to an artist's advantage to discover turf that he could stamp with his distinctive presence and look. "Mr. [Walter] Shirlaw," noted Champney, "has been attracted by the glistening caves and walls of the marble-quarries of Rutland and Manchester [Vermont]—a new field in art, and one offering brilliant effects in color, as well as strong contrasts in light and shade."[5]

Specialization extended far beyond mere subject matter, however. Painters made reputations as experts at rendering particular times of day or certain atmospheres. Charles Rollo Peters (1869–1928), while obviously indebted to Whistler, gave the nocturne his own local, personal stamp. By recycling moody, moonlit California themes, as in *Nocturnal Landscape with Adobe Building* (fig. 48), Peters gained distinction as an expert in this small department. He had set out to stake such a claim for himself. "It's the specialists that 'arrive' now-a-days," he said, "whether it is diseases of the ear . . . or Persian coins of the fourteenth century. Moonlights are my speciality." A Chicago critic wrote, "This is the age of the specialist, and in every branch of work where deep individual research is required, it is the specialist who wins. Mr. Peters is distinctly a specialist. He has found for himself a new and strongly personal story to tell. . . . In choosing as his theme the particular phase of nature, moonlight, Mr. Peters has at once a subject, although most difficult to handle, from its very character full of romance, mystery, and charm of sentiment unequalled by any other effect." That Peters had derived the idea from Whistler was of little account. What mattered was that he had mastered the theme and attached it to his own identity.[6]

The Professional Seer

The making of art took more than mere subject matter, however picturesque. It required the transformative energy of personal vision. Ownership of aesthetic "properties" was contingent on the power to see them in a certain way. The principal ability of the artist, wrote John Van Dyke, was to "see more beauties and deeper meanings in nature than the great majority. . . . He has a sense for beauty in form and color; and a mind susceptible of receiving and revealing the most delicate and poetic impressions of that beauty." The function of the artist was "primarily that of a discoverer and revealer of these hidden beauties in nature and life. . . . Because he is best qualified to reveal such beauties as these is good argument why his art should be largely confined to ideas concerning them." Landscape painter Birge Harrison took the same tack, reminding readers not to forget that "art is nature *as the artist sees it*." By the turn of the century, seeing and genius were on equal footing and

48. Charles Rollo Peters, *Nocturnal Landscape with Adobe Building,* n.d. Oil on canvas, 13 × 16. Collection of the Oakland Museum; Gift of the Art Guild.

perhaps interchangeable, and there was near-consensus that the painter's super-sensitive seeing eye, which revealed beauties unseen by others, was at bottom the true subject of every picture. Painters as different as Winslow Homer and James Whistler garnered praise for their sensitive sight, even though one was supposed to be a purely natural painter, and the other a purely artificial one. Mariana Van Rensselaer described Homer as a "serious, studious artist who is also one of the best endowed that has been born among us. . . . [His] life means simply to observe effects with wise, keen eyes and to paint them with a trained and capable brush. If we ever really see wet flesh under strong summer light with the reflections of blue-green water upon it, we shall surely note colors as bright and strong and hard as Homer painted." And Whistler, as Charles Caffin put it, made it his artistic purpose to "extract from Nature her abstract appeal to the sense of sight even as a chemist distills fragrance from flowers."[7]

William Merritt Chase most vividly embodied the figure of the artist as seeing

49. William Merritt Chase, *Near the Beach, Shinnecock,* c. 1895. Oil on canvas, 30 × 48⅛. Toledo Museum of Art, Toledo, Ohio; Gift of Arthur J. Secor.

expert. He could translate visual sensations into pictorial equivalents with dazzling skill and unerring taste. Kenyon Cox had predictable and not uncommon reservations about the absence of imagination and intellectual depth in Chase's art, but he acknowledged his colleague's powers, calling him a "wonderful human camera" and a "seeing-machine" who cared for little save the "iridescence of a fish's back" or the "red glow of a copper kettle." Chase's ability to make glistening dead fish seductive eventually became quite profitable (see fig. 23). Amos Stote reported that the "works that have become known as 'Chases's Fish Pictures' are classics from the artist's standpoint. It is rumoured that he has a standing offer of $3,000 each for as many . . . as he cares to paint." Chase could also take the unlikeliest scrap of landscape and make it interesting. John Gilmore Speed told of Chase's Shinnecock Hills neighbor, who asked what it was the artist found worth painting in the scrubby, sandy coastlands of Long Island. Surprisingly, Chase had difficulty responding. This was all the more astonishing because Speed and Chase had just then returned from a walk during which the painter had been "pointing out pictures . . . and painting them in his mind. . . . In . . . an hour and a half the artist's eyes had seen enough of beauty to keep ten men busy for fifty years, while in over fifty years the eyes of the other man had seen nothing." It was the same with Central Park. Chase had "discovered" it, wrote Charles de Kay, and by seeing and celebrating its beauty he performed a public service, pointing out to citizens "what things in that park are worth exam-

ining" and teaching them "to look at the trees, lakes, and meadows with something more than a cow's gentle but hazy satisfaction in water, grass, and sunshine." *Near the Beach, Shinnecock* (fig. 49) is a serviceable example of what it was Chase could do with a view that had nothing much in it. To describe this uneventful picture requires a mostly coloristic vocabulary, since the whole composition depends on the relations of tones and color accents: the white clouds and the sparkling white dresses; the lapis blue stripe of sea and the wide azure band of sky; the center child's vermilion stockings and tam harmonizing with the vermilion spots scattered among the yellow and white clumps of flowers in the foreground. There is also the bold and lively brush work, which invigorates the surface. This was the kind of landscape through which Chase, the professional seeing expert, could sensitize common vision.[8]

Fiction in popular magazines helped to diffuse this model of the artist-seer into mass (albeit middle-class) culture. In one story a young painter returns from Paris to his family home and his simple, rustic parents in Pennyrile, Kentucky. The parents speak dialect and stand in awe of their son Charlton, now a man of the world whose work commands staggering sums, and of whose profession they have no understanding. Barely able to communicate with her son, the old mother asks him to "show me what it means, this paintin'—what they is *to* it." One afternoon, much to her bewilderment, Charlton abandons all activity, stretching himself out under the peach trees.

> For a whole hour of one afternoon he lay there studying the way the sunlight caught the crooked stems of the trees . . . as it shifted and lowered, and he seemed to expect his mother to join him with enthusiasm in this idleness.
>
> "Just watch the gold edging on the silver-brown trunk, mother. Look. It'll turn to copper presently."
>
> As a concession to the returned prodigal, she had come out there . . . but kept busily sewing on a thing she called a "pillow-sham." "How can I watch the tree, Charlie, and attend to my work too?"
>
> "This *is* your work, mother. This is some of 'what there is to it.' "

Not until Charlton has completed a vivid portrait of his old "dadda" (fig. 50) does mother finally understand what had previously impressed her as little more than laziness and childish play. She realizes that Charlie has captured the essence of his father: "Even the dear heart inside, which she had always thought no one in the world but herself could see, Charlie had seen that too, and put it into a picture!" Smiling through her tears, the mother brings the story to a close, saying "*Now* I can see what they is to it, son—jus' as *plain!*" Old and young, rustic and sophisticated are brought together by the revelatory power of art and by the artist's vision.[9]

The new artist's occupation was to look, to register, and to communicate not so much what as how he had seen. This pronounced emphasis on visual connoisseurship—on the part of both painter and viewer—marked a departure from main-

50. A. I. Keller, *"Now* I can see what they is to it, son—jus' as *plain!"* Illustration from Ewan Macpherson, "A Revelation in the Pennyrile," *Scribner's* 31 (January 1902).

stream midcentury painting, with its reverence for detail and quasi-scientific accuracy, its narrative and didactic impulses, and its tendency to read nature (in the words of Asher B. Durand, sage of the Hudson River School) as product and type of the "Divine attributes," gloriously pictured in the natural world by the "Great Designer" himself.[10] I do not mean to insist on some sort of surgically clean split. Late in the century there were artists of stunning popularity, such as Thomas Hovenden (see Chapter 10), who worked in painstakingly descriptive storytelling modes in which color was intended to replicate nature's hues in the most literal-seeming way. Nonetheless, the turn toward increasingly pure and personal visuality in painting gathered momentum and achieved prominence by the century's end. Its advance was more than a matter of cosmopolitan younger-generation rejection of provincial paternal authority. By meshing with culturewide processes of modernization, this modal shift secured validation from new theories of sensory perception, which helped move the subjective "seeing eye" model of the artist into the mainstream and stabilize its position there.

The Mind as Artist and the Embodiment of Sight

The high valuation assigned to subjective and individual artistic vision came about just as scientific legitimization for it became available. This was no sudden development. It had been in the making at least since the turn of the nineteenth century, if not before, and it involved a pronounced shift from rationalist to physiological and psychological theories of perception. As Jonathan Crary writes, seventeenth- and eighteenth-century ideas about perception, based on the model of the

camera obscura, presupposed a disembodied subject whose vantage point on the world was analogous to the eye of God. Perception was assumed to be stable, transparent, and objective, undistorted by subjectivity. Reality was out there, beyond the body's boundaries. In the nineteenth century, however, research disclosed that the eye was simply an instrument for receiving light and that the optic nerve was the site for registering stimuli, no more. These excitations were transmitted to the brain, where perception—understanding—actually occurred. The eye could be an unreliable, fallible window on the world, as demonstrated by study of such phenomena as afterimages and optical illusions: the eye could see, and believe, what was not in fact physically, tangibly there. The mind, however, which in the act of perceiving applied experience and associations to raw sensation, could augment, interpret, and transcend the often inadequate and distorted evidence delivered by the senses.[11]

By the late nineteenth century this concept of visual perception was not only widely accepted by scientists but familiar to the educated general reader as well. The work of Hermann von Helmholtz (1821–1894), in particular, served as a repository of much-quoted and widely popularized theory. Dr. William Ireland used Helmholtz as the basis for observations about visual perception, reiterating Helmholtz's contention that landscape colors gain in brilliance if perceived upside-down because colors then are no longer signs of the nature of the objects but only of different sensations. "We read symbols upon the face of nature," Ireland wrote, "which we have learned to associate with ideas derived by the use and comparison of our senses, reflections, and desires. . . . The field of our vision then is a half figurative, half ideographic chart from which we read off what interests us." Writing for D. Appleton's popular series on the sciences, Julius Bernstein also paraphrased Helmholtz. Affirming the mechanical nature of the optical apparatus, he declared that "we really have no sensations of objects of the external world themselves, but only of the changes which occur in the sensorium," and that we learn by experience to "transfer our inward sensations to the outer world" so that we "consider external to ourselves all that we see, hear, or feel." Perception of the outside world, then, was "essentially an act of the mind." Frank Spindler went even further in his claims for mind power: "The mind . . . receives only certain excitations through the eye and brain, which are but the raw materials which the mind must work over into the intricate and wonderfully varied forms which we ascribe to the outer world. The mind, then, is a superb artist, a real creator of the picture each one has of the outside world. . . . We do not see the world as it is, but each person sees it according to his own interpretation, and the world each person sees is different to a degree from the world every other person sees." Spindler, reversing rationalist assumptions, figured perception as an act untethered, apparently, by any stable external referent.[12]

For painters, and the ways they were written about, the implications of these new models were complex yet so capacious that they could accommodate artists as dissimilar as Inness and Chase on a continuum that linked specialized, individualized

51. Frederic Edwin Church, *Sunset,* 1856. Oil on canvas, 24 × 36. Munson-Williams-Proctor Institute, Utica, New York.

seeing with modernity and progress, both physical and spiritual. If seeing was an act of mind, then certain mental processes, coupled with fine-tuned optical instruments, could produce a truer and more artistic vision of the world than the obsessively detailed topographies of the older native school could ever do. By 1870, a broad and profound aesthetic shift was in motion, gathering momentum dramatically as the century waned. Increasingly, critics found fault with Frederic E. Church (1826–1900), Albert Bierstadt (1830–1902), and their contemporaries for their mechanical precision and niggling detail. James Jackson Jarves belittled landscapes in the spirit of Church's *Sunset* (fig. 51) as "paint-millinery compositions . . . full of external artifice, dash, and eye-catching sensation, bearing about the same relation to true Art that the spicy novel of the period does to the works of George Eliot." In much the same way, Raymond Westbrook punctured the inflated rhetoric of the Hudson River School, writing disdainfully of Church's "faded topography" and Thomas Cole's "dismal hurricane." Critics found these painters doubly lacking: they expressed neither imagination nor feeling of any kind and produced no art beyond a "grim and painful perception of nature's anatomy, a scientific fervor for externalities." By contrast, the press incessantly extolled Inness, Whistler, and modern tonalists, such as Dwight Tryon, for shunning the gross materialism of the physical world to reveal higher, poetic truths. Registrations of perceptual acts both optical and mental, these were truths of a highly personal variety (see figs. 25, 58, 59, 61, 68). Inness's art

was "entirely his own," wrote W. Lewis Fraser. His landscapes manifested the painter's "transmutation of the nature of common eyesight into the refined, poetic, and prismatic." The *New York Times* noted that while Inness's landscapes might at first appear monotonous, they contained a hidden fire: "the art or character of the painter, which shines on each canvas," regardless of the place portrayed.[13]

If it were only subjective seeing that marked Inness, Whistler, and their peers for distinction, they could easily be categorized as belated romantic visionaries rather than front-rank moderns. The crucial difference was that, in line with new models of perception, critics viewed artistic sight as something embodied in physiological and psychological mechanisms and processes. As Carl Degler notes, the Cartesian gap narrowed dramatically after Darwin, causing those who sought to understand human beings to look increasingly to nature, life processes, and biology for illumination on the sources of human behavior. At about the turn of the century Dr. Luther Gulick observed that psychologists now realized the impossibility of treating mind and body as if really distinct. The two were so closely tied that nothing could affect one without equally affecting the other. Human feelings had once been treated as "mental phenomena," and the phrase "states of mind" was still current. It would be just as accurate, though, to refer to states of body. The mind in that body, however, was no mere receptor of sensory impressions or repository of animal sensations. The new psychology of William James, John Dewey, and G. Stanley Hall posited the mind as actively engaged with the environment rather than passively subject to it. In this model, truth discovered by the engaged mind was never absolute or static but dynamically mutable. No longer an evasion of reality (as it might have been for Durand or Church), subjective seeing *was* reality, albeit of a highly specific, individual sort.[14]

Whistler and Inness neatly fit these new paradigms. In Frank Fowler's view, Inness represented the most progressive tendencies of the time, since he was "perhaps the earliest to apply certain principles of the new school of impressionism to his work, in the sense of painting the effect that nature made upon the mental rather than the physical retina." Artists no longer wanted to be mere seeing-machines, and Inness had moved decisively in a different direction. His sight was spiritual; it was "insight." Whistler's gifts were of the same order. One writer noted that because of the "delicacy of his eyes and the ethereal preferences of his spirit, Whistler dreaded in a picture everything that smacked of corporeal reality. Art to him was food for the spirit . . . his eyes had both natural and spiritual sight." The locating of the spiritual within, rather than beyond, the physical was in agreement with emergent scientific and philosophical revisions of human nature in the wake of Darwin. Appearances to the contrary, neither Whistler nor Inness ever left corporeal reality behind. Rather, their vision emanated from it, since what they produced was a series of reports from the "mental retina," which in turn received its raw material from the painter's optical equipment. It was perfectly acceptable now for Inness, a painter of nature, to exclaim: "The eyes are a pair of liars." Indeed, they were; it was the

mental retina that corrected sense impressions and produced the truth of subjective reality.[15]

At the same time, the new physiological-psychological model of perception could accommodate a painter like Chase, the ultimate in seeing-machines, who merited a prosaic place on the spectrum of artistic expression, no doubt because he specialized in still lifes, sumptuous interiors, and urban or suburban landscapes, in contrast with Inness's rustic, atmospheric scenes suggestive of mystical thoughts. Chase's materialism prompted critics to represent him as a most deeply embodied subject. Singling out Chase's "quick susceptibility of temperament" as his highest quality, Kenyon Cox characterized his art as the "healthy exercise of highly organized and highly trained faculties . . . as natural as the free play of the child, and as pleasurable as the exercise of an athlete." Another critic praised the "fresh, direct, and elemental" qualities of his work, which "base[d] its existence on form and color." In this construction, Chase the embodied subject was the epitome of spontaneous and unencumbered visual response to external stimuli. Although he lacked the spirituality of Inness or Whistler, his mode of seeing was no less personal. In addition, his perceptual capacities aligned him with another track in the paradigm of progress that underlay so much of the cultural and scientific thought of the time. Writing on the evolution of a distinctively American type, H. D. Sedgwick defined the essential quality in this prospering, "brilliantly equipped" new species as the "ability to react quickly and effectively to stimuli of the immediate present." This was what Chase, with his "highly organized" faculties, was able to do so well. Even the absence of imagination in his work conformed to the pattern. Sedgwick viewed this deficiency as the "chief lack" in the new American.[16]

Mental retina or embodied vision: both were attributes of the progressive, modern artist in America. Shaped thus by new models, painters engaged with another mode of incorporation, coming to be incorporated more and more literally in themselves, spirit embedded in body, talent residing in eyes and nerves, soul and emotions coursing through mental pathways.

Paintings with Sense Appeal

The cumulative effect of remodeling vision along new theoretical lines was to give powerful reinforcement to the separation of the purely pictorial from even the most ragtag vestiges of narrative or moral baggage in painting. Whistler had long been campaigning for just such a separation, but the enlistment of scientific support, and the assimilation of new models of perception by century-end critics, were decisive in authorizing a new kind of aesthetic gaze, physiologically operative and divested of moral weight. The product of optical sensation processed by individual sensibility, pictorial art refocused its objectives and launched an appeal to spectators on the same basis. Engagement with a painting was to occur more and more exclusively on the sensory level, the aim and result being to stimulate in the beholder the optical and emotional sensations experienced by the painter. Charles W. Dempsey

stated that "Whistler's conception of art, as expressed by his works, is almost entirely sensuous. . . . His pictures are produced as painting merely . . . [His art] renounces the appeal to the imagination to minister more liberally to the senses." Charles Caffin, who attributed almost measureless influence to Whistler's example, described his art as the "keen analysis of phenomena and the independently personal bias . . . [and] the search for new sensations of the most subtle kind."[17]

Writers and lecturers on aesthetic principles endorsed, promoted, and explained art's newly fashioned role. By the 1890s, resistance to the use of art as education, instruction, or sermon found widespread support. Herbert Spencer's theories contributed authoritative scientific grounding to a discourse of aesthetic pleasure detached from such utilitarian purposes. In *Principles of Psychology,* Spencer outlined the concept of aesthetic feelings as "nothing else than particular modes of excitement of the faculties, sensational, perceptional, and emotional." Since aesthetic feelings did not in any direct way subserve the processes conducive to physical survival, they had no objective purpose at all beyond gratification, which could range from the simple physiological enjoyment of color to the more complex emotional pleasures yielded by the associations of past experience with present sensation. Spencer's aesthetic system linked the physiological and the psychological in the production of pleasure. Once more, reason was cut out of the loop. Spencer even went so far as to denounce as "perverted" the notion that art was useful for intellectual culture.[18]

Lecturing on aesthetics at Columbia College in 1894, Henry R. Marshall drew on Spencer's paradigms, which he augmented and modernized by positing an aesthetic instinct, deep-seated and primal. In Marshall's view, the aesthetic had but one function: "namely, that pleasure-getting and pleasure-giving are of the very essence of aesthetic phenomena, and that we should, therefore, treat the science of aesthetics fundamentally as a branch of the science of pleasure." For Marshall as for Spencer, the function of art in the larger scheme of things was to develop and promote social consolidation, or harmony. In his own lecture series at the Metropolitan Museum of Art in 1892–1893, painter-critic John La Farge expressed disdain for "literary critics" and asserted that art began "where language ceases." Art was an expression of sensation, and expression itself a "correspondence between the sensations of the soul and the sensations of the body." George Santayana's lectures at Harvard (1892–1895) converged at key points with the thoughts of Marshall and La Farge. Santayana maintained that while resemblance could be a "source of satisfaction," something more was required: "Science is a response to the demand for information, and in it we ask for the whole truth and nothing but the truth. Art is the response to the demand for entertainment, for the stimulation of our senses and imagination, and the truth enters into it only as it subserves these ends." Even at more popular levels, similar concepts circulated. Physiognomy "expert" M. O. Stanton observed that "art is intended more for sensuous enjoyment and amusement than for instruction, and all classes of artists are not noted for the high grade of practicality and reason which characterizes scientists, whose province is to investigate natural laws and expound

them, while Art is merely imitative, and aims at exciting the emotions mainly." Science, philosophy, and artistic practice itself tended toward the same point of agreement, and this was the point at which art restructured itself for the modern world, becoming the tool and medium of pleasure as well as a vehicle for self-expression.[19]

Painting as Rest Cure

In a world made complex and bewildering by rapid modernization, pleasure was a needed counterbalance and antidote to severe new pressures. At the same time, it became a vital component in the social and cultural economy of emergent consumer culture. The kind of pleasure that art produced defined itself in direct relation to the new American disease of neurasthenia, or nervous exhaustion. In particular, pure pictorialism—the product of the aestheticizing gaze—secured additional credibility because of its refusal to be literary just when reading and eyestrain were becoming part of a new spectrum of nervous ailments afflicting the middle and upper classes in their traumatic adjustment to modern life.

By the turn of the century, "nervousness" had become America's primary mental disorder. From the 1880s until well into 1900s it was the subject of intense interest and vigorous debate. Although some discounted it, the majority professed belief in what quickly established itself as America's national disease, the Gilded Age equivalent to chronic fatigue syndrome and other disease fashions of the overstressed late twentieth century. Dr. George M. Beard (1839–1883), a leading expert on nervousness, defined neurasthenia as the disease of the "indoor-living and brain-working classes," that is, business and professional men (and their women). One of Beard's followers declared "Anglo-Saxon Americans . . . especially those in the higher walks of life" as the principal victims. Another assigned neurasthenia to "the successful lawyer, the great jurist, the popular actor, the talented preacher, the successful politician, the skilled and publicly appreciated physician, the brilliant writer[,] . . . the artist, the architect, the zealous tradesman, ambitious politician—all and every one in every rank of life who runs for life's prizes without heeding the physiological warning on the wall . . . as if . . . there were for them no physiological reckoning, no pathological hereafter." In other words, the sufferers made up the most elite components—the brains and nerves—of the American social body. The root of the problem was that the ferocious pace of progress had far outstripped the capacity of the nervous system to keep up. Nervous exhaustion, or nervous bankruptcy, was the inevitable result.[20]

In *American Nervousness. Its Causes and Consequences* (1881), Beard blamed the rise of the disease on the devices and conditions of modern civilization itself: the invention of printing, the extension of steam power into manufacturing and transportation, the telegraph, the periodical press, and increased "mental activity" among women, which deformed, perverted, and attenuated their "natural" reproductive and nurturing functions. Beard's catalogue of symptoms included signs ranging from the trivial to the catastrophic: ticklishness, tooth decay, and cold feet among the milder

manifestations, gradually building to generalized weakness, nightmares, depression, and a host of crippling, morbid fears and phobias that resembled the stigmata of degeneration. Beard, however, avoided associating neurasthenia with degeneration by attributing its onset to external forces rather than to heredity and representing it as the price to be paid in the course of evolving an advanced and exquisitely refined species. Nervous exhaustion was the cross that the highly evolved Anglo-Saxon had to bear.[21]

The construction of nervousness had much to do with the definition, defense, and preservation of class and national identity. The most nervous, the most sensitive, were automatically superior individuals, according to Herbert Spencer's widely accepted paradigm, which tracked and rated progress as a movement from low, coarse, and crude to high, fine, and delicate. Physiognomy books consistently invoked this model to secure "scientific" proof of white preeminence. Joseph Simms's *Physiognomy Illustrated* plotted the evolutionary curve on the progressive ascent of bodily parts. The world had passed through the "Abdominal epoch, the Muscular epoch, etc., and now we have reached the mind or intellectual age." The path ahead indicated transformation toward an increasingly ethereal, spiritual state. Debased nations "naturally" harbored the thick of skin, the dark of pigment, and the coarse of hair. Thin, smooth, clear skin and bright eyes, by contrast, reliably signaled fine qualities of mind. As M. O. Stanton put it, thin-skinned people, unlike the lower races, were excessively sensitive because their nerves were closer to the surface: they had "brains all over." In Beard's *American Nervousness,* a work of greater credibility, perhaps, than a physiognomy manual, the same assumptions prevailed, though the contrasts were only implicit. [22]

Nervous sensitivity was at once the disease and the proud badge of individual and cultural evolution. Its flip side was the sizzling American nervous energy responsible for firing up the engine of progress in the first place. For every complaint about nervous exhaustion there was a boast about American nervous force. The figure of the American in a perpetual hurry was nothing new; for decades travelers and others remarked on this trait, observable everywhere—in fast trains (and more train wrecks), gobbled meals, and the obsession with business, with getting ahead. But late in the century, just when Beard and his colleagues were inventing nervous exhaustion, the idea of a special nervous electricity driving the American forward moved into the spotlight. The American was a mercurial man, wrote one reporter, "whose blood and brains are ever on a stir." Correspondingly, the climate was "electric . . . and the electricity has passed into the people, who are simply vessels charged up with a certain number of volts." Some writers viewed these characteristics as signs of a wholly new type, a kind of human dynamo. H. G. Cutler declared that "electricity is the symbol and stamp of the American" and portrayed this "New Man" as pure energy, bent on annihilating time and space, thoughts ever flying ahead of deeds. Should he push himself over the edge of endurance "he will burn

52. William Merritt Chase, *Portrait of General James Watson Webb*, 1880. Oil on canvas, 36 × 31⅛. Shelburne Museum, Shelburne, Vermont. Photograph by Ken Burris.

himself out by the fierceness of his own heat, or he will die of internal convulsions. The American will never rot."[23]

Nervousness, the master trait of the modern American, shone forth everywhere. Mariana Van Rensselaer found it in William Merritt Chase's *Portrait of General James Watson Webb* (fig. 52): "The nervous, restless, new-world spirit is vividly suggestive . . . the repose itself is instinct with activity, is momentary and brimful of life . . . a vivid reproduction of the essence of our time." American artists themselves were richly endowed with the tautly wired nervous system of the up-to-date body. Kenyon Cox envisioned how incongruous a "nervous, energetic American" like Chase must have been in the "smoky, beery Munich of his student years." Critics frequently singled out Whistler's "nervousness" as one of the painter's salient characteristics. The English critic George Moore made much of Whistler's "strained nerves" and his "highly strung, bloodless nature." Julian Hawthorne likened his studio deportment to that of a "duellist fencing actively and cautiously," and his speech to "humming-bird dartings." And Charles Henry Payne summed up Whistler for *Saturday Evening Post* readers as a "nervous nineteenth-century man." Whether Whistler and Chase were really nervous, however, is less important than the fact that such representations reveal their interpreters' preoccupations with questions of nationality, progress, and the "advanced" body and its maintenance.[24]

Body maintenance was a critical problem. The thinner the skins and the more sensitive the nerves of the highly evolved, the greater the suffering inflicted by the modern environment, resulting finally in total collapse of the system, strained beyond

53. *The Results of "High Speed" on Man and Machine.* Illustration from William S. Sadler, *Worry and Nervousness* (1914).

endurance. *Worry and Nervousness,* an early-twentieth-century self-help book, graph-ically illustrated this dire turn of events. In the upper panel of *The Results of "High Speed" on Man and Machine* (fig. 53) an automobile is stranded on a country road, women hovering while their perplexed male companions probe under the hood and chassis. In the bottom panel is a man with engine trouble, prostrate and limp in his bed, surrounded by mechanics of the body, wife and daughter in helpless attendance. The text elaborates: "The gauge on the American human being stands at high pressure all the time. His brain is constantly excited; his machinery is working with a full head of steam. Tissues are burned up rapidly, and the machine often burns up sooner than it should. The man bald and gray in his youth, the man a victim of dyspepsia, of nervousness, of narcotics and stimulants, is a distinct American insti-tution. He is an engine burned out before his time." Such equipment clearly was not built to withstand the inexorable and unnatural forces that ceaselessly impinged upon it.[25]

In this bruising climate of modern stress, no organ suffered greater debilities than the eye. Noting that the eyes were "good barometers of our nervous civiliza-tion," George Beard pointed to the pronounced increase in shortsightedness and other vision deficiencies and the "great skill and great number of our oculists" as "constant proof . . . of the nervousness of our age." Here was one area, at least, where the illiterate "savage," endowed with clear, healthy vision, enjoyed superiority. As one of Beard's successors wrote: "The strain of modern civilization rests heavier on the eyes than upon any of the other bodily organs. . . . No other part of the body has had the emphasis upon its work changed so greatly as has the eye. The savage had to look at near things and far things . . . equally—while modern man reads." The most dire ocular disaster was asthenopia, a chain of symptoms suggested by Walter L. Pyle, who argued that the "slightest disturbance of the visual mechanism," particularly in eyes used excessively at close range, produced "sympathetic irritation not only in the eyes, but in the entire motor, sensory, and psychic systems." In the worst cases, overuse of the eyes led to nervous prostration. Exacerbating the danger was that the "habit of reading" had grown enormously because of the great abun-dance and cheapness of books, magazines, and newspapers, the institution of free circulating libraries, and the perfection of artificial illumination, which made it pos-sible to "do every kind of work at night." Like Beard, Pyle maintained that in the latter half of the nineteenth century the wearing of glasses had become universal.[26]

The laboring eyes, nervousness, and sensitivity of modern brain workers helped map the new role for art. It found a place in the therapeutic pharmacy, reconstituted as a balm for weary eyes and tonic to soothe or stimulate weary minds. The process of art's incorporation into turn-of-the-century therapeutic discourse was almost ef-fortless. Living with their nerves so close to the surface, the moderns were ideally (though often painfully) receptive to the stimulation of their senses. Because of this they were made to be the beneficiaries of art's healing influence. "If they are plunged into a deeper hell," wrote Beard, "they also rise to a brighter heaven; their delicately-

strung nerves make music to the slightest breeze; art, literature, travel, social life, and solitude, pour out on them their select treasures." The "true psychology of happiness" rested entirely in such "gratification of the faculties."[27]

The development of aesthetic therapeutics took place within the establishment of a more encompassing therapeutic ethos that arose in conjunction with the emergence of nervousness itself as a bona fide disease. George Beard, S. Weir Mitchell, and other medical men instituted protocols for the treatment of neurasthenia, including Beard's electric shocks and the oppressive rest cure that Mitchell prescribed for leisure-class women. There was also an array of prescriptions for rest and recreation in a variety of physical and mental forms, all of them designed to repair nerve damage inflicted by an environment of worry, hurry, and keen competition, and to slow down driven businessmen who, as Alfred H. Peters said, had become addicted to motion and excitement. Some sufferers turned to religious and quasi-religious solutions. New Thought (which generated its own magazine subculture) denoted a cluster of tendencies loosely derived from the transcendental doctrine of divine immanence in each individual. Its subsets included Christian Science, faith healing, and Mind Cure—all dedicated to the liberation or realization of that indwelling spirit through the exercise of optimism, mental health control, and aspiration toward higher, more spiritual planes of existence. One writer reported that in New York there were now convents offering "retreats for the spirit weary." On a less spiritual note, there was also a "Don't Worry" Society enlisting "many hundreds of brain workers."[28]

Most of the mainstream popular therapies, however, recommended treatment of the body as an integrated whole, in which mind and muscles alike needed exercise, relaxation, and repose. These ideas circulated widely in a new genre of hygiene book filled with advice for physical and mental recreation tailored to the prosperous, nervous professional, managerial, and commercial classes. *Rest* in the therapeutic idiom purveyed by such manuals seldom connoted the kind of immobilization enforced by Mitchell. Rather, it meant any kind of play: games, sports, country vacations, camping, birdwatching, travel, hobbies, and cultural pursuits: theater, opera, the enjoyment of music, painting, and poetry. The object of such play, stated William Sadler, was to drain away tension, to indulge in activity for the sake of pleasure and self-development, and, in the larger scheme of things, to counter the stress of modern civilization with a harmonizing influence, social as well as individual. "This strenuous age demands not only more playgrounds, more outdoor sports, but also a revived interest in music, art, literature and other recreational and intellectual pursuits."[29]

J. W. Courteny linked mental recreation—which he defined as anything meant to divert the brain's activity into "channels that will afford a pleasant or soothing reaction upon consciousness"—with the "mental and nervous salvation of the brain-worker." Brain rest could be achieved in any number of ways, including such aesthetic pursuits as art appreciation and connoisseurship, and the study or collecting of rare books, old prints, old furniture, bookplates, and stamps. Beneficial results

were sure to follow: Courteny had once seen "complete mental prostration averted . . . by an overwrought young woman turning her attention to the study of different weaves of oriental rugs." Even an inability to rise above the merest amateur status was of no account, since the "gain from the healthful mental gymnastics involved is often incalculable," regardless of expertise. A psychologist recommended early education in art for all, because the love of art could enrich the organism to an incalculable degree: "What [the student] desires is to . . . feel with his very heart the ecstasy of love that art forever offers at nature's shrine. . . . To quote Guyau: 'Art aids in the full development of life and becomes a gymnastic of the nervous system, a gymnasium of the mind. If we do not exercise our complex organs, they will produce in us a sort of nervous plethora, followed by atrophy. Modern civilization, which multiplies capacities of all sorts, and by a true antinomy carries the division of functions to an excess, needs to compensate for this inequality by the varied play of art.' " As play, art need not and should not concern itself with the mundane realities endured by the nervous; it should neither grate upon nor irritate thin skin and sensitive eyes. It should not, above all, require *reading* of any sort. John Van Dyke stressed that most emphatically: "The sad jumbling of figment and pigment, the telling to the eye with a paint brush of half a story, and to the ear in the title or catalogue of the other half, is quite unnecessary. There is something radically wrong with those pictures, other than historical works, which require a titular explanation. For if they be pictorial in the full sense of the word, they will reveal themselves without comment or suggestion." And they revealed themselves exclusively through the eye, which they were designed both to stimulate and soothe.[30]

In this therapeutic framework, painting functioned as a rest cure for the eyes—a vacation from the labors that forced them to exceed their capacities. The overarching concern was to provide ocular exercise as different as possible from the usual: "We are prone to abuse our eyes. . . It would be good for sedentary and professional people to get away for a while each year and never see a book or paper, or any near or fine work, but to roam the fields and gaze at the distant mountains or streams. Nothing rests the eyes like the relaxation that comes when looking far away. Even in the midst of our work we do well to stop every now and then and look off into the distance." Such exercises sought to replicate, if only temporarily, the conditions so favorable to healthful vision in the "savage," immersed in nature and happily innocent of the printed word. Landscapes most effective for eye and brain rest were those in which nothing happened, in which lack of incident and inflection enhanced the pleasurable action of pure color, light, and atmosphere on the senses. A railroad commute through the New Jersey flats could for that reason yield untold therapeutic riches, as described by Herbert W. Fisher, a mental health writer: "Being tired, I forgot the newspaper. Presently, as it were, I began to regain consciousness—became aware of grass, trees, sky, and the broken light of evening. All at once there was in me a strange blend of emotions . . . a kind of confusion of

astonishment and prayer. Think of it—to 'get religion' from just looking out of a car-window across a stale New Jersey flat!" John Van Dyke found such places especially promising as subjects for paintings because of their harmonious and unified tonal qualities, which were soothing rather than "irritatingly conspicuous": "And so in the dull clouds hanging over the Jersey marshes in November, in the volumes of silvery smoke thrown up from factory chimneys and locomotives . . . there is a wealth of color-beauty which only the trained eye can appreciate." Or the inflamed and sensitive eye, presumably, of the nervous brain worker.[31]

Color was the primary therapeutic medium, because it conveyed an immediate sensation to the retina, optic nerve, and perceiving mind of the viewing subject. Earlier, medical professionals had already begun to recognize the therapeutic potential of color. Writing on the "management" of the body, Oliver Wendell Holmes endorsed Florence Nightingale's conviction that "color will free your patient from his painful ideas better than any argument. . . . No one who has watched the sick can doubt the fact that some feel stimulus from looking at scarlet flowers, exhaustion from looking at deep blue." By the turn of the century the notion of color as therapy was on its way to becoming a "scientific" discourse rather than a matter of intuition. Precisely which colors and tones had which effects remained to some extent beyond the power of science to systematize, since individual subjectivity remained unpredictable and idiosyncratic. But the healing potential of color was undisputed. *House Beautiful* readers, for example, learned that physicians who had studied the effects of color on the mind found bare white walls to be as effective as a rest cure.[32]

Fashions in art and interior decoration, as well as current notions about body management, played a part in determining the curative properties of colors, tones, and combinations. At about the turn of the century, the dominant discourse on color tended to privilege complex, muted tones over simpler, brighter hues, since they were held to be supremely soothing. Equally important, the theory of subtle tones interlocked usefully with evolutionary paradigms of high civilization, once again enabling the interests of class distinction and defense to seek shelter behind the bulwark of scientific "truth." Henry Rutgers Marshall slotted color taste into his overall theory of artistic evolution on progress from coarser to finer grades. The stages of civilization, indeed, were as easy to map as a progression from hot pink to the most pearlescent tint of rose. Among barbarians, the "chase, war, and actions determined by the lower passions" constituted the subject matter of their art. These passions also guided barbarian notions of beauty: "The Barbarian rejoices in decorations by use of brilliancy of color and strength of contrast." Children had the same proclivities, but as children grew, and as barbarians became more cultured, their mental life and standards of beauty became more "civilized"—more subtle and delicate. The same systems of differences ranked "popular" art far below elite forms of expression. The popular artist produced "art of the masses" using such "barbaric" tools as "vivid coloring and contrasts, startling forms and combinations, vivacious rhythms,

loudness of sound as in martial music." These properties, however, produced ephemeral pleasure and could quickly lead to pain. The delicate eyes of the moderns, of course, recoiled from the brutal assault of strong color, too violent to be borne. Marshall advised his readers to avoid sharp contrasts and vivid elements of novelty in the home, because their effects were too stimulating and therefore wearying. The *un*popular art of the present was like modern life itself, which at its best had become introspective, thoughtful, and refined. The subtlety of modern high art signaled a civilization, or at least the elite minority within it, nearing perfection.[33]

Artists and art writers subscribed fully to the model of refinement as index of modernity and evolutionary progress—personal, social, and aesthetic. Only the "primitive person," in Birge Harrison's words, demanded facts stated with "sledge-hammer force" and loud colors. The "more highly organized temperament" asked of the painter "only the soul of the subject," seen through a twilight veil. Less highly "evolved" artists showed the same tendencies toward overstatement and glaring hues. This coarse grain of vision was evident even in America's recent artistic past, as illustrated by contrasting the crude color sense of Frederic Church with that of John La Farge, who taste was cultivated and refined to the point of the utmost delicacy. Church (see fig. 51) painted as the "amateur china painter decorates" and saw nature "through a cloud of brick dust, through green gauze window screens, through blue glass pickle jars, through yellow tissue paper; his *ne plus ultra* painting the limit of any pure pigment on his palette; beyond a pure pigment he could not rise." La Farge, on the other hand, painted and even wrote with the "succulent color of under-glaze pottery or Japanese lacquer" (fig. 54). He sought "simile in pigment for rare and precious things, for the lavender of the orchid, the milky blue of the turquoise, the creamy yellow of . . . Satsuma porcelain. . . . The man with such a vision does not paint in a few crude colors, but attunes his chromatic scale to the pitch of the moonstone, the beryl, the opal, and lapis lazuli." The contrasting sunset scenes here exemplify the differences between the two: Church's *Sunset* is a panorama of fiery reds in violent contrast with opaque, inky silhouettes of trees and hills; La Farge's Tahitian twilight is an intricate mingling of soft pink, green, blue, and violet that create an opalescent glow. It was through the medium of such sweet, "delicious" color mosaics, noted William Howe Downes and Frank Torrey Robinson, that La Farge "stirred the sensitive spirits of his kind the world over," thus establishing an ineffable network that identified and united the truly superior of sense and taste.[34]

These were the sensitive spirits whose nerves so craved the stimulating or soothing sensations delivered by the complicated, subtle tints of modern painting. Different color tones and pitches were supposed to have specific therapeutic effects, which were often described in turn-of-the century writings. Downes and Robinson found La Farge's color incandescent and dazzling, complex and refined, "giving new and thrilling sensations to the world of art." In the realm of mental gymnastics, such color provided an aerobic workout for eyes and mind. Muted tones initiated thera-

54. John La Farge, *The Entrance to the Tautira River, Tahiti. Fisherman Spearing a Fish,* c. 1895. Oil on canvas, 53½ × 60. Adolph Caspar Miller Fund, © 1995 Board of Trustees, National Gallery of Art, Washington, D.C.

peutic action on the opposite end of the scale, inducing relaxation rather than raising the pulse rate. John Van Dyke attributed unique and enduring qualities to the modern specialty of color-tone painting: "It pleases by a subdued, yet pervading beauty, as does the blue of a clear sky, the sea-green of the ocean, the sound of an Aeolian harp, or the stir of night-winds through the trees. It neither violently vibrates nor wearies the nerves of the eyes, but is restful, good to live with, cheering at times, and soothing always. Its accompanying features in painting, such as atmosphere, soft broken light, and values, are, moreover, unfailing excellences of art, full of subtle problems of technique and delicate gradations of color which continually unfold new pleasures to us the more we study them." In Van Dyke's chapter on color, the often-repeated words *harmony* and *unity* reinforce the association of refined color with the idea of emotions tranquilized and buffered from the harsh and jangling world of work and haste. Birge Harrison, a landscape painter himself, embroidered on these themes. He assigned precise emotional equivalences to different shades: "The cool

55. Alexander Wyant, *Eventide*, n.d. Oil on canvas, 12⅛ × 20. Collection of Tweed Museum of Art, University of Minnesota, Duluth; Gift of Mrs. E. L. Tuohy.

colors—blue, green, mauve, violet, and all the delicate intervening grays—are . . . restful colors in the emotional sense; and the wisdom of the choice of these tones for the landscape scheme of the world is hardly open to question. . . . It is well known to all expert household decorators that these tones are always the most satisfactory for walls and all large spaces in interior decoration." Gazing at such bland and delicate tones constituted a sort of yoga for the eye rather than mental gymnastics, but both forms of "exercise" offered the kind of tonic thought so necessary for nervous health and salvation.[35]

The rhetoric of therapy permeated the language of critical response to painting, which, as Christian Brinton declared, "appeals no longer to the imagination, to sentiment, or to the intellect. It plays directly on the nerves, the chief possession, or affliction, of these restless modern days." The primary function of painting in this discourse was to minister to the senses, inducing delicious relaxation, as in the art of Alexander Wyant, a late convert to Inness's broad, emotional style. Some of Wyant's dim, broadly brushed twilight scenes (fig. 55), wrote Charles Caffin, breathed "simply the ineffable loveliness of quiet," while others were "astir with persuasion to spiritual reflection. . . . The music of his painting is that of the violin; tenderly vibrating. . . . He did not play on many colors, but reaches a subtlety of tone often as bewildering as it is soothing." *Soothing* was a favorite among therapeutic adjectives. In Kenyon Cox's chromatic lexicon, green was the supremely pleasant and "soothing" color. Charles Caffin praised the effect of John White Alexander's

56. John White Alexander, *The Piano*, 1894. Location unknown. Photograph courtesy of the Witt Photograph Library, Courtauld Institute of Art, London.

moody interior *The Piano* (fig. 56), in which a "faintly diffused light" contributed to the effect of "dreamy, soothing mysteriousness." For Charles de Kay, Albert Ryder's strange little paintings also found a "natural" home in this category. *Curfew Hour* (fig. 57) exemplified Ryder's ability to produce pictures of "extraordinary depth of sentiment, quietness and internal charm," exerting an "effect on the nerves like slow organ music." Brother-in-law of *Century Magazine* editor Richard Watson Gilder and art critic to the *New York Times,* de Kay (1848–1935) epitomized the refined, urban, cultivated, fin de siècle brain worker. He represented the very class that responded most gratefully to the "soothing" colors, tones, and compositions of modern painting.[36]

Dwight Tryon (1849–1925) specialized in the kind of subtle, veiled effects that appealed to the most highly organized temperaments. *Twilight: Early Spring* (fig. 58) typifies his work of the 1890s and after in its level, stratified planes that reinforce the strong surface coherence effected by the only slightly modulated tones binding foreground and background in a greenish haze of delicate, blurry brush marks. Only the slender silhouettes of several trees, rhythmically spaced, punctuate the almost

57. Albert Pinkham Ryder, *Curfew Hour,* n.d. Oil on wood, 7½ × 10. Metropolitan Museum of Art; Rogers Fund; 1909 (09.58.1).

overwhelming horizontality of the design. Nothing is in focus, nothing clearly defined. Tryon's muted and surely "soothing" green seas of mist provided just the exercise recommended by oculists and mental hygienists for the relief of overstressed eyes and nerves: aimless, distant, unfocused looking. The essence of Tryon's modernity and therapeutic powers lay in this refusal of description, which enhanced the paintings' salutary effects on battered senses. Boston critics Downes and Robinson stated that "Tryon helps us by lifting [us] . . . out of the everyday scrambling vulgarity of the street. You . . . forget business and work looking at his pictures. They lure you away from worldly interests and cares." At face value, this was not so far removed from what the American Art-Union had been saying about the function of landscape art in the 1840s: "To the inhabitants of cities . . . a painted landscape is almost essential to preserve a healthy tone to the spirits, lest they forget in the wilderness of bricks which surrounds them the pure delights of nature and a country life. Those who cannot afford a seat in the country to refresh their wearied spirits may at least have a country seat in their parlors; a bit of landscape with a green tree, a distant hill, or low-roofed cottage—some of these simple objects, which all men find so refreshing to their spirits after being long pent up in dismal streets and in the haunts of business." However, whereas the Art-Union's statement em-

58. Dwight Tryon, *Twilight: Early Spring*, 1893. Oil on canvas, 22 × 33¼. Courtesy of the Freer Gallery of Art, Smithsonian Institution, Washington, D.C.

phasized the intellectual assimilation of information in the form of pictorial anecdotes of country peace to quicken the beholder's imagination, Tryon's paintings worked on the senses through color and other formal qualities, exerting (theoretically, at least) a physio-psychological effect. The erstwhile "literary" voice of pictorial art had been filtered out, leaving a therapeutic distillate of pure tone and design: "Nothing in [Tryon's] compositions jars upon us. Of how few other American painters may this be said! What he sees in nature is a series of delicate planes melting into one another; there are no rumbling waterfalls, no deep caverns, craggy prominences, or steep mountain tops. . . . His work is delicate and fine-spun. We feel certain that at dawn spiders swiftly glide over his foregrounds, spinning innumerable webs in the dewy grasses and accentuating the gauzy effect of his veiled landscapes." This passage demonstrates the attraction of that seamless, tranquilizing harmony in Tryon's paintings, as if his mists were clouds of medicinal vapors. Tryon's gauziness fulfilled and indeed exceeded Herbert Spencer's prescriptions for pleasure in his system of physiological aesthetics, which held flowing outlines more delightful than jagged ones because a more harmonious action of the ocular muscles governed their perception, involving no strain or "jar" from abrupt changes of direction. How much less a strain, then, was no outline at all but, rather, an eye-bath or balm of soothing

green tone in which the ocular muscles could simply immerse themselves and transmit messages of sensuous relaxation to the mind.[37]

Tryon's paintings did more than soothe the eyes and nerves. Their action on physical sensation permitted exquisite psychological release. Description counted for almost nothing in Tryon's art because his concern rested with the projection of mood. "It is his belief," stated Royal Cortissoz, "that true art never enforces itself on the beholder, but drifts as quietly as it does irresistibly into the mind. The theory would be inferred from his work, of which the principal characteristics are repose, suavity, moderation, and the gentle key of color synthesized to a tone as pure as it is transparent." Uplifting the senses through the delicate spirituality of his art, Tryon proved the "great cardinal fact that, given a perfect balance between spiritual and technical qualities in a man's art, it is the higher of the two which goes swiftly to our consciousness and there refreshes and delights." Veiled and dim, tonalist landscapes seemed enticingly mysterious, and this too played a part in their therapeutic application. Sadakichi Hartmann wrote that the old masters would have laughed at painters such as Tryon, who had "actually limited himself to two phases of nature— to dawns and twilights." But limitation turned them into experts, and modern artists had become "superior to the old masters in the depiction of atmospheric effects and subtler emotions. . . . They are aware that mystery dredges deeper than any other emotional suggestion. . . . It is the endeavor to perpetuate particular moments of human happiness, vague currents of the 'unsounded sea' which at rare intervals lash our feelings into exquisite activity. And to realize this is indisputably one of the most deserving and ambitious tasks a modern artist can set himself." Confined to the narrow compass enforced by the increasing complexity and fragmentation of advanced civilization, the modern painter had become an expert in the ultra-delicate stimulation of the most refined and sensitive feelings—stimulation that in turn promoted the nervous salvation so necessary for modern health.[38]

Henry van Dyke's "White Blot. The Story of a Picture" may be the most complete exposition of a therapeutic model for modern painting. As a work of fiction it can hardly be taken as proof that anyone outside the story's space had identical notions or that it "reflected" current conditions. But by appearing when and where it did, van Dyke's story testifies to the active circulation of therapeutic metaphors in mainstream discourses about modern painting. "The White Blot" tells the tale of a picture haunted by the ghost of past emotions. The narrator, a New York writer, collects charming landscape scenes that transform his "narrow upright slice of living space in one of the brown-stone strata on the eastward slope of Manhattan Island" into an "open and agreeable site." "Through them," he says, "I go out and in upon my adventures." When the story begins, the narrator encounters his enthusiastic friend Pierrepont, who cries: " 'Why, what is the matter with you? . . . You look outdone, tired all the way through to your backbone. . . . You will have *la grippe* in your mind if you don't look out. But I know what you need. Come with me, and I will do you good!' " The narrator protests that he needs no physical remedies, no

·" 'wonderful Mexican cheroots warranted to eradicate the tobacco habit; nor a draught of your South American melon sherbet that cures all pains.' " Pierrepont sets him straight: " 'But you mistake me. . . . I am not thinking of any creature comforts for you. I am prescribing for your mind. There is a picture that I want you to see; not a colored photograph, nor an exercise in difficult drawing, but a real picture that will rest the eyes of your heart. Come away with me to Morgenstern's gallery, and be healed.' "

Pierrepont describes the work as the most modern kind of nonliterary, moody, tonalist painting: " 'It is an evening scene, a revelation of the beauty of sadness, an idea expressed in colors—or rather, a real impression of Nature that awakens an ideal feeling in the heart. It does not define everything and say nothing, like so many paintings. . . . It suggests thoughts which cannot be put into words.' " It is the work of a young American, one of the " 'real painters' " who " 'don't paint everything that they see, but . . . see everything they paint.' " The painting itself fully justifies Pierrepont's effusions: "It showed the mouth of a little river: a secluded lagoon . . . the unsailed harbor was quite still in the pause of evening, and the smooth undulations were caressed by a hundred opalescent hues. . . . [A] converging lines of trees stood dark against the sky; a cleft in the woods marked the course of the stream, above which the reluctant splendors of an autumnal day were dying in ashes of roses, while three tiny clouds . . . burned red with the last glimpse of the departed sun." There are further sights: an old deserted house with tall white pillars; subdued, sad yellows staining the foliage. The picture breathes "an air of loneliness and pensive sorrow . . . a sigh of longing and regret." The narrator buys it for an absurdly low figure and takes it home. The story then takes a rather abrupt turn to the supernatural, leaving unresolved the question of whether the painting did "rest the eyes" of its owner's heart or prevent him from contracting *la grippe* in his mind. The tale speaks of mind and heart (like Inness's mental retina) as fully embodied, interconnected with sensory receptors and neural pathways that transform sense impressions into feelings, that catalyze the change from eye balm to soothing ointment for nerves and brain. Tryon's work, along with that of such painters as Bruce Crane, Leonard Ochtman, Charles Warren Eaton, Birge Harrison, and the Dabo brothers, was the "real life" counterpart to the painting van Dyke invented for his story, a twilight suffused with subtle tones and breathing a kind of poetic melancholy that seems to have struck just the right vibrations for the "rest-cure" effect to exert its powers.[39]

Another class of painters provided a different kind of tonic: high-powered infusions of healthful, vitalizing energy. George Inness occupied his own category there, apart from the tonalist painters, in spite of his impact on them. Whereas Tryon's paintings functioned as catalysts to calm and pensive states of mind, Inness's landscapes were energizing. Blurry though they may be, the late landscapes incorporate strong tones and vivid color accents, which lend them an earthier, less ethereal character, and his compositions, such as *Sunset in the Old Orchard, Montclair* (fig.

59. George Inness, *Sunset in the Old Orchard, Montclair*, 1894. Oil on canvas, 30 × 45. Butler Institute of American Art, Youngstown, Ohio; Gift of Dr. John J. McDonough.

59), are less synthetic than Tryon's. The smoldering patch of light in the rear, toward which the tree in the center inclines as if in yearning, the gilded accents, and the emerald sweep of foreground grass create a rich sense of space and air. The sense of formal strength and vigorous feeling in Inness invited different readings. Montgomery Schuyler wrote that Inness's tones were living, glowing, vibrating, and harmonious, so much so that "we could almost think that the very life-currents of the man had commingled themselves with the tints he made use of. There is nothing sluggish here, and as though his pulses bounded in the excitement of their combination, these colors appear to have gained a vitality that mere pigments alone do not possess." William Howe Downes registered similar reactions. None could equal Inness for the impression he gave of "abounding and intense vitality." His paintings were "full of rich pulsing life" because the artist had infused his own "exuberant spirit into the inanimate canvas," making it "breathe the breath of nature." Life-currents, bounding pulse, breath: like Beard's therapeutic electric shock treatments, they passed from the inexhaustibly vital body and mind of the artist into the canvas and out again, to charge the physical and mental batteries of the typical brain worker. William Merritt Chase's cheerful celebrations of Central Park also had a place on this shelf of the aesthetic pharmacy. Although less intense and manifestly less spiritual than Inness, Chase had a reputation for vigor and health, and his paintings encour-

60. Winslow Homer, *Weatherbeaten*, 1894. Oil on canvas, 28½ × 48⅜. Portland Museum of Art, Portland, Maine; Bequest of Charles Shipman Payson, 1988.55.1.

aged exercise of a simple but wholesome kind. As Charles de Kay put it, "We may not necessarily see things just as the painter does, but the stimulus he gives us to examine in order to agree or disagree is an intellectual act which is a tonic for minds weary of sorrow."[40]

Only Winslow Homer could equal Inness in titanic vitality and endurance. His subjects, so severe and elemental, naturally encouraged such notions. Downes's feelings before *Weatherbeaten* (fig. 60) went beyond the mere appreciation of a grand, exciting scene. His response was profoundly physical: "One cannot stand before a picture like 'Storm-Beaten' without being mentally stimulated and exalted: such is the potency of a personal imagination working with natural fact for its sole material. It is, to use Mr. Berenson's happy phrase, 'life-enhancing.' Reality is made more real; we are more acutely alive when brought into its presence. Our horizons expand. . . . We are uplifted; we feel the glory of life; we take deeper breaths; we are newly heartened for our work in this best of all worlds." Here too the painting, embodiment of its author's life force, sent out a vitalizing current that worked on body and soul equally. Downes's comments on Inness and Homer betray a preoccupation with their life-giving and life-enhancing powers, and this suggests that like so many of his class he may have had, or thought he had, symptoms of neurasthenia, which helped to frame and direct his "therapeutic" readings of works by certain powerful painters. However individual, though, Downes was also socially constructed: molded by dom-

inant discourses that shaped and governed many others as well. His readings of Homer and Inness were simultaneously subjective, inflected by his own personal history and feelings, and representative of the class to which he belonged. What he wrote became part of an evolving discourse concerning class, gender, nervousness, therapeutics, and art. His criticism helped reinforce tendencies to look to art as he did: as antidote, restorative, and tonic to rest or invigorate overwrought modern nerves.[41]

The therapeutic role was one out of an array of modern social and cultural functions that art could adopt. Several New York galleries began to profit from increasingly brisk sales of modern American landscape painting at about the turn of the century. William Macbeth, one of the first New York dealers to promote American painting almost exclusively, supplied an ever-increasing demand for works by Inness, Wyant, and Homer Martin. In 1906 he was so short of paintings by Martin and Wyant that he advised would-be purchasers to sign his waiting list. After the turn of the century Macbeth did well with paintings by Wyatt Eaton, Winslow Homer, and John La Farge, among others. At the same time, as Linda Skalet reports, Daniel Cottier was doing an active business in the paintings of Ryder, Charles H. Davis, Wyant, Martin, Eaton, and Horatio Walker, all of them poetic nature seers. William Clausen also dealt successfully in works by Martin, Wyant, Inness, Eaton, Henry Ward Ranger, and Ralph Blakelock. Many of the same "therapeutic" landscape painters dominate Skalet's lists of who sold what during this period. The sale of Thomas B. Clarke's collection in 1899 helped stimulate the market for American paintings. Inness and Homer, in particular, became good investments after that time. Still, the marked preference for modern landscape paintings, restful or revitalizing, suggests that their therapeutic mystique was attractive beyond such factors as investment potential, status display, and fashion.[42]

Collectors of modern American painting were largely of the business or leisure class, often not fabulously wealthy but at least comfortably situated. They were active in gentlemen's clubs and often involved in a variety of directorships and philanthropic activities. Skalet profiles John Harsen Rhoades (1838–1906), who had made a fortune in the dry goods business and was able to retire from "mercantile pursuits" at the young age of thirty-nine, devoting himself from then on to serving as consultant to banks, businesses, and charities. He was president of Greenwich Savings Bank, president of the New York Eye and Ear Infirmary, and director of the Candelaria Mining Company, among many other such positions. He was member of no fewer than five clubs, including the Century and the Lotos. Like a number of collectors in this generation, Rhoades enthusiastically promoted contemporary American art. At the Lotos Club he frequently displayed works from his collection of about one hundred American paintings, most of them by Inness, Martin, Tryon, Charles H. Davis, and other producers of poetic landscapes. Did he buy such works because they represented an up-to-date yet not radical assimilation of the styles of voguish French Barbizon masters whose paintings occupied higher price brackets? Did the

61. Dwight William Tryon, *May*, 1898–1899. Oil on canvas, 40½ × 48¾. Collection of Mr. and Mrs. Willard G. Clark.

calm and mental repose offered by their moody visions appeal to this busy, wealthy man? Did he shut himself up with them, sinking his eyes into their soothing atmosphere, or recharging his mental batteries after long hours of committee meetings, reports, and decisions? It is not easy to pick apart an individual's motivations. Most likely they were a soup compounded of impulses and desires in a complicated mix. Even so, Rhoades's profile is suggestive for mapping the links between the brain worker and the taste for moody, modern landscape painting.[43]

Willa Cather's reviews shed a small amount of light on the fortunes of such paintings in the broader public domain. While working as a jack-of-all-trades critic in Pittsburgh she reported on exhibitions at the Carnegie Institute Art Galleries. Adopting the voice of the average viewer as she wandered through the rooms, Cather paid attention to what pleased everyday spectators. At one of the shows she reported that Tryon's *May* (fig. 61) was popular with the "people": "This is a windy May, of blues and violets and light greens and yellows, with the cleanest of color and treated with great elasticity and delightful enthusiasm and freshness." Her comments indicate that "average viewers" may have responded to Tryon's landscapes somewhat differently than elites. "I believe it is Tryon's custom," wrote Cather, "to go off somewhere in the woods in the spring, and build himself a pine shack, and work up and finish his pictures on the spot. Long after they leave his hands they keep the atmosphere in which they were done." Though a nature lover and an ardent sportsman, Tryon was the very opposite of the spontaneous plein air painter. He created his carefully wrought landscapes in the studio, building complex layers of tones on his austere compositional scaffolding. Cather's misinformation indicates that for her, and for the people who found *May* attractive, Tryon was a producer of enjoyable, undemanding views in appealing colors. Her brief remarks fail to reveal anything resembling the responses Royal Cortissoz described or prescribed, which

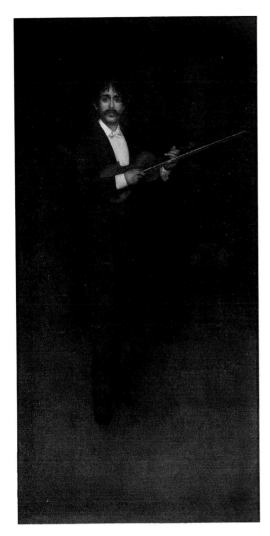

62. James McNeill Whistler,
*Arrangement in Black: Portrait of
Señor Pablo de Sarasate,* 1884.
Oil on canvas, 97¹³/₁₆ × 55⅜. Museum
of Art, Carnegie Institute, Pittsburgh;
Museum Purchase, 96.2

involved the exaltation of the senses to a higher plane. Response too can be a matter of education, of indoctrination, of class values. If the people who admired *May* in the Carnegie Galleries were an educational level or two below the cultivated middle-class elites who read *Harper's,* then they may not have been looking at, or for, the same thing the elites primed themselves to experience. Cather's observations about Whistler pointed in the same direction. She argued that it was not at all true that Whistler's art was above the heads of the common citizen. For proof, she pointed to Whistler's *Arrangement in Black: Portrait of Señor Pablo de Sarasate* (fig. 62), "one of the most popular pictures in the gallery." It was evident that "everyone" appreciated the art by which the painter had made the portrait of the famous violinist a lively and compelling presence—as a "dark, lithe man" with "character in the nervous hands and bold black eyes and the full red lip." Of course, she said, "I do

not mean to say that everybody is ready to accept some of his more extreme pictures, which Ruskin described as a pot of paint slung at the canvas. Certainly the lack of detail in some of his night scenes is calculated to puzzle the unimaginative." The variation on Ruskin's actual words is telling. Ruskin's famous jab had been at Whistler's "Cockney impudence" of asking two hundred guineas for "flinging a pot of paint in the public's face." For many of those who made up the population of "everybody," Whistler's nocturnes in Cather's construction were nothing more than unintelligible smears and streaks splashed haphazardly upon a surface. Everybody had not been acculturated, through exposure to critical discourses and agendas, to savor the nocturnes as did Charles Lang Freer, Whistler's principal American collector, or Freer's close friend and adviser Ernest Fenollosa, who pursued the delectable sensuous and spiritual pleasures to be extracted from the infinite subtleties and refinements of Whistler's mysterious creations. Contemporary criticism, along with the discourses concerning evolution, neurasthenia, and the rest, had helped to bring about a class-differentiated hierarchy of aesthetic response. The most exquisite and therapeutic delights were reserved for those most genetically advanced, with the thinnest skins and the finest nerves.[44]

The gradual change in aesthetic emphasis from moral fiber to delectable surface occurred in conjunction with the broader and profoundly transformative cultural shift that revised the production-oriented values of the nineteenth century to suit a consumption-oriented, corporate society. The therapeutic role of art in this system was in many ways an extension of the model of management, central to bureaucratic structures, into the realm of the body and culture: stress-reducing activity and experience was a mode of management that kept the individual stable and productive. As expert seers who employed their refined faculties to produce pleasure, artists became part of an ever-expanding leisure industry, which gave them license to convert nature from bedrock of moral truth to visual playground.

The actual therapeutic "formulas" of course were mutable, but the fundamental therapeutic idea was not. Throughout elite western culture in the twentieth century the "primitive," among other forms, became a major therapeutic and revitalizing agent, dramatically elevated from its once lowly rank on the cultural scale. The rise and endurance of occupations that might be grouped under the heading of "Sunday painting" also testifies to the persistence of ideas centering on the importance of self-expression and the production (as well as appreciation) of art as exalted hobby. Above all, the notion of the painter as one privileged to see, and to express deep subjectivity, has become very deeply entrenched in twentieth-century culture. There have been other trends as well, certainly, but the primacy of seeing and self-expression has remained one of the most dominant. The turning point for the exaltation of this aesthetic in America can be located in the later nineteenth century, when paintings came to be things to seen and not read.

PART THREE

Gender on the Market

5 OUTSELLING THE FEMININE

In her study of women's cultural activities from 1830 to 1930, Kathleen D. McCarthy contends that artists of the Gilded Age seemed "almost anxious" to conform to the public's "preconceived views" about them and that the comportment of such painters as Chase, La Farge, and Whistler "helped to feed public mistrust of what were viewed as the essentially feminine and passive leanings of the artistic community." Yet at the same time, "men managed to retain their professional supremacy in the field" when vast numbers of women were beginning to enter the art world in competition with men. Male artists did this by keeping their hold "over the systems of rewards that institutionally winnowed the nation's leading artists from their less fortunate peers." How could the same artists be feminized, passive, and marginalized on one hand, and, on the other, act as dominant, effective fighters and strategists? The contradiction here suggests that relations between the public realm and the domestic and cultural sphere did not necessarily fall into a binary system structured along antithetical masculine and feminine lines. Despite that, this pattern of binaries provided a deep foundation for the social construction of gender roles in the nineteenth century and has figured prominently since in the study of the period's art, culture, and ideology. These binaries imposed a particularly heavy load of metaphorical baggage on artists, requiring the most delicate management to achieve an effective balance.[1]

Jackson Lears, among others, has identified the nineteenth-century interior as the woman's sphere, a space that "embodied the iconography of female experience" and fostered the cult of "exoticism and theatrical display" as a "stage set for private fantasy." Histories of the nineteenth-century home have been attentive to the exaltation of the (feminine) domestic interior as an increasingly embattled island of culture, serenity, and taste incorporated in the commodities purchased, arranged, and displayed by feminine hands. Because "culture" through such practices bore powerful associations with femininity, goes the argument, men who "nurtured 'feminine' aspirations" toward careers in art or literature experienced severe anxiety about breaching the social norms constituting gender roles and about art's marginal position in a modernizing culture obsessed with business.[2]

In such constructions, the antipathy between art, culture, and the feminine on one hand and business, commerce, and masculinity on the other is clearly drawn. Art was something that could only be tainted by commerce, its sole hope of redemption being to secure a position remote from the marketplace, which automatically distanced it from the world of nominally masculine affairs. As I argued in Chapter 3, ostensible concern over effeminacy also masked fear of homosexual "degeneration" at the century's end. To what further extent, though, were the pressures of feminine competition, or feminized culture, genuinely threatening? By keeping institutional control firmly in hand, the male art world was scarcely insecure about the supremacy of its gender. For all their increasing numbers, women artists could easily be kept in check. Far more disturbing was the perception that male artists played an expendable role on the larger social, political, and economic stage, where business was the supreme engine of modern America's ever-increasing wealth and power. On that tremendous stage, art was little more than a garnish for commercial success. As Chicago novelist Henry Blake Fuller put it, "Art, with us, meets no real international requirements. The best of us don't need it; the second best don't want it; the third best won't stand it. . . . Art shall [only] adorn the rich man's triumph and shall prettily furnish forth our parlor mantel pieces. Having taken life unfurnished, we call upon Art to act as an upholsterer—that is all."[3]

The artist in Frank Norris's *The Pit, A Story of Chicago* (1903) plays the "upholsterer" role in feeble contrast with speculator Curtis Jadwin, the "Great Bull" of the Chicago Board of Trade. Sheldon Corthell, who works in stained glass, is slight and dark, with a romantic face, a silky beard, and a moustache "brushed away from his lips, like a Frenchman." The business district is an "unexplored country" to him, and he keeps himself "far from the fighting, his hands unstained, his feet unsullied." Laura Dearborn, vacillating between rivals, ultimately chooses Jadwin, a "heavy-built man" who "would have made two of Corthell." His hands are "large and broad, the hands of a man of affairs, who knew how to grip, and, above all, how to hang on . . . and envelope a Purpose with tremendous strength." It is Jadwin's manly toughness that fascinates and attracts Laura, much to her own surprise: "To relax the mind, to indulge the senses, to live in an environment of pervading

beauty was delightful. But the men to whom the woman in her turned were not those of the studio. Terrible as the Battle of the Street was, it was yet battle. Only the strong and the brave might dare it, and the figure that held her imagination . . . was not the artist . . . but the fighter, unknown and unknowable to women as he was; hard, rigorous, panoplied in the harness of the warrior, who strove among the trumpets, and who, in the brunt of conflict, conspicuous, formidable, set the battle in a rage around him, and exulted like a champion in the shoutings of the captains." Norris could hardly have been more obvious in denoting the artist's impotence, thinly symbolized in his softness, his unfitness for the "real" struggles of life, his contiguity and sympathy with the feminine. In this construction, the artist is without power, or at least the power that counts: he can fascinate women but is incapable of battling among men. Because of this perceived powerlessness and its attendant marginality, he is aligned with the feminine. It is not so much being an artist as the absence of power that consigns him to his privileged, comfortable, but negligible place.[4]

Against the world of affairs, the artist could not even protect and defend his own special identity: the triumphant businessman could appropriate that too. When the new Wanamaker Building opened in New York in 1906, publisher S. S. McClure declared: "All first-class institutions are founded by great artists. There is no other way to found a great institution than to have inside of it a great man who is a great artist. . . . If Mr. Wanamaker had not been a great artist he could never have founded this unique thing. This is not simply a department store—it is the expression of a great mind in a department store . . . a wonderful expression of a great human soul." Wanamaker, indeed, was doing exactly what the foremost artists of the day were celebrated for: expressing his deepest subjectivity in a compellingly individual voice. Being likened to an artist in no way diminished, softened, or feminized Wanamaker. Rather, the figure of artist took on masculine vigor by association with a powerful businessman—and by detachment from the "feminine" atmosphere that drifted through Corthell's habitat at the edges of the great affairs of life.[5]

Most artists, of course, were no less "masculine" than businessmen; however, they were in a clearly dependent position. Unable to *make* money the way Jadwin and his real-life counterparts made it—through bold and risky investment—artists were at the mercy of those who had the means to consume what they painted, carved, or molded. This seemed to situate them in about the same place occupied by wives, daughters, and others dependent on patriarchal bounty. But unlike the majority of middle-class women, who shuttled between the domestic interior and the department store, artists were free to move between the studio environment and the masculine world of the clubs and other venues, where connections could be cultivated, deals made, bargains struck. The problem for artists and their supporters was a matter of image adjustment, with the objective of at least appearing to have power of some kind, if only that which came from being or seeming to be in control.

Colonizing the Interior

One strategy in this adjustment process was to undertake relentless disparagement of the feminine in order to "sell" a dynamic construction of artistic maleness. Its deployment coincided with the point at which the opulent "show" studio had become a popular fashion, identified with a generation of artists once radical but now well established. In the 1880s and 1890s most writers represented the occupants of such studios as unproblematically male in spite of the exoticism and sensuousness of their environments. Elizabeth Bisland, for example, concluded her inventory of Chase's studio with a thumbnail sketch of the painter: "The personality of the artist is an interesting one. Short and squarely built, with a kindly, self-reliant face, a strongly cast, intellectual head, and the manner of the successful, competent man— a competency that appears to be the key-note of his work and character." Frank Norris (1870–1902), however, set up a rhetorical opposition between this kind of studio—cluttered, opulent, seductive, feminine—and the aggressive, undomesticated virility of the new fiction he was bent on producing and promoting. In an increasingly commercialized cultural realm where innovation and novelty were becoming prerequisites for success, Norris belittled the feminine in order to "sell" the masculinized aesthetic as something new, cleansing, and revolutionary:

> [W]ould-be fiction writers . . . would make the art of the novelist . . . a
> thing exclusive, to be guarded from contact with the vulgar, humdrum,
> bread-and-butter business of life . . . considering it . . . a sort of velvet-
> jacket affair, a studio hocus-pocus, a thing loved of women and aesthetes.
>
> What a folly! Of all the arts it is the most virile; of all the arts it will
> not, will not, will not flourish indoors. . . . The muse of American fiction
> is no chaste, delicate, super-refined mademoiselle of delicate roses and "el-
> egant" attitudinizings, but a robust, red-armed *bonne femme,* who rough-
> shoulders her way among men and among affairs.

Drawing on the discourse of aesthetic degeneracy to figure the decorated studio as haunt of the anemic, the passive, the powerless, and the out-of-date, Norris constructed an advantageous position for himself far from any such liabilities: outside, tough, and masculine.[6]

Critic Benjamin de Casseres was quick to detect the motivation behind such maneuvers in noting that proponents of the manly tale-teller Rudyard Kipling had set up the "decadent" poet Arthur Symons as a special target for abuse: "It is the fashion of the 'viriles'—to coin a word—to . . . class that poet of exquisite sensibilities as a 'decadent.' What is 'decadent' and what is 'virile' in literature, art, and life depend upon the point of view merely. 'Virility,' pushed to its logical conclusion, will beget a decadence of spirit, and in this sense there is a kernel of decay in all virility." The American poet Sidney Lanier adopted a similar line of criticism against Walt Whitman, who represented a kind of reverse dandyism: "The simpering beau who is the product of the

tailor's art is certainly absurd enough; but what difference is there between that and the other dandy-upside-down who from equal motives of affectation throws away coat and vest, dons a slouch hat, opens his shirt so as to expose his breast, and industriously circulates his portrait, thus taken, in his own books? And this dandyism—the dandyism of the roustabout—I find in Whitman's poetry from beginning to end. . . . Everywhere it is screwing up its eye, not into an eyeglass like a conventional dandy, but into an expression supposed to be fearsomely rough and barbaric and frightful to the terror-stricken reader." Virility was as much a fad and an image, geared for achieving notoriety in the cultural marketplace, as it was a defensive position adopted to resist the "rising tide of femininity" that threatened to engulf modern life and usher in the "day of the Subjection of Man," as Charles Dudley Warner put it. This is not to say that elite and middle-class men experienced no anxiety about the ambiguities of gender identity that clung to aesthetic and cultural discourse. But in the art world, where males continued to exercise solid control over institutions, disparagement of the feminine was less a desperate rear-guard action by beleaguered male artists than it was a step in a complicated series of moves attempting to produce the image of the modern artist as a man in control of art institutions, of culture, and of the artistic interior.[7]

In the anticommercial discourse the decorated studio figured as the false front of the false artist, the poseur, the wizard with props designed to fascinate and dupe the gullible. Such a studio could also be viewed, however, as a practical and businesslike solution to the problem of creating the environment best calculated to enhance trade. Whether it was feminine or feminized depended on context, on De Casseres's "point of view." Compare the studio (fig. 63) of Eliot Gregory (1854–1915), a successful if almost entirely forgotten New York portrait painter in the late nineteenth century, with that of Mabel R. Welch (fig. 64), who in 1896, the year both photographs appeared in *Godey's,* was launching her career after four years at the Art Students' League. While Gregory's studio appears to have been larger and more expensively fitted out, both interiors speak the studio language of the Orient, with their low divans, carelessly tossed pillows, Persian rugs, drapery swags, and exotic knickknacks. Either could have passed for Sheldon Corthell's studio, realm of orientalized relaxation and self-indulgence. W. A. Cooper described Gregory as a "cosmopolitan man of the world" born into "New York's most exclusive circle" and trained in Paris under Carolus-Duran and Cabanel. A specialist in society portraiture, he had "caught something of high-bred distinction from long association with ladies of his own and other nations." He had collected most of his exotic bibelots himself on several trips to the Orient. A photograph (fig. 65) shows the artist outfitted in what can only be described as a nonbusiness suit: a sack coat with wide, satiny, dotted lapels and flourishes of braid at the cuffs, and pants with a band of the same dotted stuff running the length of the outseam. He wears the floppy bow tie associated (often derisively) with artists (fig. 66), and a handlebar moustache decorates his face. Another reporter who visited the studio, which was near Madison

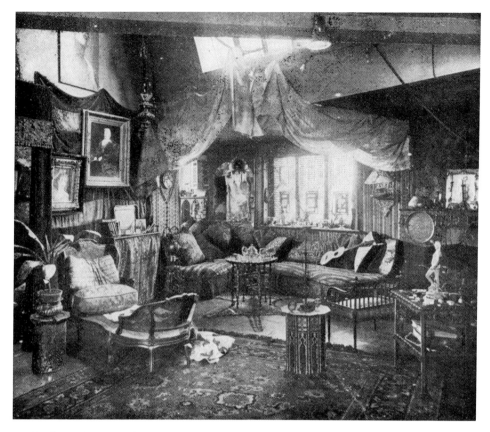

63. *Mr. Gregory's Studio.* Photograph from W. A. Cooper, "Artists in Their Studios, X—Eliot Gregory," *Godey's Magazine* 132 (January–June 1896).

Square, thought it delightful, and quite incongruous: "Although a building devoted to business offices and shops, Mr. Gregory's rooms are as unlike business as possible. They suggest literature and art only." Gregory, noted this writer, contributed a column signed "Idler" to the *Evening Post.* The identity of the author was a mystery for a long time: "I thought it must be a woman; there was a feminine touch here and there. Then I . . . concluded that it was someone writing with the knowledge of a man past middle age and the intuitions of a woman." All this might be taken as compelling evidence that young masculinist radicals like Norris did not invent their targets. Yet from an alternative angle, Gregory appears in a rather different light. As the designer of a sybaritic studio, he furthered his business interests, which were much akin to those of the department store: to attract and beguile ladies, his chief customers. From this point of view, his self-conscious costume *was* a business suit after all, and the whole point of the studio—geared to promote Gregory's success— was precisely to look "as unlike business as possible." Mabel Welch's studio figures as a beginning professional's attempt to replicate in her humbler quarters the suc-

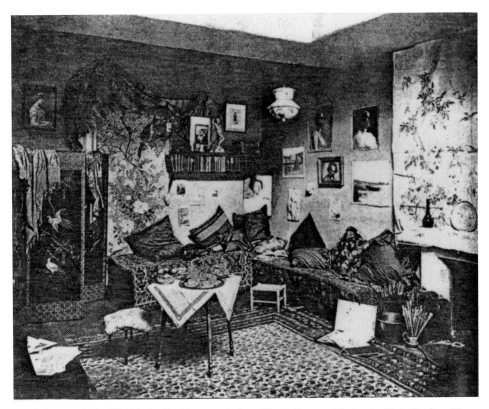

64. *A Corner of Miss Welch's Studio.* Photograph from W. A. Cooper, "Artists in Their Studios, IX—Mary E. Tillinghast, Anna Meigs Case, Mabel R. Welch," *Godey's Magazine* 132 (January–June 1896).

cessful male painter's working environment, rather than the expression of feminine artistic identity or feminized art culture.[8]

William Leach has shown that orientalism entered into all realms of cultural activity around the turn of the century, its spread propelled by the growth of "America's new consumer industries, with their high distributive and marketing demands. American business purveyed the orientalist message, and, seeing an opportunity, began to praise the very things—luxury, impulse, desire, primitivism, immediate self-gratification—that only decades before they had been disparaging as dangerous to economic productivity." While merchants continued to criticize these new values they "spoke now with two voices, each at odds with the other," emphasizing repression and rationality for business but indulgence and impulse—qualities considered nonwestern—for selling and consumption.[9] Driven by such associations, orientalism functioned as a sales strategy based on seduction. Much of the allure was concocted by advertisers and window dressers to entice women, who as shoppers far outnumbered men. A department-store display of a fashionable "cosy corner" (fig. 67) illustrates the commercial exploitation of suggestive Oriental ambience to encourage the collapse of willpower. Eliot Gregory's studio interior worked in

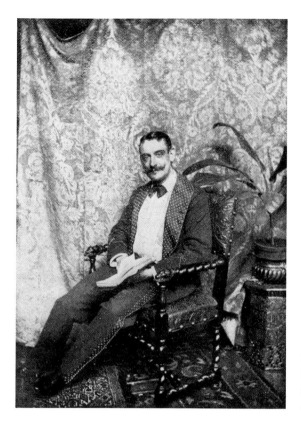

65. *Mr. Eliot Gregory.* Photograph from W. A. Cooper, "Artists in Their Studios, X—Eliot Gregory," *Godey's Magazine* 132 (January–June 1896).

much the same way, to fascinate, captivate, and ultimately profit by his female customers.

Maintaining control of the seductive environment was all important. It was "natural" for women to be seduced by the Oriental enchantment, created and regulated by men. The reverse, however, could spell disaster. In *The Damnation of Theron Ware* (1896), Harold Frederic staged the fall of a young minister in the apartments of free-spirited Celia Madden, a beautiful musician whose studio is a temptress's lair. "She takes him by night into her studio," wrote one reviewer, "whose dainty bits of decoration, its studied carelessness in light and shadow, its pictures and statues and draperies, its old-world bits of color, and, above all, the strange music that she plays to him, captivate his awakened senses and make him the willing victim of her fascinations." Husbands could be made to play the same demeaning role in their own castles. Christine Terhune Herrick argued that modern men at home were victims of "much misguided estheticism" at the hands of well-meaning wives who undertook to furnish a "den" for the "masculine beast." All a husband really wanted was a "place where he can lie and growl over his bones when he feels like it." But deluded wives insisted on decorating to realize their own overblown romantic fantasies: "Then there is a beautiful cosy corner, with [a] divan and curtains draped

66. Hy Mayer, *The Future of the Artist's Necktie.* Cartoon from *Life* 26 (October 17, 1895).

above it, and various pieces of new and shiny armor put up in conspicuous places, and bright new swords and palpably modern antique pistols and pictures. . . . From this gem of an apartment gaslight is excluded, but there are shaded and "fairy" lamps . . . calculated to induce early ophthalmia in the man who attempts to read there. . . . And in the midst of the glory and grandeur sits the poor creature for whose benefit it was composed, risking his eternal salvation by praising everything, while all the time his soul yearns for four bare walls, a floor that is carpeted all over or not at all, and an emancipation from the Orient." For all its self-deprecating humor, Herrick's article sketches the same power relations that governed the experience of young Theron Ware in Celia Madden's studio: that is, the man in such a place was not in control but was the willing or unwilling passive consumer and victim, of ambience—prisoner of the Orient.[10]

By contrast, even the most voluptuous interior created by and for masculine interests could function as the expression of masculine authority. F. Hopkinson Smith's description in *The Fortunes of Oliver Horn* of a Chase-like studio in the banquet scene included many of the same objects itemized with pitying scorn by Herrick: "barbaric" spears, armor, fencing foils, and "low, luxurious divans." Here, however, the splendor evoked an "audience chamber of the Doges at a time when Venice ruled the world." Here, too, male fellowship and revelry prevailed without

67. *Cosy Corner.* Photograph from L. Frank Baum, *The Art of Decorating Dry Goods Windows and Interiors* (1900).

domestic constraints. The same was true of Chase's "real" studio. Clarence Cook recalled that before Chase had given so much of his time to teaching in the art schools, "there was an added charm bestowed upon the handsome room by the presence of a class of young women, on studious thoughts intent, sitting before their easels and playing with the mysteries of art." Chase was a sultan of art, his earnest but trivial girl students his metaphorical harem. Like Eliot Gregory, whose studio incorporated latticework from a "hareem" window, Chase was the active creator and producer of his environment: he was in the center, in power, in charge. The young women, by contrast, were merely consuming what he had to teach them—and only playing, at that.[11]

Other dominant men also "colonized" the interior in the late nineteenth and early twentieth century: in addition to Whistler, John LaFarge, and Stanford White, there were Louis Comfort Tiffany, who ran a thriving business manufacturing sumptuous decorative accessories in glass, metals, and ceramics; leaders in the Arts and Crafts movement such as Gustav Stickley; and of course Frank Lloyd Wright, who maintained the closest control over even the smallest details of his interior designs. In other ways, too, male authority asserted itself, for example, in Edward Bok's long and profitable stint as editor of the *Ladies' Home Journal,* which with its huge

circulation purveyed Bok's ideas on good taste to millions of middle-class wives. While changing fashions determined to some extent what passed for masculine style, the question of masculine control was central regardless of differing looks. Whistler could express as much authority with pure space as Chase could with opulent clutter. His reception room in his house in Chelsea, wrote Clarence Cook, contained a few Japanese kakemonos but beyond that "no ornaments, no pictures, no bric-a-brac." Despite its spareness, it was an eloquent place: "Now anyone, competent to judge, would have known that only a man of naturally a sensitive taste, refined by constant companionship with beautiful things, could have made that room so delightful as it was at once to the eye and mind." Just as Whistler devised the tasteful emptiness of his paintings, he originated, produced, and controlled the elegant nothingness of his domestic habitat. He was commander of his environment, not victim of it.[12]

Having the Best of Both Genders

While the coupling of male artist with interior decoration had shifting meanings depending on context, the colonization of the interior was linked to the overarching discourse concerning the "natural" superiority of male intellectual and creative powers. Although the idea that higher mental capacities were exclusively male properties was hardly a new one, the maintenance of difference, often "scientifically" legitimated by recourse to evolutionary models, was studiously and often passionately tended by scores of writers around the turn of the century, when the defense of old boundary lines assumed new urgency in the face of social destabilization and change. Molly Elliott Seawell flatly refused women any creative powers whatsoever. Without men, women would have remained "in utter barbarism. . . . They could supply the civilization of the emotions, but men had to supply material civilization; and a law as inexorable as the law of gravity shuts women out from the highest forms of intellectual life." Along the same lines, Grant Allen argued that men were responsible for building up civilization while women remained its passive transmitters. "The things that produce and beget ability—commerce, manufacturing, art, invention—are and have always been entirely in male hands," he wrote.[13]

The separation of spheres was very much a one-way affair. Women invaded male territory at the peril of becoming unnatural, unsexed, repellent, barren, and offensive. Men, by contrast, could travel freely into the female preserve, appropriating what they found there and adding it to their "natural" endowments to achieve the complete and perfect, most highly evolved form of genius. In this discourse, no taint of feminization touched or compromised masculinity, since the assertion and exaltation of "natural" male powers was the objective. Most modern men, and most modern women, had evolved to perform specialized roles; men were logical and practical, women emotional and intuitive. But in the highest minds the mixture of feminine and masculine elements was always present. As Grant Allen maintained, it was this gift from the feminine half, "this sort of intuition, coupled *of course* with high mas-

culine qualities—knowledge, application, logical power, hard work—that gives us the masterpieces of the world's progress. . . . There is, indeed, in all genius, however virile, a certain undercurrent of the best feminine characteristics. I am thinking now not merely of the Raphaels, the Shelleys, and the Mendelssohns, but also even of the Newtons, the Gladstones, and the Edisons. They have in them something of the womanly, though not of the womanish. In one word, the man of genius is comprehensively human. . . . He often results from a convergence of male and female qualities" (emphasis added). Lacking masculine mental power, however, women had little hope of greatness and could excel only in the minor arts or in such activities as acting, in which imitation rather than inspiration was involved. E. A. Randall maintained that because women were "by nature or cultivation passive," they were endowed with very little "creative art." But there was something even more important that they could never possess: "Women have lacked the masculine emotions necessary for the production of great paintings. Rosa Bonheur is perhaps the only woman who was man's equal upon canvas. China painting and decorative art in general are the speciality of woman, who excels in the minor, personal artistic impulses, and in this way gives vent to her restricted life. Even the idea of maternity— the Madonna and Child—has found expression in the hands of men." Male genius had access to the best of the feminine and was empowered by nature to colonize or appropriate it. Limited by nature to minor arts of decoration, women could (theoretically) do nothing higher. Men, on the other hand, could decorate rooms and produce great paintings—could have, in short, the best of both genders.[14]

Charles Caffin's ruminations on the landscape art of Dwight Tryon show how this balance or synthesis of forces worked in the rhetoric of art criticism. Like many contemporaries, Caffin voiced the concern that an obsession with the feminine would retard the "lustier growth" of art in America. Ironically, the same poetry that distanced art from the vampire of commercialism could also weaken its masculine fibre. Thomas Wilmer Dewing's wispy, delicately rendered female figures, for example, functioned as signs of the overprecious, the insubstantial, the nonmasculine or antimasculine (see fig. 24). Even though Tryon's paintings were similar to Dewing's in tone and surface effect, they occupied a completely different category. As the foremost exponent of the "subtler kind of landscape," Tryon owed his "eminence" to the fact that "beneath this subtlety, which may easily run into a certain effeminacy of ultra-temperamental feeling, is an extremely masculine regard for the strength and solidity of the facts of nature." Like the highest type of male genius, Tryon's landscapes were androgynous, appropriating the feminine without compromising the force of masculine expression. Tryon's *Early Spring, New England* (fig. 68), awarded first prize at the Carnegie Galleries in Pittsburgh, exemplified that masterful synthesis: "His is a beautiful pastoral landscape, in composition very simple, almost primitive in its fidelity to literal rendering of tree, rock, and undulating field, but full of an illusive charm in which the subtlety of nature is seen and interpreted in a fashion common only to works of the very highest order. It is modern, while it suggests the

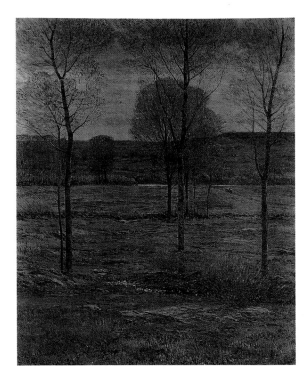

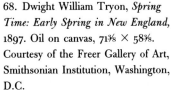

68. Dwight William Tryon, *Spring Time: Early Spring in New England,* 1897. Oil on canvas, 71⅜ × 58⅜. Courtesy of the Freer Gallery of Art, Smithsonian Institution, Washington, D.C.

severe simplicity of the early Italian painters, and is at the same time realistic and decorative." Seamlessly dovetailing masculine and feminine, Tryon's art laid claim at once to the rugged and the fragile, to history and modernity, intellect and intuition, the factual and the decorative.[15]

Women's landscape art, however, seldom if ever achieved that authoritative mix. Mary Fanton Roberts severely criticized an all-female art exhibition at the Knoedler Gallery in 1908. Male and female painters should be judged by a single standard and shown together, she maintained. Yet Roberts conceded that socially constructed gender roles enforced a "wide differentiation between the painting that men do and that women do." There were few women like portrait painter Cecilia Beaux or landscape painter Charlotte Coman (1833–1924), who managed to "subvert" their essentially characteristic outlooks, enabling their artistic impulse to become "universal, as that of the greatest men often is." Even so, Coman's compositions (fig. 69), which, like many modern landscapes, featured high horizon lines, muted atmospheric effects, and broad treatment of surfaces, showed a "woman's feeling about nature," though they could appeal equally to "all sympathetic men and women." Beyond that, Roberts found much of the poetically misty landscape painting weak and bad. Over and over she noted the "strange delusion that vagueness or dullness of color was atmosphere, that the uncertain stroke was impressionism." Indeed, in sculptor F. Edwin Elwell's view, women could almost never accomplish more than that uncertainty and vagueness because they lacked an essential ingredient: "It is rare indeed

69. Charlotte Buell Coman, *Clearing Off,* 1908. Oil on canvas, 27⅛ × 36¼. Metropolitan Museum of Art, New York; Gift of friends of the artist; 1912 (12.47). All rights reserved, Metropolitan Museum of Art.

that one finds a desire on the part of a woman to wish to learn the brutal strength of thought in a man, despite the fact that it is this very quality, so despised by the dilettante and feeble art-worker, that is the essential element in the make-up of a great female artist." Males like Tryon could be delicate without losing strength, but women could only be delicate, spineless, perpetual dabblers.[16]

Dealing with the Greatest Woman Painter

What to do, then, with a vigorously talented, professional, and ambitious woman artist? This was the problem posed by Cecilia Beaux (1855–1942), the gently reared and solidly successful painter whose dedication to her career precluded marriage. Born in Philadelphia, Beaux began her professional life in the 1880s painting in a somber realist style, but after spending time in Paris, where she studied in various academic ateliers, she developed a more brilliant and painterly technique. She settled in New York City and established a strong reputation, winning prizes in shows sponsored by the most prestigious institutions. During her heyday, at about the turn of the century, she was undoubtedly the best-known American woman artist, and she was praised by William Merritt Chase as the "greatest living woman painter."

So successful was Beaux that one critic looked to her for proof that the "sex line in Art" had finally disappeared; the last separation between the work of men and women in painting had dissolved. It had only gone into hiding, however. Homer St.-Gaudens commended Beaux for having a "capacity for strength without that brutality so common to women in search of masculine qualities." Only compare St.-Gaudens's ostensible praise with Elwell's assertion that without learning the "brutal strength of thought in a man" women were condemned to remain amateurs. The deck was stacked against women artists, even the greatest of them all: brutality unsexed them, yet without it they would always be second-rate.[17]

"Brutality" rather crudely connoted an array of purportedly masculine characteristics, such as strength, boldness, intellectual power, and merciless honesty. How it segregated the feminine can be glimpsed in a reviewer's comparison of Beaux's work with that of fashionable male portrait painters. Beaux's images, said this writer, were intimate, delightfully alive, and never exaggerated in drawing or coloring. In this she was quite distinct from her contemporaries: "The jugglery of a Zorn, the whimsicality of a Gandara, the occasional brutality of a Sargent are not for her." As fellow painter William Walton put it, Beaux had uniquely feminine capacities. He found it "most fit and admirable" that "to a woman's hand should be given the power to portray sympathetically the souls of her neighbors." Sargent was sometimes accused (admiringly) of jugglery (that is, his dazzling technical tricks), often of "brutality" or its various synonyms, but seldom if ever of sympathy. This "brutality" elevated him to a commanding rank of masculine genius and authority that Beaux, hampered by her softly feminine sympathies, could never quite attain, at least as the critical language of the day constructed it. In fact, it was largely this language that imposed gendered readings on paintings comparable in subject and style and played a powerful role in support of a specific agenda: to make sure that the "sex line in Art" maintained its critical edge after all, despite optimistic hopes of its erasure. For Beaux it was nearly always Sargent who functioned explicitly or implicitly as master, touchstone, and benchmark. In this context, the concurrent judgment against Sargent's excessive materialism mattered little: here he stood for the unconquerable supremacy of male prowess in the arts.[18]

Beaux's *Mrs. Larz Anderson* (fig. 70) and Sargent's nearly contemporary *Mrs. George Swinton* (fig. 71) are life-size, full-length portraits of white-gowned society hostesses in luxurious interiors. Sargent's painting vividly demonstrates his bravura stroke, while Beaux's is broadly rendered though somewhat less hectic in effect than Sargent's shimmer of choppy highlights. The paintings are distinguishable as the products of different hands. To determine which is the superior piece of painting— or even which is by a woman—might rest on rather arbitrarily chosen criteria. Yet for one reviewer, Beaux's works held together only when out of damaging proximity with Sargent's. Even though her work challenged comparison with the "best of its kind" and exhibited a "rare degree of accomplishment," Beaux still fell short of the mark: "Next [to] a Sargent, the best of [these portraits] would doubtless suffer; we

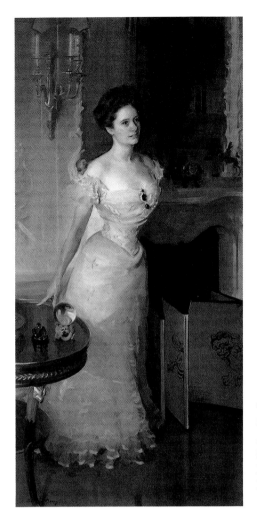

70. Cecilia Beaux, *Mrs. Larz Anderson,*
1900. Oil on canvas, 82 × 40.
Anderson House Museum of the
Society of the Cincinnati, Washington,
D.C. Photograph by Marianne Gurley,
National Portrait Gallery Staff
Photographer.

should miss the perfect grasp of things, the infallible logic that makes a good portrait
by Mr. Sargent so indisputable whether you want to like it or not. We should then
begin to find lapses in Miss Beaux's work where everything hung together with
absolute precision in her rival's; passages almost but not quite true to the intention;
approximate values almost but not quite realized; forms almost, but not quite clearly,
compassed." The difference between the two was self-evident: Sargent was better.[19]

An alternative maneuver was to characterize the two according to supposedly
gender-based traits, as Charles Caffin did in separate pieces on Beaux and Sargent.
Unlike nearly every other reviewer, Caffin criticized Beaux for what he perceived as
a disastrous lack of sympathy with her subjects, finding in some works so complete
an absence of intimacy that the effect was "positively callous." Beaux's portrait of
Mrs. Theodore Roosevelt and Daughter Ethel (fig. 72) earned his approval, though,

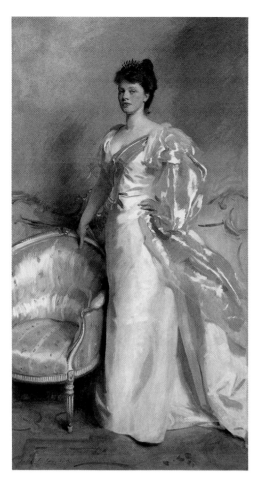

71. John Singer Sargent, *Mrs. George Swinton,* 1897. Oil on canvas, 90 × 49. Art Institute of Chicago; Wirt D. Walker Collection; 1922.4450. Photograph © 1995 Art Institute of Chicago. All rights reserved.

because here the treatment of the head was "more sympathetic" than usual. Beaux's work often lacked this quality and seemed in aggregate to be a display of "exceedingly brilliant craftsmanship" and little else. It is illuminating to turn directly from this to Caffin's appraisal of Sargent as the "Greatest Contemporary Portrait Painter." This greatness consisted of a manner "seldom sympathetic and often callously indifferent," and an attitude of "unconcealed superiority" and aloofness toward his sitters. *Mrs. Carl Meyer and Her Children* (fig. 73) exemplified the cool, factual, dissecting vision that distinguished Sargent from his contemporaries. At first glance, wrote Caffin, this portrait seemed ravishingly dainty, sweetness itself. But Mrs. Meyer's maternal gesture, the elegant, calculated gesture of a fashionable woman toward the two children "to whom she is almost entirely a stranger," revealed the exquisite blossom's flaw. What made Sargent great—his callous aloofness, his brutality—was not admissible in the female painter. By emulating such traits she caught herself in an indissoluble double bind: if she manifested sympathy in abundance she was fully

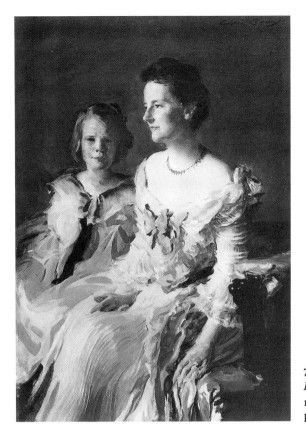

72. Cecilia Beaux, *Mrs. Theodore Roosevelt and Daughter Ethel*, 1901–1902. Oil on canvas, 42½ × 31. Mrs. Bruce K. Chapman, Seattle.

and appropriately a woman artist; if she evinced too little, she was merely a callous technician, and never quite Sargent's equal in either case.[20]

Even though the boldness of Beaux's technique prompted some to describe it as virile or masculine, those signs were almost always offset by some softening feminine trait. Mariana Van Rensselaer, for example, marveled that Beaux could simultaneously be "so masculine in the strength, so feminine in the sentiment of her work." At face value, this remark might indicate the same sort of pictorial androgyny that Caffin admired in Dwight Tryon—that is, the subtle, "feminine" surface layered over the "masculine" regard for the facts of nature. There is a critical distinction here, however, in the order of layering. Despite the surface prettiness of his effects, Tryon was male at the core; for all her masculine strength of surface, Beaux was still a woman underneath, lumbered with all of womanhood's cultural prescriptions: to be emotional, and emotionally involved with her sitters, structuring her images of them on the basis of a tolerant and sympathetic insight. A portrait by Beaux was supposed to be the result of intimate sentimental exchange between artist and model. With Sargent, the relationship with the model was entirely different and, in the eyes of his admirers, entirely masculine. Whereas Beaux communed with her sitters, Sargent simply controlled them; whereas she had sympathetic insight, he had an

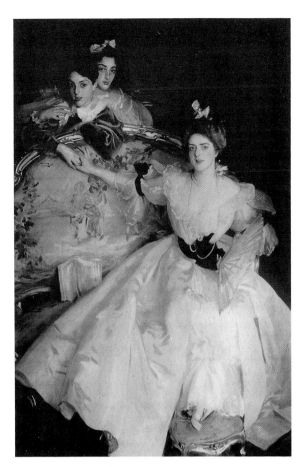

73. John Singer Sargent, *Mrs. Carl Meyer and Her Children*, 1896. Oil on canvas, 79 × 53. Private collection.

impersonal, penetrating, and masterful gaze. George W. Smalley put it bluntly: "The sitter who places himself in the hands of Sargent does so without right of appeal." This was significant in Sargent's portraits of women. As Caffin said, "No painter of the present day can better render the elegance of fashionable femininity. But while he revels in the opportunity of luxurious display, he is never carried away by it. It interests him as a problem for his brush." Like the supreme male genius, Caffin's Sargent—"dispassionate as a mirror"—was in control, calling the shots, colonizing and dominating the feminine, pinning it like a captive butterfly to his analytical canvas rather than letting it overwhelm and unman him.[21]

The Diagnostic Gaze

In keeping with this severely analytical mode of vision, it was Sargent, not Beaux, who possessed a masculine grasp on knowledge and physical truth. His scientific attitude toward his material was truly the key stroke not simply in bolstering gender difference and hierarchy but also in aligning certain branches of modern painting with those prestigious modes of seeing associated with progress and modernity.

Sargent, indeed, matched the new image of the scientist at a time when scientific expertise, and the scientific organization of knowledge, had become dominant paradigms of modernity. "America has become a nation of science," wrote W. J. McGee. "There is no industry . . . that is not shaped by research and its results; there is not one of our fifteen millions of families that does not enjoy the benefits of scientific advancement; there is . . . no motive in our conduct, that has not been made juster by the straightforward and unselfish habit of thought fostered by scientific methods." So powerful was the authority of science that it threatened to supersede religious belief altogether: Colonel Robert Ingersoll lectured widely to eager audiences, urging them to reject religious traditions and put science in their place.[22]

Of all the disciplines, the new experimental biology most dramatically carried out the mission of science to pursue nature aggressively, trap it in the laboratory, and probe it until some essential truth lay exposed, as in Dr. Oliver Wendell Holmes's crude but memorable metaphor coined on recalling the joy of seeing a "relentless observer get hold of Nature and squeeze her until the sweat broke out all over her and Sphincters loosened." That this relentless observer had to be a man almost went without saying. William Osler, one of the most distinguished and influential physicians of the time, made it plain in his lectures to Johns Hopkins medical students that science was a strictly masculine preserve. The study of biology, he said, "trains the mind in accurate methods of observation and correct methods of reasoning, and gives to a man a clearer point of view." The pursuit of science was strictly rational: "With reason science never parts company, but with feeling, emotion, passion, what has she to do? They are not of her; they owe her no allegiance." The gender bias in Osler's speech jumps into high relief when we consult his remarks delivered to student nurses at Johns Hopkins. While he urged medical men to embrace scientific knowledge as their creed, Osler admonished nurses to have nothing to do with it: such knowledge was not their territory. At most, an overcurious nurse might acquire a smattering of pseudoscientific knowledge, "that most fatal and common of mental states. In your daily work you involuntarily catch the accents and learn the language of science, often without a clear conception of its meaning." Nurses would be happier and better off if they knew nothing at all: "It must be very difficult to resist the fascination of a desire to know more, much more, of the deeper depths of the things you see and hear, and often this ignorance must be very tantalizing, but it is more wholesome than an assurance which rests on a thin veneer of knowledge."[23]

Much of the language employed to describe the highly analytical quality of Sargent's vision matched the language celebrating the analytical, critical spirit of masculine science. Sargent in some instances proved very much the equivalent of Holmes's relentless observer, squeezing the facts out of nature, often with results almost equally unpleasant. Sargent looked for reality, not sentiment, said Harrison S. Morris, director of the Pennsylvania Academy of the Fine Arts. Sargent sought the facts and "discards . . . those tender influences that may seem to hinder manly

analysis. . . . He deals by choice with the portrait as a solvent of character and enjoys the biologic practice of revealing the secrets of life with a brush." Unlike Beaux's insight, which was intuitive and emotional, Sargent's penetration was physiological, even pathological. If he saw beneath the surface, it was in a manner more X-ray than empathy. As Cortissoz put it, Sargent's scientific eye violated the "secret recesses of human vanity," bringing "hidden traits to life." Samuel Isham told of the dreadful but truthful effects wrought by Sargent's brush: "We wonder whether he cared at all for the people he painted . . . for anything except the moment that they stood before him twiddling their watch-chains or spreading their fans. Of that moment, though, we have the absolute record, and a terrible one it is sometimes, for the artist, without illusions himself, is pitiless for those of his sitters. If a lady thinks to renew by artifice the freshness of her youth, she appears not with the roses and lilies of nature on her face, but with rouge and pearl powder manifest and unmistakable; if the statesman bends his brows and puffs up his chest, he is displayed not as a thunderbolt of debate, but as a pompous ass."[24]

Commensurate with the possession of such an eye for defects was Sargent's "diagnostic" gaze, so sharp and keen that one reviewer even imagined him painting with a scalpel rather than a brush. "He shows to the world the independent diagnosis of a painter speaking for artistic effect, in place of the lisped compliments of the so-called portrait-painter," wrote Homer St.-Gaudens. As Caffin saw it, Sargent's attitude toward his sitters was entirely professional, generally free of sympathy and cynicism. In its peculiar intimacy it corresponded to the relation between physician and patient, or lawyer and client, except that these were privileged whereas "Sargent's diagnosis, and his analysis of a client's strong and weak points are published to the world."[25]

Improving on the scalpel analogy, Royal Cortissoz later commended Sargent's "deadly surgeon-like precision and success" in his single-minded concentration on the "identity of the portrait." Since surgery itself was perhaps the most stubbornly masculinized area of medical practice, Sargent's metaphorical "scalpel" and his "surgeon-like precision" clearly connoted his distinctively manly competence. As one doctor declared, "The primary requisite of a good surgeon is to *be a man*—a man of courage." Philadelphia painter and expert anatomist Thomas Eakins also saw surgery as a "natural" male province, writing, "I do not believe that great painting or sculpture or surgery will ever be done by women," though he did concede that in art "good enough work is continually done by them" to be worth while, at least—or at most. Significantly, Sargent's often-noted technical prowess and dexterity matched those skills possessed by such eminent surgeons as Dr. David Hayes Agnew, who was reported to be sure, calm, rapid, and extremely dexterous in performing operations. The information conveyed in Sargent's portraits covered precisely the same range, moreover, as Agnew recommended in his treatise on surgery. In order to deal successfully with disease, the doctor must have "knowledge of the Age, Sex, Occupation, Habits, Mental and Moral States, Personal History and

74. Cecilia Beaux, *Ernesta (Child with Nurse)*, 1894. Oil on canvas, 49 × 37. Metropolitan Museum of Art, New York; Maria DeWitt Jesup Fund, 1965 (65.49).

Temperament, Social Condition, Residence, and Knowledge of the Patient by Others." Like Agnew's ideal surgeon, Sargent probed the material and the moral circumstances of his sitters: "He is incurious as to whether his sitters have souls. . . . But as to this present commonplace world of business and pleasure he is full of the most minute and valuable information. He tells whether they are pompous or cordial or shy, if they have or have not a sense of humor, whether they are nervous or stolid, sensible or eccentric, kindly or malicious. He diagnoses their health, shows their degree of education, displays the style of their establishment, and suggests approximately their annual rate of expenditure." Only compare Cortissoz's effusions over Beaux's images of childhood, such as *Ernesta (Child with Nurse)* (fig. 74), one of her most popular paintings. The child portraits, he declared, were full of naturalness and charm, "the most artless, flowerlike interpretations of life." *Ernesta* was "enchantment itself," and the artist's sympathy had infused the workmanship with a "wave of that atmosphere which minimizes the material elements of a material side of art." Beaux, the indulgent aunt of the toddler pictured, surely intended the portrait to charm, and few critics seemed able to resist the appeal of the big dark eyes and the tiny white-gowned figure guided along by the firm hand and solid bulk of the nurse, anonymous and faceless yet tender and protective. By contrast, Sargent's portrait of Mrs. Meyer, with her two children wedged behind a rococo sofa while

their mother expansively dominates the foreground with her spreading pink skirts and cascading pearls, exemplifies the action of that "diagnostic" scrutiny dreaded and desired by sitters and admirers alike. There is nothing ostensibly pathological about it, of course. But it produces an effect of detached observation by stylistic tricks that create tension and distance: the high viewpoint, the bleached-out green and metallic pink color scheme, the strained and jagged lines so tenuously connecting Mrs. Meyer to her offspring, her direct yet guarded expression, all three subjects looking out, not at each other—these features reveal Sargent's tendency to dissect relationships, moods, and pretensions and to put them on display. It may not be callous, as Caffin said, yet neither is it a sentimental celebration of childhood or of the nurturing body of motherhood. Whether the difference between the paintings arises from the sex difference of their makers is another question. Certainly the diagnostic gaze claimed for Sargent could just as easily be matched to some of Mary Cassatt's probing, dispassionate images of maternity. At the turn of the century, however, such a question was unlikely to be raised, and no one questioned the association of breadth with masculinity, even though breadth—with its connotations of liquidity, flow, and emotional colorism as opposed to "intellectual" classical linearity—could with equal justification be assigned to the feminine. Possessor of knowledge, master of analysis, Sargent was, within the frame of dominant discourses, the superior artist. Vessel of emotion, mistress of sympathy, Beaux ranked a notch below, her linguistically and socially constructed qualities of womanly softness no match for Sargent's manly firmness of intellect.[26]

A Most Womanly Woman

Beaux's softness, though, was important in determining her status. The fact that Cecilia Beaux never seemed to transgress the boundaries of socially prescribed gender roles helped her to secure a corner in the largely male hall of contemporary artistic fame. Just as there was always some "feminine attribute" of charm or sympathy to counter the "masculine" energy of her style, there was Beaux herself to counter the idea that the professional woman artist would unsex herself in order to get an education or pursue a career. This danger was on Charles Dana Gibson's mind, when as part of a series on Social Nuisances, he drew *The Female Artist Who Has Ceased To Be Feminine* (fig. 75). Here is an artist who has leaped beyond china painting and household decorating to tackle large-scale paintings. The studio interior shows the marks of cosmopolitan fashion in the drapery swag, the little Oriental table on which the painter's brushes and solvents repose, and the tiger-skin rug snarling out at the reader. The painter herself wears an outdated aesthetic-movement gown with balloon sleeves and a trapeze back flowing from a wide collar. Her hair is bunched up into a knot, with frowsy bangs; and a prim pince-nez perches on her nose. The body language is revealing as well. Addressing her two stodgy, bemused visitors, the painter leans forward at a graceless slant and rests an elbow on one knee; she is a bundle of bulky fabric and awkward angles. A spill of sketches at the

SOCIAL NUISANCES.
THE FEMALE ARTIST WHO HAS CEASED TO BE FEMININE.

75. Charles Dana Gibson, *The Female Artist Who Has Ceased To Be Feminine.* Cartoon from *Life* 16 (August 7, 1890).

left indicate that she draws from the nude model—still a controversial practice at the time—and the big paintings on the walls and easels predictably demean her talent: two oversize still lifes and the work she is completing, featuring a skinny Bo-Peep with gigantic bows and two scrawny, shaven lambs. Gibson's other Social Nuisances included *The Man Who Never Knows When To Leave* and *The Girl Who Thinks More of Her Pets Than Her Friends*. Like them, the female artist was no more than a minor annoyance, but her greatest crime surely was to have become unfeminine. Whereas male artists could incorporate, control, and exploit the "feminine" without compromising their masculinity, the female artist was patently unable to contain and dominate the masculine, which took over and inexorably deformed her. In addition, artistic activity taken too seriously only distracted a woman from her socially ordained domestic role and visited havoc on the home. An "artistic" woman was often synonymous with a silly woman. The poem "My Artistic Wife" belittled women's art production as a ridiculous fad that plunged women into a frenzy of bad carving, modeling, and painting: "With her chisel, and her mallet, and her brushes, and her palette, / And her canvas, and her plaster, and her clay / . . . Small wonder I'm

complaining, for my love she is disdaining, / And she snubs me, and she dubs me 'in the way.' " There was nothing rational about such activity, either: "And so great is her delusion that I'm forced to the conclusion / That she's crazy and fanatical and daft." Being an artist was an unnatural condition for wives and maids alike, in fact. If it did not drive them crazy, it turned them into men.[27]

In this discourse, the ornate studio itself functioned as a sign of insincerity and fakery, supplementing its other connotations of seduction and loss of control. It was the realm of the trivial, the worthless, the poseuse. Of course the same was true of society artists and other poseurs who cynically set out to hoodwink ignorant customers. But within the set that contained the coordinates of female artistic triviality and marginality, the fancy studio was a dead giveaway. In a story by Cornelia Atwood Pratt, the wealthy Haidee has a studio "somewhat too luxuriously fitted up for a real work-room," and in due time the narrator learns that Haidee had resorted to painting as therapy when her marriage turned sour. After being happily reconciled with her husband she no longer needs to make art. William Dean Howells's *The Coast of Bohemia* features the talentless Charmian Maybough as the socialite playing at art, making a bohemian bower at the top of her mother's fashionable New York apartment. Dismissing her mother's realm as "all that unreality . . . down there," Charmian exclaims: "What I want is to have the atmosphere of art about me, all the time. I'm like a fish out of water when I'm out of the atmosphere of art." To produce this atmosphere, as she tells her fellow student Cornelia, "I must have a suit of Japanese armor for that corner, over there; and then two or three of those queer-looking, old, long, faded trunks, you know, with eastern stuffs gaping out of them, to set along the wall." Like Gibson's unfeminine artist, Charmian has a great tiger skin sprawling on the floor. She also intends to get a wolfhound (a reference to Chase's well-known pets) and put up fencing foils and masks over the fireplace. This caricature of the masculine studio is the site for little more than elaborate posturing. As Cornelia quickly sees, Charmian's sketches stuck about the walls are "all that mixture of bad drawing and fantastic thinking" that characterizes her efforts in general. This studio is all atmosphere and no art, a monument to female pretension and incompetence.[28]

Unlike Charmian, Haidee, and Gibson's unsexed female painter, Beaux managed to sustain an identity as a real artist and a real woman. Her special value lay in her ability to demonstrate that female success need not be grossly incompatible with socially constructed and approved modes of feminine behavior. Accorded the status of greatest woman painter, she functioned to affirm the possibility of feminine achievement in a world structured to discourage it. While she was indisputably an excellent painter and a successful professional, she was in a sense allowed to be the shining exception. However many commissions received or prizes won, she was an extreme minority who posed little threat to the institutions of the art world. There was nothing disturbing about her, nothing to threaten sexual equilibrium. She did not behave oddly or draw attention to herself. As Pauline King wrote, even though

76. *Harriet Hosmer at Work on Benton.* Photograph from Cornelia Carr, ed., *Harriet Hosmer, Letters and Memories* (1912).

Beaux was the greatest woman painter of the time she lived and worked "calmly and quietly," without "fireworks" or "eccentricity" of any kind: she was ladylike. To Ann O'Hagan, everything about Beaux suggested the "good word 'lady' ": the "deep intuitions, the poise, the delicate reserves of the woman of highest breeding." Sculptor Lorado Taft's remarks on Beaux make the meaning of her deportment unmistakably clear. Until today, the world had never seen a truly great woman artist, but now, through her superb accomplishment, Beaux, "as admirable technically as any of the cleverest of our men," had emancipated her sex. Having asserted Beaux's greatness in the strongest terms, Taft went on to couple her name with that of African-American artist Henry Ossawa Tanner: "She has not only made a record, but like Mr. Tanner, the colored painter, has shown the potentialities of her kind." In his day, Tanner functioned as the token great African-American painter even though he lived as an expatriate in France. Beaux's role was similar: both remained privileged Others painting to considerable acclaim in styles defined and validated by the white male mainstream. After confirming Beaux's greatness and otherness almost simultaneously, Taft took up the question of femininity. It was unfortunate that women who had won some distinction in art were often the "most manlike in characteristics"—as was the case with Rosa Bonheur or with the tomboyish, short-skirted American sculptor Harriet Hosmer (fig. 76). But on visiting Beaux's studio,

77. Passport photograph of Cecilia Beaux. Photographs of Artists Collection II, Archives of American Art, Smithsonian Institution, Washington, D.C. (Reel 1817, Frame 172).

Taft was *"relieved* to find that the gifted artist was in no sense mannish" (fig. 77); on the contrary, she gave the impression of a "most womanly woman," with an air of dignity, grace, and cultivation (emphasis added). Taft's relief was that of a well-armed guard patrolling a contested border only to discover that reports of the danger had been greatly overblown. Unlike the stereotyped "masculine" new woman, castigated in contemporary medical discourse as a monster of degeneracy, Beaux in her womanliness posed no challenge to masculine hegemony of any kind—though she remained single and therefore potentially undomesticated. As a womanly woman, she inhabited an unthreatening sphere, poised and stranded somewhere between the world of conventional domesticity and the realm of masculine endeavor. Beaux subscribed to this construction of herself as the exception to the rule. Most women, she believed, lacked the strength and stamina to sustain a career and therefore belonged at home, consigned to socially prescribed domestic functions.[29]

Early in the twentieth century the young, ambitious, and self-consciously manly George Bellows courted Beaux's favor, a fact that confirms Beaux's isolated and exceptional position. Bellows, the painter of gritty boxing scenes and other tough urban subjects, cultivated Beaux's acquaintance in part to improve his connections with the elite inner circle of the New York art world. Beaux took on Bellows as a protégé, inviting him to the opera and to tea. Established, elevated, and privileged, Beaux was useful to the career of a male artist whose subjects could not have been more different from her own. As a professional woman Beaux had undergone a kind of neutralizing process that left her womanly but never dangerous to male autonomy, never a threat to male control. Unlike Theron Ware in the seductive studio of Celia Madden, Bellows could enter Cecilia Beaux's kingdom in perfect safety and return from it intact, bearing the trophy of her goodwill. Quarantined, trivialized, and

institutionally marginalized, the woman artist posed the feeblest threat to male control during the turn of the century years. She proved instead convenient for the containment and belittlement of those "feminine" weaknesses that male artists rejected in attempting to sustain the appearance of being in charge. Male artists had little trouble outselling the feminine, and around them the art establishment continued to undermine it.[30]

6 BEING BIG

Winslow Homer and the American Business Spirit

Even though American artists had with considerable success colonized the feminine and naturalized aestheticism, some critics found much of contemporary art weak and inadequate to the spirit of modern America. As a *Harper's* editorial put it, "It is a period of refinement and decoration, in which the *how* is more important than the *what*. . . . It is a day of little masters, of the art that seeks effect but feels nothing, of small and exquisite things . . . of the dainty representation of our own small ideas." Regarding the work of Childe Hassam and other impressionists, C. Lewis Hind mused that one of the "curiosities of art" was that a young, vigorous nation should run into such "fragile, dainty ways of portraying nature." Some painters, like Gari Melchers, were sufficiently virile yet too cosmopolitan to be truly American, and neither the "tender femininity of Twachtman" nor the "pretty mondaines of Dewing" qualified as expressions of genuine, native feeling. In the work of Winslow Homer, however, were signs of a true national art, produced by a man who lived in solitude, "surrounded by the elemental forces of nature." His art was the "big, comprehensive work" that was "entirely personal and entirely American."[1]

Size and power in late-nineteenth-century America were intimately and intricately connected. As many have noted, this was the age of bigness: in business, in scale, in expansion, in material superfluity, in social inequities, even in bodies, both meta-

phorical and real. Looking back with fascination and distaste on the "Brown De-
cades" of recent memory, Lewis Mumford endorsed Vernon Parrington's
"particularly good" grasp of the period's physiognomy, the "obese and bloated mas-
ters" of postbellum America. Added Mumford, "Even the best men conformed to
the mold. [Architect H. H.] Richardson's bulky figure, to say nothing of his huge
traveling companions, attracted the attention of European gamins, who thought they
belonged to a circus: once they asked outright—When is the dwarf coming?" Mum-
ford and Parrington were clearly ambivalent about such excess, which to their gen-
eration had come to symbolize the corruption, mammonism, and spiritual bankruptcy
of the age. During that earlier time, however, bigness was synonymous with the spirit
of American energy and progress, driven forward by the engines of large-scale com-
merce, finance, and industry. The men who guided those engines had to match them
in size and force. As the president of the American Radiator Company said, there
was a need for men with "big imaginations" who could conceive and plan "big
things" for the business world.[2]

As Bruce Robertson has shown, "big" and its synonyms (along with "virile")
appeared in writings about Homer and his art with striking frequency at about the
turn of the century, when the artist's reputation was on the ascent to the pinnacle
of all-American greatness. This was almost entirely the construction of his admir-
ers. Orson Lowell's enthusiastic response to Homer's Canadian fishing scenes is
typical. Homer already ranked as one of "our strongest painters," but there was a
great deal more to it than that: "By 'strong' I do not mean merely as a painter
and draftsman. . . . His things show the big, big-hearted man; they are painted, in
whatever the medium, with a confident fearlessness and an almost brutal strength.
I used always to think of the author of the Homer pictures as a giant, or as a man
with at least hands boisterously big and having no patience with petty details. Go-
ing into the small Knoedler gallery with this idea of the man, one is not at all dis-
appointed, but surprised, feeling that he never knew how big and how fearless
and how masterly." Any photograph (fig. 78) would instantly deflate Lowell's
overblown vision: no ham-handed colossus, Homer was small, neat, and wiry. His
paintings are not big, either, in physical dimensions: compared with any typical
French history painting—Géricault's *Raft of the Medusa,* say (1819; Musée du Lou-
vre, Paris)—his canvases look puny. As critics saw them, though, they were big—
sometimes huge and vast—in metaphorical terms. "There is something rugged,
austere, even Titanic in almost everything Homer has done," declared Frederick
W. Morton. "His sea is the watery waste as the expression of tremendous force,
mystery, peril." Like other critics, Morton found Homer's sea poetry "epic" in
scope and scale, and he praised the artist for expunging the "decorative beauty"
from his compositions so severely that what remained was almost repellent:
"frankly ugly, austere even to the disagreeable." In this austerity, though, lay
Homer's compelling power, which in the public eye seemed to be the unmediated
power of nature itself, unaestheticized. Homer's art was so big and natural that it

78. Napoleon Sarony, *Portrait of Winslow Homer*, c. 1880. Silver print. Bowdoin College Museum of Art, Brunswick, Maine; Gift of the Homer Family, 1964.

scarcely belonged indoors; it was "not calculated for the drawing-room," as Cox put it. Frank Gunsaulus, owner of *On a Lee Shore* (c. 1900; Museum of Art, Rhode Island School of Design, Providence), observed whimsically that he felt the surging waters in the painting might at any moment overspill their boundaries and sweep him out of his house. Homer himself, isolated and remote, was as undomesticated as his pictures, as tough and weatherproof as the fishermen who battled his stormy seas, or the hardy woodsmen who roamed his Adirondack wildernesses. He was a "natural force rather than a trained artist," a painter entirely self-taught and self-made. In his life and work, wrote Henry Reuterdahl, Homer celebrated "manly power, the beauty of man strong in will and muscle fighting the elements."[3]

This Homer was largely a fiction. He himself referred to painting not as a struggle with the elements at all, but as a business, and his letters reveal a keen if cynical awareness of the importance of supply and demand in the art market. Homer's attitude toward his trade seemed to develop as the painter aged, coinciding with the era of his greatest fame as America's most natural and least mercenary art worker. When J. Alden Weir invited him to join the Ten American Painters, Homer declined: "You do not realize it, but I am too old for this work and I have already decided to retire from business at the end of the season." He never did retire, though he occasionally threatened to do so over the next few years, and he never failed to acknowledge the vital connection between "business" and income. In 1904 he informed his brother Arthur of a slack time in productivity: "I have not done any

79. Winslow Homer, *Eastern Point,* 1900. Oil on canvas, 30¼ × 48½. © Sterling and Francine Clark Art Institute, Williamstown, Massachusetts.

business so far this Fall and I shall only paint to see if I am up [to] it—and with a chance of paying expenses."[4]

Homer's "semi-civilized hermit life," as Mariana Van Rensselaer romantically called it, was equally a myth constructed by the media. His life in Prout's Neck on the coast of Maine was enmeshed in family economic and social activity. Charles Savage Homer, Sr., and the three Homer brothers contributed energetically to the development of the place as a resort, buying up a great deal of the Atlantic shoreline there and selling lots for cottages to well-to-do summer residents. Homer's own interest in the real estate investments eventually yielded enough income to meet his expenses and more. Prout's Neck itself, covered with sprawling hotels and elegant Shingle Style houses, was not in most ways the elemental site of primal struggle that it appeared to be in such paintings as *Eastern Point* (fig. 79), a stark vision of cold, seething waves and forbidding rocks. Carefully edited to give no hint that the landscape of elite vacation culture stood nearby, the elemental scene—Homer's own property, in fact—was one of the few remaining bits of raw nature in a well-developed resort community. Many of Homer's paintings were heavily mediated in one way or another: *The Fog Warning* (1885; Museum of Fine Arts, Boston), for example, was carefully staged, using as model a dory propped on a sand dune and occupied by a neighbor in oilskins—hardly the life-and-death drama of man and nature that the finished work proposes. Finally, Homer's own physical appearance surprised those meeting him for the first time—those who had been led by the paintings and by

critical accounts to expect a robust, uncouth hermit, a giant in a slicker, innocent of social graces. The ladylike Cecilia Beaux, for one, failed to guess or imagine that her colleague on the Carnegie International jury in 1897 was Homer: "this personage I took to be a high official in the world of the Institute, or of coal or steel. . . . He looked, I whispered to myself, as a diamond expert would, if I had ever seen one. There was something intense, observant, in his quiet. His new clothes seemed like a disguise." This was no masquerade, however. The "real" Homer was the same natty dresser encountered by Beaux. The actual disguise, draped on him by admirers, was that of the well-groomed rentier posed as a large and crusty hermit. Thus masked, Homer stepped into the hall of fame as the quintessential American artist and the quintessential American male.[5]

The Perilous Seas of Finance

Homer's success was bound up with the late-nineteenth-century anxiety and exhilaration that attended the reorganization of the American economy after the Civil War. In particular, an unacknowledged yet palpable linkage of Homer's bigness and force with the vocabulary celebrating (or deploring) the character of American business and economic life helped secure him a central place in the cultural market. His person and his art alike embodied the American business spirit and produced effects of virility, power, and centrality that moved aesthetic production decisively into the realm of masculine action. This is not to say that his paintings are not about what they seem to be: nature and natural forces. Certainly they are that, as they are also about Homer's response to those forces. But in the public realm they did more. Speaking of nature on the surface, Homer's paintings, specifically the later seascapes and hunting scenes that made his contemporary fame, at other levels spoke the language of business and wove metaphors evoking the "natural" laws and rhythms of economic forces.

This suggestion is not so far-fetched as it may seem. Sigmund Diamond has argued that during the last quarter of the nineteenth century the identification of business enterprise and religion in America became so complete that their vocabularies were almost interchangeable. The *Congregationalist* in 1876, for example, pitched the benefits of faith as sound business practice: "Men who have tried it have confidently declared that there is no sleeping partner in any business who can begin to compare with the Almighty." Homer also used business metaphors for art, on one occasion telling his dealer Knoedler (with some sly humor, probably): "I do not know the price of January pictures. You must keep me informed that I may be long or short on them as the market fluctuates." While the world of art was supposed to be as insulated from commercial influence as religion was, the boundaries of discourse were permeable at many points, allowing the contents of one to leach into the field of another, and permitting certain key metaphors to connect things that on the surface might appear utterly separate. Homer's pictures were about nature, and—paradoxically, it may seem—this was precisely what constituted the ground they

shared with the world of money and money-making. His nature was not "natural," but a construction of "naturalness" for an empirical age when nature and its laws provided a vast repository of analogies available on demand to shore up systems of value and belief. Homer's paintings, which concerned themselves with nature's rhythms and forces, enacted the same drama of natural law as that which for better or worse dictated rise, fall, and change in the often tumultuous arena of American commerce. What happened in Homer's pictured "natural" world happened in the business world as well, and it was here that a common set of references, and a common metaphorical narrative, joined them.[6]

Perhaps nowhere outside the realm of science was the authority of "natural law" invoked with greater regularity than in the world of commerce and economics, where businessmen sought infinite scope for their operations, untrammeled by government interference. Although "natural law" was rooted in classical economic theory, scientific models of natural selection (Darwin) and survival of the fittest (Herbert Spencer) endowed it with powerful new currency in the late nineteenth century. So great was the authority of the natural law model that it enabled entrepreneurs like John D. Rockefeller to position themselves "naturally" beyond the reach of any man-made legal strictures. As Charles Elliott Perkins put it, Rockefeller's Standard Oil was "simply a product of natural laws and laws which it is not safe to touch." In Frank Norris's *The Octopus,* the organic and the artificial alike were subject to the same laws that regulated the operation of all the universe. Declares one character, railroad magnate Shelgrim, " 'You are dealing with forces . . . when you speak of Wheat and the railroads, not with men. . . . The Wheat is one force, the railroad another, and there is the law that governs them both—supply and demand.' "[7]

Over the last quarter of the century, when bloody, cutthroat competition in business yielded to the encroachment of corporate rule, analogies with the natural forces that controlled economic phenomena and the physical world alike circulated widely. The corporation, the entrepreneur, and the condition of the financial world itself all found correspondence, explanation, and legitimation in the power and vastness of nature's rule. Again and again natural science, physics, chemistry, meteorology, and biology supplied the stock of analogues called into economic service, but the most dramatic imagery pictured business in metaphors of oceans, tides, and storms, forces beyond human power to divert or change. Henry Wood, a businessman who turned to writing after a nervous breakdown, produced several treatises blending Emersonian mysticism, classical economics, and Spencerian models of progress to argue the unity of forces that bound together both the natural and the economic worlds. Wood conceived of commercial activity in terms of action and reaction, pointing out that "wherever we turn to in the broad domain of nature, there are positive and negative . . . ebb and flow, general undulation." Until human nature had evolved to a higher plane, however, there would always be "flood and ebb tides in the turbulent sea of finance." Foolhardy entrepreneurs or corporations that attempted to subvert these laws would inevitably find themselves at a loss, as

did the French Copper Syndicate, formed in 1888 in order to corner the market in copper, thereby boosting prices and profits. The world, reasoned the Syndicate, *must* have copper and would be obliged to pay. What could possibly arise to dispute the supremacy of this logic? It would not be any personal or corporate opposition but "invisible forces as unrepealable as the tides." Because of these forces, the Syndicate lost its gamble, and "flood tide was followed by ebb—a very low ebb." The same laws governed the boom-and-bust cycles besetting American business all too frequently in the last century. These "financial cyclones" visited disaster upon the marketplace, but like real storms they could never be prevented. They had the positive result, however, of sweeping clean: "Panics, like thunder-storms, purify the air."[8]

The figure of the businessman also inspired metaphors of risk and peril in the natural world. For Andrew Carnegie, the businessman was a self-employed lone adventurer who depended for revenues not upon regular paychecks but upon the less reliable profits: "The business man pure and simple," he stated, "plunges into and tosses upon the waves of human affairs without a life-preserver in the shape of salary; he risks all." Such metaphors appeared in popular business advice tracts as well: "A good ship doesn't necessarily guarantee a safe port nor does a good system alone insure a successful business. A water-logged scow in the hands of a master pilot may fare better in the storm than a twin-screw ocean liner manned by incompetents. You cannot set the helm of your business barge in one fixed direction and expect it to guide you into the harbor of success. The shoals and rocks of unexpected conditions rise up in every mile of the sea. Only skillful piloting that meets each danger as it arises can steer you safely through. It's the man behind the wheel that brings the ship into the haven of profit." Of course in one respect there was nothing new about these metaphors. With their voyage-of-life allusions, they had roots deep in the culture of American religion. Considering the pervasiveness of natural-law analogies, though, they suggest the readiness whereby business behavior and economic rhythms called forth the imagery of weather, tides, and struggle against the forces of nature.[9]

While Homer was producing his dramatic paintings of the sea, the business world was in almost constant flux, going through precipitous cycles of boom and bust—or ebb and flow, to use the language of natural analogy. After the Civil War a series of catastrophes buffeted the business community. Severe panics occurred in 1873 and 1879, and a depression in the mid-1880s flattened economic growth. In 1893 another panic ushered in severe depression, supplemented by terrible labor violence and bitter political strife over the gold standard. In all, fourteen of the twenty-five years before 1895 were years of recession or depression. The failure rate for businesses was high. After the Panic of 1893 (catalyzed by the failure of the Philadelphia and Reading Railroad) five hundred banks and nearly sixteen hundred businesses fell into bankruptcy. The climate of uncertainty gave rise to chronic anxiety among businessmen. Shipbuilder John Roach observed in 1885, "There are few persons who know the excitement and the fear that exists among capitalists

80. Winslow Homer, *Lost on the Grand Banks,* 1885. Oil on canvas, 30½ × 49⅜. Los Angeles County Museum of Art; Lent by Mr. and Mrs. John S. Broome.

today," and in the tail end of 1896 Edwin Godkin found the situation little changed, noting that given the failure rate and the scarcity of successful business talent, capitalists were in just as "precarious a position as other classes in the community."[10]

Instead of affording the aesthetic escape proffered by many of his contemporaries, Homer's paintings functioned to displace the experience of precariousness and uncertainty, of unpredictable and often disastrous fluctuation, onto the natural world, source of the "natural law" that regulated economic life. Paintings such as *The Fog Warning* and *Lost on the Grand Banks* (fig. 80) are about fishing, and they heroicize the men—frail and vulnerable against the vastness and power of the sea—confronting the hazards of a risky calling. But Homer's images of lonely, endangered fishermen also thematized the uncertainty, anxiety, and confusion that pervaded the commercial and social world of the fin de siècle: the fisherman in the dory with his prize, toiling to reach the mother ship before the (unpredicted?) fog obliterates the way; the two fishermen peering in vain across the endless, trackless waters on which they drift like flotsam. Not surprisingly, Homer's series on themes of peril in the fishing trade—ranging from his Tynemouth water colors of 1882 through the monumental oils of the mid-1880s—were easy to understand, so clearly and vividly did they code the idea of elemental forces, human struggle, and the fragility of human life. It is worth looking at one critic's response to *The Fog Warning,* exhibited at the Century Association in 1885. This reviewer found the work not only powerfully dramatic in

conception but also executed with an almost grim intensity that added infinitely to its significance. Some, wrote the critic, would find the painting's emotional power even more intense than others did: "To those who know the great waters and their perils this unostentatious little drama will appeal very closely indeed." The audience at the Century was quite unlikely to have been very well acquainted with the great waters and their perils, however: attendance at these shows was limited to members and their guests, a select group of urban elites, including a number of men in trade, banking, or other commercial and financial pursuits. Perhaps they knew of the great waters and their perils through ocean crossings on passenger liners, but hardly otherwise. What would such paintings as *The Fog Warning* say to this audience? A clue can be gleaned from another reviewer's reaction to *The Herring Net* (1885; Art Institute, Chicago), exhibited along with *The Fog Warning* at the Carnegie Institute in 1908: "Mr. Homer has a way of painting what may be called uncomfortable pictures, which, however, we are compelled to admire." With their nasty weather, cold wetness, and imperiled figures struggling for survival on the treacherous sea, Homer's fishing scenes were uncomfortable indeed. Produced in the mid-1880s, a time of nervousness and uncertainty concerning America's economic and social fortunes, they captured and spun those threads of unease into compelling but unsettling images of brave men in ominous straits. Too ominous, indeed: perhaps his failure to sell any of those fishing scenes until considerably later—with the exception of the less harrowing *Eight Bells* (1886; Addison Gallery of American Art, Phillips Academy, Andover, Massachusetts) to Thomas B. Clarke for a very low figure—was a function of the way they alluded all too suggestively to the perils of the American financial waters on which the incomes of the elite audience depended, whether or not they were in trade themselves. One description of *The Ship's Boat* (1883; New Britain Museum of American Art, New Britain, Connecticut) evokes the unpleasant excitements of a Homer sea disaster in terms that could just as readily have been used to describe a Wall Street panic. Four sailors were being drawn into a "lee shore of the most inhospitable and pitiless description." Their frail craft had been overturned, and they were clinging to its bottom and sides while a "monstrous wave" was coming to "dash them upon the streaming rocks."[11]

Perhaps because they were more thrilling and hopeful, Homer's scenes of rescue from wrecks and drownings fared better. He was able fairly quickly to sell *The Wreck of the Iron Crown* (1881; private collection), *The Life Line* (1884; Philadelphia Museum of Art), and *Undertow* (fig. 81). In 1896 *The Wreck* (1896; Museum of Art, Carnegie Institute, Pittsburgh) won a gold medal at the Carnegie, which purchased the painting for $5,000. The favorable reception accorded *The Signal of Distress* (1890–1896; Thyssen-Bornemisza Collection) encouraged New York dealer C. Klackner to reproduce it as a photogravure for the popular market. Like the ebb and flow metaphors associated with economic cycles, *wreck* and its synonyms had a high rate of circulation in the business world. Financial unease in the early 1890s prompted

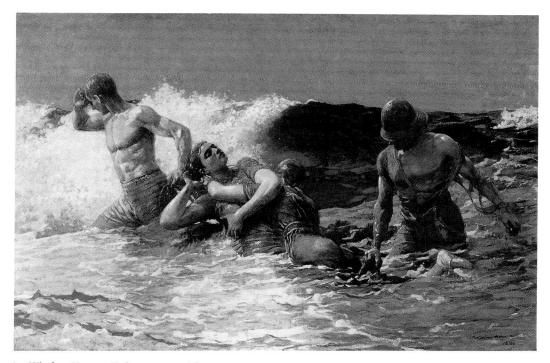

81. Winslow Homer, *Undertow*, 1886. Oil on canvas, 29¹³⁄₁₆ × 47⅝. © Sterling and Francine Clark Art Institute, Williamstown, Massachusetts.

the *Commercial and Financial Chronicle* to warn: "Passengers on a railroad train under full headway approaching a broken trestle would have no cause for alarm if they knew the engineer would stop in time to prevent the wreck, but not knowing that, would their fear wait until the leap into the chasm? Just so it is now with reference to our currency conditions. . . . We are heedlessly rushing on in a course which . . . will in the end . . . be destructive of all values." Later, when the depression was sinking in, the *Chronicle* deplored the "derangement" in business affairs, and the "wreck of our industries." Dispensing advice to the ambitious young man, Nathaniel Fowler cautioned him, "The top isn't crowded; but the way to the top is one great hurdle race of difficulty—rough and rugged, strewn with the bones of failure and the wrecks of disappointed ambition and consuming avarice." Further on, he admonished his reader to practice economy: "Extravagance is the rock upon which half our business men are wrecked."[12]

Wrecking also alluded to certain ruthless and predatory business practices of the 1870s, widely condemned by the scrupulous. In *A Little Journey in the World*, Charles Dudley Warner's genteel and morally upright New Englanders discuss railroad wrecking, described as the process whereby "wreckers" fasten upon:

"some railway that is prosperous, pays dividends, pays a liberal interest on its bonds, and has a surplus. They contrive to buy, no matter at what

82. *The Iron Jaws That Smashed Pacific Mail.* Cartoon from *The Daily Graphic,* New York, March 19, 1875.

cost, a controlling interest in it, either in its stock or its management. Then they absorb its surplus; they let it run down so that it pays no dividends and by-and-by cannot even pay its interest; then they squeeze the bondholders, who may be glad to accept anything that is offered out of the wreck, and perhaps then they throw the property into the hands of a receiver, or consolidate it with some other road at a value enormously greater than it cost them in stealing it. Having in one way or another sucked it dry, they look round for another road."

"And all the people who first invested lose their money, or most of it?"

"Naturally, the little fish get swallowed."

"It is infamous," said Margaret—"infamous!"

The Darwinian references are obvious, but they effectively portray the character of the wrecker as fearful, powerful, and amoral. The most notorious of the wreckers was the speculator Jay Gould, whose plundering earned him a fortune. More awesome than heroic, Gould inspired dread and condemnation, combined with grudging admiration for behavior so bold and unscrupulous. A contemporary cartoon (fig. 82) vividly illustrates this figure of destroying greed. A black-bearded giant, Gould hoists a toy-size steamship into the jaws of a gaping, tongue-waving, steaming, snorting locomotive engine: the big fish swallowing the little. Although Gould's role here is only that of the beast's feeder, he and the engine together constitute a colossal and

irresistible force against which the little boats are as helpless as they might be in a storm at sea.[13]

By the 1880s the situation began to change when the investment banker emerged as the rescuer of embattled, wrecked, and ruined companies, overcapitalized and in dire need of reorganization, which the savior would undertake in return for a large fee and management of the restructured company. This development proved to be the nursery of the interlocking directorates and imperial holding companies that concentrated management—and access to capital—in a few strong bankers' hands. In 1886, one financial newspaper hailed the advent of the rescuers as the sign of a new and better age about to dawn: "These events look as if our industrial interests were entering upon a new era indeed. Railroad 'wreckers' have to our shame been a fruitful production of American soil heretofore, and for a long period a blight upon all progress. Now it appears that in Mr. [J. P.] Morgan and his co-laborers, conservators instead of destructionists, have the control." This was an illusory sign of stability, as the panic and depression of the 1890s would soon prove.[14]

What did these real-life economic scenarios have to do with Homer's wreck and rescue scenes? Much financial wrecking was concentrated in the railroad business and had little to do with imperiled ships or drowning victims. Yet the imagery of wrecks and drownings, doom and salvation in Homer's works was likely to have generated connotative links beyond the self-evident nature of the subject or its metaphorical celebration of stern, selfless heroism. In this connection, it is worth examining the purchase of *Undertow* by Edward Dean Adams (1846–1931) of New York, a millionaire banker and industrialist with intricate business involvements. Adams was a friend of Homer's well-connected brother Charles, who may have helped suggest or engineer the sale. A man of considerable power and influence, Adams was at the center of American financial and industrial life, holding a number of positions in Thomas Edison's corporations and heading up the Cataract Construction Company, which built an electrical power plant at Niagara Falls in the 1890s. Deeply engaged in the production of power (and the garnering of its profits) for modernizing America, he was also the savior of numerous distressed companies. Among other feats, he "rescued" the New Jersey Central Railroad from receivership in 1887, "rescued" the American Cotton Oil Trust from impending bankruptcy in 1890, and helped "rescue" American currency in 1896 by purchasing $2 million in gold bonds for the Bank of the United States, thereby strengthening the nation's gold reserve and its credit during a dangerous period of depression. How could Homer's theme and its treatment in *Undertow* fail to appeal to such a player? The New York *Tribune* described *Undertow* as an "intense epic" that made other figure paintings look tame. The scene was "dramatic"—a favorite word for Homer's paintings—yet the artist had expressed himself "with much reserve." There was no violent attitudinizing or gesticulation, and the lifesaving men, "bronze heroes of the sea," were "entirely calm and businesslike." The image of brawny and powerful yet businesslike rescuers, salvaging victims from the pitiless waters of the sea may have

spoken to Adams, the immensely powerful savior of businesses in distress, in persuasive and personal terms. From this I do not draw any generalizations about the making of meaning in Homer's wreck and rescue scenes, nor do I suggest that Adams drew literal or obvious parallels between himself and the lifeguards. After all, the most famous of Homer's rescue scenes, *The Life Line,* was purchased by tobacco heiress Catherine Lorillard Wolfe—neither wrecker nor rescuer herself in any sense— on the opening day of its display at the National Academy of Design in 1884. Still, it is conceivable that to Adams and the other businessmen who admired and bought Homer's paintings, his sea and shore dramas spoke in stimulating figurative terms of their world and their battles. Homer's way of monumentalizing and heroicizing the fateful struggles and deeds of his actors was probably attractive to those eyes as well.[15]

The Language of Power

Homer's ascent to the rank of American master shifted to a steeper and swifter trajectory in the early 1890s, when his stormy Prout's Neck seascapes and wilderness hunting scenes began to attract excited notice and ready buyers. Although he did not abandon wrecks and rescues, he turned more often to subjects that spoke in transcendent terms of bigness and potency in the language of the ocean's vast, eternal rhythms, or of men stalking, assaulting, and subduing nature. It may have been no coincidence that his reputation gained momentum with the move from themes of peril to themes of power. Through the celebration of force Homer fashioned a mythic, irresistible image of an American spirit—masculine, independent, tough, and bold—just at the time when that spirit seemed to waver and fade. The illusions he marketed, proclaiming the survival of such traits, found receptive ground.

In 1891, Homer exhibited four new paintings at Reichard's Gallery. Of these, two in particular inaugurated the investigation of pure seascape that was to become a dominant theme in his art over the next two decades: *Sunlight on the Coast* (1890; Toledo Museum of Art) and *Winter Coast* (fig. 83); these were shown with the closely related *Summer Night* (1890; Musée d'Orsay, Paris), and with *The Signal of Distress.* Alfred Trumble could barely contain himself, writing that these were Homer's "most complete and powerful pictures ever," even, "in their way, the four most powerful pictures any man of our generation and people has painted." With these works Homer had indisputably achieved the rank of a "great American artist, in the full greatness of an art as truly American as its creator; what words could mean more?" Like bigness, power was a constant in talking about Homer, particularly his shore and ocean scenes. When the Boston *Herald* reviewed *Weatherbeaten* (see fig. 60) and *Below Zero* (1894; Yale University Art Gallery, New Haven) at Doll and Richards, it was to praise the "quality of primal power, of rugged native strength" in these pictures, both representing "titanic and terrible aspects of nature, one dynamic, the other static, but the latter as suggestive of tremendous, invincible

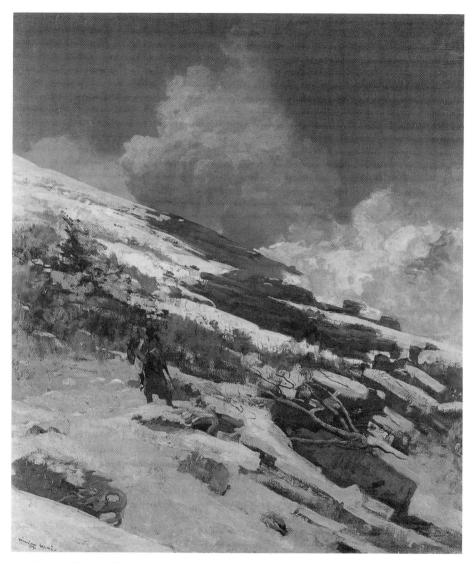

83. Winslow Homer, *Winter Coast*, 1890. Oil on canvas, 36 × 31⅝. John G. Johnson Collection, Philadelphia Museum of Art.

force as the former." The word *titanic* also recurred many times as critics tried to convey the effect of size and force in Homer's seascapes—and in the man himself, a kind of Paul Bunyan of painting. Charles Caffin praised the lack of technical refinement in Homer's paintings as the essence of their strength: "their very crudity, their occasional almost savage disregard of formula . . . that is the secret of their greatness. They rise superior to small painter shibboleths, crush and confound the formularies, and plunge one into contact with the crudeness of elemental force." Aided by no one, Homer had reached his goal by "sheer force of character," his

nearest kin the "pioneer of Modern America." His greatest work reflected the American spirit in "the largeness of outlook, the grappling with problems of vast magnitude, the independence of conventional restraints."[16]

Such representations suggest just how much power counted at that time. To understand the immense strategic advantage carried by the attribution of such power to Homer, it is necessary only to look at contemporary representations of businessmen—not ordinary businessmen, but those who had by virtue (supposedly) of sheer personal force scaled the loftiest heights of money-getting. The businessman of that time was regarded with greatest ambivalence: a crude, corrupt, amoral destroyer on one hand (like Gould and his despicable wrecking campaigns); a figure of heroic scale, a leader, a creator, a builder on the other. There was seldom any disagreement that among the great businessmen—the tycoons, the entrepreneurs, the captains of industry—there was not a weakling to be found. Indeed, representations of the "real" tycoons, capitalists, and speculators matched the invented figure of Curtis Jadwin, Frank Norris's speculator-hero in *The Pit*. A merciless marauder, the businessman often seemed living proof of Darwin's theories. When Rockefeller began to assemble the Standard Oil Trust in 1882, he made no bones about his will and ability to crush the competition: for his trust he wanted "only the big ones, those who have already proved they can do a big business. As for the others, unfortunately, they will have to die." Contemporary accounts of individual businessmen abounded in imagery of the natural force, the dauntless fighter, and the merciless predator. E. L. Godkin likened Cornelius Vanderbilt to the "unmoral, unsentimental forces of nature [that] grind down whatever opposes their blind force," and James Gordon Bennett's *Herald* celebrated the fighting spirit that propelled Vanderbilt toward his goals "like a ball from a cannon." Henry H. Rogers, one of Rockefeller's associates, welcomed the company of his despised rival A. C. Burrage at dinner parties because it so deliciously fed his fantasies: "I enjoy it immensely. I was thinking all the time how he would look after I plucked him."[17]

The most fearsome of all was J. P. Morgan, builder of the megacorporation U.S. Steel. Herbert Casson described Pittsburgh, the company's industrial center, in mighty natural analogies, portraying it as a place where "those three half-tamed monsters, fire, steam, and electricity," were "shackled and goaded into a frenzy of omnipotence," producing an effect "less like industry than war with the stubbornest elements of nature," over whose hostile forces human power strenuously imposed its will. The players in this elemental drama were correspondingly mythic in scale. There was John Warne Gates, the "wire king." "Energetic as a cyclone," he lived life as a "give-and-take battle for high stakes." Above all there was Morgan himself, the "scarred victim of a hundred battles," a financial colossus who was "almost more than a man" and to whom transactions of ordinary size seemed petty. Terribly masterful, Morgan "rushed at his work like a Titan who had at last found a task worthy of his strength." Like the artist, he was a creator, and U. S. Steel was his "financial masterpiece." Those who viewed Morgan as a brutal force of destruction

figured him in the very same analogical terms. Many had felt in their souls the "iron of his ceaseless and relentless foraging," said one; he was a modern juggernaut, "crushing, craunching, and destroying all who tried to resist," said another. Walt Whitman's friend Horace Traubel figured Morgan as something extra-human, "not quite man," and adorned with "tooth and claw, not forgiveness and reciprocity."[18]

There were some glaring inconsistencies in this picture of Morgan the titanic, towering force, whether mighty builder or crushing juggernaut, and these very inconsistencies help to make clear the meaning of Morgan and of his aesthetic counterpart, Homer. Morgan had started out as heir to a very large fortune, which he parlayed into something much bigger still. His success was as much a result of advantageous positioning in the right power networks (along with his inherited wealth, of course) as it was of fierce, solitary struggle against hostile forces in the commercial world. In this, Morgan was entirely typical of his age. In Casson's account, the same pages that described Morgan as the scarred colossus also smoothed him out as a "builder and peacemaker, the most implacable foe of hostility among capitalists," the champion of "team play" and "community of interest." Likening U.S. Steel to a modern navy, Casson announced that it was Morgan's task "to federate these proud and jealous fleets" so that there would be "no mutiny, no breaking away, no survival of old-time prejudices." Despite all evidence to the contrary, however, many persisted in seeing Morgan as a self-made, self-making, self-reliant man whose life had been a "romance of individual achievement." Ironically, Morgan's most hated rival was Andrew Carnegie, who represented a defiant, anachronistic individuality not to be tolerated in an "age of interdependence" in business.[19]

The more completely American society fell into the unifying network of consolidation, the more insistently did some defend the viability of the outmoded independent self. "The American commonwealth," said stockbroker Chauncey DePew in 1897, "was built upon the individual," the result being that "we have thus become a nation of self-made men." The American citizen, wrote Henry Wood, had for generations been "self-reliant and self-respecting" in the true "spirit of Americanism." Indeed, so essential was self-reliance that it was "inborn." Recent scholarship has unraveled the "self-made" myth, but at the turn of the century it was a belief ferociously cherished even though those who proclaimed its truth were more likely to have risen to wealth and prominence from well-connected elite or middle-class positions than from the gutter. As early as the 1870s, according to one study, the typical industrial leader was neither a once-impoverished immigrant nor a self-made former farm boy but an Anglo-American of New England ancestry who professed Congregational, Presbyterian, or Episcopalian faith, was raised in an urban environment, and was bred in an atmosphere where business and relatively high social status were intimately associated with family life. Still, earlier in the century the dominant system of individual or partnership enterprise allowed ample scope for independent operation, encouraging young men to quit their jobs and risk starting their own businesses. By the century's end, however, more and more began to leave their jobs

to transfer to competing bureaucracies. The transformation took a heavy toll on many individuals, who keenly felt the strain between personal autonomy and the restraints imposed by bureaucratic and corporate structures. George W. Perkins, for example, rose through the ranks of the New York Life Insurance Company and achieved an exalted partnership with the House of Morgan in 1901. He later resigned, "the more freely to write and speak of the conflict within men he had known who had been nurtured on the precepts of self dependence and self help only to become ensnared, as they saw it, in the new bureaucratic processes of conference, consultation, and compromise." Even the seemingly lofty were not completely independent. Charles Mellen, a Morgan associate hailed as the "Railroad Lord of New England," stated, "I suppose that there is more or less prejudice against me because I wear the Morgan collar, but I am proud of it."[20]

It was just then that the conflicting pressures of encroaching incorporation and residual but persistent individualist ideologies were at their most intense—before modes of adjustment had been fine-tuned—that Homer came so dramatically to the fore. His public image represented an anachronistic yet ardently defended ideal of pure, hardy individualism in a period when corporate, centralized, bureaucratic systems of organization increasingly threatened the sense of personal autonomy that lay at the core of earlier American democratic and social ideals. In his art, Homer celebrated a cult of power—personal, natural, and explicitly masculine. For viewers, he functioned metaphorically as a sort of surrogate self, a heroic figure as big and powerful as a Vanderbilt, a Morgan, or a Jadwin, acting out (seemingly) in person and in painting the most uncompromising independence, battling the elements single-handed, with no corporate tentacles to restrain his actions. Even though the model was anachronistic, at the same time its very survival and viability in the persons of a Morgan or a Carnegie or a Homer held out the possibility of its revitalization. Homer himself had a specific audience in mind. When he sent twenty-seven Canadian sporting scenes to the Carnegie Institute for a show, he told the director, John Beatty, "You will find that the men of Pittsburgh will like these things, and the women will be curious to know what the men are looking at, and the first thing you know you will have an audience." Of course, women were not rigidly excluded from Homer's world. They appeared often in his paintings of shore life (though most often as brawny fishwives rather than corseted bourgeoises); women critics wrote about him, and a pair of respectable maiden sisters bought one of his deer-hounding scenes. Nonetheless, whatever their appeal to women, it was to men that Homer's pictures spoke most eloquently.[21]

To what extent did Homer's tableaux of raw power strike an answering note in those who bought them? Certainly, as his paintings became increasingly prestigious commodities, simply having one might have come to outweigh or at least match the attraction of the subject matter, the power of the blunt, "big" style. The case of John Graver Johnson (1841–1917) of Philadelphia does suggest the possibility of a temperamental "match" between painter and patron. Johnson, who built a large

collection over forty years, bought paintings "purely for his own pleasure" to serve as "constant companions." One of the earliest buyers of Homer's new "pure" seascapes of the 1890s, he acquired *Winter Coast* and *Sunlight on the Coast* out of the Reichard exhibition in 1891. *Winter Coast,* part of that "most complete and powerful" quartet praised by Alfred Trumble, shows the slanting, snow-crusted ledges on the coast at Prout's Neck. A huge wave has just crashed over the rocks, shooting foam into the air against the leaden sky. Watching this display of watery might is the single figure of a hunter with a rifle, a dead goose slung over his shoulder. The only other element in the foreground is a twisted claw of driftwood. Against the tumbled blocks of the ledge and the huge bloom of spray the hunter appears very small yet sturdily planted at a prudent distance from the cold and dangerous breakers. Charles Caffin might see in this figure an analogue to the artist himself, "grappling with problems of vast magnitude." He might also relate the strength and vastness of the ocean to Homer, the artist of the colossal, boundless spirit. Did Johnson see himself there as well? This is of course impossible to guess. He was admired, though, for certain qualities of mind very like those ascribed to Homer. Johnson was an eminent and powerful lawyer, the son of a blacksmith. Orphaned young, he succeeded in earning his law degree at the University of Pennsylvania. He became one of the best-known corporate lawyers in the country, representing his clients in a number of important antitrust cases that pitted huge forces against each other. He was known and respected for the "vigorous power" of his reasoning and for his absolute integrity. His accuracy in the statement of facts was matched only by his forceful exposition of the law applicable to them. The problems submitted to his judgment were "so stupendous and the interests involved so vast, he carried a weight of professional responsibility never before placed on a single man," yet he "never swayed beneath the burden and never paused for breath," applying himself to his tasks with a concentration "like the coil of a python." Artist and lawyer, who moved in such different worlds, shared a set of characteristics—self-reliance, integrity, forcefulness, bigness— that branded them both as men larger and more heroic than life, men who served as models of what modern men should be. I would not venture to argue that Johnson self-consciously recognized "himself" in Homer's picture, any more than Edward Adams might have seen himself in *Undertow.* Since much of his collection, however, consisted of Barbizon School and other modern French paintings, his decision to buy these works by Homer indicates the probability of some powerful, personal appeal.[22]

Save for his humble origins, Johnson matched the general pattern of other Homer collectors, who for the most part were hardly in the self-made category. Edward Adams, for one, conforms to the profile of the business elite outlined above: old New England stock, university degrees, success attained through extensive connections with corporate organizations. Thomas B. Clarke (1848–1931) came from a similar background: born to moderate affluence in New York City, he traced his family roots to several generations settled in Milford, Connecticut. He prospered as a man-

ufacturer of collars and cuffs in Troy, New York, before retiring from business in 1891 to devote himself to art collecting and dealing. While there were many individual variations, a sizable group of those who bought paintings by Homer were cut from the same cloth. They were bankers, engineers, lawyers, doctors, and stockbrokers; many sat on the boards of corporations; a number were active art collectors; they belonged to elite men's clubs; they were active in philanthropy or other forms of community service. Although a few, including George Seney and William Evans, suffered financial reverses and embarrassments, most seem to have been prosperous and prominent citizens, their number including a strong component of Boston Brahmins. With their birthdates bracketing the midcentury, Homer collectors of the first generation passed their formative years in a climate different from the one that marked the post–Civil War decades, when the character of economic and social life changed so dramatically. Relatively secure they may have been, but conscious nonetheless of living in a more complex, more muddled, less predictable world, and certainly not immune to its effects. Homer offered bracing subjects, affirmations of limitless power, and the vision of a simple, elemental, antibureaucratic world of invigorating and thrilling struggle—a world profoundly different from the complicated one in which his collectors found themselves. Just as the world Homer offered was a deftly edited construction, an illusion, so was his own self-making. He did come up through the ranks in a sense, starting out as an illustrator and then breaking into the painting trade. While his formal lessons were scant, he nonetheless lived and learned amid a thriving New York art colony during the first half of his career, and during the second he derived the most substantial benefit from the support of men like Clarke, who not only bought his paintings but urged business associates and fellow club men to do so as well. The sturdily self-reliant Homer was well aware of his dependence on Clarke, writing to the him in 1892, "I never for a moment have forgotten you in connection with what success I have had in art. I am under the greatest obligation to you, and will never lose an opportunity of showing it." The fiction of Homer's self-reliance, though, was intrinsic to his selling power. By owning a Homer, a collector possessed an artifact magically imbued with an authentic and undiluted American spirit, and by *being* Homer, the artist propelled the aesthetic (metaphorically, at least) from the edges to the center of power.[23]

The Vicarious Adventure

In light of these fictions, there is a good deal of irony in the fact that Homer's scenes of rugged survivalism in the Adirondacks and Canadian wilderness should be so closely bound to corporate institutions seemingly so far away. The willingness not only to believe in the myths that the hunting and fishing scenes promulgated but also to receive them as further evidence of Homer's bigness and sturdy independence suggests once more the strength of the socially driven need for what he promised to provide: images of power, largeness, and autonomy. The Boston *Transcript's* reaction to Homer's watercolors of sport and danger along the Saguenay

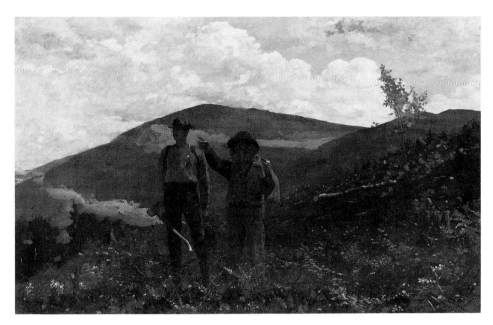

84. Winslow Homer, *The Two Guides,* c. 1875. Oil on canvas, 24¼ × 38¼. © Sterling and Francine Clark Art Institute, Williamstown, Massachusetts.

River and Lake St. John is typically fulsome. The critic (more than likely William Howe Downes) extolled the "great feeling of freedom and bigness, of wide spaces and wide opportunity, of youth and hope and joyful life" that permeated these landscapes with their boiling rapids and intrepid canoers. *The Two Guides* (fig. 84) prompted the same enthusiasm when it was exhibited at the Union League in 1890. This painting was full of what was "most original and most American" in Homer's art: "The younger has an axe in his hand, and supplies an American type which Mr. Homer, almost alone among our artists, gives us only too rarely. He is finely masculine. The way his head is set on his shoulders indicates will power. He grips his axe like a man who knows how to wield it by ancestral right as well as early training. There is something free and audacious in his pose . . . something finer and nobler than mere size and good health." Downes also found the men in *The Two Guides* to be "American types of the hardy sort. All [Homer's] characters have been outdoor men, men of action, the kind of men who make up the real backbone of the nation. Soldiers, sailors, woodsmen—this is a virile art. He does not prettify them; they are rough, tough, and will stand all kinds of weather." Clearly, the woodsmen who hounded deer, chopped down trees, and angled for game fish in wild, crystalline waters represented types to admire and emulate. The real backbone of the nation, of course, had long since been transplanted to the men of the urban marketplaces and corporations, but these bureaucrats, financiers, and businessmen could share the experience and identity of those hardy, outdoor, virile men by

retreating to the wilderness themselves, where under conditions to some degree carefully controlled they acted out revitalizing rituals of risk, conquest and control, while strengthening the male-male bonds so necessary for smooth management in the corporate world.[24]

Although Homer began to explore the Adirondacks in the 1870s, when he produced *The Two Guides* and several other images of life in the woods, in the late 1880s he began a sustained series of watercolors, and a few oils, depicting scenes in the Adirondacks and the even wilder reaches of Quebec. Like his stormy Prout's Neck seascapes, Homer's wilderness paintings represented a deliberate act of scene-staging to create the appearance of primitive nature in developing regions accessible by railroad. To the critics who admired the works in Boston, New York, or Philadelphia, though, the beautifully constructed scenes were the result of yet another voyage of "artistic discovery," a figure that reinforced the notion of Homer as a hardy, risk-taking adventurer.[25]

David Tatham and Helen Cooper have demonstrated how Homer segregated his tableaux of pristine wilderness from anything that betrayed the nearby presence of civilized comforts. The North Woods Club, which from 1888 was Homer's base of operations in the Adirondacks, was a sort of corporation itself, having been purchased in 1887 by a group of New Yorkers who had incorporated themselves in 1886 as the Adirondack Preserve Association for the Encouragement of Social Pastimes and the Preservation of Game and Forests. Homer was elected to membership in January 1888 and made his first visit in 1889 as the guest of George W. Schiebler, a wealthy manufacturer from Brooklyn. Although the majority of the members were male, wives sometimes accompanied their husbands to the resort, which featured a rustic but comfortable lodge with an adjacent dining hall, along with a few cottages built by individual members. By 1895, the club owned some five thousand private acres for the pleasures of its exclusive membership. In the mid-nineties the annual dues was fifty dollars—as much as 15 percent of the average worker's annual income at that time. Homer painted most of his Adirondacks watercolors, writes Tatham, within a few hundred yards of the clubhouse, and nearly all of them at locations most frequented by the members. As Cooper has pointed out, the "fishing fraternity" to which elites of the North Woods Club belonged were not merely men who liked to fish but part of the power network of the United States, the same network that sustained Homer's own collectors. Wilderness clubs were in effect the outposts of the urban institutions that brought businessmen together. The Tourilli Club, which Homer visited from 1895 on, was equally exclusive, limiting its membership to seventy, mostly drawn from the social elite of the Northeast, the Midwest, and of course Canada. It had a sumptuous clubhouse, although after their first season there, Homer and his brother Charles built their own log cabin some distance away. Again, the nearby availability of civilized amenities—for the affluent sportsmen at least—was nowhere hinted at in Homer's paintings.[26]

While there was some risk-taking involved in the sports enjoyed by club mem-

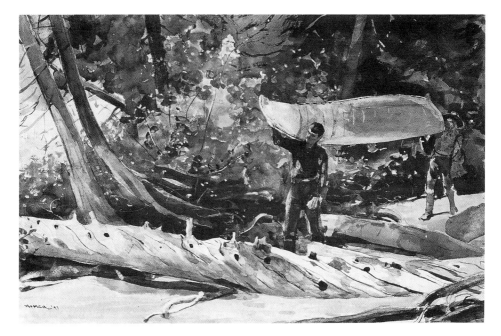

85. Winslow Homer, *End of the Portage*, 1897. Watercolor on paper, 14 × 21. Brooklyn Museum; 78.151.1; Gift of the Estate of Helen B. Sanders.

bers, it was of a mild variety. The wilderness experience offered by such institutions as the North Woods Club and the Tourilli Club was a masquerade of sorts: an impersonation of the masculinist and adventurist ideologies so tightly woven into the history of exploration, progress, and development in the United States and in Western culture generally. This helps to explain Homer's tendency to make guides, rather than guests, the stars of his paintings: dragging drowned stags from the water, maneuvering boats, casting flies, netting trout. Guide figures were part of the masquerade; they represented the sportsmen as they wanted to think of themselves, were stand-ins for the elite group of urban men who could pay to fulfill cherished fantasies of pioneering wilderness adventure. Even the paintings depicting sportsmen as part of the action are not necessarily to be taken at face value. *End of the Portage* (fig. 85), for example, shows a sportsman with a red sash and a guide in a broad-brimmed hat sharing the burden of their canoe as they encounter a tangle of tree trunks on the path. Compare Henry van Dyke's description of his own canoe trip in the same Quebec waters, a couple of years earlier: "These portages are among the troublesome delights of a journey in the wilderness. To the guides they mean hard work, for everything, including the boats, must be carried on their backs. . . . But the sportsman carries nothing, except perhaps his gun, or his rod, or his photographic camera; and so for him the portage is only a pleasant opportunity to stretch his legs, cramped by sitting in the canoe, and to renew his acquaintance with the pretty things that

are in the woods." Whether or not there were sportsmen who helped their guides carry the canoe, this example illuminates how selectively Homer constructed his scenes of wilderness action.[27]

The sportsmen's cult of adventure and Homer's celebrations of it were what tied the "wilderness" experience to the world of commerce and finance that had been left behind. Certainly revitalization, escape, and relaxation figured into the wilderness retreat. The contemporary literature of vacation earnestly counseled harried businessmen to renew their bodies and souls in the remote fastness of nature, far from "corporations, trusts, stocks, bonds; electric lights that amaze the sight, harsh warnings of trolley gongs, the rumble and grind of the wheels and the brakes on the elevated road." Against this, though, consider the reading of Homer's hunt scenes offered by John Wheelwright, writing from the vantage point of 1933:

> Americans as a people lacked . . . the habitual familiarity with tragedy, to
> give any social ritual full meaning excepting one, the ritual which acts out
> Man's primal combat with beasts and elements. . . . To leave the hateful
> city . . . and there to kill beasts, although one is not actually dependent
> upon hunting for one's food, is to make of hunting a propitiation for the
> thwarting of one's desires by groups of other men. Homer's hunters and
> fishers, going away seasonably throughout their lives to the forest and the
> sea, learned of tragedy, and to what they learned Homer gave conscious
> and purposeful expression. For this they loved him. The symbols of their
> cult were those of suffocating fishes and bleeding beasts. They were the
> priests and votaries of a religion. He was a sage of wood and sea.

The key image here is of ritual: a staged social performance invested with meaning that might be the expression and affirmation (or in some cases, subversion) of the social order, of belief systems, of tradition. The ritual in this instance was the performance of adventure, not only for the reasons Wheelwright advanced—propitiation, compensation—but also because it allowed businessmen/sportsmen to rehearse the stances and moves historically and culturally associated with the adventurous expansion, conquest, and control of continental lands, from one coast to the other. Homer's Adirondacks logging scenes fit this ritual pattern as well. Such performances reproduced capitalist ideologies in the sense that they modeled the attitudes of aggression, ferocity, and rapaciousness featured in representations of super-businessmen like J. P. Morgan, with his teeth and his claws, or Henry Rogers, who so enjoyed the thought of plucking his victims. Angling, of course, seems a long way (deer-hounding less so) from the kind of ruthless "crushing and craunching" practiced at least metaphorically by Morgan and his contemporaries. Nonetheless, it still represents an act of predation, a sublimation— with cunningly made tools and delicate skills—of the osprey seizing a fish in its talons, or the big fish swallowing the little.[28]

Very few of Homer's Adirondacks or Quebec scenes suggest fatal loss of control as a consequence of the ritual of adventurous quest. The only slaughter is that of

the deer, the trout, the salmon, and other assorted animal (and vegetable) victims. Here lies the difference between Homer's ocean scenes—the wrecks, the fishermen in peril, the drownings, the capsizings—and his forest adventures. His wilderness adventures affirmed and celebrated individual force, manly vigor, and the mastery of nature in archaic rituals of the hunt, or in the dominion of the woodsman with his ax. The wilderness experience as depicted in Homer's paintings was idealized as well as aestheticized, but that was the point: to offer a vision of perfect manliness, perfect independence, and a firm control that was seldom in question. Ruminations on death and vulnerability they may well be from certain angles, but from others they seem to proclaim the rugged individual's "natural" dominion over the natural world.

It was not only a matter of predation. The idea of adventure, writes Martin Green, "played a part in the history of capitalism. The whole idea of the joint stock company, and the Stock Exchange, on which so much else of our economic system rests, is based on adventure. . . . An adventure in medieval times could mean a share in a trading voyage. . . . This is not the primary meaning for *our* word 'adventure,' but there are connections; the idea of risk was there already, and so was the idea of travel and of passing beyond the limits of the known and secure, literally and meta-phorically." In the 1890s, Willa Cather readily perceived the analogy between ad-venture and money-getting as something intrinsic to modern business: "The great end [of] modern endeavor and the goal of the knight-errantry of fortune is money, just as literally as it was once the holy sepulchre. It is for that end that crimes are done and ventures made." Attitudes toward speculation per se were ambivalent, since speculation clashed with a residual producer ethos that to many still seemed a cleaner and much more legitimate way of making money, of working to make it. But every enterprise involved risk and uncertainty, or was supposed to. Frank Norris's de-scription of action in the Wheat Pit at the Chicago Board of Trade, where Curtis Jadwin engages in a heroic campaign to corner the market, resounds with the lan-guage of excitement and adventure: "The air of the Pit was surcharged with a veritable electricity; it had the effervescence of champagne, or of a mountain-top at sunrise. It was buoyant, thrilling. . . . The 'Unknown Bull' was to all appearance still in control; the whole market hung upon his horns; and from time to time, one felt the sudden upward thrust, powerful, tremendous, as he flung the wheat up another notch. . . . The Bears were scarcely visible. The Great Bull in a single superb rush had driven them nearly out of the Pit. Growling, grumbling, they had retreated, and only at a distance dared so much as to bare a claw." Professional he-man artist-reporter Frederic Remington struck almost the same note of excitement describing the sensations of the "real sportsman" heading toward the rapids in his canoe: "When he is going—going—faster—faster into the boil of the waters, he hears the roar and boom ahead, and the black rocks crop up in thickening masses to dispute his way. He is fighting a game battle with the elements, and they are remorseless. He may break his leg or lose his life in the tipover which is imminent, but the fool

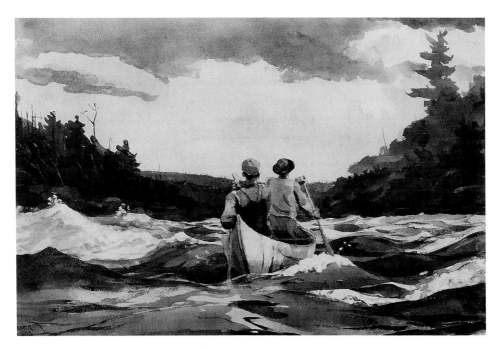

86. Winslow Homer, *Canoe in the Rapids,* 1897. Watercolor over graphite on white paper, 13⅝ × 20½. Courtesy of the Fogg Art Museum, Harvard University Art Museums; Louise E. Bettens Fund.

is happy—let him die." This is precisely the kind of excitement Homer conjured in the dramatic *Canoe in the Rapids* (fig. 86), with the two tensely poised figures deftly guiding their craft through the treacherous billows. The challenge, the danger, the suspense, the thrill, and the reward—or the (unlikely) disaster—were all part of the adventure, whether played out in the woods, on the water, in the skyscraper, or in the pit.[29]

Even Thomas B. Clarke's art collecting strategies fit this model. Just before he sold his American paintings at the famous Clarke Sale of February 1899, he was beginning to take an interest in the young California tonalist Charles Rollo Peters, for whom Clarke created the opportunity to show his paintings in New York at the Union League. One reporter commented: "Thomas B. Clarke, who has taken up Charles Rollo Peters . . . is noted as a backer of artistic 'long shots.' Inness, Homer Martin, and others were taken up by him when they were young, obscure, and ridiculed, and had their first start toward success as a result of his championship." To help his protégé, Clarke stalked some game himself. He sent Peters an account of the private view, where the artist's nocturnes were well received by a number of senators and "big men who viewed the pictures with delight. . . . I have been here all day with the art critics and have done my best to have them know how earnestly you work. You will be all right tomorrow I am confident. I really expect some fine reviews.. . . .Personally, I am delighted and amazed at the collection and I know that

the club members and their guests will derive pleasure and instruction from the exhibition." Clarke had done the same for Homer and Inness, the two stars of his collection. The 1899 sale represented the culmination of years of strategizing: showing the paintings at carefully chosen exhibitions, creating a network of cronies who bought works he did not corner himself, thus broadening the market, and taking advantage of a rebound in national confidence, expansionist sentiment, and prosperity after the Spanish-American War to make a spectacular selloff. Clarke's gamble paid off splendidly, grossing nearly a quarter of a million dollars and making banner headlines—gratifying rewards indeed to the speculator who had been warned that he was "inviting 'slaughter' " by venturing to hold the auction. "The prices realized at the sale," wrote Gustav Kobbé, "proved that American paintings were valuable investments." Clarke had been able to buy low and sell very high. The most spectacular returns were realized by George Inness's *Gray Lowery Day* (c. 1877; Wellesley College Museum, Massachusetts), bought by Clarke for about $300 and sold for a little over $10,000. Because Inness had died several years earlier, the scarcity factor was also in play. The returns on Homer, still living and producing, were impressive: *Eight Bells,* for which Clarke had paid $400, went for $4,700, and the total figure for the thirty Homer oils and watercolors in the sale was $22,345. The history of Clarke's collecting was that of a "voyage of discovery," a financial adventure: exploration, risk (of slaughter), and triumphant rewards. In comparison with the prices that European paintings could command, Clarke's triumph was modest, but considering the previous two decades of a generally flat market for American paintings, it was impressive all the same. With the sale, Homer and Inness vaulted into the privileged company of those whose works were twinned with high prices—another vital category of bigness and greatness.[30]

Stand-Ins for Manliness

Homer's sporting scenes could serve a variety of needs. Some viewers admired the fishing episodes because they displayed the painter's expert, inside knowledge of the subtleties and technicalities of angling. This allowed a kind of male bonding to form, an imaginary brotherhood of the rod and creel. Some viewers may have been attracted to the fishing and hunting themes because they bore the same powerful connotations of maleness as sports gear and trophies of the hunt. In an age when self-definition tended increasingly to be a matter of assembling and presenting the right set of commodities, sports pictures and paraphernalia were dependable tools for constructing a manly image, and here Homer's adventurous scenes of struggle in the woods and on the streams could function as potent signs in the visual and material language of masculinity. "We all, more or less, want to appear what we are not," said a writer in *The Critic.* "I know a man who theoretically is a great out-of-doors man. He fills his rooms with fishing-rods, the latest model shot-gun hangs over his fireplace . . . tennis rackets stand picturesquely crossed upon his mantle shelf. His library is stocked with sporting and nature books . . . he subscribes for

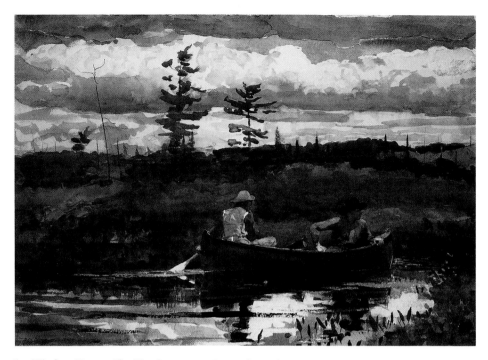

87. Winslow Homer, *The Blue Boat*, 1892. Watercolor and graphite on paper, 15⅛ × 21½. Museum of Fine Arts, Boston; Bequest of William Sturgis Bigelow, 1926.

Outing, Country Life, the *Country Calendar,* the *Rudder,* the *Rider and Driver* . . . but . . . he seldom if ever leaves New York even in the summer time, and a moth-miller beating against that wire screen of his window makes him shudder. And yet he really loves nature . . . theoretically."[31]

In Boston, Homer's paintings intersected with pronounced personal and sexual anxieties in certain cases. William Sturgis Bigelow (1850–1926)—neurasthenic, Buddhist, marksman—maintained a men-only retreat on primitive Tuckernuck Island off Massachusetts for restoring Brahmin vitality, feared by many to be on the wane in the later decades of the century. Although he had a large and varied collection, Bigelow found Homer's Adirondacks watercolors so appealing that he owned four: *The Hudson River* (1892), a logging scene; *Woodsman and Fallen Tree* (1891), *Hunting Dog Among Dead Trees* (1894), and *The Blue Boat* (fig. 87), all now in the Museum of Fine Arts, Boston. *The Blue Boat* is a reprise of *The Two Guides* in the paired figures, older and younger, in the boat, with the stock of a rifle visible between them: two tough men, combining experience and strength, venturing into the untouched heart of nature. This image reproduced, in a perfected form, the kind of revitalizing regimen offered at Tuckernuck, where even the strenuous Theodore Roosevelt came to stay in the sturdily furnished, rustic lodge, recalled by Charles Warren Stoddard as the "happy and sometimes hilarious summer home of the bach-

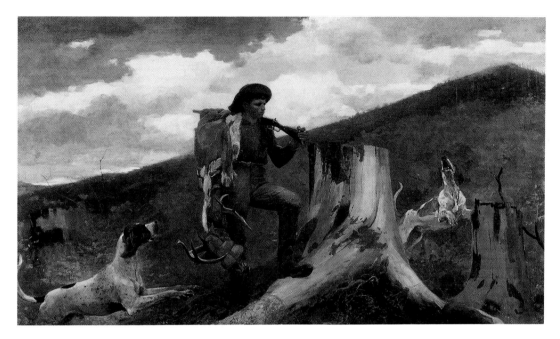

88. Winslow Homer, *Huntsman and Dogs*, 1891. Oil on canvas, 28 × 48. Philadelphia Museum of Art; William L. Elkins Collection, 1891, E'24-3-8.

elor host" and "his masculine unencumbered guests." As Trevor Fairbrother has pointed out, Bigelow shuttled between the luxury and urbanity of his Beacon Hill house and the calculated austerity of Tuckernuck, the latter a bracing antidote for too much enervating comfort and refinement. Bigelow kept these segments of his life rigidly apart, in fact. In "civilized" guise he was the besotted wooer of the Wagnerian soprano Milka Ternina, whom he showered with so much attention and so many "jools," in Henry Adams's words, that she was "always begging him to stop." He was a devoted student of Oriental religion and American transcendentalism as well as a connoisseur of Oriental art. What Tuckernuck gave him, though—and what Homer's paintings spoke to, perhaps—was the experience of regenerative male fellowship in the pure, free (albeit privately owned) wilderness. The poem "Tuckernuck," written by Bigelow's beloved protégé, George Cabot Lodge, expressed the joy of such camaraderie: "We loved too much for prayer or praise / The golden reach of noontide sea / We loved the large tranquility / Of flowing distances and days / In calm, dark sunsets or the blaze / Of moonlit waves, the ecstasy / And spacious thought of liberty."[32]

Bigelow's cousin Edward William Hooper (1839–1901) owned a large collection of works by Homer, including *Huntsman and Dogs* (fig. 88), which depicts a robust young hunter bearing the flayed hide and antlers of a stag and standing with foot planted triumphantly on the weathered stump of an ancient tree. Hooper bought the

painting straight out of the Reichard Gallery in 1891 or early 1892; he also owned the thematically related watercolors *Hunter in the Adirondacks* (1892; Fogg Art Museum, Harvard University) and a deer-hounding scene, *Deer in the Adirondacks* (1890; Thyssen-Bornemisza Collection). A Harvard alumnus and lawyer, Hooper was the antithesis of the hardy and sometimes brutal hunters in Homer's wilderness paintings. He served as Harvard's treasurer for twenty years, receiving much praise for augmenting and stabilizing the university's finances during his tenure. He was friend to the cosmopolitan painter John La Farge and the architect Henry Hobson Richardson, and friend, financial manager, and brother-in-law to Henry Adams, whom his sister Marian (better known as Clover) married; she committed suicide some thirteen years later, in 1885. Hooper's family had a history of instability. Another sister, recently widowed, threw herself under a train in 1887, following which Hooper himself suffered prolonged nervous collapse. In 1901, he died at MacLean Insane Asylum (part of Harvard's extensive institutional constellation), where he had been confined after a mysterious fall from a third-floor library window of his house on Beacon Hill. His own wife had died in 1881, leaving him with five small daughters to raise; their upbringing included extended sojourns in Europe, often with Henry Adams as avuncular shepherd. Hooper was a thorough aesthete and discriminating collector who, in addition to the many works by Homer, owned a substantial number of works by La Farge, Chinese art objects, rare books, and prints by William Blake. Most interestingly, Hooper was no sportsman. According to one relative, "he took little or no interest in sports for recreation but chose rather to go and look at pictures, and get lost in them." For Hooper, Homer's wilderness scenes may have had a number of overlapping connotations. With its clinical display of brutality and coldness that prompted Alfred Trumble to write that it seemed to be painted "on a chilled steel panel," *Huntsman and Dogs* and the other images of predation and death may have confirmed for Hooper the cruel powers of nature and civilization alike, in which delicate victims were ruthlessly hunted down, wounded, exterminated. The rude health, vigor, and possibly even the sexuality of the men in such paintings could have had a powerful appeal to someone only recently and perhaps never fully recovered from the nervous breakdown of 1888. Fears of (metaphorical) impotence assailed members of Hooper's class in the late years of the century when, in spite of their wealth and control of elite institutions, Brahmins found themselves steadily losing political ground, becoming, as Henry Adams said of himself, his brothers, Hooper, and other members of their circle, "tuskless beasts." Perhaps the image of stern, lordly, ruthless solitude projected by the young hunter provided an imaginary if temporary escape route to one surrounded and ruled by dependent girls and inherited class values, and woven into a network of institutions and approved social connections. Hooper's lifelong friend John Chipman Gray remembered him as no ordinary connoisseur. Hiding a fierce intensity of temperament beneath a quiet surface, he responded to the art he loved not with "cultivated admiration" but with the "passion of soul answering soul," Chipman wrote. *Hunts-*

man and Dogs in this scenario was Hooper's portal, perhaps, for a journey into a bleak and deadly world that was, at the same time, a space of rude health, pure, primitive manhood, conquering strength, and elemental individualism.[33]

While Hooper's was a highly individual case, the tone of much of the criticism on Homer indicates how felicitously he stepped into the large, empty spaces symbolizing the lack so many admirers seemed to perceive in themselves, in modern manhood, in modern America. William Howe Downes probably wrote more often, and more enthusiastically, about Homer than any other contemporary critic, becoming in time the artist's first biographer. Not quite a Brahmin, Downes nonetheless had a similar background, and the newspaper—the *Boston Evening Transcript*—on which he served as art critic for more than thirty years was the Brahmin paper of choice. Homer was succinct in his opinion of the *Transcript,* calling it "that old maid newspaper," and he held Downes, his major booster, in such tepid regard that the two never seem to have met, even though Homer was frequently in Boston (and wrote almost fawning letters to his material benefactor Clarke). Homer flatly turned down the critic's request for information to aid in preparing the artist's biography, telling Downes: "It may seem ungrateful to you that after your twenty-five years of hard work in booming my pictures I should not agree with you in regard to that proposed sketch of my life. But I think it would probably kill me to have such a thing appear, and, as the most interesting part of my life is of no concern to the public, I must decline to give you any particulars in regard to it." There is just a touch of flippancy here: it is difficult to believe that Homer really thought Downes's work "booming" his pictures was "hard." And in this might lie the rub, for Downes; that is, as a man in the culture industry, he may have felt as peripheral to the urgent business of life as artists were supposed to be. Considering the terms he fashioned for Homer, figuring the painter as a kind of superman, all muscle, virility, and force, it is clear that he functioned for Downes as an idealized alter ego, the powerful and desirable Other to the citified man behind the desk, who would never be more than the functionary of that old maid paper in his hero's eyes.[34]

As the Bostonian examples suggest, class, occupation, region, and personal history could play mediating roles in the reception of Homer's wilderness scenes, which had a range of resonances depending on individual positioning. Like others, the Brahmins fashioned personal variations on the thematics of autonomy, largeness, power, and control that these pictures embodied. While his Boston patrons tended as a group to be distinct in interests and class values from his patrons in other urban areas, what united them all as upper-middle-class to upper-class men was that they were prey to the many uncertainties and stresses of the waning century. Whether Homer's paintings were affirmations of bigness and control, uncomfortable dramas of peril and doubtful success, celebrations of power, raw tragedies, or escapist masquerades, they expressed and helped release some of the most grating tensions afflicting the class to whom they most appealed, and at the same time they helped sustain fictions vital to preserving belief in individual autonomy just when the threats

against it seemed most ominous. Most important for Homer's success and canonization was the way that his own masquerade presented the image of manly businessman disguised as artist—or manly artist disguised as businessman. Ostensibly detached from worldly affairs, Homer achieved a nearly perfect mesh of artistic sensibility and creativity with the masculine, risky, all-American world of big, swashbuckling business enterprise, equally a masquerade in its way, but essential to sustaining an indispensable myth of heroic individualism. Even though the original conditions of viewing have changed, those meanings still seem to buoy and perpetuate Homer's continuing appeal.

PART FOUR

The Artist in the Realm of Spectacle

7 PERFORMING THE SELF

In the late nineteenth century, writers exhibited a marked tendency to dwell on the personal traits and appearance of artists. Nowhere was this more pronounced than in the voluminous archive dedicated to the expatriate American James McNeill Whistler (1834–1903), the subject of scores of articles, a number that would rise to many hundreds (along with a large number of books) in the decades after his death.[1] Both generator and focus of a vigorous publicity enterprise, Whistler—or at least certain versions of him—lived in the public eye, his famous eccentricities widely circulated through accounts in newspapers and magazines. He exhibited himself as a figure of contradiction and paradox, his flashy, abrasive demeanor at war with his aesthetic sensibility. It was this demeanor, though, that drew attention to his art, and one critic after another succumbed to the fascination of his personality and repeated the query: how could such a caustic, pugnacious exhibitionist produce an art of such exquisite delicacy and refinement?

The case of Whistler vividly dramatizes the injection of the modern artist into the realm of spectacle, where manufactured images assumed a dynamic existence as commodities, to be desired, replicated, exchanged, consumed, exhausted, and replaced. Being an artist in the realm of spectacle entailed learning how to perform as one, cultivating the right kind of identity. At a time when a vigorous aesthetic main-

stream privileged self-expression over legibility in painting, the artistic performance of personality became an important substitute for the loss of readable narrative and conventionally symbolic meaning. Indeed, more and more painting was *about* an artist's personality and nothing more. Because of its gaudy, exaggerated outlines, Whistler's example serves as a highly suggestive vehicle by which to explore the emergence, during the latter decades of the nineteenth century, of the artist as entertainer, incorporated into the nascent culture industry that would grow to vast proportions in the twentieth century.[2]

So fascinating was Whistler's public image that on occasion articles focused almost exclusively on his looks, style, mannerisms, and quips. The title of "Whistler, Painter and Comedian," published in the popular *McClure's Magazine,* speaks for itself. The article said little about Whistler as a painter, electing instead to concentrate on the comedian in a series of colorful, recycled anecdotes, drawing the picture of a man whose every move was calculated to make an impression. The grand finale of the piece was the spectacle of Whistler's physical appearance at his weekly Sunday receptions, which attracted a "menagerie" of eccentrics and fashionables. Here Whistler was the "life and soul of the party," strolling about:

> with a little child's straw hat on the back of his head, and a bit of ribbon in place of a necktie, and chattering away unceasingly wherever he can get the largest audience. . . . He wears a well-curled gray moustache and slight imperial. His eyebrows are unusually bushy, and his glistening brown eyes peer out from underneath them like snakes in the grass. . . .
>
> When he goes out in London, he always gets himself up very elaborately, in a way that is sure to arouse attention. He wears a very long black overcoat . . . and a French top hat with the brim standing straight out. In his hand he carries a kind of wand of bamboo about four feet long and very thin. His gloves and boots are very carefully selected, and of irreproachable fit. When he walks about the streets of London, he generally has a crowd of small boys in pursuit, and nearly everybody turns around to look at him with a smile as he passes.

Whistler was almost always on stage. When he testified on behalf of his slavish admirer Joseph Pennell in a lawsuit against painter and critic Walter Sickert, *The Critic* reported that Whistler "kept the court-room in a roar" with his cheeky rejoinders: "In the cross-examination the opposing counsel asked, 'So you are very angry with Mr. Sickert?' 'Not in the smallest degree,' replied Mr. Whistler. 'If anyone could be vexed at all, it is that distinguished people like ourselves should be brought here by a gentleman whose authority has never before been recognized.' " With what the reporter described as a "nonchalant southern drawl," Whistler poured out "self complaisant witticisms" and altogether "seemed as pleased with himself as a Florida belle or a great artist. He drew his black gloves on entering the witness-box and was ready for Sir Edward Clarke. Mr. Whistler is a warrior bold, and fears no foe." The

gesture with the gloves and the mysterious drawl were by now seasoned theatrical flourishes. Even when backstage, Whistler put himself in the spotlight. His follower Mortimer Menpes recalled visiting a Regent Street hairdresser's establishment, where Whistler entertained the other customers with his flamboyant grooming display:

> Suddenly to the intense surprise of the bystanders, he put his head into a basin of water. . . . With a comb he carefully picked out the white lock . . . wrapped it in a towel, and walked about the room for from five to ten minutes. . . . This stage of the process caused great amusement at the hairdresser's. Still pinching the towel, Whistler would then beat the rest of his hair into ringlets (to comb them would not have given them the right quality) until they fell into decorative waves all over his head. A loud scream then rent the air! Whistler wanted a comb! This procured, he would comb the white lock into a feathery plume, and with a few broad movements of his hand form the whole into a picture. Then he would look beamingly at himself in the glass and say but two words,—"Menpes, amazing!"—and sail triumphantly out of the shop."[3]

Pictures of Whistler vividly reinforce prose descriptions. The illustrations accompanying the article in *McClure's* numbered only two: a reproduction of Whistler's *Arrangement in Grey and Black No. 1: Portrait of the Artist's Mother* (1871; Musée d'Orsay, Paris), widely renowned after its purchase in 1891 by the French government, and a photograph of the artist (fig. 89) displaying certain key markers of his public self: the jaunty white lock, the monocle, and the slender bamboo cane, along with the cocked head and elbow. Ernest Haskell's caricature (fig. 90) retains the cocked elbow and the cane but exaggerates the monocle to saucer size and pairs it with a ridiculously tiny straw boater. William Meritt Chase's portrait (fig. 91), painted in London in 1885, displays Whistler in much the same stance, poised with cocked elbow, flaunted cane, white tuft, and flashing monocle. This image in turn echoed the well-known caricature in London's *Vanity Fair* (January 12, 1878), in which Whistler appeared as one of the "Men of the Day." "Spy's" caricature depicted him with a tiny cane or wand, cocked elbow, monocle, white lock, and a low, round-brimmed hat resembling the headgear the painter had affected during his Latin Quarter student days. As the resemblances across these different modes of representation suggest, the border between the "real" Whistler and his mediated image was almost undetectable.

Whatever the medium, Whistler's costume, accessories, and his very body language were integral components of his public "act." By the time he began to appear in the American press, the pattern of artist as performer-entertainer was well established. Catherine Goebel has shown how deliberately and knowingly Whistler shaped, directed, and manipulated his image, using the newspaper and the periodical establishment to popularize and immortalize himself and his work. Whistler initiated his prolonged, usually abrasive dialogue with the critics by writing to the London

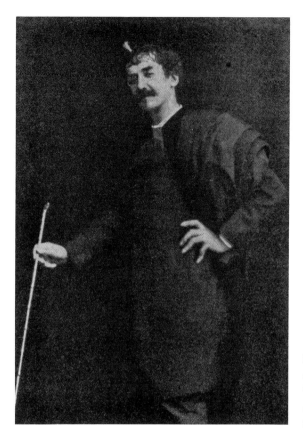

89. H. S. Mendelssohn, *James Abbott McNeill Whistler*. Photograph from "Whistler, Painter and Comedian," *McClure's Magazine* 7 (September 1896).

Athenaeum that its reporter was egregiously mistaken in assuming that his controversial painting *The White Girl* (1862; National Gallery of Art, Washington, D.C.) had been inspired by Wilkie Collins's currently popular thriller *Woman in White*. This exchange, writes Goebel, taught Whistler how to elicit attention when his pictures failed to attract enough comment on their own. While Whistler made it an aesthetic mission to deny the critic's authority to anyone save artists themselves, he was obsessed with their opinions. He wrote letters to friends instructing them to send him clippings from any papers that mentioned him and his work, and in 1865 he began to compile scrapbooks of his reviews, employing at least one press clipping agency, Romeike and Curtice, to keep abreast of what his critics said. In his attacks on critics, and in his well-known publications, notably *The Gentle Art of Making Enemies* (1890), Whistler consistently played down the substantial body of positive, serious criticism he received in order to create the appearance of a beleaguered, abused, and misunderstood painter whose belligerent stance against critics was self-evidently justifiable (and colorfully entertaining). According to Thomas Armstrong,

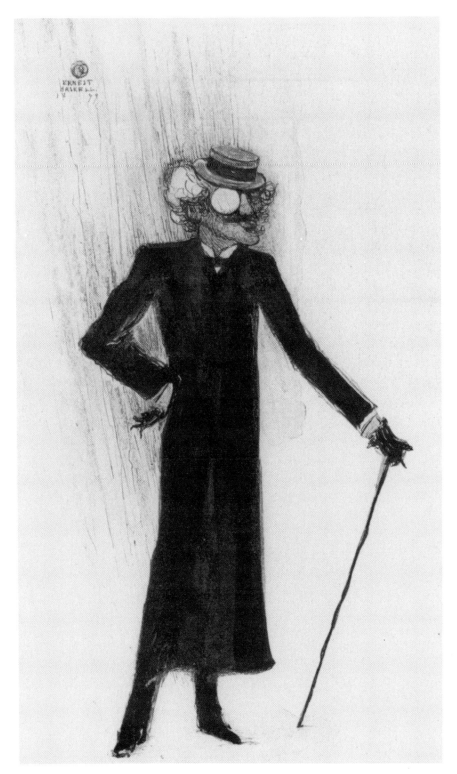

90. Ernest Haskell, *James Abbott McNeill Whistler*. Cartoon from *The Critic* 38 (January 1901).

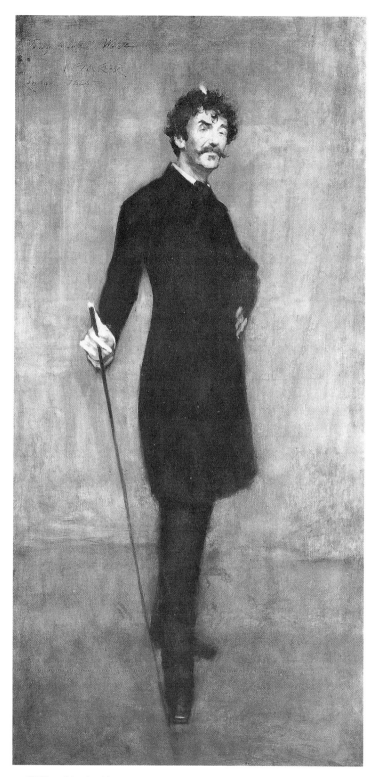

91. William Merritt Chase, *James A. M. Whistler*, 1885. Oil on canvas, 74⅜ × 36¼. Metropolitan Museum of Art, New York; Bequest of William H. Walker; 1918 (18.22.2). All rights reserved, Metropolitan Museum of Art.

in fact, Whistler fervently cherished critical approval: "I hardly ever knew anyone who set such store by favourable newspaper criticisms as Whistler did. . . . [He] treasured and carried about with him the favourable notices." His jousts with the critical establishment were all part of an energetic public relations game.[4]

For all his vaunted aesthetic purism and great earnestness about his art, Whistler's motives tended to be well mixed with worldly considerations. Not only did he recognize the value of publicity, however gained, he also was not unmindful of the possibilities for financial advantage. Neither of these less than elevated objectives was allowed to denature the carefully cultivated image of the determined aesthetic crusader for artistic autonomy and self-expression, but the case of the *Whistler v. Ruskin* trial makes it all too clear how complex were the knots that bound the aesthetic mission to practical and economic ends. As Linda Merrill has shown, Whistler's most compelling reason for pressing the lawsuit against the offending critic John Ruskin was the need to win a large amount in damages. The amount Whistler demanded was "precisely the sum Frederick Leyland had refused to pay" after Whistler, much to his patron's displeasure, completed (and insolently publicized) the flamboyant Peacock Room (1876–1877; Freer Gallery, Washington, D.C.) in Leyland's London mansion. Almost equally important to Whistler was the likelihood that the trial would afford him copious free publicity for his work and a forum from which to instruct the public on its proper appreciation. Having won a verdict in his favor only to be awarded contemptuous damages of one farthing, Whistler (as Merrill recounts) remodeled the history of the trial in *Whistler vs. Ruskin. Art and Art Critics* (1878) as a noble cause in which he had fought bravely for the rights of painters. The episode clearly shows Whistler's acute consciousness of the uses of publicity and the active energies with which he engaged it. The success of his maneuvers can be gauged from the fact that the trial was instrumental in launching his American reputation, which rapidly grew and gathered momentum from that point on.[5]

Whistler's provocative public behavior, before and after the trial, demands to be seen not as deportment partitioned off from his inner, private world of exquisite aesthetic sensations but rather as activity intricately (if not so obviously) connected to it. His public performance was a brass band, a garish parade, a sideshow; it was bait artfully strewn to lure and focus attention on the subtleties of personality and rarefied vision arrayed upon his canvases. And whether the criticism proved viciously barbed or warmly flattering, all of it served to publicize his art. As a commentator for the London *Sketch* put it: "Whistler . . . would be nobody without the society journals. He exists upon puffs, and attitudinesses over the success of his 'White Curl.' Say what he likes, Whistler would die if he were ignored. . . . The most bitter denunciation by Tom Taylor would hurt Whistler less than to be totally ignored by the *Times* for a whole year . . . and to be treated as if such an eccentric never existed. . . . How could any painter, musician or actor endure without a reporter?"[6]

Once the pattern coalesced, the notions of "Whistler" and "good copy" were

identical as far as the press was concerned. The practice of deploring or chuckling over his antics on the one hand and professing admiration or mystification before his art characterized criticism in the United States and in England. He was expected to be a figure of fun, a provocateur, and a poseur, and simultaneously (or alternatively) to be an artist of the finest grain. His exhibitions were celebrated events as well as artistic statements. When his *Etchings and Drypoints. Venice. Second Series* opened in March 1883 at the Fine Art Society in London, the decor and the catalogue received as much attention as the pictures on the wall—perhaps more. The *New York Times* reported on Whistler's white and yellow color scheme, which extended even to the livery worn by the valets, and described the crowded private view where royalty, ladies, and gentlemen exploded with laughter over the witticisms in the catalogue, which was selling "like wild-fire." The following year *The Nation* found Whistler's *"Notes"—"Harmonies"—"Nocturnes"* exhibition at Dowdeswell's Gallery to be one of the most entertaining features of the London picture season. Once again, the show and the valets were color-coordinated, this time in "flesh" color and gray. The pictures were the "same as usual": slight, foggy bits, before most of which the "unenlightened outsider can only stand in the attitude of a man to whom a mystery is shown." The presumably more enlightened reviewer, though, found the framing tasteful and professed to find Whistler's harmonies "amusing."[7]

It was the *Trilby* affair that most dramatically exposed the mechanisms of Whistler's image-making strategies. George Du Maurier's stupendously successful novel was strongly colored by reminiscences of the Latin Quarter in mid-century Paris, when he and Whistler as art students and bohemians enjoyed a brief camaraderie. Illustrated by the author, *Trilby* was launched in 1894 as a serial in *Harper's*. The March installment featured an assortment of lightly fictionalized Latin Quarter contemporaries, including Lorrimer, the "industrious apprentice," well-dressed, hardworking, and sober, and Joe Sibley, "the idle apprentice, the king of bohemia, *le roi des truands*. . . . Always in debt, like Svengali; like Svengali, vain, witty, and a most exquisite and original artist; and also eccentric in his attire (though clean), so that people would stare at him as he walked along—which he adored! . . . He was a monotheist, and had but one god. . . . For forty years the cosmopolite Joe has been singing his one god's praise in every tongue he knows and every country—and also his contempt for all rivals to this godhead. . . . For Sibley was the god of Joe's worship, and none other! and he would hear of no other genius in the world!" Du Maurier's illustration (fig. 92) showed Sibley in a broad-brimmed hat, flourishing a slim wand or maulstick. Smoking and strolling along in his patent-leather, bowtied pumps, Sibley exemplifies the self-worshipping, self-creating style of the idle apprentice, while Lorrimer, who uses his maulstick for painting, scowls as he hurries along, conventionally dressed and laden with gear. The fact that Du Maurier described Sibley as tall, slim, and graceful with a head of silky white hair did not deter the diminutive Whistler from sending a scalding letter to the *Pall Mall Gazette,* accusing his erstwhile friend of harboring thirty years' worth of "pent-up envy,

92. George Du Maurier, *The Two Apprentices*. Illustration from Du Maurier, *Trilby, Harper's New Monthly Magazine* 88 (March 1894).

malice, and furtive intent," which he had now fired off as a "bomb of mendacious recollection and poisoned rancune." To anyone who knew anything about Whistler's public image, Du Maurier's portrait could hardly have failed to evoke the "original." Perhaps it was the explicit association of Sibley with Svengali—the dirty, sinister, repellent yet magnetically fascinating Jew—that contributed to Whistler's ire. Whistler aggressively inflated the affair, demanding among other things Du Maurier's resignation from the Beefsteak Club, to which both belonged, and threatening legal action against the author and the publisher. In July, *Harper's* drew up an agreement to alter the objectionable text and illustration in the book version of *Trilby* and to print a public apology for the offense in the September or October issue of the magazine.[8]

The Critic, which chronicled every extravagance in the *Trilby* craze, published its summary and interpretation of the Whistler–Du Maurier contretemps in its June 16, 1894. number and reprinted it six months later in response to "constant

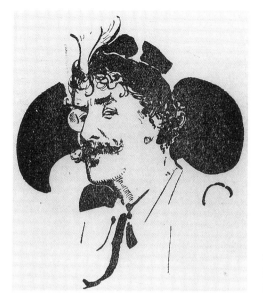

93. *James McNeill Whistler.*
Illustration from *The Critic* 25
(November 17, 1894).

demand" by "so many people" who wanted the paragraph "for the purpose of pasting it in their copies of the book." The reprinted text was embellished with a vignette (fig. 93) of Whistler's head superimposed on the butterfly emblem with which he "signed" his pictures. Although the black-and-white drawing was probably based on the London Stereoscopic Company's photograph of Whistler (fig. 94) published in *Munsey's Magazine* in October, the *Critic's* version exaggerated the famous white lock into an undulating plume, gave the eyebrows a jauntier slant, and curled the moustache a bit more to produce the effect of a slyly superior smile. The article made no bones about what Whistler was really doing: "Mr. Whistler has mastered two arts besides painting and sketching. One he has immortalized in that unique brochure, 'The Gentle Art of Making Enemies'; the other is the Gentle Art of Advertising Oneself. These two gentilities are not always to be distinguished from each other. . . . Mr. Du Maurier happens to be one of the most conspicuous figures in the field jointly occupied by Art and Letters. In choosing him as an object of clamorous attack, Mr. Whistler has shown himself a past master of the art of advertising oneself. By identifying himself with one of the characters in a story that everyone is reading, he brings himself more conspicuously before the public than by painting a new picture." This writer recognized that publicity was equal in importance to productivity—was, in a sense, as much a creative enterprise as painting itself. Another, cataloguing the standard inventory of Whistler eccentricities, observed that if Whistler had not been an artist he would have been the "Napoleon of advertisers." *The Nation's* review of *The Gentle Art of Making Enemies* neared the heart of the matter in its hesitation to take Whistler entirely at his word. Were his "serious" opinions on art and criticism

94. London Stereoscopic Company, *James McNeill Whistler.* Photograph from *Munsey's Magazine* 12 (October 1894).

truly so? Or were they "only a part of that ingenious self-advertisement of which Mr. Whistler is past-master, intended not to instruct but to draw attention? One has an uneasy suspicion that to take him in earnest is 'to consider too curiously,' and that perhaps the best answer to him would be, '*Blagueur, va!*'" (roughly, "Get lost, you joker!") *Life's* caricature (fig. 95) showed Whistler brandishing a palette labeled "My Platform" and standing amid litter from a wastebasket overflowing with papers marked "Criticism." The painter has one foot on *Trilby,* and *The Gentle Art of Making Enemies* lies on the floor before him. Behind on the left is a small figure—Whistler again—making a telephone call. The caption further spells out the message: "*The Man Whistler at the Telephone*: Are there any more publications in which I am mentioned? If so, send my lawyer to them at once. It's dirty work, but I like it, and I am getting famous." Crude and cynical though it may be, *Life's* nasty dig at Whistler—as nasty as anything the master himself could have dished out—gets it right. By keeping himself in the public spotlight by fair means (his art) or foul (everything else), Whistler stimulated interest in himself and his products. Like Oscar Wilde, so often accused of Barnumesque tactics, Whistler, as Regenia Gagnier has observed, "accepted the commercialism that artists were forced to adopt if they wanted to participate in life. In an age of debased production, their commercial products were nothing less than themselves." By *being* himself, Whistler was *selling* himself. And his attention-getting techniques fell perfectly into line with the technology and psychology of advertising, a budding new industry serving the interests of an ever more powerful consumer ethos.[9]

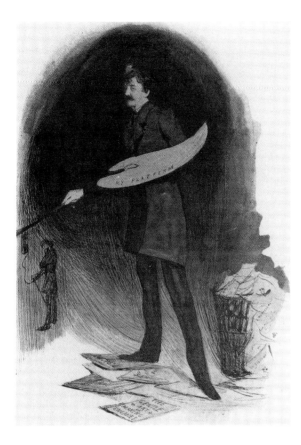

95. *The Man Whistler at the Telephone.* Cartoon from *Life* 24 (November 8, 1894).

Selling Selves

The ascendancy of self-advertisement coincided with the establishment of an entirely commercial and secular art market in which dealers retailed aesthetic products as merchants might purvey luxury goods, relying on the agency of supply and demand, the luster of famous (or soon-to-be) names, and such imponderables as fashion and novelty to move their products. At the same time, the expanding and increasingly specialized artist population exerted its own pressure, creating severely competitive conditions in which great advantage could be won by achieving a high profile as an original, an innovator, a nonconformist. While the exotic studio was often the site of persuasion and seduction, the most dynamic form of advertisement lay in the construction of an intriguing public personality, a distinctive style, with the power to attract and hold attention on exhibition walls, in the social world, and on the pages of newspapers and magazines. The public self, of which the art product with its recognizable accent of personal style was an extension, became a commodity.

This model meshes with developments in the advertising world during the same period. As Jackson Lears has noted, it was during the 1880s that advertisers, confronting the ever-mounting press of competing products, initiated strategies based on the assumption that the buying public was "increasingly remote and on the run" as

well as easily bored. To capture the interest of these consumers, many advertising men urged the lavish use of illustrations, trademarks, brand names, slogans—and in so doing "shifted their focus from presenting information to attracting attention," to arouse and excite the consuming eye. This shift toward sensational tactics was accelerated by the "broader movement from print to visual modes of expression." By the turn of the century advertising was recognized as a most formidable medium in the world of goods and their consumption: "Advertising is . . . a force made up of a hundred different elements, each one too intangible to be defined. It is something which, properly directed, becomes a powerful agency in influencing human customs and manners. All the great forces that have moved the race, the eloquence of the prator, the fervor of the religious enthusiast, superstition, terror, panic, hypnotism—all these things are utilized in advertising. All the emotions of the race are played upon, appealed to, coaxed, cultivated, and utilized." Powerful images, detached from things and replacing them in some instances, now penetrated the public and private spheres alike. Walter D. Scott argued that the "printed page, as a form of advertisement, has superseded the market-place and is, in many cases, displacing the commercial traveler." While the page could not appeal directly to any senses but the eye, the reader—or looker—could nonetheless be moved, the senses "appealed to indirectly through [the] imagination." Advertisements were the "nervous system of the business world": "As our nervous system is constructed to give us all the possible sensations from objects, so the advertisement which is comparable to the nervous system must awaken in the reader as many different kinds of images as the object itself can excite." Advertising, finally, was entertaining. So confident was business writer Nathaniel Fowler in the attraction of advertisements that he dismissed everything else in modern magazines as so much flavorless stuffing: "Long continued stories, dry articles on buried art, descriptive papers about some almost unknown queen who never did anything to merit the mention of her name in a musty encyclopedia, are today assisting in filling the magazines, and the reader, with a spasm of relief, turns to the back pages where he can read something grown of modern sense." Given the nature of the new consumer-oriented, image and advertisement-saturated environment, attracting attention and furnishing amusement were vital to getting ahead. And with the shift to increasingly visual modes of communication, having the right kind of surfaces was of course indispensable.[10]

In the modern age of advertisement and consumption, money and physical goods were no longer the only media of exchange. Socially and culturally, the public self and its distinctive style—its image—were dynamic agents for signaling and negotiating identity, status, power, and desirability. That self, in its turn, was an attention-getting and salable item when translated into copy for the vast and insatiable publishing industry. It was within these spaces that Whistler maneuvered, making himself noticeable, unique, and inimitable while at the same time being produced (or even mass-produced), advertised, and sold by and through the media. The result of this process was the celebrity, a self-made yet simultaneously media-generated person-

ality, tooled to attract attention to itself, to stimulate interest, to stimulate sales. The personality and habits of the celebrity were so much informational fodder for attracting the reading public. Singling out inquisitiveness as a "national trait," one foreign humorist observed that American journalism lived by catering to it: "Let an artist, a singer, a painter, a writer, become popular in America: will not your papers immediately inform the public what he or she has for breakfast?" Another writer, critical of the "craze for publicity," the feverish urge of Americans to have their doings recorded in print and communicated to the public, puzzled over their motivations. "If we could suppose that all this was only a subtle and highly refined mode of advertisement it would be comparatively easy to account for it. . . . But why in the world should a man or woman care to advertise things which are not to be sold— a wedding trousseau, the decorations of a bedroom, a dinner to friends?" Such "publicity," though, was exactly what the reporter claimed it was not: a form of advertising that catered to a growing and never-sated desire to possess its objects.[11]

The elusive end that readers sought by consuming media representations of celebrities was an intimate knowledge of individual personalities. Warren Susman argued that the turn of the century decades embraced a shift in "modal types" of fundamental importance to the the modern social order. This shift in turn accompanied gradual reorientation, from economic scarcity to abundance, producer to consumer values, disorganization to high organization. Modal types embody whatever traits are felt to be essential to the maintenance of the social order. In the eighteenth and nineteenth centuries, the sum of these traits was the concept of character, which intertwined the social and the moral and was driven by the values of good citizenship, duty, democracy, work, building, honor, reputation, integrity, and manhood. In the shift toward "personality," a new spectrum moved into the spotlight: "fascinating, stunning, attractive, magnetic, glowing, masterful, creative, dominant, forceful." The leveling quality of life in a mass society intensified the need to develop the self in unique, powerful, and attractive ways in order to stand out, to be Somebody. In a continuously changing social world, each individual self performed a complex charade of identity in which surfaces, manners, gestures, and things were meant to denote *who* that person was. Under such circumstances, as Stuart Ewen states, "one was repeatedly made aware of *self as other,* of one's commodity status within a vast social marketplace, and style provided its user with a powerful medium of encounter and exchange." Social performance and the displays of style were also acts of putting up a front to "protect one's inner self" in a threatening and treacherous modern world. What passed for the real person was just as likely to be a collection of external and mutable signs as it was a display of whatever made up the inner self. While surfaces purported to symbolize depth, they also functioned as barriers, blinds, false fronts. The public self became an image of personality, defined through distinguishing markers, signs, and modes of conduct. It was this self for which the reading and looking public developed its unappeasable appetite.[12]

No longer were the moderns satisfied by family and friends, observed H. W.

Boynton. They must now reach out to a "world of strangers whom we desire to know, without especially desiring to be known by them." The desire was to get at any stranger's. "true substance, his whereabouts, *himself*." "We do not mean to lose any chance of getting acquainted with personalities which have set their mark upon an age or an hour," Boynton went on, noting that the world seemed convinced that even bridges emerged from "personality" rather than from engineering expertise. Increasingly, personality dominated the foreground of life. *The Outlook* in 1903 featured an article on the personality of Ralph Waldo Emerson; in 1907 the System Company of Chicago published *Personality in Business,* which delivered the message that success or failure in business boiled down to the personality of the individual in charge, his ability to use personal influence in his systems. In the art world, critics recognized the growing fascination and importance of personality. Mariana Van Rensselaer argued that personality was the "greatest essential in every kind of art," and J. Walter McSpadden devoted *Famous Painters of America* almost exclusively to the art makers rather than their products. Acknowledging this, *The Craftsman* remarked that in McSpadden's account there is no talk of lights or values to "appall" the ordinary reader. Not a study of art at all, the book "merely sketches the personality of the men—and does so most delightfully. . . . The strange, vivid personality of Inness is sketched, and the mystic Vedder is shown to be a well-fed American. . . . Even Sargent is taken for a moment out of his dark corner of diffidence and shown as the man he is."[13]

Many remained ambivalent about the ascendancy of personality and originality as criteria for judging and desiring a work of art (and, by extension, some unmeasurable essence or aura of its creator). Should not the artist efface himself and aspire toward the loftiest and noblest heights of idealism? For worried conservatives struggling to uphold traditional values, the shift in interest from idea to individual was ominous, since it seemed to overlap and exacerbate all the dangerous tendencies evident in aestheticism. Royal Cortissoz, who equated the new cult of personality with excessive egotism that could lead to degeneration, also perceived the connections that linked these tendencies with the culture of image, advertising, and consumption: "The painter no less than the politician, the author, and the artist of interpretation makes of his personality a fetich [*sic*]. With him, too, personality has grown to be a source of self-advertising, only the advertising is of the less obvious sort. It is not for that reason any less pernicious." Wilbur Larremore, deploring the growth of "anthropomania," pointed to its deleterious impact on artist, art works, and art collecting, all of them skewed out of proportion by the rampant "hunger for personalities" that had invaded modern life. While it was acceptable for a collector to derive some pleasure from owning works by "great names," these very names all too readily became commercial assets: "There is generated in the popular mind an interest in celebrated artists independent of the quality of their work; and this not only leads to the forgery of 'Innesses' and 'Wyants' and 'Murphys,' but diverts attention from pictures without the sign-manual of fame, but whose merit might

render them delights of homes that cannot afford masterpieces. Exaggeration of the personal element, therefore, interferes with the spread of aesthetic appreciation, and delays the 'arrival' of men of genuine gifts." Larremore regretted the rise of the "baleful" star system and even singled out "over-devotion to biographical literature" as a cardinal symptom of anthropomania.[14]

Cortissoz and Larremore correctly diagnosed the problem but failed to see, or would not allow themselves to see, that the personal—the performance of identity, the profession of unique individuality—could no longer be pried from the work, having become the most highly valued component in it. This was already evident in the new emphasis placed on subjective seeing in painting. What Cortissoz and his contemporaries could not accept was the commercialization of the personal, which brought too close for comfort the recognition that modern culture had set up a base of operations in the marketplace.

The Paradox of the Poseur

The genius of Whistler lay in his ability to take advantage of changing conditions to produce himself so vividly and to act as if he were always on stage, all in the interest of creating a fascination about himself and his work that caused admirers and detractors struggle to make sense of how *that* man—that bantam, that light-weight, that jester and poseur—could have produced an art so serious, so authentic, so spiritual. Whistler grasped the importance of fashioning an original and compelling public identity, of packaging and marketing himself, of becoming, in essence, a living brand name complete with stage clothes and trademark symbols, such as the butterfly emblem and the white lock. In a society in which incorporation and the mass figured so largely, Whistler's ferociously cultivated singularity guaranteed his authenticity, or seemed to. Yet the very conditions of his existence in the public eye demanded that the artist, as performer, be a poseur.

Critics and other writers pursued an animated debate around the figure of Whistler as poseur. It was the public, posing figure that projected the personality responsible for keeping the glow of attention on the painter and his work, yet his warmest supporters insisted that this figure was a decoy fashioned to protect the real Whistler. Nonetheless, no one could deny its power or its embeddedness in the idea of Whistler. He was, in one writer's words, the "brilliant painter and *poseur*"; to another he was the "habitual *poseur*," and to another still the "inveterate *poseur*." Julian Hawthorne proposed that Whistler's public performance was an integral com-ponent of his mission to "make the Philistines realize, by hook or by crook, that art is a divinity to which they must bow in reverence, and that artists as her high priests are entitled to . . . at least as much respect and deference as is accorded to princes and millionaires. To this end he fights them with all manner of weapons; with irony and ridicule, with open contempt, with rebuffs and tantalizations, with enigmas and miracles." There was also "an immense and sweet good nature in Whistler . . . hidden from the public. . . . He will tolerate not the slightest suspicion

of humbug or pretense." Edmund H. Wuerpel subscribed to this view, figuring Whistler as a kind of winning, childish pet who had a "truly gentle, lovable nature," who danced when delighted by the prettiness of some effect in his painting, and who was usually "happy and smiling." However sincere, these defenders failed to understand the selling principle at work in Whistler's provocative behavior, and Hawthorne's allusion to Whistler's intolerance of humbug in this context is ironic. As an entertaining, performing figure in the realm of spectacle, Whistler was *expected* to be a poseur and nothing but. Like P. T. Barnum, master of the art of humbug, Whistler exploited the public's anticipation—and enjoyment—of being tricked and then piqued into wondering how the trick was done. In Whistler's case the trick involved putting up what seemed to be a smokescreen: the deftly assembled poseur figure that by some paradox was the author of those exquisitely tasteful, soulful nocturnes and ethereal portraits. The game was to find the real Whistler. Could it be the acerbic, cruel, scrappy showoff of the magazines and papers? Or was it the high-minded, tenderhearted child-man represented by his intimates? Apparently it never occurred to these intimates that Whistler's benign domestic conduct could have been as much, or as little, an act as his belligerent public comportment. The trick was that one could never be sure which, or where, was the real Whistler. Deception was built in to the very idea of Whistlerian performance, a kind of personal theater dedicated to staging persuasive illusions. The continuing tension between Whistler's performance of personality and the production of his art has been important in the longevity of his reputation. To appreciate this it is necessary to think only of a "good" Whistler as the sole and exclusive producer of his art: the dutiful son, the self-effacing, earnest, sweet, and lovable creator of quiet, tasteful, monotonous paintings and delicate, deft, picturesque etchings; a painter who sought no publicity, who did not invite legions of reporters to a "preview" of the Peacock Room—a painter who, respecting the wishes of his patron, could not even have done the Peacock Room as he did—who was never in a courtroom, who never published cheeky books needling and antagonizing his critics. Would such a personality inspire the archive of writings that now numbers in the thousands of books, catalogues, and articles? Whistler's personality added the salt, the spice, the dash that was absent—by design, certainly—from his serene, muted, delicately harmonized canvases.[15]

The modernity of Whistler's self-performance jumps into high relief in juxtaposition with the image of his contemporary, John La Farge (1835–1910). La Farge, an intimate friend of Henry Adams and other elites, presented a public image of dignity and intellect. As fully in the public eye as Whistler, he pursued an active career as lecturer, writer, and critic, working industriously to present his theories on art and aesthetics to a wide audience. His mode of communication, however, was quite different, since he acted from within established institutions (lectures at the Metropolitan Museum of Art, commissioned articles for mainstream magazines) rather than staking out an oppositional position, as Whistler so adroitly did. His

96. *John La Farge.* Photograph from *World's Work* 12 (1906).

philosophy, as Linnea Wren construes it, held that great art was indebted at once to the individuality of the artist and to the great "Ideas" of a culture. The latter ensured the continuing enshrinement of the impersonal and transcendental aspects of art while allowing space for the personal and subjective. Although his reputation as a painter may have been on the decline by the 1890s, this did not prevent a number of influential critics from exalting him as one of the greatest modern artists, an immortal, an ardent lover of beauty possessed, as William Howe Downes put it, of an "almost divine insight into the nature of things." A photograph in a 1906 issue of *World's Work* (fig. 96) showed La Farge as a kind of elder statesman of art, and fittingly, since the magazine regularly featured portraits of "world workers": diplomats, scholars, businessmen, and others whose labors contributed to progress and civilization. Nothing could be further from the photographs and caricatures of the smirking, cavorting Whistler than this sober, neat representation of the artist as fastidious and dignified intellectual. This image of conventionality was a pose all the same, revealing nothing of the neurasthenic, uneasily married, financially catastrophic La Farge, let alone the hedonistic La Farge who wandered the South Seas with Henry Adams. Nor was La Farge's great personal charm, reserved for and praised by his intimates, on show.[16]

La Farge no less than Whistler was vitally interested in the precise construction of his public image. Asked to indicate a preference among critics, he told Russell Sturgis that he would not choose William Coffin or Kenyon Cox to write an article on his work. He judged Edwin Blashfield to be generous and very careful, and John Van Dyke serious and well-intentioned. What he would really like, though, was a "good notice by our old friend [William Crary] Brownell," who alone could do

justice to the importance of color and expression in his art. Although his public image never showed it, La Farge also carefully tracked his income and financial circumstances. He employed his son Bancel to manage his finances, which entailed the production of numerous letters requesting past-due payments from patrons, or furnishing prospective buyers with detailed price lists. Although he may have been an inept money manager, the elder La Farge nonetheless entertained a precise notion of how much art a particular sum would buy. When Columbia University commissioned a stained glass window design, the money offered was less than La Farge wanted or needed for the design he had in mind. He would produce, accordingly, a "half price window," he told a correspondent, that "will be worth exactly what that half price will be."[17]

While Whistler made a spectacle of himself, La Farge and his admirers never permitted that to happen. Arrested with considerable publicity in 1885—in a dispute about the rights to designs and photographs that the artist had taken after the failure of the La Farge Decorative Arts Company—he went Whistler one better, since the latter could distinguish himself only by a lawsuit or two. Had Whistler been arrested, the event would surely have become part of the lore of the maverick performer, a badge of his thorn-in-the-side nonconformity. This was not the case with La Farge. His death occasioned no salty reminiscences but only solemn tributes to his universal genius. Writing to compliment Royal Cortissoz on his just-published memoir, Henry Adams drew a telling distinction between his admired friend and Whistler: "Your volume arrived yesterday, and I read it at once! . . . I am sure it would have pleased [La Farge]. . . . He had a true artist's longing for appreciation. There is room for a very nice parallel between him and Whistler on that line of artistic striving; for although he rarely or never resorted to Whistler's frank vulgarity of self-advertisement, he took even more trouble than Whistler did to gain a favorable press, and was equally careful of his claims on posterity." While La Farge was perfectly at home in the past, he never mastered the skills needed for managing the present. Adams had often "brutally" told his friend "that he was living in illusion; that . . . he was tearing himself to pieces for a society that had disappeared centuries ago. . . . I really suffered to see him working to create an audience in order that he might please it." La Farge's status, finally, rendered him unfit for the modern world: "He was, behind his profession, a gentleman, by birth and mind; and he never forgot it." In Adams's construction, the professional and the gentleman were two different things. By clinging to his identity as a gentleman, La Farge could never hone that "vulgar" edge—that marketing instinct—that gave Whistler his maneuverability in the realm of spectacle. Bancel's wife, Mabel, a gently reared Brahmin, recollected that her father-in-law's unwavering aim had been to get away from the taint of commercialism in art. There was no "Macy's" about him. He was only a gentleman and an artist.[18]

By noting the absence of the commercial instinct and the lack or suppression of attention-getting devices in the case of La Farge, I am not suggesting that if he had

made a more interesting spectacle of himself his bibliography might have been as hefty as Whistler's and his name as durable. As the modern Henry Adams has pointed out, La Farge's work after World War I "came to seem old-fashioned, eclectic, and removed from contemporary life—the product of a closed and snobbish society." He clung to outmoded ideals, and this, in addition to a frequently flawed, marred, or incomplete artistic performance, resulted in "a sense of unfulfilled promise," the "failures of a genius." Another way of saying this, though, would be to suggest that La Farge was unable to devise, produce, and "sell" a compelling style—either in his personal image or in his art. It rarely escapes historians of American art that La Farge was in Tahiti at nearly the same time as Paul Gauguin, yet the latter's synthetic Pacific idylls are widely known, even popular, whereas the numerous accomplished and beautiful images painted by La Farge (see fig. 54) remain the province of specialists. While outside the boundaries of this study, Gauguin deserves a passing mention simply because he, like Whistler, identified himself with a style that bound together his personal history and his artistic production—a style that seemed entirely modern, that announced itself as oppositional and radical, that was tailored, indeed, for inclusion in the canon of modernism, and the formalism it so energetically promoted. Inconveniently for his personal fortunes, Gauguin did not enter the realm of spectacle during his lifetime. But he did eventually arrive there; La Farge never reached it at all. Like Gauguin, Whistler knew how to make the surface fascinating, alluring, magnetic: qualities associated with the new cult of personality rather than with the waning culture of character. He was at home in the realm of spectacle, whereas La Farge was an anxious bird of passage there.[19]

The Little Old Master

Whistler's redoubtable prowess as performer, however, generated uncertainty about the real value of his art, and the critics expressed considerable puzzlement about just what he had done to achieve old master status—and that in his own lifetime. This puzzlement was often linked with the notion that Whistler's skill as poseur had either enabled him to achieve his lofty position by some trick or had sadly prevented him from attaining genuine, transcendent greatness. There were those who simply refused to be entertained and who read the pose as a pathological sign. When Henry Adams's wife, Clover, saw Whistler's *Harmony in Yellow and Gold: The Gold Girl—Connie Gilchrist* (c. 1878; Metropolitan Museum of Art, New York) at the progressive Grosvenor Gallery in 1879, she wrote to her Brahmin father back in Boston that "any patient at Worcester [the mental hospital where Dr. Hooper treated inmates' eye diseases] who perpetrated such a joke would be kept in a cage for life." Later that summer she went to a party at the Grosvenor and reported to Dr. Hooper, "Someone introduced Whistler to me, even more mad away from his paint pots than near them. His etchings are so charming, it is a pity he should leave that to woo a muse whom he can't win." But even the more temperate appraisers tended to believe that Whistler's graphic work was far more solid than his painting.

In the thoughtful article published soon after the *Whistler v. Ruskin* lawsuit, William Crary Brownell devoted little space to Whistler anecdotes, electing instead to deduce the artist from his work. Although his excellence as an etcher was "undisputed," in the long view, there was an "absence of any great work, any work of unmistakably large importance," which was due to Whistler's "inability to be either a child of his century or a pure pagan—to the circumstance that he is, in familiar language, more or less of a round peg in a square hole." Brownell made short work of comparisons with the old masters—"He certainly is not Velazquez"—and, ironically in hindsight, did not even think that Whistler represented "what is best in the tendencies of to-day, as does our own introspective Mr. La Farge."[20]

Whistler's credibility was powerfully bolstered when the French government purchased the famous portrait of his mother in 1891. The figure of the artist as a living old master seems to have coalesced at about that time. "All the world," reported Elizabeth Pennell from London in 1892, was "rushing to see the exhibition of Mr. Whistler's paintings" now that France's acquisition of the famous portrait had suddenly revealed that "he might after all be a painter as well as an eccentric creature who indulges in amusing law-suits." Nonetheless, Brownell's ambivalence continued to reverberate. Even after Whistler won Medals of Honor in painting and etching at the Paris Universal Exposition, Christian Brinton rated the majority of the portraits as mere novelties, "little beyond essays in subdued *Japonisme* with subtle dashes of Velazquez." Only the portrait of his mother showed "adequate depth." It was not in portraiture but in etching and lithography that Whistler had "disclosed the validity of his talent." Frank Jewett Mather dismissed the nocturnes as merely a "gossamer phase" of Whistler's art, fascinating only to "the few." But "his best tools were, after all, rather the etching needle, the dry-point, and lithographer's chalk than the brush. Exceptionally a great painter, he was habitually a great etcher."[21]

Yet it was as a painter that Whistler received admiration verging on idolatry, as in John C. Van Dyke's "plain talk" piece in *The Ladies' Home Journal,* meant to set the record straight for a huge, middle-class, feminine audience and to tell it how to value Whistler in the right way. Van Dyke admitted that when it came to certain skills, the famous expatriate was unexceptional: "Whistler's technique was possibly his weakest feature. He drew accurately enough, but with difficulty; he composed rather awkwardly; his people were sometimes wanting in proper proportions and stood badly upon their feet; and as for his brush work, there was nothing about it that a dozen of his contemporaries might not have done better." The painter's unique and precious gifts, however, transcended his shortcomings and made them less than negligible. He saw things many people could not see and painted them beautifully, with a consistent "oneness of idea and effect. . . . Taste with simplicity and the most absolute frankness were always present in his work." The portrait of his mother epitomized these qualities. Even though Whistler had been called the "grand *poseur,*" there was no pose about this painting; it was the "portrait of a noble mother by a loving son." It was, moreover, "one of perhaps a dozen pictures that entitle Whistler

to the rank of a great modern master." What Van Dyke so carefully demonstrated to his readers was that Whistler's art was indelibly stamped with the taste, refinement, and vision—the *style*—of an intense and original personality supremely sensitive to beauty.[22]

Whether ranking Whistler a superlative etcher or consigning a handful of "real" masterpieces to his credit, a good many writers considered his output uneven, small-scale, and scanty as far as great works were concerned. Yet greatness attached itself to him so tenaciously that even the fulminations of debunkers like G. K. Chesterton betray a reluctant fascination. Chesterton's essay on Whistler had a not-so-hidden agenda, which was to argue for the sanity and normality of the best and most authentic forms of genius. His Whistler was the type of the modern aesthete—strained, artificial, egotistical in the extreme, and fatally possessed of artistic temperament, which Chesterton diagnosed as a "disease that afflicts amateurs. It is a disease which arises from men not having sufficient power of expression to utter and get rid of the element of art in their being. It is healthful to every sane man to utter the art within him; it is essential to every sane man to get rid of the art within him at all costs. Artists of a large and wholesome vitality get rid of their art easily, as they breathe easily, or perspire easily. But in artists of less force, the thing becomes a pressure and produces a definite pain, which is called the artistic temperament. . . . There are many real tragedies of the artistic temperament, tragedies of vanity or violence or fear. But the great tragedy of the artistic temperament is that it cannot produce any art." A "third-rate great man," Whistler was unwholesomely bogged down by an impacted backlog of art that he could never expel and that invaded his persona instead. And what of the art he did manage to produce? Echoing Max Beerbohm, Chesterton declared, "Whistler really regarded Whistler as his greatest work of art. The white lock, the single eyeglass, the remarkable hat—these were much dearer to him than any nocturnes or arrangements that he could throw off." Chesterton, of course, took the nocturnes at face value and saw them as slight, easy bits—in contrast to the tortured complexity that was the face value public image of Whistler.[23]

The trick in reading Chesterton is to turn him inside out, to reverse his cynical stance and read the same traits for which he denigrated Whistler in a positive light. This is precisely on what the "greatness" of Whistler depended—that is, the acknowledgment and appreciation of the fact that his "greatest work of art" was a legitimate one, that "temperament"—and its near relation, personality—were as much his artistic capital as were his paintings and etchings. Within this frame, the actual amount of art that Whistler produced, and the question of how much of it deserved to be called great, receded into the background while the rare refinement of his sensibility became the basis for aesthetic judgment of his work. Theodore Child, for example, found Whistler's art to be marked by a wholly personal exquisiteness. His artistic temperament was original and fine, and he showed his personality and taste in the objects he admired, as well as in his own work. Christian Brinton later gave

a positive twist to what might otherwise sound like a reiteration of Beerbohm via Chesterton: "Quotidian art offers nothing more diverting than the spectacle of James McNeill Whistler. . . . Though in painting he vaguely harks back to Velazquez and in etching to Rembrandt, assiduous self-cultivation has kept him Whistlerian, Whistlerish, in its most acute implication. He is the apostle of the personal pronoun, first person singular, the incarnation of egomanie. . . . And perhaps, indeed, his chief title to greatness lies in the fact that he has managed to perfect the gentle art of being, in all things—himself." What the pro-Whistler remarks suggest is that Whistler's temperament, personality, and image spelled "artist" at the same time they spelled "entertaining" and "spectacle." Whistler's versions of himself, and his versions of the artistic personality, were formulations successfully compounded to attract, intrigue, and amuse in an era of surfaces, publicity, and consumption. By so inimitably displaying "artistic temperament" he performed the "act" of an artist as few others could. This clearly contributed to his triumphant installation in the pantheon of modern masters.[24]

Whistler, Good and Bad

Whistler's canonization proceeded rapidly, accompanied by efforts to neutralize the "bad" Whistler, or at least to detach that side of him from his art in the interests of elevating the latter to a transcendent, timeless, universal plane—the space of modernism. Reviewing Whistler's achievement, Frederick Keppel, who had quarreled bitterly with the painter, wrote perhaps a bit self-servingly: "Now that he is gone to the Silent Land . . . these frailties of his are already fading from our memories, while 'the immortal part of him' grows greater and brighter; and it will continue so to grow unless some still greater artist shall arise to push him from his pedestal. And even if such an unlikely thing should ever happen, still there can never be another Whistler." Keppel also noted that Charles Lang Freer's "precious collection" of Whistler's works was to be given to the nation. Freer's enshrinement of Whistler in the collection of Asian and American art that eventually came to be housed in the gallery on the mall in Washington, D.C., can hardly be overestimated as a key rite of passage in separating the good Whistler from the bad. According to Susan Hobbs, Freer—like other devotees—thought Whistler noble and true and refused to believe any of the horror stories about his behavior. In the words of Freer's consultant Ernest Fenollosa, Whistler was all-important to the collector because of his "modern centrality": "In the wide play of experimenting with absolute beauty, [Whistler] struck again and again, without consciousness of imitation, and often in complete ignorance, the characteristic beauties of the most remote masters, both Western and Eastern." With Whistler as the heart and kingpin of Freer's aesthetic enterprise, the collection would afford visitors the opportunity to compare the art of these different cultures, and to deduce the "truth" of art's space-and time-spanning transcendence. Leila Mechlin likened Freer's endeavor to reconstitution: "Gathering up the loose and broken threads of a great embroidery, he has woven, and is weaving, them into

a beautiful pattern, which will eventually discover its meaning even to the uninitiated, and point students to the fountain of all art—the simple, universal truths." Mechlin carried one of Fenollosa's own analogies further in elaborating on what it was that connected Whistler's subtle surfaces with those of ancient artifacts: "As his low-toned canvases sometimes seem to have been dipped, like a piece of pottery, in translucent glaze, so these pastels are found reminiscent of the exhumed wares which have been rewarded for their long sleep by iridescent splendor." Extracted from history, Whistler's paintings, pastels, and prints became "threads" or mosaic chips in Freer's aesthetic utopian design. Gathered in a collection that could never be dispersed, sold, lent, or otherwise altered, the works occupied a sacred space undisturbed by the clamor of the marketplace and the ceaseless flux and exchange of commerce. The bad Whistler would never fit in there.[25]

The bad Whistler, however, continued to flourish. Despite a fluctuating aesthetic reputation, his persona never faded. This was precisely what his friend and collector Richard A. Canfield feared would result from the publication of biographies like Joseph and Elizabeth Pennell's, which distorted the man into an "idiotically legendary" shape: "Already I seem to feel the mists closing in around, and hiding the real man, whom I knew. There is danger that posterity, if such things go on, will look upon the man as a fighting brawling cad, whose friendship could not be held at any price, short of abject sycophancy. If such a view ever obtains, it will be a frightful injustice to one of the most wholehearted and loveable men I have ever known." Whistler's modern bibliographers, Robert H. Getscher and Paul G. Marks, take particular note of the role Whistler's personality has played, for more than a century, in the interest he inspired: "James McNeill Whistler, a great creative artist, had one of the most memorable personalities of his time. His shimmering works, striking words, and strident personality combined to spawn an endless torrent of books and articles assessing his legacy. . . . To know Whistler, or merely to have met him, spawned a cottage industry of memoirs and reminiscences by his contemporaries. But behind the dandified, prickly facade of a complex egoist was a serious, indefatigable artist." It is unquestionably true that Whistler toiled unendingly over his productions. But he worked just as hard on his public image, which in recent years, as during his lifetime, persists in complicating any approach to his art. Getscher and Marks note this often in their commentaries. Of Denys Sutton's *Nocturne: The Art of James McNeill Whistler* (1964), they observe that "setting aside . . . Sutton's stated intention to concentrate on the art of Whistler, and to avoid still another look at Whistler's fascinating personality, this is an excellent account. For Sutton's resolve quickly dissipates, and the art is examined commingled with the man." By contrast, Hilary Taylor's *James McNeill Whistler* (1978), is an informed study "rare among general works" in focusing on "Whistler's artistic intentions and accomplishments, rather than yielding to the lure of the artist's fascinating personality." The literature on Whistler spans a huge area between the pulpiest rehashings of his life to the most meticulously documented catalogues of his work. In this span

lies the key to explaining his longevity as artist and person. By being both with such intensity and such color, and by so aggressively placing himself in the public eye—flinging himself, not his paint pot, in the public's face—Whistler managed to hold together two realms of taste, the popular and the elite, that in the late nineteenth century were just beginning to show the strains of a widening fissure between them. Writings about Whistler have in the same way spanned that gap to produce an artist whose life alone makes for a good read and whose art alone is more than enough to keep connoisseurs and scholars busy.[26]

The career of Whistler marked the point where artist and image became interdependent, where the commodified self became a vital marketing tool. It might not be going too far to suggest that in Whistler lay the germ of postmodern performance art. Not every artist thirsted after publicity, and exploited it, as insistently as he did, but his actions must be seen as forming an exemplary pattern of great significance for artists in the twentieth century. The urban realists who were labeled "The Eight," a group led by Robert Henri, benefited greatly from their publicity-generating image as brash rebels and art revolutionaries, even though they were a group neither isolated nor marginalized nor particularly radical.[27] In more recent decades, the model of Andy Warhol is almost too obvious, yet in certain key features his self-fashioning represents an update of Whistler's original "act." When first seen—and almost instantly publicized as if scandalous—Warhol's paintings and silkscreens of mass-produced, brand-name objects seemed insolent, incomprehensible, cheap, dull, and meaningless. Yet at least in part because they were linked with an artist who knew how to assemble a mystifyingly bizarre public face, his Campbell's Soup cans and garish serial images of Coca-Cola bottles or Marilyn Monroe soon began to glow with his perverse and synthetic glamor. As with Whistler, so with Warhol: without the endlessly fascinating personality as an invisible but potent presence in the art, who would have cared about those soup cans; who would have bought them at steadily rising prices? If not made by Warhol, would an eight-hour movie featuring the Empire State Building from a single vantage point even be worth talking about? Who, after his death, would have paid hefty prices for the privilege of a collection of cookie jars, had they had not been Warhol's? Warhol's image gave them value. He stamped his mystique—the Midas touch of the skillfully manufactured personality—on these unlikely objects as surely as Whistler set his butterfly seal of authenticity on his little notes and nocturnes. Just as Whistler was unique and inimitable, so was Warhol, in his personal style and, paradoxically, in his art: even though he reproduced what was already mass-produced, no one else afterward could paint a soup can without seeming weakly unoriginal. Warhol took full advantage, too, of media technologies far more sophisticated than what had been available to Whistler. His life was a movie; his sphinx's silence recorded on film, his most laconic pronouncements oracular. Warhol was of course a great deal more overtly, even egregiously, commercial than Whistler ever was, but that was intrinsic to an image that referred at every point to the commodity and commercialism. He was quite literally

the commodity self. So different in style, Whistler and Warhol shared an acute understanding of the power of the media-generated image and public performance to lend interest and desirability to their aesthetic products, and both were the magicians of the commercialized personality that contributed so much to the life of their fame.

The construction of bohemia in late nineteenth-century America involved fabricating a stage or an arena for its display. This arena was the media, which industriously circulated colorful pictures of bohemian artist life as the performance of youthful dreams, picturesque poverty, good fellowship, high spirits, and high ideals. The underlying assumption was almost always that such an existence was and must be ephemeral; it was a stage of life—a kind of adolescence—that gave way in time to maturity and good sense. In the popular view, bohemia was an Oz of sorts, exotic and perhaps bizarre, where almost nobody grew old and where there was always something odd and diverting going on. There were invariably critics who condemned the supposed freedom of bohemia as corrupt and corrupting. But to the many who found it fascinating, it remained a kind of media-made theater, operating in a space adjacent to that of ordinary life, but distanced from it, either by theatrical make-believe or nostalgic memory-making.[1]

In 1903, William Henry Shelton published "Artist Life in New York in the Days of Oliver Horn," referring to F. Hopkinson Smith's recent novel *The Fortunes of Oliver Horn*. Smith's tale was based on recollections of New York's art world some thirty years before. His account of an aspiring painter in New York's bohemia featured the Tile Club and its members, thinly disguised as the Stone Mugs, including

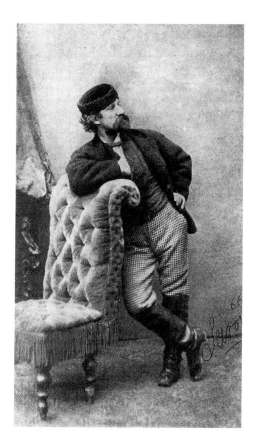

97. *Napoleon Sarony.* Photograph from William Henry Shelton, "Artist Life in New York in the Days of Oliver Horn," *The Critic* 43 (July 1903).

William Merritt Chase as Munson, celebrity photographer Napoleon Sarony as Julius Bianchi, and the author himself as Oliver Horn. In its mix of fact and fiction the novel was typical of bohemian narratives. Shelton too mingled history and myth in his account of Oliver Horn's semifictional, semihistorical New York. The development of the article took the form of leisurely, mellow reminiscence. "Times are easier now for Oliver," wrote Shelton, "but the early struggles are pleasant to remember as he sits in his studio before the fireplace bordered with blue delft tiles" by each member of the old fellowship of the Tile (or Stone Mug) Club. Shelton talked about Smith's characters as if they were interchangeable with the individuals who inspired them, reinforcing this by including as illustrations old photographs and sketches of the living counterparts of the characters in the book. His profile of Bianchi was accompanied by two photographs of Sarony (1821–1896), who enjoyed showing himself on Broadway "in a calf-skin waistcoat, hairy side out, an Astrakhan cap, and his trousers tucked into cavalry boots, accompanied by his wife in a costume by Worth." The photograph exhibits the diminutive but flamboyant Sarony (fig. 97) in just such a costume, appropriate for the artist who brought to the celebrity photograph a new lavishness of stylized, theatrical display. Bianchi-Sarony's studio was the same kind of jumbled, seductive treasure trove that painters cultivated around the same time

98. Napoleon Sarony, *F. Hopkinson Smith*. Illustration from William Henry Shelton, "Artist Life in New York in the Days of Oliver Horn," *The Critic* 43 (July 1903).

and that was associated with bohemian artiness. In Shelton's narrative, the eccentric photographer's studio boasted Russian sleighs, Chinese gods, ancient armor, and a dilapidated Egyptian mummy, along with the regulation pictures and cabinets of pottery. It was here that Oliver Horn/Smith and the Stone Mugs/Tile Club often met "to paint and drink beer and tell wonderful stories. Here came Jack Bedford from 1 Union Square; and Munson from Tenth Street, in a flat-rimmed, Latin Quarter hat, and leading a white Russian greyhound." Other anecdotes of youthful horseplay, quarrels, and excursions followed. All of the Stone Mugs "developed later into famous sculptors, authors, architects, and painters." In the days of Oliver Horn, though, they were a band of good fellows, struggling, hopeful, and wholesome, for all the colorful irregularity of their existence.[2]

Smith's own career followed the same pattern. Sarony's charcoal drawing of Smith, also in Shelton's article, shows an extravagantly unconventional young painter with a fez, an outsize handlebar moustache, a doublet of some kind, and trousers tucked into calf-high boots (fig. 98). The "real," older Smith, however, bore little

99. W. E. Mears, *F. Hopkinson Smith.*
Illustration from Gilson Willetts,
"Workers at Work. V—F. Hopkinson
Smith in Three Professions," *The
Arena* 22 (July 1899).

resemblance to the bohemian in fancy dress. W. E. Mears's illustration (fig. 99) from
The Arena, which ran an article on Smith in 1899 as part of its "Workers at Work"
series, shows a rather more portly Smith dressed as a prosperous businessman. The
moustache is the same, but there is no fez, and instead of a doublet the painter
wears the coat, tie, vest, pants, and well-polished shoes of one who could easily pass
for a stockbroker or banker. Because he was an engineer by vocation and pursued
painting and writing as a satisfying and profitable sideline, Smith did not quite fit
the profile of a full-time professional late-nineteenth-century artist. Still, he was well
known as a painter and habitué of the art world, and he fit the model of the up-to-
date artist who combined aesthetic interests with practical skills. The text emphasized
Smith's energy, competence, and diligence in all that he undertook, from making
deals in his Wall Street office to building lighthouses on the stormy Atlantic coast
and producing quantities of books and stories. He accomplished all this by observing
a strict schedule: "On the table before which he was now sitting, was a score of
thick Six B lead pencils and a big pad of yellow paper. . . . He comes up town from
his office at four in the afternoon and writes until six. When anything interrupts this
plan he writes through the two hours following midnight."[3]

He was equally efficient when painting—which occupied his summer vacations—

and he was quite successful at it. The extreme discrepancy between the younger and older Smith embodies the contrast between "bohemian" as a nostalgically viewed stage of life associated with youth, pleasure, unconventionality, and theatrical display, and the figure of the artist—the "real" artist in the present day—as worker and professional. This distinction was fundamental to the image and idea of bohemia.[4]

Looking In on the Colonies

In the media, at least, the art world of real New York and imagined bohemia most vividly resembled each other during the decades encompassing the early professional strivings of the postwar cosmopolitan generation. The center of art life was the Greenwich Village area, already the locus of an earlier literary bohemia made famous by Walt Whitman's presence at Pfaff's Beer Hall in the 1850s. After the Civil War, the Tenth Street Studio, built in 1857 by Richard Morris Hunt, became the hub of New York's art colony as the young cosmopolitans edged out the older occupants. Other populous studio buildings existed south of Union Square, along lower Broadway, and in the vicinity of Washington Square. Decay and change in the district, brought about by incoming waves of immigrant populations and the departure of the older gentry, resulted in an attractively low cost of living and generated a picturesque ambience of ethnic diversity that was sometimes—as in the case of the French émigré colony of the 1870s—associated with radical politics and subversion. Representatives of the cultural elite, such as Richard Watson Gilder, poet and editor of the *Century,* overlapped and intersected with the art community of the Village proper. Gilder held his literary and artistic salons just off Union Square in "The Studio," an old stable remodeled for him by Stanford White.[5]

The artists' neighborhood quickly acquired a distinctive character. Charlotte Adams identified it as the "artistic colony in New York," which had become a "recognized factor of the population." The term *colony* has suggestive connotations. It characterizes discrete and localized groups—prisoners, settlers, nudists—as well as aggregations of animals or other life forms existing as a single unit made up of interdependent parts. Prison colonies, of course, are composed of individuals whose association comes about involuntarily and as a result of the legal process; nudist colonies represent individuals who come together freely in order to pursue common interests, removed and protected from interference and intolerance. In either instance—prisoners or nudists—the group is set apart, contained by superior forces or containing itself. At the same time, it may be the subject of considerable unease or curiosity as the majority outside wonder what goes on inside. By their perceived difference from "normal" individuals—those who obey the law or wear clothes—the inmates or members assume the function of "others," deviants of one kind or another against which the parameters of acceptable conduct may be staked out. While nothing so extreme could be said of the New York art colony, such a conspicuous aggregation of painters, sculptors, and others in one special area almost automatically proclaimed their common interests, and their common differences from the rest of the world.

Unlike prison walls or camp barricades, however, the boundaries of the artists' "colony" were permeable, inviting observation, inspections, excursions. It was a zone for tourism, locus of diversion, an allowed and allowable space for difference, yet a space that contained that difference, inhibiting its wider circulation.[6]

Outsiders and insiders alike appointed themselves tour guides and issued colorful reports of life beyond the border. W. H. Bishop's 1880 article on the lives of young New York artists offered a typical itinerary. Bishop evoked an unstable world of flux and striving beneath the charming, "happy-go-lucky" surface, especially to be seen and felt in the "studios of the beginners . . . a great obscure body, full of aspiration, recognized failures and whimsical vicissitudes of fortune, between the student class and that of established reputation." Like Jacob Riis eight years later, penetrating the threatening, mysterious slums of New York, Bishop promised to throw a few gleams of light into the obscurity of that elusive and unknowable body. Most of the beginners' studios were on Broadway, where they could be found almost everywhere:

> Few of the older business buildings . . . but would yield to the search some obscure door in the upper regions bearing the title Artist. They are often the dingy quarters, with splintered, acid-stained floors, abandoned by photographers. . . . Disregard of conventional forms sometimes reaches the point of actual squalor. Here in one . . . three persons are sleeping, two on a lounge—which also serves as a coal box—and one on a shelf conveniently placed at night on trestles. Coffee is drunk from a tomato can. . . . The collection of dust-covered clothing, old boots and shoes, withered ferns, half dry sketches, plaster busts, groceries, books, and oil-cans, presided over by a battered lay figure in a Roman toga and slouch hat, would do little violence to the idea of symmetry in a rag and bottle shop. It is a veritable *vie de Bohème* that goes on. Such a fellow is said to have reduced to a nicety the art of renovating a linen front with Chinese white instead of sending it to the laundry. Landlords are regarded in an odious light, and if possible locked out. . . . Pictures are made a medium of exchange with the butcher and the tailor. If fortune be propitious the bohemian luxuriates at boarding-houses and restaurants, whose walls he becomingly adorns. At other times he takes but a single meal or only mush and milk.

Will H. Low's illustration, representing the Salmagundi Club in early times (fig. 100), shows high-jinks in an attic studio where two members are scrimmaging in the center of the room while others smoke, watch, eat, drink, sketch, or look at each others' work. The busy composition produces an effect of disorder and rowdiness completely absent from the companion illustration (see fig. 8) depicting club members dressing and behaving with sober decorum. The text described what went on during the club's "boisterous" early days: "In 1872 a knot of rather the most irregular young fellows was in the habit of gathering at the studio of a *confrère*. . . . A sort of

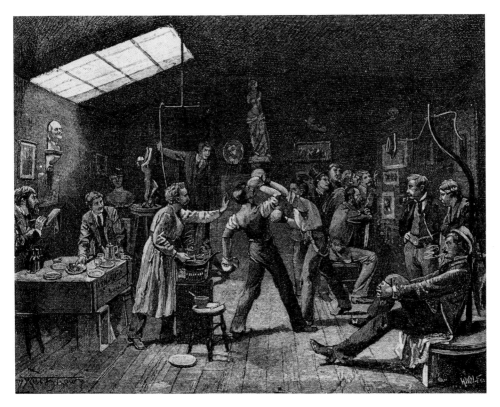

100. Will H. Low, *The Salmagundi Club in Early Times.* Illustration from W. H. Bishop, "Young Artists' Life in New York," *Scribner's Monthly* 19 (January 1880).

sketch class was formed in time which brought in all kinds of random subjects from the street. Some minor actors and newspaper men who had come once were pleased to return again to the evening assemblies. Fencing and boxing went on in one corner and declaiming in another, while the fine arts pursued their way as best they could."[7]

Bishop's tour of bohemia in New York made light of hardship and failure. There was to be sure a considerable, undifferentiated clump of mediocrities, but most of the "beginners" had brighter prospects. This construction of bohemia featured picturesque clutter and temporary poverty, bachelorhood and male fellowship, amusing narratives and anecdotes, and most of all, youth. Whether the bohemia described was historical or contemporary, the stress on being young there was unvarying. The notion of male fellowship also sounded a constant note. The Philadelphia Sketch Club as described by Henry Russell Wray could have passed easily for the Salmagundi. The club met in a "garret" on Eleventh and Walnut Streets, where the walls were hung "in artistic disorder" with sketches, etchings, armor, tapestries, draperies, and trophies. There was a huge fireplace where the members smoked their long clay pipes and sipped beer from earthen mugs or mixed toddy from a huge kettle on a crane. They entertained each other with songs and recitations and had a life class

on Monday nights. Even though they met in a garret, they were not half-starved weaklings but hearty fellows, each with a "jovial nature" and a "strong handshake." Whether the result of poverty, carelessness, bachelorhood, or careful contrivance, bohemian disorder and clutter connoted freedom from whatever standards of order and regularity certified an individual as a dependable and well-controlled member of America's modern middle and professional classes.[8]

Just as there was no dominant mainstream pattern of artistic identity, however, there was no single version of bohemia. While Bishop's account highlighted the "beginners," with their lodgings so aromatic and higgledy-piggledy that they might have passed for interiors in low-life genre scenes, there was also the aestheticized and highly calculated bohemia of such artists as William Merritt Chase, with his famously cluttered studio, as well as squalid versions associated with modern, decadent Paris. In *The Golden House,* Charles Dudley Warner used what was obviously Chase's studio as the setting for bohemian revels hinting at some encounter with the mysterious and the forbidden, with things that could be met only in the bohemian borderland of permissive space. Warner's description of Chase's studio was absolutely interchangeable with any journalistic report of the fabulous showroom, but he added a suggestive scenario. This was no polite studio reception in broad daylight but a very late evening affair featuring a performance by a sensuous and probably not at all respectable Spanish dancer. This episode was based on fact: the tempestuous Spanish dancer Carmencita had performed twice in Chase's studio, on April 1 and April 24, 1890. The fact that the studio lent itself so readily to such displays only emphasizes how closely bohemia and theater overlapped. The studio was nondomestic space, a private realm that had nothing to do with the family, mapping itself unambiguously in the territory of bohemia: "It was near midnight. The company gathered in a famous city studio were under the impression . . . that the end of the century is a time of license if not decadence. The situation had its own piquancy, partly in the surprise of some of those assembled at finding themselves in bohemia, partly in a flutter of expectation of seeing something on the border-line of propriety. The hour, the place, the anticipation of lifting the veil from an Oriental and ancient art, gave them a titillating feeling of adventure, of a moral hazard bravely incurred in the duty of knowing life, penetrating to its core." For certain out-of-town guests this venture represented an "exceptional descent." While it was not a stag party, neither was it a family affair. The dance was torrid and serpentine. Champagne flowed and young girls in Geisha costume handed round ices. Men were there without their wives and women without their husbands. One exchange summed up the character of the soiree: " 'And your wife didn't come?' 'Wouldn't,' replied Jack Delancy, with a little bow, before he raised his glass. . . . 'I know Edith thinks I've gone into the depths of the Orient. But, on the whole, I'm glad—' "[9]

The real Carmencita's performances in private studios and homes could be just as risqué. *Town Topics* aired its disapproval of what went on in the "luxurious

apartments of our more daring members of polite society." During a private performance several ladies had walked out, "their modesty in full rebellion against the sensual exhibition of which they had been made victims. . . . On stage, the torsal shivers and upheavals indulged in by Carmencita might be allowed to pass for art, but in the privacy of a richly furnished room, with innocent eyes to view her, nothing but the fatal earthiness of the woman's performance could make any impression." This passage underlines the fact that it was the collapse of the public (theater) into the private (a socialite's home or artist's studio) that gave bohemian space the tang of naughtiness. At the same time, this collapse made bohemia a carnival of pleasures for the curious, touring eye. The theatrical stylization of the behavior on display gave it just enough distance from reality to make it entertaining rather than threatening—except in the case of indignant, respectable ladies.[10]

The Trilby Paradigm

Representations of bohemia, youthfully carefree or mature and corrupt, almost always blurred boundaries so extravagantly that accounts of real bohemian life and fictional versions of it sounded very much alike. In *Trilby*, George du Maurier blended the two so suavely that this tale of an impossible, unreal, yet very believable bohemia soared to a smashing commercial success. More popular in the United States than in England, *Trilby* repays a closer look as the site of a bohemia made palatable for mass consumption. Inspired by Henri Murger's *Scènes de la vie de bohème*, Du Maurier's tragicomic tale of life in the Latin Quarter concerns a trio of young English painters—Taffy, the Laird, and Little Billee, the self-styled "three Musketeers of the Brush"—living a bohemian student life in Paris, where they befriend a charming, good-hearted laundress and model, Trilby O'Ferrall, a free spirit as innocently amoral as a child, who feels no shame over posing "in the altogether," or conducting casual love affairs. Often joined by members of their bohemian circle, including the sinister Jew Svengali, the musketeers and Trilby constitute a cozy ménage, feasting, singing, cavorting, and sometimes painting. Little Billee, the most delicate of the three, falls in love with Trilby, but his proper mother prevents him from marrying her. Fearing that their relationship will ruin Billee's prospects, Trilby disappears, bringing the first half of the novel to a close. In the last half, the three painters have returned to London, and Little Billee has become successful and famous. They revisit Paris to attend a concert by the greatest and most sensational new singer in Europe, "La Svengala," who of course is Trilby herself, now Svengali's lover and creature: he has used hypnotism to transform her from a tone-deaf musical illiterate into a fabulous songbird. The three musketeers go to a second concert in London. Seeing them, Svengali suffers a heart attack and dies. Once released from his spell, Trilby can no longer sing. But Svengali's intense mind control has fatally weakened her spirit, and she wastes away and dies. Little Billee soon follows her.[11]

Stripped to its bare bones, the plot sounds silly, feeble, and sentimental. However, Du Maurier draped it with rich, persuasive detail, drawing liberally on his

memories of carefree Latin Quarter days and spinning a romance out of carefully selected elements. *Trilby* was launched as a serial in *Harper's* in January 1894. Some readers found it offensively racy and canceled their subscriptions, but many more replaced them: Du Maurier told a friend that while *Trilby* had cost *Harper's* 30,000 old subscribers, it gained it 100,000 new ones. The squabble with Whistler, of course, contributed to the book's notoriety as well as the painter's (see Chapter 7). When the novel was issued as a book in September 1894, it became an instant bestseller, selling 200,000 copies by February 1895. (Nordau's *Degeneration* was selling briskly at about the same time.) *Trilby* was the "first of a new breed of 'sellers' . . . which were the heart of the new publishing system." A new copyright law (passed in 1891) permitted the major firms to gain control of the popular fiction market, which they secured by using ever more sophisticated promotion techniques, coupled with efficient national distribution. These marketing technologies developed a huge audience for the latest publishing phenomenon, though the demand was so high that in some cases nothing could meet it. A reader wrote to *The Critic* that the Chicago public library had twenty-six copies of *Trilby* but that they did not begin to satisfy the demand: "I believe we could use 260 and never find a copy on the shelves. Every one of our 54,000 card-holders seems determined to read the book."[12]

The *Trilby* craze escalated very quickly. Paul Potter's stage version of the novel debuted in Boston in March 1895. The play was a hit, and several touring companies were organized to take it on the road. There were twenty-four productions of *Trilby* running simultaneously in the United States by 1896. There were also *tableaux vivants* and other forms of amateur theatrical performances, including parodies such as the farce *Twillbe* in which John Sloan (later one of Robert Henri's brash "revolutionaries") performed the title role, in drag, in 1894. *Trilby* became a thriving culture industry during the height of the novel's fame, as manufacturers and merchants scrambled to capitalize on its popularity. A Broadway caterer now molded his ice cream in the "shape of a model of Trilby's ever-famous foot," and the catalogue of a Chicago shoe retailer featured a "picture of a high-heeled lady's shoe, flanked by an advertisement of 'The Trilby,' price $3, postage 15 cts." In Philadelphia, a Chestnut Street dealer was advertising the "Trilby Sausage," claimed to be "something new," filling a "long-felt want!" The craze was impressively profitable: *The Critic* estimated that "directly or indirectly" *Trilby* had caused "much more than a million dollars to change hands within the past eighteen months." Revivals of the stage version continued to draw crowds for many years, extending the profitability of *Trilby* well into the next century.[13]

What seems to have appealed to the vast readership of *Trilby* in the United States was Du Maurier's successful manipulation of the standard formulas of popular fiction, mixing "romance, sentimentality, occultism, and anti-Semitism" along with vividly detailed descriptions of places, interiors, individuals, and episodes that created the illusion of powerfully concrete actuality, enhanced by Du Maurier's abundant illustrations.[14] With *Trilby*, hundreds of thousands of readers enjoyed a tour of

a bohemia long ago yet so strongly, palpably present as to make it seem like a recent theatrical performance stamped freshly and sharply on the surface of memory. The sense of presentness was reinforced by the illustrations, in which Little Billee looks more like a Gibson Man than a mid-century art student, and the lines of Trilby's gowns trace the fashionably narrow silhouette of the 1890s. Du Maurier's bohemian tale almost seamlessly merged fantasy with fact, constructing an exotic kingdom of colorful inhabitants and unfamiliar settings, among which readers could go without anxiety under the author's expert guidance. As one reviewer said, Du Maurier actually installed "us" into this circle of gay life and careless freedom. The "secret charm" of this extraordinary story was that it did not appear to be one. It was as if "we entered the studio from time to time unnoted" and saw the friends painting away for dear life, or smoking their pipes and talking about art. Du Maurier's bohemia was both credible and appealing. The question is, what kind of bohemia did the author persuade his readers to enter and believe?[15]

This bohemia was, first of all, very clean, at least on the surface; it was something like a modern theme park where effects of picturesque clutter, age, and dilapidation are carefully planned and monitored. At the very beginning, the reader enters the studio shared by the musketeers and is allowed to inspect it minutely: "Near the stove hung a gridiron, a frying-pan, a toasting-fork, and a pair of bellows. In an adjoining glazed corner cupboard were plates and glasses, black-handled knives, pewter spoons, and three-pronged steel forks; a salad-bowl, vinegar cruets, an oil-flask, two mustard-pots (English and French), and such like things—all scrupulously clean. On the floor, which had been stained and waxed at considerable cost, lay two chetah-skins [sic] and a large Persian praying-rug." Despite an abundance of artistic bric-à-brac, this studio is a domestic and nonthreatening place—a place, moreover, of perfect male fellowship: there is an "immense divan" where three "well-fed, well-contented Englishmen could all lie lazily smoking their pipes . . . at once, without being in each other's way, and very often did!" The studio's occupants are also very clean, in contrast to Svengali, for whom the concept of bathing is entirely alien. With his blackened fingernails and matted hair, the mesmerist-musician visits Little Billee one Sunday morning and finds him "sitting in a zinc hip-bath, busy with soap and sponge." Svengali is "so tickled" by the sight that he forgets why he has come and asks: " 'Himmel! Why the devil are you doing that?' " As Little Billee proceeds after the English fashion to wash himself with much hissing and splashing, Svengali laughs "loud and long at the spectacle of a little Englishman trying to get himself clean." Even amid the raffish foreigners in the studio of the teacher Carrel (fig. 101), Little Billee remains dainty, clean, and polite.[16]

Innocent is another term of value that occurs frequently: the musketeers are stalwart young comrades, innocent of evil and impurity, and Trilby, despite her lax morals and nude posing, is an innocent as well—until the Englishmen (innocent in a quite different fashion) teach her the sentiment of shame. Although the plot turns on Little Billee's thwarted romance with Trilby, this is a sentimental concession in

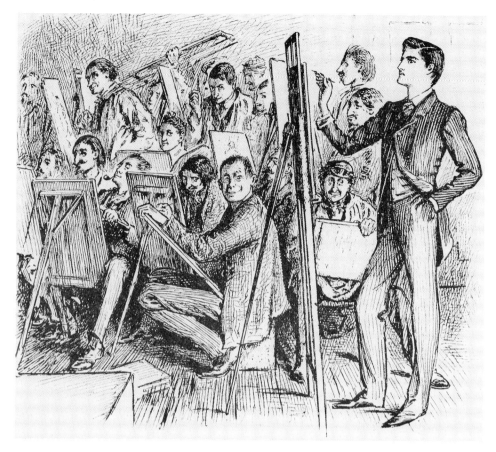

101. George Du Maurier, *'Av You Seen My Fahzer's Ole Shoes?* Illustration from Du Maurier, *Trilby* (1894).

a narrative that otherwise celebrates the joys of male friendship. Indeed, the three painters seldom paint. More often they carouse, boxing and fencing (like the real Salmagundi Club members), strolling the city streets arm in arm, cooking delectable dinners, and enjoying "jolly talk" into the "small hours." One illustration (fig. 102) represents a Sunday afternoon of lively fun in the studio. Except for the two grisettes in the foreground and the incongruous figure of Svengali behind them, the atmosphere duplicates that of the early Salmagundi Club. There is the same combination of chat, lounging, sparring (with fencing foils in this case), and looking at paintings. Having described one of the three musketeers' intimate evenings, Du Maurier permits himself to sigh: "Oh, happy days and happy nights, sacred to art and friendship! oh, happy times of careless impecuniosity, and youth and hope and health and strength and freedom—with all Paris for a playground, and its dear old unregenerate Latin Quarter for a workshop and a home! And, up to then, no kill-joy complications of love!" Even when Trilby joins the happy band, she does not impair their manly

102. George Du Maurier, *All As It Used To Be*. Illustration from Du Maurier, *Trilby* (1894).

friendships but blends in, volunteers to sew their buttons and darn their socks, listens agape to their lofty talk, and proves occasionally that she can cook even better than any skilled bachelor chef.[17]

Reviews of *Trilby* played on the novel's nostalgic tone as one of its chief attractions. In Du Maurier's Paris the mid-century, said the *Outlook,* was a "golden time of promise when the world shone in the vision of these gifted youths and Paris was not great enough to hold their ambitions and dreams." Far from wealthy, they were nonetheless happy, enjoying "devoted friendship, loyal cooperation, and uncalculating *camaraderie*." In Barnet Phillips's view, *Trilby* was "life—art life—seen through prismatic rays. Here are the rainbow colors. To a man who knew Paris, its ateliers, its art schools of forty-odd years ago, it is the most fascinating of modern books." *The Nation's* lenses, by contrast, had twilight tints: "And by casting back over a long line of years, between memory and imagination, he has . . . told us of a dead past, all radiant, and glowing now with the purple light of a vanished youth."[18]

Trilby's magical, make-believe atmosphere also exerted a powerful appeal. The *Atlantic Monthly* appreciated Du Maurier's skill as an illusionist in making so flimsy a story so captivating: "What is the bottom fact on which the whole rests? Ah, that is what one asks when he sees the juggler pulling yards and yards of bright ribbon out of a hat, setting birds flying from an empty birdcage, and performing other feats which one looks at with a vain attempt to escape his delusive action and penetrate the mystery of the sleight of hand." With his tricks, the author-magician managed

to divert the reader's attention from the nagging moral questions that *ought* to be at stage center. Somehow, the tale slipped away from the censorious grasp. It committed no offense against morality but was, rather, "an unmoral book, a nineteenth-century fairy tale for grown men and women." Indeed, this "unmorality" may have been the master key to the novel's popularity. English critic Frederick Wedmore recognized this clearly: "A good deal of Bohemianism—the rose-colored Bohemianism that manages to gratify the somewhat ignorant curiosity of people whom the Bohemianism of the realist would inevitably shock—that, of course, counts for something in *Trilby's* success. Again, while Mr. Du Maurier is a thousand times too respectable to venture boldly on the territory of the improper, he does persistently touch its fringe—and there are those whom that charms greatly."[19]

That fringe was the commercial edge of bohemia, the theatrical part, the territory that lent itself so readily to tourist excursions yet so seldom threatened seriously to undermine dominant cultural values. As a tour guide through this territory, Du Maurier so skillfully tailored his language to the task that the *Yellow Book* found it to be as rankly commercial as that of advertising circulars touting the benefits of Mother Seigel's Syrup: "that jaunty, familiar, confidential, colloquial form of writing which all lovers of advertisements know and appreciate." Du Maurier used this language to create an exclusive sense of false intimacy between himself—or the narrator—and the reader. This, as the "Yellow Dwarf" put it, was "WEGOTISM," the book's essential flavor:

> "Me and you—we see things thus; we feel thus, think thus, speak thus; and thereby we approve ourselves a pair of devilish superior persons, don't you know? Common, ordinary, unenlightened persons wouldn't understand us. But we understand each other." That is the tone of *Trilby* from first to last. The author takes his reader by the arm and flatters his self-conceit with a continuous flow of cheery, unctuous, cooing Wegotism. Conceive the joy of your average plebeian American or Briton, your photographer, your dentist, thus to be singled out and hob-a-nobbed with by a "real gentleman"; made a companion of—the recipient of his softly-murmured reminiscences and reflections, all of them trite and obvious, and couched in a language it is perfectly easy to understand. "Botticelli, Mantegna, and Co.!" Why, that phrase alone, occurring on page 2, would make your shop-walker's lady feel at home from the commencement.

Du Maurier's prose and manner did not constitute art but salesmanship. *Trilby* sold an illusory but heady sense of privileged intimacy and catered to the reader's desire to know the esoteric workings of the mysterious, titillating art world. As the economist and social critic Thorstein Veblen put it, "One will be a competent salesman in much the same measure as one effectually 'puts over' [some] line of make-believe." Indeed, the "perfect salesman . . . [would] promise everything and deliver nothing." Wedmore's comparison of Du Maurier's art with that of the juggler pulling yards of

ribbon out of a hat was thus a tacit recognition of an act of brilliant salesmanship, flattering readers and purveying the commercial "make-believe" of initiation into bohemia's inner circle.[20]

The title of William Dean Howells's *Coast of Bohemia* (1893) aligns it with the same theatrical fringe so successfully presented only months later in the more sensational *Trilby*. Howells (1837–1920), however, was not romantic enough; his bohemia did not live up to its obligations. Set in New York, *The Coast of Bohemia* followed the trials, hopes, and loves of two female art students (one poor and talented, the other a rich dabbler) at the "Synthesis," a thinly disguised Art Students League. One critic identified the "coast" where the reader was invited to linger as the "somewhat sophisticated and denationalized bohemia of the New York art schools and studios; the flavor of its life is very different from that of the enchanted region which Murger opened for us, but its ways are engaging if decorous, and its denizens very much alive while not too much in earnest." Another was more dubious. This was the coast of a "very shadowy Bohemia . . . an imitation, a make-believe, which only differs from Philistia in being more self-conscious and striving religiously to be broad. It is a clever picture of a kind of life that really exists in New York, but the men and women, nevertheless, seem to be puppets playing at life." The critics all complained, in one way or another, that Howells's *Coast* depicted an art world that was either too ordinary or too phony. Reader-tourists in bohemia, or what passed for it, wanted a romance of artist life, not any sort of reality. *Trilby* was scarcely any further away from Philistia, and if anything it was much more egregiously a sham. Du Maurier's romanticism, though, succeeded in fascinating a huge audience, whereas Howells's realism had considerably less appeal because it insisted on exposing the machinery of artistic pose and performance. Where Du Maurier's work succeeded in making the effects seem "natural," in Howells's production the "make-believe" and the puppetry were too obtrusive.[21]

The *Trilby* paradigm helped to create a social as well as cultural space for modern, commercialized artistic identity. These were borderline areas where artists were *expected* to be different, and to be different in such a way—by being eccentric, bizarre, immature, promiscuous—as to make them interesting and entertaining figures. They were free to act out a range of social or cultural aberrations as long as those spaces contained them. Certainly this was no one-way system; artists in the "real" world (like Whistler) readily learned how to exploit their "difference" as a selling point, and seemingly bohemian art worlds were in fact networks of institutions for social and economic support and exchange. And as Ulrich Keller has demonstrated in the case of pictorial photography, the cultivation of elite difference was a key maneuver in constructing the identity of the artistic photographer, as opposed to the commercial-grade technician. For such purposes, William Merritt Chase's theatrical costume-party bohemianism furnished a valuable model to Alfred Stieglitz and his cohorts in the Photo-Secession.[22]

One has only to imagine how pedestrian the stories of the art world would have

been if the artists had always been represented as leading conventional lives—working regular hours, sitting down to formal dinners—to realize that artist figures and their lives had far higher currency as mass entertainment if they were colorful, offbeat, and theatrical. J. Carroll Beckwith's diary provides a striking gauge of the difference between romantic bohemian docudramas and the daily life of a working artist. In 1895, Beckwith at forty-three was a bit superannuated for true bohemian status, perhaps, but he was very much a part of the world Howells explored in *The Coast of Bohemia*. One of his acquaintances was the playwright Clyde Fitch, whose *Bohemia,* a revival of Murger's *Scènes,* was produced in New York in 1896, and one of his portrait subjects was Thomas Janvier, a genteel chronicler of New York bohemian life. Despite such "bohemian" associates, there was little bohemian or romantic about his existence. He shared a settled though childless domestic life with his wife, Bertha, and worried a great deal about money, which might be bohemian in a dusty, skylighted garret but not in Beckwith's comfortable quarters in the Sherwood Studio Building on Fifty-Seventh Street, where his wife employed a maid to cook, serve, and clean. In 1894 he bought a tenement house on West Sixty-Sixth Street, where he had much difficulty collecting the rent. Unlike his spectacularly successful friend and fellow student John Singer Sargent, Beckwith, though very much an art world insider, had to work hard to secure commissions, and when he did get them, he was almost morbidly self-critical of his results. He did socialize a great deal with artistic and literary friends, and like a number of artists, he belonged to the Players Club, though he resigned once his name came up for membership in the more prestigious Century. With the exception of an occasional bacchanale, such as the Pie Girl Dinner, Beckwith's daily life was prosaic. On February 19, 1895, for example, his diary entry read: "Schools all day. Met Bertha at 4:30 at Wunderlich's where I went to see Weir's exhibition and thence we went to Macy's and bought a gas fixture for 67¢ for our bedroom." Like the incorporated artists discussed in Chapter 1, he attended meetings of the National Academy of Design and the Society of American Artists; he engaged in political maneuverings, looked at magazines at his club, and went to a fencing club for exercise. During the summer of 1895 he spent two months with Bertha in a cottage at the summer colony of Onteora in the Catskills. One of the events he recorded there was the contretemps stirred up by designer Candace Wheeler and her son-in-law Boudinot Keith, who wanted to incorporate the colony and tried unsuccessfully to force other residents to buy stock in Catskill Camp and Cottage Company. That summer he also complained of a distaste for dinner parties at 7:30 in the evening, since that meant "going to bed at 12 and breakfast at 9 with generally bad sleeping." This was no wild, free artistic existence but a life of routine and ritual. By any standards, Beckwith, despite a chronic need for cash, lived a life of material comfort and social privilege. His difficulties were practical rather than romantic, though he did have a tendency to suffer depression when discouraged by his prospects or by the inability to get his work to look right. While it holds considerable interest for a scholar, Beckwith's world was

no bohemia that could rivet the attention of a reader in search of entertainment. Indeed, the only "fit" between Beckwith and popular representations of bohemia occurred when the trope of bohemian failure coincided with what was by no means an outstandingly successful career. Beckwith had the double misfortune of pursuing his career during the late-century decades when the market for American paintings was bad, and of seeking work in the shadow of his celebrated expatriate friend Sargent, who managed to secure a good many of the prestigious commissions not snapped up by fashionable foreign competition. These circumstances contributed significantly to the sense of failure that plagued Beckwith and kept him in somewhere between youthful bohemian poverty and stable, mature prosperity.[23]

Safe Sex

Trilby may have enjoyed its stupendous success in America in part because it appeared at the right cultural moment. While the setting happened to be Paris, and the artist "heroes" Englishmen, *Trilby* nonetheless furnished an all-purpose model of what an acceptable bohemia might be. The model was particularly timely in light of growing ambivalence about contemporary Paris, the principal source, as many supposed, of modern corruption and decadence. *Trilby* provided a sanitized alternative: a Paris colorful yet ultimately benign, the picturesque setting for a whimsical and touching romance of youthful artist life.

In the "real" Paris, denizens of bohemia were all Svengalis, and American art students—male and female alike—just so many Trilbys. One "talented young fellow" had fallen victim to the deadly rhetoric of art for art's sake. Several months of Parisian life, "led unfortunately in close contact with a man who holds these same views," had tumbled him into the abyss of a degradation so profound that the fallen youth now must shun "all those whom he [had] known." The need for vigilance was critical: "Does it not stun you, when I tell you that not only do young men see, hear, and breathe this moral decay, but that some of the Paris doctors themselves are leagued with men and with devils to drag them down. . . . Mothers and fathers, think more than twice before you let your boy enter this Bohemian life, without a sure anchorage. . . . I say openly that I know the majority of the leading studios for men in Paris to be hotbeds of immorality. . . . Do we dare imperil our future by too close an intimacy with this frightful quality of Parisian life?"[24] Young Americans needed something akin to the purity and manliness of the "three Musketeers of the Brush," who were able—not without heartaches—to negotiate in relative safety the morass of Parisian immorality, excess, and filth. Du Maurier's anglicized, sweetened, and lightened bohemia was a welcome, if fictional, corrective.

By contrast, J. Carroll Beckwith found the style of Emile Zola's *L'Oeuvre* (1886) repellently blunt in its treatment of Parisian artist life. "What a needlessly dismal work Zola has made of it," he wrote in his diary. "To be realistic it is not necessary to search out the exceptional horrors in life and paint them in the most lurid language. Realism is the proportionate blending of good and bad, happy and unhappy."

The only redeeming feature of this "objectionable novel" lay in its "fine descriptions of local incident and color." Otherwise, it was not worth reading. The preferred fin de siècle construction of bohemia exhibited those redeeming characteristics while excluding for the most part the "exceptional horrors."[25]

Trilby, unlike *L'Oeuvre,* sold safe sex, in a sense. For all its waxworks realism of detail, the novel was a romance, and as such it functioned as an antidote to the microscopic inspection of nastiness widely associated with Zola's brand of realism. Moral objections inevitably were raised, along with doubts about whether a fallen woman could still be considered pure even in spirit, but such questions were of little consequence for many. In Willa Cather's opinion, for years there had been no book "more free from the fleshly and sensual" than *Trilby,* with its "clean, dainty pages." "It is full of the spirit of humor and good fellowship, but of the grossness of passion there is not a touch." *The Outlook* admired the novel's restraint and good literary hygiene. The three companions, who constituted a kind of "tri-personal hero" in the narrative, were true, genuine, chivalrous young men. Little Billee could have made Trilby his mistress, but it did not occur to him even in thought, and not being able to have her for his wife killed him. No book in English literature sounded a "nobler note in honor of masculine chastity."[26]

The tri-personal hero, of course, was noble and pure, but the single figure of Svengali more than matched them in a scheme pitting cleanliness, chastity, and Anglo-Saxonism against dirtiness, venery, and Jewishness. In Richard Kelly's reading, Svengali is Du Maurier's vehicle for the "daring theme of sexual domination," which figures the Jewish mesmerist as "a potent, dreadful, all-devouring sexual force, more appropriate to Victorian nightmares than to rational discourse." Since Trilby's own sexuality emerges only as a result of Svengali's hypnotism, however, there are in essence two Trilbys. The "other" Trilby's sexual nature remains suppressed "so as not to threaten her three male friends." Because of this, Kelly argues that the novel involves, among other things, a "fear of female sexuality."[27] The binarism of the three musketeers and Svengali, however, also ensures the segregation and confinement of male lust to the territory of the Other, where it can be savored, shuddered over, and kept safely compartmentalized, at a distance. Svengali's convenient demise at the end works to assert the triumph of purity and chaste manliness, but without having deprived the reader of any prurient thrills.

More fascinating was the persistent current of sexual ambiguity that trickled teasingly through the narrative, especially in the first part—the most bohemian—in which the musketeers enjoy each other's company in a state of bachelor bliss. This is an odd trio (fig. 103) consisting of the strapping, hairy, muscular Taffy and the Laird, and the small, slender, delicate, graceful, dapper Billee, with his big blue eyes and delicate features, which harbor (significantly?) the "faint suggestion of some possible very remote Jewish ancestor." Taffy and the Laird are "as fond of the boy as they could be" and find his "almost girlish purity of mind" so charming that they do all they can to preserve it in the risky atmosphere of the Latin Quarter. Billee,

103. George Du Maurier, *Three Musketeers of the Brush*. Illustration from Du Maurier, *Trilby* (1894).

for his part, wonders whether "any one, living or dead, had ever had such a glorious pair of chums as these." The girlish painter falls in love with Trilby, who makes her first appearance in cropped hair, a military jacket, and a huge pair of men's slippers. "She would have made a singularly handsome boy," says the narrator, and a little later: "one felt instinctively that it was a real pity she wasn't a boy, she would have made such a jolly one." As she falls in love with Billee, Trilby abandons boyishness for demure femininity; Billee, however, never becomes more conventionally masculine. Svengali likes to amuse himself by pinning Billee and swinging him around, saying: "Himmel! what's this for an arm? It's like a girl's!" When Billee's mother and sister visit him in Paris to convince him that Trilby is the wrong match, he responds with full-blown, hysterical fury during which he rants about poor, weak women " 'that beasts of men are always running after and pestering and ruining and trampling underfoot . . . Oh! oh! it makes me sick—it makes me sick!' " and finally gasps, screams and falls down "in a fit on the floor." Of the other two musketeers, the figure of Taffy—Billee's protector—is in pointed contrast to that of Billee, his physique constituting a "perpetual feast to the quick, prehensile, aesthetic eye," the male eye as much as any, presumably, which delights in the "gladiatorlike poise of his small round head on his big neck and shoulders, his huge deltoids and deep chest and slender loins . . . all the long and bold and highly finished athletic shapes of him." The fact that in the end both Trilby and Billee waste away and die signals the fact that neither the boyish girl nor the girlish man is equipped for "normal,"

mature, moral heterosexual relations. The parts they play were written for bohemia and could be safely carried out there, to be phased out and retired in the final pages. The teasing allusions to unconventional sexual orientation were all of a piece with the license allowed to operate on the fringe of impropriety, where the possibilities of perversion were still only a form of play as long as the actors remained in character and did not stray into the ordinary middle-class world. In Du Maurier's novel, there was little of the intensity that made the representation (or insinuation) of alternative sexual activity in Wilde's *Dorian Gray* so much more threatening. *Trilby's* bohemia was by contrast an aesthetic Never-Never Land of carefree happiness (or poetic sadness), perpetual immaturity, and carnivalesque inversions of conventional moralities and sex roles.[28]

Never-Never Land

Bohemia was for the most part the country of youth, aspiration, and temporary release from the strictures of convention and the burdens of maturity. There were exceptions to these patterns, of course: Whistler successfully purveyed himself as a kind of ageless bohemian performer, and Chase, married and many times over a father, continued in later years to flaunt the signs of bohemian nonconformity. But the predominant focus was on the threshold of the artist's career, that literally liminal space marking off a zone of freedom during the passage to adulthood, which was expected to proceed in season. The entertainment value of bohemian life was vested in its temporary and hence always elusive character. The bohemian population therefore tended to fall into young hopefuls and old, feckless has-beens. All others had moved on and up. Being or seeming young, bohemian, and radical became the stock-in-trade of the artist at the outset of his career, but it was understood that with the passing of youth, youthful stances would give way to adult concerns. This had happened, as *The Critic* wryly observed, to the inventor of bohemia himself, Henri Murger, who after *Scènes de la vie de bohème* became a popular success "went across the river to live, affected new and fashionably cut coats and abandoned the pork-merchant's celebrated garment to his factotum Baptiste, who now became his valet." For youth, bohemia might be a temporary abiding place, wrote Willa Cather, but "an old man who is still hanging about the outskirts of Bohemia is a symbol of the most pitiful failure on earth." The business of an artist's life was not bohemianism but "ceaseless and unremitting labor."[29]

In popular representations, the bohemian was a perpetual adolescent—a role much in keeping with the fairy tale or Never-Never Land character of the kingdom of Little Billee and Oliver Horn, as well as real artists' clubs like the Salmagundi, in which boyish good fellowship was unimpeded by the socializing and domesticating influence of women. "The average man," stated Emilie Ruck de Schell, "is by nature a Bohemian until his deeper being is awakened by the touch of a woman's hand. The loose, irresponsible life of the college chapter-house or the club-room possesses a fascination for him that is irresistible until he becomes satiated with its shams and

follies." Because of its undomestic nature, bohemia held great perils for the female bohemian, defined as the independent working girl—the artist or the writer—living on her own, away from her family, in the big city. These young women were all too easily led to ruin by cynical men of the world or unscrupulous artists who took fullest advantage of their loneliness and insecurity, taking them step by step to the point of no return.[30] The only "natural" female inhabitants of bohemia, indeed, were the women who had marginalized themselves by choice or necessity—actresses, models, adventuresses—and who lived beyond the sting of censure, in bohemian freedom. But on the whole, at the turn of the century, bohemia—realm of bizarre, picturesque characters—bore the character of a boys' club, jolly or tragic as the case may be.

Emergent paradigms of artistic identity late in the century reinforced or were reinforced by the Never-Never Land construction of the artist's adolescent world. In an era burdened by the sense of overcivilization, childlike or primitive attributes enjoyed rising currency as the artist figure came to be associated with and admired for the marks of healthy atavism. "A world grown old in feeling," said one writer, "would be an exhausted world, incapable of production along spiritual or artistic lines. Now, the artist is always a child in the eagerness of his spirit and the freshness of his feeling; he retains the magical power of seeing things habitually and still seeing them freshly." Another was even more emphatic: "But to be an artist at all, it is absolutely necessary that the child be there. The presence of the man does not seem so essential." Jolly, boyish camaraderie, vagaries, and unconventionalities of all kinds found sanction in this construction. In many ways, the world of the studios was commensurate with the idea of youth and freedom. While a number of married artists (such as Carroll Beckwith) combined living quarters with work areas, studios persistently connoted undomesticated space. Opened in 1879, the Tuckerman Building—popularly known as The Benedick—on Washington Square offered apartments for "unwed 'artistic' gentlemen of means." Once, wrote James L. Ford, bachelorhood had been a temporary condition to be weathered in boardinghouses, but there were a "few adventurous spirits" who owned their pictures, linen, and carpets; in particular, "artists were expected to live this way." The artists' example and the "attractive freedom of studio life" were largely responsible for the present popularity of bachelor apartments. "The old Studio Building in West Tenth Street and the picturesque University Building on Washington Square have sheltered in their day many of the most famous of New York bachelors, and were always famous abiding places for men of artistic appreciation." (Winslow Homer, famous and ageless bachelor, had once been a tenant in the University Building.) Shrines to quasi-adolescent, predomestic liberty, the studios were masculine sanctuaries, the clubhouses as well as the workshops of bohemia.[31]

A World on Paper

No one agreed on how real bohemia actually was, or how much of it was real, but nearly everyone concurred that a large proportion of it existed only on paper,

"more between the covers of books than anywhere else," as *The Critic* put it. Indeed, nature had imitated art in the sense that Murger's creations had spawned the cult of bohemia in real life. His subjects "did not know that they were Bohemians until he told them. . . . For was there ever a real Bohemia? Wasn't it after all called into fictitious life by its sponsor?" Bohemian deportment was the enactment of fictional ideals in real life and was thereby intrinsically "untrue"—that is, it involved the active and ongoing production of illusion. Fakery and bohemia were inseparable in many a story about artist life. Most of the artist figures in Charles de Kay's *The Bohemian, A Tragedy of Modern Life* (1878) were hypocrites and frauds, some bland, others dangerous. James L. Ford, chronicler of New York's various bohemias, attacked the literary conventions used to represent it. Noting the rise of interest in the "field of Bohemianism" since the *Trilby* craze, he set out to expose its props:

> In this field are many studios, each one tenanted by a "struggling" artist. In real life the artist is a sedentary character, but in this literary field he is always "struggling," after the fashion of a worm on a hook. . . .
>
> He always has plenty of "grand ideals," which are inadequately described to us, and in entertaining his friends serves refreshments in what is termed a "motley array" of broken goblets, shaving mugs, and other comedy vessels. . . . It is true that a complete supply of domestic utensils can be purchased in any five cent store, but the recognized laws of "Bohemianism" forbid the use of any dish that is not either cracked, broken, or, best of all, intended originally for some other purpose.

Ford diagrammed the network of bohemian social relations, which crisscrossed with other territories of metropolitan life to gather actresses, millionaires, and newspaper reporters. In these interconnections lay the true character of bohemianism as pretense: "[T]he fact that the actress is 'received by some of the very best people,' and that the artist's aunt gives receptions and dinners which are reported in every greasy society column, lends a certain halo to these 'merry studio gatherings.' . . . It is at these points that the fields of Bohemianism and society come into contact, while that of low life is entirely cut off from both by a chasm which is temporarily bridged now and then for the benefit of 'slumming parties,' or writers in search of 'local color.' " This was the critical difference between true low life and its bohemian imitation: artists might play at poverty or suffer privation early or even later in their careers, but it was in no way the poverty of the unskilled and often illiterate slum dwellers packed into New York's tenements and relegated to menial labor and low-paying task work. Artists were tourists in the field of poverty just as socialites were in the field of bohemia. In William Bishop's account of young artists in New York, artistic poverty was a spectacle to be enjoyed: neither artists nor readers expected it to last. Of course, real discomforts, frustrations, and failures existed in the artist community. All the same, those who were written about, and whose studios were featured in the periodical and news-

paper press, enjoyed a comfortable standard of living, and this was what Bishop's "Young Artists" expected to achieve. As white, middle-class or higher, well-educated men (and women) who by virtue of profession could number themselves among the cultural elite, most artists embraced bohemianism as an option, a performance, or a temporary inconvenience.[32]

The question of bohemia's "reality" also bears on the nature and rapidity of its commercialization. As a tourist zone—on the street or on paper—the bohemian world of artists promised novelty, exoticism, and forbidden delights to the middle-class thrill-seeker. The incursion of spectators, however, destroyed bohemia's authenticity and forced the genuine bohemians to migrate to places yet untouched, which in turn would be despoiled by the curious. It was difficult, indeed, to find a genuine bohemian even in bohemia, wherever it happened to be:

> Ten or fifteen years ago the "French Quarter" got its literary introduction
> to New York, and the fact was revealed that it was the resort of real Bo-
> hemians—young men who actually lived by their wit and their wits, and
> who talked brilliantly over fifty-cent table-d'hôte dinners. This was the sig-
> nal for the would-be Bohemian to emerge from his dainty flat or his oak-
> panelled studio in Washington Square, hasten down to Bleeker or
> Houston Street, there to eat chicken badly braisé, fried chuck-steak and
> soggy spaghetti, and to drink thin blue wine and chiccory-coffee that he
> might listen to the feast of witticism and the flow of soul that he expected
> to find at the next table. If he found it at all, he lost it at once. If he
> made the acquaintance of the young men at the next table, he found them
> to be young men of his own sort—agreeable young boys just from Colum-
> bia and Harvard, who were painting impressionless pictures for the love
> of Art for Art's sake, and living very comfortably on their paternal allow-
> ances.

These "innocent youngsters" continued to pervade the Quarter, and "by much drinking of ponies of brandy and smoking of cigarettes" they in time got to fancy that they themselves were bohemians.[33]

Garrets and Pretenders, Albert Parry's history of American bohemians, returned many times to the theme of artist in-groups fleeing the invasion of middle-class tourists trying to inhale the atmosphere of art, freedom, and wildness associated with bohemian places. The publication of Sinclair Lewis's *Babbitt* in 1922 set "many thousands of Middle Westerners toward Greenwich Village," so that by 1927 "thanks to this invasion, the word was wide and firm that the Village was nothing but bogus and a lewd bore." The commercialization of bohemia, like that of artistic identity itself, was in large part a product of the publishing industry, which so efficiently circulated the latest coordinates and current attractions of the "genuine" place. As Jan Seidler Ramirez writes, the "native colony of iconoclasts" in the early twentieth-century Village were "not reluctant to carry on a dialogue with the bourgeois press

they loudly condemned," and some, like Djuna Barnes, wrote features about Village life that piqued the "very interest from outsiders that Village natives professed to loathe." With the upswing of tourist curiosity came a thriving guidebook industry as well: for example, Egmont Arens, *The Little Book of Greenwich Village* (1918), Ralph Carpenter, *Souvenir Book of Greenwich Village* (1920), and Henry Collins Brown, *Valentine's City of New York* (1920). The same industry sprang up in other artist colonies, such as Provincetown, Massachusetts, where Nancy W. Paine Smith published *A Book About the Artists: Who They Are, What They Do, Where They Live, How They Look,* in 1927.[34]

The media played a cardinal role in constructing the figure of the bohemian artist and artistic haunts as desirable and consumable forms of entertainment. Many would never visit the metropolitan centers or idyllic retreats that harbored bohemian or simply artistic enclaves, but thousands would enter those haunts through the pages of Sunday supplements, magazines, and books. Parry's *Garrets and Pretenders* demonstrates how artists, when peeled from their productive activity, could be represented as bohemian performers and laughable eccentrics. This study enjoyed high status as an authoritative if energetically anecdotal text on the anthropology and sociology of artists in America. In his introduction to the revised edition, Parry noted that the book had become a "classic of a sort," cited by "many an article and every new book on Greenwich Village or other areas of Bohemianism . . . as the prime source of facts and comments on the subject." It does incorporate a wealth of information. However, it is light and chatty, as if such a tone were commensurate with the trivial nature of the subject. The chapters throng with unconventional characters—some funny, some weird, but very few threatening. The illustrations are nearly all cartoons and caricatures. While it may not be as "wegotistical" as *Trilby,* the book, with its condescending references to the bourgeoisie and the "Babbitts," encourages a sense of intimacy and even identification with the subject. One of the final scenes offers the reader a tour of the annual Independents exhibition in New York (c. 1930), an occasion signifying a "true freedom of spirit and non-deliberate picturesqueness": "A visitor is lost between his wonder at the exhibits and his curiosity toward the other visitors. What beards, what hair at the fringe of enormous bald spots, what skulls, eyes, and manners! What ties, flapping in declaration of independence! What outlandish shapes and colors of coats and dresses! It looks and feels like old times in the Village, before the pretenders and tea-room hostesses moved in. The press of New York is, of course, fully awake to this rare opportunity, and rails at the mad exhibits and the picturesque crowd of the opening night, but the railing is sophisticated and gently respectful in spite of its laugh-raising quality." This passage has much of the nostalgic and touristic spirit of *Trilby* condensed into it; in both, the artist and his (or her) colorful habitat have been assimilated into the realm of media-generated spectacle.[35]

104. Alice Boughton, *Albert Pinkham Ryder,* 1905. Photograph. Library of Congress, Washington, D.C.; Gift of Everett Boughton.

The "Real" American Bohemian

Of the few late-nineteenth-century American artists whose currency remained high through decades of alternating, colliding, and blending modernist and nativist mainstreams, Albert Pinkham Ryder (fig. 104) probably owed the survival and aggrandizement of his reputation in part to his many-times-recorded eccentricities. The representation of this artist in the media exemplifies the fascination exerted by what was perceived to be bizarre and bohemian in Ryder's character and domestic habits. The interest in his personality was analogous to the interest inspired by Whistler's, although while Whistler staged an elaborate and self-conscious performance of himself, Ryder allowed the critics to produce his show. In both cases the result was to make the artist's work more interesting. An emissary from some "genuine" bohemia, Ryder was fittingly a permanent resident there; indeed, the young Marsden Hartley placed him even further out, "among the first citizens of the moon." Ryder had not moved on like those bound for worldly success, yet he was not an old failure by any means: his perceived "childlike temperament" made bohemia his natural habitat. He was the perpetual artist-child, so lost in his dreams that he could not even pick up after himself: the ultimate undomesticated painter who as he aged needed responsible adults to look after him. Sadakichi Hartmann's report on a visit to Ryder's studio contained most of the ingredients of the Ryder "legend." Hartmann found it

extremely difficult to find Ryder (the elusiveness of Bohemia) and had to call "more than a dozen times" at the "simple, old-fashioned house in East Eleventh Street." Finally arranging by letter to meet his mysterious host in a tavern, Hartmann remarked on his bushy beard, dreamy eyes, and awkward demeanor. The critic was hardly prepared, however, for the astonishing spectacle of Ryder's studio: "As I entered the little two-windowed den—Mr. Ryder lighting the gas jet which could not even pride itself on having a globe—my eye met a great disorder of canvases of a peculiar dark turbid tone, lying about in every possible position, amidst a heap of rubbish and few pieces of old, rickety, dusty furniture; everything spotted with lumps of hard, dry color and varnish. I involuntarily had to think of a dump in which street urchins might search for hidden treasures." This atmosphere made the visit memorable: "Perhaps my impulsive nature, the extraordinary hour, the gaslight's hectic glare o'er the lapis-lazuli spots on his canvases may explain a good deal of the enchantment I felt on that evening." Although Hartmann found it difficult to explain, it was somehow the condensation of Ryder's personality and soul into his strange, dense little paintings that made them great, his "overflow of sentiment," his "patient waiting (running away from his studio to absorb November skies or moonlit nights, and returning to his canvases at all times of the day and night whenever a new idea suggests itself)." Ryder was almost a Svengali, without the sinister intentions. Scattered in Hartmann's account were references to fairy land, enchantment, and witchery. He caught sight of a life-size portrait in a corner and found his attention riveted on the face, "*the eyes* . . . as if a soul were bursting from them, and then it seemed to me as if Ryder, his soul was steadily gazing at me." Ryder's paintings—stand-ins for his soul—mesmerized and swept the viewer away, just as Svengali mesmerized the hapless Trilby with his gaze. Supported and probably indulged by admirers and critical mythmakers, Ryder derived a great deal of his cultural capital from his difference and oddity. In Ryder, admirers believed that they had found the heart of bohemia, the real thing. James L. Ford's dig at the bogus bohemians' use of broken goblets and shaving mugs to serve refreshments came to authentic and overwhelming life in the figure of Ryder, chronically and presumably helplessly in disarray. Lloyd Goodrich, certainly one of the most influential supporters of the Ryder "legend," sustained the same tone of indulgence decades later: "In all practical matters Ryder was completely unworldly. Reputation, money, social standing, even ordinary comforts, meant nothing to him. He never married, he dressed shabbily, his living quarters were in the utmost disorder." His paintings too embodied the very disorder of Ryder's life in their notorious instability caused by thick layering of wet on wet and "lean" on "fat" pigments.[36]

Ryder may or may not have been an authentic eccentric; chances are his strangeness was genuine enough. Did the figure of this painter click without scraping into a template for bohemian artistic strangeness, or was he the original from which the mold was taken? The answer lies in between: he helped to reinforce the pattern, just as the pattern helped fix attention on him. In certain ways, he materialized the

"myth" and legitimated it. Ryder occupied that liminal, permissive space identified with bohemian freedom. As an artist insistently labeled a mystic, a recluse, and a visionary, he was celebrated for habits that in most other cases would seem repulsive. Indeed, his role as artist-bohemian in part was to act out repressed impulses toward disorder, irregularity, and rambling unpredictability that could find no space in modern America, where discipline, punctuality, and responsibility were paramount in carrying on with business and moneymaking. Questions of genius, connections, and luck aside, a Beckwith going to the Macy's with his wife to buy a gas fixture for the bedroom could hardly exert the same fascination as the bizarrely undomesticated Ryder. And while it might seem that such a figure would resist commercialization, the brisk business in Ryder forgeries that began even before his death indicates that there was money in him.[37] Just as novels like *Trilby* and *Oliver Horn* confounded the reader's ability or inclination to separate fact from fiction, so Ryder, in his physical being, seemed like a character who might have shambled out of some picturesque Latin Quarter tale. He was the kind of artist people wanted to see, the kind of artist that fully met expectations of weirdness and nonconformity. That such patterns only grew stronger can be deduced from Parry's wegotistical enthusiasm for the beards, the eyes, and the outlandish shapes to be seen at the carnivalesque Independents exhibitions in New York. Whether Ryder willed it or not, he became one of the stars in the cast that performed artistic identity in the spectacle of modern American culture.

PART FIVE

Oculus Populi

9 DABBLE, DAUB, AND DAUBER

Cartoons and Artistic Identity

On the cover of the July 28, 1892, issue, *Life* featured an elaborately detailed cartoon (fig. 105) of a social gathering in a studio outfitted with tapestries, portieres, antique chests, old books, crammed portfolios, and bric-à-brac. In the foreground, an attractive young woman and a clean-shaven, broad-shouldered young man examine some prints or drawings. To the rear, the resident artist shows off a painting on his easel to a flock of admiring ladies, one of whom gazes at him, rather than the painting, with her hands rapturously clasped. The artist has a Van Dyke beard and a curly moustache. He is shorter and slighter than the women surrounding him, and, unlike the solid fellow in the foreground, he seems soft and pliable. The caption consists of a brief exchange between the solid fellow and his companion:

He: I wonder why Dabble doesn't turn out more work.
She: More work! Why should he—when he feels that he will never be able to sufficiently admire what little work he has already turned out?

This bit of dialogue duplicates the formula used to deadly effect by George Du Maurier in his broadside attacks on aestheticism (figs. 30 to 33). The man in the foreground represents the desirable, conventional norm; the artist in the background is feminized by association and by contrast. The caption tells us that he is a poseur (since he turns out

105. W. E. Day [?], "*I wonder why Dabble . . .*" Cartoon from *Life* 20 (July 28, 1892).

very little work) and a narcissist who thrives on unearned adoration liberally supplied by his feminine coterie. Perhaps it is the name Dabble, with its connotations of clumsy, childish spattering, that bestows the final mark of belittlement.

Dozens of similar cartoons in American periodicals at the fin de siècle established the artist in the public realm as target of mockery and source of momentary entertainment. Whereas Whistler, certainly the consummate entertainer and media manipulator, was after all a productive artist, the cartoon artist was almost purely a figure of fun, a full-blown clown. The fact that artist cartoons could appear not only in the satirical *Life* but also in the joke section at the back of *Harper's,* which in its front pages was likely to feature some intensely earnest piece about contemporary art, indicates how fragmented (or plural) artistic identity had become by the end of the century.

The Dabble cartoon also illuminates the ongoing and highly territorial filtration of "fine" from commercial art production. John Ames Mitchell (1845–1918), founder and editor of *Life,* defended "Contemporary American Caricature," as a legitimate

art of refinement and maturity thanks to improvements in public taste on one hand, and to the rise of the well-trained and abundantly gifted "artist in black and white" on the other. As the proprietor of a humor magazine lavishly illustrated in black and white, Mitchell had a vested interest in advancing the status of the illustrator and the cartoonist. But the terms in which he couched his celebration had a sharp competitive edge: "The vast field rapidly unfolding itself for the artist in black and white is one of the most interesting features of our modern civilization. Time was when he was looked upon as a painter who was unable to paint. To-day he occupies a position which in many important points is unquestionably superior to that of his brother of the palette. In America, especially, is this true. His standard of excellence is perceptibly higher. To one draughtsman who is obviously incompetent and yet perseveres in his career, there are dozens of painters who seem to revel in obscurity and failure, deluging the community with canvases they rarely sell, and excited to still weaker efforts by the unflagging enthusiasm of their female friends." Americans were not an "artistic people," and this at least excused the "absence of artistic quality in our painters."

> They are aesthetic, rich in sentiment and poetic feeling, with an honest love of nature, but they are not virile, and, as a rule, do not know their business. The American public have a weakness for intellectual art. They like an idea in their pictures, and if they can have it well told, graphic, technically good, and with a touch of human nature, they like it all the better. The American artist in black and white can do this, and it is here that he is immeasurably ahead of the American painter. The painter, when he sells his picture, if he sells it, sees it hung upon the walls of a private house as a part of the decoration. It is practically buried. The drawing of his black and white contemporary, on the other hand, is multiplied indefinitely and spread broadcast throughout the land, finding its way into the homes of thousands who enjoy it, and he in his work soon becomes the friend of the family and a welcome guest. Lastly, but of some importance, the wolf is not forever barking on his doorstep.

Mitchell's not-so-covert sense of "aesthetic" harked back to the laughable yet threatening figure of the Oscar Wilde aesthete, habitué of boudoirs and intimate of the feminine soul. Mitchell was really saying that the black and white artist was a real man, whereas his "more aesthetic brother"—surrounded by women who leached his strength, unable either to put ideas into his works or successfully market them—was not. Ironically, Mitchell attributed the development of public taste and refinement to the "aesthetic wave" that had "swept over this country about twenty years ago," but he deftly separated the positive results of that movement from what could be made usefully ridiculous.[1]

Although it is unclear whether the solid fellow in the Dabble cartoon is supposed to be an "artist in black and white," this hardly dulls the jab aimed at "aesthetic" pain-

106. William Henry Hyde, *A Surprise*. Cartoon from *Life* 3 (April 3, 1884).

ters, since the drawing itself is the work of a professional graphic artist. Seemingly a humorous moment in the studio, the cartoon undercuts the authority and credibility of the aesthetic painter while implicitly exalting the value of the illustrator. A cartoon by William Henry Hyde (fig. 106) published in an early issue of *Life* reinforces the likelihood that such scenarios were consciously intended to sideswipe aesthetic painters. Hyde's drawing, which occupies an entire page, represents a studio interior furnished much like Dabble's, with an antique high chest, a potted palm, ornamental plates and medallions, low divans, and other bibelots. On the left, a painter holds up a just-completed life-size portrait for the inspection of three visitors:

> *(Van Trupper, who is taken to Cadmium's studio by his wife and sister as they have a little surprise for him. Mrs. Van Trupper having had her portrait painted on the sly.)*
>
> Excellent, Mr. Cadmium, excellent! It isn't so effective a painting as I like myself, but I know it must be a good likeness. Who is it?
> *(Cadmium mutters something.)*

The joke is simple enough: Cadmium, despite his fancy studio, is an inept painter who cannot even approximate a sitter's features on canvas. More interesting is the fact that Cadmium's studio so strikingly recalls that of William Merritt Chase (fig. 107) by its prominent display of the classical head atop the distinctive Renais-

107. *The Studio of W. M. Chase.* Photograph from Elizabeth Bisland, "The Studios of New York," *The Cosmopolitan* 7 (May 1889).

sance cabinet. In 1884, Chase, his Munich "radicalism," and his flamboyantly ornate studio were well known. The cartoonist may simply have borrowed the look of the famous Tenth Street rooms to function as generic signifier for the cosmopolitan aesthetic painter. It is equally plausible, though, that Hyde, a professional illustrator who contributed to *Life* from its inception, relished the opportunity to take aim at a contemporary famous for his unabashed devotion to art for art's sake. Hyde's *Like the Wrong Man* (fig. 108) is a variation on the same theme. The joke here is that style has utterly superseded fidelity to the subject. This painter's studio features a wide-open Oriental parasol, a mandolin, and various other artistic odds and ends. In the background sits the model in a Renaissance chair; in the foreground Miss Jones inspects the result of Daubman's work:

Daubman: Looks a good deal like Velazquez, doesn't it?
Miss Jones: Well, it may; I never saw him. But it doesn't look a bit like my father.

Daubman invokes the authority of Velazquez, the inspiration and reference point of many a modern portrait painter, from Whistler to Sargent and Beckwith. There may be a sly reference here, in fact, to Whistler himself, since over and

108. William Henry Hyde, *Like the Wrong Man*. Cartoon from *Harper's New Monthly Magazine* 78 (March 1889).

over again critics debated the expatriate's debt to and departures from the Spanish master. According to one much-circulated anecdote, Whistler, ever eager to press his claims to greatness, drawled, "Why drag in Velazquez?" when an admirer gushed that Whistler and Velazquez were the greatest painters of all time. In Hyde's satire, the picture may be a good "Velazquez," but it is a bad portrait all the same.[2]

Turf Wars

It is evident that the model and inspiration for the artist cartoons, and for *Life* itself, was George Du Maurier; indeed, many of *Life's* jokes literally recycled his formulas. Du Maurier's chief outlet, the English satirical journal *Punch*, had done more than any other medium to popularize and thereby confer notoriety on the aesthetic movement. Founded by Henry Mayhew in 1841, *Punch* initially featured social and political criticism with a radical edge, but it soon shifted into alignment with middle-class interests, upholding normative values and attitudes while ridiculing aberrations of all kinds. It became a "school for the British nation," inculcating "correct" ideals of good citizenship and proper deportment. Its function as a satirical magazine was conservative: to defend convention and hold off whatever was new, different, and dangerous.[3]

As representative and shaper of British middle-class norms, *Punch* provided an outlet tailored to Du Maurier's own biases. Along with Whistler, Du Maurier studied

at the *atelier Gleyre* in the 1850s, but he abandoned painting and in the 1860s entered into a longstanding association with *Punch*. A full-time illustrator who wrote his own captions, Du Maurier socialized freely with prominent painters (including George Frederick Watts and Lawrence Alma-Tadema) and became a close friend of the erstwhile Pre-Raphaelite John Everett Millais and the American novelist Henry James. According to Leonée Ormond, however, the gulf between Du Maurier and successful Royal Academicians was the source of a constant irritation. Du Maurier never contributed more than a handful of drawings to R. A. shows, and during his lifetime no *Punch* artist was admitted even to Associate status. As a result, frustration born of envy and thwarted ambition infused Du Maurier's long series of cartoons poking fun at aestheticism and artistic men, so unsettlingly distinct from the normative construction of middle-class masculinity that Du Maurier endorsed. Despite *Trilby's* warm reminiscences of Bohemian student days, the older Du Maurier experienced sharply uncomfortable "outsider" feelings in the presence of such unconventional men as Dante Gabriel Rossetti and his circle. He described one particular soiree with the poet Swinburne as that "gorgeous nightmare of an evening," which had made him feel like the most thoroughgoing bourgeois, "so healthy and human." Like Mitchell, Du Maurier mounted a defense of the black and white artist, drawing the same lines of contrast between the "elder brother of the brush" who labored an entire twelvemonth to produce "that one priceless work of art, which only one millionaire can possess at a time," and the "great little artist" whose pictures, easy to grasp, reached thousands. In terms of understanding and feeling, the "little brother" could be a very big man indeed, "bestowing on innumerable little pictures in black and white all the wit and wisdom, the wide culture, the deep knowledge of the world, and of the human heart, all the satire, the tenderness, the drollery, and last, but not least, that incomparable perfection of style." The artist in black and white, in short, would be a Thackeray gifted with pictorial rather than literary powers of expression: a man of broadest universal sympathies. By contrast, the painter not only directed his efforts toward the few, but very often muddled his message, if he had one at all. Du Maurier's cartoon *Equal to the Occasion* (fig. 109) represents just such a hopeless impasse. In this instance, several visitors admire "Our Artist's" latest painting, displayed by accident upside down. When the artist rights the picture, Mrs. Gushington, undeterred, exclaims, "Oh! Oh! Oh! why, *that* way it's even more lovely still!" The joke is at the expense of artist and audience alike: both seem foolish, the artist for producing an unintelligible composition and the audience for "buying" it. As in Hyde's cartoon, there may be a veiled dig at Whistler here. In 1883, Oscar Wilde (much to Whistler's envious scorn) was invited to address students at the Royal Academy. According to Richard Ellmann, Wilde's lecture proclaimed the superiority of Whistler (who had coached Wilde for the occasion), even while evoking the authority of Whistler's nemesis Ruskin on some theoretical points. When a listener objected that Whistler's paintings "looked as well upside down as they did right side up," Wilde retorted: "Why shouldn't they? Either way

109. George Du Maurier, *Equal to the Occasion.* Cartoon from *Harper's New Monthly Magazine* 87 (June 1893).

they gave delight." In Du Maurier's cartoon, Our Artist's painting does indeed give delight—but it makes no sense; it is pictorial non-sense. Given Du Maurier's humorously hostile construction of the young Whistler in *Trilby,* along with the likelihood that he (as an equally hostile and fascinated Wilde watcher) knew about the poser of the upside-down painting, it is not difficult to read from this cartoon the insecurity of the illustrator (popular, successful, and loved) taking potshots at the painter who breathes the air of privilege yet "speaks" an unintelligible, nonsensical pictorial language. This insecurity—along with the need to attack and metaphorically disable the aesthete or the aesthetic (that is, narcissistic and noncommunicative) painter—underlay many of Du Maurier's artist cartoons. His attitude was partly personal, and yet by being made so public, and so popular, it assumed the function of representing class attitudes as well.[4]

There were strong similarities between *Punch* and *Life*. John Ames Mitchell was a Harvard graduate with architectural training; he was also an artist who drew a number of *Life*'s early cartoons. Mitchell's aim was to produce a high-quality picture paper that would attract a more refined audience than *Puck* and *Judge,* with their somewhat more rough-and-tumble brand of heavy-hitting political humor. The new photomechanical zinc etching process, which facilitated crisp, accurate reproduction of drawings and cartoons, was an important technological aid to the realization of Mitchell's ambitions. For staff he recruited a clutch of friends and associates from Harvard, such as *Lampoon* artists Harry Whitney McVickar and F. G. Attwood, as well as Robert Bridges, a Princeton graduate who wrote literary criticism under the

name Droch. Mitchell and other editors were closely involved in all aspects of the magazine's production. Sharp, deftly worded captions were considered essential to the success of the cartoons, and in the later 1880s Gibson and Mitchell formed the habit of lunching together once a week to think up subjects and work out appropriate dialogue. This suggests that the artist cartoons, like those making fun of other topics, represented editorial views as well as those of individual draftsmen: they formed a harmony and consensus of opinion.[5]

Although the magazine had a hard struggle for the first six months, it eventually reached its audience, the circulation numbering about 20,000 in 1885 and rising to 50,000 in 1890. By the early nineties it had established such a distinctive identity that, as Nathaniel C. Fowler stated in 1893, "Ten years ago LIFE was considered an impossibility, to-day it is almost a necessity. It goes to the best people in the United States and it goes to their homes. Every line of it is read and its influence is felt by every reader whether in its editorial columns or in its advertising pages." Fowler's extensive comments on *Life* are useful in helping to determine its readership. For all that it was a pictorial and humor magazine, it was meant to appeal to the better-educated classes:

> The aim of the publication was first of all to please, and to please without offense to morals and good taste. It was to be humorous and artistic, honest and fearless, satirical when it seemed that satire would do good, but above everything else it was to be so clean and wholesome that no parents need hesitate to lay it before their children. Most of the previous publications had been issued at five cents a copy. The publishers of LIFE believed that the better class of Americans preferred a good thing to a cheap one and placed the price at ten cents with the idea that they would give their patrons the best of their respective kinds in the way of artistic, literary, and mechanical work. This policy has, perhaps, kept LIFE from circulating so largely among the masses as it might, but it certainly confirms its position as the favorite publication of the best American families who know a good thing when they see it and are willing to give fair value for it. And the experience of the publishers has been that in America this class is increasing with tremendous rapidity.

The magazine described itself as a publication "by gentlemen and for gentlemen," though there is no evidence to indicate that readership was overwhelmingly male. *Puck* and *Judge* were identified with the masculine world, since they appeared in clubs, hotels, barbershops, and other male venues, whereas *Life* linked itself with the home as well. Roland Elzea's assessment of the audience seems close to the mark: middle- and upper-class Anglo-Saxon Protestants of a somewhat liberal variety (more or less in alignment with the magazine's generally liberal stance)—and probably largely urban and suburban, I would add, since the magazine regularly denigrated the rural population as a group of shuffling, ignorant hicks. It also attempted to demolish a variety of

other targets, predictable for the era: Jews, African-Americans, and all kinds of immigrants, in addition to Anglomania, Boston elites, Sunday museum closings, and the foibles of high society and the nouveaux riches. The high society cartoons treated such subjects as elites on vacation, elite courtship, marrying for money, fashionable empty-headedness, consumerism, pretension, materialism, and manners. It was in this category that most of the cartoons of artists and art life belonged.[6]

The society life cartoons, in William Murrell's view, functioned rather like those in *Punch*: "From both text and drawings readers might gather hints as to dress and conduct. Censor and mentor, *Life* spoke *for* those who knew and *to* those who aspired to know, and always in a delicate, refined manner." The early volumes of *Life* represented the "genteel school of humor at its best—and at its worst." Thomas L. Masson, an early contributor to *Life,* presented his insider's point of view, reinforcing Murrell. "The real humorist," he declared, "is always a conservative. He stands upon the established order of things, largely overlooking the abuses which have crept in among them. He does not seek to invent anything new, so much as to attack it when it appears." The humorist therefore eagerly scanned the horizon for approaching fads, which sometimes stabilized to take their place in the "national consciousness" as "permanent butts," such as golf or bridge. The most profitable subject was that which was understood by the greatest number of people and which was vividly personal (a bad golfer) rather than vague and controversial (weakness in the social structure). Since people wanted new jokes yet wanted to be informed, the "skilled editor" hid the "deep-seated conservatism of his humorists under changing aspects of ridicule as applied to the new aspects of things in general," and simultaneously, he mirrored the times. The humorist always maintained a "certain definite attitude or standard," treating humbugs, for example, "from his own concealed standard of honesty and candor." The result of this activity was to uphold certain standards of normality, to filter what was acceptable from what was not, and to transmit these conclusions to readers: "The best humorous papers the world over have always been the work of a small group of devotees; thus, the periodical itself becomes a kind of mentor and guide to the body politic." *Life* perfectly fit Masson's model, just as *Punch* did. Product of a small band of elites from the best colleges (and in many cases the best art schools), *Life* represented the world in its image, which its readers were expected to recognize and endorse.[7]

The artists working for *Life* were mostly free-lancers. They sold their drawings to competitors, and many were also "straight" illustrators for various publishers. Those who most frequently lampooned artists and their foibles (in addition to a range of other "society" topics) included William Henry Hyde, Harry McVickar, Albert Sterner, and, occasionally, Gibson, along with an assortment of names that appeared with less regularity, such as C. Carleton and S. S. Van Schaick. Whoever the artist, there was a kind of house style that created strong similarities among the cartoons, further reinforced by the stock nature of the jokes. Hyde and Sterner also contributed artist cartoons to the humor pages of *Harper's New Monthly Magazine*,

whose readership (and editorial structure) overlapped with *Life*'s if it did not duplicate it. These prolific illustrators made their living primarily in the publishing field, yet their training took place largely within the system that produced the cosmopolitan painters of their generation. Gibson (1868–1944) actually had the most domestic course of study, attending day classes from 1884 to 1886 at the Art Students League, which produced a substantial number of the professional illustrators who began to enter the market late in the century. McVickar (d. 1905), a native of Southampton, New York, was a Harvard alumnus and member of the Century Club. Hyde (1858–1943), was born in New York, graduated from Columbia in 1877 with an A. B. degree, and began to draw for *Life* almost as soon as it began. In the late eighties he traveled to Paris, where he studied under Gustave Boulanger and Jules Lefèbvre at the Académie Julian, home to so many young American students; he exhibited at the Salon in 1890 to 1893 and later showed in a number of international expositions. Sterner (1863–1946) was born and educated in England but at age eighteen moved to Chicago, where he practiced lithography, scene painting, and drafting. In 1885 he moved to New York and began contributing to many of the leading magazines, including *Life, Harper's,* and *St. Nicholas.* Like Hyde, he went to Paris in the late 1880s and studied at the Académie Julian. He exhibited at the Salon and various international expositions. Gibson himself went to Paris in 1889 and enrolled in the same atelier, though according to his biographer, none of the famous teachers ever made an appearance while Gibson was in attendance. The pattern of making a Parisian pilgrimage after the start of their careers suggests that Hyde, Sterner, and Gibson either wanted to hone their skills or to retool themselves to enter the ranks of "real" painters. Their continuing activity as full-time illustrators of course had its benefits: the money was good, and in some cases it was simply impossible to give it up. Like many other artists of the period, however, they operated as professional illustrators and as exhibiting painters. Sterner sustained such a professional commitment to illustration that he helped found the Society of Illustrators in 1901. Upon invitation, Gibson joined in 1902 and later served as president.[8]

Whether the artist cartoons produced by such illustrators and their colleagues carry the kind of complex personal feelings evident in Du Maurier's satires is the question here. Were they attacks launched by illustrators against "aesthetic" painters—and as such embodiments of the rivalry noted by John Ames Mitchell in such loaded, gendered terms—or did they cater to an audience wary of the new in art and happy to see it ridiculed? Considering Mitchell's strong rhetorical position on illustrators' preeminence in art and manhood, a case can be made for interpreting artist cartoons as emasculating belittlements of aesthetic painters. Seen in this light, such cartoons illustrate the mechanisms of ethnic humor—that is, ridicule of the Other—explained by Joseph Boskin and Joseph Dorinson, who state that "humor based on stereotype, the nastiest cut, can emasculate, enfeeble, and turn victims into scapegoats."[9] The Dabble cartoon does this quite nastily indeed. A look at the names assigned painters in other cartoons is also revealing. Some are given labels referring

110. Charles Dana Gibson, *At the Academy*. Cartoon from *Life* 12 (December 6, 1888).

to studio tools and pigments: Van Kuller, Chalkley, Palette, Broadbrush, Chrome, Cadmium. Others, though, are plays on Daub, even more denigratory than Dabble in its connotations of the crudest, clumsiest smearing: Daub, Daubman, Van Daub, Daubley, Dauber, Daubson, Daubstick. Gibson's memorable broadside against aestheticism (see fig. 40) set the scene of the aesthetic salon at Mrs. Daubleigh Crome's, which suggests that Daub not only denoted the incompetent paint-spreader but pointed to the degenerate and the deviant as well.

Whatever the name, Dauber and cohorts were invariably incompetent, laughably so, as in Gibson's *At the Academy* (fig. 110) in which a painter sporting a dude's monocle leans deferentially toward two stylish young women standing in front of a picture-hung wall:

Mr. Broadbrush (a promising painter): Good morning! Mrs. Budrose; good morning! Miss Violet. You must excuse me, ladies, but I've been watching you admire my picture.

111. S. S. Van Schaick, *How She Knew.* Cartoon from *Life* 13 (January 3, 1889).

Both ladies (suddenly and without thought): Oh, Mr. Broadbrush, I hope you
didn't hear what we said!

It is not clear which of the sketchily indicated paintings is Broadbrush's. One
is a Barbizon peasant scene, with a sunbonneted woman leading cows; another is a
seated nude; the last is illegible. In this case the artist is doubly entertaining: to the
readers, and to his guiltily surprised audience within the cartoon. S. S. Van Schaick
(1848–1920), another one of *Life's* high society specialists (and student of Jean-Léon
Gérôme in Paris), made the same point in *How She Knew* (fig. 111), a studio scene,
once more very much like one of Chase's Tenth Street interiors, with portieres,
potted palm, and other suggestions of exotic decor, along with a painter in a flashy
jacket—possibly velveteen—a Chase-like beard and moustache, and fancy slippers.
He is conversing with his lady visitor:

He: What made you think that picture in the exhibition was mine?
You must be a judge of style, because it was unsigned.
She (modestly): You flatter me. I really didn't know it was yours until I saw every-
body laughing at it.

For all his fashionable accessories, this is no real artist but merely a clown,
down to his outlandish footgear suggestive of the harem and decadent eastern
lands. In both Gibson's and Van Schaick's variations on the joke, the artist can be

read as something of a sissy—velveteen, Oriental shoes, and embroidery in one case, and the dude's monocle in the other. More important, the only pleasure their paintings yield is laughter—appropriate for the cartoonist, who by making his own sly joke affirms his competence as artist and humorist—but hardly the reaction dearly sought by the aesthetic painter who aimed to elevate, soothe, or move the viewer. By such strategies, the aesthetic painter is shown to be ineffective, powerless, and considerably less than manly, no match for the talents of the masculine, modern illustrator.

Artist versus Audience?

What about the illustrators' own dual identities? Sterner, Hyde, and Gibson, among others, made their own belated student pilgrimages to the same Parisian atelier that trained their painter contemporaries, and they cherished ambitions to be "real" painters themselves. What was at stake in belittling the very enterprise in which they themselves had stock? Certainly, many cartoons were just as hard on the public—audience and critics alike—as on the painter-clowns. At a time when artistic identity was mutating because of the changing nature of the market and the introduction of such professional opportunities as illustrating, along with ongoing conflicts about what painting was supposed to do, the gulf between artist and viewer could be great. Artist cartoons incorporated and expressed some of the anxieties and uncertainties felt on both sides. Many of these little comedies, in fact, may be read as responses to the forms of art practice then most severely under attack: new and unfamiliar styles, imported from Paris or Munich, and unintelligible to a wide public. A good number of the foreign-trained, after all, were classical painters—like Kenyon Cox—or popular realists, like Thomas Hovenden. Such figures were seldom under attack in the cartoons. The major targets seem to have been painters who espoused any variation on art for art's sake, that large, loose category embracing Chase's sensuous Munich materialism as well as French and American impressionism, in addition to styles, such as Aubrey Beardsley's, specifically associated with decadence.

The middle and upper urban classes constituting the core audience for this humor evidently found something both amusing and consoling in its conservatism. The "solid citizen," a stock comic character type that began to develop around the turn of the century, provides a useful point of reference here. Complement to the "crackerbox oracle," the solid citizen, writes Norris W. Yates, was "an idealized figure of the common man, representing not what most native-born Americans thought they were but what they hoped to become—a business or professional man who owned his own home (or could if he wanted to), and earned a substantial income which gave him some, but not too much, leisure. The idealization was not so extreme that the common reader could not easily identify himself with this figure." The solid citizen (and his counterpart, the Gibson Girl) had good diction and good manners and a "moderate acquaintance with culture":

"His acquaintance with music and the fine arts was limited, but he respected the arts as such, although he mistrusted painters, musicians, poets, and novelists as unstable, and he was suspicious about people too enthusiastic about these unprofitable occupations. Sketchy though his cultural background was, it placed him in sharp contrast with the crackerbox philosopher, who garbled Shakespeare and who distrusted culture categorically." In general, the solid citizen sought and advocated a norm between extremes. This profile closely matches that of Thomas L. Masson's humorist: the closet conservative whose job it was to ridicule the new, expose humbugs, and preserve solid standards of value and normality. What was allowed to be normal, of course, could shift from one generation to the next, but within this frame whatever smacked of the faddish was a legitimate subject for satire. *Life's* audience may have been a little more sophisticated than the solid citizen was supposed to be. Certainly *Harper's,* where many of the artist cartoons appeared, attracted a well-educated readership, though perhaps of a slightly older and better-heeled generation. In comparison with the stupendous mass appeal of magazines like the *Ladies' Home Journal,* with a circulation of one million in 1903, neither *Life* nor *Harper's* had anything approaching a mass audience. Their circulation figures, hovering around the hundred thousand mark, suggest a reasonably large yet to some extent exclusive readership, upwardly mobile or already there, interested in the modern yet suspicious of extremes, and a bit snobbish about it.[10]

Cartoons and comic dialogues featuring the illegible painting played to the solid citizen reader's distrust of the new in art, and his (or her) fear of being defrauded by aesthetic con men. C. Carleton's drawing for *Life's* title page in 1891 (fig. 112) follows the formula used to signal art's uneasy public relations. Once again the setting is a studio interior, with bits of drapery, a divan, a mask and Chianti bottle on the wall to suggest "art atmosphere." The artist, wearing a billowy bow tie—one of several signs regularly used to identify the artist figure (see fig. 66)—has just put his latest painting on the easel. Still awkwardly stooping and grasping the frame, he glances over at his silk-hatted visitor, who has just entered the studio. Hand to cheek, rocking back on his heels, the caller pronounces on the work before him, much to the indignation of its creator: "Ah! That's an original idea—pin-wheel in motion." "Pin-wheel, sir! That is a sunset."

The man who misreads the painter's sunset as a pinwheel fits the pattern of solid citizen, the individual who has good reason to distrust artists as creators of tricky, illegible paintings. But the cartoon's title, *Not an Expert,* further complicates the nature of the exchange between painter and beholder. Is it a snide poke at the ignorant yet opinionated public, ill-schooled in the ability to read and understand modern art, and unwilling to try, the kind of viewers who would happily enlist under Ruskin's banner to belittle new work as so much more paint impudently flung in the public's face? Or does it target the painter: an impressionist of some new school whose egotistical outpourings on canvas far outdistance his desire or ability to reproduce the scene observed

112. C. Carleton, *Not an Expert*. Cartoon from *Life* 17 (November 5, 1891).

(or imagined) and make it meaningful to others? Vilifying impressionism as the refuge of the mediocre, *Broadway Magazine* spelled out what Carleton's cartoon implied about the modern painter's status as anything but expert:

> Of course, the ultra crowd will insist that this impressionism run rampant is artistic and mystic, and it is the evidence of great genius, and all that sort of drivel.
>
> As a matter of fact, when an artist finds he cannot draw pictures for sane folks, he turns his pen to impressionism, and soon we are called upon to stand aghast with admiration and wonderment at the sight of girls with square faces and hair like cable; houses with impossible roofs, and cows with faces like a full moon after a night's debauch.
>
> No doubt if you are essentially aesthetic you will be able to find much that is grandly artistic in [such] pictures.
>
> I call them rot.

113. Albert Sterner, *Impertinently Pertinent.* Cartoon from *Harper's New Monthly Magazine* 88 (December 1893).

And so do you if you're honest.
All of them are supposed to be symbols and all of them mean about as much as a swash of green paint against the side of a red barn.[11]

Who was to detect and expose the signs of incompetence? In Sterner's *Impertinently Pertinent* (fig. 113) the critic assumes this role. Here, the Friendly Critic in his derby hat lounges in a bentwood chair while Dauber stands over him, stiff with indignation down to his very moustache:

Friendly Critic: They're a beastly lot, Dauber, and no mistake. What isn't disgusting in them is due to Monet. Have you anything else to show me?

Dauber: What's the matter with the door?

This cartoon's title is as ambiguous as *Not an Expert:* Is Dauber in his rudeness doing the logical, necessary thing by casting the Philistine out, or is the critic in his

114. Charles Dana Gibson, *A Discerning Friend.* Cartoon from *Life* 26 (October 31, 1895).

frankness telling the bald truth? What the critic says is a little slippery as well. Dauber's paintings are beastly and full of disgusting things. However, there is nothing to indicate that what is "due to Monet" in Dauber's paintings redeems them; the only thing we know is that these traces are something other than disgusting, but they could be just as bad in a different way. Gibson produced a variation on Sterner's theme in 1895—the year of the Wilde trials and also the year when *Life* ran its spoofs of *The Yellow Book*. In *A Discerning Friend* (fig. 114), there is no studio decor but only the basic elements: easel, painter—tipped back on a camp stool—and visitor, standing with hands in pockets and an impassive face:

The Artist: How do you like it?
The Friend: Best work you ever did. What does it represent?

Once more, the title is a bit ambiguous. Is it sarcasm thrust at a friend who, far from being discerning, is an aesthetic dunderhead? Or does it nod approval to one who can get to the heart of the problem with modern painting: that there is nothing in it—even the best? The styling of the artist here offers a clue. While it is in no sense a portrait, it distinctly refers to the Whistler type in the tousled, wavy hair, the jaunty moustache, and the puny physique. This was not the kind of artistic

115. *Charles Dana Gibson*. Photograph from *The Critic* 34 (January 1899).

identity Gibson himself projected. A photograph from the 1890s (fig. 115) highlights the illustrator's square-jawed, clean-shaven, sleek-haired ruggedness, quite at odds with the flimsy figure of the painter in the cartoon. Given Gibson's adulation of Du Maurier, and Du Maurier's notorious complex of feelings about Whistler, the brilliant, enviable Butterfly, *A Discerning Friend* helps pinpoint Gibson's own position well back from the border on the side of the competent, hard-working, manly, socially responsible and genuine artist in black and white.[12]

Bound up with the artist's perceived incompetence was the suspicion of fraud and duplicity. A comic dialogue in *Munsey's* bluntly addressed this. "In an Art Gallery" is a conversation between two spectators: Miss Daisy Chane, the purest type of the Philistine, and Mr. Soft Toane, a languid aesthete. They argue their way through the exhibition, disagreeing about everything they see. Finally Toane leads Miss Chane to look at something by a "new man," a little painting containing "nothing in it ... that you would call natural." Miss Chane looks at it intently without seeing a thing: "I can't quite make it out, but it's real bright, and that big splotch of crimson down in the corner is a perfectly lovely shade. That girl we met as we were coming in has a bonnet trimmed with exactly that color." Mr. Toane, by contrast, stands in rapture, exclaiming: "How tender and subtle and exquisite! Ah, that sky! Ah, that lake with the wonderful sunset! What superb treatment! That man must have a soul!" A third voice then breaks in: "*Jack Daubley* (a practical, modern artist, *sotto voce* to his friend)—'I told you that racket would work. You remember that piece of burlap I had in the studio to wipe my brushes on? Well, I cut it up and framed it. You saw this thing standing on my mantel just before the exhibition opened. That one had a crimson sky? I tell you it's the same picture, only I decided to hang it the other way, and now the sky's a lake.' " The scenario reproduces the situation Du Maurier made fun of in *Equal to the Occasion* (see fig. 109), but with

116. Albert Sterner, *Quantity Not Quality.* Cartoon from *Harper's New Monthly Magazine* 94 (February 1897).

the important difference that whereas Du Maurier's painter and his audience were merely silly, Jack Daubley is a cynical opportunist, passing off a paint-smeared rag as a beautiful sunset. There is no work in this picture, no thought, no taste. It is pure humbug. Significantly, though, Miss Chane, the Philistine, is merely puzzled by it, while Mr. Soft Toane, completely bamboozled, makes a fool of himself by falling into ecstasy before it—as genuine a daub as might be seen anywhere.[13]

Stakes rose significantly higher, of course, when actual monetary transactions were involved. Sterner's *Quantity Not Quality* (fig. 116) shows Mr. Chrome display-ing a Whistlerian seascape—nothing more than water, horizon, and heavens—to a pair of ladies. Propped up against a chair between the painter and his clients is another canvas, depicting sheep in a pasture. The conversation has to do with the fact that Chrome is asking the same price for both. On hearing this, Mrs. Gotthair makes her decision: "Oh, then send me home the sheep picture. I couldn't think of giving so much for *just sea and sky*." This cartoon directly addresses the issue of value for labor in painting—a point of contention going back at least as far as the *Whistler v. Ruskin* trial, during which Whistler was asked to justify the high price

117. Albert Sterner, *The Point of View*. Cartoon from *Harper's New Monthly Magazine* 98 (December 1898).

he set on paintings executed in the course of a day or two. Are the buyers here exercising practical judgment, acquiring a work that guarantees and shows the signs of labor, or are they merely Philistines unable to grasp the aesthetic, subjective, and poetic dimensions of Chrome's minimalist formalism? Is Chrome a faker, a Daubley, attempting to profit by the sale of paintings with nothing in them but two bands of color? Or is he a sincere and sensitive artist at the ignorant mercy of a dull-minded public? The cartoon's title suggests that in this instance at least it is the clients who are dense. However, Sterner's *The Point of View* (fig. 117) reveals the painter as a passive fraud if not a cynically active con artist. Standing at his easel, the smirking artist announces: "The fact is, old chap, that not one purchaser out of ten knows a good picture from a bad one." "That must console you, old man," responds his friend.

No single meaning or target can be extracted from the murky webs of meaning traced by such cartoons. It is clear, though, that they appeared in great numbers during a period of instability in the world of art and the public's apprehension of it—that is, during the very epoch when America painting began to modernize—and that they represented response and resistance to changes that often seemed incomprehensible and threatening. Artist jokes functioned as a mode of control and containment in the attempt to recover stability and to make sense, or nonsense, of the transformations. After about 1900, neither *Life* nor *Harper's* continued to feature artist cartoons very often, which suggests that some sense of balance had been achieved by then, with impressionism on its way to becoming acceptably nativized and cosmopolitanism now tempered by stronger native feeling. The cartoons answered a cultural need to resist what was perceived as excess. Once the excess had returned to comprehensible proportions, their function was fulfilled. The Armory Show of 1913, however, brought forth a bumper crop of pictorial derision (fig. 118), much of which replayed, in more lurid and violent form, themes previously introduced: painters as frauds, getting drunk and splattering their canvases with mean-

How to Become a Post-Impressionist Paint Slinger

By John T. McCutcheon.

Copyright, 1913, by John T. McCutcheon.

First imbibe eight (8) quarts of absinthe quickly (see plate 1). Then approach your canvas with undoubted and unerring aim (see plate 2); apply your brush with vigor, endeavoring to get a wide sweep of color (see plate 3). Add other media; whatever is convenient (plate 4). Add some more media (plate 5), and then look around for some more media (plate 6), which you should apply with broad, dashing strokes (plate 7). Then when the painting is finished call it "The Aurora Borealis on Mount Chimborazo" or "Twilight in the Zoo," and the critics will rave about it.

118. John T. McCutcheon, *How to Become a Post-Impressionist Paint Slinger.* Cartoon from *The Evening Sun,* March 6, 1913. Walt Kuhn Papers, Archives of American Art, Smithsonian Institution (Reel D73, Frame 507).

ingless marks to be raved over by gullible aesthetes and partisan critics, or laughed at by sensible Philistines. Late-nineteenth-century cartoons mocked aesthetic painters and their publics while helping illustrators define their own professional identity. They were outgrowth and symptom of the mass publishing market that steadily swelled the number and promoted the specialization of magazines in the 1880s and after, and in that sense they complemented and tracked the artist's passage into the world of spectacle and commerce. Cartoons lampooning artists before the Civil War are few in number; in the late nineteenth-century they emerged in response to the fragmentation and plurality of artistic identity that accompanied the modernizing process.

The questions remain: What were the effects of these representations? What did they signify to the casual reader? Robert Limpus notes that Du Maurier's cartoons were familiar to Americans well before the visit of Oscar Wilde, whose lectures in America had the legitimate aim of raising aesthetic consciousness, whether Americans wanted it or not. But Du Maurier's drawings had just the opposite result: "As might be expected, [they] chiefly had the effect of interesting people in the movement as a new kind of entertainment, rather than as a serious evangelism."[14] That was also the effect of the artist cartoons in the American media at the turn of the century. Although readers need not be current with the finer points of contemporary aesthetic controversies, it is true that the cartoons catered to the audience's sense of sophistication, since—just as in the case of the famous *New Yorker* artist cartoons in the twentieth century—a certain degree of cultural literacy was necessary to get the joke.[15] However, such representations encouraged all readers, regardless of their cultural credentials, to regard the artist as a "new kind of entertainment," not to be taken seriously, worth a chuckle or two and a shake of the head, before moving on to the serious business of life. If the humor magazine was a mentor and guide to the body politic, then what *Life* suggested to that body—albeit a smallish and fairly sophisticated one—was that artists and jokes occupied the same territory. In cartoons, the less artists did and the more they bungled it, the funnier they were. Artist figures seldom received the savage treatment that made caricatures of African-Americans, Jews, and other minorities so grotesque; rather, they were trivialized by association with the category of the "society" fads and foibles that *Life* took so much pleasure in satirizing. Playing their high society bit parts, artists became part of the ever-changing world of spectacle, in which it was only necessary to give a diverting performance. If they were frauds, their juggling acts were confined to the safety of the humor pages, where the public could enjoy the assurance that it was in the know and got the joke, instead of being the gullible victim. The figure of the artist as clown entertained while drawing attention to excesses that fell beyond acceptable limits. While being used to enforce or assert norms, cartoons simultaneously abnormalized painters by directing readers to notice, again and again, what made them different, ineffectual, and laughable.

In 1962, critic John Canaday reviewed an exhibition of nineteenth-century American genre paintings selected to highlight the "almost forgotten" name of Thomas Hovenden (1840–1895). Canaday focused on Hovenden's *Breaking Home Ties* (fig. 119), noting that when the painting was on display at the World's Columbian Exposition in 1893, "people lined up for blocks to see it, and wore out several replacements of the carpet in front of [it] as they stood admiring it." It was unlikely that anyone would line up to see the painting now, wrote Canaday, describing the stagelike and painstakingly detailed New England farmhouse interior, where a mother (framed by well-grouped family members) bids goodbye to her gawky, adolescent son, leaving to seek his fortune. Rather to his surprise, Canaday found that the painting harbored unexpected pleasures, but he hastened to assure his readers that he was not so unsophisticated as to be moved by the picture's story: "Let us say immediately that this picture, which sounds so desperately maudlin and which depends to such a great degree on standard anecdotal associations for its effect, is nevertheless a legitimate work of art, superbly painted, expertly assembled in all its parts, and remarkable for the luminosity of some of its portions and the warm, shadowy depths of others. As a narrative, it not only saves itself from absurdity but also achieves a certain dignity by a restraint similar to that of the family who so

119. Thomas Hovenden, *Breaking Home Ties,* 1890. Oil on canvas, 52¼ × 72¼. Philadelphia Museum of Art; Gift of Ellen Harrison McMichael in memory of C. Emory McMichael.

touchingly bid the son farewell. And it is wonderfully, completely, unquestioningly a part of the America of its time." Hovenden's *Bringing Home the Bride* (fig. 120) also had the redeeming feature of rich tonalities, "like the first declarations in a love affair with impressionist light." Indeed, if only it were possible to scissor out and isolate the figure of the little girl in the window seat, "one would be torn by temptation to identify it as Renoir, Degas, Monet, or even Bonnard, knowing that none could be exactly right but that this was a real painter who should be related to them. There are delicious passages in this picture, so delicious that the story-telling becomes obtrusive as a distraction from pleasure in the painter's method." Because of those obtrusive stories, American genre painting was now done for—the aesthetic equivalent of the Dodo bird: "It was done in by impressionism, which took the subject of daily life and raised it above the level of narrative reporting, and by the camera. . . . Such genre painting as we have is relegated to the covers of popular magazines and illustrations for the stories in them, thus eliminating such independent functions as genre used to have."[1]

In his dismissal of narrative, exaltation of pure visuality, and investment in artistic

120. Thomas Hovenden, *Bringing Home the Bride,* 1893. Oil on canvas, 56 × 78. The University of St. Thomas, St. Paul, Minnesota; Gift of William P. Consedine.

innovation and progress, Canaday could hardly be more fully in the mainstream of modernist criticism. He was somewhat wide of the mark, though, in figuring *Breaking Home Ties* as "wonderfully, completely" a part of its time. *Breaking Home Ties* was of course part of its time but in no way wonderfully or completely. Rather, by making an eloquent case for friendly, open relations between artist and public, it held a tenuous position as battle standard for an alternative aesthetics of the popular at a time when the issue of aesthetic authority still occupied contested ground.

Canaday may have thought his views on *Breaking Home Ties* were thoroughly up-to-date, but in fact they only echoed what certain critics had said about the painting in the early 1890s. As an immense and—to some—unaccountable popular success, the painting became the target of critical scrutiny, puzzlement, and celebration. As the Chicago *Inter Ocean* put it: "That picture, in light of its popularity, must be marked as great. It has been reproduced by the engraver's art, and is on sale in nearly every art store in the city. . . . This picture is an object lesson worth a dozen of the Declaration of Independence, for in spite of the fact that most art critics condemn it, the American people have set the seal of their approval upon it, and there it will stay." Here was a model of greatness unendorsed and indeed opposed by "most art critics," who had so much invested in the authority to assess

aesthetic value. "There is little in the picture which might be termed artistic," wrote the *Chicago Tribune*, "but there is a sturdy realism in it which is not to be depreciated. . . . The subject, while it may be a trifle overwrought, like a certain class of popular American dramas, is one which strikes a sympathetic chord on the heartstrings of every one who loves home and family. It is a picture which is full of truth, and it is in this that the greatest value of the work lies—even though there is a certain triteness about it." There was "nothing artistic" about the picture in terms of modernist aesthetic criteria then forming. Within that frame, *Breaking Home Ties* might have functioned brilliantly as an egregious example of everything Whistler disparaged: it was full of claptrap, visually and aesthetically muddled, cluttered, and impure. The *Tribune*'s reviewer carefully qualified what merit the picture had by hedging about with "but" and "even though," further compromising the case with "a certain triteness" and "a trifle overwrought."[2]

Given the picture's popularity in the face of critical indifference, it is worth asking whether *Breaking Home Ties* could be rated an artistic success by any alternative criteria. Scores of contemporary comments suggest that there existed a well-articulated set of benchmarks for popular aesthetic judgment, in which formal values were incidental to the story rather than the other way around. These criteria occupied a different class and (metaphorically) a different region from those identified with formalism and cosmopolitanism. Few of the major East Coast magazines—aimed at cultivated middle-to upper-middle-class readers—had much to say about *Breaking Home Ties* at the Columbian Exposition. Articles on the fair in elite journals, such as *The Nation* and *Century Illustrated Magazine*, praised John Singer Sargent, Whistler, Winslow Homer, and a host of young cosmopolitans. By contrast, several metropolitan and many more eastern and midwestern small-town newspapers and journals were eloquent in its praise. Philadelphia, where the picture was first displayed and where it found a munificent purchaser, endorsed *Breaking Home Ties* as a matter of civic pride, and much more. When the picture went to the National Academy of Design in New York, however, reviews were tepid compared with the lavish praise that would greet Hovenden's painting in Chicago two years later. Those later reviews accounted for a constituency of admirers emphatically at variance with the art audiences of New York.

To this constituency, stated *The Farm and Fireside*, the jargon of aesthetic terminology was meaningless: " 'Technique,' 'values' are enigmatical to the mass of art observers, but the simplest child knows when a picture rouses a gentle or generous feeling." The appeal of the painting had little to do with subtle harmonies of tone or exquisite calibrations of arrangement for their own sake. The work was great because it combined strong human interest with an affecting story. "This picture," wrote another paper, "has taken hold upon the public because it is instinct with humanity; because it tells a familiar story, one that all can understand; because it is honestly and wholesomely American." Several commentators asserted that the painting had "soul," a cardinal distinction from fashionable modern styles like impres-

sionism, which to Hovenden's constituency often seemed nothing more than the production of colorful and bleary surfaces. At the Art Institute of Chicago, Ernest Poole recorded a "free day" encounter with a plain-spoken grocer from "down the State." This "short, stout, middle-aged man" was just beginning to "get the hang of pictures" but found an impressionist landscape unintelligible: "I can't make head nor tail to the thing! I've figured and figured, but the closer I get, the worse it looks. . . . Give me scenes to make me think and feel, and then rich colors to give 'em a tone. That's it." Refusing to accept the modern criteria that redefined painting as a specialized art of pure and very personal visuality, popular aesthetics demanded the whole body—not just the eyes.[3]

Self-Made Connoisseurs

Popular aesthetics also demanded a script, and *Breaking Home Ties* not only had one, but it also put on a superb and evocative performance. It invited every individual to recognize in it a bit of his or her own experience and to spin the story back into the past or launch it into the future. A great many viewers were unable to resist embroidering the tale unfolding before their eyes, and like most, the Philadelphia *Press* was certain of a happy ending: "The boy who stands on the threshold of his home in this picture is going out into the world to make his own way, and it is one of the significant elements of the situation that, being an American boy, we do not need any visible assurance written on his forehead that he is destined to succeed. The artist has, no doubt with purpose, avoided vesting him with any conquering-hero attributes. He hasn't the square jaw of determined energy, nor the set mouth of a masterful disposition, nor the piercing eye of high ambition—he is just a good, honest, faithful, right-minded, pure-souled lad, with a great lump in his throat, trying his best not to break down and cry like a baby while parting from his mother." Viewers filled in plot details in a stunning variety of ways. Over and over again, admirers expanded on the narrative implications of the scene, writing of what all the characters were doing (even the dog), how they were feeling, and how they might feel later on. One predicted that "after the mother has said 'good bye,' she will go into her room, and as she buries her face in the old blue and white counterpane, she will weep and pray." Another imagined the smallest child suddenly realizing that now no one would "make her sleds and whittle animals from blocks of wood to fill her stockings at Christmas time," while the boy saying good-bye "knows what makes the carpet bag so lumpy, and why it has such a spicy smell, and is sure there is no danger of his ever running out of doughnuts or seedcakes, but—there is a lump in his throat and he looks away from the care-seamed, tender face as his mother pleads with him to be a good boy. 'There is a little book in the carpet bag,' she tells him. She wants him to read a portion of it every day."[4]

Writers elsewhere also noted the importance of story in the paintings that appealed to the nonelite. Reviewing the Founder's Day Exhibition at the Carnegie Institute, Willa Cather tracked two (invented?) working girls through the galleries,

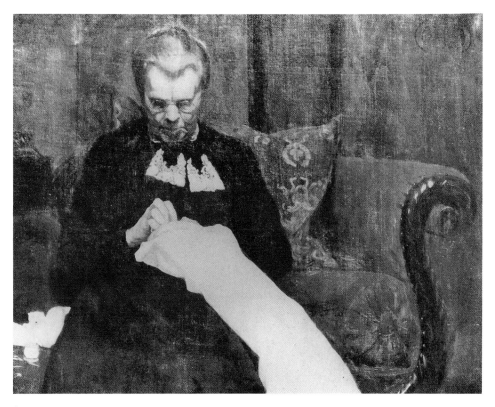

121. Ellen Ahrens, *Sewing—A Portrait,* c. 1901. Location unknown. Published in *International Studio* 15 (1902).

abundantly stocked that year with "pictures which the most unpretentious Philistine can enjoy." Cather's "girls" expressed strikingly different reactions to Ellen Ahrens's *Sewing—A Portrait,* and Alfred Maurer's *An Arrangement* (figs. 121, 122). Cather observed that the "Philistine" admired Ahrens's realism, "the successful coloring of the hair and the lines in the forehead, and the decision with which the old lady speeds the needle with her middle finger." The Philistine might not notice or appreciate the effective simplicity of the composition but *would* see something "more important . . . a wonderfully thrifty, executive old woman, one who is the prop of a household and community; who has brought her own family up well and . . . could take up a business that was run down, or a family of children that had run wild, and institute order and discipline and thrift; a woman of strong prejudices and narrow sympathy, tireless in energy and unsparing in the administration of justice; who, with more of common sense than imagination, has made a decent, practical, substantial success of living, though she probably sees very little worth while in Browning or Chopin." Such a figure was so intrinsically "literary" that to the Philistine mind, at least, it vividly recalled characters encountered in fiction: "Only yesterday afternoon I heard a typewriter girl, viewing the pictures in her half holiday,

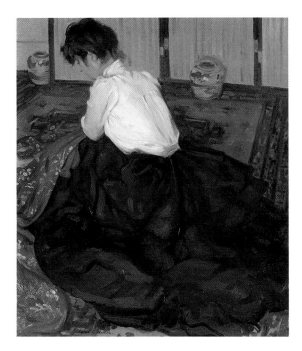

122. Alfred Maurer, *An Arrangement,*
1901. Oil on cardboard, 36 × 31⅞.
Whitney Museum of American Art,
New York; Gift of Mr. and Mrs.
Hudson D. Walker; 50.13. Photograph,
Geoffrey Clements.

remark that the 'old lady made her think of one of Mary Wilkins' short stories
somehow.' " Mary Wilkins Freeman's New England tales abounded in plain, flinty,
austere old ladies, their hair skinned back into buns, their bony limbs draped in
limp calico, though they were more often spinsters than mothers. In responding to
Ahrens's work, the typewriter girl made the move effortlessly from picture to (rec-
ollected) text, refusing to acknowledge, if she even knew, the barriers set between
them by modernist aesthetics. Maurer's painting, by contrast, evoked no literary or
sentimental associations:

> "It's nothing in the world, Myrtle, but a girl sewing the binding on her
> skirt," declared the typewriter girl, in a tone of amazement and disap-
> pointment. The peculiar difficulties in the drawing, the remarkable paint-
> ing of the white silk shirtwaist appealed not at all to Edna, the
> stenographer, because a shirtwaist is a thing of common use, and how can
> it possibly have anything to do with art? She sees nothing in the picture
> simply because it tells no story, because her imagination finds no delight,
> no pleasurable suggestion in "skirt binding." If the girl were leaning over
> to pick up a child, or to solemnly burn love letters, or to weep beside a
> bier, both Edna and Myrtle would have found the picture resplendent
> with beauty, they would really have experienced pleasure in looking at it.

Later on, Edna declares that the Maurer "might do for [a] streetcar advertisement
by some binding manufacturer." It is impossible, in fact, to determine what Maurer's

figure is doing, if anything. So great was Edna's indifference to abstract values and need for legibility, however, that she "read" the skirt-binding scenario into the design, which even then failed to trigger aesthetic or emotional response. While at first glance Cather's assessment of the office girls as connoisseurs may seem condescending, it appears on closer inspection that her project was to clear out for such viewers a legitimate aesthetic space, where there was no onus upon those who found pleasure in pictorial storytelling and romance.[5]

Cather aligned her voice with those of others who vigorously argued for a popular aesthetics in which audiences enjoyed the freedom to exercise preference rather than be subjected to judgments handed down from above. Regionalist writer Octave Thanet modeled this beholder in "The Provincials," a narrative that celebrates the intelligence and simplicity of small-town Americans in their encounter with the high urban culture so magnificently arrayed at the Columbian Exposition. Contrary to Eastern assumptions, the West was no bastion of "philistinism in its rankest form" but a region of self-educated, unpretentious, and highly independent citizens, the "pith of the Republic." Exemplifying the type was the homegrown son of a self-made man: "Educated in the public schools and the State university[,] he has never been outside his own country, he is provincial to his finger tips, as the French would say." This "handsome fellow," with his "good, keen, kindly eyes," astonishes a sophisticated friend as they tour the Art Building:

> "Who would think it?" said she, "that man, with the manners of a
> cowboy-cavalier, is one of the finest art critics I ever met; it is so refresh-
> ing, too, to hear a picture talked about in straight English! He has a
> beautiful collection of etchings. . . . He says himself, that he hasn't money
> enough to have good paintings, but he can have the best etchings, with an
> occasional water-color or pen-and-ink drawing. Do you know he is what I
> call a magazine-cultivated man? . . . [He has] not had the time for an ex-
> haustive education, he has had to make a fortune; he is a splendid busi-
> ness man, I was told, and so decent and honest, too. . . . *So,* he has been
> obliged to get, instead of all sorts of studies and experiences, the short-
> hand culture of the magazines; and really it is a very fair working substi-
> tute."

This self-cultivated, provincial critic was in most ways quite different from Cather's Pittsburgh office girls, urban new women of limited means and education. Yet by constituting his own aesthetic authority, he too claimed occupancy of a site within the same autonomous zone. Of course his "magazine" education exposed him to the influence of critics. There is little doubt, however, that this sensible man was meant to appear as a self-made connoisseur who had used others' judgments only as aids in forming his own opinions.[6]

The illustration (fig. 123) by Arthur Burdett Frost, who specialized in folksy and rustic subjects, shows the "provincial" art lover gazing at a picture with concentration

123. Arthur B. Frost, *"One of the Finest Art Critics I Ever Met."* Illustration from Octave Thanet, "The Provincials," *Scribner's* 15 (May 1894).

as he holds the catalogue in one hand and traces the movement of a line, or the effect of a tone, with the other. Both he and his lady companion wear plain, sturdy-looking costumes without frill or exaggerated cut. Behind them is an older, dowdier rustic couple, also with catalogue in hand, gazing intently at a different work. It is worthwhile to compare Frost's representation of this viewing public with W. T. Smedley's illustrations to accompany Brander Matthews's prose vignette of a private view at New York's Society of American Artists. Smedley's lively technique conveys an effect of movement and scintillation as opposed to the solid sobriety communicated by Frost's more deliberate approach. In one of Smedley's drawings (fig. 124) two slouchy young men in evening dress distract a stylish lady in bustle and flounces from her examination of the paintings on the wall. The text explains:

> Miss Marlenspuyk lingered before Olyphant's portrait of Laurence Laugh-ton, whom she had known for years. She liked the picture until she over-heard two young art-students discussing it. "It's a pity Olyphant hasn't any idea of color, isn't it?" observed one. "Yes," assented the other; "and the head is hopelessly out of drawing." . . . The two young art-students stood before the portrait a few seconds longer, looking at it intently. Then they moved off, the first speaker saying, "That head's out of drawing too." It gave Miss Marlenspuyk something of a shock to learn that the heads of two of her friends were out of drawing; she wondered how seri-ous the deformity might be; she felt for a moment almost as though she were acquainted with two of the startlingly abnormal specimens of human-ity who are to be seen in dime museums.

Unlike the self-educating, self-informing provincials, viewers in this scenario have no right to their opinions, which are merely raw stuff subject to radical reshaping by the pressure of authority, here vested in a pair of "young art students." Unlike the provincial connoisseur, these pundits deploy mystifying jargon, meaningless when taken literally, as Miss Marlenspuyk discovers.[7]

Whereas the viewing ritual described by Thanet constitutes a serious process of self-culture, in Matthews's account it is the occasion for posturing and flaunting esoteric expertise among a crowd of parading socialites. For young art students and other experts, aesthetic experience cannot be detached from the formal values they declare valid. While in this instance it was only wobbly drawing that drew fire, in others it could be a matter of wrong versus right values. Here the case of *Breaking Home Ties* is illuminating. Little if anything in this painting was out of drawing: it was designed and executed with all the skill and finesse that several years of French training could perfect. Within one set of aesthetic values, it could be ranked a great painting because its skillful fabrication enhanced its legibility, while its polished realism intensified its believability. Inspected through the lenses of another set, how-ever, it became inartistic for precisely those reasons.

124. Walter T. Smedley, *"She Overheard Two Art Students Discussing."* Illustration from Brander Matthews, "A Private View," in *Harper's New Monthly Magazine* 88 (March 1894).

Achieving Aesthetic Independence

The constituency of *Breaking Home Ties* was diverse, a grouping of classes and regions separate in most ways yet occupying in common a particular stretch of aesthetic territory. Here businessmen, farmers and other country folk, plain-living "provincials," the older generation, and urban working girls came together in their shared preference for pictures that told stories well enough, and good enough, to stimulate the imagination, stir the memory, and wrap the beholder in a fiction so compelling it seemed real. Despite varying degrees of sophistication, they stood for the right to make their own judgments rather than submit to the professional expertise of cultural plutocrats in the shape of critics and the institutions they represented. This was not exactly a self-conscious class. It was created piecemeal, by various observers, and it has to be reconstituted from accounts such as Cather's, or Thanet's, or from archives such as the body of clippings in Hovenden's scrapbook. This class was the public at large, the majority, caught up in a process of aesthetic disenfranchisement. Its very visibility and topicality at the time are indicators of friction between artist and audience. What "the public" liked was never fixed, certainly. Work that initially seemed radical and illegible became more accessible along gradual inroads established by education, popularization, and the displacement of whatever had once been threatening by newer modes still unsettling and strange. Thus French impressionist paintings, once so aggressively subversive, have long since settled into the category of pretty pictures, calendar art, probed for deeper and still-subversive meanings only by the academic establishment.

Breaking Home Ties represented the public forum where the turf wars between populist aesthetics and cultural plutocracy played themselves out. Significantly, Hovenden's most famous painting soared to the heights of popular success at nearly the same moment that political populism launched a ferocious campaign against the power of big business in league with corrupt government. The People's Party, organized in 1892, announced a radical platform attacking monopoly capitalism and the extreme class divisions that it had been so instrumental in creating. An outgrowth of radical, largely midwestern agrarian movements such as the Grange, Populism called for nationalization of the railroads and communications systems, the abolition of private banks, and other measures for establishing collective ownership and control of exchange systems and for putting wealth back into the hands of the producer. Populism was much more than a political skirmish. As Alan Trachtenberg has argued, the movement instituted "a *cultural* campaign of great magnitude" in its efforts to give expression to the people as a political entity outside the party system. Drawing on Lawrence Goodwyn's portrayal of the movement as one in which "people learned to act independently on their own behalf, to think critically about their common predicament," Trachtenberg figures Populism as the projector of "an unmistakable cultural ferment, a ferment in which the cultural practices and political ideas mixed in a campaign to restore America to original meanings." Of course those meanings were layered in ambiguity: Was "America" a "*nation,* a body joined by

shared cultural values and experiences?" Or was it "a political state, an apparatus for governance in which laws serve to protect classes rather than universal interests in the society?" At bottom, says Trachtenberg, Populism represented one version of the "hope of utopia within the American polity," a new social order attending the emergence of the nation as a collective body of shared wealth as well as culture.[8]

This Populist utopia was no egalitarian paradise, all barriers leveled. The platform called for immigration restriction, and Populist rhetoric resounded with anti-Semitism and Anglophobia as it hunted villains in the "conspiracy" to uphold the pernicious gold standard identified with the interests of Big Business. The party failed, moreover, to attract urban working classes in significant numbers. The "America" it represented was largely white, small-town, rural, and removed from eastern, metropolitan centers of power. To a considerable extent, the Populist "set" overlapped with the constituency that endorsed *Breaking Home Ties* and the popular, metaphorically "provincial" aesthetics it embodied. In the act of admiring *Breaking Home Ties* and all other paintings that were legible, meaningful, realistic, and storytelling, the "people" asserted their independence, claiming individual authority while subscribing to an ideal of a shared, truly popular culture. This was the lesson too of political Populism.[9]

The question that follows is: To what extent did the "people" achieve that cultural independence? After a disastrous rout in the 1896 presidential campaign, organized Populism disintegrated, while big business and big government proceeded along the track of imperial expansion into world markets and global power. As a spirit and an ideal, however, populism resurfaced in later decades, always in tension with competing ideologies. In the case of populist aesthetics, the answer is more complex than it might initially appear. There is an argument for a foregone conclusion scenario; that is, that *Breaking Home Ties* and everything it stood for constituted an anachronism, the last gasp of antebellum "democratic" aesthetics, giving way to the forces determined to install modernist values in the place of honor while demoting storytelling art into the mean ranks of old-fogeyism and bad taste. A different case also presents itself: Hovenden's constituency did achieve aesthetic independence after all, in the sense that its marginalization in relation to high cultural standards liberated it to pursue another direction, along another trajectory leading toward mass entertainment in a myriad of forms. In this scenario, the productions of the mass media constituted a true shared, national culture, however debased it may have appeared in the eyes of elites. The barriers tended to be quite porous, and the media could embrace a range of cultural positions. The *Saturday Evening Post,* for example, effortlessly combined an article explaining high art to the masses with stories and features embellished by popular professional illustrators. Cultural plutocrats, too, persisted in the campaign for cultural elevation begun in the middle of the nineteenth century with the purpose of creating—and controlling—a body politic in peaceful harmony with the elites' own lofty cultural norms. The point of such aesthetic

education and propaganda was to bring the masses up, to prevent or suppress the development of alternative and potentially disruptive countercultures.

Hovenden himself straddled the line between catering to ordinary tastes and lifting them up. He told the Pittsburgh *Dispatch* that public galleries should take the public's taste into account, and he criticized the tendency to buy pictures for names, to the neglect of other considerations: "No matter how great the picture is in art for art's sake qualities—a masterpiece even—it has no place on the walls by right of fitness, and an inferior work of art that teaches deserves the place." The "teaching" works could be upgraded as public taste improved. At the same time, Hovenden took a strong "buy American" position. He exhorted collectors to "have the courage to break away from the almost universal custom of buying French pictures" and urged his peers to make a "local tone" in their paintings rather than waste time trying to paint French pictures themselves. This was ironic, since Hovenden's own tableaux were more like academic French work than anything in the American tradition, and *Breaking Home Ties* itself was a Yankeefied replay of his Salon picture *In Hoc Signo Vinces* (1880; Detroit Institute of Arts), in which a Breton royalist leaves home and family to battle the forces of Revolutionary France. Still, Hovenden put his French skills to work on American themes of wide appeal, and his "Purpose of Art" endowed his work with a strong populist cast: "If I can give pleasure, if I can give comfort, if I can give strength to those around me by word or act of mine, what manner of man am I if I do not? For what object was power given? . . . Art is for the world." Such a stance was at the far end of the earth from Whistler's: "With the man, then, and not with the multitude, are [Art's] intimacies; and in the book of her life the names inscribed are few."[10]

Clean, Decent, American, and Popular

Hovenden's commitment to localism and native feeling almost automatically enlisted him in the ranks of those who painted for the people rather than the plutocrats. At a time when the majority of collectors, especially the super-rich, were indulging insatiable appetites for European painting—old master as well as modern—and paying high prices for it, the American art community and its supporters campaigned to improve the market for American paintings. *Breaking Home Ties* appeared on the scene at the height of the fashion for the cosmopolitan styles adopted by so many younger painters and used to compete directly with real European work on its own turf—figuratively and often literally as well. Despite its camouflaged Frenchness, *Breaking Home Ties* became the rallying point for native, popular feeling, so glaringly absent from much of the other "American" painting at the Columbian Exposition. Everything about *Breaking Home Ties* could be constructed as a refutation of the alien look and sensibility of the cosmopolitan painting that dominated the show. And real people—genuine, uncorrupted, rural Americans—flocked to Hovenden's picture: "The country folk who visited the Art Building yesterday lingered long before this painting, which is the more remarkable in that it is surrounded by pictures

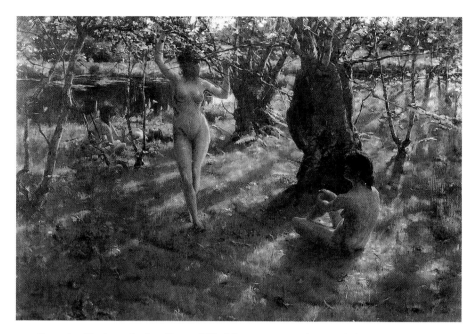

125. Alexander Harrison, *In Arcadia*, c. 1886. Oil on canvas, 77½ × 114¼. Musée d'Orsay, Paris. Photograph © Réunion des musées nationaux.

of American artists representing, with scarcely an exception, foreign scenes." Many another commentator remarked on the crowds that never seemed to thin out in front of this picture. Weighing Hovenden's picture against the others, one critic saw signs of hope. Because it spoke of the "national heart and characteristics," *Breaking Home Ties* was "infinitely more promising for the future of true American art than . . . the imitative French indecencies of [Alexander] Harrison that take up half the side of the wall." The painting by Harrison (1853–1930) was *In Arcadia* (fig. 125), an "ideal" essay featuring classical nudity in a sylvan setting—patently not an American scene. Daniel Ridgway Knight's *Hailing the Ferry* (fig. 126), another huge canvas, representing two strapping French peasant girls on a riverbank, also exemplified the fashion of painting foreign subjects in a foreign manner.[11]

Together, the nude and the peasant embodied the un-Americanizing of American art: "What are . . . [Alexander] Harrison . . . D. Ridgway Knight . . . and hosts of our most talented American born doing for us? In one way nothing, and less than nothing, for they've educated the public into thinking that a picture isn't good for much unless dated and signed abroad. Is a Brittany peasant more to us than anything else? . . . American art must be developed by the artists in happy sympathy with American surroundings, and supported by a public loving home things more than imported foreign sentiment. . . . Painting is more than paint, and sunlight is more than orange and purple, and a landscape as well as a figure means more than a symphony in color, a 'pang in grey,' or a 'whoop in violet.' " Charles M. Stevens's

126. Daniel Ridgway Knight, *Hailing the Ferry*, 1888. Oil on canvas, 64½ × 83⅛. Courtesy of the Pennsylvania Academy of the Fine Arts, Philadelphia; Gift of John H. Converse.

story of the rustic "Uncle Jeremiah" at the Chicago Fair vividly demonstrates the association of nudity with Frenchness. While the visiting hayseeds are obviously caricatures, their attitudes are perfectly plausible. Unschooled in aesthetics they may be, but they have pronounced opinions. Their tour of the French paintings section of the art exhibit convinces them that French people are the "most shocking people in the world," and they remark how different the French section is from the American (where they have somehow failed to notice the work of Harrison and his cohorts). Young Johnny pipes up: " 'Say, Grandpa, I can see why the sculpturs [*sic*] can't sculpture clothes on their folks; but I don't see why the painters can't paint their folks up some more decent.' . . . That same thing puzzled Uncle, and he could not answer. He thought a great deal, but he only muttered something about pictures not fit to be stuck on his horse-lot gate posts." Although *Breaking Home Ties* was not mentioned, it cannot be doubted that Uncle Jeremiah and Johnny would find Hovenden's painting entirely to their taste and entirely comprehensible.[12]

In *Salon, 1888* (fig. 127) Harry McVickar lampooned a similar episode. An old father and his son stand before a row of large paintings, all featuring the nude: an exotic empress on a throne, a dancer with diaphanous veils, and a languid odalisque. Like the old couple in A. B. Frost's illustration of "provincial" art connoisseurs, the

127. H. W. McVickar, *Salon 1888.* Cartoon from *Life* 11 (June 14, 1888).

elder man is rustic and out of date, with tufts of hair over his ears, a long-skirted coat, and a bunchy umbrella. The other, with his waxed moustache, goatee, and floppy bow tie, is obviously an artist. The conversation confirms the cultural gap implied by their sartorial differences:

Uninitiated father: So that is the "*line,*" is it?
Artistic son: Yes, that is what we call "the line."
Uninitiated father: Well, it would never be mistaken for a *clothes* line!

Everything hinges on the fact that the father is uninitiated—that is, no one has indoctrinated him with the correct perspective for rationalizing and enjoying the nude in art, and the classical tradition it purports to honor. From a populist point of view, however, the question is whether he ought to be.

Of course the whole subject of the nude in American visual culture was controversial and complex. Offensive and incomprehensible to cultural provincials, the nude was almost equally problematic for elites. Even so refined a painter as Boston's Edmund Tarbell (1862–1938) failed, in one critic's eyes, to protect the figure in *The Bath* (1893; location unknown) from the taint of mundanity:

A young woman of fair proportions sits on her divan with one foot in a
bath while a maidservant kneels and dries her arms. Here is a case for the

little less or the little more, showing how dangerous it is for an artist to paint the nude realistically without being coarse. . . . Unintentionally Tarbell has suggested in the vacant face, the luxurious surroundings and the maid washing her naked mistress an improper character such as French novels love to depict and often merely imagine. The Boston painter, trying to be real, has been indecent, and the artists of the Society [of American Artists] have not been delicate enough to realize that the way Tarbell has done it is the wrong way and as such ought not to have received the stamp of their approval. The natural asylum for such a picture is a barroom.

This comment sums up the thorny issue of the nude, introduced (via cosmopolitanism) rather precipitously into a culture almost innocent of the traditions that sanctified it. The writer, presumably, was tolerably well-informed and trained to recognize the subtle, wavering line that separated the real from the ideal. If this was the reaction of an "initiated" observer, then it is not difficult to imagine how much more threatening the presentation of the nude might appear to a "public" ill equipped to see it as anything other than literal, un-American, and—no matter what the mythological evasions—indecent. The unidentified critic of Tarbell may or may not have been a person of broad cultivation. But take the case of Boston collector and connoisseur Edward W. Hooper, Brahmin aristocrat and seasoned art lover, who professed the greatest delight over Titian's *Rape of Europa,* Isabella Stewart Gardner's latest trophy. Although Hooper had been one among several "grave" doubters, once he saw *Europa,* he "wallowed at her feet," as Mrs. Gardner reported to Bernard Berenson. When it came to the display of the modern nude, however, Hooper was ambivalent. In his capacity as trustee of the Museum of Fine Arts, he counseled against exhibiting photographs of paintings by Gustav Boulanger (teacher of many young Americans in Paris): "As a whole they seem to me bad in *tone*. They are painted with some technical skill, with a purpose (as it seems to me) to gratify a vicious taste for the display of mere nakedness. I am quite in favor of exhibiting *clean* nudes, and even some less clean if painted by very great men, or having a classical reputation." If he had his way, he would quietly take down the Boulanger pictures without explanation, and so avoid all discussion of so delicate a question.[13]

Hooper's nice distinctions—clean nudes, or less clean if by great men—would be meaningless to the Uncle Jeremiahs or downstate grocers of the cultural provinces. It was for them, the populist constituency, that Hovenden's art, and the pattern of artistic identity it constituted, offered a viable, accessible, and decent alternative. A cosmopolitan gone native, Hovenden may only have had a sharp sense of audience and market, but his words suggest a genuine conviction that art should teach, cheer, entertain, and never offend. He projected an image distinctively different from that of the cosmopolitan, urban sophisticate, with his flashy studio and egocentric productions. By contrast, Hovenden was unpretentious, almost self-effacing, described

by one reporter as a "respectable middle-aged man, who is his own coachman to a steed not gaily caparisoned, and a wagon which bears no impress of fashion or style." No one would imagine that "the occupant was the great artist, whose pictures have a market value of six thousand dollars." His house in Plymouth Meeting, Pennsylvania, was large, rambling, and old-fashioned, an "ancestral heirloom" owned for generations by the family of his wife, the painter Helen Corson. His studio was "without architectural pretensions" and cluttered with "a great number of pieces of old-fashioned furniture." Hovenden explained how he acquired these pieces, and why: " 'I have picked these things up at country auctions . . . for the purpose of working them in my pictures. This old rag carpet you see on the floor is that in "Breaking Home Ties." And that mantelpiece fixed up there was my model for the chimney corner in that picture.' " Despite the simplicity of his surroundings, Hovenden was prosperous: he retained the copyright and exhibition privileges of paintings sold, and the revenues often amounted to as much as a picture's sale price. These word-pictures showed a man who was the soul of modesty, honesty, and truthfulness. He searched the countryside for real artifacts to put into his paintings, and he worked hard to replicate them faithfully. He seemed to honor the producer ethos, giving value for money. Perceived neither as con man nor social climber, he produced honest work for honest pay and catered to the many, rather than the few. He was respectable, stable, and good. Even his death in 1895 fit this pattern: he was killed allegedly trying to save a little girl from an onrushing freight train on the tracks at the Plymouth Meeting station.[14]

As a professional painter, Hovenden embodied the possibility at least of a different model of artist, even though he remained very much a part of the eastern, urban art world, exhibiting at the National Academy of Design and teaching at the Pennsylvania Academy of the Fine Arts. Significantly, many of his personal and aesthetic traits coincided with those admired in the most important contemporary illustrators, praised by Philip Rodney Paulding as a special American breed: "If we would find where in the world of art the artist is most sure of winning and keeping the heart of the people . . . we must turn to illustration, a field which is perhaps on a lower plane than some branches of painting, but which requires the keenest perception of detail and the most facile handling of human nature and its surroundings. Here the very practicality which has retarded our appreciation of ideal art is a potent factor in our enjoyment of the artist's work. We care less, as a people, for the lofty canvases of some modern Rafael, than for the most tangible and useful excellences of beautiful books and handsome periodicals. It is these that have furnished to our artists their surest means of reaching the public." Despite the apologetic about the "lower plane," Paulding considered it a comfortable and genuinely American site for modern art. A. B. Frost, so popular for his country bumpkins and clownish African-Americans, epitomized the emergence of the illustrator as a serious artist, however comic. H. C. Bunner described him as an artist whose pictures were true to nature in addition to being funny. He was a hard worker, and his art was honest, not tricky,

with no meretricious effects. Like Hovenden he was associated with the Pennsylvania academy—he had studied with Eakins—and he lived on a farm near Philadelphia. Charles Dana Gibson presented a different variation on these themes. Based in New York, he satirized the doings of the rich and foolish, and then rose to stupendous popular acclaim with the Gibson Girl. But he was renowned for drawing people with their clothes on. An 1892 review observed that it was easy to find a model for a nude Venus, but for an artist like Gibson "it is a most difficult thing to find professional models who will carry themselves or wear their clothes like members of Mr. McAllister's One Hundred and Fifty."[15]

Howard Pyle (1853–1911) most completely realized the image of the true American artist as the professional illustrator, sharing and dramatizing many of the characteristics attributed to Hovenden, and going Hovenden one better in that he had never been abroad, as Jessie Trimble noted approvingly. Pyle, declared Trimble, was the progenitor and master of a truly American school of art, and his genius too was genuinely American. He was a worker of such "untiring persistence, and in so splendid an array of ways" that he seemed "like an American business man." His doctrine of work was coextensive with democratic ideals mandating the production of accessible, truthful, and above all useful art. He was also a great educator, helping his pupils to "see straight" at his school in Wilmington, Delaware, and inculcating a passion for "honest art, no affectation, no sham." Many of Pyle's illustrations were historical and romantic, but they were based on solid research, in addition to being solidly drawn, well composed, visually appealing, and vividly believable no matter how fantastic the subject.[16]

While there were many varieties of specialists among illustrators, nearly all earned praise for being nativist, commercially successful, practical, decent, hard-working, and highly competent. Even their studios were down to earth. Trimble described Pyle's studios as "workshops, plain as they are attractive," and a picture essay in *The Booklover's Magazine* featuring notable illustrators in their studios showed nearly all of them in rooms remarkable for their lack of decoration. Frederick C. Yohn, for example (fig. 128), a specialist in battle scenes, sat in a sturdy Arts and Crafts chair in a studio furnished with a chest of drawers, a glass-doored bookcase, and a couple of small matted pictures. Illustrators, it appeared, had little need of creating the kind of art atmosphere associated with the cosmopolitan artist and his environment. These patterns were representations, of course: selective constructions forming a design meant to highlight the traits on which the illustrator based his (or her) claim to greatness. Not surprisingly, there were many deflections from the generic type. Edward Austin Abbey (1852–1911), prolific and much admired, was a permanent expatriate, living and working in England from 1878 on. Gibson, so famous for the modesty of his Girls, was a presumably contented guest at Henry Poor's Pie Girl Dinner, with its titillating show of young female flesh (see Chapter 3). And in later years (1934 and 1952) Howard Chandler Christy (1873–1952), one of Gibson's most successful imitators, covered the walls of the Café des Artistes in New York with

128. *Frederick Yohn.* Photograph from *Booklover's Magazine* 5 (1905).

fifty frolicking nude girls. In return for pleasing the "public," however, much could be forgiven, or ignored.[17]

For artists like Hovenden, Pyle, Gibson, and their peers, working in "popular" storytelling modes, the returns could be considerable. With the sale of *Breaking Home Ties* for $6,000, Hovenden surpassed Winslow Homer's lifetime record for the price of a single painting, even though Homer in the 1890s had risen near the summit of contemporary fame and prestige. This furnishes a timely reminder of those different constituencies. Homer, who sent fifteen major paintings to the Columbian Exposition, as opposed to Hovenden's three, does not appear to have earned the favor of "the people" who so overwhelmingly voted *Breaking Home Ties* their favorite painting in the show. In turn, the market for a mass visual culture designed to please and entertain hundreds of thousands, even millions, was stupendously lucrative. At the Columbian, the work of Frost, Pyle, Gibson, and other illustrators was not to be found among the exhibits in the Fine Art Building. Instead, it was housed in the Liberal Arts Building, where publishing houses had their displays and circulated information, including *The Century's* statement that each issue of the magazine represented an outlay of $10,000 to writers and artists. Gibson was especially well rewarded for his efforts. His income rose steadily, from $600 to $800 a month

in 1890 (according to his biographer) to $2,000 and more a month by the middle of the decade. By the early twentieth century he was making $65,000 a year from magazine illustrations and royalties, and during the same period other top illustrators were earning yearly incomes ranging from $15,000 to $50,000. The equation of fabulous profits with the production of art forms intended for the diversion (and seduction) of a mass audience constituted a heady argument in favor of pleasing the public.[18]

To Please or Not To Please

As Michele Bogart has established, the practice of illustration was fraught with conflicts, anxieties, dissatisfaction, and the problem of an identity in flux, between fine art aspirations and compromises imposed by the structure and demands of the publishing industry. Contracts, deadlines, art editors, and the texts themselves all conspired to inhibit the artist's creative energy with repressive criteria for style and manner of representation. Although the borders between illustration and fine art were still fluid in the late nineteenth century, the lines between them soon began to solidify, resulting, as Bogart conclusively demonstrates, in a nearly complete separation by the 1920s. Albert Sterner, who painted independently while continuing his career as a successful illustrator, warned of the demoralization likely to befall the illustrator subjected to the dual curse of "prudishness and commercialism" that ruled the publishing industry and its public relations. N. C. Wyeth (1882–1945), one of the most successful illustrators of the early twentieth century, so thoroughly absorbed the desideratum of untrammeled self-expression that he was incapable of finding satisfaction in his role as the illuminator of texts. The true function of a picture, he wrote on one occasion, was to express an artist's inner feeling. Illustrating for money and the market inexorably stifled that voice.[19]

The preeminence of undiluted individuality in artistic practice was so entrenched a premise of emerging modernist aesthetics that any compromise between creative freedom and public expectations seemed to degrade art, making it too transparently the commodity it surely was. If even the most respected and beloved of illustrators chafed under what they perceived to be bondage to commercial demands, it seems clear that the Hovenden/Pyle pattern could be an uncomfortable one to wear. Yet this was so only from the illustrator's point of view. On the other side was the satisfied and comfortable "public," with the potential for lavishing massive quantities of admiration and worship on those who amused and taught them well. It was this "public" that accepted, enjoyed, and consumed the accessible fare publishers distributed, and these mass-produced images constituted the only art world that many would ever know.

The case of Norman Rockwell (1894–1978), perhaps the most popular American illustrator of the twentieth century, demonstrates how the Hovenden/Pyle pattern continued to flourish in the sphere of professional illustration, unhindered by the plutocrats of high culture and modernist aesthetics. Even today, long after Rockwell's

death, there is a thriving industry in Rockwell artifacts, and a museum and foundation have been established to preserve the legacy of an art produced for "the people" on scores of *Saturday Evening Post* covers, celebrating a utopian vision of the lives of "average" Americans. Rockwell's statement on the aims of his art fits perfectly the pattern sketched around the wholesome figure of Hovenden and his art: "Maybe as I grew up and found that the world wasn't the perfectly pleasant place I had thought it to be I unconsciously decided that, even if it wasn't an ideal world, it should be and so painted only the ideal aspects of it—pictures in which there were no drunken slatterns or self centered mothers. . . . The people in my pictures aren't mentally ill or deformed. The situations they get into are commonplace, everyday situations, not the agonizing crises and tangles of life." Like Hovenden's characters in *Breaking Home Ties,* Rockwell's were ordinary, plain, never too rich or too beautiful or too glamorous. Like Pyle, Rockwell projected a public image of down-to-earth, hard-working, straightforward productivity. And as with Hovenden, but even more so, elite critical opinion dismissed Rockwell's art as sentimental, out-of-date, anecdotal treacle. Meanwhile, the public for *Saturday Evening Post* continued to enjoy Rockwell's covers, much as the "common" people had once clustered so thickly before *Breaking Home Ties.* The fact that Rockwell even produced his own version of the theme (fig. 129) only underscores the link between the painter, the illustrator, and their publics. Like Hovenden, Rockwell, mediated by his publishers, pitched his art to "the world" rather than the few, and for that he was well rewarded, his name becoming a household word where the names of very few elite painters would ever resound. He achieved his fame by purveying the same "claptrap" that Whistler expunged from painting as unfit, irrelevant, and hopelessly vulgar. Rockwell's public (or his curse), like Hovenden's, exercised again and again its privilege of independent aesthetic judgment.[20]

I have not yet addressed the issue of quality. Nearly every thoroughgoing modernist (from Clement Greenberg on) would condemn Rockwell's paintings as bad art, not for their painstaking effects of realism alone, but equally because they told stories and promulgated comforting, mendacious, self-congratulatory myths, and because they did not seek to progress or change but chose to stay on safe, familiar ground.[21] Hovenden's art was "bad" in similar terms, and indeed, modern eyes find aspects of it uncomfortable, notably his scenes of humble but respectable African-American life, once considered good-humored and tolerant, now difficult *not* to see as intrinsically racist and condescending. It was not simply that Hovenden and his aesthetic descendants promulgated false mythologies, though. After all, a great deal of traditional Christian art did the same thing, promulgating and propagandizing orthodox notions in support of a certain belief system claiming status as the true faith in a world where many others competed for the same territory. And in many hands, Christian religious subjects and iconography were nothing if not formulaic. The problem was that storytelling art in a realist mode aligned itself with the wrong set of myths, myths toward which progressive artists and their supporters had

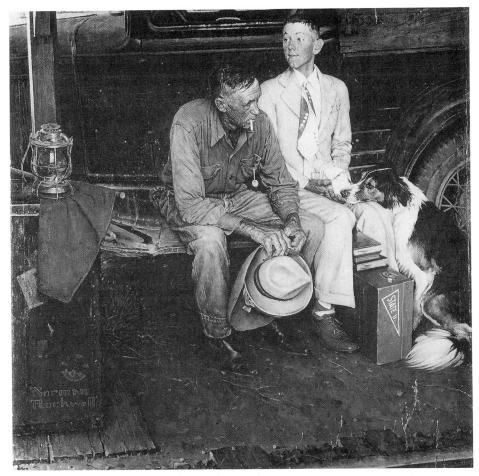

129. Norman Rockwell, *Breaking Home Ties.* Cover of *Saturday Evening Post,* September 25, 1954. Norman Rockwell Museum, Stockbridge, Massachusetts. Printed by permission of the Norman Rockwell Family Trust © 1954 the Norman Rockwell Family Trust.

adopted an oppositional stance while proclaiming modernist "truths" of solitary in-
dividualism, esoteric subjectivity, and formal purity as the new, authoritative para-
digms of high art. Clearly the exaltation of this paradigm had much to do with the
desires of critics, collectors, curators, academics, and the producers themselves to
retain whatever cultural power they could, at a time when mass culture was becoming
an awesome and uncontrollable force. Elites clung to their authority to shape mu-
seum collecting patterns, to write mass art and popular art out of canonical histories,
to guard the privilege of being able to disclose or suggest meaning in works where
meaning became ever more elliptical and abstruse. Hovenden, so folksy, sentimental,
and easy to read, accordingly vanished through the cracks of the art historical canon,
while others became heroes in the story of American art.

It is worthwhile, finally, to interrogate the brief flowering of grand-scale mural
painting around the turn of the century. Here was a high-minded and deliberately
organized effort on the part of America painters—some of them illustrators—to bring
art of high quality and high ideals to the public, to embellish the public sphere with
beautiful, ennobling designs, to tell magnificent stories in paint that any viewer could
understand, and to fashion artistic identity in the mold of public servant. In a general
way—in its aims of pleasing and engaging the mass public—mural painting was
aligned with illustration and storytelling art. Unlike illustration, it was better able to
mask any commercial motives under the appearance of civic-mindedness. And unlike
illustration, it failed to become truly popular. Much of the rhetoric about public art
stressed the vital role it might play in refining mass taste to bring it into subservient
harmony with the taste and traditions of the cultivated elite. Not long after after the
Columbian Exposition, Frank Fowler suggested that public art might be used in
such places as railroad stations to "carry art's message to the masses." By educating
the mass public to the proper appreciation of beauty, and by schooling their sen-
sibilities, art could make better citizens, which was good in many ways for business,
from the producer's end to the consumer's.[22]

Mural painting embraced the loftiest of aspirations. Kenyon Cox declared that
the days of "mere fact" and "mere research" were coming to an end with the revival
of the "old, true notion that art's highest aim is to make something useful beautiful."
Art would once again serve the public good, as painters carried out their exalted
aim to "beautify the walls of the temples and palaces of the people." Edwin Blashfield
(1848–1936), perhaps the most prominent muralist of his generation, indicated the
advantages of such adornments from a practical standpoint: in addition to their
elevating effects, "muraled temples of beauty" attracted tourists, who brought not
only their eyes but their wallets, "which go into the market and keep things stirring."
It was rare, however, for the muralists themselves to spend much time showcasing
the practical and commercial advantages of their high-minded endeavor. For painters
such as Will H. Low, who created a ceiling decoration for the ladies' reception room
in the Waldorf Hotel, new opportunities to produce large-scale public art signaled
the progress of culture in America and the evolution of painting from easel propor-

130. *Mr. Low in His Studio in Paris, While Engaged on the Painting for the Waldorf Hotel Ceiling.* Photograph from Cleveland Moffett, "Will H. Low and His Work: The Career of an American Artist," *McClure's Magazine* 5 (September 1895).

tions to something truly big and grand. A photograph of Low working on the Waldorf commission in his Paris studio (fig. 130) figures the artist as a kind of heroic, neo-Renaissance man covering acres of canvas with ideal, inspiring, symbolic figures. Mural production extended from hotels and banks to libraries, courthouses, college buildings, and state capitols. Whether for business or government, mural decoration was supposed to beautify (and enrich, literally and figuratively) commercial civilization while teaching the "masses" to venerate a common set of American standards, values, and ideals.[23]

Hopes for mural painting as the pinnacle of American artistic achievement ran high, and it was regularly discussed, encouraged, and praised in the media. Blashfield and other leaders in the mural movement earned substantial sums for their efforts. Curiously enough, though, mural painting, like illustration, was largely written out of canonical American art history, while its effects on the "masses" appear to have been negligible. This was so even though the art of the mural, designed to communicate, was inherently legible—though sometimes a script was needed; the Abbey and Sargent murals at the Boston Public Library, for example, are difficult to decipher without one. Blashfield proclaimed mural painting an art "of the people, for the people, by the people. It is of the people, for it celebrates their annals; it is for them, for it is spread upon the walls of their buildings—the public buildings; it is

by the people, for it is created by the men who were born on our prairies or in our cities. It is nonpartisan." It was actually quite partisan, however. Michele Bogart argues that while the muralists truly wished to reach a broad public and to create a common American culture, they failed because they spoke primarily "to their own favored group—a public conceived as an enlightened civic body of upright men and women, people like themselves. Their images were visualizations of the mythical way life should be ordered, and of the social structure and processes needed to produce that result." It is unlikely that Willa Cather's typewriter girls and stenographers numbered among this select company, let alone Uncle Jeremiah. As Bailey Van Hook has pointed out, classical allegory and symbol failed to mesh very tightly with the desires, interests, and expectations of the masses for whose benefit the works were supposedly fashioned. The problem lay even deeper within the mural painters' mode of address, which sought to counteract the effects of modern life—its materialism, its sensationalism, its consumerism, its heterogeneity, its cult of the momentary, of temporary celebrity—with elevated, didactic, and anachronistic visual speech that often quite literally looked down at its audience. It tended to be an art of command, rather than an art of demand catering to what the public really wanted, which was something more down to earth.[24] Public art failed to be popular because the real public art was that which circulated far and wide between the covers of illustrated magazines, newspapers, and books. This art had to be entertaining in order to create the desire for more. It told stories or highlighted episodes in the narratives it embellished. Comic strips, then movies, and finally television all supplemented and to a large extent eventually supplanted the role once performed by storytelling painting and illustration in their heyday. In whatever medium, mass-reproduced pictorial forms of narrative, instruction, and amusement constituted the dominant visual culture of "the people" in modern America. Of course this audience was no more unified than the audience for mural painting was supposed to be (or to become), and multiple publications catered to as many special interests. Museums and galleries may have been open to all, but they remained enclosed treasure houses, occasionally visited, while popular visual culture was everywhere.[25]

Certainly there have been many episodes of interaction between mass cultural forms and modernist expression. The "populist" pattern remained an option to be selectively rehearsed by such regionalists as Grant Wood or the commercially successful and resoundingly popular Andrew Wyeth, who returned the tradition of illustration, in which his father so ambivalently toiled, to the scale, presence, and status of "fine art" easel painting. Crossovers also occurred in the careers of early-twentieth-century urban painters, including John Sloan, William Glackens, and Everett Shinn, all of whom came out of professional illustration into painting and garnered praise for the truth, humanity, and sympathy of their work. It is not my intention to idealize this populist pattern. After all, popular or mass cultural forms are the products of a huge culture industry, heavily mediated, stylized, and market-driven. It is difficult to agree with Alan Gowans's contention that the "Low Arts"

of illustration, cartooning, and other visual narrative forms, are still in touch with life, however much "Fine Art" activity devotes itself to producing "Precious Objects for Exhibition." Rather, these modes of cultural production are in touch with different markets and different constituencies that identify with, appropriate, and assimilate those forms insofar as they serve the interests and desires of self, cultural subgroup, and class.[26] Those whose appetite for claptrap remains sharp are still as unlikely as ever to heed the authoritative words of critics in the elite art world. The story of *Breaking Home Ties* helps us to locate just when and how those constituencies began to sort themselves out, and how a great deal of elite art production has isolated itself in the process.

NOTES

Introduction: Templates for Modernity

1 "Yankee Art at Paris," *Inter Ocean* [Chicago] June 10, 1900; Philadelphia *Times,* June 17, 1900, clippings, Cecilia Beaux Papers, microfilm roll 429, Archives of American Art, Smithsonian Institution, Washington, D.C. See Patricia Hills, *Turn-of-the-Century America: Paintings, Graphics, Photographs, 1890–1910* (New York: Whitney Museum of American Art, 1977) for a comprehensive and illuminating survey of the period's highly diversified visual culture.

2 See John Higham, "The Reorientation of American Culture in the 1890s," in Higham, *Writing American History: Essays on Modern Scholarship* (Bloomington: Indiana University Press, 1970), 76. Higham seeks to locate a shift in cultural patterns during that decade but expects this shift "to be manifest . . . only in an emergent and formative stage," visible as a "set of attitudes that became prominent at the time but developed much more fully in the twentieth century." The model that I propose is similar, though in some instances the attitudes under review were already well developed before the turn of the century. Also see Daniel Joseph Singal, "Towards a Definition of American Modernism," *American Quarterly* 39 no. 1 (Spring 1987): 7–26.

3 I have somewhat arbitrarily selected the term *Gilded Age* to designate the last two decades of the nineteenth century, during which much of my narrative unfolds. Here I follow and extend upon Alan Trachtenberg's bracketing of the period, roughly from the Reconstruction to the middle of the 1890s, in *The Incorporation of America: Culture and*

Society in the Gilded Age (New York: Hill and Wang, 1982). I prefer *Gilded Age* over *fin de siècle* for its resonance and accessibility.

4 I follow Janet Wolff, *The Social Production of Art* (New York: St. Martin's, 1981), 62, in establishing the artist as the obverse of a free, creative spirit: that is, someone "with a given social and historical situation, confronted by [external] conditions of artistic production" and to a large extent determined by them.

5 See Amy B. Werbel, "The Critical Reception of Thomas Eakins's Work, I: Lifetime," in John Wilmerding, ed., *Thomas Eakins* (London: National Portrait Gallery, 1993), 192–194.

6 Michele H. Bogart examines sculpture, its publics, and its conflicts in *Public Sculpture and the Civic Ideal in New York, 1880–1930* (Chicago: University of Chicago Press, 1989).

7 Henry James, "Charles S. Reinhart," *Harper's Weekly Magazine* 34 (June 14, 1890): 471; Henry Blake Fuller, "Art in America," *The Bookman* 10 (November 1899): 220. For discussion of the rise of publicity and its effects see Leo Braudy, *The Frenzy of Renown: Fame and Its History* (New York: Oxford University Press, 1986), esp. 566–583. The title of my introduction is a play on that of Walter Benjamin's essay, "The Work of Art in the Age of Mechanical Reproduction" [1936], in Hannah Arendt, ed., and Harry Zolin, trans., *Illuminations* (New York: Harcourt, Brace, and World, 1968), 219–253.

8 On Church see Gerald Carr, "Church in Public, 1859–1863," in *Frederic Edwin Church: The Icebergs* (Dallas: Dallas Museum of Fine Arts, 1980), 21–33. Gladys Engel Lang and Kurt Lang, *Etched in Memory: The Building and Survival of Artistic Reputation* (Chapel Hill: University of North Carolina Press, 1990), 8–9, note the "growing interest in the persona of the artist" in the modern period, and the increasing value assigned to individuality and personal expression in the production of art. Also see Nicholas Green, "Dealing in Temperaments: Economic Transformations of the Artistic Field in France during the Second Half of the Nineteenth Century," *Art History* 10 No. 1 (March 1987): 59–78.

9 M. H. Vorse, "A Writer Who Knows the Sea," *The Critic* 43 (September 1903): 280; Percival Pollard, *Their Day in Court* (New York: Neal, 1909), 459.

10 Nathaniel C. Fowler, *Building Business: An Illustrated Manual for Aggressive Business Men* (Boston: Trade Co., 1893), 131; Sidney Fairfield, "The Tyranny of the Pictorial," *Lippincott's Monthly Magazine* 55 (1895): 861–864. See Neil Harris "Iconography and Intellectual History: The Half-Tone Effect," in John Higham and Paul Conkin, eds., *New Directions in American Intellectual History* (Baltimore: Johns Hopkins University Press, 1979), 196–211. My discussion of developments in the late-nineteenth-century magazine trade is based on Frank Luther Mott, *A History of American Magazines, 1885–1905* (Cambridge: Belknap Press of Harvard University Press, 1957), and John Tebbel and Mary Ellen Zuckerman, *The Magazine in America, 1741–1990* (New York.: Oxford University Press, 1991).

11 See Theodore P. Green, *America's Heroes: The Changing Models of Success in American Magazines* (New York: Oxford University Press, 1970), 59–109, for an analysis of demographic and other factors affecting magazine circulation in the 1890s.

12 Mott, *History of American Magazines, 1885–1905*, 147; Tebbel and Zuckerman, *Magazine in America*, 141; *National Republic*, 1877, cited in Tebbel and Zuckerman, *Magazine in America*, 61.

13 On Downes see *National Cyclopedia of American Biography* (New York: James T. White, 1945), 32: 509. On Caffin see Sandra Lee Underwood, "Charles H. Caffin: A Voice for Modernism" (Ph.D. diss., Indiana University, 1981). Information on Cortissoz is in *National Cyclopedia of American Biography*, vol. 36 (1950), 549, and *Dictionary of American Biography* (New York: Charles Scribner's Sons, 1974), Supplement 4: 182–183; on Van Rensselaer see *Dictionary of American Biography* (New York: Charles Scribner's Sons, 1964), 10: 207–208. See also H. Wayne Morgan, *Keepers of Culture: The Art-Thought of*

Kenyon Cox, Royal Cortissoz, and Frank Jewett Mather, Jr. (Kent, Ohio: Kent State University Press, 1989), and his *New Muses: Art in American Culture, 1865-1920* (Norman: University of Oklahoma Press, 1978), 39-47, for a brief discussion of the emergence of the "new critics" in late-nineteenth-century America. There were variations from the pattern, of course. Cortissoz, son of an English immigrant of Spanish descent, was educated in the public schools of Brooklyn; his entrée into the world of culture came about through the affiliation with McKim, Mead, and White. Yet similarities outweighed the minor differences in most cases. This is not to discount the existence of mavericks, however: the German-Japanese Sadakichi Hartmann (1867-1944) led a theatrically unconventional life and devoted much of his activity as art critic to championing the experimental, the innovative, and the avant-garde; see *Sadakichi Hartmann: Critical Modernist* (Berkeley: University of California Press, 1991). Willa Cather (1873-1947) represents in these pages an alternative aesthetic: of the West, the "people," and the independent, iconoclastic New Woman.

14 Morgan, *New Muses,* 40-41.

15 In my discussion of cultural transmitters, I follow Barbara Ehrenreich and John Ehrenreich, "The Professional-Managerial Class," *Radical America* 11 (March-April 1977): 7-31. On the development of centralized systems see Robert Wiebe, *The Search for Order, 1877-1920* (New York: Hill and Wang, 1967), and Trachtenberg, *Incorporation of America.* On the rise of professions see Burton J. Bledstein, *The Culture of Professionalism: The Middle Class and the Development of Higher Education in America* (New York: Norton, 1976); Nathan O. Hatch, *The Professions in American History* (Notre Dame, Ind.: University of Notre Dame Press, 1988); Samuel Haber, *The Quest for Authority and Honor in the American Professions, 1750-1900* (Chicago: University of Chicago Press, 1991); and Bruce A. Kimball, *The "True Professional Ideal" in America* (Oxford, Eng.: Blackwell, 1993). On the concept and dynamics of cultural capital see Pierre Bourdieu, *Distinction: A Social Critique of the Judgement of Taste,* trans. Richard Nice (Cambridge: Harvard University Press, 1984).

16 Recent scholarship on popular culture challenges the Frankfurt School elitism that saw the culture industry as a unidirectional enterprise, from high to low, using its products to lull and numb the senses. For an overview see " 'The Special American Conditions': Marxism and American Studies," *American Quarterly* 38, no. 3 (1986): 356-380, esp. 362-370. John Fiske, *Understanding Popular Culture* (London: Routledge, 1989), argues that rather than receiving cultural products passively, consumers appropriate and manipulate them to create their own meanings.

17 Charles Dudley Warner, "What Is Your Culture To Me?" *Scribner's Monthly Magazine* 4 (August 1872): 470-478; William Ordway Partridge, "The Development of Sculpture in America," *The Forum* 20 (January 1896): 563, 566; "The East Side Free Art Exhibition," *The Critic* 26 (May 11, 1895): 346; Carroll D. Wright, "The Practical Value of Art," *Munsey's Magazine* 17 (July 1897): 565. On the controversy about the Sunday opening of the Metropolitan Museum of Art see Calvin Tomkins, *Merchants and Masterpieces, the Story of the Metropolitan Museum* (New York: E. P. Dutton, 1970), 75-79. Trachtenberg, *Incorporation of America,* 208-234, interprets the 1893 World's Columbian Exposition in Chicago as a vast material symbol of the drive for cultural unity that dominated the period; the desire for cultural unification was also a fundamental motivation of the "American Renaissance" in architecture and city planning; see Richard Guy Wilson, Diane H. Pilgrim, and Richard R. Murray, *The American Renaissance, 1876-1917* (New York: Brooklyn Museum, 1979).

18 G. B. Rose, "A Plea for Sanity in Art Criticism," *Sewanee Review* 5 (July 1897): 308; Oscar Lovell Triggs, "Democratic Criticism," *Sewanee Review* 6 (October 1898): 418.

19 "A Conversation," *Life* 14 (December 19, 1889): 349. For a survey and analysis of American reactions to Millet, and the publicity surrounding the sale and exhibition of *The Angelus* in 1889 see Laura L. Meixner, "The 'Millet Myth' and the American Public" in Meixner, *An International Episode: Millet, Monet, and Their American Counterparts* (Memphis, Tenn.: Dixon Gallery and Gardens, 1982), 68–91.

20 Emma Helen Blair, survey of American periodicals in *Andover Review* 18 (August 1892): 154, cited in Mott, *History of American Magazines, 1885–1905,* 14. Tebbel and Zuckerman note that media historians have challenged Mott's warning that it would be a mistake to exaggerate the influence of magazines on thought and assert, by contrast, that "the importance of magazines in national life should not be underestimated in this period" (*Magazine in America,* 66).

21 Henry Sandham to William Howe Downes, March 31, 1899; E. H. Clement to Downes, August 11, 1894; W. Stanton Howard to Little, Brown, April 26, 1900; Laura R. McAllister to Downes, 1901; Frank W. Gunsaulus to Downes, April 20, 1901. William Howe Downes Papers, Boston Athenaeum.

22 William A. Coffin, "American Illustration of Today," part 3, *Scribner's Magazine* 11 (March 1892): 348. Alexander Nemerov has dismantled the credibility of Remington and other western image makers in "Doing the 'Old America': The Image of the American West, 1880–1920," in William Truettner, ed., *The West as America: Reinterpreting Images of the Frontier, 1820–1920* (Washington, D.C.: National Museum of American Art, 1991), 285–343. Also see Nemerov, *Frederic Remington and Turn-of-the-Century America* (New Haven: Yale University Press, 1995).

23 Amy Kaplan, *The Social Construction of American Realism* (Chicago: University of Chicago Press, 1988), 13.

24 Henry Wood, "The Psychology of Crime," *The Arena* 47 (October 1893): 532, 534.

25 Thomas Wilmer Dewing to *Harper's New Monthly Magazine* and to Royal Cortissoz, August 19, 1895, Royal Cortissoz Papers, Yale Collection of American Literature, Beinecke Rare Book and Manuscript Library, Yale University. The article that Dewing so much appreciated was "Some Imaginative Types in American Art," *Harper's New Monthly Magazine* 91 (July 1895): 165–179.

26 J. Foxcroft Cole to Downes, March 12 [1885?]; Childe Hassam to Downes, January 11, 1887, and 1889. William Howe Downes Papers, Boston Athenaeum. On another occasion (April 24, 1902), Downes wrote to Charles Walker Stetson: "I see no harm in accepting the proffered gift and will regard it as putting me under no bonds to favor you in a professional way. Should the improbable occasion arise, I would 'roast' you with the same warmth as ever." Relations between critics and painters may not have been quite so pure as this letter attempted to establish, however.

27 Brander Matthews, "Vignettes of Manhattan," *Harper's New Monthly Magazine* 88 (March 1894): 491–492. James Brander Matthews (1852–1929) was a central figure in New York's turn-of-the-century cultural scene. A Columbia professor, he also wrote extensively on the theater and published several volumes of fiction based on his own social world in New York. See *Dictionary of American Biography,* 6: 414–416.

28 The Homer scrapbook is in the Winslow Homer Papers, Bowdoin College Museum of Art, Maine, and on microfilm roll 2932, in the Archives of American Art, Smithsonian Institution, Washington, D.C.

Chapter 1: Finding the "Real" American Artist

1 W. Ray Crozier, "The Personality of the Artist: Current Psychological Perspectives," *The Structurist* 25–26 (1985–1986): 36–40.

2 "An Artist on Art Criticism," *The Times* (Philadelphia), February 13, 1895, clipping in

Thomas Hovenden Papers, microfilm roll P13, Archives of American Art, Smithsonian Institution, Washington, D.C.

3 James William Pattison, "William Merritt Chase, N. A.," *The House Beautiful* 25 (February 1909): 52; William Howe Downes, "William Merritt Chase, A Typical American Artist," *The International Studio* 39 (December 1909): xxix.

4 Alfred Trumble, "Art's Summer Outings," *The Quarterly Illustrator* 2 (1894): 406; William Walton, "Some Tendencies in Contemporary American Art," *Scribner's Magazine* 34 (November 1903): 638. Contemporary sources strongly support Lois Marie Fink's observation in *American Art at the Nineteenth-Century Paris Salons* (Washington, D.C.: National Museum of American Art, Smithsonian Institution, 1990), 246, that in this generation artists represented themselves as confident, fashionable, socially acceptable, and financially secure; Fink notes that this was the model of the successful Parisian painters who taught American students at various ateliers. Neil Harris, *The Artist in American Society: The Formative Years, 1790–1860* (1966; rpt., New York: Simon and Schuster, 1970), 251, argues that by the eve of the Civil War the "fictional artist of romance, handsome and magical, was gradually replaced by the honest, hard-working, straightforward and respectable professional." Certainly, such prominent painters as Asher B. Durand fit this pattern, and this suggests all the more that the younger generation, in styling itself as newly professional and competent, was maneuvering for a position, rather than reflecting on historical circumstance, in casting aspersions on the long-haired garret dwellers of the recent past.

5 "The Lounger," *The Critic* 13 (May 31, 1890): 273.

6 "Trilbyana," *The Critic* 25 (December 8, 1894): 399; George Du Maurier, *Trilby* (New York: Harper and Brothers, 1895), 12.

7 Robert Grant, "Richard and Robin," *Harper's New Monthly Magazine* 90 (December 1894): 140–141.

8 M. O. Stanton, *Encyclopedia of Face and Form Reading* [1897], 3rd ed. (Philadelphia: F. A. Davis, 1913), 78, 79, 288; V. G. Rocine, *Heads, Faces, Types, Races* (Chicago: Vaught-Rocine, 1910), 238, 282–284. Nineteenth-century systems for deducing character traits from material evidence continued to be influenced by the theories of the eighteenth-century philosopher and phrenologist Johann Casper Lavater.

9 On the formation of artist communities and institutions in the early years of the century see Harris, *Artist in American Society*.

10 Hobson Dewey Anderson and Percy E. Davidson, *Occupational Trends in the United States* (Stanford, Calif.: Stanford University Press, 1940), 493–501; James Carroll Beckwith Diary, October 8, 1895, James Carroll Beckwith Papers, microfilm roll 800, Archives of American Art, Smithsonian Institution, Washington, D.C. Howard S. Becker, *Art Worlds* (Berkeley: University of California Press, 1982), provides a general sociological model for the study of the formation and maintenance of commercial and professional art institutions and networks; his concept of the "integrated professional" converges at many points with my model of the dominant "incorporated artist" of the late nineteenth century (228–233). H. Wayne Morgan, *New Muses: Art in American Culture, 1865–1920* (Norman: University of Oklahoma Press, 1978), surveys artists' attempts to enhance their status and authority in the decades after the Civil War; Gladys Engel Lang and Kurt Lang, *Etched in Memory: The Building and Survival of Artistic Reputation* (Chapel Hill: University of North Carolina Press, 1990), 227–266, consider the social and historical elements that go into reputation building, including the role of insider and mediator networks in the creation of recognition and renown.

11 "Painting as a Profession," *New York Times*, May 14, 1882. See Jennifer A. Martin Bienenstock, "The Formation and Early Years of the Society of American Artists, 1877–1884"

(Ph.D. diss., City University of New York, 1983). Linda Henefield Skalet, "The Market for American Painting in New York: 1870–1915" (Ph.D. diss., Johns Hopkins University, 1980), examines in detail a variety of artists' organizations, from schools to clubs and galleries. Also see Saul E. Zalesch, "Competition and Conflict in the New York Art World, 1874–1879," *Winterthur Portfolio* 29 (Summer–Autumn 1994): 103–120.

12　See Marchal E. Landgren, *Years of Art: The Story of the Art Students' League of New York* (New York: R. M. McBride, 1940). On summer schools of art, see Lorraine T. Kuczek, "Beneath the White Umbrella: An Exploration of the Cultural and Social Implications of the American Summer School of Art at the Turn of the Century," M. A. thesis, Indiana University, Bloomington 1991; William H. Gerdts, "The Teaching of Painting Out-of-Doors in the Late Nineteenth Century," *In Nature's Ways: American Landscape Painting of the Late Nineteenth Century* (Norton Gallery of Art, West Palm Beach, Florida, 1987), 25–41.

13　Skalet, "Market for American Painting," 74.

14　The major source on the Salmagundi Club is William Henry Shelton, *The Salmagundi Club* (Boston: Houghton Mifflin, 1918), and Shelton, *The History of the Salmagundi Club As It Appeared in The New York Herald Tribune Magazine on Sunday December 18, 1927* (New York: Privately printed, 1927). Skalet, "Market for American Painting," 109–113, gives an account of the club as a professional organization, focusing in particular on the commercial orientation of their exhibiting activities.

15　On the Tile Club see *A Book of the Tile Club* (Boston: Houghton Mifflin, 1886), a collaborative effort by the members; J. B. Millet, "The Tile Club," in *Julian Alden Weir: An Appreciation of His Life and Works* (New York: Century Club, 1921), 75–87; Mahonri Sharp Young, "The Tile Club Revisited," *American Art Journal* 2 (Fall 1970): 81–91. The contemporary articles about Tile Club activities were W. Mackay Laffan, "The Tile Club at Work," *Scribner's Monthly* 17 (January 1879): 401–409; W. Mackay Laffan and Edward Strahan [Earl Shinn], "The Tile Club at Play," *Scribner's Monthly* 17 (February 1879): 464–478; W. Mackay Laffan and Edward Strahan [Earl Shinn], "The Tile Club Afloat," *Scribner's Monthly* 19 (March 1880): 641–671; W. Mackay Laffan, "The Tile Club Ashore," *Century Illustrated Magazine* 23 (February 1882): 481–498.

16　[Free Lance], "The Career of Art," *New York Times,* February 13, 1882.

17　See Robert H. Wiebe, *The Search for Order, 1877–1920* (New York: Hill and Wang, 1967); Alan Trachtenberg, *The Incorporation of America* (New York: Hill and Wang, 1982); and Olivier Zunz, *Making America Corporate, 1870–1920* (Chicago: University of Chicago Press, 1990).

18　Anna Youngerman, *The Economic Causes of Great Fortunes* (New York: Bankers Publishing, 1909), 5; "The Passing of the Individual," *Scribner's Magazine* 32 (September 1902): 252; Montgomery Ward, "The Elements of Personal Power," in *Personality in Business,* vol. 9 of *The Business Man's Library* (Chicago: System Co., 1907): 5; Henry C. Lytton, "The Personal Basis of Success," *Personality in Business,* 25.

19　Will H. Low, "The Art of the White City," in *Some Artists at the Fair* (New York: Charles Scribner's Sons, 1893), 66–67. On the White City as microcosm of corporate America see Trachtenberg, *Incorporation of America,* 208–234.

20　Cleveland Moffett, "Will H. Low and His Work. The Career of an American Artist," *McClure's Magazine* 5 (September 1895): 291–312. See Will H. Low, *A Chronicle of Friendships, 1873–1900* (New York: Charles Scribner's Sons, 1908), and *A Painter's Progress* (New York: Charles Scribner's Sons, 1910).

21　William A. Coffin, "Kenyon Cox," *Century Illustrated Magazine* 41 (January 1891): 335, 337. See Chapter 10 for more on the issue of the nude in late-nineteenth-century American art.

22 On summer activities see Lizzie W. Champney, "The Summer Haunts of American Artists," *Century Illustrated Magazine* 30 (October 1885): 845–860, and Trumble, "Art's Summer Outings." Information on the Beckwith household is from occasional references in J. Carroll Beckwith, Diary, 1895, and Bertha Beckwith, Diary, March 4, 1904, Beckwith Papers, microfilm rolls 800 and 1418, Archives of American Art. An introduction to the general subject of art colonies is Michael Jacobs, *The Good and Simple Life: Artist Colonies in Europe and America* (Oxford, Eng.: Phaidon, 1985).

23 George Parsons Lathrop, "The Progress of Art in New York," *Harper's New Monthly Magazine* 86 (April 1893): 740–752.

24 William Walton, "The Field of Art," *Scribner's Magazine* 34 (November 1903): 638; Benjamin Lander, in "Thoughts and Suggestions from Studio and School," *The Quarterly Illustrator* 2 (July–September 1894): 339; Margaret Field, "The Art Schools of New York," *Munsey's Magazine* 8 (March 1893): 677.

25 Angela Miller and Robert Jensen, "Authenticity, Aesthetic Brotherhood, and the 'Currency' of History," paper delivered at the American Studies Association annual conference, Baltimore, 1991. Miller and Jensen discuss the creation of a late-nineteenth-century artistic aristocracy that constituted itself as an exclusive community with important ties to European contemporaries as well as to the greatest of the old masters; this group consciousness manifested itself in portraits and self-portraits that alluded to those ties in presenting the artist as a member of a privileged company.

26 According to H. Barbara Weinberg, *The Lure of Paris: Nineteenth-Century American Painters and Their French Teachers* (New York: Abbeville, 1991), 202, the sketches are Beckwith's and the fencing mask his as well. However, A. Hyatt Mayor, *American Art at the Century* (New York: Century Association, 1977), 82, states that the "fresh private sketches hanging in the background" are by Walton. See *Artists by Themselves: Artists' Portraits from the National Academy of Design* (New York: National Academy of Design, 1983), and Ann C. Van Devanter and Alfred V. Frankenstein, *American Self-Portraits, 1670–1973* (Washington, D.C.: International Exhibitions Foundation, 1974).

27 Patricia G. Berman, "Edvard Munch's *Self-Portrait with Cigarette*: Smoking and the Bohemian Persona," *Art Bulletin* 75, no. 4 (December 1993): 627–646, links Munch's cigarette to contemporary discourses of bohemianism, degeneracy, class, and gender. As cosmopolitans, artists of Chase's generation shared at least some of these links with their European contemporaries, and in America, according to Henry Collis Brown, *New York in the Elegant Eighties* (New York: Valentine's, 1925), 135, in the 1880s cigarettes were considered too exotic for enjoyment in banks and offices. However, as Lois Banner points out in *American Beauty* (New York: Knopf, 1983), 241, by the 1890s the "popularity of cigarettes was demonstrated by the casualness with which young men in the novels by such popular writers as Richard Harding Davis [a celebrated journalist] and Constance Carey Harrison smoked them." Cigarettes in American artists' hands probably sent mixed signals.

28 Nathaniel C. Fowler, *The Boy: How to Help Him Succeed* [1902], 2nd ed. (New York: Moffat, Yard, 1912), 102. Michael Quick, "Introduction," *Artists by Themselves*, 28, argues that the vase in Weir's self-portrait is an emblem of his career that bespeaks his spiritual identity as an artist. But the vase does not pinpoint the subject's status unequivocally, as easel, palette, and brushes would. Weir's self-portrait was a National Academy of Design "diploma" portrait (required of all new associate members) and therefore subject to size restrictions. Nonetheless, the format did not necessarily limit the use of more traditional attributes.

29 William Howe Downes and Frank Torrey Robinson, "Later American Masters," *New England Magazine* 14 (April 1896): 131–151.

30 Armand Dayot, "John W. Alexander," *Harper's New Monthly Magazine* 99 (October 1899): 694; Charles Caffin, *The Story of American Painting* (New York: Charles Scribner's Sons, 1907), 245-261.

31 Ellis T. Clarke, "Alien Element in American Art," *Brush and Pencil* 7 (1900): 36.

32 Henry Adams to Mabel Hooper, January 12, 1897, in J. C. Levenson, Ernest Samuels, Charles Vandersee, and Viola Hopkins Winner, eds., *The Letters of Henry Adams* (Cambridge: Belknap Press of Harvard University Press, 1982), 4: 90; Henry Rutgers Marshall, "Shall Artists Be Trained in Our Universities?" *Scribner's Magazine* 33 (February 1903): 254.

33 Downes and Robinson, "Later American Masters," 132-134. Downes and Robinson also nominated Whistler, La Farge, and Albert P. Ryder for the top rank of contemporary Americans.

34 Charles L. Buchanan, "Inness and Winslow Homer," *The Bookman* 47 (July 1918): 487. Clarke did in fact continue to buy American paintings after 1899. See Chapter 6 for further discussion of Clarke.

35 George William Sheldon, *Hours with Art and Artists* (New York: D. Appleton, 1882), 137; Augustus Stonehouse, "Winslow Homer," *The Art Review* 1 (February 1886): 84.

36 Lang and Lang, *Etched in Memory*, 7; "American Painters—Winslow Homer and F. A. Bridgman," *Art Journal*, n.s. 4 (August 1878): 226-227; Charles H. Caffin, "American Painters of the Sea," *The Critic* 43 (October 1903): 552. The best-known ambivalent critique of Homer in the 1870s is probably Henry James, "On Some Pictures Lately Exhibited," *Galaxy* 20 (July 1875): 89-97. Like most contemporaries, James complained of Homer's baldness and crudeness while reluctantly admiring his artistic eye.

37 George William Sheldon, "Characteristics of George Inness," *Century Illustrated Magazine* 49, n.s. 27 (February 1895): 532-533; Arthur Hoeber, "The Story of Art in America," Part 4: "The Beginnings of Modern Tendencies," *The Bookman* 31 (May 1910): 254-256; "Inness and His Art," *The Outlook* 51 (January 19, 1895): 110.

38 H. C. Merwin, "A National Vice," *Atlantic Monthly Magazine* 71 (June 1893): 769; Hamilton Wright Mabie, "The Artist Talks," in Mabie, *My Study Fire* (1890; rpt., New York: Dodd, Mead, 1899), 117-118.

39 S. G. W. Benjamin, "George Inness," *Life* 25 (January 3, 1895): 5; Woodrow Wilson, address to the American Bar Association, 1910, cited in Thomas C. Cochran and William Miller, *The Age of Enterprise: A Social History of Industrial America* (1942; rpt., New York: Macmillan, 1960), 193.

40 Ronald G. Pisano traces the fluctuating profile of Chase's twentieth-century reputation in *A Leading Spirit in American Art: William Merritt Chase, 1849-1916* (Seattle: Henry Art Gallery, 1983), 13-19.

Chapter 2: The Artist in the Age of Surfaces: The Culture of Display and the Taint of Trade

1 An earlier version of this chapter appeared as "The Price of Beauty: Art, Commerce, and the Late Nineteenth-Century American Studio Interior," in David Miller, ed., *American Iconology: New Approaches to Nineteenth-Century Art and Literature* (New Haven: Yale University Press, 1993), 209-238. B. O. Flower, "The Vital Issue in the Present Battle for a Great American Art," *The Arena* 34 (November 1905): 480; "At the Academy," *Life* 11 (April 19, 1888): 219. For studies of the rise of consumer culture see Richard Wightman Fox and T. J. Jackson Lears, eds., *The Culture of Consumption: Critical Essays in American History, 1880-1940* (New York: Pantheon, 1983), 3-38; Neil Harris, "The Drama of Consumer Desire," in Otto Mayr and Robert C. Post, eds., *Yankee Enterprise: The Rise of the American System of Manufactures* (Washington, D.C.: Smithsonian Institution Press, 1981), 189-216; Grant McCracken, *Culture and Consumption: New Approaches to*

the Symbolic Character of Consumer Goods and Activities (Bloomington: Indiana University Press, 1988); and Simon J. Bronner, ed., *Consuming Visions: Accumulation and Display of Goods in America, 1880–1920* (New York: Norton, 1989).

2 William Lewis Fraser, "Exhibition of Artists' Scraps and Sketches," *Century Illustrated Magazine* 42 (May 1891): 96–97.

3 William J. Stillman, "The Decay of Art," in *The Old Rome and the New, and Other Studies* (Boston: Houghton Mifflin, 1898), 197.

4 Homer to J. Eastman Chase, May 14, 1888, cited in J. Eastman Chase, "Some Recollections of Winslow Homer," *Harper's Weekly Magazine* 54 (October 22, 1910): 13; Homer to Knoedler, January 1901 and Autumn 1900, cited in Lloyd Goodrich, *Winslow Homer* (New York: Macmillan, 1944), 166, 162; Homer to Grenville Norcross, January 19, 1910, Norcross Autograph Collection, Massachusetts Historical Society; "Winslow Homer," *The Outlook* 96 (October 1910): 339.

5 The debate over commercialism had roots in the antebellum decades, when blockbuster exhibition practices and other techniques of self-promotion threatened to undermine ideologies of aesthetic purity and high-mindedness. See Gerald Carr, "Church in Public, 1859–1863," in *Frederic Edwin Church: The Icebergs* (Dallas: Museum of Fine Arts, 1980), 21–33; and Linda S. Ferber, "Albert Bierstadt: The History of a Reputation," in Nancy K. Anderson and Linda S. Ferber, *Albert Bierstadt: Art and Enterprise* (New York: Brooklyn Museum, 1991), 32–34.

6 Elizabeth Bisland, "The Studios of New York," *The Cosmopolitan* 7 (May 1889): 7. See also Celia Betsky, "In the Artist's Studio," *Portfolio* 4 (January–February 1982): 32–39, and Richard N. Gregg, *The Artist's Studio in American Painting, 1840–1983* (Allentown, Pa.: Allentown Art Museum, 1983). American studios followed a pattern established by such prominent Europeans as Karl Theodor von Piloty and Jean-Léon Gérôme; see John Milner's *The Studios of Paris* (New Haven: Yale University Press, 1988). On the aestheticized domestic environment see Roger B. Stein, "Artifact as Ideology: The Aesthetic Movement in Its American Cultural Context," *In Pursuit of Beauty: Americans and the Aesthetic Movement* (New York: Metropolitan Museum of Art, 1986), 23–51.

7 John Moran, "Studio-Life in New York," *The Art Journal* 5 (1879): 344–345. On Chase's studio see Nicolai Cikovsky, Jr., "William Merritt Chase's Tenth Street Studio," *Archives of American Art Journal* 16 (1976): 2–14. On Tenth Street in general see Annette Blaugrund, "The Tenth Street Studio Building: A Roster, 1857–1895," *American Art Journal* 14 (Spring 1982): 64–71; Mary Sayre Haverstock, "The Tenth Street Studio," *Art in America* 54 (September 1966): 48–57; and Garnett McCoy, "Visits, Parties, and Cats in the Hall: The Tenth Street Studio Building and Its Inmates in the Nineteenth Century," *Archives of American Art Journal* 6, no. 1 (January 1966): 1–8.

8 Lizzie W. Champney, "The Summer Haunts of American Artists," *Century Illustrated Magazine* 30 (October 1885): 846.

9 John Wanamaker Firm, *Golden Book of the Wanamaker Stores: Jubilee Year, 1861–1911* (Philadelphia: John Wanamaker, 1911), 70–71; New York *World*, December 19, 1886, cited in Ralph M. Hower, *History of Macy's of New York, 1858–1919: Chapters in the Evolution of a Department Store* (1943; rpt., Cambridge: Harvard University Press, 1967), 164. On the department store see H. Pasdermadjan, *The Department Store, Its Origins, Evolution, and Economics* (London: Newman, 1954); Susan Porter Benson, "Palace of Consumption and Machine for Selling: The American Department Store, 1880–1940," *Radical History Review* 21 (Fall 1979): 199–221. William Leach's work has been especially useful and suggestive: see *Land of Desire: Merchants, Power, and the Rise of a New American Culture* (New York: Pantheon, 1993). See also Leonard Marcus, *The American Store Window*

(New York: Watson-Guptill, 1978), and Rémy G. Saisselin, *The Bourgeois and the Bibelot* (New Brunswick, N.J.: Rutgers University Press, 1984).

10 Richard Spenlow, "Decorating and Furnishing," *New York Times,* October 9, 1887.

11 Nathaniel C. Fowler, *Building Business: An Illustrated Manual for Aggressive Business Men* (Boston: Trade Co., 1893), 434–436. On Baum see Leach, *Land of Desire,* 59–61, 247–260.

12 L. Frank Baum, *The Art of Decorating Dry Goods Windows and Interiors* (Chicago: Show Window Publishing, 1900), 7, 147, 14, 23–26, 149.

13 Kendall Banning, "Staging a Sale: The Setting in Which the Man Who Sells Displays His Wares to Command the Attention of the Man Who Buys," *System* 16 (September 1909): 280; Tudor Jenks, "Before Shop Windows," *The Outlook* 51 (April 27, 1895): 689; Wanamaker Firm, *Golden Book of the Wanamaker Stores,* 172, 203–204.

14 Baum, *Art of Decorating Dry Goods Windows,* 8; Lillie Hamilton French, "Shopping in New York," *Century Illustrated Magazine* 61 (March 1901): 651; Anne O'Hagan, "Behind the Scenes in the Big Stores," *Munsey's Magazine* 22 (January 1900): 537.

15 Linda Henefield Skalet, "The Market for American Painting in New York: 1870–1915" (Ph.D. diss., Johns Hopkins University, 1980), 39, 54.

16 "Commerce in Art," *New York Times,* February 26, 1882.

17 "The Rewards of Painters," *New York Times,* October 1, 1882. Skalet, "Market for American Painting in New York," 11–16, offers a brief analysis of the showroom function of the studio and notes the overlap that linked the artist's carefully contrived environment with the elite domestic interior of the same period—an overlap designed to "create the most advantageous atmosphere" to attract patrons.

18 "Artists Receiving," *New York Times,* March 5, 1882.

19 See Skalet, "Market for American Painting in New York," 51–54, for a sample of McEntee's preoccupation with money and sales.

20 Frederic Harrison, "Art and Shoddy: A Reply to Criticisms," *The Forum* 15 (August 1893), 718–726; Flower, "The Vital Issue in the Present Battle," 483. Flowers's article incorporated material from an interview with Frank Edwin Elwell (1858–1922), sculptor of high-minded statues and monuments.

21 W. Carman Roberts, "Are We Becoming 'Civilized' Too Rapidly?" *The Craftsman* 17 (January 1910): 359; "Our National Genius and Our National Art," *Harper's Weekly Magazine* 47 (February 28, 1903): 349; John Graham Brooks, "Is Commercialism in Disgrace?" *Atlantic Monthly Magazine* 93 (February 1904): 201.

22 Charles Eliot Norton, "A Definition of the Fine Arts," *The Forum* 17 (March 1889): 39; Marie C. Remick, "The Relation of Art to Morality," *The Arena* 19 (April 1898): 491; Elizabeth Stuart Phelps, "The *Décolleté* in Modern Life," *The Forum* 9 (August 1890): 680.

23 Amy Kaplan, *The Social Construction of American Realism* (Chicago: University of Chicago Press, 1988), 4, 7, notes that whereas earlier scholarship tended to equate romance with the "exceptional nature of American culture" and make realism "an inherently flawed imitation of a European convention," recent studies, which treat literary form as social practice, have reclaimed the "American novelist's engagement with society. . . . Realism is now related primarily to the rise of consumer culture in the late nineteenth century, in which the process of commodification makes all forms of the quotidian perform in what Guy Debord has called the 'society of the spectacle.'" See also Rachel Bowlby, *Just Looking: Consumer Culture in Dreiser, Gissing and Zola* (New York: Methuen, 1985); and June Howard, *Form and History in American Literary Naturalism* (Chapel Hill: University of North Carolina Press, 1985).

24 William M. Mallock, "The Relation of Art to Truth," *The Forum* 9 (March 1890): 41–44;

Hiram M. Stanley, "The Passion for Realism, and What Is To Come of It," *The Dial* 14 (April 16, 1893): 238–240.

25 Royal Cortissoz, "Books New and Old" (review of Alice Meynell, *The Work of John Singer Sargent, R. A.*), *Atlantic Monthly Magazine* 93 (March 1904): 412–413; Christian Brinton, "Sargent and His Art," *Munsey's Magazine* 36 (December 1906): 265–284. On Sargent see Patricia Hills et al., *John Singer Sargent* (New York: Whitney Museum of American Art, 1986).

26 Cortissoz, "Books New and Old," 413; John Cournos, "John Singer Sargent," *The Forum* 54 (August 1915): 235–236. See Roger Fry, "Art: J. S. Sargent at the R. A.," *The Nation and the Athenaeum* 38 (January 23, 1926): 582–583.

27 Edith Wharton, *The Custom of the Country* (1913; rpt., New York: Berkeley Books, 1981), 121–128; F. Hopkinson Smith, *The Fortunes of Oliver Horn* (1902; rpt., New York: Scribner's, 1915), 437–438.

28 Aline Gorren, "American Society and the Artist," *Scribner's Magazine* 26 (November 1899): 628–633. On Smith see Nick Madorno, "Francis Hopkinson Smith (1838–1915): His Drawings of the White Mountains and Venice," *American Art Journal* 12, no. 1 (Winter 1985): 68–81.

29 Harrison, "Art and Shoddy," 726; John La Farge, "The Teaching of Art," *Scribner's Magazine* 49 (February 1911): 187–188; Stinson Jarves, "The Priesthood of Art," *The Arena* 17 (April 1897): 736–739.

30 Frances Hodgson Burnett, "A Story of the Latin Quarter," *Scribner's Monthly* 18 (May 1879): 25; William Ordway Partridge, "The Development of Sculpture in America," *The Forum* 20 (January 1896): 569.

31 Will H. Low, "The Field of Art. The American Art Student in Paris," *Scribner's Magazine* 34 (October 1903): 511.

32 George Wharton Edwards to Violet Oakley, January 12, 1901; Oakley to Edwards, January 14, 1901, Violet Oakley Papers, 1841–1981, microfilm roll 3719, Archives of American Art, Smithsonian Institution, Washington, D.C.

33 Harriet Monroe, "Painting in Chicago," *Art Amateur* 21 (1889): 90; William Howe Downes, "William Merritt Chase, a Typical American Artist," *The International Studio* 39 (December 1909): xxxii, xxxvi; Mariana Van Rensselaer, "William Merritt Chase," *American Art Review* 2 (1881): 141.

34 Blashfield cited in George Parsons Lathrop, "The Progress of Art in New York," *Harper's New Monthly Magazine* 86 (April 1893): 748–749; George William Sheldon, *Recent Ideals of American Art* (New York: D. Appleton, 1890), 45–46. See Doreen B. Burke, "Painters and Sculptors in a Decorative Age," *In Pursuit of Beauty,* 294–339, and other essays in the catalogue. Also see *The Quest for Unity: American Art Between World's Fairs, 1876–1893* (Detroit: Detroit Institute of Arts, 1983). Elizabeth Broun, *Albert Pinkham Ryder* (Washington, D.C.: National Museum of American Art, 1990), 42–55, discusses Ryder's involvement with the decorative movement; on Whistler see David Park Curry, "Total Control: Whistler at an Exhibition," in Ruth E. Fine, ed., *James McNeill Whistler: A Reexamination, Studies in the History of Art* (Washington, D.C.: National Gallery of Art, 1987), 19: 67–82. Also see L. Bailey Van Hook, "Decorative Images of American Women," *Smithsonian Studies in American Art* 4 (Winter 1990): 44–69.

35 Katherine Metcalf Roof, "The Work of John Twachtman," *Brush and Pencil* 12 (1903): 243–244.

36 Royal Cortissoz, "Some Imaginative Types in American Art," *Harper's New Monthly Magazine* 91 (July 1895): 167–168. Dewing to Freer, February 16, 1901, Freer Papers, microfilm roll 77, Archives of American Art, Smithsonian Institution, Washington, D.C. Kathleen A. Pyne, "Evolutionary Typology and the American Woman in the Work of Thom-

as Dewing," *American Art* 7 (Winter 1993): 13–29, reads Dewing's figures in light of the period's pervasive "scientifically" grounded rhetoric of progress and Anglo-American hegemony.

37 Kenyon Cox, "The Art of Whistler," *Architectural Record* 15 (May 1904): 478; Richard Muther, *The History of Modern Painting* (London: Henry and Co., 1896), 3: 662; Christian Brinton, *Modern Artists* (New York: Baker and Taylor, 1908), 101–102.

38 Edward Simmons, *From Seven to Seventy: Memories of a Painter and a Yankee* (New York: Harper and Brothers, 1922), 130; Bisland, "Studios of New York," 16; "James Abbott M'Neill Whistler," *Harper's Weekly Magazine* 47 (August 1, 1903): 1253.

39 Arthur Jerome Eddy, *Recollections and Impressions of James McNeill Whistler* (1904; rpt., New York: Benjamin Blom, 1972), 265–266; Dewing to Freer, December 20, 1893, Freer Papers, Archives of American Art.

40 Sadakichi Hartmann, "An American Painter," Hartmann Papers, University of California Riverside Library, cited in Broun, *Ryder*, 149. Broun (134–141) examines the formation of the "Ryder legend" of the painter's eccentricity and reclusiveness.

41 Elizabeth Milroy, *Painters of a New Century: The Eight and American Art* (Milwaukee: Milwaukee Art Museum, 1991), 16–17, notes that Henri and his cohorts were solidly in the mainstream but used publicity knowingly to draw attention to themselves as rebels and revolutionaries.

42 "The Field of Art," *Scribner's Magazine* 19 (April 1896): 522–523. See H. Barbara Weinberg, Doreen Bolger, and David Park Curry, *American Impressionism and Realism: The Painting of Modern Life, 1885–1915* (New York: Metropolitan Museum of Art, 1994), 42–49, for another discussion of generational differences between the studios of William Merritt Chase and George Bellows.

Chapter 3: Fighting Infection: Aestheticism, Degeneration, and the Regulation of Artistic Masculinity

1 Richard Burton, "The Healthful Tone for American Literature," *The Forum* 19 (April 1894): 252–253; Harry Thurston Peck, "Swinburne and the Swinburnians," *The Bookman* 29 (June 1909): 374–384. On American reactions to decadence see Robert Moore Limpus, "American Criticism of British Decadence, 1880–1900" (Ph.D. diss., University of Chicago, 1937).

2 Charles H. Caffin, "The Story of American Painting," *American Illustrated Magazine* 41 (March 1906): 596; Stinson Jarves, "The Truly Artistic Woman," *The Arena* 18 (December 1897): 814; Elliott Daingerfield, "Nature vs. Art," *Scribner's Monthly Magazine* 49 (February 1911): 256.

3 Charles M. Skinner, "From Many Studios," F. Hopkinson Smith et al., *Discussions on American Art and Artists* (Boston: American Art League, n.d.), 96; "Shall Our Young Men Study in Paris? Written by an American Girl after Two Years of Parisian Art Study," *The Arena* 13 (June 1895): 133–134. There was a counter-discourse on Paris as well. See, for example, E. L. Good, "American Artists in Paris," *Catholic World* 66 (January 1898): 453–463, which sees Paris and its cultural impact on Americans as wholly positive. Lois Marie Fink, *American Art at the Nineteenth-Century Paris Salons* (Washington, D.C.: National Museum of American Art, Smithsonian Institution, 1990), 286–288, discusses the use of such adjectives as *virile* and *manly* to characterize American painting in the debate over French training, and the formation of national identity in American art.

4 I base my survey of degeneration theory on Eric T. Carlson, "Medicine and Degeneration: Theory and Praxis," in J. Edward Chamberlin and Sander L. Gilman, eds., *Degeneration: The Dark Side of Progress* (New York: Columbia University Press, 1985), 121–144; George Frederick Drinka, M.D., *The Birth of Neurosis: Myth, Malady, and the Victorians*

(New York: Simon and Schuster, 1984). Milton Painter Foster, "The Reception of Max Nordau's *Degeneration* in England and America" (Ph.D. diss., University of Michigan, 1954) remains the most exhaustive study of the reaction to degeneration theory around the turn of the century. Foster notes the book's best-seller status in New York (3). Lombroso's study was first published as *Genio e folia* in 1863; the first edition in English translation was *The Man of Genius* (London: Scott, 1891); Scribner's published it in New York in 1895. Nordau also drew on theories advanced by Benedict-Augustin Morel and Jacques Joseph Moreau.

5 Regenia Gagnier, *Idylls of the Marketplace: Oscar Wilde and the Victorian Public* (Stanford: Stanford University Press, 1986), 150.

6 "Degeneration," *Literary World* 26 (April 6, 1895): 100; James Gibbons Huneker, *Musical Courier* 31 (July 3, 1895): 18–20, cited in Arnold T. Schwab, *James Gibbons Huneker: Critic of the Seven Arts* (Stanford: Stanford University Press, 1963), 79; "Imbeciles All," *The Nation* 60 (April 25, 1895): 328; William James, "Psychological Literature. Degeneration and Genius," *Psychological Review* 2 (May 1895): 289, 294. Foster, "Reception of Max Nordau's *Degeneration*," lists more than one hundred articles reacting to Nordau, and several dozen books. I am indebted to Foster, 179–242, for my summary of the anti-Nordau campaign. Important counterattacks against Nordau included George Bernard Shaw, *The Sanity of Art: An Exposure of the Current Nonsense about Artists Being Degenerate*, first appearing in the American periodical *Liberty* (July 27, 1895) and then issued as a book in 1908 by the New Age Press in London; Alfred Egmont Hake, *Regeneration: A Reply to Max Nordau* (New York: G. P. Putnam's Sons, 1896); and William Hirsch, *Genius and Degeneration* (London: William Heinemann, 1896).

7 Kenyon Cox, "Nordau's Theory of Degeneration, I.—A Painter's View," *The North American Review* 160 (June 1895): 734–740; Cox, "The Carnegie Institute Exhibition," *The Nation* 84 (April 18, 1907): 368–370; Giles Edgerton [Mary Fanton Roberts], "American Art Triumphs at Pittsburgh," *The Craftsman* 14 (August 1908): 470.

8 Henry Loomis Nelson, "The People and Their Government," *Harper's New Monthly Magazine* 97 (July 1898): 188–189; William Dean Howells, "Degeneration," *Harper's Weekly Magazine* 39 (April 13, 1895): 342; Harry Thurston Peck, "Degeneration and Regeneration," *The Bookman* 5 (July 1896): 407.

9 Frank Luther Mott, *A History of American Magazines, 1885–1905* (Cambridge: Belknap Press of Harvard University Press, 1957), canvasses the issues that preoccupied magazine editors and writers and profiles the political and cultural positions of a range of periodicals. On the literature of populism see Richard Hofstadter, *The Age of Reform from Bryan to F. D. R.* (New York: Vintage, 1955), 60–93.

10 William Barry, "Signs of Impending Revolution," *The Forum* 7 (April 1889): 165–174. See Emile de Laveleye, "The Perils of Democracy," *The Forum* 7 (May 1889): 235–245; John Brooks Leavitt, "Criminal Degradation of New York Citizenship," *The Forum* 17 (August 1894): 659–665; Richard J. Hinton, "Organizations of the Discontented," *The Forum* 7 (July 1889): 540–552; A. Cleveland Cox, "Government by Aliens," *The Forum* 7 (August 1889): 597–608; Stanley G. Fisher, "Alien Degradation of American Character," *The Forum* 14 (January 1893): 608–615.

11 John H. Denison, "The Survival of the American Type," *Atlantic Monthly* 75 (January 1895): 16–28. Also see Robert Grant, "The Art of Living: The Conduct of Life," *Scribner's Magazine* 18 (November 1895): 581–592: "the pioneer strain of blood has been diluted by hoards of immigrants from the scum of the earth" (582).

12 Henry Adams to Charles Milnes Gaskell, April 28, 1894, J. C. Levenson, Ernest Samuels, Charles Vandersee, and Viola Hopkins Winner, eds., *The Letters of Henry Adams* (Cambridge: Belknap Press of Harvard University Press, 1982), 4: 185. On Brooks Adams's

theory of disintegration see Robert C. Bannister, *Social Darwinism: Science and Myth in Anglo-American Thought* (Philadelphia: Temple University Press, 1979), 236–238.

13 Paul Baker, *Stanny: The Gilded Life of Stanford White* (New York: Free Press, 1989), 251; "The Story of an Artist's Model . . . A New York 'Trilby,' " New York *World,* October 13, 1895.

14 "The Democracy of Darkness: A Fruit of Materialistic Commercialism," *The Arena* 36 (August 1906): 192; "The Artist in Our World," *The Nation* 83 (July 1906): 5–6; and *American Architect and Building News* 90 (July 7, 1906): 6. For details and discussion of the White murder and its consequences see Baker, *Stanny,* 369–400; the *Vanity Fair* headline is at 377. Artist friends and elite institutions closed ranks around the murdered architect; allies who included the popular novelist Richard Harding Davis and Richard Watson Gilder, editor of *The Century,* published tributes to White's genius, generosity, and love of beauty.

15 The literature on Wilde is extensive; for much background material I have relied on Richard Ellmann, *Oscar Wilde* (1987; rpt., New York: Vintage, 1988). On Du Maurier see Leonée Ormond, *George Du Maurier* (London: Routledge and Kegan Paul, 1969), and Richard Michael Kelly, *George Du Maurier* (Boston: Twayne, 1983). Studies of the aesthetic movement in England and America include Elizabeth Aslin, *The Aesthetic Movement: Prelude to Art Nouveau* (1969; rpt., New York: Excalibur, 1981); Robin Spencer, *The Aesthetic Movement: Theory and Practice* (London: Studio Vista, 1972); Diana Chalmers Johnson, *American Art Nouveau* (New York: Harry Abrams, 1979); *In Pursuit of Beauty: Americans and the Aesthetic Movement* (New York: Metropolitan Museum of Art, 1986). Gary Schmidgall decodes homosexual innuendoes in Du Maurier's aesthetic movement cartoons in *The Stranger Wilde: Interpreting Oscar* (New York: Dutton, 1994), 43–63.

16 Ed Cohen, *Talk on the Wilde Side: Toward a Genealogy of a Discourse on Male Sexualities* (New York: Routledge, 1993), 17.

17 The standard work on Oscar Wilde's American tour is Lloyd Lewis and Henry Justin Smith, *Oscar Wilde Discovers America* (1936; rpt., New York: Benjamin Blom, 1967).

18 Mrs. Frank Leslie is quoted in Lewis and Smith, *Oscar Wilde Discovers America,* 55–56.

19 Anna, Comtesse de Brémont, *Oscar Wilde and His Mother; A Memoir* (London: Everett, 1911), cited in E. H. Mikhail, ed., *Oscar Wilde: Interviews and Recollections* (New York: Barnes and Noble, 1979), 1: 100–105. Not every woman, of course, was attracted to Wilde. Clover Adams, Henry's wife, called Wilde "that vulgar cad" in a letter to her father, Dr. Robert W. Hooper, February 19, 1882, in Ward Thoron, ed., *The Letters of Mrs. Henry Adams, 1865–1883* (Boston: Little, Brown, 1936), 352.

20 Thomas Wentworth Higginson, "Unmanly Manhood," *Woman's Journal* 13 (February 4, 1882): 33; Jonathan Katz, *Gay American History: Lesbians and Gay Men in the U. S. A.* (New York: Thomas Y. Crowell, 1976), 448, 481, 643 n. 7. Julia Ward Howe, who had entertained Wilde in her home, mounted a spirited attack against Higginson in a letter to the *Boston Evening Transcript,* February 16, 1882: see Ellmann, *Oscar Wilde,* 182–183. On Higginson see Tilden G. Edelstein, *Strange Enthusiasm: A Life of Thomas Wentworth Higginson* (New Haven: Yale University Press, 1968), and John A. Lucas, "Thomas Wentworth Higginson: Early Apostle of Health and Fitness," *Journal of Health, Physical Education and Recreation* 42 (February 1971): 30–33.

21 Professor David Swing in *The Alliance,* March 1882, cited in Lewis and Smith, *Oscar Wilde Discovers America,* 213; Richard Hofstadter, *Anti-Intellectualism in American Life* (New York: Knopf, 1966), 188–189.

22 "How Far Is It from This to This?" *Washington Post,* January 22, 1882; Sandra Siegel,

"Literature and Degeneration: The Representation of 'Decadence,' " in Chamberlin and Gilman, *Degeneration: The Dark Side of Progress,* 199–219.

23 Gagnier, *Idylls of the Marketplace,* 98, points to the outbreak of a "crisis in the 1890s of the male on all levels—economic, political, social, psychological, as producer, as power, as role, as lover." Although Gagnier's focus is England, this applied equally to America during the same period. On male sexual identity at the fin de siècle see also Eve Kosofsky Sedgwick, *Epistemology of the Closet* (Berkeley: University of California Press, 1990), 180–195. Elaine Showalter, *Sexual Anarchy: Gender and Culture at the Fin de Siècle* (New York: Penguin, 1990), has contributed greatly to my understanding of sex and gender issues in the late nineteenth century.

24 Harry Pringle, *Theodore Roosevelt: A Biography* (1931; rpt., New York: Harcourt, Brace, 1956), 47. Tom Lutz discusses Roosevelt's masculinization in *American Nervousness, 1903: An Anecdotal History* (Ithaca: Cornell University Press, 1991), 77–84. See Mark Sullivan, *Our Times: The United States, 1900–1925* (1927; rpt., New York: Charles Scribner's Sons, 1936), 215–218; Edmund Morris, *The Rise of Theodore Roosevelt* (New York: Coward, McCann, and Geoghegan, 1979), 161–162.

25 Ellmann, *Wilde,* 362, 379.

26 Henley is quoted in Gagnier, *Idylls of the Marketplace,* 59; Richard Dellamora, *Masculine Desire: The Sexual Politics of Victorian Aestheticism* (Chapel Hill: University of North Carolina Press, 1990), 208. See Julian Hawthorne, "The Romance of the Impossible," *Lippincott's Monthly Magazine* 46 (September 1890): 412–415; Anne H. Wharton, "The Revulsion from Realism, *Lippincott's Monthly Magazine* 46 (September 1890): 409–412; "The Baron de Book-Worms," "Our Booking-Office," *Punch* 99 (July 19, 1890): 25; "A Study in Puppydom," *St. James Gazette* 20 (June 24, 1890): 3–4.

27 George Parsons Lathrop, quoted in "Mr. Oscar Wilde's 'Mission,' " *Munsey's Magazine* 10 (November 1893): 224; "More Filth," *Life* 22 (December 21, 1893): 398; Charles Dudley Warner, "Editor's Study," *Harper's New Monthly Magazine* 90 (February 1895): 481–482. On *The Yellow Book* see Katherine Lyon Mix, *A Study in Yellow; the Yellow Book and Its Contributors* (New York: Greenwood, 1969). Ironically, Henry Harland, the editor of the magazine, was a cosmopolitan New Englander who had gone to England in the wake of Whistler and Henry James (Mix, 55). According to Albert Parry, *Garrets and Pretenders: A History of Bohemianism in America* [1933], rev. ed. (New York: Dover, 1960), 129, "Oscar Wilde nurtured an intense dislike for the magazine and never wrote for it," despite which, in the "minds of many Americans, the *Yellow Book* was synonymous with the Wilde spirit." *The Yellow Book* helped spark the fashion for the "little" or "dinkey" magazines that flourished in the mid-1890s: the *Chap-Book, M'lle New York,* and a host of others; see Larzer Ziff, *The American 1890s: The Life and Times of a Lost Generation* (New York: Viking, 1966), 132–145.

28 Robert Hichens, *The Green Carnation,* Stanley Weintraub, ed. (1894; rpt., Lincoln: University of Nebraska Press, 1970), 151; H. Montgomery Hyde, *The Trials of Oscar Wilde,* vol. 6 of *Notable British Trials* (1948; rpt., London: William Hodge, 1949), appendix E, 370, identified the green carnation with the homosexual subculture of Paris. Limpus, "American Criticism of British Decadence," 100–101, notes the best-seller status of *The Green Carnation* and surveys the reputation of *The Yellow Book* in America, 102–105.

29 Nordau, *Degeneration,* cited in "Nordau on Ego-Mania," *The Critic* 26 (April 20, 1895): 296–297; *Philadelphia Press,* cited in "Oscar Wilde's Disgrace," *Public Opinion* 18 (April 11, 1895): 374; unsigned editorial, *Life* 25 (April 18, 1895): 254; *Chicago Tribune,* 1882, cited in Lewis and Smith, *Oscar Wilde Discovers America,* 174; Cohen, *Talk on the Wilde Side,* 136; Thomas Beer, *The Mauve Decade: American Life at the End of the Nineteenth Century* (1926; rpt., Garden City, N.Y.: Garden City Publishing, n.d.), 131, 129.

30 J. Carroll Beckwith diary, April 6, 1895, J. Carroll Beckwith Papers, microfilm roll 800, Archives of American Art, Smithsonian Institution, Washington, D.C. On Fitch's connection with Wilde see Schmidgall, *Stranger Wilde*, 178–181.

31 Bert Hansen, "American Physicians' 'Discovery' of Homosexuals, 1880–1900: A New Diagnosis in a Changing Society," in Charles E. Rosenberg and Janet Golden, eds., *Framing Disease: Studies in Cultural History* (New Brunswick, N.J.: Rutgers University Press, 1992), 105–106; Earl Lind, *The Female Impersonators* (1918), cited in Katz, *Gay American History*, 366; Colin A. Scott, "Sex and Art," *American Journal of Psychology* 7 (January 1896): 216; John R. Wood testimony, New York State, *Report of the Special Committee of the Assembly Appointed to Investigate the Public Offices and Departments of the City of New York . . . Transmitted to the Legislature January 5, 1900*, vol. 5, cited in Katz, *Gay American History*, 46. See George Chauncey, *Gay New York: Gender, Urban Culture, and the Making of the Male Gay World, 1890–1940* (New York: Basic Books, 1994).

32 There were small gay subcultures in the art world of the time, notably that of F. Holland Day, who with Herbert Copeland published Wilde's *Salome* and *The Yellow Book* in America. Copeland and Day were members of the Visionist group in Boston, which formed in the early 1890s and included Bliss Carman, Bertrand Goodhue, Richard Hovey, the painter Tom Meteyard, and the architect Ralph Adams Cram, author of *The Decadent,* privately printed for him at Harvard University Press in 1893. See Estelle Jussim, *Slave to Beauty: The Eccentric Life and Controversial Career of F. Holland Day, Photographer, Publisher, Aesthete* (Boston: David R. Godine, 1981).

33 The class and cultural connotations of the "dude" were complex. As a dude, Roosevelt obviously fell into the category of upper-class intellectual scorned by the rough and ready machine politicians that dominated the New York legislature at the time of Roosevelt's fledgling term there. On the other hand, as an Americanized dandy, the dude could also be one who asserted his status or pretended to a higher class through distinctive dress and deportment. The term came into use in the 1880s, notes Lois Banner in *American Beauty* (New York: Knopf, 1983), 239, and "although the new word reflected the fact that Edward, Prince of Wales, had become the new model of dress and behavior for men, its derivation came from the western United States and reflected the perplexity of westerners in the face of well-dressed easterners." Among the working classes a "similar individual appeared. . . . This new type was known as a 'masher,' " whose flashy dress and sexually assertive behavior certainly had little in common with the alleged effeminacy of the upper-class dude.

34 The monocle or the pince-nez could also function as ambiguous signs for actual artists who, like Whistler or Chase and a number of young cosmopolitans, adopted such accessories as tokens of artistic individuality and nonconformity. The style of eyewear was part of a system denoting identity, much as the stethoscope and white coat signal the professional identity of the doctor. The monocle and the pince-nez carried just enough suggestion of difference to accentuate artistic self-representation without, in most cases, approaching too near the border separating the Oscar Wildes from other men.

35 On the bicycle craze and women see Harvey Green, *Fit for America: Health, Fitness, Sport, and American Society* (Baltimore: Johns Hopkins University Press, 1986), 228–233. Women on bicycles received much the same treatment in English and French cartoons of the same period. See Patricia Marks, *Bicycles, Bangs, and Bloomers: The New Woman in the Popular Press* (Lexington: University Press of Kentucky, 1990).

36 See Mary Douglas, *Natural Symbols: Explorations in Cosmology* (New York: Vintage, 1973), chs. 5, 6, 10.

37 Theodore Roosevelt, address to the Congress of Mothers, Washington, March 10, 1908, in *Addresses and Papers,* Willis Fletcher Johnson, ed. (New York: Unit Book Publishing,

1909), 432-433. Roosevelt himself coined the strenuous life epithet, and his speeches on this and related matters were collected in *The Strenuous Life: Essays and Addresses* (New York: Century, 1900). See Gerald F. Roberts, "The Strenuous Life: The Cult of Manliness in the Era of Theodore Roosevelt" (Ph.D. diss., Michigan State University, 1970); John Higham, "The Reorientation of American Culture in the 1890s," in Higham, *Writing American History: Essays on Modern Scholarship* (Bloomington: Indiana University Press, 1970), 74-102.

38 John Stokes, *In the Nineties* (Chicago: University of Chicago Press, 1989), 26-27; Dr. Allen W. Hagenbach, "Masturbation as a Cause of Insanity," *Journal of Nervous and Mental Diseases* 6 (1879): 603-612, cited in Katz, *Gay American History,* 641 n. 1.

39 "The Etching Club Exhibition," *The Nation* 38 (February 28, 1884): 199; Royal Cortissoz, "Egotism in Contemporary Art," *The Atlantic Monthly* 73 (May 1894): 644-652; "Chronicle and Comment," *The Bookman* 8 (December 1898): 300.

40 William Ordway Partridge, "Manhood in Art," *New England Magazine,* n.s. 9 (November 1893): 281-288.

41 John C. Van Dyke, *Art for Art's Sake* (New York: Charles Scribner's Sons, 1893), 10. Van Dyke's lectures were originally presented to students at Princeton, Columbia, and Rutgers Colleges. Van Dyke (1856-1932) fits the general profile of "new critic" described in my introduction. His father, descended from a seventeenth-century Dutch settler, was a Congressman and a justice of the Supreme Court of New Jersey; his mother was a professor's daughter. He studied law at Columbia and was admitted to the bar, but in 1878 he became a librarian at the New Brunswick Theological Seminary, where he pursued personal studies in art. From 1891 to 1929 he also held the position of professor of art history at Rutgers. He was the "favorite contributor" to *Century Magazine* from 1884 to about 1904, and he wrote several popular books on art. See *Dictionary of American Biography* (New York: Charles Scribner's Sons, 1964), 10: 188-189. See Jonathan Freedman, "An Aestheticism of Our Own: American Writers and the Aesthetic Movement," *In Pursuit of Beauty,* 385-399, for a discussion of the shifting patterns of American reaction to English aestheticism. Freedman notes that while some forms became "increasingly legitimate," this "was attended by a continuing rejection of aestheticism's more eccentric forms" (391). Freedman says that this "dual process of incorporation and rejection" generated a fascination among the younger generation for the rejected modes, which "retained a healthy charge of the forbidden." This fascination bore fruit at universities, where certain young men threw themselves eagerly "into the imitation of some of [aestheticism's] more disreputable aspects."

42 Hamilton Wright Mabie, "Sanity and Art," *My Study Fire,* 2nd ser. (1895; rpt., New York: Dodd, Mead, 1900), 116-118; Mabie, "Health," *Essays on Nature and Culture* (New York: Dodd, Mead, 1896), 268-271; Stinson Jarves, "The Priesthood of Art," *The Arena* 17 (April 1897): 735-741.

43 Alfred Trumble, "Three Special Exhibitions," *The Collector* 2 (February 1, 1891): 78; "National Academy of Design," *The Art Review* 2 (December 1887): 85; Edward King, "Straightforwardness versus Mysticism," *Quarterly Illustrator* 5 (1895): 29-32.

44 On the importance of sexual activity as a means of asserting masculinity see Charles E. Rosenberg, "Sexuality, Class, and Role in Nineteenth-Century America," *American Quarterly* 25 (May 1973): 131-153.

45 Fairfax Downey, *Portrait of an Era as Drawn by Charles Dana Gibson* (New York: Charles Scribner's Sons, 1936), 83, 176, 224; Charles Belmont Davis, "Mr. Charles Dana Gibson and His Art," *The Critic* 34 (January 1899): 49, 53-54.

46 Frank Fowler, "An Exponent of Design in Painting," *Scribner's Magazine* 33 (April 1903): 639-640. Bruce Robertson, "Americanism and Realism," in Robertson, *Reckoning with*

Winslow Homer (Cleveland: Cleveland Museum of Art, 1990), 63–80, surveys criticism celebrating virility and other manly qualities in Homer's art and illuminates connections between such criticism and other cultural issues.

47 William Howe Downes, "The Fine Arts," *Boston Evening Transcript* (August 8, 1894); Montgomery Schuyler, "George Inness: The Man and His Work," *The Forum* 18 (November 1894): 310–313; Frank Fowler, "A Master Landscape Painter. The Late George Inness," *Harper's Weekly Magazine* 38 (December 29, 1894): 1239; "Inness and His Art," *The Outlook* 51 (January 19, 1895): 110. In the late nineteenth century there existed a strong bias against epileptics and a tendency to view them as degenerates: see Ellen Dwyer, "Stories of Epilepsy, 1880–1930," in Rosenberg and Golden, eds., *Framing Disease*, 248–272.

48 George William Sheldon, "Characteristics of George Inness," *Century Illustrated Magazine* 49 (February 1895): 532–533. See Sylvia L. Yount, "Marketing Madness: The Artistic Identity Construction of Albert Blakelock" (paper delivered at the College Art Association annual meeting, Washington, D.C., 1991).

49 Ormond, *George Du Maurier*, 446, 473. Whistler and Wilde skirmished regularly from the early 1880s until about 1890 through an exchange of acerbic published reviews and letters. At issue was Whistler's ownership of his ideas, and Wilde's alleged poaching on Whistler's territory. See Richard Ellmann, *Oscar Wilde* (1987; rpt., New York: Vintage, 1988), 270–274; and Stanley Weintraub, *Whistler: A Biography* (1974; rpt., New York: E. P. Dutton, 1988), 289–307. On gender, costume, and dandyism see Marjorie Garber, *Vested Interests: Cross-Dressing and Cultural Anxiety* (New York: Routledge, 1992); and Jessica R. Feldman, *Gender on the Divide: The Dandy in Modernist Literature* (Ithaca: Cornell University Press, 1993).

50 E. Anthony Rotundo, *American Manhood: Transformations in Masculinity from the Revolution to the Modern Era* (New York: Basic Books, 1993), ch. 2, 31–55, and ch. 10, 222–246; Robert Raymond Williams, "Physical Prowess," *Munsey's Magazine* 8 (November 1892): 176–177. Robert M. Crunden, *American Salons: Encounters with European Modernism, 1885–1917* (New York: Oxford University Press, 1993), 20, suggests factors in Whistler's past that may have contributed to his aggressive, combative tendencies: "The stupidity of the criticism he received not only irritated him, it reenforced all the unfortunate tendencies which an erratic childhood, great talent, and a censorious mother all seemed to encourage. Under stress, Whistler became a caricature of the whimsical, brutal Russian aristocrat and the Southern, slave-whipping gentleman." See E. L. Doctorow, *Ragtime* (1974; rpt., New York: Fawcett Crest, 1991), 36. Harry Houdini figures here as the "last of the great shameless mother lovers, a nineteenth-century movement that included such men as Poe, John Brown, Lincoln, and James McNeill Whistler."

51 Samuel Swift, "Revolutionary Figures in American Art," *Harper's Weekly Magazine* 51 (April 13, 1907): 534; Marianne Doezema, *George Bellows and Urban America* (New Haven: Yale University Press, 1992), 73. Rebecca Zurier, "Real Life, Real Art, Real Men" (paper delivered at the American Studies Association annual conference, Baltimore, 1991), also discussed the shift toward a rhetoric and stance of vigorous, masculine energy in the early twentieth century.

52 J. Nilsen Laurvik, "Edward W. Redfield—Landscape Painter," *The International Studio* 41 (August 1910): xxix–xxxvi. Also see B. O. Flower, "Edward W. Redfield: An Artist of Winter-Locked Nature," *The Arena* 36 (July 1906): 21–22: "Mr. Redfield is a fine type of sturdy American manhood. His life is sincere and simple as are his pictures enthralling in their witchery and compelling power."

53 Christian Brinton, "The New Spirit in American Painting," *The Bookman* 27 (June 1908): 352, 354, 358; Guy Pène Du Bois, "The Boston Group of Painters: An Essay on National-

ism in Art," *Arts and Decoration* 5 (October 1915): 457–460. The painting purchased by the Metropolitan Museum was Alexander's *Study in Black and Green* (1906).

54 The progress of normalization of aestheticism and impressionism can be seen, for example, in the fact that most members of the Ten eventually rejoined such mainstream organizations as the National Academy of Design. See Ulrich W. Hiesinger, *Impressionism in America: The Ten American Painters* (Munich: Prestel Verlag, 1991).

Chapter 4: Painting as Rest Cure

1 Linda Merrill, *A Pot of Paint: Aesthetics on Trial in Whistler v. Ruskin* (Washington, D.C.: Smithsonian Institution Press, 1992), 148; James McNeill Whistler, "Mr. Whistler's 'Ten O'Clock' " (delivered 1885, published 1888), in Whistler, *The Gentle Art of Making Enemies* (1890; rpt., New York: G. P. Putnam's Sons, 1953), 135–159. For a concise review of Whistler's aesthetic theories and their sources see Ron Johnson, "Whistler's Musical Modes: Numinous Nocturnes," *Arts Magazine* 55 (April 1981): 169–176.

2 Frank Fowler, "Impressions of the Spring Academy," *The Nation* 84 (March 28, 1907): 297–298; "Special Exhibitions at the Dealers'," *The Independent* 64 (January 23, 1908): 201–202.

3 Nathaniel C. Fowler, *The Boy: How to Help Him Succeed* [1902], 2nd ed. (New York: Moffat, Yard, 1912), 13; Frederic Harrison, "Art and Shoddy: A Reply to Criticisms," *The Forum* 15 (August 1893): 719.

4 Herbert Spencer, *Principles of Sociology* (1874–1875; rpt., New York: G. Appleton, 1883), 3: 306–321. See Lois Fink, "Nineteenth Century Evolutionary Art," *American Art Review* 4 (January 1978): 74–81, 105–109, and Kathleen A. Pyne, *Art and the Higher Life* (Austin: University of Texas Press, 1996) for discussions of the impact of evolutionary thought on American art and culture in the late nineteenth century. Also see James R. Moore, *The Post-Darwinian Controversies: A Study of the Protestant Struggle to Come to Terms with Darwin in Great Britain and America, 1870–1900* (Cambridge: Cambridge University Press, 1979).

5 Lizzie W. Champney, "The Summer Haunts of American Artists," *Century Illustrated Magazine* 30 (October 1885): 845–860. On the subject of artists' tourism see, for example, Margaretta M. Lovell, *A Visitable Past: Views of Venice by American Artists, 1860–1915* (Chicago: University of Chicago Press, 1989), and Theodore E. Stebbins, Jr., *The Lure of Italy: American Artists and the Italian Experience, 1760–1914* (Boston: Museum of Fine Arts, 1992).

6 Charles Rollo Peters, quoted in *The Wave*, March 1897; F. W. Ramsdell, "Charles Rollo Peters," *Brush and Pencil* 4 (July 1899): 205–206.

7 John C. Van Dyke, *Art for Art's Sake* (New York: Charles Scribner's Sons, 1893), 8, 10; Birge Harrison, *Landscape Painting* [1909], 5th ed. (New York: Charles Scribner's Sons, 1911), 224; Mariana Van Rensselaer, *Six Portraits* (Boston: Houghton Mifflin, 1894), 264; Charles Caffin, *The Story of American Painting* (1907; rpt., Garden City, N.Y.: Garden City Publishing, 1937), 291.

8 Kenyon Cox, "William Merritt Chase, Painter," *Harper's New Monthly Magazine* 78 (March 1889): 549; Amos Stote, "The Painter and His Profits," *The Bookman* 30 (October 1909): 191; John Gilmore Speed, "An Artist's Summer Vacation," *Harper's New Monthly Magazine* 87 (June 1893): 10; Charles de Kay, "Mr. Chase and Central Park," *Harper's Weekly Magazine* 35 (May 2, 1891): 327.

9 Ewan Macpherson, "A Revelation in the Pennyrile," *Scribner's Magazine* 31 (January 1902): 44–56. The motif of the illustration in fact recapitulates (whether the artist knew it or not) an older icon of democratic art, William Sidney Mount's *The Painter's Triumph* (1838; Pennsylvania Academy of the Fine Arts, Philadelphia). The story itself

also plays on earlier images of the artist as seer; for example, Nathaniel Hawthorne's "The Prophetic Pictures" (1860).

10 Asher B. Durand, "Letters on Landscape Painting," *The Crayon* 1 (1855): 35.

11 In my outline of the changing models of visual perception in the nineteenth century I have depended heavily on Jonathan Crary, *Techniques of the Observer: On Vision and Modernity in the Nineteenth Century* (Cambridge: MIT Press, 1990). In addition to Crary, useful material on visual perception is collected in William N. Dember, ed., *Visual Perception: The Nineteenth Century* (New York: Wiley, 1964), an anthology of primary documents with editorial commentary, and Ian E. Gordon, *Theories of Visual Perception* (Chichester: Wiley, 1989). Richard Shiff, "The End of Impressionism. A Study of Theories of Artistic Expression," *Art Quarterly* 1, no. 4 (1978): 338–378, examines the relations between the new psychology of perception and the theory and practice of French impressionist and symbolist painting in the later nineteenth century. Also see José Arguelles, *Charles Henry and the Formation of a Psychophysiological Aesthetic* (Chicago: University of Chicago Press, 1972).

12 William W. Ireland, *The Blot upon the Brain: Studies in History and Psychology,* 2nd ed. (Edinburgh: Bell and Bradfute, 1893), 254–256; Julius Bernstein, *The Five Senses of Man* (New York: D. Appleton, 1881), 5, 162; Frank N. Spindler, *The Sense of Sight* (New York: Moffat, Yard, 1917), 45, 47. Helmholtz's influential study was first published as *Handbuch der physiologischen Optik* (Leipzig: L. Voss, 1867). Although the *Handbuch* was not translated into English until 1924, Helmholtz's theories became widely known through his *Popular Lectures on Scientific Subjects* (New York: D. Appleton, 1873), which were reprinted in numerous editions.

13 James Jackson Jarves, "American Art in Europe. The Proposed Exhibition in London," *Art Journal* (London) 18 (1879): 137; Raymond Westbrook, "Open Letter from New York," *Atlantic Monthly Magazine* 41 (February 1878): 238; "Taine's Art Lectures," *Scribner's Monthly* 2 (October 1871): 666; W. Lewis Fraser, "American Artists Series. George Inness," *Century Illustrated Magazine* 45 (April 1893): 957–958; "Paintings by Inness," *New York Times,* December 21, 1880. See Doreen Bolger Burke and Catherine Hoover Voorsanger, "The Hudson River School in Eclipse," in *American Paradise: The World of the Hudson River School* (New York: Metropolitan Museum of Art, 1987), 71–90.

14 Carl N. Degler, *In Search of Human Nature: The Decline and Revival of Darwinism in American Social Thought* (New York: Oxford University Press, 1991), 32; Luther H. Gulick, M.D., *The Efficient Life* (1906; rpt., Garden City, N.Y.: Doubleday, Page, 1924), 23. See Morton White, *Social Thought in America: The Revolt Against Formalism* (Boston: Beacon, 1957); George Cotkin, *William James: Public Philosopher* (Baltimore: Johns Hopkins University Press, 1989); Neil Coughlan, *Young John Dewey: An Essay in American Intellectual History* (Chicago: University of Chicago Press, 1975).

15 Frank Fowler, "A Master Landscape Painter. The Late George Inness," *Harper's Weekly Magazine* 38 (December 25, 1894): 1239, 1242; Edmund Robert Otto von Mach, *The Art of Painting in the Nineteenth Century* (Boston: Ginn and Co., 1908), 110–111; Elliott Dangerfield, "Nature vs. Art," *Scribner's Magazine* 49 (February 1911): 256.

16 Cox, "William Merritt Chase, Painter," 552, 554; Mariana Van Rensselaer, "William Merritt Chase," in Walter Montgomery, ed., *American Art and American Art Collections: Essays on Artistic Subjects* (Boston: S. Walker, 1889), 1: 229; William J. Baer, "Reformer and Iconoclast," *Quarterly Illustrator* 1 (1893): 139–140; H. D. Sedgwick, "The New American Type," *Atlantic Monthly Magazine* 93 (April 1904): 541.

17 Charles W. Dempsey, "Advanced Art," *Magazine of Art* 5 (1882): 359; Charles H. Caffin, *American Masters of Painting* (Garden City, N.Y.: Doubleday, Page, 1913), 49–50.

18 Herbert Spencer, *The Principles of Psychology* (1855; rpt., New York: D. Appleton, 1897),

2: 626–648; Herbert Spencer, "The Purpose of Art," in *Facts and Comments* (1902; rpt., New York: D. Appleton, 1910), 45–46.

19 Henry Rutgers Marshall, *Aesthetic Principles* (New York: Macmillan, 1895), 64, 82; John La Farge, *Considerations on Painting* (New York: Macmillan, 1895), 129–130, n. 1; George Santayana, *The Sense of Beauty: Being an Outline of Aesthetic Theory* (New York: Charles Scribner's Sons, 1896), 22; M. O. Stanton, *Encyclopedia of Face and Form Reading* [1889], 3rd ed. (Philadelphia: F. A. Davis, 1913), 288. Yet another writer who borrowed heavily from Spencer and Helmholtz was Grant Allen, in *Physiological Aesthetics* (New York: D. Appleton, 1877), which set out to exhibit the "purely physical origin of the sense of beauty and its relativity to our nervous system" (2). Peter Bermingham, *American Art in the Barbizon Mood* (Washington, D.C.: National Collection of Fine Arts, 1975), 87–96, has been helpful to my thinking here in his survey of the organization of late-nineteenth-century critical theory and its culmination, in the United States, in the lectures of La Farge and Santayana. The situation in England shows clear parallels with that in the United States at about the same time; see John Stokes, *In the Nineties* (Chicago: University of Chicago Press, 1989), 33–52. In America the writings of Matthew Arnold and Walter Pater also contributed to the redirection of aesthetic aims, as did Whistler, but none of them wielded the authority of Spencer to give incontrovertible physiological and sociological shape to the new paradigms. For a consideration of the Arnoldian strain in American aestheticism see David C. Huntington's essay in *The Quest for Unity: American Art Between World's Fairs, 1876–1893* (Detroit: Detroit Institute of Arts, Michigan, 1983), 11–46.

20 F. G. Gosling, *Before Freud: Neurasthenia and the American Medical Community* (Urbana: University of Illinois Press, 1987), 12–13; George M. Beard, *American Nervousness. Its Causes and Consequences* (New York: G. P. Putnam's Sons, 1881), 98; Edward Wakefield, "Nervousness: The National Disease of America," *McClure's Magazine* 2 (February 1884): 305; Charles H. Hughes, "Neurotrophia, Neurasthenia, and Neuriatria," *Alienist and Neurologist* 15 (1894): 215, cited in Gosling, *Before Freud*, 86. I have relied on Gosling and on George Frederick Drinka, M.D., *The Birth of Neurosis: Myth, Malady, and the Victorians* (New York: Simon and Schuster, 1984), for the general outline of my discussion of neurasthenia; however, the literature on the subject is extensive. See, for example, Tom Lutz, *American Nervousness, 1903: An Anecdotal History* (Ithaca: Cornell University Press, 1991); Barbara Sicherman, "The Paradox of Prudence: Mental Health in the Gilded Age," *Journal of American History* 62 (March 1976): 890–912; and Lynn Gamwell and Nancy Tomes, *Madness in America: Cultural and Medical Perceptions of Mental Illness Before 1914* (Ithaca: Cornell University Press, 1995).

21 Beard, *American Nervousness*, vi–ix.

22 Joseph Simms, *Physiognomy Illustrated; or, Nature's Revelations of Character* [1872], 10th ed. (New York: Murray Hill, 1891), 93; Stanton, *Encyclopedia of Face and Form Reading*, 114. It is easy to hold nineteenth-century physiognomy in contempt for its egregious racism, but these texts only duplicated the racist structure of the dominant culture itself, a structure that was literally built into the design of the 1893 Columbian Exposition in Chicago, where most Asians, Africans, and Native Americans had roles as entertainers or anthropological specimens while Euro-Americans boasted of their own triumphs in scientific progress and cultural advancement. See Robert W. Rydell, *All the World's a Fair: Visions of Empire at American International Expositions, 1876–1916* (Chicago: University of Chicago Press, 1984), 38–71.

23 John Watson, "The Restless Energy of the American People—an Impression," *North American Review* 169 (October 1899): 568–574; H. G. Cutler, "The American Not a New

Englishman, but a New Man," *The New England Magazine,* n.s. 9 (September 1893): 29–30.

24 Van Rensselaer, "William Merritt Chase," 227; Cox, "William Merritt Chase, Painter," 550; George Moore, *Modern Painting* (New York: Charles Scribner's Sons, 1893), 5–6; Julian Hawthorne, "A Champion of Art," *The Independent* 51 (November 2, 1899): 2957; George Henry Payne, "A Living Old Master: Whistler Seen at Close Range," *The Saturday Evening Post* 171 (February 25, 1899): 552.

25 William S. Sadler, *Worry and Nervousness; or, the Science of Self-Mastery* (Chicago: A. C. McClurg, 1914), 117.

26 Spindler, *Sense of Sight,* 114; Beard, *American Nervousness,* 44–46; Gulick, *Efficient Life,* 167; Walter L. Pyle, "The Eye," in Walter L. Pyle, ed., *A Manual of Personal Hygiene* (Philadelphia: W. B. Saunders, 1901), 210, 245. On the material culture of vision see Asa Briggs, " 'The Philosophy of the Eye': Spectacles, Cameras and the New Vision," in Briggs, *Victorian Things* (Chicago: University of Chicago Press, 1988), 103–141.

27 Beard, *American Nervousness,* 276.

28 Alfred H. Peters, "The Extinction of Leisure," *The Forum* 7 (August 1889): 685; J. W. Courteney, M.D., "Hygiene of the Brain and Nervous System," in Pyle, ed., *Manual,* 97. Herbert Spencer concluded his celebrated visit to New York in 1882 with a speech to an elite group of supporters at Delmonico's in New York. Preaching a "gospel of relaxation," Spencer warned his American admirers that business and "money getting" were soul-destroying activities. Studies of the rest cure have tended to focus on the treatment of women. See, for example, Barbara Ehrenreich and Deirdre English, *For Her Own Good: 150 Years of the Experts' Advice to Women* (1978; rpt., New York: Doubleday, 1989), 101–138. Lutz, *American Nervousness,* 32, notes that in contrast to the enforced debilitation of the female rest cure, men were prescribed regimens of sport, exercise, and action. E. Anthony Rotondo, *American Manhood: Transformations in Masculinity from the Revolution to the Modern Era* (New York: Basic Books, 1993), 185–193, discusses male neurasthenia as a form of regression and retreat from manhood, work, and socially prescribed manly virtues. New Thought magazines included *Suggestive Therapeutics* and *Nautilus.* See Charles S. Braden, *Spirits in Rebellion: The Rise and Development of New Thought* (Dallas: Southern Methodist University Press, 1963); Gail T. Parker, *Mind Cure in New England: From the Civil War to World War I* (Hanover, N.H.: University Press of New England, 1973). Fred Matthews traces one strain of the legacy of New Thought in "In Defense of Common Sense: Mental Hygiene as Ideology and Mentality in Twentieth-Century America," *Prospects* 4 (1979): 459–516, an examination of the mental hygiene movement that promoted the maintenance of well-adjusted citizens by experts in the "helping professions." William Leach, *Land of Desire: Merchants, Power, and the Rise of a New American Culture* (New York: Pantheon, 1993), 225–262, examines the cash value and popular culture of mind cure. T. J. Jackson Lears, *No Place of Grace: Antimodernism and the Transformation of American Culture, 1880–1920* (New York: Pantheon, 1981), discusses the approaches to therapeutic salvation that eased individual accommodation to the forces of modernization.

29 Sadler, *Worry and Nervousness,* 383, 389. See Harvey Green, *Fit for America: Health, Fitness, Sport and American Society* (Baltimore: Johns Hopkins University Press, 1986), for a comprehensive look at the history of physical and mental fitness.

30 Courteney, "Hygiene of the Brain and Nervous System," 298–300; Colin A. Scott, "Sex and Art," *American Journal of Psychology* 7 (January 1896): 225–226; Van Dyke, *Art for Art's Sake,* 13. Jean-Marie Guyau was the author of *L'Art au point de vue sociologique* (Paris: F. Alcan, 1889).

31 Spindler, *Sense of Sight,* 148; Herbert Westcott Fisher, *Making Life Worth While* (New

York: Doubleday, Page, 1910), 219; Van Dyke, *Art for Art's Sake,* 60. For a different approach to the subject see Kathleen A. Pyne, "John Twachtman and the Therapeutic Landscape," in Deborah Chotner, Lisa N. Peters, and Kathleen A. Pyne, *John Twachtman: Connecticut Landscapes* (Washington, D.C.: National Gallery of Art, 1989), 49–69. Pyne interprets Twachtman's landscapes, especially his winter scenes, as approximating "mind cure's meditative experience," which allowed the self to obtain emotional release and merge with the "universal spirit of the cosmos."

32 Oliver Wendell Holmes, "Talk Concerning the Human Body and Its Management" [1869], in *Pages from an Old Volume of Life,* vol. 8 of *Complete Works* (New York: Sully and Kleinteich, 1911), 211; Una Nixson Hopkins in *House Beautiful,* cited in Gwendolyn Wright, *Building the Dream: A Social History of Housing in America* (Cambridge: MIT Press, 1981), 162.

33 Marshall, *Aesthetic Principles,* 45–46, 169–170, 185.

34 Birge Harrison, "The 'Mood' in Modern Painting," *Art and Progress* 4 (July 1913): 1016; "American Studio Talk," *International Studio* 11 (September 1900): xvi–xv; William Howe Downes and Frank Torrey Robinson, "Later American Masters," *The New England Magazine* 14 (April 1896): 136–137.

35 Downes and Robinson, "Later American Masters," 137; B. Harrison, *Landscape Painting,* 24; Van Dyke, *Art for Art's Sake,* 90.

36 Christian Brinton, *Modern Artists* (New York: Baker and Taylor, 1908), 112; S. N. Carter, "National Academy of Design," *The Art Journal* (New York) 6 (1880): 156; Caffin, *American Masters of Painting,* 149–150; Kenyon Cox, *Concerning Painting: Considerations Theoretical and Historical* (New York: Charles Scribner's Sons, 1917), 48; Charles Caffin, "American Studio Notes," *International Studio* 15 (1902): Supplement, lxi; Henry Eckford [Charles de Kay], "A Modern Colorist. Albert Pinkham Ryder," *Century Illustrated Magazine* 40 (June 1890): 258. See the entry for de Kay in *National Cyclopedia of American Biography* (New York: James T. White, 1897), 4: 206.

37 American Art-Union sale catalogue (1840s), cited in John William Ward, *Red, White, and Blue: Men, Books, and Ideas in American Culture* (New York: Oxford University Press, 1969), 278; Clipping from *The Art Interchange,* mid-1890s; Winslow Homer Scrapbook, Winslow Homer and Homer Family Papers, microfilm roll 2932, Archives of American Art, Smithsonian Institution, Washington, D.C., quoted by permission of Bowdoin College Museum of Art, Brunswick, Maine, gift of the Homer Family (1964.69.185); "American Studio Talk," *International Studio* 10 (March 1900): iii; Spencer, *Principles of Psychology,* 2: 639. Before the Civil War, Henry Tuckerman and James Jackson Jarves were already recommending that businessmen and other comfortably situated Americans take up art patronage as a remedy for boredom and nervousness: see Joy S. Kasson, *Marble Queens and Captives: Women in Nineteenth-Century American Sculpture* (New Haven: Yale University Press, 1990), 16.

38 Sidney Allan [Sadakichi Hartmann], "The Technique of Mystery and Blurred Effects," *Camera Work* 7 (July 1904): 26. Royal Cortissoz, "Some Imaginative Types in American Art," *Harper's New Monthly Magazine* 91 (July 1895): 165–166, 170, 172. The groundbreaking study of tonalism is Wanda Corn, *The Color of Mood: American Tonalism, 1880–1910* (San Francisco: M. H. De Young Memorial Museum and the California Palace of the Legion of Honor, 1972). See also William H. Gerdts, Diana Dimodica, and Robert R. Preato, *Tonalism: An American Experience* (Phoenix: Phoenix Art Museum, 1982); and William Robinson, *The Edwin C. Shaw Collection of American Impressionist and Tonalist Painting* (Akron, Ohio: Akron Art Museum, 1986).

39 Henry van Dyke, "The White Blot. The Story of a Picture," *Scribner's Magazine* 18 (December 1895): 693–704. John C. Van Dyke and Henry van Dyke were descendants of the

same seventeenth-century Dutch settler. Henry (1852–1933) was a prolific and versatile writer, a cultivated, gregarious elite who hobnobbed with presidents and literary lights and who was devoted to angling. "He called himself an adventurous conservative, and this sums up his essential quality as a man and writer." See *Dictionary of American Biography* (New York: Charles Scribner's Sons, 1964), 10: 186–188.

40 Montgomery Schuyler, "George Inness," *Harper's Weekly Magazine* 38 (August 18, 1894): 1242; William Howe Downes, "The Fine Arts," *Boston Evening Transcript,* August 8, 1894; de Kay, "Mr. Chase and Central Park," 327.

41 William Howe Downes, *The Life and Works of Winslow Homer* (Boston: Houghton Mifflin, 1911), 170–171.

42 Linda Henefield Skalet, "The Market for American Painting in New York: 1870–1915" (Ph.D. diss., Johns Hopkins University, 1980), 201–217.

43 Skalet, "Market for American Painting," 160–162.

44 Willa Cather, "A Philistine in the Gallery," *Library,* April 21, 1900, cited in William M. Curtin, ed., *The World and the Parish: Willa Cather's Articles and Reviews, 1893–1902* (Lincoln: University of Nebraska Press, 1970), 2: 763. See Lawrence W. Chisolm, *Fenollosa: The Far East and American Culture* (New Haven: Yale University Press, 1963), and Thomas Lawton and Linda Merrill, *Freer: A Legacy of Art* (Washington, D.C.: Freer Gallery of Art, Smithsonian Institution, 1993).

45 For another reading of the therapeutic dynamic of twentieth-century art see Donald Kuspit, *The Cult of the Avant-Garde Artist* (Cambridge, Eng.: Cambridge University Press, 1993), 28–39.

Chapter 5: Outselling the Feminine

1 Kathleen D. McCarthy, *Women's Culture: American Philanthropy and Art, 1830–1930* (Chicago: University of Chicago Press, 1991), 98–99.

2 T. J. Jackson Lears, "Beyond Veblen: Rethinking Consumer Culture in America," in Simon Bronner, ed., *Consuming Visions: Accumulation and Display of Goods in America, 1880–1920* (New York: W. W. Norton, 1989), 86–88; T. J. Jackson Lears, *No Place of Grace: Antimodernism and the Transformation of American Culture, 1880–1920* (New York: Pantheon, 1981), 221. See also, for example, Michael Davit Bell, *The Problem of American Realism: Studies in the Cultural History of a Literary Idea* (Chicago: University of Chicago Press, 1993), 22. For William Dean Howells, writes Bell, realism mattered "not as an aesthetic theory but as one more in a continuing series of attempts at reconciliation—attempts to portray the 'artist' as a 'real' man by obscuring the distinction between 'a thing . . . said' and 'a thing . . . done.' The problem, for Howells as for many of his contemporaries and successors, was that the 'artist' was by accepted definition *not* a 'real' man." Also see Ann Douglas, *The Feminization of American Culture* (New York: Knopf, 1977). Of course, the twinning of middle-class woman with domestic space was the norm in nineteenth-century advice books and other literature.

3 Henry Blake Fuller, "Art in America," *The Bookman* 10 (November 1899): 220. See Michael S. Kimmel, "Men's Responses to Feminism at the Turn of the Century," *Gender and Society* 1 (September 1987): 261–283.

4 Frank Norris, *The Pit, a Story of Chicago* (1903; rpt., New York: Grove, n.d.), 17, 23, 33–34, 64–65. For a discussion of the artist versus the businessman figure in fiction see Carl S. Smith, *Chicago and the American Literary Imagination, 1880–1920* (Chicago: University of Chicago Press, 1984), 15–90. Unlike the Wildean aesthete (though not unrelated), this model of the artist posed no threat to conventional masculinity.

5 John Wanamaker Firm, *Golden Book of the Wanamaker Stores: Jubilee Year, 1861–1911* (Philadelphia: John Wanamaker, 1911), 107.

6 Elizabeth Bisland, "The Studios of New York," *The Cosmopolitan* 7 (May 1889): 6;

Frank Norris, "Novelists of the Future: The Training They Need," *Boston Evening Transcript,* November 27, 1901.

7 Benjamin de Casseres, "Arthur Symons: An Interpretation," *The Critic* 45 (October 1903): 354; Sidney Lanier, "The English Novel" [1881], in Clarence Gohdes and Kemp Malone, eds., *The English Novel and Essays on Literature, Centennial Edition* (Baltimore: Johns Hopkins University Press, 1945), 5: 53-54; Charles Dudley Warner, "Editor's Drawer," *Harper's New Monthly Magazine* 80 (May 1890): 972.

8 W. A. Cooper, "Artists in Their Studios, IX—Mary E. Tillinghast, Anna Meigs Case, Mabel R. Welch," and "Artists in Their Studios, X—Eliot Gregory," *Godey's Magazine* 132 (January-June 1896): 68-76, 187-192; "The Lounger," *The Critic* 34 (April 1899): 298-299.

9 William Leach, *Land of Desire: Merchants, Power, and the Rise of a New American Culture* (New York: Pantheon, 1993), 104-111

10 Harold Frederic, *The Damnation of Theron Ware* (Chicago: Stone and Kimball, 1896); "The Damnation of Theron Ware," *The Bookman* 3 (June 1896): 352; Christine Terhune Herrick, "Man, the Victim," *Munsey's Magazine* 27 (September 1902): 889-893. Terhune's critique coincided with the commercialization of an Arts and Crafts aesthetic that preached no-nonsense "masculine" simplicity, efficiency, and naturalness.

11 Francis Hopkinson Smith, *The Fortunes of Oliver Horn* (1902; rpt., New York: Charles Scribner's Sons, 1915), 488; Clarence Cook, "Studio-Suggestions for Decoration," *Quarterly Illustrator* 4 (1895): 235-236. See Eileen Boris, "The Social Meaning of Design: The House Beautiful and the Craftsman Home," in Boris, *Art and Labor: Ruskin, Morris, and the Craftsman Ideal in America* (Philadelphia: Temple University Press, 1986), 53-81; and Cheryl Robertson, "Male and Female Agendas for Domestic Reform: The Middle-Class Bungalow in Gendered Perspective," *Winterthur Portfolio* 26, no. 2-3 (Summer–Autumn 1991): 123-142.

12 Clarence Cook, "Shall Our Rooms Be Artistic or Stylish?" *Quarterly Illustrator* 5 (1895): 53. The title of David Park Curry's "Total Control: Whistler at an Exhibition," in Ruth E. Fine, ed., *James McNeill Whistler: A Reexamination,* vol. 19 of *Studies in the History of Art* (Washington, D.C.: National Gallery of Art, 1987), 67-82, is suggestive for the argument presented here. Something similar was happening in the world of middle-class domestic life during the same period; see Margaret Marsh, "Suburban Men and Masculine Domesticity, 1870-1915," *American Quarterly 40* (June 1988): 165-186. Women competed with men over territorial control of the interior, attempting to assert their authority through advice books and magazine articles. Candace Wheeler (1827-1923), for example, who established herself as a prolific and professional textile designer in the last decades of the century, published essays and books on domestic decor, including *Principles of Home Decoration with Practical Examples* (New York: Doubleday, Page, 1903). As bachelor editor of a highly successful women's magazine, Bok did come in for some twitting by male contemporaries. Although the quips and lampoons continued even after Bok's marriage, they did not prevent him from parlaying the *Ladies' Home Journal* into an immensely profitable and influential enterprise. See Frank Luther Mott, *A History of American Magazines, 1885-1905* (Cambridge: Belknap Press of Harvard University Press, 1957): 538-547.

13 Molly Elliott Seawell, "On the Absence of the Creative Faculty in Women," *The Critic* 19 (November 29, 1891): 292-294; Grant Allen, "Woman's Place in Nature," *The Forum* 7 (May 1889): 263. See Christine Battersby, *Gender and Genius: Toward a Feminist Aesthetics* (Bloomington: Indiana University Press, 1990).

14 Grant Allen, "Woman's Intuition," *The Forum* 9 (May 1890): 333-340; E. A. Randall, "The Artistic Impulse in Man and Woman," *The Arena* 24 (October 1900): 415-420. Bat-

tersby, *Gender and Genius,* 87, notes that the figure of the androgynous mind in a male body was put forward as a model for genius by Samuel Taylor Coleridge and other romantic theorists at the start of the nineteenth century. Also see Susan Casteras, "Excluding Women: The Cult of the Male Genius in Victorian Painting," in Linda M. Shires, ed., *Rewriting the Victorians: Theory, History, and the Politics of Gender* (New York: Routledge, 1992), 116–146. Roszika Parker and Griselda Pollock discuss the issue of male domination of artistic practice in *Old Mistresses: Women, Art, and Ideology* (New York: Pantheon, 1981), 41. For an investigation into the role of institutional control regulating the entry and rise of women in the illustration professions see Michele H. Bogart, "Artistic Ideals and Commercial Practices: The Problem of Status for American Illustrators," *Prospects* 15 (1990): 232–237.

15 Charles H. Caffin, "The Story of American Painting," *American Illustrated Magazine* 61 (March 1906): 597, 599; "The Exhibition at the Carnegie Galleries, Pittsburgh, Pennsylvania," *Brush and Pencil* 3 (December 1898): 168.

16 Giles Edgerton [Mary Fanton Roberts], "Is There a Sex Distinction in Art? The Attitude of the Critic Toward Women's Exhibits," *The Craftsman* 14 (June 1908): 249–251; F. Edwin Elwell, "Mart.," *The Arena* 34 (October 1905): 350.

17 "Palette and Brush," *Town Topics* March 1, 1900, clipping, Cecilia Beaux Papers, microfilm roll 429, Archives of American Art, Smithsonian Institution, Washington, D.C. (hereafter Beaux Papers, Archives of American Art); Homer St.-Gaudens, "Cecilia Beaux," *The Critic* 47 (July 1905): 39. Chase praised Beaux's greatness in an 1899 speech on Founders' Day at the Carnegie Institute, Pittsburgh, where Beaux had just won first prize in the Carnegie Galleries exhibition for *Mother and Daughter* (Pennsylvania Academy of the Fine Arts). For a more extended consideration of the issues involved in the construction of gender by language see Sarah Burns, "The 'Earnest, Untiring Worker' and the 'Magician of the Brush': Gender Politics in the Criticism of Cecilia Beaux and John Singer Sargent," *Oxford Art Journal* 15, no. 1 (Spring 1992): 36–53. On Beaux see Tara L. Tappert, "Choices, the Life and Career of Cecilia Beaux: A Professional Biography" (Ph.D. diss., George Washington University, 1990), and *Cecilia Beaux and the Art of Portraiture* (Washington, D.C.: National Portrait Gallery, 1995).

18 "Art," *The Mail and Express,* March 3, 1903, clipping, Beaux Papers, Archives of American Art; William Walton, "Cecilia Beaux," *Scribner's Magazine* 22 (October 1897): 485.

19 "Miss Cecilia Beaux and Mr. W. M. Chase," *New York Evening Sun,* March 6, 1903, clipping, Beaux Papers, Archives of American Art.

20 Charles H. Caffin, "The Picture Exhibition at the Pan-American Exposition," *International Studio* 14 (Spring 1901): xxviii; Charles H. Caffin, "Exhibition of the Pennsylvania Academy," *International Studio* 19 (March 1903): cxvi; Charles H. Caffin, "John Singer Sargent, the Greatest Contemporary Portrait Painter," *World's Work* 7 (November 1903): 4100, 4116.

21 Mariana Griswold Van Rensselaer, "The Great Portrait Exhibition," *The World,* November 11, 1894, Beaux Papers, Archives of American Art; George W. Smalley, "American Artists Abroad," *Munsey's Magazine* 27 (April 1902): 47; Charles H. Caffin, *The Story of American Painting* (New York: Frederick A. Stokes, 1907), 246–249.

22 W. J. McGee, "Fifty Years of American Science," *Atlantic Monthly Magazine* 82 (1898): 320; on Ingersoll see Carl N. Degler, *The Age of the Economic Revolution, 1876–1900* (Glenview, Ill.: Scott, Foresman, 1967), 184.

23 Holmes to S. Weir Mitchell, May 8, 1862, in Anna Robeson Burr, *Weir Mitchell: His Life and Letters* (New York: Duffield, 1929), 82–83; William Osler, "The Leaven of Science" and "Nurse and Patient," in Osler, *Aequanimitas; with Other Addresses to Medical Students, Nurses, and Practitioners of Medicine,* 2nd ed. (Philadelphia: P. Blackiston's Son

and Co., 1910), 97–99, 161. Charles Rosenberg, *No Other Gods: On Science and American Social Thought* (Baltimore: Johns Hopkins University Press, 1976), examines the growth of scientific prestige and influence in the late nineteenth century and its social implications and consequences. Also see Evelyn Fox Keller, *Reflections on Science and Gender* (New Haven: Yale University Press, 1985).

24 Harrison S. Morris, "American Portraiture of Children," *Scribner's Magazine* 30 (December 1901): 650; Royal Cortissoz, "John Singer Sargent," *Scribner's Magazine* 34 (November 1903): 524; Samuel Isham, *History of American Painting* [1905], 2nd new ed. with supplemental chapters by Royal Cortissoz (1927; rpt., New York: Macmillan, 1936), 433. "Monthly Record of American Art," *Magazine of Art* 14 (1891): xxv; "Portraits of Women," *The Critic* 25 (November 10, 1894): 317.

25 Christian Brinton, "Sargent and His Art," *Munsey's Magazine* 36 (December 1906): 284; Homer St.-Gaudens, "John Singer Sargent," *The Critic* 47 (October 1905): 327; Caffin, "John Singer Sargent," 4116.

26 Edward Andrews, "The Surgeon," *Chicago Medical Examiner*, vol. 2, 1861, quoted in Regina Markell Morantz-Sanchez, *Sympathy and Science: Women Physicians in American Medicine* (New York: Oxford University Press, 1985), 53; Thomas Eakins to Edward Horner Coates, September 11, 1886, in Kathleen A. Foster and Cheryl Leibold, *Writing About Eakins: The Manuscripts in Charles Bregler's Thomas Eakins Collection* (Philadelphia: University of Pennsylvania Press, 1990), 236; Margaret Supplee Smith, "*The Agnew Clinic*: 'Not Cheerful for Ladies to Look At,' " *Prospects* 11 (1987): 168–169; D. Hayes Agnew, *The Principles and Practice of Surgery* (Philadelphia: Lippincott, 1878), vol 1., ch. 1, quoted in Diana Long, "The Medical World of *The Agnew Clinic*: A World We Have Lost?" *Prospects* 11 (1987): 188; Isham, *History of American Painting*, 434; Royal Cortissoz, "Cecilia Beaux, Her Portraits of Children and Women," *New York Daily Tribune*, June 16, 1895. I thank Kathleen Foster for bringing the Eakins letter to my attention.

27 "My Artistic Wife," *Munsey's Magazine* 15 (September 1896): 758.

28 Cornelia Atwood Pratt, "Indian-Gift," *Scribner's Magazine* 31 (May 1902): 625–630; William Dean Howells, *The Coast of Bohemia* (1893; rpt., New York: Harper and Brothers, 1899), 124–134.

29 Pauline King, "Cecilia Beaux," *Harper's Bazaar*, 1899, clipping, Beaux Papers, Archives of American Art; Ann O'Hagan, "Cecilia Beaux," *Harper's Bazaar* 45 (March 1911): 119; Lorado Taft, "Work of Cecilia Beaux," [Chicago] *Record*, December 21, 1899, Beaux Papers, Archives of American Art; "Cecilia Beaux, Artist: Her Home, Work, and Ideals," [Boston] *Sunday Herald*, September 23, 1910. Tappert, "Choices, the Life and Career of Cecilia Beaux," 416–432, discusses Beaux's attitudes toward other women artists. On Tanner see Dewey F. Mosby, *Henry Ossawa Tanner* (Philadelphia: Philadelphia Museum of Art, 1991). For a representative case of the talented woman who migrated back to the home see Karal Ann Marling, "Portrait of the Artist as a Young Woman: Miss Dora Wheeler," *Bulletin of the Cleveland Museum of Art* 65 (February 1978): 47–57.

30 Marianne Doezema, *George Bellows and Urban America* (New Haven: Yale University Press, 1992), 183; Charles Morgan, *George Bellows: Painter of America* (New York: Reynal, 1965), 94–95, discusses Beaux and her tendency to take on young male protégés.

Chapter 6: Being Big: Winslow Homer and the American Business Spirit

1 "Editor's Study," *Harper's New Monthly Magazine* 96 (May 1898): 966–967; C. Lewis Hind, "American Paintings in Germany," *International Studio* 41 (September 1910): 184, 189.

2 Lewis Mumford, *The Brown Decades: A Study of the Arts in America, 1865–1895* (1931; rpt., New York: Dover, 1971), 8; Clarence M. Woolley, "Injecting Personality into an Organization," in *Personality in Business*, vol. 9 in *The Business Man's Library* (Chicago:

System Co., 1907), 47. Bruce Robertson, "Americanism and Realism," in Robertson, *Reckoning with Winslow Homer: His Late Paintings and Their Influence* (Cleveland: Cleveland Museum of Art, 1990), 63–80, helped to inspire the themes addressed here.

3 Orson Lowell, "Water Colors by Winslow Homer," *Brush and Pencil* 2 (1898): 131; Frederick W. Morton, "The Art of Winslow Homer," *Brush and Pencil* 11 (1902): 40–42; John W. Beatty, "Recollections of an Intimate Friendship," in Lloyd Goodrich, *Winslow Homer* (New York: Macmillan, 1944): 225; Kenyon Cox, "Three Pictures by Winslow Homer in the Metropolitan Museum," *Burlington Magazine* 12 (October 1907): 124; Henry Reuterdahl, "Winslow Homer, American Painter: An Appreciation from a Sea-Going Viewpoint," *The Craftsman* 20 (April 1911): 10. Standard biographical sources for Homer are William Howe Downes, *The Life and Work of Winslow Homer* (Boston: Houghton Mifflin, 1911); Goodrich, *Homer*; Philip C. Beam, *Winslow Homer at Prout's Neck* (Boston: Little, Brown, 1966); and Gordon Hendricks, *The Life and Work of Winslow Homer* (New York: Abrams, 1979). Also see Nicolai Cikovsky, Jr., and Franklin Kelly, *Winslow Homer* (Washington, D.C.: National Gallery of Art, 1995).

4 Homer to J. Alden Weir, c. 1898, cited in Goodrich, *Homer,* 154; Homer to Arthur Homer, January 1904, cited in Hendricks, *Life and Works of Winslow Homer,* 259.

5 Mariana Van Rensselaer, review of Homer's *Fox Hunt,* clipping, Winslow Homer and Homer Family Papers, microfilm roll 2932, Archives of American Art, Smithsonian Institution, Washington, D.C (hereafter cited as Homer Papers, Archives of American Art); Goodrich, *Homer,* 91; Cecilia Beaux, *Background with Figures* (Boston: Houghton Mifflin, 1930), 211. On Homer's participation in the development of Prout's Neck see Patricia Junker, "Expressions of Art and Life in *The Artist's Studio in an Afternoon Fog,*" in Philip C. Beam et al., *Winslow Homer in the 1890s: Prout's Neck Observed* (Rochester, N.Y.: Memorial Art Gallery, University of Rochester, 1990), 34–53. Bruce Robertson notes that the "mythic" Homer has had a greater presence than the real one (*Reckoning with Winslow Homer,* 3). The original Homer scrapbook is owned by Bowdoin College Museum of Art, Brunswick, Maine, gift of the Homer Family (1964.69.185). All quotations from clippings in the scrapbook appear here by permission.

6 Sigmund Diamond, *The Reputation of the American Business Man* (1955; rpt., New York: Harper and Row, 1966), 170. Homer to Michel Knoedler, December 1900, cited in Goodrich, *Homer,* 170. See William Leach, "Wanamaker's Simple Life and the Moral Failure of Established Religion," in Leach, *Land of Desire: Merchants, Power, and the Rise of a New American Culture* (New York: Pantheon, 1993), 191–223, which looks at the accommodation of Protestant values to the marketplace in the career of department store magnate John Wanamaker.

7 Edward Chase Kirkland, *Dream and Thought in the Business Community, 1860–1900* (Ithaca: Cornell University Press, 1956), 11–26; Charles Elliott Perkins to Edward Atkinson, June 7, 1881, cited in Kirkland, *Dream and Thought,* 23–24; Frank Norris, *The Octopus: A Story of California* (New York: Doubleday, Page, 1901), 576. In addition to Kirkland, *Dream and Thought,* I have relied for the economic and business background in this chapter on Thomas C. Cochran and William Miller, *The Age of Enterprise: A Social History of Industrial America* (1942; rpt., New York: Macmillan, 1960); William Miller, ed., *Men in Business: Essays on the Historical Role of the Entrepreneur* (1952; rpt., New York: Harper, 1962); Edward Chase Kirkland, *Business in the Gilded Age: The Conservatives' Balance Sheet* (Madison: University of Wisconsin Press, 1952); Carl N. Degler, *The Age of the Economic Revolution, 1876–1900* (Glenview, Ill.: Scott, Foresman, 1967); and Diamond, *Reputation of the American Business Man.*

8 Kirkland, *Dream and Thought,* 11–26; Henry Wood, *The Political Economy of Natural Law* (1894; 4th ed., Boston: Lee and Shepard, 1899), 65, 197, 198. On Wood see Robert

C. Bannister, *Social Darwinism: Science and Myth in Anglo-American Thought* (1979; rpt., Philadelphia: Temple University Press, 1988), 163. Recent studies examining American art forms in light of economic systems include Walter Benn Michaels, *The Gold Standard and the Logic of Naturalism* (Berkeley: University of California Press, 1987); and Howard Horwitz, *By the Law of Nature: Form and Value in Nineteenth-Century America* (New York: Oxford University Press, 1991).

9 Andrew Carnegie, lecture to students at Cornell University, January 11, 1896, in Carnegie, *The Empire of Business* (1902; rpt., New York: Doubleday, Doran, 1933), 160; "The Man Behind the System," *Personality in Business*, 51.

10 See Degler, *Age of the Economic Revolution*, 124-133, on the anxiety and bankruptcies occasioned by the Panic of 1893; statistics cited here on the frequency and severity of depressions are from Willard Thorp, *Business Annals* (New York: National Bureau of Economic Research, 1926), 31-37; John Roach, in *Report of the Committee [on Education and Labor] of the Senate upon the Relations Between Labor and Capital*, 1885, vol. 1, 1013, cited in Kirkland, *Dream and Thought*, 25; Edwin L. Godkin, "Social Classes in the Republic," *Atlantic Monthly Magazine* 78 (December 1896): 725.

11 Unidentified and undated review [c. 1885] of *The Fog Warning* at the Century Association; undated review of *The Herring Net* at the Carnegie Institute, *Evening Telegraph* (Philadelphia); undated and unidentified review (c.1883) of Homer watercolors exhibited at Doll and Richards Gallery, clippings, Homer Papers, Archives of American Art. For information on exhibitions at the Century Association see Linda Henefield Skalet, "The Market for American Painting in New York: 1870-1915" (Ph.D. diss., Johns Hopkins University, 1981), 79-81. For other interpretations of Homer's fishing pictures see Henry Adams, "Mortal Themes: Winslow Homer," *Art in America* 71 (February 1983): 113-126, and Paul Raymond Provost, "Winslow Homer's *The Fog Warning*: The Fisherman as Heroic Character," *American Art Journal* 22, no. 1 (1990): 20-27. Nicolai Cikovsky, Jr., "Homer Around 1900," in Cikovsky, ed., *Winslow Homer: A Symposium*, vol. 26 of *Studies in the History of Art* (Washington, D.C.: National Gallery of Art, 1990): 137-140, relates Homer's paintings of peril at sea to the voyage of life tradition. *Fog Warning* did sell in the uneasy year of 1893, for $1,500, quite a high price for an oil by Homer at that time, as Goodrich notes (*Homer*, 153). The buyer was Homer's wealthy Boston cousin Grenville Norcross, who gave the painting to the Museum of Fine Arts, Boston, in March 1894. *Lost on the Grand Banks* did not sell until 1900, to John A. Spoor, out of the Knoedler Gallery, for $2,850; see Hendricks, *Life and Work of Winslow Homer*, 243.

12 On Klackner see Beam, *Homer at Prout's Neck*, 96; on Homer's interest in wreck themes see Beam, *Homer in the 1890s*, 139-140. "What Gold Imports Are Costing Us," *Commercial and Financial Chronicle* 57 (August 5, 1893): 200; "Comprehensive Derangement in Business Affairs," *Commercial and Financial Chronicle* 57 (August 26, 1893): 321; Nathaniel C. Fowler, *The Boy: How To Help Him Succeed* (1902; rpt., New York: Moffat, Yard, 1912), 58, 94. *The Iron Crown* was bought by Edward Hooper of Boston; *The Life Line* was purchased immediately for $2,500 by tobacco heiress Catherine Lorillard Wolfe, though Thomas B. Clarke bought it from her sometime during the next three years. Col. George C. Briggs, a friend from Civil War days, purchased *The Signal of Distress*, c. 1896. See Downes, *Life and Work of Winslow Homer*, 126, on Wolfe; Goodrich, *Homer*, 102, on Adams; Barbara Novak and Elizabeth Garraty Ellis, *Nineteenth-Century American Painting in the Thyssen-Bornemisza Collection* (New York: Vendome, 1986), 257-258, on *Signal of Distress*; Beam, *Homer at Prout's Neck*, 149-151, on *The Wreck*. For a psychohistorical interpretation of *The Life Line* and other paintings see Jules Prown, "Winslow Homer in His Art," *Smithsonian Studies in American Art* 1 (Spring 1987): 31-45.

13 Charles Dudley Warner, *A Little Journey in the World* (New York: Harper and Brothers,

1889), 164–165; see Cochran and Miller, *Age of Enterprise,* 147–149, on Gould and the practice of railroad wrecking.

14 "The Financial Situation," *Commercial and Financial Chronicle* 42 (February 13, 1886): 197; See Cochran and Miller, *Age of Enterprise,* 149, on the role played by investment banks in the rescue of wrecked companies.

15 "The National Academy of Design," New York *Tribune,* April 2, 1887. See Goodrich, *Homer,* 102, for details on the purchase of *The Undertow* by Adams; biographical data on Adams is taken from *Dictionary of American Biography* (New York: Charles Scribner's Sons, 1944), Supplement 1: 7, and *National Cyclopedia of American Biography* (New York: James T. White, 1910), 10: 419.

16 Alfred Trumble, "Three Special Exhibitions," *The Collector* 2 (February 1891): 78–79; re- view of Doll and Richards show, the Boston *Herald* [c. 1895], Homer Papers, Archives of American Art; Charles H. Caffin, "A Note on the Art of Winslow Homer," *Bulletin of the Metropolitan Museum of Art, New York* 6 (March 1911): 52.

17 John D. Rockefeller, quoted by Degler, *Age of the Economic Revolution,* 41; Edwin L. Godkin, "The Vanderbilt Memorial," *The Nation* 9 (November 18, 1869): 431–432; on Vanderbilt, *New York Herald,* January 5, 1877, cited in Diamond, *Reputation of the Amer- ican Business Man,* 57; Henry H. Rogers, quoted in William Miller, "The Business Elite in Business Bureaucracies: Careers of Top Executives in the Early Twentieth Century," in Miller, *Men in Business,* 296.

18 Herbert N. Casson, "The Romance of Steel and Iron in America—The Story of a Thou- sand Millionaires, and a Graphic History of the Billion-Dollar Steel Trust," part 9: "Pitts- burgh" (December 1906): 307, and part 7: "J. P. Morgan and the U.S. Steel Corporation," *Munsey's Magazine* 35 (October 1906): 72–73, 77, 92; *Rocky Mountain News* (Denver), April 1, 1913; *Daily Argus-Leader* (Sioux Falls), March 31, 1913; Horace Traubel in *The Conservator* 24 (1913), all cited in Diamond, *Reputation of the American Business Man,* 88–91.

19 *New York Tribune,* April 1, 1913; *Christian Science Monitor* (Boston), March 31, 1913, cited in Diamond, *Reputation of the American Business Man,* 82, 95; Casson, "J. P. Mor- gan and the U. S. Steel Corporation," 72, 85.

20 Speech by Chauncey DePew, October 11, 1897, at Vanderbilt University for the unveiling of its benefactor's statue, quoted in Diamond, *Reputation of the American Business Man,* 52; Wood, *Political Economy of Natural Law,* 135; Frances W. Gregory and Irene Neu, "The American Industrial Elite in the 1870s: Their Social Origins," in Miller, *Men in Business,* 193–211; William Miller, "The Business Elite in Business Bureaucracies," in Mil- ler, *Men in Business,* 292–293. See also Irvin G. Wyllie, *The Self-Made Man in America, the Myth of Rags to Riches* (New Brunswick, N.J.: Rutgers University Press, 1954); Rich- ard Weiss, *The American Myth of Success, from Horatio Alger to Norman Vincent Peale* (New York: Basic Books, 1969).

21 Homer to John W. Beatty, January 12, 1898, cited in Goodrich, *Homer,* 149. Philip C. Beam, *Winslow Homer Watercolors* (Brunswick, Maine: Bowdoin College Museum of Art, 1983), 35, notes that the "highly respectable Walker sisters [Harriet and Sophie]" saw nothing objectionable in *The End of the Hunt* (1892; Bowdoin College Museum of Art), which shows the "seemingly peaceful and harmless aftermath" of slaughter; accordingly, the sisters purchased it in 1892 at an exhibition of Homer's Adirondack scenes at the Doll and Richards Gallery in Boston. Sarah Wyman Whitman, a Boston painter, was also a patron. The model of residual and emergent culture is Raymond Williams's: see *Marx- ism and Literature* (New York: Oxford University Press, 1977), 121–127.

22 Caffin, "Note on the Art of Winslow Homer," 52. Biographical data on Johnson is from *Dictionary of American Biography* (New York: Charles Scribner's Sons, 1957), vol. 5, pt.

1, 106–107; *National Cyclopedia of American Biography* (New York: James T. White, 1918), 16: 421–422. I am much indebted to Abigail Booth Gerdts for helping to sort out the history of Johnson's purchases.

23 Homer to Thomas B. Clarke, March 28, 1892, cited in Goodrich, *Homer,* 130. On Clarke see Linda Skalet, "Thomas B. Clarke, American Collector," *Archives of American Art Journal* 15, no. 3 (1975): 2–7; and H. Barbara Weinberg, "Thomas B. Clarke: Foremost Patron of American Art from 1872 to 1899," *American Art Journal* 8, no. 1 (1976): 52–83. On Evans see William H. Truettner, "William T. Evans, Collector of American Paintings," *American Art Journal* 3, no. 2 (1971): 30–79, also including a checklist of the collection. *Dictionary of American Biography, National Cyclopedia of American Biography* (various volumes and supplements) and *New York Times* obituaries were among the major sources used to build the profile of representative Homer collectors at about the turn of the century. A few other dates follow: Frank Lusk Babbott (1854–1933), William Sturgis Bigelow (1850–1926), George W. Elkins (1858–1919), William T. Evans (1834–1918), Desmond Fitzgerald (1846–1926), Charles Winthrop Gould (1849–1931), Frank Gunsaulus (1856–1921), Emerson McMillin (1844–1922), Burton Mansfield (1856–1932), Thomas Lincoln Manson (1849–1918), George Seney (1826–1893), John A. Spoor (1851–1926), Edward T. Stotesbury (1849–1938).

24 "The Fine Arts," *Boston Evening Transcript,* c. 1895; "Art at the Union League," 1890, clippings, Homer Papers, Archives of American Art; William Howe Downes and Frank Torrey Robinson, "Winslow Homer, N. A.," *The Art Interchange* 32 (May 1894): 137.

25 "Mr. Homer's Water Colors. An Artist in the Adirondacks," Homer Papers, Archives of American Art.

26 David Tatham, "Winslow Homer at the North Woods Club," in Cikovsky, *Winslow Homer: A Symposium,* 115–130; Helen A. Cooper, *Winslow Homer Watercolors* (Washington, D.C.: National Gallery of Art, 1986), 162–195; on the Tourilli Club see Beam, *Winslow Homer Watercolors,* 38–41. Information on average incomes is from Cochran and Miller, *Age of Enterprise,* 261. See also Tatham, *"The Two Guides:* Winslow Homer at Keene Valley, Adirondacks," *American Art Journal* 20, no. 2 (1988): 20–34, and "Trapper, Hunter, and Woodsman: Winslow Homer's Adirondack Figures," *American Art Journal* 22, no. 4 (1990): 40–67.

27 Henry van Dyke, "Au Large," *Scribner's Magazine* 18 (September 1895): 294.

28 Dr. A. T. Bristow, "The Most Healthful Vacation," *World's Work* 6 (June 1903): 3551; John Wheelwright, "Remington and Winslow Homer," *Hound and Horn* 6, no. 4 (July–September 1933): 616.

29 Martin Green, *The Adventurous Male: Chapters in the History of the White Male Mind* (University Park: Pennsylvania State University Press, 1993), 163; Willa Cather, review in *Nebraska State Journal,* March 22, 1896, cited in William M. Curtin, ed., *The World and the Parish: Willa Cather's Articles and Reviews, 1893–1902* (Lincoln: University of Nebraska Press, 1970), 1: 288; Frank Norris, *The Pit, a Story of Chicago* (1903; rpt., New York: Grove Press, n.d.), 269; Frederic Remington, "Black Water and Shallows," *Harper's New Monthly Magazine* 87 (August 1893): 450.

30 *The Wave* (San Francisco), December 9, 1899; Thomas B. Clarke, letter to Charles Rollo Peters, both quoted in Megan Soske, "Charles Rollo Peters: The Prince of Darkness" (M.A. thesis, Indiana University, 1992), 27–28; Gustav Kobbé, "American Art Coming into Its Own," *The Forum* 27 (May 1899): 297–302. Gordon Hendricks, "The Flood Tide in the Winslow Homer Market," *Art News* 72 (May 1973): 69–71, provides an overview of the history of Homer's prices before and after the Clarke sale.

31 "The Lounger," *The Critic* 47 (October 1905): 296.

32 Trevor Fairbrother, *The Bostonians: Painters of an Elegant Age, 1870–1930* (Boston: Mu-

seum of Fine Arts, 1986), 81; Henry Adams to Elizabeth Cameron, January 28, 1901, in J. C. Levenson, Ernest Samuels, Charles Vandersee, and Viola Hopkins Winner, eds., *The Letters of Henry Adams* (Cambridge: Belknap Press of Harvard University Press, 1982), 5: 190; George Cabot Lodge, "Tuckernuck," *Ave Maria,* January 2, 1904, 16–17. On Bigelow see Akiko Murakata, "Selected Letters of Dr. William Sturgis Bigelow" (Ph.D. diss., George Washington University, 1971); T. J. Jackson Lears, *No Place of Grace: Antimodernism and the Transformation of American Culture, 1880–1920* (New York: Pantheon, 1981), 225–234. See Fairbrother, *The Bostonians,* 79–82, for a look at Boston collecting in the context of gender relations during the period; and Sue Welsh Reed, "Watercolor: A Medium for Boston," in Reed and Carol Troyen, *Awash in Color: Homer, Sargent, and the Great American Watercolor* (Boston: Museum of Fine Arts, 1993), xvii–xxi, for profiles of the major Boston collectors of Homer watercolors, including Bigelow.

33 Information on Hooper was culled from a variety of sources, many of them studies or letters of individuals in his circle. Henry Adams's letters (Levenson et al., *Letters of Henry Adams*) make frequent references to Hooper, as do those of Marian "Clover" Hooper Adams, collected in Ward Thoron, ed., *The Letters of Mrs. Henry Adams, 1865–1883* (Boston: Little, Brown, 1936); Edward W. Emerson memoir of Hooper in Mark Anthony DeWolfe Howe, *The Later Years of the Saturday Club, 1870–1920* (Boston: Houghton Mifflin, 1927), 254–261; the file of press clippings and other material on Hooper in the Harvard University Archives; Eugenia Kaledin, *The Education of Mrs. Henry Adams* (Philadelphia: Temple University Press, 1981); Patricia O'Toole, *The Five of Hearts: An Intimate Portrait of Henry Adams and His Friends, 1880–1918* (New York: C. N. Potter, 1990); and Otto Friedrich, *Clover* (New York: Simon and Schuster, 1979). John Chipman Gray's statements are from the typescript of a commemorative piece written for the *Boston Evening Transcript,* July 3, 1901, Edward W. Hooper file, Harvard University Archives, by permission of the Harvard University Archives; Henry Adams to Lucy Baxter, June 12, 1894, in Levenson et al., *Letters of Henry Adams,* 4: 192, refers to himself and friends as "tuskless beasts." See Goodrich, *Homer,* 123, for data on Hooper's purchase of *Huntsman and Dogs* from Reichard. I am grateful to Erica Hirshler for sharing with me information and insights on Hooper that contributed significantly to my understanding of his personality and activity as a collector. Ronald Story, *The Forging of an Aristocracy: Harvard and the Boston Upper Class, 1800–1870* (Middletown, Conn.: Wesleyan University Press, 1980), was useful for abundant information on the constitution of Hooper's social class. Also see Betty G. Farrell, *Elite Families: Class and Power in Nineteenth-Century Boston* (Albany: State University of New York Press, 1993).

34 Homer to Arthur Homer, November 19, 1909, Homer Papers, Archives of American Art, quoted by permission of Bowdoin College Museum of Art, Brunswick, Maine, gift of the Homer Family (1964.69.143); Homer to Downes, August 1, 1909, cited in Beam, *Winslow Homer at Prout's Neck,* 245.

Chapter 7: Performing the Self

1 Even the bibliographic compendia on Whistler are extensive: see Robert H. Getscher and Paul G. Marks, *James McNeill Whistler and John Singer Sargent: Two Annotated Bibliographies* (New York: Garland, 1986), for a comprehensive inventory of previous bibliographic collections. I am indebted to Getscher and Marks for their meticulously annotated references, which help to chart paths through the dense forest of Whistler material. An earlier, different play on the material in this chapter was published as "Old Maverick to Old Master: Whistler in the Public Eye in Turn-of-the-Century America," *American Art Journal* 21, no. 1 (1990): 29–49.

2 The concept of spectacle is associated with Guy Debord, whose *Society of the Spectacle*

(1967; rev. ed., Detroit: Black and Red, 1983) defines the spectacular mode as a culture of images endlessly reproduced and renewed, in the support of an economic and social system critically based on maintaining the cycles of desire and consumption that perpetuate the conditions of the modern marketplace. Although Debord was primarily interested in exposing the mechanisms of spectacle in the twentieth century, its roots date to the nineteenth. See Rachel Bowlby, *Just Looking: Consumer Culture in Dreiser, Gissing, and Zola* (New York: Methuen, 1985), and Stuart Ewen, *All Consuming Images: The Politics of Style in Contemporary Culture* (New York: Basic Books, 1988). Also see H. Barbara Weinberg, Doreen Bolger, and David Park Curry, *American Impressionism and Realism: The Painting of Modern Life, 1885–1915* (New York: Metropolitan Museum of Art, 1994), 36–38, for a brief survey of contrasting artistic self-representations at the turn of the century.

3 "Whistler, Painter and Comedian," *McClure's Magazine* 7 (September 1896): 374–378; "Mr. Whistler as a Witness," *The Critic* 30 (May 22, 1897): 361; Mortimer Menpes, *Whistler as I Knew Him* (London: Adams and Charles Black, 1904), 34–35. Whistler's private life was scrupulously kept from view: at the very time the *McClure's* article was published, Whistler's wife, Beatrice Godwin Whistler, had just died of cancer. So many pictures and caricatures of Whistler were in circulation that Albert E. Gallatin collected and published a catalogue of nearly three hundred; see Gallatin, *Portraits of Whistler: A Critical Study and an Iconography* (New York: John Lane, 1918). Also see Eric Denker, *In Pursuit of the Butterfly: Portraits of James McNeill Whistler* (Washington, D.C.: National Portrait Gallery, 1995).

4 Whistler to the Editor, *The Athenaeum*, no. 1810 (July 5, 1862): 23; Catherine Carter Goebel, "Arrangement in Black and White: The Making of a Whistler Legend" (Ph.D. diss., Northwestern University, 1988), 11, 162–163, 140–142; Thomas Armstrong, *A Memoir* (London: Martin Secker, 1912), 203. I am indebted to Goebel for my understanding of how Whistler mastered the techniques of public relations early in his career.

5 Linda Merrill, *A Pot of Paint: Aesthetics on Trial in Whistler v. Ruskin* (Washington, D.C.: Smithsonian Institution Press, 1992), 279, 161, 252–262.

6 *The Sketch*, January 25, 1879, 2, cited by Goebel, *Arrangement in Black and White*, 550. Other writers have of course recognized Whistler's tactics as part of his publicity-seeking game; see James Laver, *Whistler* (1930; rpt., London: Faber and Faber, 1951), 183: "An artist must have some kind of fame during his lifetime if he is to do his best work. If that is so, then the artist is justified in organizing his own fame if he can, . . . [because] publicity is an essential part of his business."

7 "Varied British Topics," *New York Times*, March 17, 1883; "Whistler's Criticism on the Art of Painting," *The Nation* 38 (June 26, 1884): 549. For detailed discussions of Whistler's exhibition practices see David Park Curry, "Total Control: Whistler at an Exhibition," in Ruth E. Fine, ed., *James McNeill Whistler: A Reexamination*, vol. 19 of *Studies in the History of Art* (Washington, D.C.: National Gallery of Art, 1987), 67–82, and Robin Spencer, "Whistler's First One-Man Exhibition Reconstructed," in Gabriel Weisberg and Laurinda Dixon, eds., *The Documented Image: Visions in Art History* (Syracuse, N.Y.: Syracuse University Press, 1987), 27–49.

8 Whistler to *Pall Mall Gazette*, May 15, 1894; George Du Maurier, *Trilby*, part 3, *Harper's New Monthly Magazine* 88 (March 1894): 577–578.

9 "Trilbyana," *The Critic* 25 (November 17, 1894): 331; "James Abbott McNeill Whistler," *The American Architect and Building News* 22 (November 26, 1887): 259; "Whistler's Own," *The Nation* 51 (August 7, 1890): 116; *Life* 24 (November 8, 1894): 293; Regenia Gagnier, *Idylls of the Marketplace: Oscar Wilde and the Victorian Public* (Stanford: Stanford University Press, 1986), 83.

10 T. J. Jackson Lears, "From Salvation to Self-Realization: Advertising and the Therapeutic Roots of Consumer Culture, 1880–1930," in Richard Wightman Fox and T. J. Jackson Lears, eds., *The Culture of Consumption: Critical Essays in American History, 1880–1940* (New York: Pantheon, 1983), 17–18; Earnest Elmo Calkins and Ralph Holden, *Modern Advertising* (New York: D. Appleton, 1905): 61; Walter D. Scott, "The Psychology of Advertising," *The Atlantic Monthly Magazine* 93 (January 1904): 33–34; Nathaniel C. Fowler, *Building Business: An Illustrated Manual for Aggressive Business Men* (Boston: Trade Co., 1893), 130. Also see T. J. Jackson Lears, "Some Versions of Fantasy: Toward a Cultural History of American Advertising, 1880–1930," *Prospects* 9 (1984): 349–405.

11 Andrew Lang and Paul Bouet [Max O'Rell], "The Typical American," *The North American Review* 150 (May 1890): 590; "The Craze for Publicity," *Century Illustrated Magazine* 51 (February 1896): 631. See Richard Schickel, *His Picture in the Papers: The Culture of Celebrity* (Garden City, N.Y.: Doubleday, 1985), and Leo Braudy, *The Frenzy of Renown: Fame and Its History* (New York: Oxford University Press, 1986).

12 Warren I. Susman, " 'Personality' and the Making of Twentieth-Century Culture," in *Culture as History: The Transformation of American Society in the Twentieth Century* (New York: Pantheon, 1984), 271–285; Ewen, *All Consuming Images,* 76. Susman derived the concept of modal types from Philip Rieff, who introduced it in *The Triumph of the Therapeutic Uses of Faith After Freud* (New York: Harper and Row, 1966). T. J. Jackson Lears discusses the emergence of the discontinuous modern self, defined by mutable and buyable external signs, in *No Place of Grace: Antimodernism and the Transformation of American Culture, 1880–1920* (New York: Pantheon, 1981), 32–47. Ewen, *All Consuming Images,* 57–108, discusses the subject of "image and identity," focusing on the "commodity self" constructed out of consumer goods. While Susman makes a compelling case for the emergence of the "personality" modal type in the early twentieth century, abundant references to personality in the 1880s and 1890s suggest that the transformation was already well under way before the turn of the century. On the issue of self-presentation and self-representation earlier in the century see Karen Halttunen, *Confidence Men and Painted Women: A Study of Middle-Class Culture in America, 1830–70* (New Haven: Yale University Press, 1982), and John F. Kasson, *Rudeness and Civility: Manners in Nineteenth-Century Urban America* (New York: Hill and Wang, 1990).

13 Charles Dudley Warner, "Newspapers and the Public," *The Forum* 9 (April 1890): 203; H. W. Boynton, "Personal," *The Critic* 46 (May 1905): 457–458; Thomas Wentworth Higginson, "The Personality of Emerson," *Outlook* 74 (May 23, 1903): 221–227; Henry C. Lytton, "The Personal Basis of Success," in *Personality in Business*, vol. 9 of *The Business Man's Library,* (Chicago: System Co., 1907), 25; Mariana Van Rensselaer, "Winslow Homer," in *Six Portraits* (1889; rpt., Boston: Houghton Mifflin, 1894), 270; "Notes and Reviews," *The Craftsman* 14 (April 1908): 124.

14 Henry Blake Fuller, "Art in America," *The Bookman* 10 (November 1899): 220; Royal Cortissoz, "Egotism in Contemporary Art," *Atlantic Monthly Magazine* 73 (May 1894): 646; Wilbur Larremore, "Anthropomania," *Atlantic Monthly Magazine* 102 (November 1908): 668–669. For European parallels and precedents in the marketing of art on the basis of individuality and personality rather than the merit or status of the work alone see Nicholas Green, "Dealing in Temperaments: Economic Transformations of the Artistic Field in France During the Second Half of the Nineteenth Century," *Art History* 10, no. 1 (March 1987): 59–78

15 "The Lounger," *The Critic* 26 (March 30, 1895): 247; A. J. Bloor, "Whistler's Boyhood," *The Critic* 43 (September 1903): 253; Frank Fowler, "Whistler—An Inquiry," *Scribner's Magazine* 35 (June 1904): 639; Julian Hawthorne, "A Champion of Art," *The Independent* 51 (November 2, 1899): 2958, 2955; Edmund H. Wuerpel, "My Friend Whistler," *The*

Independent (January 21 1904): 132. On Barnum see Neil Harris, *Humbug; the Art of P. T. Barnum* (Boston: Little, Brown, 1973).

16 For my discussion of La Farge I have relied on Henry Adams, "The Mind of John La Farge," in *John La Farge* (Pittsburgh: Carnegie Museum of Art, 1987), 11–77, and Linnea H. Wren, "John La Farge: Aesthetician and Critic," in *John La Farge* (Pittsburgh: Carnegie Museum of Art, 1987), 225–237; the material quoted here is at 233. H. Barbara Weinberg notes the decline of La Farge's reputation as a painter in the 1890s in "The Decorative Work of John La Farge" (Ph.D. diss., Columbia University, 1972), 441–442; William Howe Downes and Frank Torrey Robinson, "Later American Masters," *The New England Magazine* 14 (April 1896): 137.

17 John La Farge to Russell Sturgis, April 15, 1898, and to Alfred Roelker, August 3, 1905, La Farge Family Papers, Manuscripts and Archives, Yale University Library.

18 Henry Adams, "The Mind of John La Farge," 70; Henry Adams to Royal Cortissoz, May 12, 1911, in J. C. Levenson, Ernest Samuels, Charles Vandersee, and Viola Hopkins Winner, eds., *The Letters of Henry Adams* (Cambridge: Belknap Press of Harvard University Press, 1982), 6: 442–443; Mabel La Farge, "John La Farge. The Artist," *Commonweal* 22 (May 3, 1935): 7.

19 Adams, "The Mind of John La Farge," 70.

20 Marian Hooper Adams to Dr. Robert W. Hooper, June 15, 1879, and July 27, 1879, in Ward Thoron, ed., *The Letters of Mrs. Henry Adams, 1865–1883* (Boston: Little, Brown, 1936), 139, 159; William Crary Brownell, "Whistler in Painting and Etching," *Scribner's Monthly Magazine* 18 (August 1879): 492, 495.

21 N. N. [Elizabeth Pennell], "Mr. Whistler's Triumph," *The Nation* 54 (April 14, 1892): 280; Christian Brinton, "Whistler and Inconsequence," *The Critic* 38 (January 1901): 32; Frank Jewett Mather, Jr., "The Art of Mr. Whistler," *World's Work* 6 (September 1903): 3922–3924. See Margaret F. MacDonald and Joy Newton, "The Selling of Whistler's 'Mother,'" *The American Society Legion of Honor Magazine* 49 (1978): 97–120. Whistler was literally accorded old master rank in George Henry Payne, "A Living Old Master: Whistler Seen at Close Range," *The Saturday Evening Post* 171 (February 25, 1899): 552–553.

22 John C. Van Dyke, "What Is All This Talk About Whistler?" *The Ladies' Home Journal* 21 (March 1904): 10.

23 Gilbert K. Chesterton, "On the Wit of Whistler," in *Heretics,* 13th ed. (1905; rpt., London: John Lane, 1923), 234–246.

24 Theodore Child, "American Artists at the Paris Exposition," *Harper's New Monthly Magazine* 79 (September 1889): 492, 495; Brinton, "Whistler and Inconsequence," 32.

25 Frederick Keppel, "Whistler as an Etcher," *The Outlook* 85 (April 27, 1907): 977, 974; Susan Hobbs, "A Connoisseur's Vision: The American Collection of Charles Lang Freer," *American Art Review* 4 (August 1977): 93; Ernest F. Fenollosa, "The Collections of Mr. Charles L. Freer," *The Pacific Era* 1, no. 2 (November 1907): 62; Leila Mechlin, "The Freer Collection of Art," *Century Illustrated Magazine* 73 (January 1907): 357–359. On Whistler's relations with Freer and on Freer's collecting patterns see Thomas Lawton and Linda Merrill, *Freer: A Legacy of Art* (Washington, D.C.: Freer Gallery of Art, Smithsonian Institution, 1993), and David Park Curry, *James McNeill Whistler at the Freer Gallery of Art* (Washington, D.C.: Freer Gallery of Art, Smithsonian Institution, 1984). Kirk Savage, "'A forcible piece of weird decoration': Whistler and *The Gold Scab,*" *Smithsonian Studies in American Art* 4, no. 2 (Spring 1990): 47, notes that Freer in assembling his huge Whistler collection was also engaged in constructing a purified account of the artist and his achievement.

26 Richard A. Canfield to Royal Cortissoz, December 13, 1908, Royal Cortissoz Papers, Yale

Collection of American Literature, Beinecke Rare Book and Manuscript Library, Yale University; Getscher and Marks, *James McNeill Whistler,* Foreword (n.p.), 127, 149.

27 See Elizabeth Milroy, "Modernist Ritual and the Politics of Display," *Painters of a New Century: The Eight and American Art* (Milwaukee: Milwaukee Art Museum, 1991), 21–58.

Chapter 8: Performing Bohemia

1 The concept and culture of an artistic bohemia had French roots but international ramifications. See especially Jerrold Seigel, *Bohemian Paris: Culture, Politics, and the Boundaries of Bourgeois Life, 1830–1930* (New York: Viking, 1986), which situates bohemia in its place "as part of the history of a developing bourgeois consciousness and experience" (404). Also see Marilyn R. Brown, *Gypsies and Other Bohemians: The Myth of the Artist in Nineteenth-Century France* (Ann Arbor, Mich.: UMI Research Press, 1985), and César Graña and Marigay Graña, eds., *On Bohemia: The Code of the Self-Exiled* (New Brunswick, N.J.: Transaction, 1990). For nineteenth-century American bohemianism Albert Parry, *Garrets and Pretenders: A History of Bohemianism in America* (1933; rev. ed., New York: Dover, 1960), remains indispensable. Jan Seidler Ramirez, "Within Bohemia's Borders: Greenwich Village, 1830–1930," Interpretive Script accompanying an Exhibition at the Museum of the City of New York, 1990, has been particularly useful here; the offspring of this exhibition is Rick Beard and Leslie Cohen Berlowitz, *Greenwich Village: Culture and Counterculture* (New Brunswick, N.J.: Rutgers University Press for the Museum of the City of New York, 1993), which addresses a range of topics, from the physical characteristics and archaeology of Greenwich Village to its people, politics, and culture.

2 William Henry Shelton, "Artist Life in New York in the Days of Oliver Horn," *The Critic* 43 (July 1903): 31–40. On Sarony see Barbara McCandless, "The Portrait Studio and the Celebrity: Promoting the Art," in Martha Sandweiss, ed., *Photography in Nineteenth-Century America* (Fort Worth, Texas: Amon Carter Museum, 1991), 63–75. Smith's *The Fortunes of Oliver Horn* was serialized in *Scribner's,* vols. 30–32 (1901–1902) and published in New York by Collier in 1902.

3 Gilson Willetts, "Workers at Work. V.—F. Hopkinson Smith in Three Professions," *The Arena* 22 (July 1899): 68–70.

4 The same transformation can be seen in the contrast of other youthful self-portraits with their middle-aged counterparts. See, for example, Thomas Hovenden's *Self-Portrait of the Artist in His Studio* (1875; Yale University Art Gallery, New Haven), showing the young painter as a Parisian bohemian with a cigarette and a violin, and the self-portrait (c. 1890; Fine Arts Museums of San Francisco) in which the artist is now neatly groomed and well shorn.

5 See Parry, *Garrets,* 62–94; Ramirez, "Within Bohemia's Borders," 2–20. See Thomas Bender, *New York Intellect: A History of Intellectual Life in New York City, from 1750 to the Beginnings of Our Own Time* (Baltimore: Johns Hopkins University Press, 1987), 206–222, on overlapping literary "bohemias" of the period.

6 Charlotte Adams, "Artists' Models in New York," *Century Illustrated Magazine* 25 (February 1883): 569.

7 W. H. Bishop, "Young Artists' Life in New York," *Scribner's Monthly Magazine* 19 (January 1880): 355–368.

8 Henry Russell Wray, "A Bohemian Art Club," in F. Hopkinson Smith, *Discussions on American Art and Artists* (Boston: American Art League, n.d.), 223–227.

9 Charles Dudley Warner, "The Golden House," *Harper's New Monthly Magazine* 89 (July 1894): 165–168.

10 *Town Topics,* quoted by Trevor Fairbrother, "Notes on John Singer Sargent in New York, 1888–1890," *Archives of American Art Journal* 22, no. 4 (1982): 31. On Carmencita

in New York see Fairbrother, 30–32; Charles Merrill Mount, *John Singer Sargent: A Biography* (1955; rpt., New York: Kraus, 1969), 164–174; Doreen Bolger Burke, *American Paintings in the Metropolitan Museum of Art* (New York: Metropolitan Museum of Art, 1980), 3: 87–89. For Chase's involvement in the Carmencita episodes see Keith L. Bryant, Jr., *William Merritt Chase: A Genteel Bohemian* (Columbia: University of Missouri Press, 1991), 124–126.

11 Edition used: George Du Maurier, *Trilby* (1894; rpt., New York: Harper and Brothers, 1895). Henri Murger's *Scènes de la vie de bohème* (serialized in newspapers in 1845–1846 and published in book form 1851), was one of the most enduring and influential tales to mythologize bohemia as a glamorous world of art, youth, hope, freedom, creativity, and emotional excitement on the margins of society. It was translated into twenty other languages in the decade after its publication and was adapted and revived many times for the stage.

12 Leonée Ormond, *George Du Maurier* (London: Routledge and Kegan Paul, 1969): 477; *Trilbyana* (New York: Critic Co., 1895): 22.

13 *Trilbyana*, 25–26. See L. Edward Purcell, "Trilby and Trilby Mania: The Beginning of the Bestseller System," *Journal of Popular Culture* 11 (Summer 1977): 62–76, and Richard Michael Kelly, *George Du Maurier* (Boston: Twayne, 1983), 119–123. On Sloan and "Twillbe" see William Innes Homer, *Robert Henri and His Circle* (Ithaca: Cornell University Press, 1969), 28.

14 Purcell, "Trilby and Trilby Mania," 65.

15 "Books and Authors. Trilby," *The Outlook* 50 (October 6, 1894): 553.

16 Du Maurier, *Trilby*, 2–3, 66, 79.

17 Du Maurier, *Trilby*, 40, 147–148, 91.

18 "Books and Authors. Trilby," *The Outlook* 50 (October 6, 1894): 553; Barnet Phillips, "Trilby—The Art Side Only," *Harper's Weekly Magazine* 39 (March 9, 1895): 222; " 'Trilby' and Other Novels," *The Nation* 59 (October 25, 1894): 311.

19 "Three English Novels," *The Atlantic Monthly Magazine* 75 (February 1895): 269–270; Frederick Wedmore, "The Stage. 'Trilby,' " *The Academy* 48 (November 9, 1895): 394.

20 [Henry Harland], "A Birthday Letter from the Yellow Dwarf," *The Yellow Book* 9 (April 1896): 15–17; Thorstein Veblen, *Absentee Ownership and Business Enterprise in Recent Times: The Case of America* (New York: B. W. Huebsch, 1923), 320–322.

21 "Recent Fiction," *The Dial* 15 (December 1, 1893): 341.

22 Ulrich Keller, "The Myth of Art Photography: A Sociological Analysis," *History of Photography* 8, no. 4 (October–December 1984): 249–273. Also see Robert Jensen, "Selling Martyrdom," *Art in America* 80, no. 4 (April 1992): 139–144, 175, which examines how commercial galleries capitalized on the artist outcast image, and Jensen, *Marketing Modernism in Fin-de-Siècle Europe* (Princeton, N.J.: Princeton University Press, 1994).

23 J. Carroll Beckwith diary, February 19, September 15, July 8, 1895, J. Carroll Beckwith Papers, microfilm roll 800, Archives of American Art, Smithsonian Institution, Washington, D. C. Mount, *John Singer Sargent*, 160, writes of Sargent's visit to Beckwith during his second American tour. Sargent told Beckwith "of having received a letter from Richard A. C. McCurdy, president of the Mutual Life Insurance Co., asking him to call 'concerning a portrait.' Though he said nothing, the news came as a personal blow to Beckwith, who had painted Mrs. McCurdy and believed he had an understanding with McCurdy himself." When Sargent got the commission, the agreed-upon price was $3,000, more than twice what Beckwith had received for his portrait of Mrs. McCurdy.

24 "Shall Our Young Men Study in Paris? Written by an American Girl after Two Years of Parisian Art Study," *The Arena* 13 (June 1895): 131–134.

25 J. Carroll Beckwith Diary, July 7 and July 10, 1895, Beckwith Papers, Archives of American Art.

26 Willa Cather, review of *Trilby, Nebraska State Journal,* December 23, 1894, cited in William M. Curtin, ed., *The World and the Parish: Willa Cather's Articles and Reviews, 1893–1902* (Lincoln: University of Nebraska Press, 1970), 1: 133; "Trilby," *The Outlook* 50 (September 22, 1894): 457–458.

27 Kelly, *George Du Maurier,* 90–97.

28 Du Maurier, *Trilby,* 6, 9, 16, 114, 204, 355–356. Eve Kosofsky Sedgwick, *The Epistemology of the Closet* (Berkeley: University of California Press, 1990), 193–194, includes *Trilby* among a group of novels, including Henry James's *The Ambassadors* (New York: Harper, 1903), that explore the theme of the bourgeois bachelor in bohemia. For another reading of *Trilby* see Mary Russo, *The Female Grotesque: Risk, Excess, and Modernity* (New York: Routledge, 1994), 129–157.

29 "Behind the Scenes in Bohemia," *The Critic* 7 (June 18, 1887): 305; Willa Cather, review of Clyde Fitch, *Bohemia, Nebraska State Journal,* April 5, 1896, cited in Curtin, *The World and the Parish,* 1: 294–295.

30 Emilie Ruck de Schell, "Is Feminine Bohemianism a Failure?" *The Arena* 20 (July 1898): 68–75.

31 "Freshness of Feeling," *The Outlook* 54 (September 5, 1896): 423; Mary Taylor Blauvelt, "The Artistic Temperament," *Book Buyer* 21 (January 1901): 548; Ramirez, *Within Bohemia's Borders,* 17; James L. Ford, "Luxurious Bachelordom," *Munsey's Magazine* 20 (January 1899): 584.

32 M. H. Vorse, "Bohemia as It Is Not," *The Critic* 43 (August 1903): 178; James L. Ford, "The Froth of New York Society," *Munsey's Magazine* 21 (September 1899): 952–953.

33 H. C. Bunner, "The Bowery and Bohemia," *Scribner's Magazine* 15 (April 1894): 453–454.

34 Matthew Josephson, cited in Parry, *Garrets and Pretenders,* 325–326 See Ramirez, "The Tourist Trade Takes Hold," in Beard and Berlowitz, *Greenwich Village,* 371–391.

35 Parry, *Garrets,* ix–xix, 348.

36 Marsden Hartley, "Albert Pinkham Ryder: The Spangle of Existence" [1936], in Gail R. Scott, ed., *Marsden Hartley: On Art* (New York: Horizon, 1982), 261; Henry Eckford [Charles de Kay], "A Modern Colorist. Albert Pinkham Ryder," *Century Illustrated Magazine* 40 (June 1890): 252; Sadakichi Hartmann, "A Visit to Albert Pinkham Ryder," *Art News* 1 (March 1897): 1–3, cited in *Sadakichi Hartmann Newsletter* 2, no. 3 (Winter 1971): 4–5; Lloyd Goodrich, *Albert Pinkham Ryder* (Washington, D.C.: Corcoran Gallery, 1961), 15. I am indebted to the work of Michael Freeman, "Albert Pinkham Ryder, 'Genius' or Media Hype?" (research paper, Indiana University, Department of Art History, 1993). See Elizabeth Broun, *Albert Pinkham Ryder* (Washington, D.C.: National Museum of American Art, 1990), 134–137, on the Ryder "legend" and its elements. For a challenging alternative view of Ryder see Eric M. Rosenberg, "Albert Pinkham Ryder: A Kinder, Gentler Painter?" *Art History* 14 (March 1991): 129–134. Rosenberg argues that the terms of understanding Ryder—framing him as a primitive, a barbarian, and so forth—were ideologically constructed, "used to render the subject comprehensible and safe for a discourse which clearly valued something in Ryder's art." The production of that discourse, in Rosenberg's view, was to neutralize and domesticate the image and work of a painter whose seemingly chaotic and illegible colorism identified him with the potential for social upheaval and other subversions in the notoriously unstable social climate of the time.

37 See William Innes Homer, "Observations on Ryder Forgeries," *American Art Journal* 20, no. 2 (1988): 35–52, and Broun, *Albert Pinkham Ryder,* 153–163.

Chapter 9: Dabble, Daub, and Dauber: Cartoons and Artistic Identity

1 John Ames Mitchell, "Contemporary American Caricature," *Scribner's Magazine* 6 (December 1889): 735-736, 729.

2 This, along with other anecdotes of Whistler's ego and wit, became so well known that Sadakichi Hartmann did not even feel the need to tell the whole story, merely noting that "we all remember his 'Why drag in Velasquez!' " See Hartmann, *The Whistler Book* (Boston: L. L. Page, 1910), 192. The Velazquez anecdote appears to have been published for the first time in "Two Whistler Stories," *Suffolk Chronicle,* July 26, 1884.

3 Maurice Horn, "Humor Magazines: A Brief History," in Maurice Horn and Richard Marschall, eds., *The World Encyclopedia of Cartoons* (New York: Chelsea House, 1980), 27-28. *Punch's* Charles Keene also produced artist cartoons along the same "Philistine" lines as Du Maurier's. See George Melly, "Jokes About Modern Art," and J. R. Glaves-Smith, "Cartoons and the Popular Image of Modern Art," in *Cartoons About Modern Art* (London: Tate Gallery, 1973), 9-13; 97-101. This mostly visual survey, which begins in the late nineteenth century and proceeds through much of the twentieth, offers abundant evidence of the formulaic and repetitious nature of the art cartoon, in both Europe and America. Glaves-Smith (101) notes, however, that in France there was a tradition dating to the early nineteenth century in which the most academic works were no more exempt from ridicule than were the most progressive. In England and the United States, by contrast, there was a preponderance of antimodernist cartoons.

4 George Du Maurier, "Social Pictorial Satire," *Harper's New Monthly Magazine* 96 (March 1898): 518-520; Richard Ellmann, *Oscar Wilde* (1987; rpt., New York: Vintage, 1988), 238-239. On Du Maurier's conservatism and insecurities see Leonée Ormond, *George Du Maurier* (London: Routledge and Kegan Paul, 1969), 172, 174, 184, 248.

5 The most comprehensive study of *Life* is John Flautz, *Life: The Gentle Satirist* (Bowling Green, Ohio: Bowling Green University Popular Press, 1972). Also see William Murrell, *A History of American Graphic Humor (1865-1938),* vol. 2 (New York: Macmillan, 1938) 93-111; Frank Luther Mott, *A History of American Magazines, 1885-1905* (Cambridge: Belknap Press of Harvard University Press, 1957), 556-568; Horn and Marschall, *World Encyclopedia of Cartoons,* 739-745.

6 Nathaniel C. Fowler, *Building Business: An Illustrated Manual for Aggressive Business Men* (Boston: Trade Co., 1893), 163; Rowland Elzea, "That Was 'Life' (and its artists)," in Dorey Schmidt and Rowland Elzea, eds., *The American Magazine, 1890-1940* (Wilmington: Delaware Art Museum, 1979), 10-11; "By gentlemen, for gentleman," cited in Elzea, "That Was 'Life,' " 11.

7 Murrell, *History of American Graphic Humor,* 2: 121; Thomas L. Masson, "Humor and Comic Journals," *Yale Review* 15 (October 1925): 113-123.

8 On William Henry Hyde see *World Encyclopedia of Cartoons,* 1: 310; on Sterner see *World Encyclopedia of Cartoons,* 2: 258; *Biographical Sketches of American Artists* (Lansing: Michigan State Library, 1915), 297-298. According to Flautz, *Life,* 78, McVickar, like Gibson, was a disciple of Du Maurier but was superseded by Gibson. He published *Society, the Greatest Show on Earth* in 1892. Van Schaick was an active pictorial humorist, supplying drawings for John Kendrick Bangs's first book, *The Lorgnette,* in 1886. See his obituary, *New York Times,* February 27, 1920. On Gibson's experiences at the Académie Julian and relations with Mitchell see Fairfax Downey, *Portrait of an Era as Drawn by Charles Dana Gibson* (New York: Charles Scribner's Sons, 1936), 70, 88. For an illuminating account of the professionalization of illustration at the turn of the century see Michele H. Bogart, "Artistic Ideals and Commercial Practices: The Problem of Status for American Illustrators," *Prospects* 15 (1990): 225-282.

9 Joseph Boskin and Joseph Dorinson, "Ethnic Humor: Subversion and Survival," in Ar-

thur Power Dudden, ed., *American Humor* (New York: Oxford University Press, 1987), 100.

10 Norris W. Yates, *The American Humorist: Conscience of the Twentieth Century* (Ames: Iowa State University Press, 1964), 23-27; circulation figures and audience profile are from John Tebbel and Mary Ellen Zuckerman, *The Magazine in America, 1741-1990* (New York: Oxford University Press, 1991), 68, 76.

11 J. A. B., "The Ridiculous in Art," *Broadway Magazine* 1 (June 1898): 275.

12 Downey, *Portrait of an Era,* 84, records Gibson's longstanding adulation of Du Maurier. On his first trip abroad in 1889, Gibson sought out the English artist and told him: "I draw and you have been my master for years."

13 "In an Art Gallery," *Munsey's Magazine* 8 (November 1892): 234-235.

14 Robert Moore Limpus, "American Criticism of British Decadence" (Ph.D. diss., University of Chicago, 1937), 117.

15 See M. Thomas Inge, "*The New Yorker* Cartoon and Modern Graphic Humor," *Studies in American Humor,* n.s. 3, no. 1 (Spring 1984): 61-73.

Chapter 10: Populist versus Plutocratic Aesthetics

1 John Canaday, "Change of Pace," *New York Times,* April 8, 1962.

2 "About the Studios," *Inter Ocean* [Chicago], November 12, 1893, and *Chicago Tribune,* October 29, 1893, clippings, Thomas Hovenden Scrapbooks, microfilm roll P13, Archives of American Art, Smithsonian Institution, Washington, D.C. (hereafter cited as Hovenden Scrapbooks, Archives of American Art); James McNeill Whistler "The Red Rag" [1878], in Whistler, *The Gentle Art of Making Enemies* (1890; rpt. of 1892 ed., New York: G. P. Putnam's Sons, 1953), 126-128.

3 Unidentified Chicago newspaper, November 11, 1893, clipping, Hovenden Scrapbooks, Archives of American Art; Ernest Poole, "Art and Democracy. First Paper. How the Chicago Art Institute Reaches the People," *The Outlook* 85 (March 23, 1907): 666.

4 "Thomas Hovenden," *Telegraph* (Philadelphia), January 31, 1891; E. E. C. A. (A Dubuque Artist), "Breaking Home Ties," *Dubuque Daily Telegraph,* August 3, 1893; *Sunday Inter Ocean,* May 14, 1893, clippings, Hovenden Scrapbooks, Archives of American Art.

5 Willa Cather, "The Philistine in the Art Gallery," *Pittsburgh Gazette,* November 17, 1901, in William A. Curtin, ed., *The World and the Parish: Willa Cather's Articles and Reviews, 1893-1902* (Lincoln: University of Nebraska Press, 1970), 2: 864-867; Mary E. Wilkins Freeman wrote stories of rustic New England life, rich in homely though unsentimental detail as to speech patterns, customs, and behavior of her homespun characters.

6 Octave Thanet [Alice French], "The Provincials. Sketches of American Types," *Scribner's Magazine* 15 (May 1894): 565-572.

7 Brander Matthews, "Vignettes of Manhattan, IV.—At a Private View," *Harper's New Monthly Magazine* 88 (March 1894): 492-493.

8 Alan Trachtenberg, *The Incorporation of America: Culture and Society in the Gilded Age* (New York: Hill and Wang, 1982), 178-181. See Lawrence Goodwyn, *Democratic Promise: The Populist Movement in America* (New York: Oxford University Press, 1976); also see Michael Kazin, *The Populist Persuasion: An American History* (New York: Basic Books, 1995).

9 See Richard Hofstadter, *The Age of Reform: From Bryant to F. D. R.* (1955; rpt., New York: Vintage, n.d.), 77-81, on Populist anti-Semitism.

10 "Interesting Views," Pittsburgh *Dispatch,* January 20, 1895; *Philadelphia Inquirer,* February 18, 1891, clippings, Hovenden Scrapbooks, Archives of American Art; Thomas Hovenden, "What Is the Purpose of Art?" lecture, 1895, cited in Lee Edwards, "Noble Domesticity: The Paintings of Thomas Hovenden," *The American Art Journal* 19, no. 1

(1987): 23; James McNeill Whistler, "Mr. Whistler's 'Ten O'Clock' " [delivered 1885, published 1888], in Whistler, *Gentle Art of Making Enemies,* 157.

11 Chicago *Tribune,* May 11, 1893, and unidentified Philadelphia newspaper, 1893, clippings, Hovenden Scrapbooks, Archives of American Art.

12 "Impressions on Impressionism," *The Literary Bulletin of South Bend,* February 1895, clipping, Hovenden Scrapbooks, Archives of American Art; Charles M. Stevens [Quondam], *The Adventures of Uncle Jeremiah and Family at the Great Fair* (Chicago: Laird and Lee, 1893), 103–104. See Carolyn Kinder Carr, *Revisiting the White City: American Art at the 1893 World's Fair* (Washington, D.C.: National Museum of American Art and National Portrait Gallery, 1993) for a comprehensive accounting of American works at the fair.

13 "Monthly Record of American Art," *Magazine of Art* 16 (1893): xxv; Isabella Stewart Gardner to Bernard Berenson, September 19, 1896, in Rollin van N. Hadley, ed., *The Letters of Bernard Berenson and Isabella Stewart Gardner, 1887–1924* (Boston: Northeastern University Press, 1987), 66; Edward W. Hooper to General Charles Loring, January 26, 1889, Archives, Museum of Fine Arts, Boston. On the nude in America see William H. Gerdts, *The Great American Nude* (New York: Praeger, 1974); Bailey Van Hook, "Milk White Angels of Art: Images of Women in the Late Nineteenth Century," *Women's Art Journal* 11 (Fall–Winter 1990): 23–29; and H. Wayne Morgan, *Kenyon Cox, 1856–1919* (Kent, Ohio: Kent State University Press, 1994), 70–108. For the antebellum issues concerning the nude see Joy S. Kasson, *Marble Queens and Captives: Women in Nineteenth-Century American Sculpture* (New Haven: Yale University Press, 1990).

14 "Academy of Fine Arts," *Morristown Herald,* February 2, 1891; "Hovenden at Home," *The Times* (Philadelphia), February 23, 1891, clippings, Hovenden Scrapbooks, Archives of American Art. See Anne Gregory Terhune, "Thomas Hovenden (1840–1895) and Late-Nineteenth-Century American Genre Painting" (Ph.D. diss., City University of New York, 1983), and *Thomas Hovenden, 1840–1895, American Painter of Hearth and Homeland* (Philadelphia: Woodmere Art Museum, 1995).

15 Philip Rodney Paulding, "Illustrators and Illustrating," *Munsey's Magazine* 13 (May 1895): 152; H. C. Bunner, "A. B. Frost," *Harper's New Monthly Magazine* 85 (October 1892): 699–706; Fairfax Downey, *Portrait of an Era as Drawn by Charles Dana Gibson* (New York: Charles Scribner's Sons, 1936), 130.

16 Jessie Trimble, "The Founder of an American School of Art," *Outlook* 85 (February 25, 1907): 453–460. Like Gibson and a few other superstar illustrators, Pyle was accorded a full-length biography: Charles D. Abbott, *Howard Pyle: A Chronicle* (New York: Harper and Brothers, 1925). See also Henry C. Pitz, *Howard Pyle: Writer, Illustrator, Founder of the Brandywine School* (New York: Clarkson N. Potter, 1975).

17 Trimble, "Founder of an American School of Art," 455. Popular and successful illustrator Maxfield Parrish also produced scenes featuring nude young women, such as *Daybreak,* which adorned the Edison-Mazda calendar for 1925, but such figures were very much in line with those Van Hook discusses in "Milk White Angels of Art": modest, fairylike, calculated not to offend. The less constrained culture of the 1920s probably helped make them more acceptable than they might have been earlier. Popular entertainment, including art, was of course not always strictly confined to "decency." The fact that Carl Marr's *The Flagellants* (1889; West Bend Gallery of Fine Arts, Milwaukee) was also a popular American picture at the Columbian Exposition suggests the persistence of the fascination with violence, eroticism, and melodrama that has claimed an increasing share of the popular cultural market in the twentieth century.

18 Downey, *Portrait of an Era,* 99, 158, 183, 289; James J. Best, *American Popular Illustration: A Reference Guide* (Westport, Conn.: Greenwood, 1985), 6. Also see Judy L. Lar-

son, *American Illustration, 1890–1925: Romance, Adventure, and Suspense* (Calgary, Alberta: Glenbow Museum, 1986), 20, 31–33, for an overview of illustrators' incomes at the turn of the century.

19 Christian Brinton, "Albert Sterner: An Appreciation and Protest," *Putnam's Monthly Magazine* 2 (July 1907): 399; N. C. Wyeth to Edwin Rudolph Wyeth, December 5, 1943, in Betsy James Wyeth, ed., *The Wyeths. The Letters of N. C. Wyeth, 1901–1945* (Boston: Gambit, 1971), 830. I owe a great debt to the scholarship of Michele H. Bogart, whose groundbreaking study *Artists, Advertising, and the Borders of Art* (Chicago: University of Chicago Press, 1995) has contributed most significantly to my understanding of the history, conflicts, and issues of "commercial" art practice in late-nineteenth and early-twentieth-century America. Much of what I sketch in this section of Chapter 10 is treated in far greater depth and detail in Bogart's book. See Best, *American Popular Illustration*, for a good general introduction to the history of American illustration, with abundant bibliographic citations.

20 Norman Rockwell, *My Adventures as an Illustrator* (New York: Doubleday, 1960), 46–47. Bogart, *Artists, Advertising, and the Borders of Art*, 72–78, vividly demonstrates how thin was the veneer of Rockwell's wholesome small-town image, noting his urban upbringing, his actual interest in modernist ideas, especially those of Picasso, his divorce, his bouts of depression, and his status as a client of psychoanalyst Erik Erikson. The Norman Rockwell Museum is in Stockbridge, Massachusetts. Walter Benjamin should not be forgotten in this discussion. His contention that through mass reproduction an art object lost that dimension of uniqueness and authenticity described by Benjamin as its "aura" opens up another field of inquiry that would lead us in the directions explored by Stuart Ewen in his critique of the empty, morally bankrupt, consumerist image culture that increasingly dominates everyday life; see Ewen, *All Consuming Images: The Politics of Style in Contemporary Culture* (New York: Basic Books, 1988). Here, however, I am interested in shifting the axis of discussion to accommodate the question of reception. See Walter Benjamin, "The Work of Art in the Age of Mechanical Reproduction" [1936], in Hannah Arendt, ed., and Harry Zolin, trans., *Illuminations* (New York: Harcourt, Brace, and World, 1968), 219–253.

21 See Clement Greenberg, "Avant-Garde and Kitsch," *Partisan Review* 6, no. 5 (Fall 1939): 34–49.

22 Frank Fowler, "The Outlook for Decorative Art in America," *The Forum* 18 (February 1895): 686–693.

23 Kenyon Cox, "Puvis de Chavannes," *Century Illustrated Magazine* 51 (February 1896): 569; Edwin H. Blashfield, "Mural Painting in America," *Scribner's Magazine* 54 (September 1913): 356.

24 Edwin H. Blashfield, *Mural Painting in America* (New York: Charles Scribner's Sons, 1913), 97; Bogart, *Artists, Advertising, and the Borders of Art*, 218; Bailey Van Hook, "Clear-Eyed Justice: Edward Simmons's Mural in the Criminal Courts Building, Manhattan," *New York History* 73 (October 1992): 457. In addition to Blashfield's, the other contemporary full-length study of mural painting was Pauline King, *American Mural Painting* (Boston: Noyes, Platt, 1902). Also see Michele H. Bogart, *Public Sculpture and the Civic Ideal in New York, 1890–1930* (Chicago: University of Chicago Press, 1989).

25 Alan Gowans, *The Unchanging Arts: New Forms for the Traditional Functions of Art in Society* (Philadelphia: J. B. Lippincott, 1971), argues the case for regarding commercial art as a legitimate, mainstream form of aesthetic expression and communication rather than as an inferior, degraded art on the periphery of the field dominated by transcendent modernism. Gowans paints his picture in broad strokes, and in ignoring the question of marketing and profit making in the realm of popular culture he tends to idealize the "low" as

much as modernists idealize the "Fine." Since the book's publication, an explosion in popular culture studies has done much to problematize issues in the field. A recent staging of the relation between modernist art and "low" cultural forms is Kirk Varnedoe and Adam Gopnik, *High and Low: Modern Art, Popular Culture* (New York: Museum of Modern Art, 1990). Also see Tom Crowe, "Modernism and Mass Culture in the Visual Arts," in Francis Frascina, ed., *Pollock and After: The Critical Debate* (New York: Harper and Row, 1985), 233–266; and Lawrence W. Levine, *Highbrow/Lowbrow: The Emergence of Cultural Hierarchy in America* (Cambridge: Harvard University Press, 1988), which explores the "sacralization" of culture in the nineteenth century.

26 See "Foremost American Illustrators; the Vital Significance of Their Work," *The Craftsman* 17 (December 1909): 266–280, for a typical representation of Sloan and his colleagues as honest, sincere observer-reporters of the modern American scene. Gowans, *The Unchanging Arts*, 19–20.

INDEX

art organizations, 27–30

Art Students League, 27, 28, 33, 69, 163

art teaching, 27–28

art training: opposition to, 41–42

artistic identity, marks of: beret, 21, 23, 24, 38, 58, 113; cigarette, 37, 335 *n27*; facial hair, 21, 35, 163, 222, 249, 270, 277, 289, 293, 294; long hair, 23, 34, 37, 38, 92, 94, 103, 115, 270; monocle, 101, 102, 103, 223, 290, 344 *n34*; necktie, 21, 23, 163, 291; velvet jacket, 23–24, 34, 35, 92, 94, 113, 162, 289, 290

artistic temperament, 242

artists: as Anglo-Saxons, 19; and businessmen, contrasted, 24–26, 160–161; as children, 267; as cosmopolitans, 34; and critics, 14–16; feminization of, 157–161; and incorporation, 32–34, 38–40, 333 *n10*; and individualism, 41–45; life styles of, 28–30, 34, 252–254, 262–263, 272; physiognomy of, 25–26; population of, 27; and power, 161; as professionals, 35–38, 333 *n4*; as saints, 65; as salesmen, 57–59; and scientists, contrasted, 26; as seeing experts, 123–124, 125–129; territoriality of, 124–125. *See also* bohemia; illustrators; painters; women artists

artists in fiction. *See* Burnett, Frances H.; de Kay, Charles; McPherson, Ewan; Norris, Frank; Smith, F. Hopkinson; *Trilby*; van Dyke, Henry; Warner, Charles Dudley; Wharton, Edith; Zola, Emile. *See also* society painter; women artists

artists' studios. *See* studios

audience for art: conservative values in, 290–291; elite, 146–153; elite vs. popular, 71, 142–143, 154–156; and illustration, 321–322; satirized, 291–298. *See also* taste, popular

Barnum, Phineas T., 98, 231, 237

Baum, L. Frank: *Art of Decorating Dry Goods Windows and Interiors*, 54–55, 56–57

Beard, George M.: *American Nervousness*, 135–136; on eyestrain, 140

Beardsley, Aubrey, 98

Beaux, Cecilia: and Bellows, 185; career of, 172–173; on Homer, 191; reputation of, 3; and Sargent, compared, 173–176, 180–181; and Tanner, compared, 184; as woman artist, 173, 176, 180, 183, 184, 186; womanliness of, 181, 183, 185; *works mentioned: Ernesta*, 180, *180*; *Mrs. Larz Anderson*, 173–174, *174*; *Mrs. Theodore Roosevelt and Daughter*, 174–175, *176*

Beckwith, James Carroll: life style of, 34, 262–263; at Pie Girl Dinner, 87; *Portrait of William Walton*, 35–37, *36*; on sales, 59; and Sargent, 263, 365 *n23*; on teaching, 27; on Wilde, 100, 101; on Zola, 263–264

Bellows, George: artistic vision of, 122; and Beaux, 185; masculinity of, 116, 117; *River Rats,* 122, *132*

Bierstadt, Albert, 49, 131

Bigelow, Sturgis, 213–214

Bishop, W. H.: on bohemian life, 252–253

Blakelock, Ralph Albert, 115

Blashfield, Edwin H.: on decorative art, 69; on mural painting, 324

bohemia: and bachelorhood, 267; commercialization of, 269–270; costume in, 247–248; and difference, 261; ephemerality of, 266, 267; male fellowship in, 266–267; as pretense, 268–269; squalor in, 252; as theater, 254–255; as tourist zone, 252, 253, 260, 269–270; women in, 267. *See also Trilby*

Bok, Edward, 168–169; 353 *n12*

Bouguereau, Adolphe William, 42, 43, 117, 170, 287

Bonheur, Rosa, 170, 184

Brown, J. G., 50

Brownell, William Crary, 238–239, 241

Burnett, Frances H.: "Story of the Latin Quarter," 65, 73

business: and adventure, 209–212; and economic cycles, 193–194; and natural law, 192–193

businessmen, 201–202

Caffin, Charles H.: on aestheticism, 80; background of, 7; on Beaux, 174–175; on Homer, 200–201; on Sargent, 175, 177, 179; on Tryon, 170–171; on Whistler, 134

Canaday, John, 300–302

canon formation, 4

Carleton, C., 292, *292*

Carmencita, 254–255

Carnegie, Andrew, 31, 193

cartoons: audience for, 290–292; conservative values in, 286, 297–298; cultural function of, 286, 291

cartoonists. *See* illustrators

Cassatt, Mary, 3, 181

Cather, Willa: on adventurism, 210; on bohemia, 266; on popular taste, 154–156, 304–307; on *Trilby*, 264; on Whistler, 155–156

celebrity, 233–234

Century Club, 14, 28, 37, 262

Chase, William Merritt, 3; and art for art's sake, 281; bohemian persona of, 21, 248, 254, 261, 266; and Central Park, 127; competency of, 162; fish still lifes, 127; as gentleman, 22–23; as human camera, 127; materialism of, 67–69; and nervousness, 137; professional image of, 34; as radical, 281, 290; sales of, 16; satirized, 21, 280–281, 289; as seeing specialist, 126–127, 130, 133; at Shinnecock, 28, 127; as teacher, 45; as typical

American, 23, 43, 133; vitality of, 151; and Whistler, 69, 71, 72, 73, 74; *works mentioned: In the Studio*, 67–68, *67*; *Near the Beach, Shinnecock*, 127, *127*; *Portrait of Gen. James Watson Webb*, 136–137, *137*; *Portrait of James McNeill Whistler*, 223, *226*

Chase, William Merritt, studio of: described, 50–52; as masculine space, 168; receptions in, 58; sale of, 75

Christie, Howard Chandler, 319

Church, Frederic Edwin, 4, 49, 131, 132, 143; *Sunset*, 131, 143, *131*

Clarke, Thomas B.: background of, 204–205; as collector, 16, 42, 115, 195, 211–212; *1899 sale*, 153, 212

Cleveland Street scandal, 98

Cole, Thomas, 131

collectors. *See* art collectors

color: and emotions, 143–145; taste in, 142–143; as therapy, 142–146

Coman, Charlotte: *Clearing Off*, 171, 172; and feminine expression, 171

commerce: artistic resistance to, 65–66; and culture, 65–66; and degradation of art, 59–62

consumer culture, 60–61

Cook, Clarence, 7

Cortissoz, Royal: background of, 7, 331 *n13*; on Beaux, 180; club memberships of, 14; on egotism, 108; on La Farge, 239; on personality, 235; pessimism of, 86; on Sargent, 179; on Tryon, 149

cosmopolitanism: opposition to, 41–44, 313–315

"cosy corner," 165, 166

Cottier, Daniel, 69, 153

Cox, Kenyon, 290; on color, 145; *A Corner of the Studio*, 32, *33*; as critic, 7, 82; and professionalism, 33–34; on Whistler, 71

Crary, Jonathan, 129–130

critics. *See* art critics

Cropsey, Jasper, 38

Crozier, W. Ray: on artistic personality, 19–20, 45

cultural transmitter, 8–9

culture. *See* incorporation; mass culture; modernism; social class, and aesthetic experience; taste, popular; race

dandyism, 101–102, 162–163. *See also* dudes

Darwin, Charles, 96, 132, 192; and degeneration theory, 80–81

Day, F. Holland, 101, 344 *n32*

degeneration in America, 85–88; antidotes to, 108–110; causes of, 86; denial of, 83, 85; effeminacy and, 101–105; perceptions of, 85–86

degeneration in Europe: American perceptions of, 82–83, 85, 109. *See also* Nordau, Max

de Kay, Charles: *The Bohemian*, 268; on Chase, 127–128; on Ryder, 146

department stores: displays, 53–57; growth of, 53; show windows, 54, 55, 56

Dewing, Thomas Wilmer, 72, 108; anticommercial stance of, 74; and Cortissoz, 14; decorations by, 70–71, 73; as decorator, 69; feminization of, 170; and originality, 42; *The Recitation*, 71, 73, *70*; and the Ten, 168; as womanizer, 73

discipline, bodily, 106–110

Douglas, Mary, 105–106

Downes, William Howe, 14; authority of, 11–12; background of, 7; on Chase, 68–69; gifts from artists to, 15, 332 *n26*; on Inness, 114; on La Farge, 238; response to Homer, 152–153, 216

dudes, 37, 101, 102, 103, 344 *n33*

Du Maurier, George: and aestheticism, 89–92; artistic identity of, 283, 284; career of, 282–283; defends illustrators, 283; influence of, 282; satires on Whistler by, 228–231, 283–284, *90*, *91*, *92*, *93*, *229*, *284*. *See also Trilby*

Durand, Asher B., 129, 132

Eakins, Thomas, 3, 179

Elliott, Charles L.: *Portrait of Jasper Cropsey*, 38

Elwell, F. Edwin, 171–172, 173, 338 *n20*

Ewen, Stuart, 234

eyestrain, 139; art as therapy for, 139–142

fame: manufacture of, 4

feminization: and male artists, 157–161

Fenollosa, Ernest, 156, 243–244

Fitch, Clyde: *Bohemia*, 262; and Wilde, 100

Flower, B. O.: on commerce and art, 46, 60

Fowler, Nathaniel C., 5, 37, 54, 123, 196, 233, 285

Frederic, Harold: *Damnation of Theron Ware*, 166, 185

Freeman, Mary W., 306, 368 *n5*

Freer, Charles Lang: and Dewing, 70, 71, 74; and Whistler, 243–244

Frost, Arthur Burdett, 21, 307–309, 315; authenticity of, 318–319, *21*, *308*

Fry, Roger, 63

Fuller, Henry Blake, 4, 160

Gauguin, Paul, 240

gender roles, 89, 95, 97, 106, 159–160, 178

genius: and androgyny, 169–170, 354 *n14*; and degeneration, 81; and masculinity, 169–170; and neurosis, 81

Gibson, Charles Dana, 3, 288; on aestheticism, 103–104; on Anglomania, 101–102; decency of, 319; and Du Maurier, 293–295, 368 *n12*; income of, 320–321; masculinity of, 113, 294–295; in Paris, 113, 287; at Pie Girl Dinner, 319; power of

expression in, 132, 133; vitality of, 150–151; *works mentioned: Gray, Lowery Day,* 213; *Sunset in the Old Orchard, Montclair,* 150, *151*

interior, domestic: as feminized space, 160, 162; and male control, 167–169; as man trap, 166–167

James, William, 82, 132
James, Henry, 4
Janvier, Thomas, 262

Knight, Daniel Ridgway: *Hailing the Ferry,* 314, *315*
Knoedler Gallery, 48, 49, 188, 191

La Farge, Bancel, 239
La Farge, John, 108, 239, 241; on aesthetic sensation, 134; anticommercialism of, 65, 239–240; color sense of, 143; as critic, 7; as decorator, 69, 168; *Entrance to the Tautira River,* 143, *144*; and Gauguin, compared, 240; and Whistler, compared, 237–239
Lanier, Sidney, 162–163
Lears, T. J. Jackson, 160, 233–234
Life: artists on staff of, 286–287; audience for, 285–286, 290–291; circulation of, 285, 291; ideology of, 284–286
Lombroso, Cesare: *Man of Genius,* 81
Low, Will H., 9, 252; anticommercialism of, 66; as critic, 7; as mural painter, 324–325; and originality, 42; as professional, 32–35; and Salmagundi Club, 28

Mabie, Hamilton Wright, 44, 110; "Sanity and Art," 110
Macbeth Gallery, 153
McCarthy, Kathleen D., 159
McEntee, Jervis, 59
McPherson, Ewan: "Revelation in the Pennyrile," 128
McSpadden, J. Walter: *Famous Painters of America,* 235
McVickar, Harry, 315, 367 *n8*; training of, 286; *316*
Macy's, 53, 54, 65, 239
magazines: audience for, 6; authority of, 11–12; circulation of, 6–7; publishing boom in, 5, 6; specialization in, 6. See also *Life*
man-milliner, 95–96, 109
market for art, 29, 57, 66, 69, 153; and collectors, 16; competition in, 27; European, 58; and tonalist painting, 153–154
Marshall, Henry R.: on aesthetic sensation, 134; on art training, 42; on color, 142–143
masculinity: in artists, 108–109, 112, 113, 115, 295; and bodily discipline, 106–110; and genius, 169–

170; in illustrators, 279, 287–290; and scientific knowledge, 177–178; and surgery, 177–178. *See also* virility
mass culture: and American artists, 2, 4, 5; and art public, 2; and celebrity, 233–234; expansion of, 2, 4; modernism, 326–327; as national art, 326; and power of images in, 12–14
materialism, 60–62
Matthews, Brander, 15, 309, 332 *n27*
Maurer, Alfred: *Arrangement,* 306–307, *306*
mental gymnastics, 140–141, 143
Metropolitan Museum of Art, New York, 9, 35, 286
Millet, Jean-François: *Angelus,* 10–11
Mind Cure, 140, 351 *n31*
Mitchell, John Ames: defense of illustrators by, 279; as *Life* editor, 284–285
Mitchell, S. Weir, 140
modal types, 234
modernism: authority of, 309, 322–324; and mass culture, 326–327; and popular painting, 322–323; values of, 301–302, 304, 324
modernity: Americanism and, 2; and artistic identity, 2; components of, 1; and eyesight, 131
modernization: author's definition of, 2
Moore, Humphrey: studio of, 52, *52*
morbidity, 107–108
Morgan, J. Pierpont, 198, 201–202
mural painting, 324–326
Murger, Henri: *Scènes de la vie de bohème,* 255, 266, 365 *n11*

National Academy of Design, 59, 116, 122
natural law, 192–193
nature: as antidote, 110–112
nervousness: and progress, 136; and social class, 136; symptoms of, 135–136, 137–139
New Thought, 140
New Women, 104–105, 185
Nordau, Max, 111, 115; conservatism of, 82; *Degeneration,* 80–86, 256; on genius, 81; on Wilde, 99
Norris, Frank, 164; *The Octopus,* 192; *The Pit,* 160–161, 201, 210; on virility in art, 162
Norton, Charles Eliot, 60
nude figure painting, 315–318, 369 *n17*

Oakley, Violet, 66
orientalism, 165–167
Osler, William, 178

painters: emasculation of, 287–290; as frauds, 292–297; satirical names for, 287–288
painting: abstract values in, 133; as commodity, 67–68; elimination of narrative in, 133–135, 141;

painting (continued)
and revitalization, 150–152; and sensation, 133–135; as therapy, 141–142, 145–149
painting, popular: characteristics of, 303–304; and modernist canon, 323–324
painting, tonalist, 143–149, 150; market for, 153–154
Paris: American art training in, 34, 41, 113, 163, 172, 287, 313; immorality of, 263
Pène du Bois, 118–119
Pennell, Elizabeth, 241, 244
Pennell, Joseph, 222, 244
perception: and subjectivity, 131–133; theories of, 130–131
personality: in art, 235–236; artistic, 19–20, 45; as commodity, 5; cult of, 4; and modal type theory, 234–236; and morbid egotism, 108
Peters, Charles Rollo: and Clarke, 211; *Nocturnal Landscape with Adobe Building,* 125, *126;* as specialist, 125
Phelps, Elizabeth S., 60
Philadelphia Sketch Club, 253
physiognomy: and artistic identity, 25–26
picture frames, 46–48
Pie Girl Dinner, 86–88, 112
populist aesthetics. *See* painting, popular; taste, popular
Populist Movement, 311–312
professionalism: in art world, 31–34; and modernization, 34; negative connotations of, 38–40
professional-managerial class, 8
progress, 83, 85
publicity: and rise of mass media, 4. *See also* advertising
Punch: ideology of, 282–283
Pyle, Howard: authenticity of, 319; and Salmagundi Club, 28; studio of, 319

race: and culture, 3, 349 *n22*
railroad companies: wrecking of, 196–198
realism: and materialism, 61; opposition to, 61–62; and popular painting, 312
Redfield, Edward: masculinity of, 117; *The Riverbank, Lambertville, New Jersey, 118*
Remington, Frederic: power of images in work of, 12, 13, 14; on sportsmen, 210–211
rest cure, 139–140, 350 *n28*
Richardson, Henry Hobson, 188
Riis, Jacob, 252
robbery-box, 48, 49, 59
Rockefeller, John D., 192, 201
Rockwell, Norman: artistic identity of, 370 *n20; Breaking Home Ties, 322, 323;* and modernist canon, 322, 324; popularity of, 322

Roosevelt, Theodore, 116; strenuous life doctrine of, 106; at Tuckernuck, 213; and Oscar Wilde, compared, 97, 102
Rossetti, Dante Gabriel, 24, 283
Ryder, Albert Pinkham, 3; anticommercialism of, 74–75; authenticity of, 272–273; *Curfew Hour,* 146, *147;* as decorator, 69; eccentricity of, 271–272; and Whistler, 75

Sadler, William: *Worry and Nervousness,* 138–139
St.-Gaudens, Augustus: *Portrait of William Merritt Chase,* 20, 21, *20*
Salmagundi Club, 28–29, 252–253, 266
Santayana, George, 134
Sargent, John Singer, 1, 3, 16, 108, 125; analytical vision of, 177–181; criticized by Fry, 63; imitators of, 39–40; masculinity of, 173, 177–181; materialism of, 62–63; personality of, 235; as society painter, 62–63; surgical skills of, 179–180; *works mentioned:* Boston Public Library murals, 63, 325; *Mrs. Carl Meyer and Her Children,* 1, 175, 180–181, *177; Mrs. George Swinton,* 173–174, *175*
Sarony, Napoleon, 248–249
seeing: as artistic specialty, 123–124, 125–129. *See also* perception
self as commodity, 231, 232, 233–234
self-culture, 307–309
self-made man, myth of, 202–203
self-portraits, 35
sight. *See* perception
Simmons, Edward, 73, 87, 118
Sloan, John: anticommercial stance, 75; revolutionary image of, 2; as *Twillbe,* 256
Smedley, Walter T., 309, *308*
Smith, F. Hopkinson: as artist-tourist, 125; bohemian persona of, 249; commercial success of, 64; *Fortunes of Oliver Horn,* 64, 167–168, 247–249; professional persona of, 249–250
social class: and aesthetic experience, 142–143, 147, 154–156; and nervousness, 135–136, 145–146; in wilderness clubs, 208–209. *See also* taste, popular
Society of American Artists, 27–28, 48, 59
society, high. *See* high society
Society of Illustrators, 287
society painter: corruption of, 63–64; in fiction, 63–64
specialization: and evolutionary progress, 123–124; and modernity, 124–125. *See also* professionalism
Spencer, Herbert: on aesthetic pleasure, 148; on evolutionary progress, 124, 136, 192; influence of, in America, 350 *n28; Principles of Psychology,* 134; *Principles of Sociology,* 124

Whistler (continued)
Falling Rocket, 120, 121; *Nocturne in Blue and Silver,* 71, 73, 72; *Peacock Room,* 69, 227, 237; *The White Girl,* 224

Whistler v. Ruskin trial, 120, 156, 227, 241, 296–297

White, Stanford: as decorator, 168; double life of, 88, 112; murder of, 88; at Pie Girl Dinner, 87; as symbol of depravity, 88, 89; and Tile Club, 29; as womanizer, 73

Whitman, Walt, 163

Wilde, Oscar, 111, 231, 279; American lecture tour of, 92–97; attacks on, 94–95; and Barnum, compared, 98; in caricature, 89–96; conviction and jail term of, 99–100; costume and grooming of, 92, 94; criticism of works by, 98; as degenerate, 99, 100, 101; and effeminacy, 95–96, 99; femininity of, 94; and homophobia, 95–96, 98–100; *Picture of Dorian Gray,* 97–98, 266; and regression, 96; *Salome,* 98; *Vera; or, The Nihilist,* 97; and women, 92–94, 103

Wilde, Willie, 97

wilderness clubs: social aspects of, 208–209

window dressers, 54, 55

women: creativity and, 169

women artists: biases against, 170, 171–172; denigration of, 181–183; domination by men, 160; in fiction, 182–183; population of, 160; seen as mannish, 184

Wood, Henry, 192–193, 202

World's Columbian Exposition, Chicago: and corporate culture, 32, 331 *n17;* decoration of, 34; elite culture and, 307; Hovenden's *Breaking Home Ties* at, 300, 303, 313, 320

wreck: as business metaphor, 195

Wright, Frank Lloyd, 168

Wyant, Alexander: *Eventide,* 145, *145*

Wyeth, N. C.: and artistic identity, 321

Yellow Book, 98, 260, 294, 343 *n27*

Yohn, Frederick C.: studio of, 319, *320*

Zola, Emile: criticism of, 61; *L'Oeuvre,* 263–264